RUSSIA!

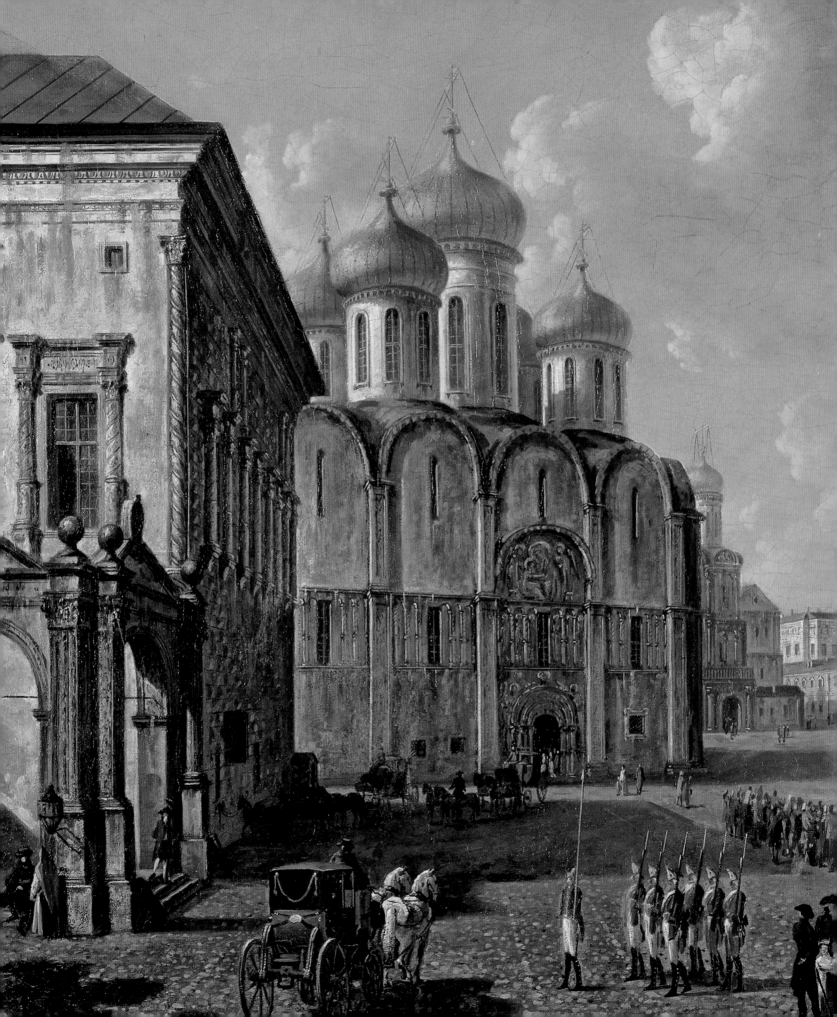

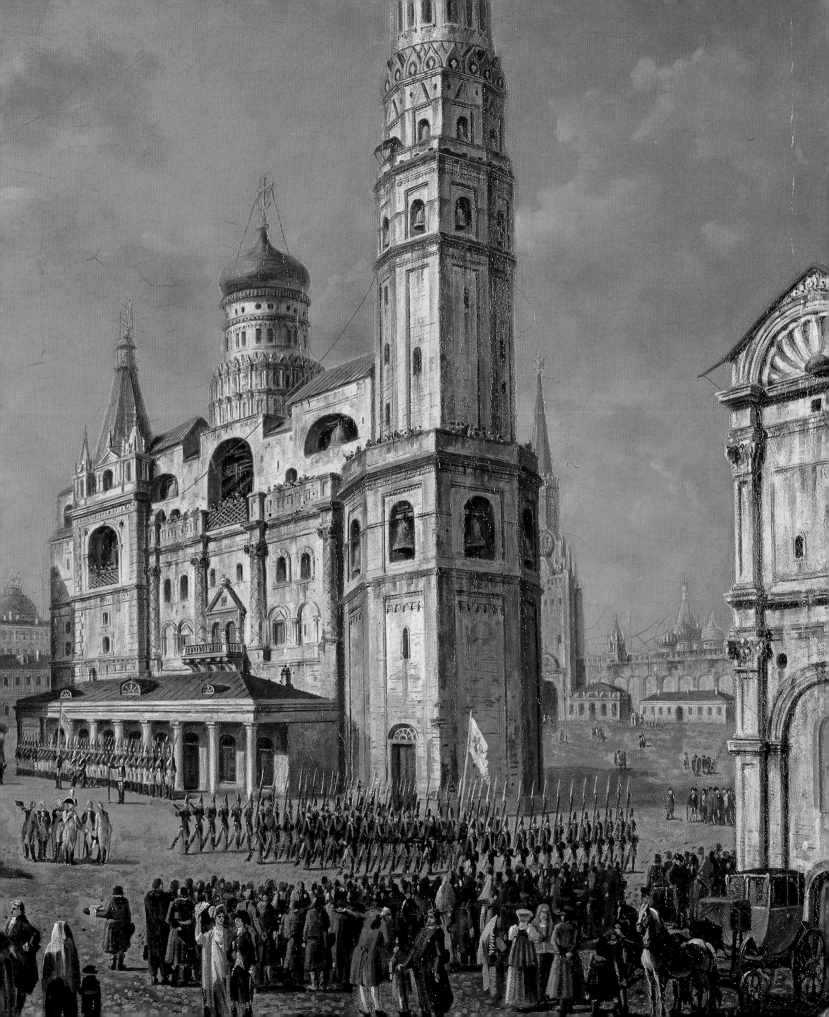

RUSSIA!

NINE HUNDRED YEARS OF MASTERPIECES
AND MASTER COLLECTIONS

Guggenheim MUSEUM

Published on the occasion of the exhibition *RUSSIA!*

Solomon R. Guggenheim Museum, New York
September 16, 2005–January 11, 2006

RUSSIA! © 2005 The Solomon R. Guggenheim Foundation,
New York. All rights reserved.

ISBN 0-89207-329-2 (hardcover)
ISBN 0-89207-330-6 (softcover)

Guggenheim Museum Publications
1071 Fifth Avenue, New York, New York 10128

Available through:
D.A.P./Distributed Art Publishers
155 Sixth Avenue, 2nd floor
New York, New York 10013
Tel.: (212) 627–1999; Fax: (212) 627–9484

Distributed outside the United States and Canada,
by Thames & Hudson, Ltd., 181A High Holborn Road
London WC1V7QX, United Kingdom

Design: Sarah Gephart, mgmt. design
Production: Melissa Secondino, Cynthia Williamson
Editorial: Elizabeth Franzen, David Grosz, Stephen Hoban,
 Edward Weisberger

Printed in Germany by GZD

Front cover: Alexei Venetsianov, *On the Harvest: Summer*, mid–1820s
(detail, plate 82)
Back cover: Gelii Korzhev, *Raising the Banner*, 1957–60 (detail, plate 228)

Pages iv and v: Fedor Alexeev, *Cathedral Square in the Moscow Kremlin*,
1800–02 (detail, plate 70)
Pages xxviii and xxix: Viktor Popkov, *Builders of the Bratsk Hydroelectric
Power Station*, 1960–61 (detail, plate 232)

CONTENTS

RUSSIA!

This exhibition has been realized under the patronage of Vladimir Putin, President of the Russian Federation.

This exhibition has been organized by the Solomon R. Guggenheim Foundation in collaboration with the Federal Agency for Culture and Cinematography of the Russian Federation, State Russian Museum, The State Tretyakov Gallery, State Hermitage Museum, and ROSIZO State Museum Exhibition Center.

This exhibition is made possible by

Major exhibition sponsorship provided by

This exhibition is further made possible by Lazare Kaplan International, Thaw Charitable Trust, The International Foundation of Russian and Eastern European Art, Trust for Mutual Understanding, an indemnity from the Federal Council on the Arts and Humanities, together with the generous support of the RUSSIA! Leadership Committee.

Transportation assistance provided by

Media partner Thirteen/WNET.

Special thanks to the Hermitage Guggenheim Foundation for its assistance with this exhibition.

RUSSIA! LEADERSHIP COMMITTEE

Chairs

Vladimir Potanin, *Chairman of the Board of Trustees of the State Hermitage Museum and Trustee of the Solomon R. Guggenheim Foundation*

William L. Mack, *Chairman of the Solomon R. Guggenheim Foundation*

Honorary Co-Chairs

James A. Baker, III, *Former Secretary of State of the United States*

Lee C. Bollinger, *President, Columbia University*

Andrey Denisov, *Permanent Representative of the Russian Federation to the United Nations*

Elena Gagarina, *General Director, Moscow Kremlin State Museum-Preserve of History and Culture*

Leslie E. Gelb, *President Emeritus, Council on Foreign Relations*

Valery Gergiev, *Artistic and General Director, Mariinsky Theatre*

Jacques Grange, *President, Jacques Grange*

Richard N. Haass, *President, Council on Foreign Relations*

Sergei Lavrov, *Minister of Foreign Affairs of the Russian Federation*

Eugene K. Lawson, *President, U.S.-Russia Business Council*

The Honorable Earle I. Mack

Mikhail Piotrovsky, *Director, State Hermitage Museum*

The Honorable Charles E. Schumer

Mikhail Shwydkoi, *Head, Federal Agency for Culture and Cinematography of the Russian Federation*

Yuri Ushakov, *Ambassador of the Russian Federation to the United States*

Members

Alain J. P. Belda, *Chairman and CEO, Alcoa*

Alexandre P. Gertsman, *President, International Foundation of Russian and Eastern European Art (IntArt)*

Leonid L. Lebedev, *Senator, Federal Assembly of the Russian Federation*

Harvey S. Shipley Miller, *The Judith Rothschild Foundation*

Paul Rodzianko

Mark A. Schaffer, *A La Vieille Russie*

Maurice Tempelsman, *Chairman, Lazare Kaplan International*

Thomas P. Whitney and Faye Dewitt, *The Julia A. Whitney Foundation*

List in formation as of June 29, 2005

LENDERS TO THE EXHIBITION

Central Museum of the Armed Forces, Moscow

Jörn Donner

Alexandre Gertsman

Solomon R. Guggenheim Museum, New York

Hillwood Museum and Garden, Washington, D.C.

International Foundation of Russian and Eastern European Art (IntArt), New York

Ivanovo Regional Art Museum

Kostroma State Unified Art Museum

Kovalenko Art Museum, Krasnodar

Marlborough Gallery, New York

Mead Art Museum, Amherst College

The Metropolitan Museum of Art, New York

Moscow Kremlin State Museum-Preserve of History and Culture

Musée Nationale d'Art Moderne, Centre Georges Pompidou, Paris

Museum für Moderne Kunst, Frankfurt-am-Main

Museum of History and Art, Serpukhov

Museum of History, Architecture, and Art, Kirillo-Belozersk

Pozhalostin Regional Art Museum, Ryazan

Radishchev Art Museum, Saratov

State Hermitage Museum, St. Petersburg

State Historical Museum, Moscow

State Russian Museum, St. Petersburg

The State Tretyakov Gallery, Moscow

XL Gallery, Moscow

Jane Voorhees Zimmerli Art Museum, Rutgers, The State University of New Jersey,
 New Brunswick

Anonymous lenders

**VLADIMIR POTANIN
CHARITY FUND**

The Vladimir Potanin Charity Fund, Russia, is pleased to support *RUSSIA!*, an exhibition of unparalleled scope and significance showcasing masterpieces of Russian art from the thirteenth century to today, as well as works drawn from the magnificent collections of Russian tsars and merchants.

We are proud to support this project, which reveals the character of our Russian nation through its artistic accomplishments. We are hopeful that this cultural exchange will help to strengthen ties between Russia and the United States and to enhance the mutual understanding of our two countries among our people, as well as our leaders.

The opening of *RUSSIA!* has been scheduled to coincide with the sixtieth-anniversary celebration of the United Nations. This coincidence is more than symbolic, as the humanities and cultures of nations have been, and always will be, envoys of peace, much like the UN with its mission to safeguard the world. We hope that this exhibition allows a broad public to discover a new Russia and through our cultural heritage see and appreciate our country in a new light.

We wish to express our sincerest gratitude to the many staff members of the participating museums in Russia, as well as to the Solomon R. Guggenheim Museum, who dedicated their time, expertise, and resources to create this extraordinary exhibition. We are proud to be associated with this historic endeavor.

Vladimir Potanin
Founder, The Vladimir Potanin Charity Fund, Russia

RUSSIA! is an ambitious undertaking. This exhibition began with a conversation I had with Thomas Krens, Director of the Solomon R. Guggenheim Foundation, over three years ago on the balcony of the Peggy Guggenheim Collection in Venice. We envisioned a comprehensive and spectacular presentation of Russian art. The goal of RUSSIA! is nothing less than to reveal the creativity and worldview of a nation through eight hundred years of Russian masterpieces and more than two hundred years of art collecting. This exhibition paints a compelling visual portrait of a nation confronting the travails and triumphs of its history.

The multiplicity and spirituality of Russian culture is represented through the greatest masterworks of Russian painting and sculpture, many of which have never before been exhibited together. The artworks in the show—produced over a period spanning the thirteenth century to the present—are the greatest treasures from our most illustrious museums, including the State Hermitage Museum, the State Russian Museum, the State Tretyakov Gallery, and the Moscow Kremlin State Museum-Preserve of History and Culture, as well as regional museums and private collections in the Russian Federation. This exhibition underscores the perspicacity of Russians as art collectors and as caretakers of some of the most remarkable expressions of world culture through periods of war and peace. Select works from museums and private collections outside of Russia testify to the international significance and appeal of our nation's greatest artistic achievements.

The Federal Agency for Culture and Cinematography is delighted to partner with the Solomon R. Guggenheim Museum in the development and execution of RUSSIA! This landmark exhibition fulfills the agency's mission to nurture and study Russian art and to foster international awareness of our exceptional culture. For almost the entire twentieth century, the work of many of Russia's most talented artists was sealed off from the rest of the world. RUSSIA! offers fresh perspectives and new insight on our culture. What was only seen in fragments will now be presented in sweeping totality. From this unique international collaboration, we will all experience a profound understanding about the Russian nation, the Russian people, and the Russian soul.

Mikhail Shwydkoi
Head of the Federal Agency for Culture and Cinematography of the Russian Federation

SINTEZ

SINTEZNEFTEGAZ Co. is delighted to participate in the Guggenheim Museum's unprecedented exhibition *RUSSIA!* This is the first time that Western audiences are able to see a comprehensive show of Russia's rich heritage of painting and sculpture. Russian culture, and Russian painting in particular, with the exception of icons and the avant-garde, is little known in the West. Yet art is the universal language that transcends all barriers. Through music, literature, theater, and the fine arts, people come to understand and appreciate other cultures and mentalities.

While Russian painters and sculptors created most of the works shown in the Guggenheim exhibition, there are also a number of Western masterpieces on display, which the Russian imperial family acquired in the eighteenth and early nineteenth centuries.

Additionally, the show highlights two of the most avid and discerning collectors of French Impressionist and Post-Impressionist art: two Russian merchants, Sergei Shchukin and Ivan Morozov, who reflected the new evolving breed of the Russian art patron in the late nineteenth and early twentieth centuries. These true connoisseurs of the contemporary art of their time purchased and commissioned works in Paris and built up their collections, which today form the basis of the Impressionist galleries at the Pushkin Museum of Fine Arts in Moscow and the State Hermitage Museum in St. Petersburg. Even before Shchukin and Morozov, though, another such merchant, Pavel Tretyakov, began to assemble a collection of Russian art that forms the basis of the remarkable holdings of the State Tretyakov Gallery, which is celebrating its 150th anniversary in May 2006. Fortunately, nowadays, these long-standing traditions are being revived as more and more Russian corporations and enlightened businessmen begin to appreciate the personal satisfaction and noteworthy national enrichment that comes from their support of the arts.

The Guggenheim, the only major global museum, is the most appropriate venue to provide this unprecedented international exposure for Russian culture. *RUSSIA!* comes to New York as the ambassador of Russian art in time for the sixtieth anniversary of the UN General Assembly. We believe that this exhibition will do more to promote an understanding of Russia internationally than most diplomatic efforts.

Leonid L. Lebedev
Founder of the SINTEZNEFTEGAZ Co.
Senator, Federal Assembly of the Russian Federation

ALCOA FOUNDATION

Alcoa Foundation and Alcoa are proud to sponsor *RUSSIA!*, the most comprehensive and spectacular exhibition of Russian art ever presented in the United States. For most of the twentieth century, the talented work of Russian artists was little known to the outside world, and this gateway to understanding Russian society was largely closed off. A presence in both Russia and New York, we are pleased to sponsor this exhibition and to help offer visitors to the world-renowned Guggenheim Museum in New York City insights about Russian heritage and society that have never before been available without traveling abroad.

As major sponsors of this impressive exhibition spanning eight hundred years of Russian culture, we hope *RUSSIA!* will foster a dialogue. The arts challenge all of us to explore new and diverse perspectives—a value that Alcoa promotes as 131,000 individuals across the globe and collectively as Alcoa. When we view the history of Russia through the lens of its great artists, may their spirit of innovation and quest for excellence be an inspiration to us all.

In sharing these guiding principles, Alcoa Foundation and Alcoa are honored to partner with the Solomon R. Guggenheim Foundation to present *RUSSIA!*, thus telling the remarkable and interconnected history of Russia through its art.

Alain J. P. Belda
Chairman and CEO, Alcoa

FOREWORD

RUSSIA!—the most comprehensive exhibition of Russian art since the end of the Cold War—
was initially conceived three years ago during a conversation in Venice with my longtime
friend Mikhail Shwydkoi, then the Minister of Culture, now the Head of the Federal Agency
for Culture and Cinematography of the Russian Federation. The exhibition is timed to open
during the sixtieth anniversary of the United Nations, and we are deeply honored that
Russian Federation President Vladimir Putin has agreed to be its official patron.

During my discussion with Mr. Shwydkoi, we talked about the Guggenheim's long
history of organizing major exhibitions of the Russian avant-garde. In 1981, the Guggenheim
mounted the first presentation of George Costakis's extraordinary collection of avant-garde
art, which at that time had been seen outside the Soviet Union only once. This show helped to
introduce audiences to the rich achievements of the generation of artists whose experimental
art of the first decades of the twentieth century looks fresh to this day. In 1992, we opened the
expansive survey *The Great Utopia: The Russian and Soviet Avant-Garde, 1915–1932*, which explored
multiple facets of the avant-garde's art production, including not only painting and sculpture,
but also architecture, design, decorative arts, textiles, photography, and film. At this same
time, we presented an exhibition at the Guggenheim Museum SoHo of Marc Chagall's renow-
ned murals of 1920 for the Jewish Chamber Theater in Moscow, which had been rolled up in
storage since 1950 in the State Tretyakov Gallery. In 2000, we revisited the Russian avant-garde
with *Amazons of the Avant-Garde*, a show that highlighted the remarkable achievements of a
group of women artists. In 2003, we turned our attention to *Kazimir Malevich: Suprematism*, the
first exhibition to focus exclusively on this defining moment in Malevich's career.

During our conversation, Mr. Shwydkoi and I discussed the origins of the avant-garde,
as well as the fact that the art produced between the age of the icon and the early twentieth
century—in other words the art of the eighteenth and nineteenth centuries—remained vir-
tually unknown outside Russia. We also noted that the complex history of Soviet art, which
spans nearly fifty years, had not been adequately presented to the public. It became clear to
us that the best way to redress this situation would be to organize an exhibition that included
the greatest Russian masterworks from the thirteenth century to the present, which encom-
pass five centuries of icons; portraiture in both painting and sculpture from the eighteenth
through the twentieth centuries; critical realism in the nineteenth century as well as Socialist
Realism of the Communist era; landscapes through the centuries; pioneering abstraction;
and experimental contemporary art. We also thought this show should account for another
very important aspect of Russian culture, the great imperial and merchant collections of
Western art, which testify simultaneously to the discriminating taste and daring of Russian
art collectors, the discernible influence of these outstanding collections on the development
of Russian art, and the special relationship between Russia and the West. Thus the concept for
RUSSIA! was born.

Hard work lay ahead of us, but it became much easier once we assembled a remarkable
team of Russian and American curators. At the Guggenheim, we turned to Robert Rosenblum,

the Stephen and Nan Swid Curator of Twentieth-Century Art, and Valerie Hillings, Curatorial Assistant. In Russia, we enlisted our longstanding friends Evgenia Petrova, Deputy Director and Chief Curator of the State Russian Museum; Pavel Khoroshilov, Deputy Head, Department of Mass Communication, Culture, and Education of the Government of the Russian Federation; and Zelfira Tregulova, Deputy Director for Exhibitions and International Exchange, Moscow Kremlin State Museum-Preserve of History and Culture. We also engaged Lidia Iovleva, First Deputy Director for Scientific Work at the State Tretyakov Gallery; Anna Kolupaeva, Head of the Administration for Cultural Heritage, Art Education and Science, Federal Agency for Culture and Cinematography of the Russian Federation; and Georgii Vilinbakhov, Deputy Director, the State Hermitage Museum. Together, this group developed an unprecedented selection of the greatest masterworks in Russian art history.

The curatorial team has secured loans from Russia's greatest museums—the State Russian Museum, the State Tretyakov Gallery, the State Hermitage Museum, and the Moscow Kremlin State Museum-Preserve of History and Culture—as well as regional museums, private collections, and a select number of museums and private collections outside of Russia. We are especially grateful to our friends Vladimir Gusev, General Director, State Russian Museum; Valentin Rodionov, General Director, The State Tretyakov Gallery; Mikhail Piotrovsky, Director, State Hermitage Museum; and Elena Gagarina, General Director, Moscow Kremlin State Museum-Preserve of History and Culture, for their major collaboration to this project. We would also like to acknowledge ROSIZO State Museum Exhibition Center, and in particular Evgenii Ziablov, General Director; Alexander Sysoyenko, First Deputy General Director; Victoria Zubravskaya, Head of the Exhibition Department; and Olga Nestertseva, Chief Curator, for their help with the regional loans and logistical support for the show.

A significant number of remarkable artworks have either rarely or never traveled abroad, notably: icons by the fifteenth-century painter Andrei Rublev and the sixteenth-century painter Dionysii; icons from the Deesis Tier of the Kirillo-Belozersk Monastery; Ivan Aivazovsky's epic seascape *The Ninth Wave* (1850); Vasily Perov's introspective portrait of Fedor Dostoevsky (1872); Ilya Repin's iconic *Barge Haulers on the Volga* (1870–73); Mikhail Vrubel's haunting Symbolist masterpiece *Lilacs* (1900); Valentin Serov's painting of the myth of the *Rape of Europa* (1911); and Kazimir Malevich's *Black Square* (ca. 1930) from the Hermitage.

The unique architecture of the Guggenheim's Frank Lloyd Wright building has played a key role in the conception of the show, which consists of a series of chapters that unfold chronologically from the bottom to the top of the museum: medieval Russia (the age of the icon, thirteenth–seventeenth centuries), the eighteenth century (the age of Peter the Great and Catherine the Great, including both Russian art and imperial collections of Western art), the nineteenth century (academic art and Romanticism in the first half of the century and critical realism in the second half), the early twentieth century (the collections of Sergei Shchukin and Ivan Morozov and the historic avant-garde), the 1930s through 1960s (Soviet), and art from 1970 to the present (post-Soviet). One additional chapter is being presented concurrently at the Guggenheim Hermitage Museum in Las Vegas, *The Majesty of the Tsars: Treasures from the Kremlin Museum*, which brings the spectacular world of the tsars of pre-Petrine Russia to life through masterful objects of the sixteenth and seventeenth centuries.

The designer for the New York exhibition, the renowned interior decorator Jacques Grange, selected a palette reflective of Russian palaces and museums: taupe, green, blue, gray, and white, which move in tandem with the chronological chapters of the exhibition. He has created two particularly evocative spaces. In the High Gallery, he invokes the reverence of Russian Orthodox churches through two ancient Russian chandeliers from the State Russian Museum, and a display wall suggestive of an iconostasis, which separates the congregation from the holy space behind it. With the imperial collections, he transports the viewer into another time and place—namely the Hermitage—through color and fabric.

The complexity of this exhibition presented unusual challenges, and its realization is the result of the work of all the departments of the Guggenheim Museum. We would like to acknowledge in particular Jessica Ludwig, Director of Planning and Implementation, New York, and Valerie Hillings, who together have coordinated all aspects of this project. Special thanks must go to Nicolas Iljine, Director of Corporate Development Europe and Middle East, whose tireless and passionate work played a major role in the successful realization of this project.

An exhibition of this magnitude would not be possible without the generous support of our sponsors. Chief among them is the Vladimir Potanin Charity Fund, Russia. Over the last three years, I have had the privilege of getting to know Vladimir Potanin as a member of our board of trustees and the chairman of the Hermitage's board of trustees. He has repeatedly demonstrated his dedication to culture and, in particular, to the preservation and celebration of Russian art, as evidenced by his 2002 gift to the State Hermitage Museum of Malevich's *Black Square*, which is included in this exhibition. We are deeply indebted to the Vladimir Potanin Charity Fund for encouraging our efforts and supporting this endeavor from its earliest stages. In addition to Mr. Potanin, we would like to acknowledge Larisa Zelkova, General Director; Natalia Samoilenko, Acting Director; and Liudmila Burashova, Head of the Press Department; as well as Lev Belousov, Director of the Department of International Programs of the Interros Holding Company.

Our major corporate sponsors, Alcoa and SINTEZNEFTEGAZ have expressed their deep commitment to promoting an understanding of Russian heritage and culture through their generous support of this exhibition. In particular, I would like to thank Alain J. P. Belda, Chairman and CEO of Alcoa, for his steadfast enthusiasm for this project. In addition, both Barbara Jeremiah, Executive Vice President, Corporate Development, and Jake Siewert, Vice President, Global Communications and Public Strategy, at Alcoa, as well as Kathleen Buechel, Director of the Alcoa Foundation, have been instrumental in creating a successful partnership between Alcoa and the Guggenheim. The assistance provided by SINTEZNEFTEGAZ has proved invaluable to our ability to share this remarkable culture with our New York audience. We are further indebted to Senator Leonid L. Lebedev, Federal Assembly of the Russian Federation, for his inspired commitment to this exhibition.

The Federal Agency for Culture and Cinematography—especially Mikhail Shwydkoi, its Head, and Anna Kolupaeva, Head of the Administration for Cultural Heritage, Art Education and Science—deserves special recognition for its role in making this exhibition possible. The agency was vitally important in facilitating the Guggenheim's relationships with the Russian

museums involved in this project, and served as our key advocate in Russia in helping to coordinate many of the logistical, on-the-ground arrangements. Our appreciation goes as well to Aeroflot for much needed transportation assistance, with special thanks to Valery M. Okulov, Director General, and Lev S. Koshlyakov, Deputy Director and Head of the Communications Department, and to Stella Kay, Head of the New Art Foundation, for her logistical support. We would also like to thank the individuals of the *RUSSIA!* Leadership Committee, as well as participating sponsors Lazare Kaplan International, Thaw Charitable Trust, and the Trust for Mutual Understanding for providing additional support critical to making this exhibition possible. Finally, we are grateful to our media partner, Thirteen/WNET, for its help in promoting the exhibition to a broad audience.

We would additionally like to acknowledge the support of various representatives of the government of the Russian Federation, in particular Ambassador Andrei Denisov, Permanent Representative of the Russian Federation to the United Nations; Consul General Sergei Garmonin, Consulate General of the Russian Federation in New York; Ambassador Yuri Ushakov, Embassy of the Russian Federation, Washington, D.C.; and Dmitry M. Amunts, Deputy Minister of Culture and Mass Communications of the Russian Federation. We would also like to thank our longtime friend, Leonid Bazhanov, Head of the State Contemporary Art Center, Moscow. We would also like to recognize Alexander Musienko, Counselor, Permanent Russian Mission to the United Nations; Mikhail Pronin, Vice-Consul, Consulate General of the Russian Federation; Boris Marchuk, Senior Counselor, Embassy of the Russian Federation; and Irina Popova, Cultural Attaché, Embassy of the Russian Federation. In the United States Government, we thank Laurence D. Wohlers, Minister Counselor for Public Affairs, and James J. Kenney, Cultural Attaché, United States Embassy, Moscow; Ambassador John Tefft and Jennifer Sheap, United States Department of State; and Rosemary DiCarlo and Richard Phillips, National Security Council.

Due to the tireless efforts and generosity of so many individuals and organizations, the Guggenheim is pleased to present this historic exhibition, which reveals the vast and complex historical phenomenon embodied by the simple word *RUSSIA!* The spectacular art in this show demonstrates not only the richness of Russian art and collections, but also the enduring and significant place it has within the history of world art. And it represents the culmination of the Guggenheim's nearly twenty-five-year commitment to celebrating the artistic achievements of this great nation.

Thomas Krens
Director, Solomon R. Guggenheim Foundation

CURATORIAL ACKNOWLEDGMENTS

While the nine members of our curatorial team represent different nationalities, genders, generations, fields of expertise, institutions, and experiences, we are firmly united in our conviction that *RUSSIA!* is an exhibition of the greatest historical significance. In the aftermath of the Cold War, many important Russian-American cultural projects have been realized—and many of us have participated in them—but none has been as ambitious in scope and quality as this show, which definitively demonstrates that Russia's contributions to art history include but also extend far beyond icons and the historic avant-garde. The official patronage of Vladimir Putin, President of the Russian Federation, underscores the importance of this exhibition.

Each of us added something unique to the development of the checklist and the realization of *RUSSIA!* Our colleagues Lidia Iovleva and Evgenia Petrova deserve special recognition, as they formed the core leadership of the team. Drs. Iovleva and Petrova generously shared their vast knowledge of the amazingly rich collections of their respective museums, the State Tretyakov Gallery and the State Russian Museum, which are the leading museums of Russian art in the world. They offered the presentation concept of Russian art from the eighteenth century to the early twentieth century for this exhibition and contributed to the acquisition of artworks from both museums.

RUSSIA! invites visitors to embark on an exciting journey that spans hundreds years of art and of art collecting. Thus the show testifies to the determined and accomplished creative spirit of the Russian people throughout the nation's tumultuous history. And it highlights both their passionate, foreword-looking art collecting and commitment to preserving the greatest artistic treasures, even in the face of the Great Patriotic War (as World War II is known in Russia).

This show is above all the result of collaboration between the Solomon R. Guggenheim Museum and the three most important museums in the Russian Federation, the State Hermitage Museum and the State Russian Museum in St. Petersburg and the State Tretyakov Gallery in Moscow. We would like to acknowledge the directors of these distinguished institutions, Mikhail Piotrovsky, Vladimir Gusev, and Valentin Rodionov, respectively, who, along with our fellow curator and Guggenheim Director Thomas Krens, have provided leadership for this complex project.

As evidenced by the Project Team list that follows, there are many individuals who contributed to the success of *RUSSIA!* We would like to give special recognition to those whose constant support allowed us to accomplish the challenging tasks at hand. At the State Hermitage Museum, we thank Vladimir Matveyev, Deputy Director for Exhibitions and Development, and Olga Ilmenkova, Head of the Exhibition Department, and we are grateful for the tireless efforts of Anna Konivets, Coordinator of the Hermitage-Guggenheim Program, and Anastasia Mikliaeva, Head of the Section for Rights and Reproductions Office. At the State Russian Museum, we would like to acknowledge Ivan Karlov, Deputy Director for Inventorization, Storage, and Restoration, and Evgeny Soldatenko, Chief Restorer, for

their support of this project and organization of restoration; as well as Pavel Rosso, Head of the Exhibitions Department; Elena Tyun, Specialist of the Department of Exhibitions Projects; Anna Laks, Head of the Publishing Department; Joseph Kiblitsky, Art Director, Palace Editions; Tatyana Melnik, Specialist of the Publishing Department; and especially Marina Panteleymon, Head of the Department of External Relations. At the State Tretyakov Gallery, we wish to express our gratitude to Ekaterina Selezneva, Deputy Director and Chief Curator; Tatiana Gubanova, Head of the International Department; and Liudmila Izyumova, Head of the Photo Library.

Other museums, private collections, and galleries in Russia, Europe, and the United States generously contributed to the realization of this exhibition, and we greatly appreciate their participation in this project. For their assistance with the shipping and crating for the show, we acknowledge Pavel Rosso of Hasenkamp-SRM, Igor Filatov of John Nurminen CiS, Alexander Ursin of Joint Stock Company VkhPO, and Vladimir Ejakov of "VKHUTEMAS XXI CENTURY" Ltd. We would like to recognize ROSIZO State Museum Exhibition Center, and in particular Olga Nestertseva, Chief Curator, for their major role in coordinating all of the loans from regional museums in Russia and providing on behalf of the Federal Agency for Culture and Cinematography general organizational support of the project.

We also want to thank the superlative authors who contributed essays to this catalogue. Librarian of Congress James Billington has long been one of the most important authorities on Russian cultural history, making him the ideal author for the introduction. Mikhail Shwydkoi generously shared his reflections on Russian culture, a subject he is intimately familiar with, having received a Ph.D in art history, and having served previously as the Minister of Culture of the Russian Federation and presently as Head of the Federal Agency for Culture and Cinematography of the Russian Federation. In addition to four members of our curatorial team who contributed essays in their areas of expertise—Valerie Hillings, Lidia Iovleva, Evgenia Petrova, and Robert Rosenblum—we are honored to present texts by Gerold Vzdornov, Mikhail Allenov, Sergei Androsov, Albert Kostenevich, Dmitry Sarabianov, Boris Groys, Ekaterina Degot, and Alexander Borovsky.

Many individuals at the Guggenheim contributed to the success of this exhibition. Meryl Cohen, Director of Registration and Art Services, headed the outstanding staff of the Registrar Department, who shepherded us through Indemnity, Immunity from Seizure, and the extremely complex shipping arrangements for this show. We would like to recognize Jeri Moxley, who repeatedly helped us to find database solutions to facilitate our work. We would also like to extend particular recognition to Ana Luisa Leite, Manager of Exhibition Design, and Carolynn Karp, Exhibition Design Coordinator, who collaborated with us and designer Jacques Grange on all aspects of the design and installation. All of our efforts would have been for naught without the resources made available through the hard work of the Guggenheim's Development Department. We would like to echo Thomas Krens's thanks to Nic Iljine, Director of Corporate Development, Europe and the Middle East, who is a long-time friend of the members of this team and a truly dedicated supporter of Russian art.

In addition, we would like first and foremost to acknowledge Masha Chlenova, Project Research Assistant, New York, and Maria Khitryakova, Project Research and Administrative

Assistant, Moscow. They worked endlessly to assist us on so many aspects of the project and always did so with a positive attitude, sense of humor, and remarkable intelligence. Guggenheim curators Lisa Dennison, Nancy Spector, Susan Davidson, and Tracey Bashkoff gave invaluable input. Outside the Guggenheim, a number of curators also offered important counsel, chief among them Alexander Borovsky, Head of the Department of Contemporary Art at the State Russian Museum, and Alla Rosenfeld, Senior Curator of Russian and Soviet Nonconformist Art, Jane Voorhees Zimmerli Art Museum. Teresa Mavica, Art Director, Stella Kay Gallery, Moscow, also provided assistance. Finally, we are grateful for the dedicated work of three interns, Megha Gupta, Maeve O'Donnell-Morales, and Scott Niichel, and for the ongoing support of members of the Director's Office: MaryLouise Napier, Deputy Chief of Staff; Katerina Bernstam, Assistant to the Director; and Sarah Cooper, Administrative Assistant.

Among the most challenging aspects of this project were this vast, beautifully produced, and scholarly publication, and a second book, *RUSSIA! Catalogue of the Exhibition at the Solomon R. Guggenheim Museum, New York, and the Guggenheim Hermitage Museum, Las Vegas*, which contains illustrated entries for every object in both exhibitions. Elizabeth Levy, Director of Publications, led a remarkable, dedicated staff that included Elizabeth Franzen, Managing Editor; Edward Weisberger, Editor; David Grosz, Associate Editor; Stephen Hoban, Assistant Managing Editor; Melissa Secondino, Production Manager; and Cynthia Williamson, Associate Production Manager; to them we say a sincere thank you. Additionally, project editors Catherine Bindman and Jean Dykstra and translators Antonina Bouis, David Riff, and Julia Trubikhina have our gratitude for working to meet tight deadlines. In Russia, we would like to acknowledge Sergei Obikh, Izdatelstvo Severnii Palomnik, who photographed the iconostasis of the Kirillo-Belozersk Monastery, as well as Alexander Lavrentyev, who provided valuable photographic material for the catalogue.

As these lengthy acknowledgments demonstrate, *RUSSIA!* could never have happened without the contributions of a plethora of people. Nonetheless, we may inadvertently have forgotten to name some of those who helped with this historic project; to them we extend both our apologies and heartfelt thanks.

Thomas Krens, *Director, Solomon R. Guggenheim Foundation*
Robert Rosenblum, *Stephen and Nan Swid Curator of Twentieth-Century Art, Solomon R. Guggenheim Museum*
Evgenia Petrova, *Deputy Director and Chief Curator, State Russian Museum*
Lidia Iovleva, *First Deputy Director for Scientific Work, The State Tretyakov Gallery*
Pavel Khoroshilov, *Deputy Head, Department of Mass Communication, Culture, and Education of the Government of the Russian Federation*
Anna Kolupaeva, *Head of the Administration for Cultural Heritage, Art Education and Science, Federal Agency for Culture and Cinematography of the Russian Federation*
Zelfira Tregulova, *Deputy Director for Exhibitions and International Exchange, Moscow Kremlin State Museum-Preserve of History and Culture*
Georgii Vilinbakhov, *Deputy Director, State Hermitage Museum*
Valerie Hillings, *Curatorial Assistant, Solomon R. Guggenheim Museum*

PROJECT TEAM

CURATORIAL

Guggenheim Museum
Thomas Krens, *Director*
Robert Rosenblum, *Stephen and Nan Swid Curator of Twentieth-Century Art*
Valerie Hillings, *Curatorial Assistant*
Masha Chlenova, *Project Research Assistant*
Megha Gupta, *Intern*
Maeve O'Donnell-Morales, *Intern*
Scott Niichel, *Intern*

Russian Federation
Lidia Iovleva, *First Deputy Director for Scientific Work, The State Tretyakov Gallery*
Pavel Khoroshilov, *Deputy Head, Department of Mass Communication, Culture, and Education of the Government of the Russian Federation*
Anna Kolupaeva, *Head of the Administration for Cultural Heritage, Art Education and Science, Federal Agency for Culture and Cinematography of the Russian Federation*
Evgenia Petrova, *Deputy Director and Chief Curator, State Russian Museum*
Zelfira Tregulova, *Deputy Director for Exhibitions and International Exchange, Moscow Kremlin State Museum-Preserve of History and Culture*
Georgii Vilinbakhov, *Deputy Director, State Hermitage Museum*
Maria Khitryakova, *Project Research and Administrative Assistant, Moscow*

GUGGENHEIM MUSEUM

Executive Staff
Thomas Krens, *Director*
Lisa Dennison, *Deputy Director and Chief Curator*
Anthony Calnek, *Deputy Director, Communications and Publishing*
Judith Cox, *Deputy Director, Special Projects*
Marc Steglitz, *Deputy Director, Finance and Operations*
Gail Scovell, *General Counsel*

Art Services and Preparations
Scott Wixon, *Manager of Art Services and Preparations*
Barry Hylton, *Senior Exhibition Technician*
Derek DeLuco, *Technical Specialist*
Mary Ann Hoag, *Lighting Designer*

Conservation
Carol Stringari, *Senior Conservator, Contemporary Art*
Gillian McMillan, *Senior Conservator, Collections*
Julie Barten, *Conservator, Exhibitions and Administration*
Eleonora Nagy, *Conservator, Sculpture*
Jennifer Sherman, *Project Conservator*

Construction
Michael Sarff, *Construction Manager*

Development
Beth Allen, *Corporate Development Associate*
Peggy Allen, *Special Events Coordinator*
Anne Bergeron, *Director of Institutional and Capital Development*
Antonina Bouis, *Consultant, Corporate and Individual Development*
Julia Brown, *Assistant Manager of Membership*
Stephen Diefenderfer, *Special Events Manager*
Pepi Marchetti Franchi, *Executive Associate*
Nicolas Iljine, *Director of Corporate Development, Europe and the Middle East*
Abigail Lawler, *Individual Development Assistant*
Renee Schacht, *Manager of Institutional and Capital Development*
Nick Simunovic, *Director of Corporate Development, Americas*
Helen Warwick, *Director of Individual Development*
Cecilia Wolfson, *Manager of Individual Giving*
Pallavi Yalamanchili, *Individual Giving Coordinator*

Director's Office
MaryLouise Napier, *Deputy Chief of Staff*
Katerina Bernstram, *Assistant to the Director*
Sarah Cooper, *Administrative Assistant*

Education
Kim Kanatani, *Gail Engelberg Director of Education*
Sharon Vatsky, *Senior Education Program Manager, School Programs*
Elizabeth Lincoln, *Education Coordinator, Public Programs*

Exhibition Design
Ana Luisa Leite, *Manager of Exhibition Design*
Melanie Taylor, *Exhibition Designer Coordinator*
Carolynn Karp, *Exhibition Design Coordinator*
Lisa Smith, *Exhibition Design Assistant*
Angela Vinci, *Exhibition Design Assistant*

Exhibition Management
Jessica Ludwig, *Director of Planning and Implementation, New York*
Alison Weaver, *Director of Programs and Operations, Affiliates*
Hannah Byers, *Exhibitions Manager*

Fabrication
Peter B. Read, *Manager of Exhibition Fabrications and Design*
Stephen M. Engelman, *Technical Designer/Chief Fabricator*
Richard Avery, *Chief Cabinetmaker*

Facilities
Brij Anand, *Director of Facilities*
Ian A. Felmine, *House Electrician*

Finance
Amy West, *Director of Finance*
Christina Kallergis, *Budget Manager for Program and Operations*
Pater Lau, *Financial Analyst*

Graphic Design
Marcia Fardella, *Chief Graphic Designer*
Concetta Pereira, *Production Supervisor*
Christine Sullivan, *Graphic Designer*
Janice Lee, *Graphic Designer*
Julie Applebaum, *Graphic Designer*

Information Technology
Danielle Uchitelle, *Crystal Report Writer*

Legal
Brendan Connell, *Associate General Counsel*
Stefanie Roth, *Associate General Counsel*

Marketing
Laura Miller, *Director of Marketing*
Ashley Prymas, *Marketing Manager*
Lexie Greene, *Marketing Coordinator*

Photography
David M. Heald, *Director of Photographic Services and Chief Photographer*
Kim Bush, *Manager of Photography and Permissions*
Raphaele Shirley, *Digital Imaging Specialist*
Nicole Heck, *Temporary Photography and Permissions Manager*

Public Affairs
Betsy Ennis, *Director of Public Affairs*
Leily Soleimani, *Public Affairs Coordinator*

RUSSIAN CONTRIBUTING INSTITUTIONS

Central Museum of the Armed Forces, Moscow
Alexander Nikonov, *Head of the Museum*
Alla Legeida, *Deputy Head for Scientific Work*

Ivanovo Regional Art Museum
Marina Krainik, *Director*
Galina Solnstseva, *Chief Curator*

Kostroma State Unified Art Museum
Natalia Pavlichkova, *General Director*

Kovalenko Art Museum, Krasnodar
Tatiana Kondratenko, *Director*
Olga Garmash, *Chief Curator*

Moscow Kremlin State Museum-Preserve of History and Culture
Elena Gagarina, *General Director*
Olga Mironova, *Chief Curator*
Zelfira Tregulova, *Deputy Director for Exhibitions and International Exchange*
Anastasia Parshina, *International Relations Department*

Museum of History, Architecture, and Art, Kirillo-Belozersk
Galina Ivanova, *Director*
Olga Voronova, *Chief Curator*

Pozhalostin Regional Art Museum, Ryazan
Vladimir Ivanov, *Director*

Radishchev Art Museum, Saratov
Tamara Grodskova, *General Director*
Liudmila Dalskaya, *Chief Curator*

Serpukhov Museum of Art and History
Liudmila Gafurova, *Director*

State Historical Museum, Moscow
Alexander Ivanovich Shkurko, *Director*
Tamara Igumnova, *Deputy Director*
Eduard Zadiraka, *Chief Curator*

XL Gallery, Moscow
Elena Selina, *Director*

EXHIBITION DESIGN

Jacques Grange's Office
Jacques Grange
Serge Barbosa
Béatrice Loubet
Pierre Passebon
Hervé Aaron

CATALOGUE

mgmt. design
Sarah Gephart
Ariel Apte
Alicia Cheng
Rachel Griffin

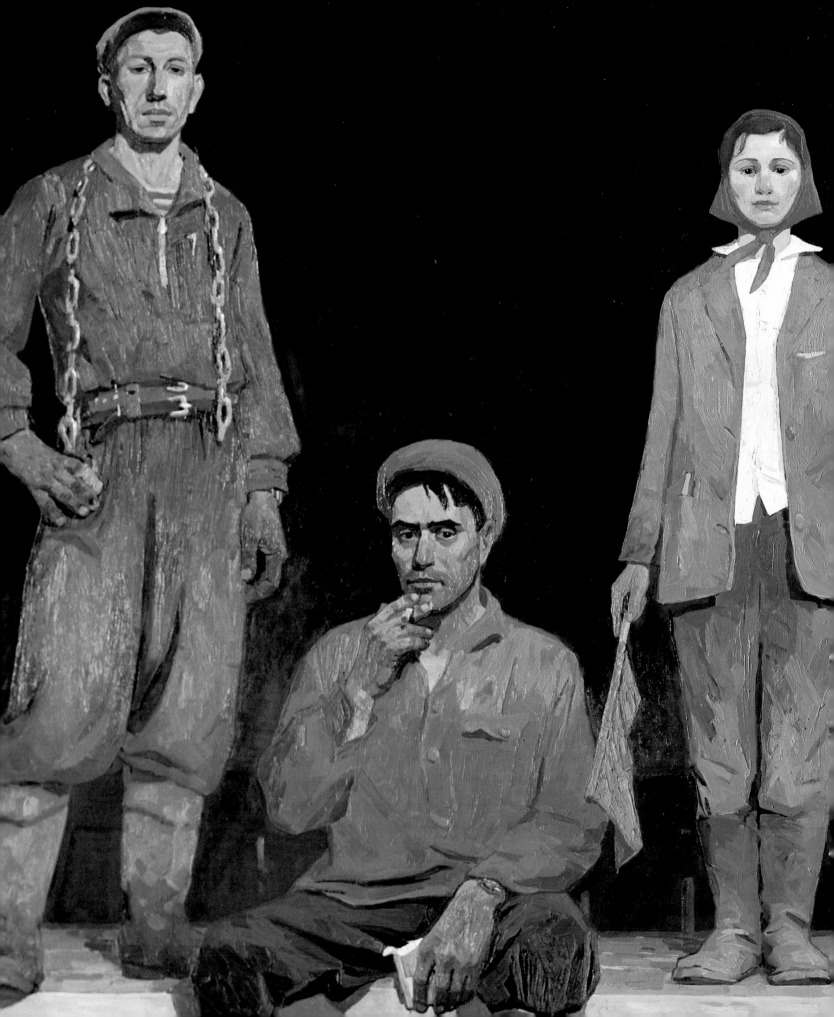

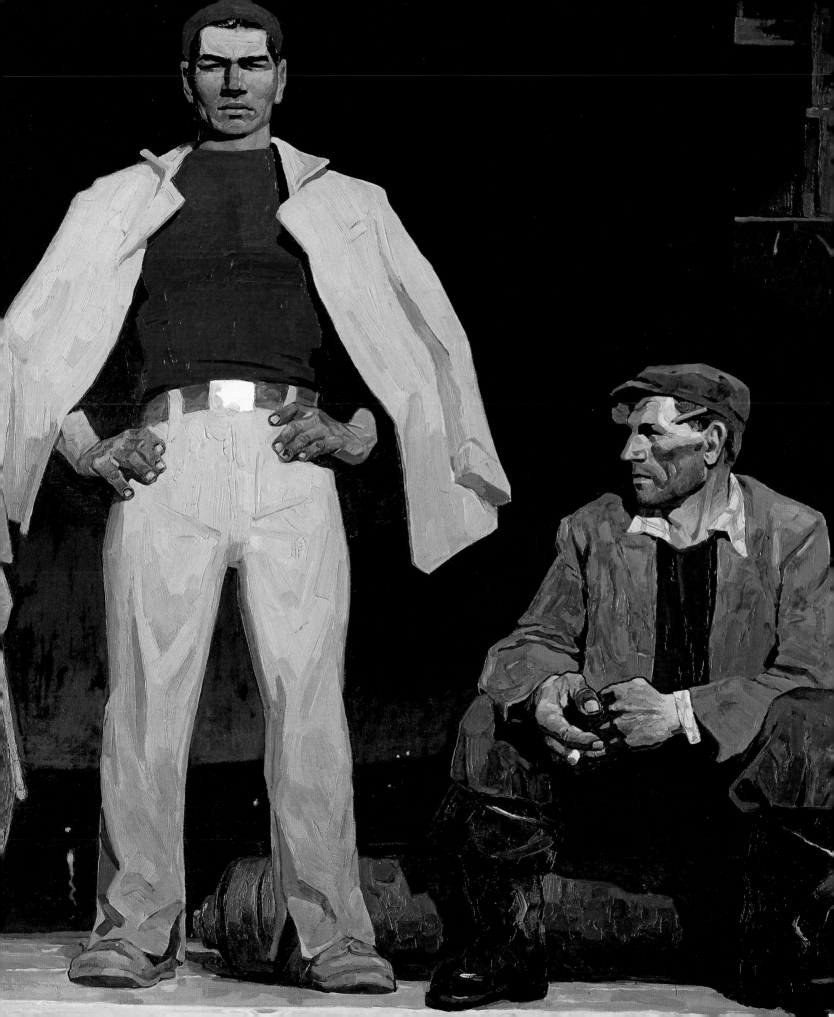

RUSSIA: FATE AND PROPHECY
MIKHAIL SHWYDKOI

The German writer Thomas Mann described English, French, Italian, and German litera-ture as great—and Russian literature as holy. This notion of holiness could equally be applied to Russian culture as a whole, as is evident from the extraordinary examples of the art of the great Eurasian state presented in RUSSIA!, on view at the Guggenheim Museum in New York.

Over the centuries, Russian culture has been formed both in opposition to social and material reality—and as an inalienable, essential part of that reality. Artists, writers, and musi-cians, among others, have transformed the tragedy of existence into metaphysical beauty, into prophetic revelation, tempted not simply by the magic of the real world but also by a sense of the need to make the miraculous an essential component of everyday life. Until the end of the twentieth century and Russia's adoption of democracy, culture undeniably pre-vailed in the conflict between culture and civilization, between spiritual wealth and physi-cal comfort and positive well-being. Reading was generally considered a nobler and more interesting activity than living. For many people, the word and the artistic image represented life itself. The notion of spirituality as a means of overcoming the obscenity of real life was tied to an understanding of its holiness and rituality.

During the Middle Ages, the isolation of monastic life would not have been possible without service in the secular world. In the realm of secular heroism, too, spiritual service was valued over individual status and power. In Fedor Dostoevsky's novel *The Brothers Karamazov* (1880), the monk Zosima, revered by many as a saint, sends the youngest brother, Alyosha, out into the world—not so much because Alyosha is unsuited to monastic life, but because Zosima believes that Russian life must be sanctified by certain spiritual people living in the very thick of its beautiful and sinful reality.

The desire for otherworldly perfection and the joyful burden of immersion in secular life was shared by all of Russia's great painters from Andrei Rublev and Daniil Cherniy to Kazimir Malevich and Pavel Filonov, from Dionysii to Pavel Korin, from the unknown painters of the village icon of St. Nikolai of Zaraisk in the fourteenth century to the anonymous creators of wooden sculptures of Christ in the nineteenth and twentieth centuries. The mys-tery of Creation was discovered in Russia not through experimentation but revelation, not through practice but through miracle, not through experience but by great effort. Before starting work on painting monastery walls or creating an iconostasis, the team of painters was blessed by the priest, attended a church service, and fasted as if before a church feast, until the project was completed. Secular human passions were forged in an act of creation directed at heaven. The outstanding filmmaker Andrei Tarkovsky represented the mysterious nature of Russian creativity in an astonishingly visual manner in his 1966 film *Andrei Rublev*. In the mystery of existence, in the conflict and intertwining between the highest and lowest points of human experience is born art, which requires self-denial and spirituality—and the blessedness of human existence.

This messianic attitude toward creativity (and human life) has always existed in Russia; it was there when Andrei Rublev was creating icons in the fifteenth century and during the early twentieth century when the artists of the Russian avant-garde like Marc Chagall, Vasily Kandinsky, and Kazimir Malevich changed the very concept of the relationship between the visible and invisible worlds. The artist is always a missionary who must look beyond the objective world into the mysteries of existence.

In Russia, art is a significant part of the national sense of destiny; thus, Russians emphasize the significance of their national history not only within the context of world history but also within that of the spiritual realm. Perhaps no other country has seen such fierce arguments over the meaning of national existence, about the essence and significance of the nation in the very plan of creation, and its place in world civilization.

During the early and high Middle Ages, Eastern Slavs were unusually close to the Scandinavians, Germans, and Franks in Kiev, Moscow, Novgorod, Pskov, Suzdal, and Vladimir; they were happy to be part of Europe. Divided by the Christian church schism in the ninth century (the legacy of the Western and Eastern Roman Empire), Rome and Byzantium continued to be mutually complementary. The Latin (accepted in Western Europe) and Cyrillic-Methodian orthography (accepted in Eastern and Southern Europe) embodied the single experience of ancient European civilizations: Cyrillic harked back to Ancient Greece, and Latin to pre-Christian Rome. By contrast Russia, first Kievan and then Muscovite, was open to the Asian East, to the culture of the steppes, that stood in opposition to that of the Slavic Russian forests and at the same time was closely linked to it in many ways. The influential Russian princes of the twelfth and thirteenth centuries and later, found wives first in the Polovetsian steppes and then among the members of the Turkic Golden Horde (the Mongol descendents of Genghis Khan who ruled Russia between 1237 and 1480); the many representatives of noble Tatar families served in the court of the Moscow tsar during the fifteenth through seventeenth centuries, thus founding famous aristocratic families. The conflict between "forest" and "steppe" remained outside Russian Slavic life until the twelfth and thirteenth centuries, when Muscovite Russia internalized it after freeing itself from the yoke of the Tatar-Mongols imposed by Genghis Khan and his descendants. In 1380, united Russian forces headed by Dmitry Donskoi shattered the army of the Tatar-Mongol Golden Horde on Kulikovo Field (not far from today's regional city of Tula) just 150 kilometers from Moscow. A hundred years later, Russia was not only free of its almost three-hundred-year domination but had begun expansion to the east, south, and north in the enormous Eurasian continent.

As in the fifth through ninth centuries, the Turkic, Ugro-Finnish, and pre-Mongol tribes had moved through Russia into Western and Central Europe to settle there; in the middle of the second millennium, the Slavs thus headed east, taking on a new sense of space and time, a new world view. The apparent physical boundlessness, the infinite expanses of their newly discovered world demanded a new kind of person: enterprising, adventurous, and energetic. But at the same time, the sense of the immeasurability of the territory could swallow up and dissolve all initiative, prompting contemplation, an almost Buddhist acceptance

of all change. The pioneers, heroes, and fighters of this period brought incredible energy into this new territory, but it was too huge; in trying to vanquish it, they were necessarily reminded of the finite nature of human existence in the face of eternity. The new sense of space also determined a new approach to religious painting and to religious culture as a whole, which, until the second half of the seventeenth century, had been a powerful expression of the emerging nation's spiritual experience. The sense of the infinite nature of God's world was reinforced by the apparent infiniteness of the visible world.

Icon painting and religious art of the fourteenth through seventeenth centuries was an expression of the Russian Renaissance, the liberation from the Horde, and the formation of the new Russian Muscovite state. Russia had rather broad relations with Renaissance Europe. This is exemplified by the work of Italian architects in the Moscow Kremlin as well as by Ivan the Terrible's proposal of marriage to Queen Elizabeth I of England (or, in another version of the story, to her niece), who gave Russia one of the best collections of English Renaissance silver, now at the Museum of the Moscow Kremlin. But in Russia the artistic and philosophical experience of the Renaissance was transformed into the richest religious art, including the paintings of Rublev in the early fifteenth century or the frescoes of Dionysii in the early sixteenth. Most people believe that the Renaissance bypassed Russia; it could be argued, however, that Russia experienced this transformation in its own manner, in a way that was sensitive to the secular aspects of events while remaining reverential before the spiritual.

Moscow was the heir to Byzantium, proclaiming itself the Third Rome—"and there will be no fourth"[1]—and the idea of the majesty of the new kingdom was in keeping with the majesty of the world that opened before the subjects of the Russian state in the early sixteenth century. The almost three hundred years of dependence on the Golden Horde had not so much slowed Russia's development as changed its path, establishing the discourse that continues to this day about Russia's special process of development, its mysterious soul, and the need to formulate a national idea that will establish what distinguishes this country from other parts of the world. Russian advocates of the Western European path of development find themselves in endless debate with the proponents of Russian uniqueness. Sometimes it seems that a compromise has been found; philosophers like Nikolai Berdyaev (1874–1948) or Lev Gumilev (1912–1992) manage to dissipate the original dispute and try to persuade everyone that Russia is both a great European and a great Asian state. But such moments of accord are far and few between.

Even before Peter the Great there were several efforts to graft the European experience onto Russian soil. Such attempts were very evident in the reign of Tsar Alexei Mikhailovich Romanov, Peter's father. It was under Alexei Mikhailovich that the secular portrait (*parsuna*) and secular literary works became popular, and in 1693 a German troupe with guest performers from among the courtiers of the Moscow tsar put on a performance of the famous *Artakserksovo deistvo* (The Act of Artaxerxes), a play based on the biblical subject. That performance laid the foundation for professional theater in Russia. Alexei Mikhailovich and his closest boyars were also interested in engineering, science, and the economy, and the wise tsar was known as "the Quiet." However, Peter the Great's wild energy and unbridled political will were needed to effectively transform Russia along the Western European model.

There is endless argument about what Peter's reforms brought to Russia and how many lives it cost for the Russian people to become familiar with Western-European civilization and experience, as well as about the price Peter paid for the grandeur of the Russian crown. In any case, St. Petersburg became the symbol of the new Russia of the eighteenth century, a Russia turned toward the West, discovering Western values from enlightened leaders like Catherine the Great and Paul I, a Knight of Malta. And paradoxically, Russians learned of the ideas of the French Revolution from the officers of the regiments who conquered Napoleon and took Paris.

Peter I led young aristocrats from Moscow, which symbolized ties with the East and its ritualized somnolence, and dragged them to the West, forcing them to test with their own blood the living nerve of European history and to add to it their own exciting pages. In the Russian art of the eighteenth and nineteenth centuries, real human subjects that reflected new ways of life in Europe crowded out the religious symbolism and the pagan, pre-Christian symbolism that had always lived in Russian folk art. Russian artists of this period greedily sought to close the gap between world history and national life, exploring "missed" styles and periods of art history with incredible energy, but they tested everything against the realities of Russian life.

Beginning in the second half of the eighteenth century, Russian art developed in parallel with Western European art, passing through the same stages of artistic exploration: from classicism to realism and from realism to naturalism and symbolism and so on. But because of the speed with which Russia went through the "missed" styles of the Renaissance, they unexpectedly reappear in Russian art of the eighteenth and nineteenth centuries in a clearer way than in the art of Western European painters. The opposition of East and West, once so important, took on yet another dimension during the eighteenth and nineteenth centuries as it manifested itself in Russian society. It was seen in the contrast between the members of the educated elite who had certain freedoms—the aristocracy and, by the second half of the nineteenth century, also the bourgeoisie—and the people, oppressed by serfdom, who seemed almost to live in a different, pre-Petrine time. The adherents of the idea of Russian uniqueness, known in the nineteenth century as Slavophiles, cultivated this juxtaposition, stressing the conflict between the "natural" and true national culture with its religious and ethical concepts, and European culture, which was alien to Russia.

The genius of the great poet Alexander Pushkin, the creator of the new Russian literature and the Russian language, a great European who had never crossed the borders of the Russian Empire, was that he did not even suspect that these contradictions existed. Nonetheless, the idea of a Third Way, of Russia's special, non-European destiny, is still attractive to many Russians who repeat the words of Fedor Tyutchev (a Russian poet with German roots) from his untitled poem of 1866:

> *Russia is not accessible to reason*
> *and cannot be measured with a yardstick;*
> *Russia is a special country*
> *that can only be taken on faith*

In the nineteenth century, Russia absorbed numerous people of different Western and Eastern nationalities, and with them their cultures and faiths; nonetheless, traditional folk art and the lives of ordinary Russians provided the primary sources of inspiration for Russian literature, music, and painting during this period. The life of the simple Russian people became the object of study and veneration for nineteenth-century Russian painters. The ordinary man, whether peasant or impoverished nobleman, received not only attention and compassion at this time, but also came to be seen as a kind of bearer of the high moral values of a society in which eras and socioeconomic systems had become confused. Russia in the second half of the nineteenth century lived simultaneously with feudalism and capitalism; the patriarchal lifestyle and mentality coexisted with aggressive and harsh acquisitiveness, and European bourgeois individualistic values coexisted with Eastern acceptance of fate and indifference to the material world. Everything seemed precarious. Russian artists and writers of the period thus tried desperately to find a pillar of support in the moral world of the "little man."

Russian realism was always more than a mere representation of reality. In the realistic portrait it is still possible to make out an iconic face and in such genre paintings as Ilya Repin's *Barge Haulers on the Volga* (1870–73, cat. no. 104), to discern the elements of a biblical parable. Even in the middle of the nineteenth century, when numerous influential Russian art critics asserted that realistic representation was the primary criterion of quality in art, artists were apparently moved not only by fidelity to nature but also by a relentless drive to access the mystery of the universe. The great realistic novels of the nineteenth century, by Fedor Dostoevsky, Nikolai Gogol, Ivan Goncharov, Lev Tolstoy, and Ivan Turgenev, in expressing the uniqueness of Russian national life and at the same time its universality, determined a most important artistic gene in Russian culture; it was not only realistic but also based on a profound archetypical symbolism drawn from the depths of the collective and the individual unconscious. Reverence for the author as teacher reached messianic proportions at this time. Regardless of their religious and ethical principles and how much they strove to limit themselves, the great Russian literary masters were never mere imitators of nature and other people's wisdom. Their boldness determined the special energy of an entire artistic milieu, one that included composers, dramatists, painters, and sculptors.

Russian painters were at the very center of the theatrical revolution initiated by Konstantin Stanislavsky and Vladimir Nemirovich-Danchenko. While they rejected the stylized forms of the traditional Russian theater of the nineteenth century in favor of greater realism, these men, who founded the Moscow Art Theater in 1897, were not interested in a straightforward imitation of reality; rather, they were tempted by higher meanings hidden behind the shell of objects and phenomena and behind the faces of people. Similarly, the Russian novel was least of all a description of life and manners—it sought other, more profound revelations. The style known as "fantastic realism" was in fact introduced to literature by nineteenth-century Russian writers rather than Latin American writers of the twentieth century, as might be assumed. The prose of Dostoevsky, Gogol, and Tolstoy; the painting of Mikhail Vrubel; and the music of Alexander Glazunov and Alexander Scriabin are unthinkable outside a dialogue with the spiritual realm that makes all human experiences ephemeral. For artists of this period, the mastery of the visible world was merely a step toward comprehension of the invisible one.

In striving to represent reality, Russian artists of the late nineteenth century, like their European colleagues, succeeded in escaping beyond it. For the material world had turned out to be dangerously unpredictable. Its precariousness and ephemeral nature stunned not only artists but also scientists, who discovered that physics, like Euclidian geometry, was only a chapter in the endless book of knowledge. It was not until World War I, however, and the catastrophic emergence of an entirely unfamiliar new era, that politicians were finally disabused of their faith in the solid power of neopositivist progress.

At the turn of the twentieth century, the crisis of Renaissance tradition and humanism resulted in a turn toward pre-Renaissance and even pre-Christian forms in Russian art. The sources of Kandinsky's abstract art or of Malevich's Suprematism are properly sought in icon painting, folk lubok drawings, and sign painting (which is related to the lubok). As if it were the philosopher's stone, these artists returned to the material prototypes that might help to restore existence as they had once known it. The Russian avant-garde artists of the first two decades of the twentieth century did not simply take over the Renaissance painting tradition, however. They adapted it to their own ends, trying to make overt the secret magic of numbers and geometric figures that had occupied Giotto and Leonardo, Rublev and Dionysii.

It was not until the eve of the great cataclysms brought about by World War I and the series of revolutions set off by it, that a new understanding of the world became necessary. The artists of the Russian avant-garde art did not rush the coming catastrophe, did not capture it in time, but they did try to overcome it creatively. For the first time, in the years that preceded the war, during the bloody slaughter of the period of war and revolution from 1914 to 1922, and in the post-revolutionary period, artists tried not only to express the music of revolution but also to produce work that was revolutionary in itself. Russian literature, theater, music, painting, and architecture defined the thrust and tragedy, the life-affirming optimism and the howl of horror before the irreparable step into the abyss of Stalin's Great Terror.

The revolutionary energy that gave rise to the idea of a utopian land of justice for the suffering also produced great symbols, metaphors for heaven on earth that were meant to overcome the real pain and blood of the process. Artists took on some of the responsibility for emerging socialism, creating it onstage and on canvas, in sounds and colors. The energy of that art infected all of Russia and the entire world. Utopian ideals and the sanctification of creativity during this period were designed to overcome the tragic imperfection of the real Russia, a tormented, bankrupt country. What H. G. Wells referred to as "Russia in the Shadows" (the title of his 1921 book) was illuminated not by real electricity but the energy of the new revolutionary prophets—in both life and art. Human existence in this enormous country was expected to adapt to political and artistic theories. If it did not fit, "living life" (as Dostoevsky described it in his Notes from the Underground of 1864) was sacrificed rather than the ideas. Dreams of world revolution engulfed the eternal East-West opposition. The Utopia dared to swallow reality.

In the twenties, many cultural figures were enthralled by the sincere desire to turn fairy tale into reality. But during the thirties and forties, the fairy tale turned into Stalin's bloody reality. It was only during World War II, which in Russia is thought of as the Great Patriotic War, that all the mythologies fell away before the need to salvage the people and

the country. The Great Utopia fed the work of Soviet artists even when the myth of freedom of creativity in revolutionary Russia shattered on the unyielding wall of Bolshevik dogma in the thirties, even when the Stalinist regime, which had created a strict system of the artist's subordination to the state, tried to rule not only over men but over the secret realms of art.

Socialist Realism was the state Bolshevik doctrine that called for ennobling "imperialist banditry" and demanded faith in a nonexistent reality. The state aesthetic required unmitigated optimism and flawless heroes who were prepared to sacrifice themselves to the common good, and an unflagging conviction that only the true teachings of Lenin and Stalin would lead the peoples of the Soviet Union to certain happiness. And in spite of the ironic commentary of the last quarter century on imperial Stalinist style, it is nonetheless true that the original Bolshevik Soviet fairy tale once incorporated the eternal dream of a better life and of a perfect humanity.

In fact, it is easier to talk about the utopian charm of Socialist Realism today, when there is no Soviet Union, when the leading role of the Communist Party has been forgotten, and when Socialist Realism is no longer an ideological noose around the throat and heart of anyone who criticized Soviet life in any way. The opportunity to expand artistic integrity in the mid-twentieth century, during the "Khrushchev Thaw" after Stalin's death in 1953, and especially after Nikita Khrushchev's secret speech at the Twentieth Party Congress, when the tragedy caused by the Stalin regime was spoken of for the first time, often led to high art taking a back seat to truth; the bitter truth by its power became art. Utopian realism was shunted aside by the grim reality. The lines of the famous nineteenth-century poet Nikolai Nekrasov, "You don't have to be a Poet, but you must be a Citizen," were echoed by the famous late-twentieth century poet Yevgeny Yevtushenko: "A poet in Russia is more than a poet."

The ideals of messianic teaching, civil disobedience, and artistic dissidence corroded Soviet culture in the twentieth century. One might argue about the artistic quality of Alexander Solzhenitsyn's prose, but no decent person could doubt his courage in combating the Soviet regime. Freedom of creativity in the second half of the twentieth century in the Soviet Union became a kind of sacred tablet of faith: for those who pushed the limits of what was permissible within the framework of official Soviet art and for those who went underground at home or left for the West. People sacrificed a great deal for the right to create freely—money, security, even physical freedom. As in all periods of Russian history, the real artist paid an enormous price; such artists were not inspired by personal ambition, however, but by fear for the fate of the country. For in Russia the fate of the artist and the fate of the people are closely intertwined—even if the people do not accept or understand the artist. But the artist is always motivated by pain and compassion for Russia's fate.

In the last twenty years—during perestroika under Mikhail Gorbachev, and in the new Russia under Boris Yeltsin, and now under the presidency of Vladimir Putin—Russian artistic life is emerging within the context of international culture. Today you can find Russian painters and sculptors in Berlin, New York, Paris, and Prague; nonetheless freedom has not been an unalloyed joy for all. Russian artists now suffer the tragedy of the condition of

freedom: instead of dealing with politics, they must now address the higher aims of art. There are no more struggles about artistic styles and trends. There is a place for everything and a market for everything. As the great nineteenth-century poet Alexander Griboedov put it, talent sets the standards by which it can be judged. It is only through the tragedy of isolation that artists achieve true revelation. Russian artists only remain Russian as long as they sense Russia as their fate. It is only on this basis that they retain the right to be its prophets.

Malevich's well-known series of four paintings titled *Black Square* (produced between 1915 and the early thirties) became the most famous examples of Suprematist art; indeed, his earliest experiments with Suprematism were presented in the Futurist opera *Victory Over the Sun*, first seen in St. Petersburg in 1913, and for which the artist designed costumes with bright geometric shapes and a backdrop that incorporated a black square that anticipated the later painting series. Russia was plunged into the darkness brought by wars and revolutions. But *Black Square* is not monochromatic in the least. In the black areas of the painting other colors can be discerned, particularly red, the symbol of the sun and of life. Malevich believed that his *Black Square* was not merely a canvas but an animate creation, whose fate depended on the course of Russian history and Russian life. He believed that the time would come when the black would dissolve and the sun would triumph. If only we knew when this would happen.

Translated from the Russian by Antonina W. Bouis.

1. After the fall of Byzantium, the second Rome, Russia saw itself as the third great empire. In 1510, Tsar Vasily III proclaimed: "Two Romes have fallen. The third stands. And there will be no fourth."

INTRODUCTION
JAMES BILLINGTON

The culture of Russia has effectively been shaped by three powerful forces: its vast territory, its Orthodox Christian faith, and its ambivalent relationship with the West.

Russia is the northeastern frontier of Europe. It commands the largest landmass of any country in the world. But its history has been influenced by the fact that it has no natural protection—from either the unimaginable cold to the north or the alien civilizations to the south. Between the permafrost and the steppe lies a wooded region that stretches through eleven time zones from the Baltic to the Pacific. Still largely uncultivated and without roads, the great Russian forest remains today the last lung of our planet. And it is here that Russians seem to breathe most freely and feel most securely at home.

Modern Russia acquired a cultural identity distinct from that of the other Eastern Slavic countries (modern Ukraine and Belarus) in the thirteenth century when governmental power moved north from Kiev beside the open steppe to Vladimir and Moscow in the sheltered forest. The Mongol invaders who sacked Kiev in 1226 never reached Novgorod, a town that colonized the wooded northern frontier of Russia. The relatively new city of Moscow began to increase its authority by acting as the collection point for the tribute that Russians paid to the Mongols, but it was never sacked or occupied by them. The new capital was sufficiently protected by the surrounding forest to be protected from later attacks by Tamerlane in the fourteenth century and Tatars as late as the seventeenth century.

One of the popular tales told about the period of internecine conflict between the fall of Kiev and the emergence of Moscow as the site of political power describes two warring northern cities that set out to fight one another. Both armies went into the forest, got lost, and simply settled down to clear enough land to found new communities of their own and live happily ever after in the safe confines of the wooded frontier.

Moscow took over control of the northern frontier from Novgorod in the fifteenth century, and Muscovite Russia began its inexorable expansion eastward—ultimately to Alaska and even to Fort Ross near San Francisco. In the process, Russians became fascinated with the enormity of the space that their civilization had grown to encompass. Indeed, the Russian words for space (*prostor, prostranstvo*) came to be widely used by philosophers—especially to characterize the nature of a freedom that Russians never quite possessed (*Na prostore* means "in full freedom," while *svoboda* = *volia* + *prostranstvo* translates as "freedom is will plus space").

Nikolai Berdyaev, perhaps the most influential of the Russian émigrés from the USSR, suggested that creativity in Russia reflects "a sort of immensity, vagueness, a predilection for the infinite, such as is suggested by the great plain of Russia."[1] Berdyaev argued that Russian art aspired to be *theurgic* (referring to the art of persuading a god or other supernatural power to do or to refrain from doing something) and that Russian artists were basically "wanderers over the Russian land." They were—or should aim to be—"pilgrims," seeking to transcend material difficulties by becoming spiritual pathfinders. One of post-Communist Russia's leading thinkers has urged his countrymen not to repeat the tragic

mistake of modern Western culture, which has replaced the ideal of the dedicated "pilgrim" with that of the dilettante "tourist."[2]

The Christian ideal of life as a pilgrimage of faith through "unclean lands" toward salvation somewhere in the interior space of Russia supplanted—but never fully replaced—the early paganism of the Eastern Slavs. Their polytheistic worship of the forces of nature survives in rural areas to this day. A kind of popular animism sometimes mixes with Christianity, reflecting the distinctive Russian phenomenon of *dvoeverie* ("duality of belief").

The adjectival form of the Russian word for art (*iskusstvennyi*) also means "imitative" and "false." Thus, the word "artistic" in Russian is identical to—rather than merely related to—that for "artificial." And the adjectival form of the word for "poetry" (*stikhiinyi*)—arguably the most popular art form in modern Russia—is also the word for "elemental."

Pictorial art was the first form of expression that lifted the Eastern Slavs from primitive paganism into a distinctive place in the mainstream of world culture. It was introduced to them as a result of the wholesale adoption of Byzantine Christianity by Kievan Rus in the late tenth and eleventh centuries, the first of many sudden cultural explosions to have shaped Russian culture. The Scando-Slavic cities attached to Kiev contained no preexisting wall paintings, nor was any other pictorial art produced in Kievan Rus on the open Eastern steppe. Ancient Scythian art was not uncovered until much later. The primitive pagan idols in Kiev were immediately cast into the river after the adoption of Christianity. Their shapes lived on only marginally in decorative wooden carvings, mainly in rural regions.

The sheer artistic beauty of the interiors of Byzantine churches is thought to have inspired the Eastern Slavs to adopt Orthodoxy. *The Russian Primary Chronicle*, the earliest monastic history of Rus, tells us that, after examining and rejecting Western Christianity and Islam, "the Greeks led us to the edifices where they worship their God, and we knew not whether we were in heaven or on earth. For on earth there is no such beauty.... We know only that God dwells there among men, and their service is more beautiful than the ceremonies of other nations."[3]

The importation of Byzantine culture on a vast scale enabled the princes of Kiev to impose a unifying faith on a scattered patrimony, using a new and uplifting pictorial language to impart a sense of historical destiny to an overwhelmingly illiterate population. The first native Slav to become head of the Church hierarchy in Kiev described the rapid transformation of his town into "a city glistening with the light of holy icons, fragrant with incense, ringing with praise and holy, heavenly songs."[4]

After the center of power and frontier colonization moved north from Kiev to Moscow, however, Russian icon painting became less imitative. In fact, the late fourteenth and fifteenth centuries produced a true golden age of religious painting in the Russian north. Artists introduced elements of abstraction and expressiveness to holy subjects, depicting them with bolder lines and deeper colors than ever before. Wooden icons were consolidated into many-layered icon screens, which replaced Byzantine-type mosaics as the main focus of contemplation for worshipers in church. And individual icons proliferated not only in centers of worship, power, and commerce but also in houses, huts, and fields.

The greatest of all the icon painters during this golden age, from artists like Andrei Rublev to Dionysii, were not solitary geniuses working on imaginary compositions. They

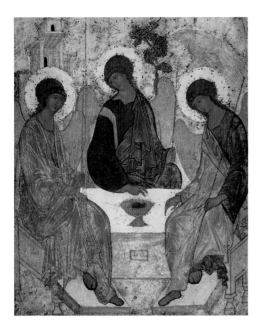

Andrei Rublev, Trinity, 1420s.
Tempera on wood, 142 x 114 cm.
The State Tretyakov Gallery, Moscow

were monks who worked in teams, bringing new simplicity and serenity to the traditional ways of depicting holy figures and events.

Icon painters were guided by collective prayer and worked collaboratively according to an established division of labor—preparing the board, cutting lines on the surface, mixing the colors, and layering them on in a pre-designated sequence of steps. In the absence of an understanding of natural perspective, they used variations in the depth of colors and the flow of lines to draw the viewer into what has been called "meditation in colors."[5]

Russians tended to pray with their eyes open in front of these holy pictures, which performed a pedagogic as well as a devotional function. The icon screen illustrated the entire story of sacred history, from the Old Testament patriarchs on the top row to the local saints on the lowest level. On the opposite, western wall of the church, the departing believer usually saw a giant fresco of the Last Judgment, depicting the future rewards and punishments that gave urgency to efforts to become "very like" (*prepodobnye*) the holy figures represented there.

An icon was not a portrait, but an *obraz*, an ideal model or "form" intended to be emulated. Even today the basic word for education is *obrazovanie*, one that suggests the transformation of the individual into an ideal image.

The figures depicted in icons were to be venerated, but not worshiped. They had risen to heaven, shed their material bodies, and been brought back to earth in transfigured form. They provided believers with a recognizably human window into the heavenly life. Orthodox Christians believed that they, too, could aspire to this condition, because God himself had taken human form in Jesus. He, in turn, had opened the gates to heaven by rising through suffering and death to eternal life and unending atonement for all the failings of humanity.

Even the most terrible of all human events, the crucifixion of Christ, was represented in a harmonious—even lyrical—tableau in Dionysii's famous icon of 1500 included in the Guggenheim exhibition. White robes lined with gold were used to depict the direct intrusion of divinity into humanity from the scene of Christ's first appearance to his disciples as the Messiah (the Transfiguration) to that of his final ascension into heaven.

Orthodoxy taught that the essential doctrinal questions had been settled in verbal form by the first seven ecumenical councils. As late converts in the exuberant period after the rejection of iconoclasm, Orthodox Russians sought to celebrate and beautify—rather than to talk and write about—the mysteries of their faith.

One of the most inscrutable parts of all Christian doctrine, that of the Holy Trinity, was celebrated each June with the popular proclamation: "It is Trinity, and all the forest is bursting out" (*Troitsa! Ves les raskroitsia*). Perhaps the most beautiful of all icons is Rublev's early-fifteenth-century depiction of the Trinity for the new Monastery of St. Sergius and the Holy Trinity. This frontier monastic complex in the forest east of Moscow replaced the Monastery of the Caves in Kiev as the most important spiritual center of the Eastern Slavs. It became the starting place for missionary colonization to the north and east. Rublev's last and largest icon became an emblem of the advancing faith.

In this work Rublev did not attempt to represent either directly or allegorically the mystery of God in three elements. He followed the Orthodox tradition of depicting the historical anticipation of the Trinity in the appearance of three angels to Sarah and Abraham

as described in the Old Testament. But he stripped the composition of distracting incidentals and wove the three figures into the classical mystical vision of three luminous and inter-secting circles that Dante also invoked in the final canto of his *Paradiso*. And he used inverse perspective to focus the worshipful viewer on the only point of access he or she could gain to the triune God: the elements of holy communion. The central figure is colored by the red of martyrdom and the blue of heaven—and is pointing to Christ's presence in the dark chalice that appears to be extended to the viewer from the white background. The framed lines of the other two figures also make the chalice seem to extend toward the worshipers rather than into the picture as in natural perspective.

Muscovite Russia was a patriarchal society dominated by monks and warriors who were popularly acclaimed as *podvizhniki* (heroic movers) on their expanding frontier. The empire was ruled from Moscow by an authoritarian father figure, the *Tsar-batiushka*, who was surrounded by long-robed male courtiers (*boyars*). But if this world was controlled by men, the world to come was ruled by a woman: the mother of Christ and "the Queen of Heaven." She was revered more as the Mother of God than as the Virgin Mary and invari-ably dominated the omnipresent icons of the holy mother and child. The main place of worship inside the Moscow Kremlin, the Cathedral of the Assumption (*Uspenskii sobor*) where tsars were crowned and marriages were sanctified, was dedicated to Mary's entry into heaven. The most famous of all Muscovite churches, St. Basil's, just outside the Kremlin on Red Square, was dedicated to the protection (*pokrov*) of the Holy Mother, and the Protection of the Virgin became the subject of an icon unknown in Byzantium.

The Orthodox service of worship was experienced on several levels. The often unintelli-gible Church Slavonic text of the liturgy was sung entirely without accompaniment in an aromatic atmosphere of ritual processions, gestures, and prostrations. But it was the beauty of holy pictures that basically shaped the identity of what came to be called Holy Rus. For two-thirds of the second Christian Millennium, religious painting was the chief form of cul-tural expression in Russia.

The dominance of ethereal, two-dimensional religious painting ended in the 1660s and early 1670s, however, when Western-style portraiture was introduced into Russia during the reign of Peter the Great's father, Tsar Alexei Mikhailovich Romanov. A Dutch artist painted a portrait from life of Patriarch Nikon, the leader of the Russian Orthodox Church, and a new school of more naturalistic icon painting was set up in the armory of the Kremlin. The form was traditional; but the spirit of these paintings, like the place of their production, was secular.

Alexei presided over a veritable cultural revolution. Music was transformed from unac-companied monodic chanting to instrumental polyphony; literature evolved from simple oral narrative to written syllabic poetry, allegory, and philosophical argumentation. And the tsar's public spectacles developed—for the first time in Russian history—from outdoor religious processions to secular theatrical productions held inside and including dancing.

Horrified Old Believers fled deep into the forests to keep alive the old rituals and traditional Muscovite culture; many committed collective suicide in wooden churches that they set on fire, convinced that the world was coming to an end. These changes signaled

the emergence of the altogether different kind of culture that would rise up in the new capital of St. Petersburg at the beginning of the eighteenth century.

But even after the iconographic tradition was eclipsed by secular painting in the modern period, Russian artists remained haunted by the memory of a time when pictures were signposts of beauty on a rocky road to salvation rather than delectations intended for palatial pleasure domes. Creative Russians would look to other art forms—once again return to painting in the early twentieth century—in pursuit of their continuing hope that (in the words of Fedor Dostoevsky) "beauty will save the world."

"Russian culture has been one of recurrent explosions," according to the last book of the great cultural historian Yuri Lotman.[6] Every new cultural creation seemed to arrive suddenly and to demolish its predecessor in order to make possible an entirely new beginning. Such had been the case in 988 when Vladimir of Kiev accepted Christianity and systematically destroyed all pagan idols. It also characterized the period during the early eighteenth century when the new city of St. Petersburg (which was founded on May 16, 1703) was suddenly raised up from a swamp and developed as the very antithesis of—and replacement capital for—Moscow.

The building of this celebrated "window to Europe" was Russia's first great governmental architectural project based on forced labor; people were literally worked to death. Unlike other great cities largely reclaimed from the sea, such as Venice and Amsterdam, St. Petersburg never became the starting point for a far-flung overseas empire. On the contrary, it was created by an already existing land empire. And unlike almost all capital cities, St. Petersburg was located near an exposed border rather than somewhere in the interior. Yet, almost alone among all great European capitals, it has never fallen to a foreign foe.

In contrast to most great cities of Eurasia, St. Petersburg did not evolve gradually from a favorable natural location on top of which a series of historical layers had already been superimposed. It was built suddenly and artificially in an extremely inhospitable climate and location at the latitude of Labrador and over the bones of thousands of forced laborers.

St. Petersburg was a seaport with canals, broad boulevards, rectilinear patterns, and ornate palaces with multiwindowed facades, and interior courtyards. It was a planned city with open vistas that stood in stark contrast to Moscow: a cramped inland complex of narrow, curving streets, innumerable churches, and a profusion of subcommunities, which had ballooned out chaotically as the city expanded in concentric circles from a central, closed Kremlin. While the inhabitants of Moscow, a city built mainly of wood, lived in perpetual fear of fires, an increasingly stone-and-brick St. Petersburg was haunted by periodic and unpredictable floods.

Peter the Great built the foundations of the new city on the Baltic after becoming the first ruler of Russia to visit the West. But the city was not named for him, and none of the distinctive structures that we admire today were constructed under his reign. The city was named for St. Peter, and was envisaged as a new Rome that would link the Russian empire more closely to Europe. The palatial, secular culture of imperial St. Petersburg was created by the remarkable series of Westernizing empresses who succeeded Peter and ruled Russia for most of the rest of the eighteenth century.

The utilitarian Peter had taken his Western models from the Protestant North of Europe, imitating Swedish governmental institutions, Dutch naval architecture, British shipbuilding, and a German Academy of Sciences. But the women who reigned after him took their models instead from Catholic Europe, creating an aristocratic culture that was linguistically French and audiovisually Italian. The Eastern culture established by men in Muscovy was challenged by a new Western culture created by women in St. Petersburg.

The dominant art forms were monumental architecture and the supporting decorative arts of the great new palaces and architectural ensembles built in and around the city. A succession of mainly Italian architects was brought in by the three empresses who ruled Russia between 1731 and 1796: Anna, Elizabeth, and Catherine the Great. The greatest of these imported architects was Francesco Bartolomeo Rastrelli, who, during Elizabeth's reign (1741–61), designed the three most imposing imperial residences in Russian history: the first stone Winter Palace, Peterhof, and Tsarskoe Selo. These structures provided the focal points for theatrical entries to and exits from a city that was in some ways like an open-air theater in itself.

One entered St. Petersburg by ship—passing, as if in review, by Peterhof, its cascade of fountains suggesting imperial dominion over the sea below. The visitor arrived by boat at the Winter Palace on the Neva River and reached center stage by ascending the magnificent Parade Staircase that led to the throne room of the empress. Exits from the imperial stage were by carriage into the landlocked empire—again passing in review before the 978-foot facade of the "imperial village" (Tsarskoe Selo), then parading all the way back on foot to bid farewell in the most famous of all Rastrelli's glittering amber throne rooms.

There were theaters in all the palaces; and Catherine the Great, herself a playwright, filled them all with operas, farces, ballets, and masquerades. Under Catherine's reign, the official culture was no longer centered on a *sobor* (meaning both "cathedral" and the "gathering" within it), but on a *sobranie*, the gathering in a palace for an evening of theater and dance in which aristocrats enjoyed "the freedoms of the ball" (*bal'nye vol'nosti*).[7]

Portraits drawn from life became status symbols for members of the aristocracy, and they proliferated in and beyond the new capital. Such portraits represented a profane innovation and an explosive rejection of the preexisting religious tradition. Everything about the new painting was different. Portraits did not represent the ideal form (*obraz*) of a two-dimensional, heavenly figure, but the natural appearance (*parsuna*) of a three-dimensional, earthly authority. Oil on canvas replaced egg-based tempera on wood. Portrait painters began with the face and then filled in the clothing and the background. Icon painters followed precisely the opposite sequence. Believing they were following "the steps of divine creation" described in the Book of Genesis, they began with light (a gold background), followed by all the "pre-facial" (*dolichnoe*) objects in the natural world, then the garments, and finally the human face (*lichnoe*), the high point of creation according to the Book of Genesis.[8]

The new portraiture was characterized by natural perspective and was introduced to Russia at the same time as three-dimensional sculpture. Portraits were hung inside and sculpture placed on the roof of the new imperial residence, the Winter Palace. Figures from classical mythology replaced those from sacred history, and both sculpture and painting represented Russian imperial figures. Peter the Great was all but deified by a series of heroic

statues, beginning with a portrait bust and an equestrian statue cast by Rastrelli's father during Peter's lifetime. Etienne Falconet's laboriously produced bronze statue of Peter on a rearing horse surmounting a giant boulder was erected in 1782 and was, in many respects, to become the symbol of the city.

By the 1720s, portraits were not only being painted by foreigners but also by Russians. Royal patronage was extended in 1727, when Peter's widow, Catherine I, established a department of art within the Academy of Sciences. And in 1767, Catherine II established the Academy of Fine Arts, in which a classicist artistic program was instituted. The portraits made at and outside the imperial court during the eighteenth century were intended to represent the medals and uniforms as much as the physical features of the person depicted. As a result, many of the portraits that best indicate the individuality of their subjects are those of people not involved in the aristocratic hierarchy, like Ivan Nikitin's early portrait of a Ukrainian cossack leader and his later distinctive portraits of peasants and provincial figures.

Many of the most appealing Russian portraits of the eighteenth and nineteenth centuries were of women, perhaps because these subjects were without the masculine compulsion to display the uniforms and decorations that established their rank. And many of the best painters came from the more Westernized Ukraine, an area that was being reintegrated into the Russian empire in the late seventeenth and eighteenth centuries. The two greatest Russian portraitists of the late eighteenth century, Vladimir Borovikovsky and Dmitry Levitsky, were both Ukrainians who created particularly memorable images of women.

Portraits of the two empresses largely responsible for the establishment of the new court culture illustrate how the new secular art of St. Petersburg could incorporate realism and allegory into a single canvas. The painting of Elizabeth II by Liudovik Karavak that hung in the palace at Tsarskoe Selo until Soviet times portrayed a dignified likeness of the empress's face superimposed on a nude body, a stylized representation of Venus.[9] This device might seem incongruous to a modern viewer but reflects an accepted artistic convention of the time. In his famous 1783 portrait of Catherine the Great, Levitsky depicted both a realistic face and an eagle at the empress's feet, symbolizing power.

Classical imagery was repeatedly used to glorify Alexander Suvorov, the greatest Russian military hero of the late eighteenth century. His likeness appeared on ordinary objects of everyday aristocratic life. As Gabriel Derzhavin, the leading poet of the era, put it: "He who blazingly leads the troops/ends up on jade and crackers."[10]

The Russian victory over Napoleon in 1812 created a surge of national pride and a growing desire for heroic historical tableaux. Russian artists sought to depict episodes of history that were thought to be important in establishing a unique identity for Russia. The result was the series of increasingly large and labored canvases that emerged both in the classical aristocratic painting of the academy at the beginning of the nineteenth century and in the more plebeian realism that predominated in the second half of the century.

The academy prescribed a formal classicism in both style and subject matter. This kind of training impelled the two greatest Russian painters of the first half of the nineteenth century, Karl Briullov and Alexander Ivanov, to spend long periods of residence in Rome. Once there, each became absorbed with painting a single, monumental historical canvas. They

captivated the Russian imagination with their respective schemes for these paintings, and with them established the new artistic genre of history painting with a contemporary message.

Briullov's enormous *Last Day of Pompeii* (1833, page 93) showed a melodramatic scene of people recoiling from the eruption of Mount Vesuvius. Painted in Rome between 1830 and 1833, it was inspired by a novel by the English writer Edward Bulwer-Lytton and an Italian opera, both of which bore the same title. When exhibited in Russia, *Last Day of Pompeii* was seen as an icon of the inevitable decline of the West and an indication that the future of civilization lay in Russia. Briullov was invited back to Russia to redecorate the tsar's Winter Palace (now the Hermitage Museum); most of his frescoes there have since been destroyed.

Ivanov labored for twenty-five years and produced more than six hundred preparatory sketches in Rome for his *The Appearance of Christ to the People*. He worked on it from 1833 to 1857. In 1845, when he was at the height of his power, Tsar Nicholas I visited Rome to see it, and Ivanov came to believe that his painting would transform and re-Christianize the Russian people. The great Russian writer Nikolai Gogol was close to Ivanov in Rome. When Gogol realized that he would not complete *Dead Souls*, his attempt to write a Russian *Divine Comedy*, he attached almost messianic hope to Ivanov's project. But Ivanov's style had become more naturalistic, his faith had weakened, and the final painting was widely disparaged as "the disappearance of Christ among the people." The dominant figure in the composition is John the Baptist, but the person nearest to the distant figure of Christ is Ivanov's representation of Gogol. (In the small variant of this painting shown in the State Russian Museum [see page 93], Gogol is seen turning his head away from Christ; in the larger and nearly identical version in the State Tretyakov Gallery [see page 105], Gogol faces Christ.)

In the mid-nineteenth century, Russian culture took a sharp turn away from aristocratic classicism and romantic idealism towards a more plebeian realism. Defeat in the Crimean War (1853–56) was followed by the freeing of the serfs in 1862 and a series of liberalizing reforms under the reign of Tsar Alexander II (1855–81). The new generation depicted in Ivan Turgenev's novel *Fathers and Children* (1862) adopted materialism and the natural sciences as vehicles for questioning all existing institutions and beliefs. Prose, often charged with bleak pictures of society, replaced romantic poetry as the dominant form of literature.

A distinctively Russian school of composers based music on the sounds of Russian speech. Many left the St. Petersburg Conservatory amidst the tumultuous student demonstrations of 1862–63, determined to find among the people a Russian alternative to the music of Verdi and Wagner, both of whom had visited St. Petersburg that season. At the same time, many painters left the academy to set up their own school of "Wanderers." They were seeking new subject matter from ordinary Russian life and refused to accept the academy's prescribed foreign theme for that year: The Entrance of Wotan into Valhalla.

The Wanderers used portraiture for the naturalistic depiction of peasants as well as for untitled professional people. Aristocrats were often portrayed in psychologically penetrating images as individual personalities rather than as stylized authority figures. And a distinct tradition emerged during this period of what might be described as "mood landscape painting." From Ivan Shishkin to Arkhip Kuindzhi, Russian artists used a variety of styles to convey their often melancholy feelings about the forests, the steppe, and the rivers of Russia.

Isaak Levitan, Above Eternal Rest,
1894. Oil on canvas, 150 x 206 cm.
The State Tretyakov Gallery, Moscow

Ilya Repin, Zaporozhians, 1880–91.
Oil on canvas, 203 x 358 cm. State
Russian Museum, St. Petersburg

Buildings and animals were rarely included in such pictures. Isaak Levitan, the greatest of all Russian landscape painters, occasionally included a small church or hut in his canvases, but such architectural details always seemed overwhelmed in his work by the vast spaces of the Russian interior. Levitan and others generally sought to focus their landscapes on a small cluster of trees, which seemed to make Russia's vast expanses more manageable.

The most original and influential of all the new realistic paintings were those in which the artist sought to use the new, naturalistic style to send an uplifting message to a nation just entering the modern world. Paintings were viewed by a much wider audience during the more open and liberal reign of Tsar Alexander II. Artists now felt that if they could focus all their efforts on a single project, or on a large enough single canvas, they could provide the Russian people with a transforming, if not transcendent, artistic experience.

During the late nineteenth century, Russian artists began using a new kind of painting to renew an old quest: to establish paintings as signposts on a road to salvation. Artists sought in various ways to realize the manic dream of Ivanov. In his late years he had turned from his labors on *The Appearance of Christ to the People* to an even more megalomaniac scheme: the invention of paintings for a temple to be built on Red Square in Moscow and dedicated to "the golden age of all humanity." During the last decade of his life, he produced some 250 original sketches for this imaginary project; but he never left a clear design for the giant fresco that was to dominate the temple. One half of it was to depict the Holy Land at the time of Christ; the other half, the Holy Land at the time of the Second Coming, with Nicholas I in the center representing the ultimate guise of the Messiah.

Vasily Polenov spent much of his life painting a series of canvases on the life of Christ. It was an evangelical project intended to renew the faith that Ivanov had largely lost in the course of a similar project. Many Russians saw the revolutions of 1848 in the West and the revolt of the Paris Commune in 1871 as signs of approaching apocalypse. In 1850, Ivan Aivazovsky, the great painter of seascapes, produced a monumental canvas, *The Ninth Wave* (plate 100), illustrating the last flood predicted by the Book of Revelation.

In the 1860s and 1870s, the earlier idealism of both Westernizers and Slavophiles gave way to the more militant teachings of revolutionary populists and imperial pan-Slavs. Central to the belief of the new generation of radical social theorists was the idea that they were speaking truth to power. Pictures of Christ before Pilate became the subject of Ivan Kramskoy's large canvas, *Khokhot*,[11] and of a famous painting by Nikolai Ge, *What Is Truth?* (1890). Lev Tolstoy much admired both of these works.

In the mid-1890s, the Siberian artist Vasily Surikov created huge, bold scenes of Russian military victories such as *General Suvorov Crossing the Alps* and *Yermak: The Conquest of Siberia*[12] The most popular of all the paintings in this genre was Ilya Repin's large and laboriously produced *Zaporozhians* (1880–91).[13] The painting appealed to conservative nationalists because it showed warriors loyal to the tsar rebuking the Ottoman oppressor of their Balkan brethren. It also appealed to social revolutionaries because it represented ordinary people spontaneously defying power from the *Sich*, the place in which the cossacks assembled free from all authority. (In the early 1890s Lenin used this word to describe the cafeteria in which he organized his first revolutionary group.)

Inspired by the simple sight of a black crow on a snowy field, Surikov produced numerous sketches that culminated in the largest of all the monumental Russian history paintings: *Boyarina Morozova*. It depicts a famous Old Believer being hauled off on a sled to exile in Siberia. It was completed in 1887, just as the largest church in Russia, the Church of Christ the Savior, was finished with vast interior frescoes showing scenes from Russian history.[14]

Ilya Repin (1844–1930) was the longest-lived of the original Wanderers. In his work he covered the entire range of subject matter of the Russian realist painters. His *Barge Haulers on the Volga* (1870–73, plate 104) inspired many young revolutionaries to swear vows before it as medieval warriors had done before icons. Repin made wonderfully individual portraits of all kinds of artists, as well as a particularly haunting picture of Modest Mussorgsky that he painted just a few days before the composer's death in 1881.[15] Dmitry Shostakovich kept a reproduction of this portrait before him when writing his own music.

Repin's great bloody portrait of Ivan the Terrible cradling the son he has just murdered (1885) suggests that the tsar is insane and his son is a kind of Christ figure.[16] Unlike many of the realist painters, Repin welcomed Russia's first attempt at a parliament after the Revolution of 1905; he painted the Duma as a whole, as well as many of its individual members. During his last years in exile, he painted a series of crucifixion scenes, including a particularly grotesque one in which wolves are shown licking up blood at the foot of the cross.

During the nineteenth century, Russia experienced a rapid and overlapping series of cultural revolutions: the emergence of its first great vernacular poetry (Mikhail Lermontov and Alexander Pushkin); its first national school of music (Alexander Borodin, Mikhail Glinka, Mussorgsky); and a sudden rush of novelists, among them Dostoevsky and Tolstoy. But by the end of the century, Russia's continuing autocracy also produced a group of alienated intellectuals who first adopted the word terrorism as a badge of pride—along with the technology of secret, hierarchical organization based on escalating, targeted violence designed to overthrow a government.[17]

This Russian prototype for modern revolutionary movements was called—and believed it represented—"The People's Will" (*Narodnaia Volia*). Its members succeeded in murdering a host of tsarist officials, climaxing in the spectacular 1881 assassination in St. Petersburg of Alexander II, the most liberal leader Russia has ever known. This shock produced the repressive reign of Tsar Alexander III (1881–94) and a wave of nationalistic reaction, symbolized by the insertion of an incongruous, neo-Muscovite church (Our Savior on the Spilled Blood) into Westernized St. Petersburg on the spot where a bomb had killed the tsar-liberator.

A new group soon sought to continue the terror by assassinating this tsar, but was rounded up and executed.[18] The improving security forces thought they had ended the threat, but it was just beginning. One of the executed revolutionaries was the older brother of Vladimir Lenin, who began his long march to power as an act of homage to his martyred sibling.

The year 1881 represented a cultural as well as a political turning point in Russia. In that year, both Dostoevsky and Mussorgsky died, and Surikov produced the first of his large canvases portraying the victims rather than the heroes of imperial militarism. His *Morning of the Execution of the Streltsy* (1881) depicted a crowd in Red Square fearfully awaiting the

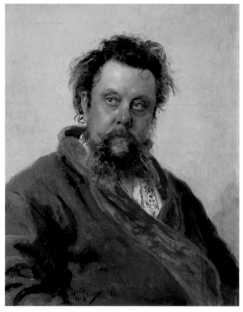

Vasily Surikov, Boyarina Morozova, 1887. Oil on canvas, 304 x 587.5 cm. The State Tretyakov Gallery, Moscow

Ilya Repin, Portrait of the Composer Modest Mussorgsky, 1881. Oil on canvas, 69 x 57 cm. The State Tretyakov Gallery, Moscow

collective massacre of the old Muscovite troops by Peter the Great's new regiment.[19] The anguished figures in the painting, put on exhibition in 1881 just before the assassination of Alexander II, seemed to prefigure the fear of impending violence that followed the killing of the tsar and moved his successor towards repression.

Between the birth of a popular national culture in the tsarist nineteenth century and its destruction in the Soviet twentieth century, Russia produced one of the world's most innovative explosions of artistic modernism. This extraordinarily creative period between the late 1890s and the outbreak of World War I is sometimes called the Silver Age, but is also more accurately described as the Russian Renaissance.

Like the earlier Renaissance in the West, this belated "rebirth" in Russia began with the rediscovery of a forgotten ancient culture. It was radically different from either the populist realism that came before or the socialist realism that came later. Music looked back to real or imagined pre-Christian antiquity for its leap into the pioneering, discordant modernism of Igor Stravinsky's *Rite of Spring* (1912) and Sergei Prokofiev's *Scythian Suite* (1914–15). Painters were dazzled into pure abstraction by the restoration (newly possible) of icons that now revealed their pure lines and colors, long obscured from view by a dark overlay from candle smoke.

Seeking to restore the spiritual and meditative dimension of visual art, Vasily Kandinsky produced a series of swirling, brightly colored compositions, which established the evocative power of Abstract Expressionism. His many paintings of St. George slaying the dragon, for example, produced between 1911 and 1921, show how his work evolved from the recognizable iconic form to pure abstraction.[20]

Kazimir Malevich's work was equally groundbreaking. Malevich began his flight from realism by reproducing the simple black-and-white crosses and other geometric forms painted on the garments of saints in icons. He also portrayed ordinary people as composites of basic geometric shapes, each with its own dominant color.

The Russian Renaissance produced a profusion of artistic styles that drew on almost all the Western European Impressionist and Post-Impressionist schools. Poetry now replaced prose as the dominant literary form and exploded into a bewildering variety of schools: Symbolism, Acmeism, Imagism, and so on. The entire culture was becoming pluralistic, and society itself was changing dramatically. Russia realigned its diplomatic alliances from the emperors of Germany and Austro-Hungary to the more democratic and open states of France and Great Britain. Censorship was abolished for the first time in Russian history in 1907 and the economy continued to grow as never before.

There were some threads that ran through all the artistic innovations of this period and that made the rediscovery of pure artistic form something more than merely a return to art for art's sake. Artists were reaching for some kind of transcendence after what Kandinsky called "the nightmare of materialism, which turned life into an evil, senseless game."[21] He argued that art must be generated by, and call forth in the viewer, "spiritual vibrations."[22] Malevich saw his new "Suprematism" as rising through "the fourth dimension" of time to produce truly new and "subjectless" forms suitable for a space-beyond-space altogether disconnected from earth.[23] Velimir Khlebnikov, one of the most inventive of the pleiad of new poets, sought to use

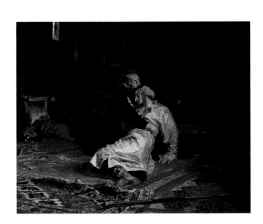

Ilya Repin, Ivan the Terrible and His Son Ivan, 1885. Oil on canvas, 199.5 x 254 cm. The State Tretyakov Gallery, Moscow

a "language beyond thought" (*zaumnyi iazyk*) that would lift listeners up to a higher realm.[24]

Equally characteristic of the age was the central role played by music in the constant search by artists for something to bind the arts together into a higher synthesis. Music, the most immaterial of the arts, appealed to the new generation of artists in rebellion against materialism. Kandinsky thought painting should move from a "melodic" to a "symphonic" stage.[25] Malevich put great skill and energy into designing costumes and sets for the composer Mikhail Matiushin's neo-pagan, mixed-media opera, *Victory Over the Sun*. This production for the "first in the world theater of futurists"[26] also brought together the talents of Khlebnikov and a host of other artists. It opened in December 1913, playing in tandem with a tragedy, *Vladimir Mayakovsky*, written and directed by Mayakovsky himself and with sets by Pavel Filonov. Mayakovsky was to become publicly lionized in the USSR. Filonov's haunting canvases were never signed or sold or put on public view from the late 1920s till long after his death in 1941.

The aged Nikolai Rimsky-Korsakov, no less than the young Kandinsky, believed that colors had musical equivalents. And the exploding musical stage increasingly synthesized innovative sets, costumes, dance, and gestures with music and poetry. The composer Alexander Scriabin scored color projections and odors into his late music and left behind at his death in 1915 his unfinished and unperformable *Mystery*, which required two thousand performers to synthesize mystery play, ritual dance, and oratory with music.

The new artistic center created at Abramtsevo in the 1890s by the railroad baron Savva Mamontov added majolica to the mix, as well as other decorative arts derived from the folk tradition. All the arts came together in new opera productions there. The great and unique modernist painter Mikhail Vrubel, sometimes called "the Russian Cézanne," designed sets and decor for these operas that often featured his wife, the great soprano Nadezhda Zabela-Vrubel (1898, plate 139). His paintings of her, made between 1898 and 1905, are among the most striking examples of all Russian portraiture. Just as painters of that period sought to illustrate parts of the Bible not covered in traditional iconography, so Vrubel all but invented a rich lavender pigment unknown to icon painters, which dominated many of his largest canvases and became the subject of often ecstatic critical acclaim.

Sometimes the artistic search for new subjects and for a transcendental dimension led painters back to the Orthodox Church, which was gaining intellectual respectability during this period. Mikhail Nesterov used a softened realism to depict his pictorial visions of a rediscovered Holy Russia that combined earlier figures like Gogol and Dostoevsky with people from the burgeoning religious revival, including perhaps the greatest polymath of the age, the monastic mathematician-aesthetician Pavel Florensky.

Before Stalin had him shot in a gulag, Florensky was working on one of the most ambitious synthetic projects of the Russian Renaissance: the creation of a universal encyclopedia of symbols involving all languages and forms of human communication. His unrealized idea of creating such a "Symbolarium" has been taken up again in post-Soviet Russia by the renowned linguist and semiotician, Viacheslav Vsevolovovich Ivanov.

Alexander Blok, the chief poet of the Silver Age, wrote that the revolution that brought Communism to power late in 1917 arose out of the "spirit of music." He introduced

Kazimir Malevich, Red Cavalry,
1928–32. Oil on canvas, 91 x
140 cm. State Russian Museum,
St. Petersburg

the sound of the wind into his most famous poem, "The Twelve," that described a band of revolutionaries sweeping into St. Petersburg in a modern version of the twelve apostles following a mysterious figure identified in the final line as Jesus Christ. Such vaguely positive images of the revolution encouraged many artists to continue working in the new Communist state. Many, however, left permanently in the twenties, and many more were killed or brutalized into silence in the thirties.

When Stalin proclaimed Socialist Realism as the only approved style for his totalitarian regime, all surviving experimental artists went underground—and had difficulty resurfacing under later Soviet leaders. As a result, throughout most of the Soviet period Russian artistic creativity resided with three groups or organizations: the émigrés, the public institutions of the Soviet Union, and the private world of often dissident art within the USSR itself.

The new freedoms of post-Communist Russia have produced an "interrupted renewal" of the great cultural ferment of the pre-revolutionary Silver Age.[27] A variety of styles and points of view quietly grew within the decaying Soviet system and have blossomed since its collapse. The current Guggenheim exhibition includes some florid examples of Stalinist art, but also more than the usual number of recent paintings from the late Soviet and post-Soviet periods. If these works seem less charged with ideological messages than many earlier Russian paintings, it may simply be because more people are now involved in creating and viewing art and most are skeptical of ideology as such.

While the new paintings may not satisfy the Western critics' appetite for innovation, they seem on the whole to represent a maturing desire to draw on all three of the historic wellsprings of Russian culture rather than relying disproportionately on one or the other.

The legitimacy of the Soviet system was undermined partly by a new political and cultural concern for the environment. The so-called "village writers" and provincial leaders denounced the pollution of lakes and plans to reverse the flow of rivers in the late Soviet era, and many visual artists are now finding new ways to portray their beloved but still endangered lands and waterways. They continue the tradition that Arkady Plastov and Nikolai Romadin kept alive in the late Soviet period.

The Orthodox Christian substratum of Russian culture is also playing a renewed role after the collapse of the world's first effort to impose atheism on an entire population. Religious themes and symbols play an important role in post-Communist Russian art and the Orthodox component is being enriched with themes from other denominations and religions.

Finally, and perhaps most importantly, the influence of the West, in all its creative variety and post-modernist confusion, is having such an impact that contemporary Russian painting is now more part of the European and North American mainstream than it has ever been. Russia continues to produce distinctive variants on Western art that reflect its still unresolved search for a satisfying national identity. But contemporary Russia is undergoing more than just a renewal of the cosmopolitan Silver Age, when both Picasso and Matisse felt obliged to visit and learn from Russian artists even as Russians were learning from the West. They are creating a new artistic pluralism and a more open culture that offers hope for the future if Russia can sustain its still precarious democracy and avoid a return to authoritarianism.

1. Nikolai Berdyaev, *The Russian Idea* (New York: Macmillan, 1948), p. 2.

2. Alexander Panarin, *Iskushenie globalizmom* (Moscow: Russkii natsional'nyi fond, 2000); and see James Billington, *Russia in Search of Itself* (Baltimore and London: Johns Hopkins University Press, 2004), pp. 78–80.

3. *The Russian Primary Chronicle*, trans. and ed. Samuel Cross and Olgerd Sherbovitz-Wetzer (Cambridge, Mass.: The Medieval Academy of America, 1953), p. 111.

4. Illarion of Kiev, cited in James Billington, *The Icon and the Axe: An Interpretive History of Russian Culture* (New York: Alfred Knopf, 1966), p. 7.

5. Evgeny Trubetskoy, *Umozrenie v kraskakh* (Moscow: Tipografia I. D. Sytina, 1916).

6. Yuri Lotman, *Kul'tura i vzryv* (Moscow: Gnozis, 1992), p. 269.

7. Yuri Lotman, *Besedy russkoi kul'ture. Byt i traditsii russkogo dvorianstva*. XVIII–Nachalo XIX veka (St. Petersburg: Iskusstvo, 1994), pp. 91–92. See also the full description of the centrality of the education of women (particularly at the Smolny Institute, perhaps Rastrelli's greatest architectural achievement) to aristocratic culture, and to the institution of the ball.

8. See the discussion of Pavel Florensky's analysis in Victor Bychkov, *The Aesthetic Face of Being* (Crestwood, N.Y.: St. Vladimir's Seminary Press, 1993), pp. 90–95.

9. The two paintings are discussed in Lotman, *Besedy*, pp. 180–81. Neither the present location of the painting of Elizabeth II nor the exact name of Karavak is given by Lotman. However, the portrait appears to have been produced by a Russified Frenchman, Ludwig Caravaque, shortly before his death in 1752; he was reputed to be a particularly accurate portraitist. See N. Subko, "Frantsuzskie khudozhniki v Rossii v XVIII v.," *Istoricheskii Vestnik* 4 (1882) and the same author's article "Dopolnitel'nye svedeniia o zhivopistse Liudovike K.," *Istoricheskii Vestnik* (1882), pp. 5, 6. Additional material can be found in E. Gollerbakh, *Portretnaia zhivopis v Rossii XVIII vek* (Moscow and Petrograd: Gosudarstvennoe Izdatel'stvo, 1923), p. 71; pp. 25–31.

10. Cited in Lotman, *Besedy*, p. 181.

11. Kramskoy was a skilled portraitist, but his uncompleted and rarely exhibited *Khokhot* (now in the State Russian Museum) preoccupied him from 1872, when he completed his painting *Christ in the Desert* and concluded that the figure was "not Christ … It is the expression of my own personal thoughts." He traveled to Pompeii in 1876 to make sketches and worked on the large canvas intermittently until his death in 1887. See Frida Roginskaia, *Tovarishchestvo peredvizhnykh khudozhestvennykh vystavok*, (Moscow: Iskusstvo, 1989), pp. 68 ff.

12. Ge's *What Is Truth?* is now housed in the State Tretyakov Gallery, while both the Surikov paintings are in the State Russian Museum.

13. The painting is in the State Russian Museum.

14. This church, decorated by a variety of painters, was a laboriously constructed monument to the victory over Napoleon. Blown up by Stalin in 1931, it has been reconstructed in post-Soviet Moscow.

15. *The Haulers* is in the State Russian Museum; the portrait of Mussorgsky is in the Tretyakov.

16. *Ivan the Terrible and His Son on November 16, 1581*, now in the Tretyakov.

17. James Billington, *Fire in the Minds of Men: Origins of the Revolutionary Faith*. (New York: Basic Books, 1980), pp. 405–09.

18. Lenin's older brother, Alexander (Sasha), was a student organizer of the "Terrorist Faction of the People's Will," which he founded in the Volga region in 1886 after a St. Petersburg group seeking to keep the revolutionary movement alive was rounded up in 1884. Sasha was captured and executed in 1887. Ibid., pp. 409–12.

19. The painting is in the Tretyakov.

20. Kandinsky's fascination with St. George lasted from 1911 to 1921. His conception of white as the color of transcendence (see Armin Zweite, *The Blue Rider in the Lenbachhaus Munich* [Munich: Prestel-verlag, 1989]) is similar to that of icon painters. Kandinsky moved rapidly from painting on glass to complete abstraction on canvas in the period before World War I; the St. George theme is visible in the major abstract canvas in the Guggenheim collection *Bild mit weissem Rand* of 1912. In 1917 he returned to a more figurative form of St. George in a painting made in oil on cardboard to support the Russian war effort with a more recognizable image of St. George. See Vivian Barnett et al., *Vasily Kandinsky. Rétrospective*. Exh. cat. Fondation Maeght. (St. Paul, France, 2001).

21. Vasily Kandinsky, *Concerning the Spiritual in Art* (New York: George Wittenborn, Inc., 1947), p. 24.

22. Ibid., p. 74.

23. See Andrei Nakov, *L'avant-garde russe*, (Paris: Fernand Hazan, 1984), pp. 6–39; 54–56, for a concise discussion of the centrality of Malevich to the artistic developments of the period. Malevich derived the term "suprematism" from his native Polish. In 1919 he called for "an economic council (of the fifth dimension) to liquidate all the arts of the old world." The conclusion of Malevich's "Resolution 'A' in Art," trans. by John Bowlt in Stephanie Barron and Maurice Tuchman, *The Avant-Garde in Russia 1810–1930* (Los Angeles: Los Angeles County Museum of Art, 1980), p. 201.

24. This subject is analyzed in Vladimir Markov, *The Longer Poems of Velimir Khlebnikov* (Berkeley and Los Angeles: University of California Press, 1962).

25. *Concerning the Spiritual*, pp. 76–77.

26. Alexandra Shatskikh, *Kazimir Malevich* (Moscow: Slovo, 1996), p. 37.

27. Vladimir Weidlé, *Russia: Absent and Present* (London: Hollis & Carter, 1952), p. 80, uses the term "interrupted renewal" to describe the Silver Age itself, since it came after a long period in which most literature and art was required to be strictly realistic and to carry a social message. The term seems even more applicable to the post-Soviet period, which has experienced a conscious renewal of the ferment of the Silver Age. See Billington, *Russia in Search*, pp. 53–57.

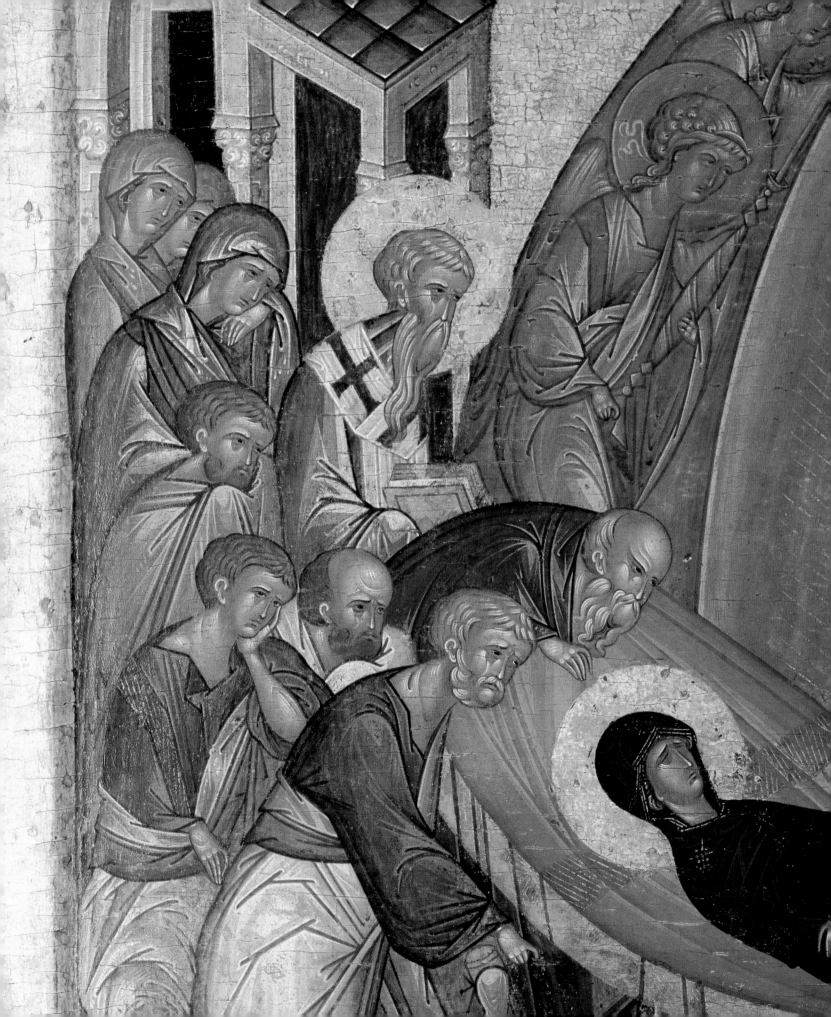

12TH–17TH CENTURIES:
THE AGE OF THE ICON

THE ICON IN THE LIFE AND HISTORY OF THE RUSSIAN PEOPLE
GEROLD VZDORNOV | 18

THE ICON IN THE LIFE AND HISTORY OF THE RUSSIAN PEOPLE
GEROLD VZDORNOV

Less than a hundred years has passed since the first scientific investigations of early Russian icons. The first significant attempts at cleaning early icons were undertaken in 1909 and 1910 by S. P. Ryabushinsky, a well-known Old Believer, and the artist I. S. Ostroukhov. The newly revealed beauty of ancient Russian painting was a sensation to scholars and to artistic life not only in Russia itself, but also in Western Europe. The early twentieth century was marked by many outstanding art-historical discoveries. It was at that time that the overall achievement of Piero della Francesca in Italy, Matthias Grünewald in Germany, and the Van Eyck brothers in the Netherlands came to be understood and appreciated. Italian primitive art of the thirteenth and fourteenth centuries was also being studied during this period. At the same time, the Russian icon was triumphantly introduced as a worthwhile subject of art-historical investigation within the context of world painting. It was enthusiastically greeted by Alexander Benois, Roger Fry, Igor Grabar, Henri Matisse, Pavel Muratov, and other European artists and critics. From 1929 to 1930 Russian icons were shown at exhibitions in Germany, Austria, and England, and from 1930 to 1932 American viewers got an opportunity to see them at exhibitions in New York, Boston, and Chicago.

The Russian icon has long since come to symbolize Russian culture. It has received more universal recognition than any other form of art that emerged from ancient Rus. Popular life in Russia as a whole was unthinkable without the holy images that filled churches, chapels, peasants' huts, tsars' palaces, and the houses of the aristocracy. Everyone was equal before the primary images of Christ, the Virgin, and the saints; these images served as unifying motifs that could bring the people together at moments of national crisis. There are several early icons on the subject of the battle between the Novgorodians and the Suzdalians; or rather on the theme of the Virgin of the Sign, in which the main "character" is the miracle-working icon of the Virgin, which, when carried out onto the ramparts of Novgorod in the twelfth century, saved the city from the besieging army of Andrei, prince of Vladimir.

The origin of Russian art, as well as of other Christian monuments of ancient Rus, was Byzantium and Byzantine art. The spread of Greek art to Rus began in the middle of the tenth century: in 955, according to the Primary Chronicle (also known as *The Tale of Bygone Years*, the first Russian annals begun by monks in about 1040 and continuing through 1118), Olga, a Kievan princess, visited Constantinople (Tsargrad), where she converted to Christianity and received baptism under the name of Elena; in 988, in Cherson of Tauria, the Grand Prince Vladimir of Kievan Rus officially converted to Christianity, and this date came to signify the Christianization of the Russian land. The magnificent churches of St. Sofia in Kiev and Novgorod (eleventh century) remain as visible evidence of the beginning of the expansion of Byzantine artistic culture to ancient Rus. The earliest Russian icons date from around the same time.

A unique characteristic of the earliest Russian-Byzantine art of the eleventh to twelfth centuries is the remarkably large size of the icons. *The Apostles Peter and Paul* (Novgorod Museum) is almost two and a half meters tall and one and a half meters wide. The Novgorodian icon of the standing *St. George* (State Tretyakov Gallery), the *Ustiug Annunciation* (State Tretyakov Gallery) the *Dormition from the Desiatina* (tenth) *Monastery* (State Russian Museum), the *Great Panagia* from Yaroslavl (State Tretyakov Gallery), and other rare Russian icons of the pre-Mongol period are of similarly large size. The scale of these works can be best understood within the context of the monumental architecture of the period. Though smaller than Hagia Sophia in Constantinople, the cathedrals in Kiev and Novgorod are much bigger than other Byzantine churches known to us; naturally, they demanded icons of corresponding size. The painting and architecture of the eleventh and twelfth centuries were therefore united in vast and magnificent ensembles.

There were other ancient icons, however, whose sizes were adapted to small churches or even domestic worship. In 1973–77 in Novgorod, archaeologists discovered a large city estate dating to the end of the twelfth and the beginning of thirteenth century, where Olisei, an icon painter, lived and had his workshop. In the workshop and subsidiary premises they found fifteen panels prepared for icons that were very small in size, between eight and twenty centimeters high. Such tiny sizes are evidence that some of the paintings made during this period were intended to be transportable during military operations or as objects of worship in extremely small chapels of the kind that the many *terems* (boyars' castles; the term also refers to the women's quarters in a boyar residence) had in abundance on the Novgorodian and other Russian city estates.

Russian museums house a vast number of early and modern Russian icons. There are an estimated one hundred thousand or more of them; annual discoveries and the transfer of new icons to museums and private collections constantly increase this significant cultural heritage. Inevitably not all icons can be considered highly important works of art; on the other hand, many of these objects have long since been understood as valuable monuments to Eastern European artistic traditions.

The Russian icon, as a church object of religious worship, deals with many of the same subjects as Western European religious compositions, such as Italian or German altar paintings of the Middle Ages. Obviously, there is a genetic resemblance between Russian icons and works produced by Byzantine artists, since both of these Christian civilizations have the same roots. However, unlike Greek icons, Russian painting developed such individual characteristics over the centuries that it cannot be viewed merely as an appendix to Byzantine art. It is a different artistic phenomenon altogether. Moreover, after the fall of the Byzantine Empire in 1453, Russian icons came to embody the Orthodox Christian art of all of Eastern Europe and spread to other countries and geographical locations: to Greece and Mount Athos, to Bulgaria and Serbia, to Romania and Hungary.

Classical Russian icons were created in the fourteenth and fifteenth centuries, when Russia overthrew its dependence on the Tatar-Mongols, completed the centralization of its state, and developed a unified system of church and state government with Moscow at its head. The completed centralization of the Russian lands in the second half of the

fifteenth century did not have the best influence on the unique style of the Rostov, Novgorod, and even Pskov icons, but for a long time they still managed to preserve the artistic ideas that had been established when ancient Russian cities had political independence and autonomous churches.

The artistic value of early Russian icons lies in their coloring, lines, and careful composition. Their aesthetic cohesiveness and beauty are enhanced by their metaphysical profundity. E. N. Trubetskoy, a well-known scholar of the philosophy underlying Russian icons, has described the art of the icon as "philosophy in colors." The colors were seldom mixed. Most often, icon painters preferred pure, vivid pigments. As the work was finished, the basic colors could be highlighted in white in order to emphasize volume, or the convex forms of the body, or specific architectural elements. But volumetric, stereoscopic technique, which was already used in Giotto's works, was absolutely alien to Russian icon painters. They preferred the "flattening" of the figures and objects on a two-dimensional plane, which, after the outlines were filled in with colors, created an artistic effect worthy of ancient Greek vase painting: maximum artistic expression achieved by minimal artistic means. The many depictions of St. George on horseback or the compositions on the theme of the Miracle of the Archangel Michael and SS. Florus and Laurus are good examples of icons of this kind. In both cases, the icons feature black-and-white horses, as well as brightly colored cloaks on the saints; these vivid patches of color define the joyous, major-key "sound" of the icons.

The favorite color of ancient Russian painters was cinnabar, a red pigment present in almost every old icon. Fiery patches of cinnabar stand out even in those icons in which the artist otherwise used more somber coloring. The icons dating from the fifteenth and sixteenth centuries from the ancient city of Pskov are wonderful examples of this; in them, the dark green, almost black color is literally pierced and illuminated by bright patches of cinnabar, which create dramatic contrast. White, also loved by ancient Russian painters, provides a stark contrast to the cinnabar as well. At the end of the fifteenth century, when the workshop of the great Dionysii was active in Moscow, white often dominated icons and murals. Mixing it with small amounts of cinnabar or ocher, Dionysii and the artists of his circle achieved softly nuanced tones in their works, the very existence and perception of which can be likened to a form of lyrical poetry.

The idea of a relationship between a specific color and a specific subject was evidently alien to Russian icon painters. Tragic depictions of the Crucifixion and the Pietà, as well as scenes of the martyrdom of the saints, are often presented in remarkably light and even bright colors. The Crucifixion from the Paulo-Obnorskii Monastery (plate 18), painted in 1500 and attributed to Dionysii, is, beyond doubt, one of the most festive Russian icons: it seems as if the entire rich palette of the ancient Russian icon painter were used in this work—from pure white to black—while the color scheme of the painting, in which white, yellow, red, and rose tones predominate, was nonetheless preserved. There is similar artistry in the icons from Kargopol, which are now housed in three different museums: the Kiev Museum of Russian Art, the State Tretyakov Gallery, and the Sergiev Posad Museum-Preserve. The resoundingly red color of the clothing of Mary Magdalene, with her hands dramatically raised to heaven, is etched in the memory of anyone who has ever seen this extraordinary icon.

Iconostatsis of the Trinity Cathedral, 1425–27, in the Trinity-Sergius Monastery, Sergiev Posad

The soul of the Russian people is extremely receptive to artistic beauty, especially when each color in a work is imbued with its own symbolic meaning. While white signifies the purity and virginity of nature and man in the Garden of Eden, where the souls of the dead stroll in white garments, the soft light-blue and lapis lazuli hues symbolize the firmament, whose dome encompasses the lands and the seas. Due to the intensity of one color or another in their palette, later icons often received strange and unusual titles, such as the *Blue Dormition*, the *Angel with Golden Hair*, the *Savior with Golden Hair*, the *Red-Background Prophet Elijah*, or the *Red-Background St. George*. Gold leaf and later gold *assiste* were widely used in the practice of icon painting. The commissioners would spare no expense on an icon for a church or a house chapel. Even more generous were the church hierarchs, grand and local princes, aristocratic boyars, and rich merchants, who often acted both as the builders of churches and the commissioners of their interior decorations. Gold, silver, pearls, and precious stones were customary, not only in the making of church vessels and vestments, but also in the production of icons.

No icon could do without gold or, if gold could not be afforded, a substitute—silver, or at least the color yellow. Gold is a privileged color, symbolizing Christ and heavenly beauty, the ineffable shining of Christ, the Virgin, and the holy martyrs who suffered for the faith. One of the oldest and most beautiful Russian icons, *St. George*, in the Moscow Kremlin's Cathedral of the Dormition, is painted on gold leaf, slightly darkened with time, creating a shiny ground against which the silhouette of the saint stands out. White or colored garments of the saints finished with gold *assiste* often removed any sense of the material existence of the figures and translated the language of plasticity into the realm of the ethereal.

Before the fourteenth century, the icons in a Russian church were displayed according to the Greek tradition of the iconostasis. The boundary of the altar, made of stone or wood in the shape of a small portico, was decorated with a half-figure or full-figure *Deesis* (the largest and most important row on an iconostasis) placed above the architrave and the Royal Doors. Large local icons of Christ, the Virgin, and the feast to which a particular church was dedicated, were placed in the space between the columns of the sanctuary partition. Icons of the saints were displayed above the pillars of the dome. A later tendency gradually transformed the sanctuary partition into a high, solid wall of icons of different format whose central part was occupied by the *Deesis*. This transformation was completed between the fourteenth and fifteenth centuries, when the iconostasis of the Cathedral of the Annunciation of Moscow Kremlin by Theophanes the Greek (in the 1390s) and the iconostasis of the Trinity Cathedral in the Trinity-Sergius Monastery, Sergiev Posad (1425–27), were created.

Space does not permit a detailed examination here of the reasons for the transformation of the sanctuary partition of the Byzantine style into the high, solid iconostasis that for many centuries had been a purely Russian artistic creation. Suffice it to say that this change was related to nuances of liturgical practice and the new version of the canon. In any case, the original three-figure *Deesis* expanded through the addition of the icons of the Archangels Michael and Gabriel, of SS. Peter, Paul, John Chrysostom, and Basil the Great, and of the holy martyrs George and Demetrius of Thessaloniki. A new tier of the register of the Great Feasts appeared above the *Deesis*; they illustrated the earthly life and miracles of Christ, his death on

the cross, his entombment and resurrection. Later, yet another register—that of the Prophets—was added above the tier of the Feasts. It is represented by such wonderful icons as the prophets from the iconostasis in the Cathedral of the Dormition in the Kirillo-Belozersk (St. Cyril of Belozersk) Monastery (1497) and the Cathedral of the Birth of the Virgin in the Monastery of St. Ferapont (1502). During the sixteenth and seventeenth centuries, another tier of Old Testament Patriarchs was added. These innovations, however, complicated and obscured the original and clearly defined concept of the iconostasis. The still later iconostases are represented in numerous Russian icons of the eighteenth and nine-teenth centuries that depict the high iconostasis in their composition.

The iconostasis is such a widespread liturgical object in Russian Orthodoxy that an explanation of its significance in the life of the church and of its profound spiritual and mystical meaning becomes not only a scholarly problem but also an important element of the Russian Orthodox religion. From the point of view of liturgical practice, there are no meaningful differences between the function of the Byzantine sanctuary partition and the high iconostasis. Both the partition and the iconostasis separate the space of the altar niche, where the liturgical mystery takes place, from the *naos*, where the congregation prays. The division of the church into two unequal parts was itself evidence of the symbolic role of the sanctuary; it allowed the faithful to partake of heavenly grace in the course of the liturgy, since the communion of bread and wine connects man to the body and blood of Christ, who died as a martyr on the cross for the sake of the salvation of "Adam's flock."

The sanctuary partition, which was low and rather long, did, however, allow the congre-gation a view of the fresco or mosaic decorations of the altar niche. Moreover, the Russian Orthodox believer participated in a manner analogous to the priest's service behind the sanc-tuary partition through the painting of the altar niche of the church, which was dominated by the depictions of Christ, the Virgin, the Services of the Holy Fathers, and the Eucharist. However, since every mystery requires inward concentration, in the course of time the sanc-tuary partition itself was gradually transformed into a solid wall, impenetrable to the eyes of the laymen. The spaces between the columns were covered with large icons; the Royal Doors, originally very low, were veiled with finely embroidered fabrics, often with depictions of Christ, the Virgin, and the saints. An example of such a veil is the *katapetasma* (Veil of Heaven) from the Holy Monastery of Chelandari on Mount Athos that was sent by Ivan the Terrible as a gift to the monastery in 1533. Its fabric is embroidered with depictions of Christ as the great archbishop, of the monumental *Deesis*, and with numerous busts of the saints, related in one way or another to the family of the Russian tsar and to the destination of the gift.

The next stage of the development of the sanctuary partition or, to be more precise, of its transformation into the high iconostasis, is represented exclusively by the Russian icons. It is significant that the creation of the high iconostasis coincided with the terms of Cyprian, a Serb by birth and an Athenian monk by education, and Photius, a Pelopponesian Greek, as the Metropolitans of Russian Orthodox Church (1390–1406 and 1410–31, respectively). They came to Rus from Constantinople. The creation of the high iconostasis also coincided with the introduction into the Russian liturgical practice of the Jerusalem canon, which required a greater isolation of the priest at the time of the preparation of the holy gifts from

Iconostasis in Ilyinsky Church, 1657, in a graveyard in Chukherma Holmogoroskiy, Arkhangelsk. A few of the icons taken from this iconostasis before the church and iconostasis were lost in a fire in the 1920s are held in the State Tretyakov Gallery, Moscow.

the congregation of the faithful, as well as a more significant role for the clergy during prayer and service. Significantly, the high iconostasis first appeared in Moscow, the seat of the Russian Metropolitans, and only later arrived in Novgorod and other Russian cities.

The central nucleus of the iconostasis is the half-figure and later full-figure *Deesis*, which was set above the architrave of the sanctuary partition and the lower tier of locally venerated icons. Excellent examples of half-figure *Deeses* are represented by three icons of the Zvenigorod *chin* (meaning, row), attributed to Andrei Rublev, and the icon of John the Baptist from the Monastery of St. Nikolai of Pesnosha (Andrei Rublev Museum of Ancient Russian Art, Moscow). Similar icons were also preserved in the Russian provinces: for example, in the Church of Ioann Lestvichnik (sixteenth century) and in the Cathedral of the Dormition (1533), both in the Kirillo-Belozersk Monastery. The appearance of the full-figure *Deesis* and the addition of other saints initiated a real flourishing of this form of iconostasis in Russia.

The high iconostasis, with Christ in Glory and a multitude of angels and saints at its center, embodies the idea of divine intercession for the community of men as a whole and each individual believer in particular. This simple and at the same time programmatic idea of the iconostasis was enriched by the very course of the service, when the Royal Doors opened, allowing the congregation to contemplate the altar—the mystical site of Christ's presence in the church.

Originally, the icons that made up part of the iconostasis, with the exception of the tier of local icons, had not been separated from one another by pillars and formed continuous registers. The side margins of individual icons divided the iconostasis into its composite parts. The upper and lower parts of the icons were set in the grooves in the horizontal beams; thus the stability of the entire construction was insured. This original method of securing the icons in grooves was later replaced by a new one, in which the icons were set in the special nests of a "frame," richly decorated with gilded carving.

The early Russian high iconostasis, incorporating all the later tiers of the Prophets and the Patriarchs, consisted of dozens and dozens of icons. According to an inventory of 1617, the iconostasis of the Cathedral of St. Sofia in Novgorod consisted of more than eighty icons of different formats. According to an inventory of 1601, the Cathedral of the Dormition in the Kirillo-Belozersk Monastery had more than 110 icons (including the local register of smaller icons, the so-called *piadnitsy*). These numbers correspond approximately to the number of icons in the iconostases depicted in the icons of the eighteenth and nineteenth centuries. According to the same inventory, the overall number of icons (in the iconostasis, on the pillars and walls, in the altars and behind the altars) in the Cathedral of the Dormition in the Kirillo-Belozersk Monastery alone was close to one thousand. The cathedral therefore represented such a concentration of holiness that it became in itself a colossal object of worship.

In order to imagine the "life" of the icons in the Middle Ages, we must consider the archaeological evidence and correctly interpret the works of art that have survived but were moved from their original location. The richly ornamental icons in luxurious frames carved of wood or stone, which were most venerated in a particular church, were placed

in the *solea* (the space in which all the sacraments and processions occur) in front of the iconostasis or even in front of the *solea*.

Huge attention was paid to certain icons famous for the miracles they produced; they were set in a special place of honor near the congregation, where the believers could pray to them during periods of difficulty. Often two or three steps led up to a miracle-working icon, which separated the holy image from everything earthly and base. There was a widespread practice of carrying the icons out of the church during solemn processions. The icon was carried at the front of the procession either in the hands of the believers or on a special pole attached to the lower part of the icon. Thus the icon of the *Virgin of the Sign* was brought out onto the ramparts of Novgorod and the miracle-working icon of the *Virgin of Vladimir*, and later the *Iverskaia Virgin*, were carried out in Moscow. The icons "lived" their everyday lives unattached to a particular location, as later became customary in almost all Russian churches. Among the traditional church processions, preserved from early times and still observed today, the most spectacular is the carrying out of the colossal icon of the *Savior in Majesty* from the Church of the Resurrection in the town of Romanov-Borisoglebsk. The icon is then brought to the other side of the river Volga, which splits this town in two parts: in the presence of enormous crowds of people the icon is transported to the Romanov side of the river on a specially equipped ferry.

The early Russian icon seldom existed in its "pure" form, as we imagine it from museum exhibitions and scholarly publications. Veneration and worship of holy images, so typical of the Russian Middle Ages, encouraged the commissioners, *ktitors* (leaders of the church), and contributors to decorate the icons with precious *oklads* (chased silver or gold encasements for the icon) and embroidery. The earliest icon from the Church of St. Sofia of Novgorod, *Peter and Paul*, still has its beautifully preserved chased silver *oklad* from the eleventh century, which gives some idea of the luxury with which the icons of the sanctuary partition were decorated before its replacement with the high iconostasis in the fifteenth century. The main icon of the Cathedral of the Dormition of Moscow Kremlin—the *Virgin of Vladimir*—was even more lavishly ornamented. It was encased in three gold-filigree *oklads*, the work of Greek, Russian, and Greco-Russian master craftsmen. Even an icon as famous as the *Old Testament Trinity* by Rublev was set in a beautiful gold *oklad* with splendid semiprecious stones, created in the time of Ivan the Terrible and Boris Godunov. Apparently, most of the early icons, independent of their size and purpose, were set in *oklads*. We know of the majestic icons from the *Deesis* tier of the Cathedral of the Dormition in the Kirillo-Belozersk Monastery (ca. 1497, plates 10–14), set in silver *oklads* of 1540–42, as well as of numerous small icons—gifts to the *riznitsas* (rooms for the church vessels and vestments) of the Trinity-Sergius Monastery and the Solovetskii Monastery. A classic example of the decoration of the early Russian icon is that of the *Virgin Hodegetria* of the sixteenth century from the Monastery of the Intercession in Suzdal. The icon has preserved not only a beautiful gold *oklad*, but also numerous decorative *priklads* (ornamental attachments to the *oklad*) with precious stones, enamels, and pearls, as well as the original *pelena* (a rectangular piece of textile attached to the bottom part of the icon) with a reproduction of the same image of the Virgin, decorated with fine large pearls.

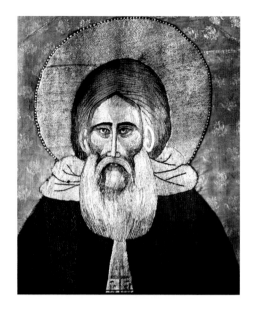

St. Sergei Radonezhsky, 1420s,
an embroidered shroud in the
Museum of the Trinity-Sergius
Monastery, Sergiev Posad

SS. Sergei and Nieon Radonezhsky, 1569–70, an embroidered icon in the Museum of the Trinity-Sergius Monastery, Sergiev Posad

Icons in ancient Rus were decorated not only with the *oklads*, crowns, *tsatas* (a half-moon shaped ornament, attached to the neck of the icon's figure), and *riasna* (precious pendant ornaments attached to the sides of the figure's head and hanging down its temples). Ornamental textiles and embroidery were also already widespread in the earliest period: the altar veils and pre-altar *pelenas*, pendants to icons, vestment embroidery. Family life was the lot of the Russian woman, and her specialties were tapestry, sewing, and embroidery. The *terems* of princes and boyars were known for their special chambers—workshops led by wives and daughters of the family; they selected skilled needlewomen who made precious ornamental textiles and embroidery, which were then donated to churches and monasteries. Starting from the fourteenth century, there are specific names associated with such workshops: Princess Maria Alexandrovna, wife of Moscow's Grand Prince Simeon the Proud (1389); Anastasia Ovinova, a Novgorodian boyar's wife (fifteenth century); Princess Evfrosinia Staritskaya, aunt to Ivan the Terrible (sixteenth century); Tsarina Irina, wife of Tsar Fedor Ioannovich (late sixteenth century); Marfa, mother of Tsar Mikhail Fedorovich (seventeenth century); as well as the wives of the boyars from the families of the Mstislavskys, Osoevskys, Volynskys, Godunovs, Trakhaniotovs, in addition to the merchant-industrialist Stroganovs, and innumerable others. One of the venerable scholars of early Russian tapestry, N. M. Shchekotov, has justifiably called the technique "painting with a needle." This is an apt description, since the beauty of early Russian ornamental textiles certainly equals that of the Novgorod, Moscow, Pskov, Tver, and Rostov-Yaroslavl icons. The needlework technique of these textiles is surprisingly sophisticated. Another specific characteristic of the early Russian ornamental textiles was that dozens, if not hundreds, of them were accompanied by the texts from the chronicles that indicated the place of their manufacture, their destination as gifts, and the names of the women who made them. In essence, the early Russian icon receives its complete "orchestration" as a work of art only when it is presented in its exquisite "ornamentation," which itself required much talent and artistry.

Hundreds of Russian churches from Novgorod to Moscow and Nizhny Novgorod, and from Ryazan to the Solovetskii Monastery were filled with such treasures. The Antiochian Patriarch Makary, who visited Russia in the mid-seventeenth century, was struck by the cathedrals of the Moscow Kremlin. His son, the Archdeacon Paul of Aleppo, described his impressions of the Church of the Annunciation in his diary: "As to the icons there, no jeweler who knows his trade would be capable of correctly appreciating the large precious stones, diamonds, rubies, and emeralds on the icons and the crowns [of the icons] of the Lord and the Virgin. In the dusk they glow like red-hot coals, and the pure gold of the icons and the exquisite multicolored enamels, made with fine and sophisticated artistry, amaze the connoisseur."

The destruction of the decorations on the early icons started long before the Revolution of 1917. The requisition of the church, carried out on a great scale in 1922, completed the barbaric elimination of the jeweled objects that had formed an artistic whole with the icons. Today only the rare surviving icons, mostly from church *riznitsas*, serve as illustrations of the past magnificence of the miraculous and locally venerated early Russian icons.

In ancient Rus, there were several important centers of icon painting that, over the centuries, developed certain stylistic features. When the cities and their gravitating suburbs were independent states, conditions were favorable for the development of different regional schools of icon painting. It is perhaps significant in this respect that the city-states were often covertly or even overtly hostile to one another and jealously preserved their own customs and traditions.

During the existence of the unified ancient Russian state, in the tenth and eleventh centuries, Kiev was naturally the main artistic center; it maintained ties to Constantinople and claimed the glamour of the unified Russian capital. As feudal strife began and peaked in the twelfth century, the ties between the cities became weaker. Novgorod, Pskov, Tver, Vladimir, Rostov, and Suzdal, which were geographically distant from Kiev, created their own, very different culture, one that was increasingly removed from their Byzantine origins. Though they lost glamour and grandeur, these cities gained much in terms of authentic, local material culture, literature, and art. The capture of Constantinople by the Crusaders in 1204 and the destruction of Kiev and other southern Russian cities by the Tatars in 1239–40 made the city-states of northwestern and northeastern Russia even more isolated from the south of the country, and in the thirteenth century their spiritual culture was already distinctive.

The surviving icons from the thirteenth through the sixteenth centuries (and there are a significant number of them) allow five leading artistic centers to be distinguished: Novgorod, with its vast territories in the North, and Pskov, Tver, Rostov, and Moscow. Vladimir and Suzdal, which endured the hardships caused by the Tatar-Mongol invasion in 1238, failed to restore their former power and high culture and, like Kiev, ended up in the backwaters of the new history of the Russian state.

Not all of the aforementioned cities were ultimately to prove their artistic viability, however. The history of icon painting in Tver and Rostov still remains unclear, its features undefined, and dated and topographically documented works are practically absent. The art of Nizhny Novgorod, Vologda, Kostroma, and Yaroslavl remains even more obscure, although the latter two cities became prominent in the seventeenth century. In other words, the Russian art of the thirteenth through sixteenth centuries is fully represented only by Novgorod, Moscow, and Pskov.

The most characteristic features of the Novgorodian icons are the distinctness and constructivism of their lines, the sharp outline of their drawings, the pronounced "calculated" highlighting, and the characteristic shading of faces and drapery of the vestments of the saints, elements that recur in the works of different artists and of various periods. The Novgorodian icon painters, more than the artists of other schools, preferred bright, audaciously contrasting colors, with rich red and lapis lazuli predominant. The crystalline clarity and formal refinement of artistic technique in this field reached their peak in the works of the Novgorodian artists. It is amazing that that they retain their vibrance and give no sense of mere soulless craftsmanship.

The position of icon painting of Novgorod's "younger brother"—the city of Pskov— was quite different. One of the most appealing schools of early Russian painting emerged

Mother of God Hodegetria, from the Cathedral in the Pokrovskiy Monastery, Suzdal, 1360s, an icon in the State Tretyakov Gallery, Moscow. The icon's precious dress, made with silver, gold, pearls, and gemstones, was created in Moscow by order of the wife of Ivan the Terrible, Tsarina Anastasia Romanovna.

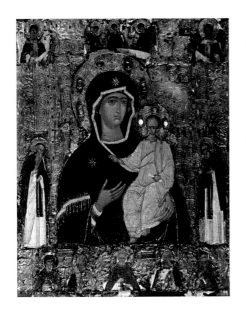

Mother of God Hodegetria
with Selected Saints, from the
Trinity-Sergius Monastery, second
half of 15th century, an icon in
the State Tretyakov Gallery, Moscow

there. It is best represented by the icons of the fifteenth and early sixteenth centuries: *The Synaxis of the Virgin* (State Tretyakov Gallery), the *Deesis with SS. Barabara and Paraskeva* (Museum of History and Architecture, Novgorod), *The Descent into Hell with Saints* (Pskov Museum), *The Nativity of Christ with Saints* (State Russian Museum), the *Old Testament Trinity* (State Tretyakov Gallery), and other outstanding works. The masterpiece of Pskov painting is the monumental image of the four saints: *SS. Paraskeva Pitanitsa, Gregorii the Theologian, John Chrysostom, and Basil the Great* (early fifteenth century, State Tretyakov Gallery). The icon is painted in the white, green, and red hues that are typical of Pskov. The faces of the saints are boldly defined by the strokes of highlighting against the dark, almost brown flesh tones. The expression of the saints' faces is severe, almost fierce, devoid of any hint of the warmth and tenderness of the Moscow icons. Their deep-set eyes burn with some kind of internal flame, which enhances the hypnotic and disturbing power of the images. The *Synaxis of the Virgin* is even more expressive; all the elements in it—the Magi, the heavenly chorus of angels, the allegorical figures of Earth and Desert—completely defy the traditional canons of icon painting and achieve a remarkable, purely aesthetic quality.

The third large artistic school of ancient Rus, the Moscow school, was formed later than the others. The earliest Moscow icons are dated to the mid to late fourteenth century. Due to its active ties to Constantinople and the Greco-Slavic centers in the Balkans (Bulgaria, Thessaloniki, Mount Athos) toward the end of the fourteenth century, Moscow became an authentic international capital, a site of the cross-pollination of different styles. Between the fourteenth and fifteenth centuries the great Greek painter Theophanes worked in Novgorod, Nizhny Novgorod, and Moscow and his art greatly influenced Russian painters. However, Andrei Rublev, a contemporary of Theophanes, decisively severed his ties to the Greek artistic heritage and developed an authentic Russian style. Rublev's famous masterpiece, the mysterious *Trinity* (see page 3) remains fascinating to art lovers five centuries after it was made. The biblical subject matter and its profound theological interpretation are embodied in a presentation of rare clarity and equilibrium. It is impossible to add or take away anything without destroying the heavenly beauty of this icon, in which the solemn, life-enhancing love that fills the images of the three angels under the oak of Mamre reigns supreme.

From the fifteenth century, Moscow painters actively introduced the subjects traditionally represented by earlier icon painters to the art of Russia as a whole. These subjects are represented by the wonderful works from the period of Rublev and his contemporaries. Examples include the *Virgin of Vladimir* from the Cathedral of the Dormition in Vladimir, and the *Savior in Majesty* from the "icons of Zvenigorod" (which were named for the town where they were found). The grandeur of the Virgin and Christ in these icons is combined with tenderness, sadness, and soulful warmth. The fifteenth century was not only the apogee of the Moscow school but also saw the peak of the development of Russian icon painting as a whole, when the transcendent values of Russian national culture were created.

There is yet one other vast region without which it would be impossible to understand much of the history of Russian art. This is the north of Russia, which geographically encompassed distances of thousands of kilometers from Yaroslavl to the Arctic Ocean, and from modern-day Karelia to Perm and Verkhoturie in the Ural Mountains. It was

precisely in the Russian North, owing to its distance from the cities of central Russia and its inaccessibility because of the rivers and *taiga* (a word used to describe Russian coniferous forests, especially in Siberia), that the purest forms of the traditional Russian economy, church, daily life, and fine art were preserved. The Russian North is known for its monasteries, such as those of Valaam and the Solovetskii, of St. Cyril of Belozersk, of St. Ferapont, of the Savior of Prilutsk, of Alexander of Svirsk, of Kornily of Komelsk, and of St. Paul of Obnora, as well for such centers of the Old Believers' faith as the Danilov *skits* (monasteries of the Old Believers) on the Vyga and Leksa in the Olonetsk province. Almost all monasteries founded by the clergy from Novgorod or Moscow maintained close relationships with the big cities and were filled with works of art from the capital. However, it was the icon painters of the Russian North who were responsible for the numerous surviving works executed in the so-called "Northern Manners." The Northern Manners are characterized by the ingenuousness of a project and its realization but are often touching in their sincerity. They compliment the icon painting of the large cities with the powerful and fresh creativity of the local people.

Relatively few names of the icon painters of ancient Rus are known to us. The twelfth century is represented by the legendary Alimpii and the aforementioned Olisei; the thirteenth century by Alexa Petrov; the fourteenth by Theophanes the Greek; and the fifteenth by Rublev and Dionysii, although the latter also worked into the first decade of the sixteenth century. We know dozens of the names of seventeenth-century icon painters, most important among them Prokopii Chirin, Simon Ushakov, and Cyril Ulanov. However, the vast majority of Russian icons, both early and later, were created by anonymous artists, who labored humbly at their task. This makes it even more remarkable that the works in question are often true artistic masterpieces that are now part of the permanent exhibits of many museum collections.

Ancient Rus was a land of agriculture, craftsmanship, and trade. Regardless of the provenance of an individual icon, it is often possible to determine the specific reasons for its commission and realization. SS. Modestus and Blaise were protectors of herds, and all peasants thought it was necessary to have their images in their homes. St. Nikolai the Miracle-Worker protected seafarers and travelers, and also helped carpenters. His multiple functions as a saint caused the creation of a huge number of churches and icons of St. Nikolai. The Prophet Elijah was also among the most popular saints: he ruled over thunder and lightening and provided rain, on which the harvest depended in the years of drought. St. George protected the knights, breeders of horses, and agricultural workers and was thus frequently depicted by early Russian icon painters. St. Paraskeva Piatnitsa was a helper in trade: she was an important "presence" in city squares during the bazaars and at village fairs. St. Barbara, a virtuous virgin, was a patroness of maidens and women, and was venerated by them alongside the most important saints of the Christian pantheon. Much later, in the eighteenth and nineteenth centuries, cunning icon painters and icon traders started to attribute different powers to other saints. John the Baptist was attributed with the power to cure headaches. St. Antip was said to cure toothaches. SS. Gurii, Samon, and Aviv protected the well-being of the family; St. Niphont helped against evil spirits. People

prayed to St. Boniphatius to deliver them from drinking binges and to SS. Martinian and Moses Murin to defend them against "illicit passion." In other words, the Russian people attributed to virtually all saints various qualities that helped in different aspects of their daily lives. The angels and saints entered everyday life not as abstract forces but as real protectors and helpers in both the military and peaceful exploits of the Russian people.

The miracle-working icons were especially venerated, and they were often widely known: the *Virgin of Vladimir*, the *Virgin of Kazan*, *Troeruchitsa* ("the three-handed"), the *Iverskaya Virgin*, the *Virgin of Tikhvin*, the *Virgin Hodegetria of Smolensk*, and other early icons, mostly of the Virgin. The national significance of these icons and the stories of the miracles attributed to them inspired the many literary works dedicated to them. As a rule, these stories were written during the sixteenth through eighteenth centuries; some, however, also date to the fifteenth century. Among those that were preserved and enjoyed great popularity are the *Tales of the Icons of the Virgin of Vladimir*, as well as *Tales of the Virgin of Tikhvin*, *of the Iverskaya Virgin*, *of the Virgin of Abalatsk*, *of the Virgin of Orant*, *of the Virgin of Tolga*, *of the Fedorovskaya*, and *of the Wonders of the Virgin of Vladimir*. The guides to iconography, the *podlinniks* (originals), also have certain literary qualities. One of the best known is the *Icon-Painting Podlinnik of Siisk* of the seventeenth century, created in the Monastery of St. Anthony of Siisk in the Russian North.

In contemporary Russia, the early icons tend to have a dual role: some of them have long since acquired the status of museum-quality valuables; others serve as cult objects in the functioning churches. Despite the persecution its proponents endured after 1917, Russian Orthodoxy has recently become an active force again. The new life of the church has also introduced a certain confusion into the established distribution of certain icons into museum collections: the *Virgin of Vladimir* and Rublev's *Trinity* have been placed in a functioning church, and the miraculous Novgorodian *Virgin of the Sign* has been moved to the Cathedral of St. Sofia. However, thousands of other icons of the eleventh through seventeenth centuries are now concentrated in state museums, private collections, and church treasuries. These artistic treasures are still only superficially described in the scholarly literature; many collections have no scholarly catalogues, and there are no monographs about the earliest Russian-Byzantine icons. Only temporary exhibitions, such as the present one at the Guggenheim, provide an opportunity to learn about and appreciate the vital imperatives of the Russian people and their art.

We should also be aware that many of the icons on display in such exhibitions were intended to be viewed as part of a church's interior, one that would also have been painted with frescoes and decorated with mosaics. Rublev painted the monumental iconostasis for the Cathedral of the Dormition in Vladimir at the same time as he painted the frescoes in 1408. Dionysii and his workshop also painted both the frescoes and the iconostasis of the Cathedral in the Monastery of St. Ferapont at the same time (1490–1502). The stylistic integrity of easel painting and of monumental painting allowed the two forms to complement each other. When the icons of the iconostasis were removed from the cathedral, the beauty of the St. Ferapont frescoes was diminished; the Ferapont icons, dispersed among several museums also lost much of their presence without the frescoes that used to surround

them. These icons and frescoes once formed a colorful ensemble, perhaps unequaled in any early Russian church.

Historically the icon has been studied predominantly by Russian scholars, who were naturally especially familiar with their subject. With few exceptions, such as F. Schweinfurt in 1930, K. Onash in 1968, and W. Felicetti-Liebenfels in 1972, Western European and American scholars remained methodologically unprepared to consider the icon seriously within the broader context of the history of painting. Only in the last twenty years, due to exhibitions in both Europe and America, has the Russian icon finally emerged from a narrowly defined national framework to become appreciated as an object of medieval artistic culture.

The Russian icon is of scholarly interest on several levels: it is an object of church life, an example of Byzantine artistic heritage, an archaeological object, an illustration of the scriptures, and a realization of philosophical and theological concepts. It is also a beautiful aesthetic creation, quite understandably described as embodying "philosophy" and "thelogy" "in colors" by two past scholars. These words incorporate the primary qualities of all Russian icons: the profundity of the spiritual world and the artistry of the material one.

Translated from the Russian by Julia Trubikhina.

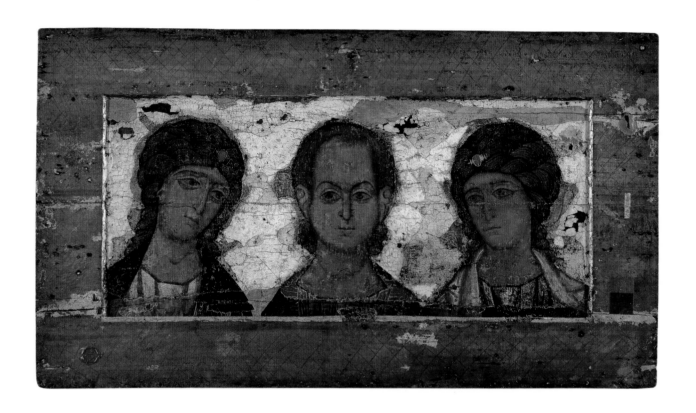

1. *THE SAVIOR EMMANUEL WITH*
ARCHANGELS, VLADIMIR-SUZDAL, LATE
12TH CENTURY. TEMPERA ON PANEL.
72 X 129 CM. THE STATE TRETYAKOV
GALLERY, MOSCOW

2. *(OPPOSITE) ST. NICHOLAS OF ZARAISK*
WITH SCENES FROM HIS LIFE, VILLAGE
OF PAVLOVO NEAR ROSTOV, SECOND
HALF OF THE 14TH CENTURY. TEMPERA
ON PANEL, 128 X 75 CM. THE STATE
TRETYAKOV GALLERY, MOSCOW

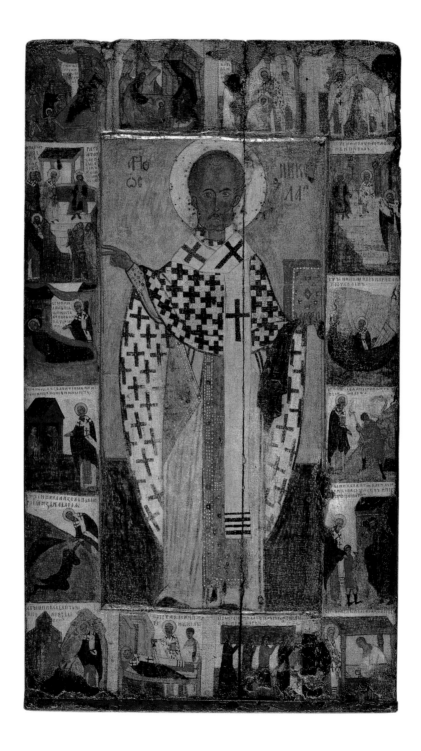

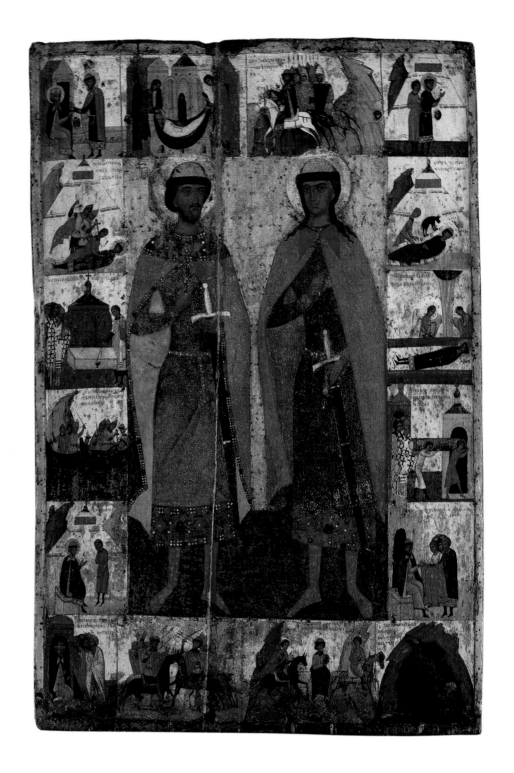

3. *SS. BORIS AND GLEB WITH SCENES FROM THEIR LIVES*, MOSCOW, SECOND HALF OF THE 14TH CENTURY. TEMPERA ON PANEL, 134 X 89 CM. THE STATE TRETYAKOV GALLERY, MOSCOW

4. (OPPOSITE) *TRANSFIGURATION*, FROM THE TRANSFIGURATION CHURCH, SPAS-PODGORYE, NEAR ROSTOV VELIKII, 1395. TEMPERA ON PANEL, 116 X 87 CM. THE STATE TRETYAKOV GALLERY, MOSCOW

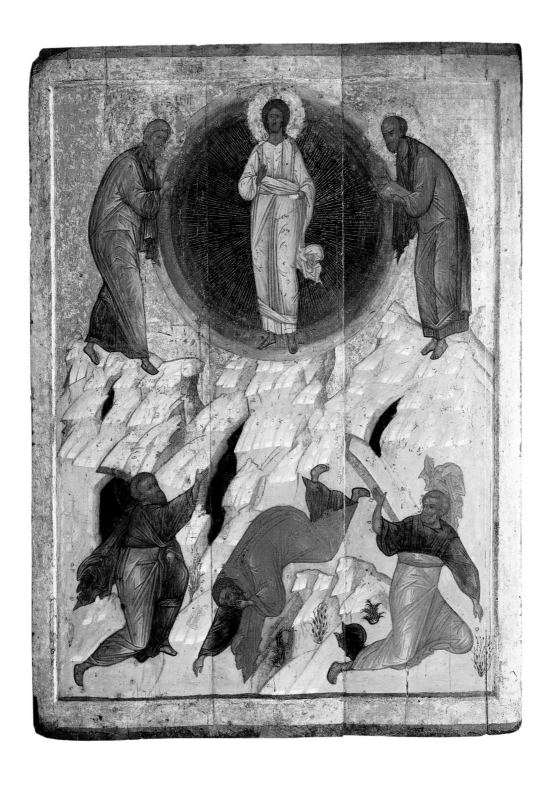

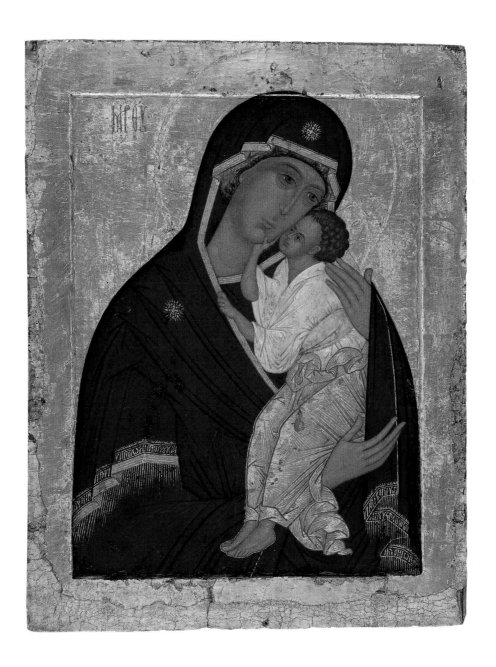

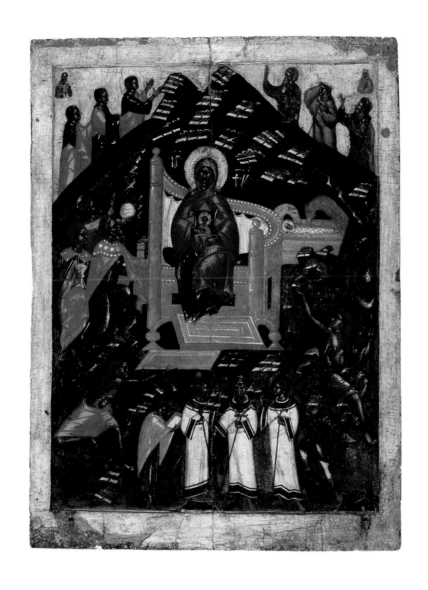

5. (OPPOSITE) OUR LADY OF YAROSLAVL,
SECOND HALF OF THE 15TH CENTURY.
TEMPERA ON WOOD, 54 X 42 CM. THE
STATE TRETYAKOV GALLERY, MOSCOW

6. ASSEMBLY OF OUR LADY, PSKOV,
LATE 14TH – EARLY 15TH CENTURY.
TEMPERA ON PANEL, 81 X 61 CM. THE
STATE TRETYAKOV GALLERY, MOSCOW

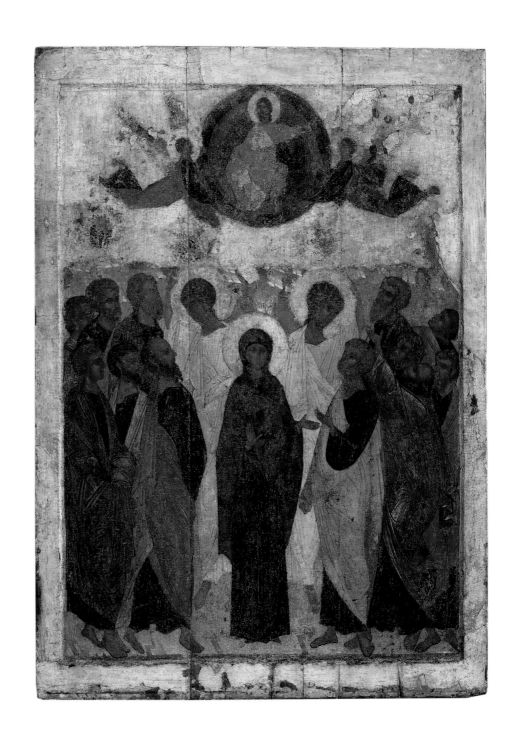

7. ANDREI RUBLEV AND DANIIL
CHERNYI, *ASCENSION*, 1408. TEMPERA
ON PANEL, 125 X 92 CM. THE STATE
TRETYAKOV GALLERY, MOSCOW

8. (OPPOSITE) *DORMITION OF THE
VIRGIN*, TVER, 15TH CENTURY. TEMPERA
ON PANEL, 113 X 88 CM. THE STATE
TRETYAKOV GALLERY, MOSCOW

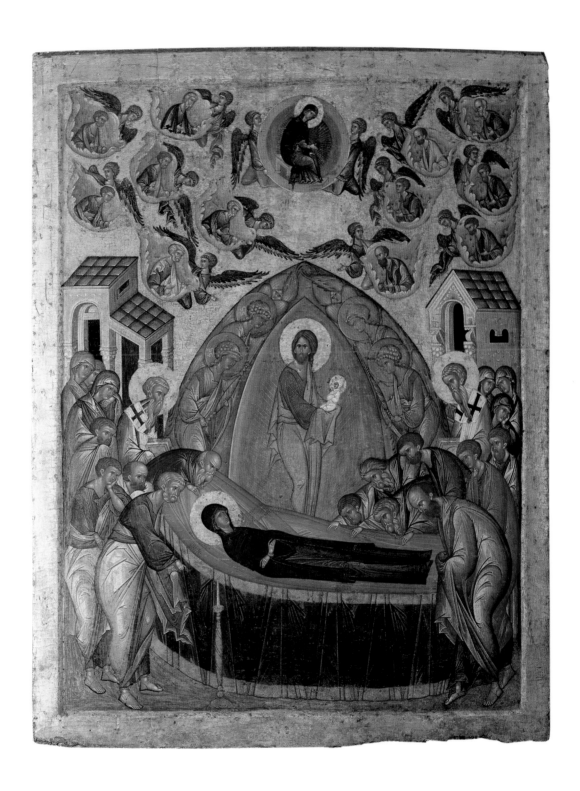

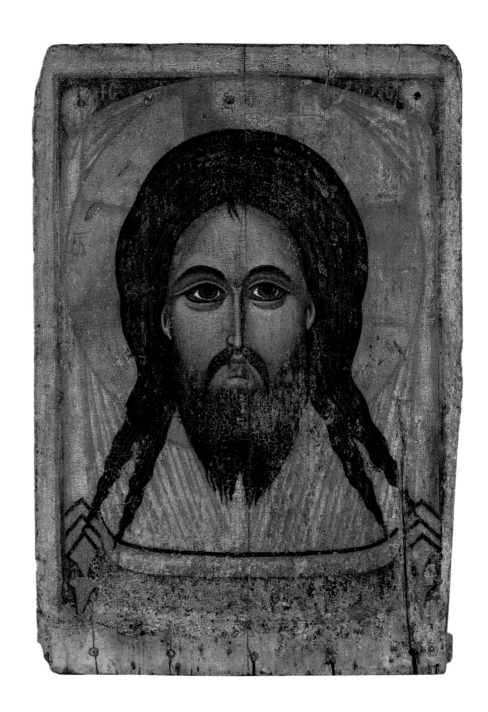

9. *SAVIOR ACHEROPITA*, VILLAGE OF
NOVOE NEAR YAROSLAVL, LAST
QUARTER OF THE 14TH CENTURY.
TEMPERA ON PANEL, 104 X 74 CM. THE
STATE TRETYAKOV GALLERY, MOSCOW

10. (OPPOSITE) *CHRIST IN GLORY*, FROM
THE DEESIS TIER IN THE CATHEDRAL
OF THE DORMITION AT THE KIRILLO-
BELOZERSK MONASTERY, CA. 1497.
TEMPERA ON PANEL, 192 X 134 CM.
MUSEUM OF HISTORY, ARCHITECTURE,
AND ART, KIRILLO-BELOZERSK

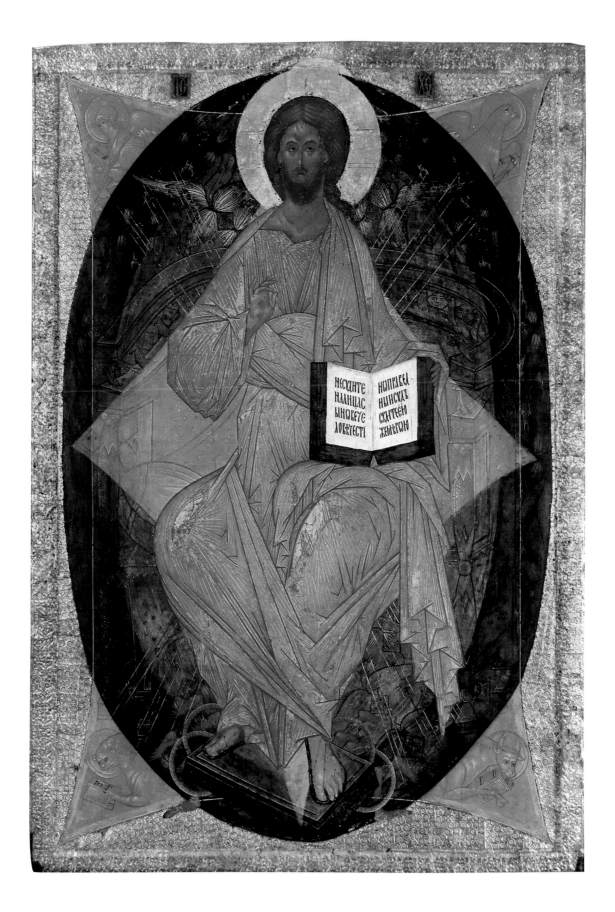

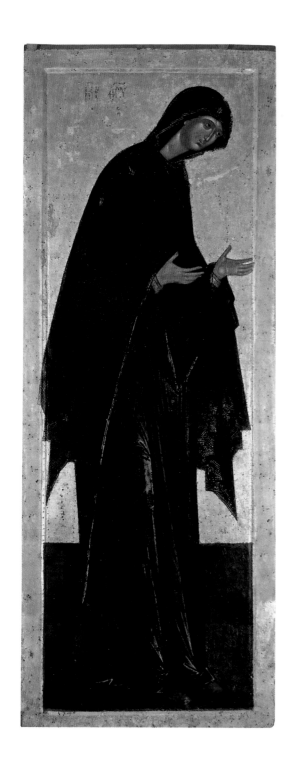

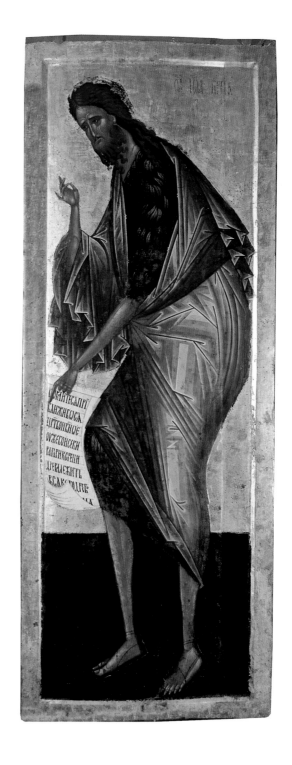

11. (LEFT) *THE VIRGIN*, FROM THE
DEESIS TIER IN THE CATHEDRAL OF THE
DORMITION AT THE KIRILLO-BELOZERSK
MONASTERY, CA. 1497. TEMPERA ON
PANEL, 191 X 72.5 CM. MUSEUM OF
HISTORY, ARCHITECTURE, AND ART,
KIRILLO-BELOZERSK

12. (RIGHT) *ST. JOHN THE BAPTIST*, FROM
THE DEESIS TIER IN THE CATHEDRAL OF
THE DORMITION AT THE KIRILLO-
BELOZERSK MONASTERY, CA. 1497.
TEMPERA ON PANEL, 191 X 72.5 CM.
MUSEUM OF HISTORY, ARCHITECTURE,
AND ART, KIRILLO-BELOZERSK

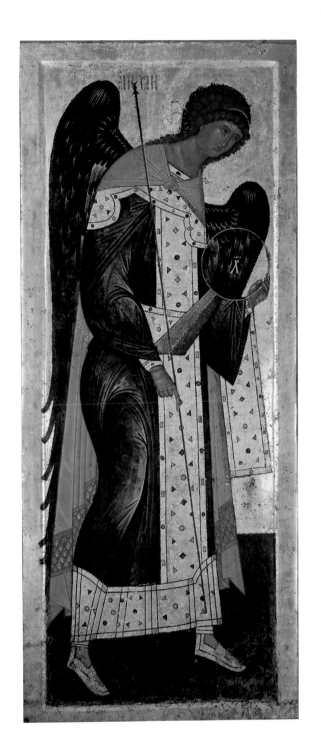

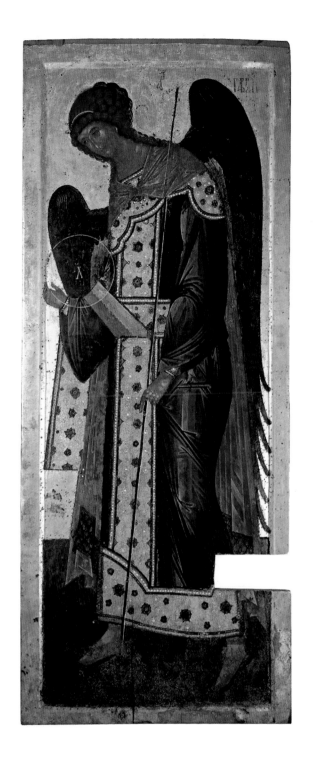

13. (LEFT) *ARCHANGEL MICHAEL*, FROM
THE DEESIS TIER IN THE CATHEDRAL OF
THE DORMITION AT THE KIRILLO-
BELOZERSK MONASTERY, CA. 1497.
TEMPERA ON PANEL, 191 X 78 CM.
MUSEUM OF HISTORY, ARCHITECTURE,
AND ART, KIRILLO-BELOZERSK

14. (RIGHT) *ARCHANGEL GABRIEL*, FROM
THE DEESIS TIER IN THE CATHEDRAL OF
THE DORMITION AT THE KIRILLO-
BELOZERSK MONASTERY, CA. 1497.
TEMPERA ON PANEL, 191 X 78 CM.
MUSEUM OF HISTORY, ARCHITECTURE,
AND ART, KIRILLO-BELOZERSK

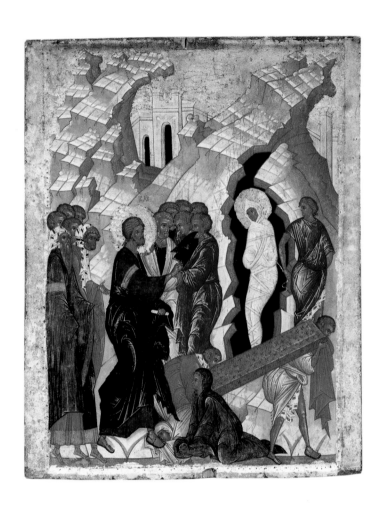

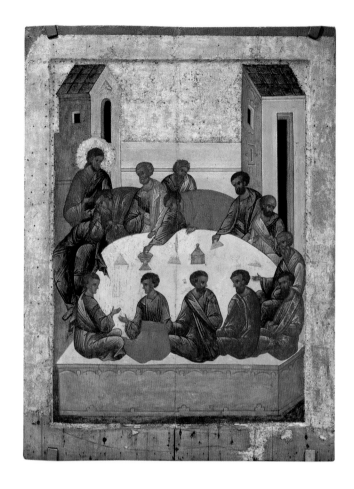

15. (LEFT) *RAISING OF LAZARUS,*
NOVGOROD, CA. 1497. TEMPERA ON
WOOD, 72.4 X 58 X 2.7 CM. STATE
RUSSIAN MUSEUM, ST. PETERSBURG

16. (RIGHT) *THE LAST SUPPER, FROM THE*
FESTIVE TIER IN THE CATHEDRAL OF THE
DORMITION AT THE KIRILLO-BELOZERSK
MONASTERY, CA. 1497. TEMPERA
ON PANEL, 83.5 X 63 X 2.5 CM. STATE
RUSSIAN MUSEUM, ST. PETERSBURG

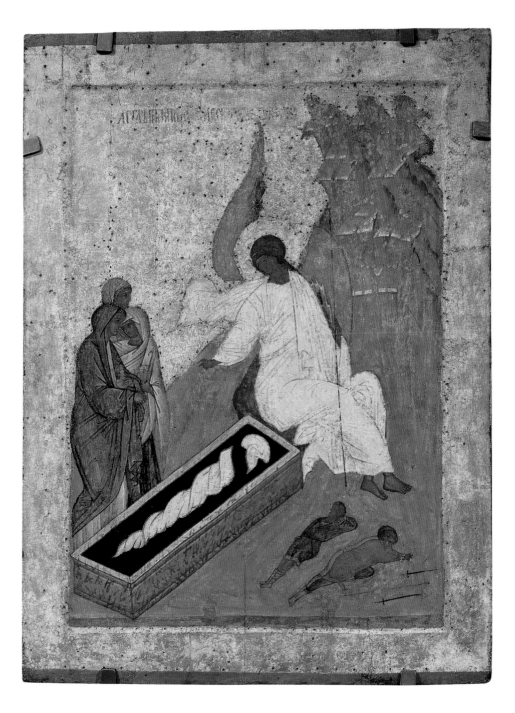

17. *THE MYRRH-BEARING WOMEN BY THE TOMB OF CHRIST, FROM THE FESTIVE TIER IN THE CATHEDRAL OF THE DORMITION AT THE KIRILLO-BELOZERSK MONASTERY, CA. 1497. TEMPERA ON PANEL, 84.5 X 63 X 3.2 CM. STATE RUSSIAN MUSEUM, ST. PETERSBURG*

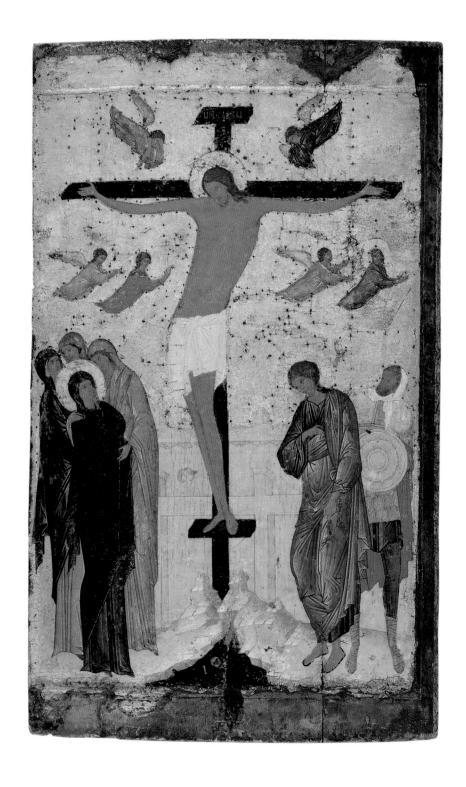

18. DIONYSII, *CRUCIFIXION*, FROM THE
PAVLO-OBNORSKII MONASTERY,
MOSCOW, 1500. TEMPERA ON PANEL,
85 X 52 CM. THE STATE TRETYAKOV
GALLERY, MOSCOW

19. (OPPOSITE) *THE VIRGIN OF VLADIMIR*,
1514. TEMPERA ON PANEL, 107.5 X
69.5 X 3.5 CM. MOSCOW KREMLIN
STATE MUSEUM - PRESERVE OF HISTORY
AND CULTURE

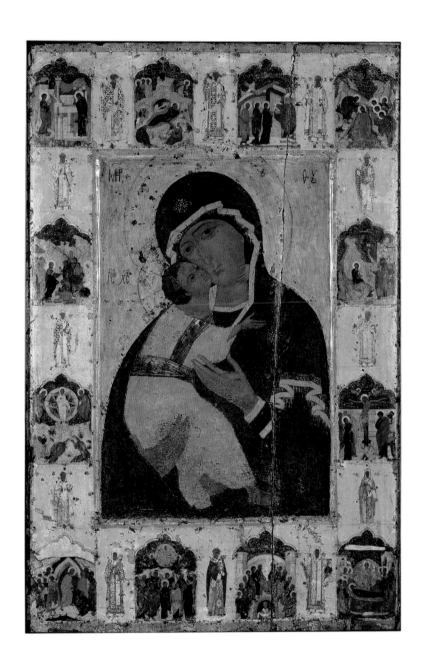

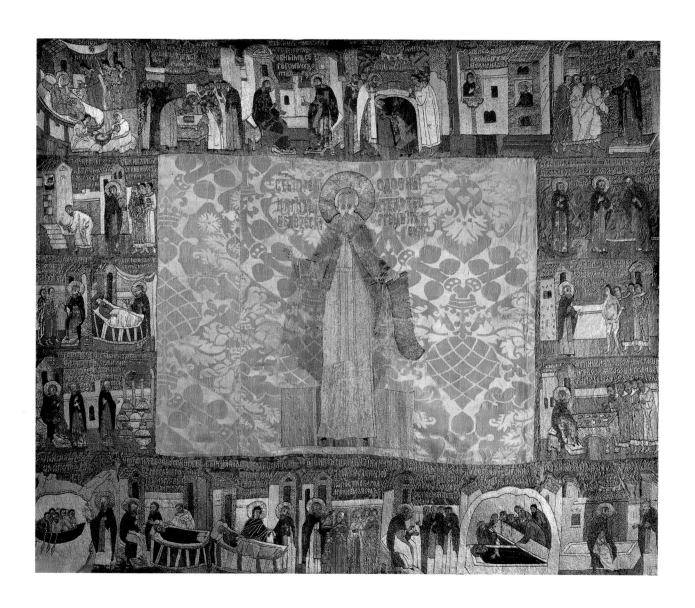

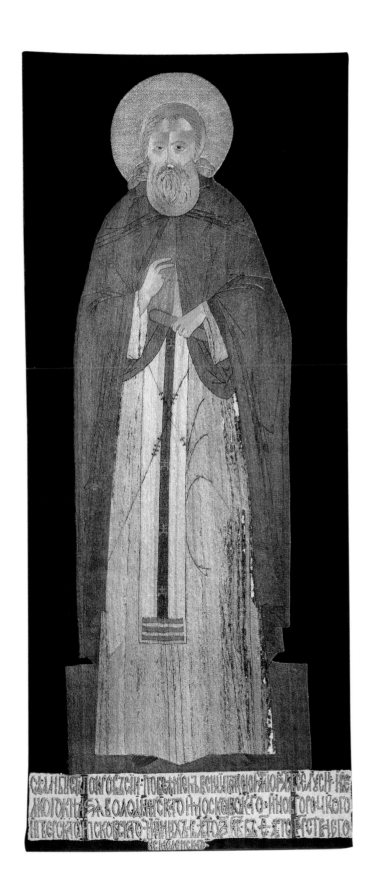

20. (OPPOSITE) *ST. KIRILL OF BELOZERSK*
WITH SCENES FROM HIS LIFE, EARLY
16TH CENTURY. DAMASK, SILK, AND
GOLD AND SILVER THREAD,
99.5 X 118 CM. STATE RUSSIAN
MUSEUM, ST. PETERSBURG

21. *ST. KIRILL OF BELOZERSK*, 1514.
TAFFETA, SILK, AND GOLD AND SILVER
THREAD, 198.5 X 84 CM. STATE
RUSSIAN MUSEUM, ST. PETERSBURG

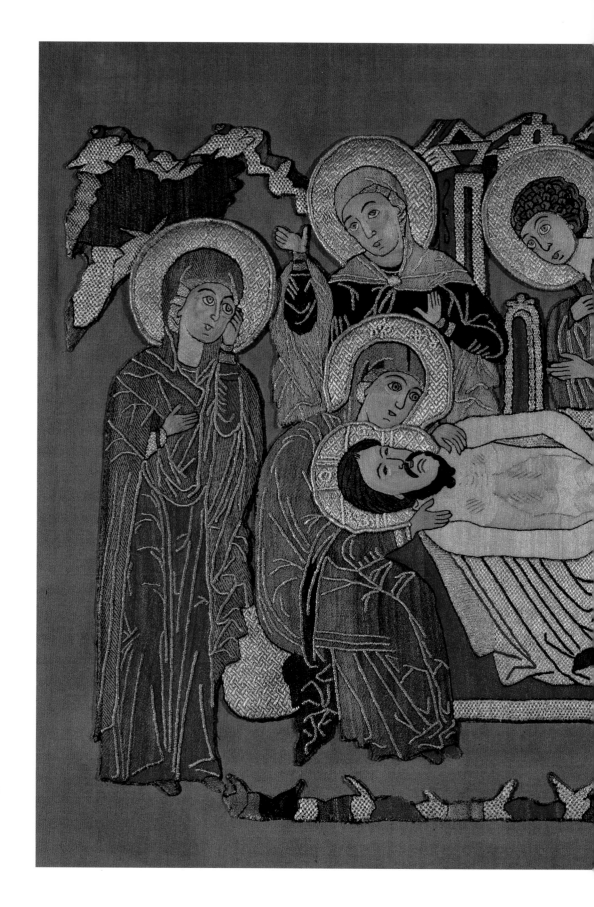

22. THE ENTOMBMENT, SECOND HALF
OF THE 16TH CENTURY.
GOLD AND SILK EMBROIDERY AND
PEARLS ON SILK, 73 X 113.5 CM.
STATE RUSSIAN MUSEUM,
ST. PETERSBURG

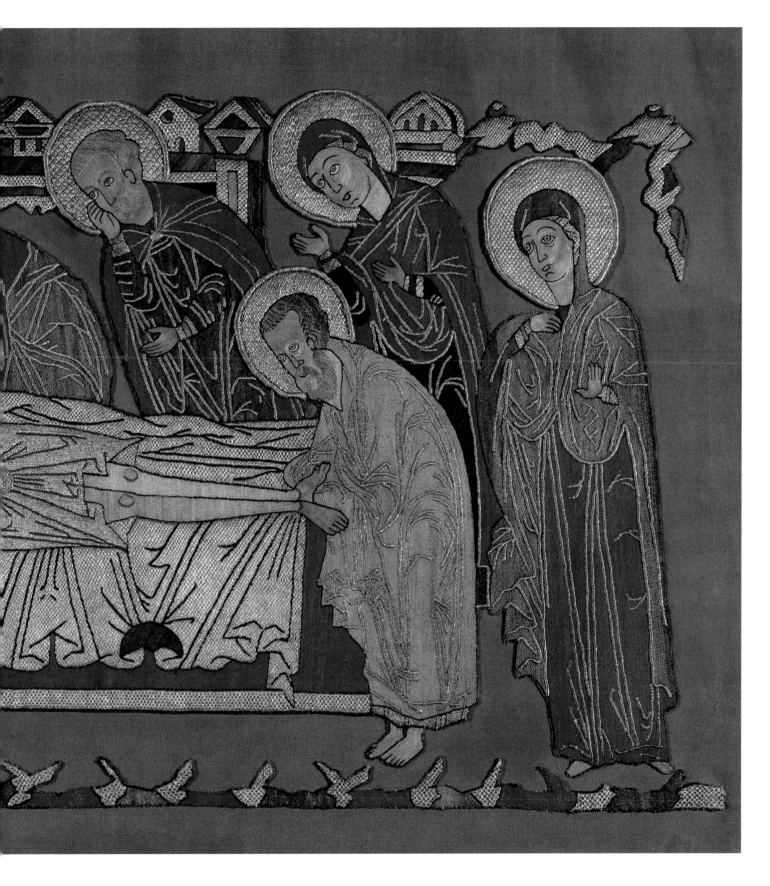

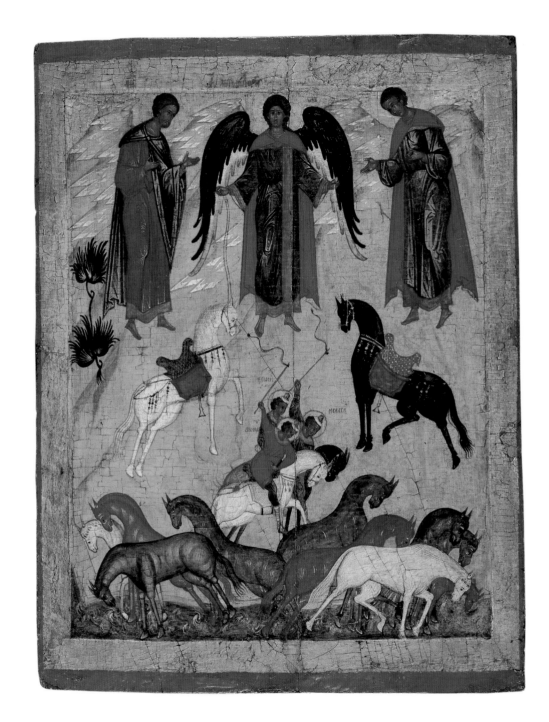

23. *THE MIRACLE OF THE ARCHANGEL
MICHAEL AND SS. FLORUS AND LAURUS,
NOVGOROD, EARLY 16TH CENTURY.
TEMPERA ON PANEL, 67 X 52 CM. THE
STATE TRETYAKOV GALLERY, MOSCOW*

24. (OPPOSITE) *THE TSAR'S GATES,
MOSCOW, MID–16TH CENTURY.
TEMPERA ON PANEL, TWO PANELS:
169 X 40 CM, 176 X 41 CM. THE
STATE TRETYAKOV GALLERY, MOSCOW*

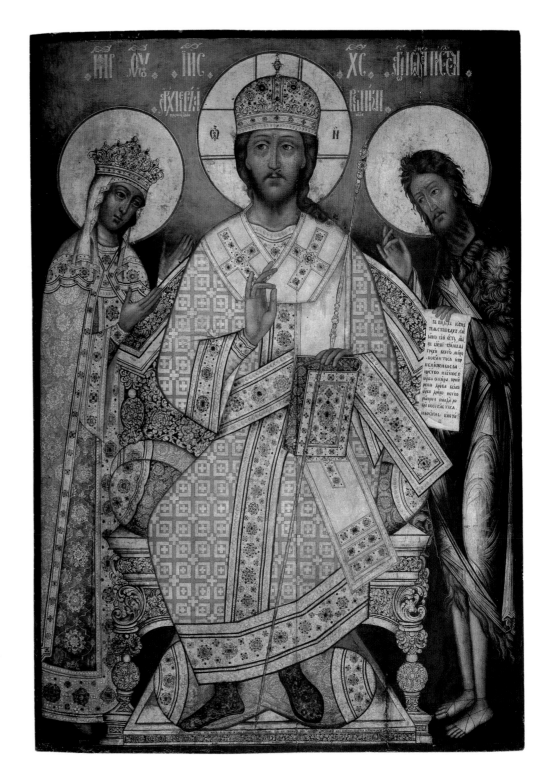

25. NIKITA PAVLOVETS, *KING OF KINGS OR THE QUEEN ENTHRONED*, SCHOOL OF THE ARMORY CHAMBER, 1676. TEMPERA ON PANEL, 184 x 130 CM. THE STATE TRETYAKOV GALLERY, MOSCOW

26. (OPPOSITE) FOLLOWER OF DIONYSII, *ST. JOHN THE DIVINE ON PATMOS WITH SCENES FROM HIS LIFE AND TRAVELS*, MOSCOW, LATE 15TH–EARLY 16TH CENTURY. TEMPERA ON PANEL, 132 x 98 CM. THE STATE TRETYAKOV GALLERY, MOSCOW

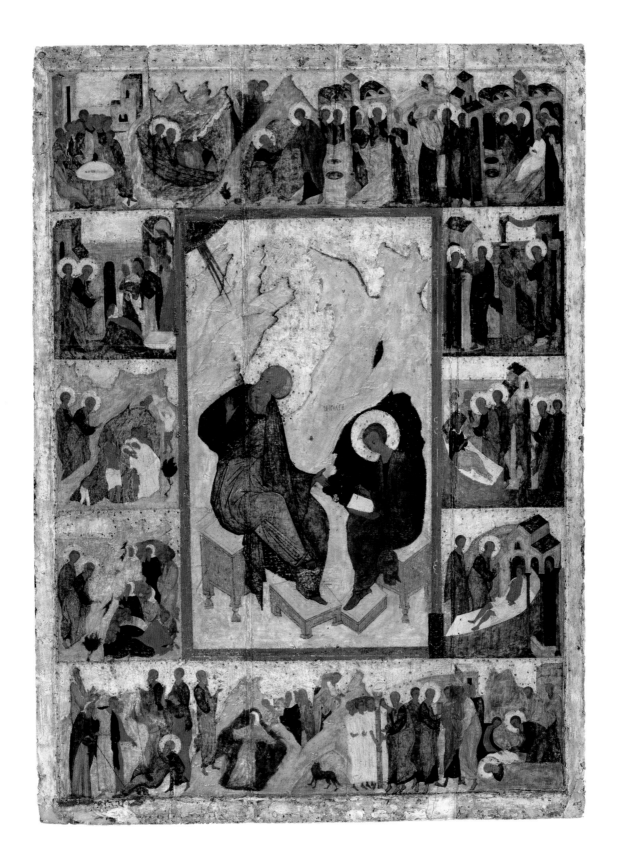

THE IMPERIAL COLLECTIONS OF
PETER THE GREAT AND CATHERINE THE GREAT

THE HERMITAGE AND THE ROMANOV FAMILY COLLECTIONS
SERGEI ANDROSOV | 58

SERGEI ANDROSOV

During the Renaissance, the ideal ruler was conceived not only as a military leader and politician but also as a lover of the arts, a patron, and a collector. In France, during the seventeenth century, Louis XIV, known as the Sun King, left a legacy of numerous architectural monuments built at his command (including Versailles with its palace and park) and became the model monarch for subsequent generations of rulers in France as well as in other countries. Beginning with the era of Peter I, when Russia took an active part in Europe's political and cultural life, Russian tsars and tsarinas of the Romanov dynasty, as well as members of their families, continued the tradition begun by Louis XIV. Some were more successful than others, but the model of the leader as a patron of the arts led to the creation of very rich collections of cultural and art objects in the imperial palaces of St. Petersburg and its environs, the most famous of which is the Hermitage, a truly unique museum of the artistic culture of the world.

These collections began with the towering figure of Peter I, who reigned from 1682 to 1725. The tsar who entered history as a reformer not only founded the city of St. Peter at the mouth of the Neva River in 1703, but also made it, in the vivid description of Alexander Pushkin, "a window onto Europe" (from his poem "The Bronze Horseman"). The tsar, who had no formal education, thirsted for knowledge and acknowledged no obstacles in his quest for it. For instance, in 1697–98, as part of the Great Embassy,[1] he visited many European countries incognito, and under the name Peter Mikhailov worked privately in shipyards in Holland and England—an act that would have been impossible for his predecessors on the Russian throne.

When he returned to Russia, Peter I embarked on a reformation of the political system, the army and navy, the economy, and the nation's cultural life. The last did not consist in simply banning traditional Russian garb and beards. The tsar wanted to change the mentality of his people, creating a new generation of educated and European-thinking Russians. Russian students were sent abroad to study, and foreign scholars and experts were invited to Russia. Part of his policy included a reformation of the visual arts and architecture, which he also oriented toward Europe.

It would be incorrect to assume, however, that pre-Petrine Russia had no painting in the European manner. A small number of Western paintings were found in royal palaces and in the homes of important boyars in Moscow in the late seventeenth century. But under Peter's reign, the collection of paintings took on a completely different scale, and the tsar himself was one of the greatest enthusiasts. In 1716, Osip Solovyov, a Russian trade agent, purchased 121 paintings at auctions in Holland, including Rembrandt's *David's Parting from Jonathan* (1642). Interestingly, Peter felt himself a competent connoisseur of painting by then. In a letter dater May 7, 1716, he asked Solovyov to send five or six of the paintings he had bought at auction to the German city of Schwerin (where the tsar was at the time), "which we will look at and write to you what further needs to be

Rembrandt Harmensz. van Rijn,
David and Jonathan, *1642. Oil on*
panel, 73 x 61.5 cm. State Hermitage
Museum, St. Petersburg

bought."[2] Later, in 1717, Yuri Kologrivov, whose artistic knowledge the tsar trusted, bought paintings in Haarlem, Amsterdam, The Hague, Antwerp, and Brussels. According to our calculations,[3] he acquired at least 165 paintings, including Jan Steen's *Marriage Contract* (ca. 1650s; Hermitage) and David Teniers's *Temptation of St. Anthony* (ca. 1640s; State Museum at Peterhof).

At the same time, approximately seventy paintings, primarily by Italian painters of the seventeenth and eighteenth centuries, were purchased in Venice by the Russian trade agent Peter Beklemishev. Most notably they included *The Entombment* (ca. 1520s, plate 27) by Garofalo, the first Renaissance work to reach Russia (now in the Hermitage). Beklemishev received that painting as a gift from Cardinal Pietro Ottoboni when he visited Rome in 1719. In the early eighteenth century, the painting was ascribed to Raphael himself, and Beklemishev wrote to Peter stressing its great value: "here in all of Venice there is not a single painting by the above-mentioned artist."[4]

The picture gallery created by Peter I ultimately had no fewer than four hundred works acquired in the West. If works bought individually from private collectors are included, as well as works done in Russia, the collection was much richer. Its fate was not a happy one, however. At first the paintings were divided among the tsar's palaces, many of which were not used and were not heated in winter. Consequently, some paintings were damaged and lost as late as the eighteenth century. The surviving works are found primarily in the palaces of the Peterhof: the Hermitage, the Marly, and Monplaisir. The best were transferred over the years to the St. Petersburg Hermitage.

Even more exceptional than Peter the Great's interest in painting, though, was his life-long fascination with sculpture. That form of art was previously unknown in Russia because of the Russian Orthodox Church's ban on idolatry. But by 1690, and undoubtedly with the tsar's support, Prince Boris Golitsyn, one of his tutors, built on Dubrovitsy (his estate near Moscow) the Church of the Sign of the Mother of God, which was abundantly decorated with reliefs in the interior and three-dimensional ornamentation on the exterior. A bit later, around 1710, the Dutch ambassador Just Juel noted that the Winter Garden in St. Petersburg had around thirty marble statues (he must have included busts).[5]

But the largest purchases of sculpture were made between 1716 and 1722 in Venice, where Count Savva Vladislavic, known in Russia as Raguzinsky, was living. A Serb by birth, he executed various diplomatic and trade assignments for the tsar. His correspondence shows that he sent to St. Petersburg, primarily by ship, approximately fifty life-size marble statues and groups, a dozen smaller statues, and more than one hundred busts.[6] Usually these were works commissioned by the Russian representative from the best Venetian sculptors.

During the same period, in 1718–19, Kologrivov was buying sculptures in Rome. He had excellent opportunities to purchase antiquities, at the special request of Peter I. His most famous acquisition was the marble Aphrodite later known as the Tauride Venus (its name is from the Tauride Palace in St. Petersburg, where it was located before it was moved to the Hermitage). The statue, which was discovered buried outside Rome in early 1719, was bought cheaply by Kologrivov. But the papal authority declared the deal void and confiscated

Aphrodite. It required lengthy negotiations, which involved Raguzinsky and Beklemishev as well, to return the statue, which was classified this time as a gift from Pope Clement XI to the Russian tsar. With great care, the statue was shipped by land to St. Petersburg and placed in a special gallery by the entrance to the Summer Garden. According to contemporaries, Peter held it so dear that he had a special guard for it.[7] Today it is in the Hermitage, and some researchers consider it a Greek original from the second century BC.[8]

Most of the other statues and busts acquired for Peter also ended up in the Summer Garden. The works of contemporary sculptors were situated in the allées, and the antiquities and smaller works were placed in the Grotto, a small pavilion on the banks of the Fontanka. With time, some of the works vanished and others were moved to the summer residences of the tsars—Tsarskoe Selo and Peterhof—but many statues and busts remain to this day in the Summer Garden, making it a marvelous corner of Petrine St. Petersburg.

Peter's successors did not have such a marked interest in figurative art, preferring their own portraits to masterpieces of painting. In addition, Peter's collection was more than enough to decorate the existing palaces as well as those under construction. Perhaps the most important event related to the acquisition of paintings took place during the reign of Elizabeth (1741–62), Peter's daughter, when the court painter Georg Christoph Grooth bought 195 paintings in Prague. They were intended for the new palace designed by Francesco Bartolomeo Rastrelli, under construction in Tsarskoe Selo, now known as the Catherine Palace.

A major change came only with the accession to the throne of Catherine the Great (Catherine II), who reigned from 1762 to 1796). A princess from the German principality of Anhalt-Zerbst, she came to Russia as a fourteen year old, converted to Russian Orthodoxy, and always stressed her affinity for Russia and Russians. Her husband, Peter III, the grandson of Peter I, was, on the contrary, an avid admirer of Frederick II, the king of Prussia. He surrounded himself with Germans and displayed scorn for his own people. After deposing her spouse, who was generally hated, Catherine became a wise and just ruler.

As tsarina, Catherine was able to realize her interest in art and architecture, which had begun in her youth, displaying a profound knowledge and subtle taste. Count Fedor Golovkin, who knew the empress well, later wrote: "It is difficult to explain to oneself how this woman, brought so young from a Prussian garrison town to the milieu of a palace that was half German, developed flawless taste."[9] It is enough to note that it was in Catherine's reign, thanks to the buildings designed by outstanding architects both from Europe (Antonio Rinaldi, Giacomo Quarenghi) and Russia (Ivan Starov, Nikolai Lvov), that St. Petersburg acquired the "severe and elegant look" that Pushkin described.

Catherine also had the honor of founding the Hermitage as an art museum that belonged personally to the monarch and passed from one member of the royal family to the next.[10] The impetus for that event, so important in Russian history, was the acquisition of the collection belonging to Berlin merchant Johann Ernst Gotzkowsky in late 1763 and early 1764. It had been intended originally for Frederick II of Prussia; so the purchase not only had aesthetic importance, but also political significance. It awakened in Catherine

Aphrodite (Tauride Venus),
Rome, 2nd century; Roman copy
from a Greek original. Marble,
h. 167 cm. State Hermitage Museum,
St. Petersburg

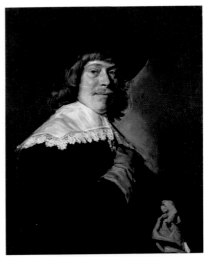

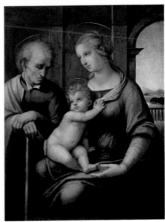

Frans Hals, *Portrait of a Young Man Holding a Glove, ca. 1650. Oil on canvas, 80 x 66.5 cm. State Hermitage Museum, St. Petersburg*

Raphael, *The Holy Family (The Madonna with Beardless Joseph), 1505–06. Tempera and oil on canvas, 72.5 x 56.5 cm. State Hermitage Museum, St. Petersburg*

a passion for collecting, and in the next few years she made a number of important purchases of entire collections or individual paintings, primarily in France. In 1767, paintings were acquired from the collection of Jean de Julienne; in 1768, from the collection of Carl Cobenzl and Prince Charles Joseph de Ligne; in 1769, from the collection of Count Heinrich Bruhl; in 1770, from the collection of Francois Tronchin; in 1771, from the collection of Braamkamp (most of which were lost in a shipwreck); in 1772, the famous gallery of Louis Antoine Crozat, Baron de Thiers; in 1773, paintings from the collection of the Duke de Choisel; and in 1779, the collection of Sir Robert Walpole (not to mention a number of less significant acquisitions).

Without a doubt, the first ten years were the time of Catherine's greatest activity in painting acquisition. It was during that period that the Hermitage received such masterpieces as *Portrait of a Young Man Holding a Glove* (ca. 1650) by Frans Hals (from the collection of Gotzkowsky), *Maecenas Presenting the Liberal Arts to Emperor Augustus* (ca. 1745) by Giovanni Battista Tiepolo, *Perseus and Andromeda* (ca. 1620–21) by Peter Paul Rubens, *Portrait of an Old Man in Red* (ca. 1652–54) by Rembrandt (Bruhl), *The Holy Family (The Madonna with Beardless Joseph)* (ca. 1506) by Raphael, *Judith* (ca. 1504) by Giorgione, *Danae* (ca. 1545) by Titian, *Bacchus* (ca. 1638) and *Portrait of a Lady-in-Waiting to the Infanta Isabella* (ca. 1625) by Rubens, *Holy Family* (1645) and *Danae* (1636) by Rembrandt (Crozat). Additions to the Winter Palace were added for picture galleries, first the Small Hermitage (1764–75, by the architect Jean Baptiste Vallin de la Mothe) and then the Old Hermitage (1771–87, by the architect Yuri Velten). Commenting on her activity in the art market, Catherine wrote to Voltaire on January 30, 1772: *"Vous vous étonnez de mes emplettes de tableaux; je ferais mieux peut-être d'en acheter moins pour ce moment, mais des occasions perdues ne se retrouvent pas."* ("You are amazed by my purchases of paintings; I might do better perhaps to buy less at the moment, but lost occasions never return.")[11]

Catherine's personal involvement in these acquisitions, which were almost always made on her behalf, remains controversial. We hardly ever know anything about the empress's opinion of her purchases. However, she had an indisputable gift for finding people who not only had good taste but who could also execute the most daring plans. Her art agents in Paris, for example, were the Ambassador Prince Dmitry Golitsyn, the sculptor Etienne Maurice Falconet, and art critic Denis Diderot. In St. Petersburg, Catherine took the advice of a narrow circle of connoisseurs that included the president of the Academy of Arts, Ivan Betskoi; the president of the Commercial Collegium, Ernst Munnich (the author of the first unpublished catalogue of the paintings of the Hermitage); the artist and restorer Lucas Konrad Pfandzelt of Germany; and later also the Venetian painter Giuseppe Martinelli, who became the curator of the collection; Count Alexander Stroganov; and Ivan Shuvalov. Discussions with these experts decided the fate of paintings, and only a select few made it into the Hermitage.

We can assume that Catherine the Great had a special interest in contemporary artists. On her commission, in Paris, Jean-Baptiste Greuze painted *The Paralytic* (1763) and Jean-Simeon Chardin painted *Still Life with Attributes of the Arts* (1766); and in Rome, Pompeo Batoni created *The Continence of Scipio* (1772) and *Thetis Takes Achilles from the Centaur*

Chiron (1770). (All of these paintings are in the Hermitage today.) She dreamed of acquiring the interiors of Roman basilicas by Giovanni Paolo Panini and paintings by Anton Raphael Mengs, writing to Friedrich Melchior Grimm on November 19, 1778: "When will the day come when I can say: I have seen the works of Mengs?"[12] That wish was granted only after Mengs's death, when five of his paintings were purchased for the Hermitage from his heirs.

Through the efforts of Catherine and her agents, a picture gallery for the Hermitage that was rich in quantity and quality was created in a relatively short time. The first manuscript catalogue, completed in 1785, listed 2,658 paintings. The description of the paintings left after Catherine's death, which included paintings in suburban palaces, cited almost four thousand works.

Starting in the 1780s, Catherine showed an interest in collecting cut stones. This may have been related to her growing interest in antiquities and classical art, typical of the last quarter of the eighteenth century. But it was also probably related to the fascination for cut stones of her young favorites, Alexander Lanskoi and Ivan Dmitriev-Mamonov. Once again, in a relatively short time, Catherine created a collection of more than ten thousand objects by 1794.

Catherine was notably less interested in sculpture, but she nevertheless approved an invitation, proposed by Diderot and Golitsyn, to Falconet to come to Russia, where he created his brilliant monument to Peter I. Catherine also patronized Falconet's young student, Marie Anne Collot, who made several portraits of the empress from life. With a nod to the fashion of the times, Catherine gladly acquired works by Jean-Antoine Houdon, including a marble *Diana* (now in the Gulbenkian Museum, Lisbon) and the famous *Voltaire Seated in an Armchair* (1781). But it was only with the purchase of the collection of John Lyde Browne, director of the Bank of Britain, that the imperial collection acquired a large number of antique statues and busts as well as a Renaissance masterpiece, a statue by Michelangelo, known as *Crouching Boy* (ca. 1530–34). However, almost all of these works did not go directly to the Hermitage, which the empress seemed to regard primarily as a Pinakotek, but to the Grotto pavilion in Tsarskoe Selo.

Catherine's son, Paul I (reign 1796–1801), also displayed a strong interest in art. In 1781–82, while still heir to the throne, he traveled in Europe where he readily commissioned and bought paintings and statues. During the construction of the new imperial residence in St. Petersburg, the Mikhailovsky Castle, Paul spared no expense, buying paintings and French decorative bronzes and commissioning statues in Italy. However, his reign was very brief: he was murdered by conspirators in 1801, and his son Alexander I became tsar.

Alexander's early reign was a return to the policies of Catherine II. Unfortunately, a significant part of his reign coincided with the Napoleonic wars, which were not conducive to the acquisition of artworks. During the brief ceasefire and alliance with Napoleon, several purchases were made in Paris—in 1808 Caravaggio's *The Lute-Player* (ca. 1595–96) and Pieter de Hooch's *A Mistress and Her Maid* (ca. 1660s), and a bit later two monumental works by Bartolomé Esteban Murillo, *Isaac Blessing Jacob* and *Jacob's*

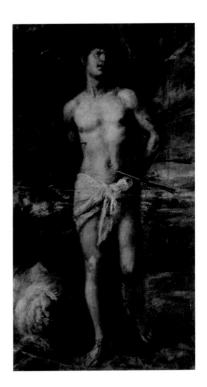

Titian (Tiziano Vecellio),
St. Sebastian, ca. 1570. Oil on
canvas, 210 x 115.5 cm. State
Hermitage Museum, St. Petersburg

Dream (both 1665–70). After Napoleon's abdication, Alexander gave orders to acquire the collection of the emperor's first wife, Josephine Beauharnais, which included thirty-eight paintings (among them Rembrandt's *The Descent from the Cross*, 1634) and four sculptures by Antonio Canova. A year earlier, he had acquired the collection of the banker W. Coeswelt, which consisted primarily of works by Spanish painters. This purchase enriched the Hermitage with such masterpieces as *Portrait of Count-Duke Olivares* (ca. 1640) by Diego Velázquez and *The Childhood of the Virgin* (ca. 1660) by Francisco de Zurbarán.

Unlike Alexander I, his brother Nicholas I (reign 1825–55) ruled Russia in a comparatively peaceful time, when it seemed that Russia's hegemony in Europe would last forever. Nicholas's model was Peter the Great, whose example he tried to follow, becoming involved in many details of governance and personally handling the country's foreign policy. In addition, he focused a great deal of attention on the imperial collections.

The early years of Nicholas's reign were not marked by significant acquisitions of paintings, though, except for the purchase of the second part of W. Coeswelt's collection in 1836. That brought the Hermitage Raphael's *Madonna Alba* (ca. 1511–13; now in the National Gallery Gallery of Art, Washington, D.C.).

In 1837, a fire destroyed the Winter Palace (designed by Rastrelli in the mid-eighteenth century), but the Hermitage was saved. Nicholas personally supervised the work and expended great efforts to have the palace restored quickly. Most of the interiors were given a new neoclassical look. Apparently, in the course of the reconstruction, the tsar realized the need for an expansion of the Hermitage, which had been unchanged since Catherine II's day. For the sake of the collection, Nicholas decreed that another museum building be added, later known as the New Hermitage. The project was executed by the Bavarian architect Leo von Klenze, who had built museum structures in Munich; it was intended to hold specific collections and to receive visitors. Opened on February 5/17, 1852, the New Hermitage was the first museum to belong to the royal family but accessible to the public.

During the construction of the building, there was accelerated acquisition of works intended for the new museum. Nicholas played the most active role and considered himself a great connoisseur of art. He made decisions on the purchase of paintings and sculptures on the basis of his own ideas, which are not always easy to explain. We can imagine that the tsar wanted first of all to fill in certain gaps in the Hermitage collection. Therefore, he bought paintings by sixteenth-century artists from Italy and the Netherlands and by seventeenth-century Spanish masters, who were almost unknown before the Napoleonic wars. In that context must first be mentioned the acquisition in Venice in 1850 from Count Nicolo Antonio Giustiniani Barbarigo of the collection of the Barbarigo family, known for its paintings by Titian, including *Mary Magdalene* (ca. 1565) and *St. Sebastian* (ca. 1570). That same year Nicholas selected several works to purchase, including *Portrait of an Old Man* (ca. 1520s) by Ridolfo Ghirlandaio (then attributed to Raphael), *Flora* (ca. 1520s) by Francesco Melzi (then attributed to Leonardo da Vinci), *The Lamentation* (1516) by Sebastiano del Piombo, and *Descent from the Cross* (1521) by Jan Gossaert. Acquired at the sale of the collection of French marshal Nicola Jean Soult in 1852 were *The Liberation of St. Peter* (ca. 1667–70) by Murillo and

St. Lawrence (1636) by de Zurbarán. Earlier, when visiting Italy in 1845, Nicholas made numerous commissions for marble statues and groups from neoclassical masters—Pietro Tenerani, Luigi Bienaimé (plate 43), Emile Wolff, and others. In time, their works also took their places in the New Hermitage.

Under the direct supervision of Nicholas, the imperial collections were systematized, a gigantic undertaking. Now visitors to the New Hermitage could see not only paintings by European masters, hung by school, but also the works of Russian artists and sculptors, including Karl Briullov's *Last Day of Pompeii* (1833). (Works of the Russian school were given to the newly created State Russian Museum toward the end of the eighteenth century.) The first-floor rooms of the New Hermitage were devoted to sculpture, both antique and contemporary. It was then that numerous works from Tsarskoe Selo, Mikhailovsky Castle, and Tauride Palace were moved to the Hermitage, including the Tauride Venus and Michelangelo's *Crouching Boy*, acquired respectively by Peter I and Catherine II.

At that time a significant portion of the paintings, most from the seventeenth and eighteenth centuries, were acknowledged to be unworthy of the Hermitage. More than eight hundred of them were distributed to the suburban imperial palaces (many returned to the Hermitage only in the twentieth century), and more than 1,200 were auctioned in March 1854. Only an insignificant number of those works have been returned over the years to the Hermitage, and as a rule for incomparably higher prices than those for which they were sold.

Although Nicholas's interference in the affairs of the Hermitage was contradictory in effect, he was the last Russian tsar who was truly interested in the museum and devoted much time to it.

Under Alexander II (reign 1855–81), however, a number of important acquisitions were made for the Hermitage. In 1861 in Rome, the collection of antique statues belonging to the Marquis Giovanni Pietro Campana was acquired, enriching that department. In 1865, Duke Litta sold four paintings, including the *Litta Madonna* (ca. 1490) by Leonardo da Vinci. Five years later, Alexander II purchased Raphael's *Madonna Conestabile* (ca. 1503–04), which was first given to his wife, Maria Alexandrovna, and hung in the Winter Palace. It was only transferred to the Hermitage in 1881.

The most important acquisitions under Alexander III (reign 1881–94) were the purchase in 1885 of the collection of Alexander Basilevsky, which enriched the collection of sculptures and applied arts of the Middle Ages and the Renaissance, and of the Golitsyn Museum as whole in 1886.

Not long before World War I, the Hermitage received its last major acquisitions. More than seven hundred paintings, primarily of the seventeenth-century Dutch school, were given to the museum for a very modest sum by the famous geographer Petr Semenov-Tyan-Shansky. Equally generous toward the Hermitage were members of the famous artistic Benois family, and in particular, Maria Benois, née Sapozhnikova, who had inherited her father's Madonna and Child, determined to be an early Leonardo with the date 1478. The museum acquired that masterpiece, known as the Benois Madonna, on credit and for a much more modest price than that offered by foreign antiquarians.

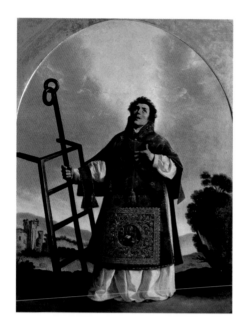

Francisco de Zurbarán, St. Lawrence, 1636. Oil on canvas, 292 x 225 cm. State Hermitage Museum, St. Petersburg

These acquisitions close the more than two centuries of collecting by the Romanovs. During that time, the Hermitage, founded by Catherine II and incorporating works of an earlier time, became not only a major world museum but also an important factor in the development of culture in Russia and Europe as a whole.

Translated from the Russian by Antonina W. Bouis.

1. Russian ambassadors were sent to many countries in Europe.

2. S. O. Androsov, *Russkie zakazchiki i ital'ianskie khudozhniki v XVIII v* (St. Petersburg, 2003), pp. 13, 14.

3. Ibid., p. 15.

4. N. Moleva, *Ivan Nikitin* (Moscow, 1972), p. 129.

5. *Zapiski Justa Julia datskago poslannika pri Petre Velikom (1709–1711)* (Moscow, 1899), p. 203.

6. S. O. Androsov, *Italianskaia skulptura v sobranii Petra Velikogo* (St. Petersburg, 1999), p. 25.

7. Ibid., p. 92 and on.

8. A. V. Kruglov, "Venera Tavricheskaia–Afrodita?" *Ermitazhnye chteniia pamiati V. F. Levinsona-Lessinga* (St. Petersburg, 2003), p. 26.

9. N. Shilder, "Dve kharaktersitiki," *Russkaia starina*, vol. 88 (1896), p. 372.

10. Important publications for the history of the Hermitage are V. F. Levinson-Lessing, *Istoriia kartinnoi galerei Ermitazha (1764–1917)* (Leningrad, 1986), and *Ermitazh, Istoriia i sovremennost* (Leningrad, 1990).

11. *Sbornik Imperatorskago Russkago istoricheskago obshchestva*, vol. 13 (St. Petersburg, 1874), p. 214.

12. Ibid., vol. 23 (St. Petersburg, 1878), p. 110.

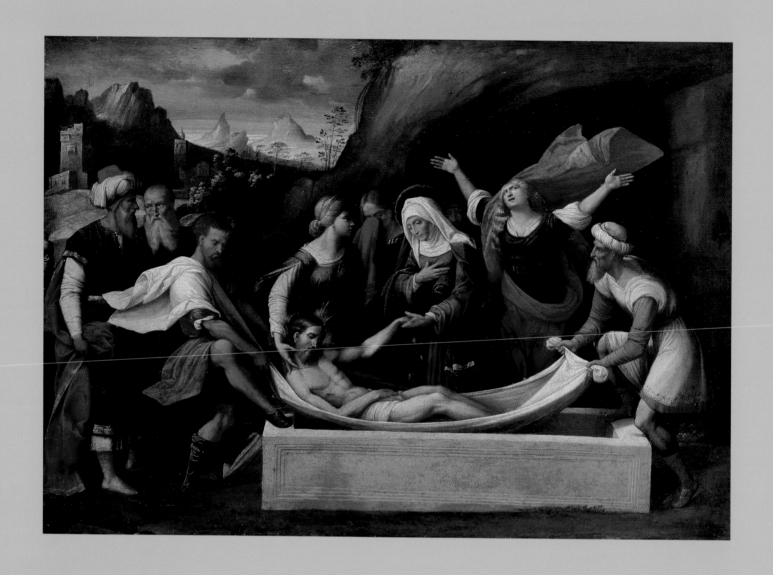

27. GAROFALO (BENVENUTO TISI), THE
ENTOMBMENT, 1520S. OIL ON CANVAS,
53 X 75.5 CM. STATE HERMITAGE
MUSEUM, ST. PETERSBURG

28. (OPPOSITE) ANTHONY VAN DYCK,
THE APPEARANCE OF CHRIST TO HIS
DISCIPLES, 1625–26. OIL ON CANVAS,
147 X 110.3 CM. STATE HERMITAGE
MUSEUM, ST. PETERSBURG

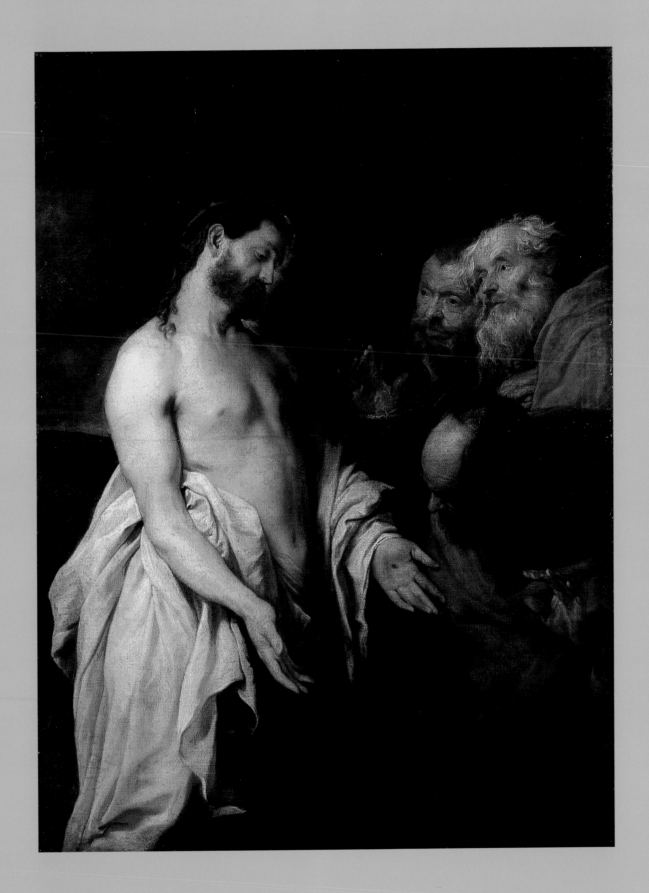

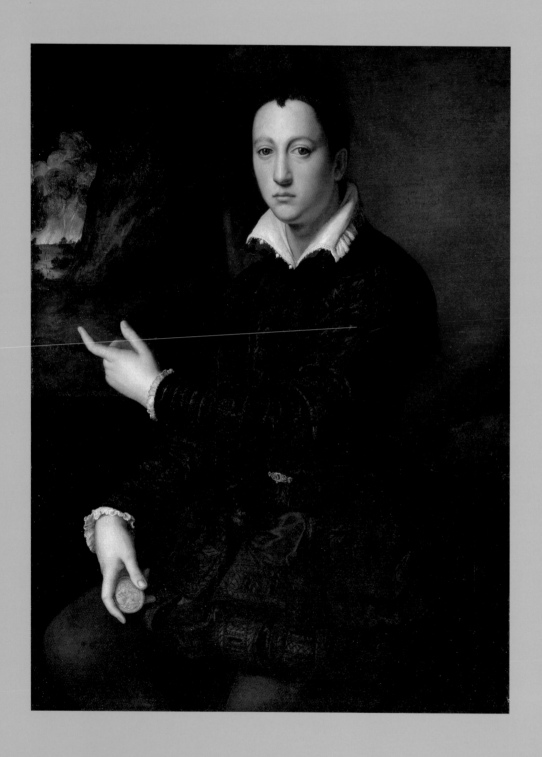

29. ANGELO BRONZINO, *PORTRAIT
OF COSIMO DE MEDICI I, 1537. OIL ON
CANVAS, 117.5 X 87.5 CM. STATE
HERMITAGE MUSEUM, ST. PETERSBURG*

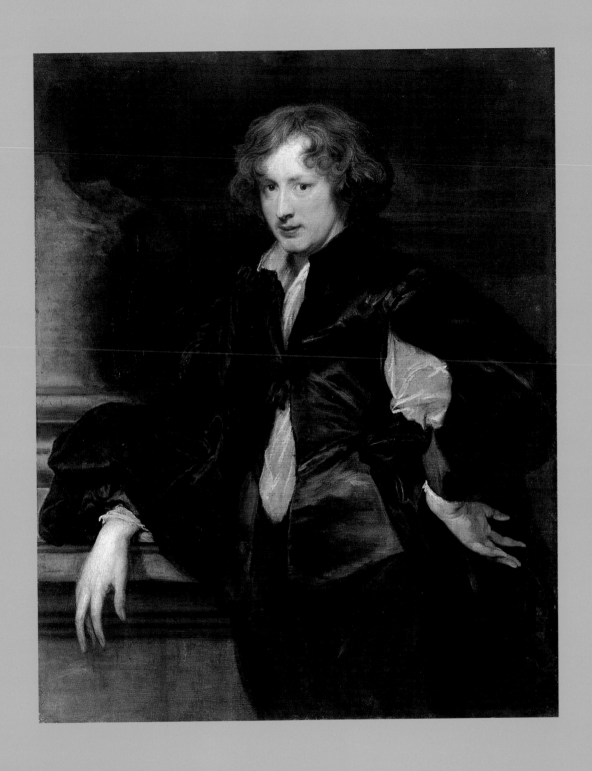

30. ANTHONY VAN DYCK, SELF-
PORTRAIT, 1622–23. OIL ON CANVAS,
116.5 X 93.5 CM. STATE HERMITAGE
MUSEUM, ST. PETERSBURG

31. PETER PAUL RUBENS, HEAD OF A
FRANCISCAN MONK, 1615–17. OIL
ON CANVAS, 52 X 44 CM. STATE
HERMITAGE MUSEUM, ST. PETERSBURG

32. (OPPOSITE) PETER PAUL RUBENS,
THE ARCH OF FERDINAND, 1634. OIL ON
PANEL, 104 X 72.5 CM. STATE
HERMITAGE MUSEUM, ST. PETERSBURG

33. GUIDO RENI, *REPENTANCE OF ST. PETER, CA. 1635. OIL ON CANVAS, 73.5 X 56.5 CM. STATE HERMITAGE MUSEUM, ST. PETERSBURG*

34. (OPPOSITE) BARTOLOMÉ ESTEBAN MURILLO, *THE ESQUILACHE IMMACULATE CONCEPTION, 1645–55. OIL ON CANVAS, 235 X 196 CM. STATE HERMITAGE MUSEUM, ST. PETERSBURG*

37. LOUIS LE NAIN, *THE MILKMAID'S FAMILY*, CA. 1641. OIL ON CANVAS, 51 X 59 CM. STATE HERMITAGE MUSEUM, ST. PETERSBURG

38. (OPPOSITE) JEAN-SIMEON CHARDIN, *THE LAUNDRESS*, 1730S. OIL ON CANVAS, 37.5 X 42.7 CM. STATE HERMITAGE MUSEUM, ST. PETERSBURG

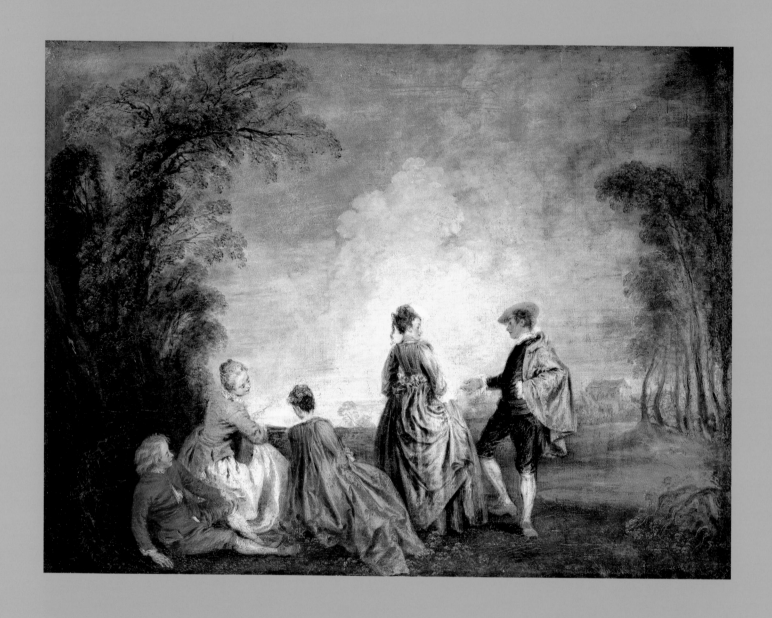

39. JEAN-ANTOINE WATTEAU, *AN EMBARRASSING PROPOSAL*, 1715–16. OIL ON CANVAS, 65 X 84.5 CM. STATE HERMITAGE MUSEUM, ST. PETERSBURG

40. (OPPOSITE) PHILIPS WOUWERMAN, THE *HORSING MANEGE IN THE OPEN AIR*, MID-17TH CENTURY. OIL ON CANVAS, 61.5 X 77 CM. STATE HERMITAGE MUSEUM, ST. PETERSBURG

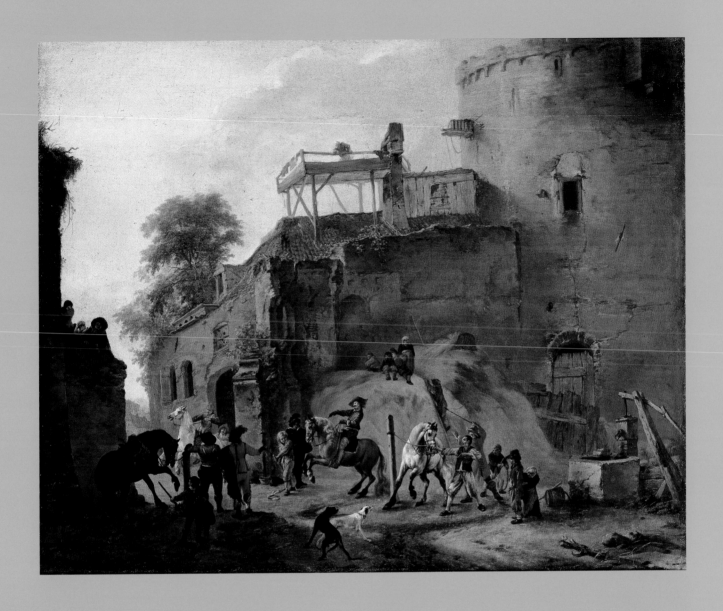

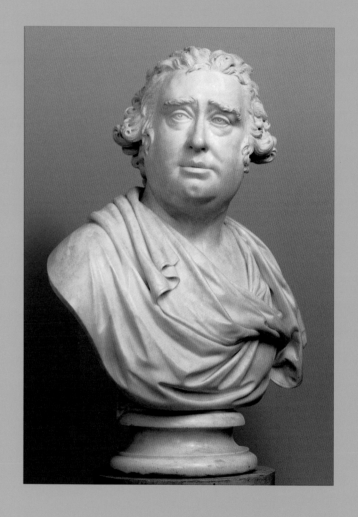

41. (LEFT) JACQUES-AUGUSTIN PAJOU,
PRINCESS OF HESSE-HOMBURG BEFORE THE
ALTAR OF IMMORTALITY, 1759. MARBLE,
H. 100 CM. STATE HERMITAGE MUSEUM,
ST. PETERSBURG

42. (RIGHT) JOSEPH NOLLEKENS,
CHARLES JAMES FOX, 1791. MARBLE,
H. 56 CM. STATE HERMITAGE MUSEUM,
ST. PETERSBURG

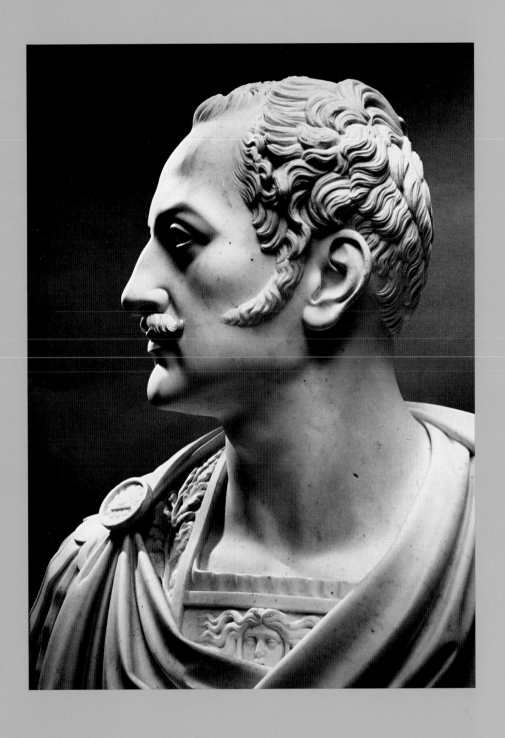

43. LUIGI BIENAIME, PORTRAIT OF
NICHOLAS I, CA. 1850, MARBLE,
H. 92 CM. STATE HERMITAGE MUSEUM,
ST. PETERSBURG

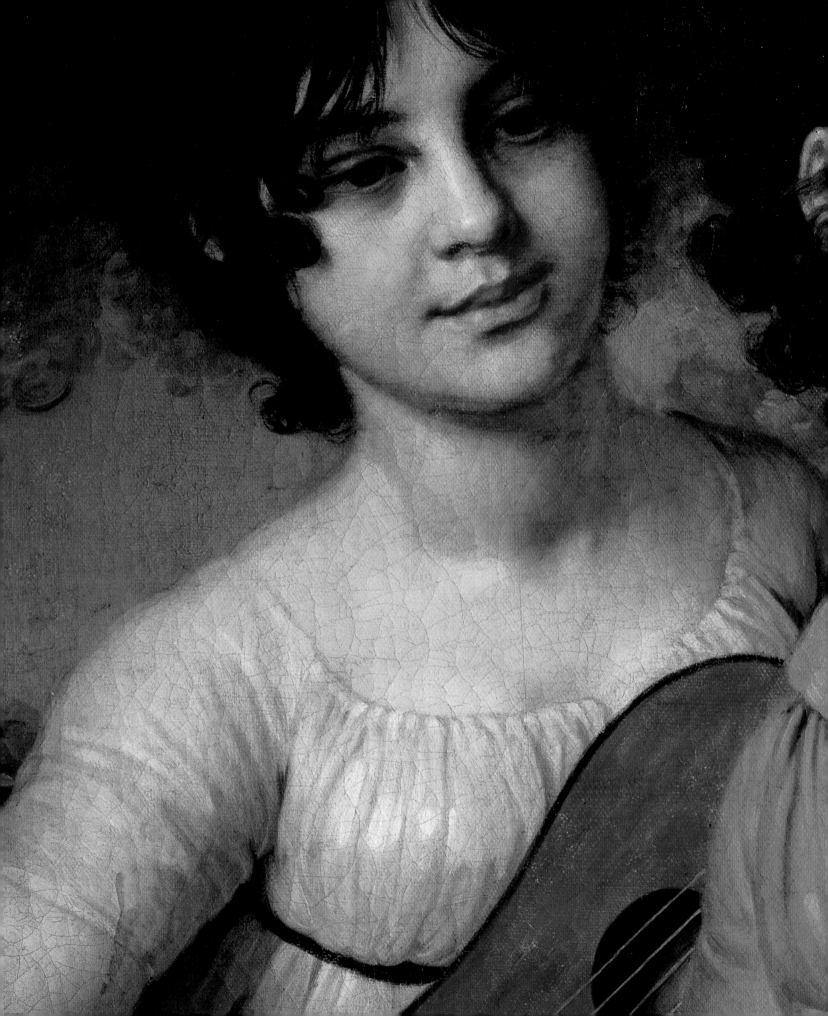

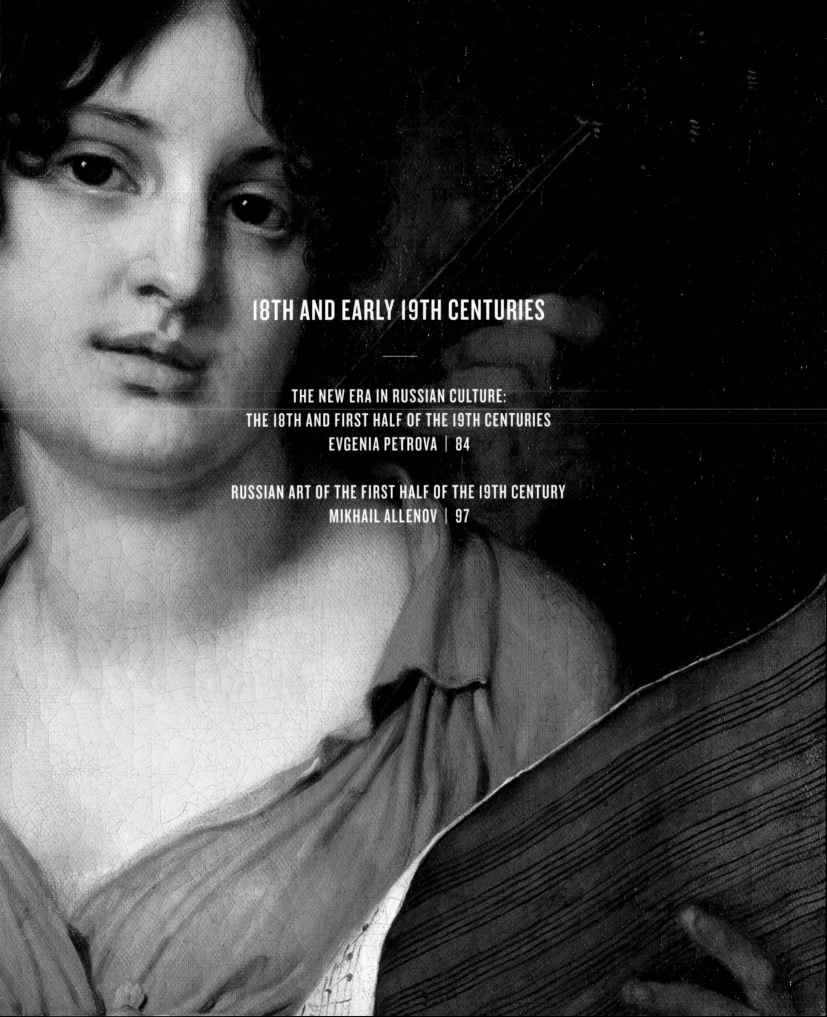

18TH AND EARLY 19TH CENTURIES

THE NEW ERA IN RUSSIAN CULTURE:
THE 18TH AND FIRST HALF OF THE 19TH CENTURIES
EVGENIA PETROVA

Russian culture did not pass through the age of antiquity and thus did not know the rich spiritual achievements of ancient civilization that served as an inexhaustible resource in the development of Western European culture. When it acquired Christianity from Byzantium, Russia essentially leapt from tribal archaism directly to Christian civilization. By selecting the Eastern Orthodox variant of Christianity in the tenth century and at the same time establishing their own state system, as well as written language, the Russians revised the canons of Byzantine culture in their own way, creating a synthesis of lofty Orthodox spirituality that strove for absolute perfection, pagan realism, and Slavic sensitivity toward beauty and the diversity of life. The results of that synthesis were such significant cultural phenomena as ancient Russian icons and pre-Mongol religious architecture. The originality of Russia's cultural development became clear within two centuries of the conversion to Christianity.

But just as quickly, problems arose, which Russia had to solve in a most unfavorable historical situation. The translation of the Bible into Slavonic in the ninth century promoted a manifestation of national specifics within the Byzantine spirituality that Russia chose as a cultural and intellectual system of norms and values, but it also deprived Russian culture of any reason to master the original sources of its Greco-Roman legacy, thereby minimizing its universal orientation.

This could have been compensated by free cultural contacts with the Western Christian world, if not for the growth of the schism in the church, the military expansion of the Teutonic knights, and the military expansion from the East culminating in the Tatar-Mongol conquest. As a consequence, Russian culture developed in isolation. The issue of retaining national and religious identity blocked any desire in Russia for intercultural dialogue and precluded any attempts to disseminate universal intellectual values (for example, the trial of Maxim the Greek[1]). Peter the Great (Peter I) understood with unusual clarity that Russian culture and civilization could stagnate if Russia continued on this isolated path. A comparison with Western Europe is illuminating. When analogous problems (though not as acute) presented themselves, Western European nations turned to their heritage, the ancient world, in order to renew and enrich their own culture. It was the epoch of the Renaissance, an era that became a true cultural watershed and established the foundation for further spiritual, scientific, ideological, technological, and artistic renewal throughout Europe.

There was no Renaissance in Russia because there had been no period of antiquity. There was nothing to revive, because the archaic, tribal past could not offer solutions to the problems that faced Petrine Russia; it did not hold the answer to the challenge of the new era. Western European antiquity was unfamiliar to Russia, and it was perceived as being "alien," so it could not stimulate a local renaissance, as it had in Western Europe. Russia in the early eighteenth century found its own way of compensating for the inadequacies of its cultural development, of enriching and transforming the sources of its

historical experience. Since it was impossible to turn to its own past, the inspiration for transformation had to come from "alien" and contemporary experience.

Peter the Great led Russia in the direction of modernization. Peter's reforms, which touched every aspect of the country's life, were truly revolutionary. In the eighteenth century, as in the tenth, Russia chose a course that would determine the nation's history for many centuries. A new state, a new society, and a new culture began to be constructed. Peter's transformations were truly irreversible in the cultural sphere. The cultural cohesiveness of the traditional society, which had been held together by the overwhelming influence of Christian values, was shattered.

The determining factor for the future of Russian culture was a complex, yet not fully investigated process of acquiring, mastering, and transforming the most varied forms, models, genres, and institutions of European culture. Many cultural innovations in eighteenth-century Russia were influenced by the West. However, the results of this process—evident enough in the nineteenth century—allow us to say that mastering Western European cultural forms did not involve a simple transplantation of Western achievements onto Russian soil. The most significant cultural process in Russia during the eighteenth century and the first half of the nineteenth was the transition from learning and imitating to reworking Western cultural forms to make them applicable to Russia and the creation of an original national image and specific national system of values on the new cultural path that Russia followed from the early eighteenth century. By the middle of the nineteenth century there was not only an equal cultural dialogue between Russia and the West, but also one that was based on the synthesis of domestic and Western cultural traditions that in one and a half or two centuries would form a new Russian cultural identity no less unique and expressive than the culture of pre-Petrine Rus. But it was completely different in spirit. It was no accident that the Westernization of Russian culture created, at a certain point, an independent culture different from that of medieval Russia. There appeared a new—though no less Russian—mentality. There are several reasons to stress Russia's independence from the West, and its multifaceted process of learning from Western Europe.

First of all, in absorbing Western cultural influences and inviting artists from the West to visit, Peter the Great, and subsequently the Russian elite, made a free choice that was not related to any form of political, military, or colonialist coercion. Russia herself "chopped a window into Europe," to paraphrase Alexander Pushkin's *The Bronze Horseman* (1833), not the other way around. At the beginning of the eighteenth century, Russia was an independent country with a powerful ideology and a strong national spirit. Russia's problems and needs regarding modernization were determined by the excesses of isolationism. Freedom of choice determined the absence of political complexes among Russians.

In addition, two variants of Christian culture came into contact, promoting an organic acquisition of learned lessons. A common ground and cultural compatibility were based on the cultural and genetic closeness of the core religious values.

Also, Russia and Europe were neighbors and their mutual contacts had their own history. And since the tenth century Russia had been forging its own values out of alien influences.

This was the general historical and cultural context of the unique Russian cultural trajectory at the start of the new era that followed the Renaissance.

Russian art of the eighteenth century illustrates significant cultural shifts. There is, first of all, the appearance, and ultimately the dominance, of secular genres, primarily portraits. The transition of influence and power from the church to the state during this period also influenced artistic monuments. There was a boom in the construction of administrative and private architectural complexes in the European style. The new, secular regime needed confirmation of its own significance by immortalizing its own image. The icon, in its sacred function as representative and substitute for the saint on earth, could no longer satisfy the new ethics. The icon is a divine, spiritual representation of the holy, a window into eternity. Its creation is a ritual process: preparation of the board, covering it with *levkas* (gesso), selection of a proper model for the painting of the face, and finally the painting of the icon, accompanied by prayer and fasting. An icon generally took a long time to make, and was often created by more than one artist. The depiction of a real, living person demanded a different approach—hence, the appearance of portraits in oil paint on canvas or metal at the end of the seventeenth century. This was both necessary and logical.

Parsuna (from the Latin persona), as such early depictions of eminent figures are known, is a unique phenomenon in the figurative culture of late-seventeenth-century Russia. Its sources can be seen in the icon painting of the mid-seventeenth century. Simon Ushakov and other masters of this period moved away from the traditional depiction of saints. For example, Ushakov's depiction of Christ (*The Vernicle*, 1677) takes on a certain portrait quality. His face has volume and features that resemble those of an ordinary person.

The masters specializing in *parsuna*, who worked primarily at the Armory in Moscow, worked to create a resemblance to a real person, an image of an earthly being. The names of the painters of what came to be called *parsuna* in the nineteenth century are still unknown. There are approximately thirty extant works of this nature. Others were lost over time. The surviving *parsunas* are an amalgam of old icon traditions with European methods of portrait painting.

The same qualities are retained in such later works as an entire group of portraits of Peter the Great's associates, known as the Preobrazhensky series. It was painted on Peter's commission between 1692 and 1700 for the Preobrazhensky Palace, built in 1692. The series includes portraits of Peter's closest friends, with whom the tsar enjoyed various festivities, often of symbolic significance. They were a sign of the rejection of church rules. The parodic, ironic character of the events invented by Peter was made clear by their name: "Most Drunken Synod of Jesters and Fools of the Prince-Pope." These festivities with masquerades, fireworks, drunkenness, gluttony, and other forms of revelry often took on rather crude guises. But the fact that Peter had the participants depicted in portraits suggests how important these anticlerical "synods" were to him. The portraits of the Preobrazhensky series are severe and austere in style (see plate 44); the compositions are static and the figures are represented in majestic poses. These elements reinforce the resemblance to icons. But the faces are nonetheless true portraits. The buffoonish symbols given to the subjects (robe, sash, head gear), imitating and parodying the attributes of saints, reveal the roles of specific

Simon Ushakov, The Vernicle, 1677. Tempera on panel, 37.5 x 32.5 x 3.5 cm. State Russian Museum, St. Petersburg

individuals in Peter's assemblies. The irony, theatricality, *épatage*, and travesty that characterize the attitude in Peter's age toward the church and the traditions of the previous era are expressed vividly and blatantly in the portraits of this series.

Culture under Peter the Great's reign was not, however, limited to such amusements. Peter cared deeply about contemporary forms of culture. He took a personal interest in Western art during his trips abroad. He often brought back works by European masters. And, of course, he dreamed of creating a school for Russian architects, sculptors, painters, and graphic artists. In the absence of such a school, the Armory in Moscow, the Chancellery of Construction in St. Petersburg, and printing houses attended to a wide variety of artistic matters. Nonetheless, the few Russian masters working in those organizations could not handle the growing need for the construction and design of new buildings.

Since he lacked the artists and craftsmen required to satisfy the country's growing artistic and architectural needs, Peter the Great and his successors throughout the eighteenth century were forced to invite artists and architects to Russia from abroad. Johann Gottfried Tannauer, Louis Caravaque, Pietro Rotari, Etienne-Maurice Falconet, Georg Christoph and Johann Grooth, Johann-Baptist Lampi the Elder and the Younger, Jean-Baptiste Leprince, Domenico Andrea, Pietro Antonio and Giuseppe Tresini, Jean-François Thomas de Tomon, Bartolomeo Carlo and Francesco Bartolomeo Rastrelli, Johann Georg Mayr, and Gérard Delabart form an incomplete list of the foreign artists who left notable traces of their presence in Russia in the eighteenth century. Many set out for Russia—cold, grim, and unknown—with natural trepidation and the hope that they would not be staying for long. But after a while, many grew accustomed to the terrible cold and lack of basic comfort and convenience. Many of the artists created their best works in Russia. In the early eighteenth century, for example, the Swiss architect of Italian descent Domenico Trezzini (1670–1734) designed the Cathedral of St. Peter and St. Paul in St. Petersburg, the building of the Twelve Colleges (today the St. Petersburg State University), the palace for Peter I in the Summer Garden, and other edifices that defined the look of eighteenth-century St. Petersburg. In the same century an Italian, Rastrelli, built the Winter Palace (today, the State Hermitage Museum), the Smolny Cathedral, the Summer Palace at Tsarskoe Selo, and other architectural masterpieces in which the Western European baroque is softened in a marvelous way by the plasticity of Russian church design.

Painters, carvers, and sculptors who came to Russia from Italy, Switzerland, Holland, and Germany not only executed commissions for new buildings for the court and nobility, but also had contracts that tended to include a paragraph on teaching Russian artists. Certainly, Peter I and his followers were not happy about this forced dependence on foreign masters. Peter personally selected talented young Russian artists who were considered worthy to be sent abroad to study at government expense.

The first holders of such stipends were Andrei Matveev (1702–1739) and Ivan Nikitin (ca. 1680–ca. 1742). Nikitin was Peter the Great's favorite. Upon his return to Russia, Nikitin painted the tsar and members of his family from life. It was Nikitin who depicted Peter on his death bed (*Peter I on His Death Bed*, 1725, State Russian Museum). We can assume that Nikitin's works appealed to Peter not only because of their mastery, which was equal to that

of Western contemporaries, but also because they combined a fully European level of execution and concept with clear indications of Russian styles. But his *Portrait of a Field Hetman* (1720s, plate 47), for example, is not, of course, a *parsuna*. It is more than a diligently painted, three-dimensional representation of a person with distinctive individual features. The portrait of the hetman suggests character and individuality. This is a portrait image created in the baroque era—austere, even severe. The subject's character is suggested by a palette dominated by red, which reveals the artist as a former icon painter.

Nikitin, like other eighteenth-century Russian artists, worked on many different commissions. While painters of that era continued to work on churches, they often also executed purely decorative commissions such as paintings for triumphal arches erected to commemorate a particular occasion and subsequently taken down. They also painted walls and ceilings in palaces and mansions.

These petty assignments distracted them from their painting, which many former icon painters were working on by the mid-eighteenth century. In that sense, the most fortunate artists were those with only one or very few patrons, such as Ivan Vishnyakov, who worked for the Fairmore family. His portraits of the Fairmore sister and brother (ca. 1749 and 1750s, plates 52 and 53) are his most famous works and suggest his considerable talent.

Vishnyakov had never been outside Russia. Thus he could have seen examples of Western European formal portraiture only in the collections of his benefactors and their friends. While using the typical attributes of formal depiction in the seventeenth and early eighteenth centuries (column, landscape in the background), Vishnyakov created works of a completely different emotional tenor than those by European artists of this period. He transformed the young Fairmores into adults, a gentleman and a lady. Wigs, formal dress, and ceremonial poses hide the sweet seriousness of the childish faces. The exquisitely painted moiré fabric of the girl's dress, the laconic combination of red, black, and yellow-gold in the boy's costume, and the static poses somehow resonate with Goya's future masterpieces. In the Russian tradition those qualities have their source in icon images. The flatness of the figures and their disconnectedness with the background also come from icons, but these archaic features do not interfere with the figurative composition. On the contrary, they heighten their directness, purity, and simplicity

The mid-eighteenth century in Russian art is known as the "Age of the Portrait" for good reason. Until 1764, when the Academy of Arts (also known as the Academy of Painting, Sculpture, and Architecture) opened its doors in St. Petersburg, the main genre—although not the only one—was portraiture. Alexei Antropov, Vladimir Borovikovsky, Dmitry Levitsky, Fedor Rokotov, and Vishnyakov are the most famous portraitists of that time. They are united primarily by the fact that none of them studied at the academy. Their professional methods were based on those of church painters and the advice of foreign mentors. With talent and ability, each portraitist reflected the era in which he and his subjects lived. The sound, slightly heavy portraits by Antropov suggest a Russian version of the baroque. The light refined faces and characters captured by Rokotov are animated by the rococo style. Levitsky is a typical artist of the reign of Catherine the Great (Catherine II). The Enlightenment ideals of society are evident in the list of people Levitsky painted, which

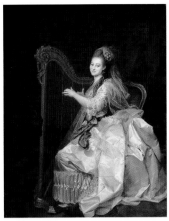

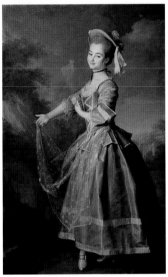

Dmitry Levitsky, Portrait of
Ekaterina Nelidova, 1773. Oil on
canvas, 164 x 106 cm). State
Russian Museum, St. Petersburg

Dmitry Levitsky, Portrait of
Glafira Alymova, 1776. Oil on
canvas, 183 x 142.5 cm. State
Russian Museum, St. Petersburg

includes Denis Diderot (Museum of Fine Arts and History, Geneva); Nikolai Lvov (1780s, State Russian Museum), a philosopher, scholar, architect, artist, and poet; the empress herself, depicted as befits an enlightened monarch with the symbols of various spheres of activity (*Portrait of Catherine II as Legislator in the Temple of the Goddess of Justice*, 1783, State Russian Museum); and many other outstanding figures of the day. Service to one's country was the ideological postulate that determined the content of art in Catherine the Great's era and in particular the work of Levitsky.

Even Levitsky's cycle of portraits of the young charges of the Smolny Institute for Young Ladies of the Nobility (late 1770 to the 1780s, State Russian Museum) commissioned by Catherine II is, in essence, an ensemble of virtues as depicted by the artist. Each of the young ladies is shown in a specific guise: harpist, actress, scholar. Levitsky's portrait of young Alexander Lanskoi (1782, plate 62), Catherine's favorite, represents him first and foremost as a worthy citizen loyal to his empress. Her bust and Lanskoi's military uniform leave no doubt as to the state significance of this man, who, in real life, was simple and merry, completely uninterested in formal show.

As Catherine II's reign drew to a close, so did the aging empress's ideals of enlightenment. Russia was quick to learn about world events. The French revolution and its consequences stunned Russia along with other countries. Faith in an enlightened despot, in reason, and in the civic virtue of politicians was shaken. Russian society, like that of Western Europe, sought refuge in the idea of the individual, his life, feelings, and personal attachments. Sentimentalism, which turned into Romanticism in the early nineteenth century, entered Russian art in the late eighteenth century.

Borovikovsky represented this movement in portraiture. Like the others, he had painted icons in his youth. Without an academic education, he studied with Levitsky as well as with Lampi the Elder. He soon became famous as a portraitist and his work was highly valued by many patrons. The focus on the quotidian qualities of his subjects and on the natural atmosphere surrounding them distinguishes Borovikovsky's portraits. He also made formal portraits, of Paul I, Count Alexander Kurakin (1799, plate 72), and a few others, in which he stressed their state functions. These works, regardless of the time of their creation, tie Borovikovsky to the eighteenth century and its enlightenment ideals.

Russian art of the eighteenth century was more European than Russian. That was the course set by Peter the Great. It was followed in different ways by Catherine the Great, a German princess from Anhalt-Zerbst who became empress in 1762. Voltaire and Diderot also had a strong influence on the aesthetic and ethical views of educated people of the period. By the end of the eighteenth century, Russia had fully cultivated European forms in many spheres of life. "Who could have said in 1700," wrote Voltaire of Russia, "that a magnificent and enlightened court would appear in the ends of the Gulf of Finland, that a state that was almost unknown to us would in fifty years become enlightened, that its influence would extend to all our courts and that in 1759 the most fervent patrons of the humanities would be the Russians."[2] Voltaire was seconded in this view by Diderot, a philosopher of the same level and also a witness, who wrote to the sculptor Falconet, "The sciences, art, and reason are on the rise in the North, and ignorance and its fellow travelers are descending to the South."[3]

During Catherine II's reign, many European cultural phenomena, forms of behavior and social exchanges, artistic standards and models (from antiquity to the present time) were mastered and reworked. There was the first public museum since Peter the Great's reign, the Kunstkamera, public—and not just court—theaters, newspapers, journals, as well as academies of science, literature, and the arts. The elite, like their lower specialized brethren, the free scholarly and scientific societies, lived a natural life, multiplied, and took on professional qualities. Previously unknown or little known in the seventeenth century, art and cultural forms—tragedy, comedy, the ode, the narrative poem, lyric genres, instrumental music, opera, ballet, historical and fictional narratives, and satire—found a footing on Russian soil, steadily absorbing national specificity and originality. Russia mastered not only contemporary European styles—the baroque, classicism, and rococo—but also Western art history, most importantly antiquity and the Renaissance. Russian culture grew considerably more complex in the social plane (secular and church, elite and popular, high and mass) and was enriched by the cultivation of a multiplicity of genres, styles, types, and themes.

The most outstanding monument of the Enlightenment was, of course, the capital of St. Petersburg itself. The scope of its design and execution and the freedom with which the best of the sciences and arts of the world were used to serve Russian needs demonstrate the breadth and depth of thought that characterized Russia's new era. One of the most important stages in Russia's cultural development was the creation of the Academy of Arts. In opening the academy in 1764 in St. Petersburg, Catherine II solidified the Western path of development initiated by Peter I. The Russian academy, modeled on comparable European educational institutions, quickly established itself.

In the late eighteenth century and particularly in the first half of the nineteenth, quite a few artists who represented Russia in the international artistic community came from the academy. During the mid-eighteenth century, the general educational program was mandatory for students. Historical subjects, which included the Bible and mythology, held the central place in the hierarchy of genres. Anton Losenko and Pyotr Sokolov were among the first and best graduates of the Academy of Arts. Their biblical and mythological compositions fit the European context perfectly. Losenko's *Vladimir and Rogneda* (1770, plate 57) is distinguished from Russian art of the time not so much for its use of a subject from national history (which was hardly unprecedented), but because it depicted a moment of personal drama between its characters. And even though the representation of the suffering Rogneda borrowed much from theatrical productions, the very attempt to go beyond a mere revelation of the theme is remarkable for its day.

History painting had a difficult development in Russia. This genre, always programmatic, rarely found patrons and buyers. History canvases, usually painted on the initiative of the academy, remained in the building. Many graduates of the class of history painting found no application for their skills and worked in other genres, most often becoming portraitists while leaving their history compositions on paper. A rare few, like Karl Briullov, successfully combined history and portrait genres in their work.

The academy also stressed landscape; the reality of Russian life at the turn of the nineteenth century dictated a need for views. The conquest of new territories required that they

be fixed on canvas. The construction of cities, particularly St. Petersburg and its environs, were also obvious subjects. Until Russian landscape painters appeared on the scene, however, Moscow and St. Petersburg were drawn and painted by foreigners—Delabart, Mayr, John Atkinson, and others. But by the end of the eighteenth century, a number of Russian artists had mastered the landscape view. One of the most prolific and talented of these was Fedor Alexeev (ca. 1753–1824). His *View of the Palace Embankment from the Peter and Paul Fortress* (1794, plate 69) is one of the first urban landscapes in Russian art.

After that, Alexeev created a kind of portrait of St. Petersburg, a city he adored. He rendered the broad expanses of the Neva, its embankments surrounded by palaces and mansions, with great authenticity. The artist found a wonderful balance between water, sky, and architectural mass. His views of St. Petersburg are majestic and formal and as emotionally restrained as the city itself. Alexeev used a very different palette and mood for his paintings of Moscow. Crowds and bright colors predominate. For Alexeev, and many others of the time, Moscow personified the old, pre-Petrine Russia. The architecture and the atmosphere of the city in the late eighteenth century were associated with national traditions. Alexeev took delight in the colorful old architecture and its simple mores, and that is the Moscow he rendered on canvas for future generations.

This artist, who began his career under the influence of classicism, ended it during a period when Romantic tendencies were very strong in Russia. Alexeev's student and successor in landscape views was Maxim Vorobiev, who painted one of the most poetic visions of a corner of St. Petersburg next to the Academy of Arts. The Egyptian sphinxes set there in 1834 are the main motif of the work. In fact, this landscape has no view of St. Petersburg, but it shows an image of the city with its monuments, appearing unexpectedly and organically fitting into the moisture-laden atmosphere. Vorobiev's *Neva Embankment by the Academy of Arts: View of the Wharf with Egyptian Sphinxes in the Daytime* (1835, plate 86) was also one of the very few pure landscape paintings produced in Russia between 1810 and 1830 (most of these were, in any case, views of Italy, done by Fedor Matveev, Semyon Shchedrin, and others). The landscape as a fully fledged independent genre was not known in Russia until the second half of the nineteenth century. For the first three decades, landscape images, like views, included genre elements that added an emotional component.

This combination of elements also characterized the works of Silvester Shchedrin, painted for the most part in Italy. Ivan Aivazovsky's *The Ninth Wave* (1850, plate 100) is built on the same principle. It is landscape and genre painting merged into one, giving rise to a thematic canvas of epic character. A similar mix of genres seemed to reflect the worldview of the first half of the nineteenth century, an attitude revealed in Russian art in the first three decades of the century and most clearly evident in the portrait. The most conservative genre in function, the portrait, in its best examples, nevertheless effectively illustrates contemporary tendencies in Russian art.

Portrait of Colonel Evgraf Davydov by Orest Kiprensky (plate 75) was painted in 1809. At that point the artist had not yet traveled abroad and naturally could not have seen the work of Gérard or David. Of course, he had read extensively and studied the old masters, including Rembrandt, in the Hermitage and in private collections in St. Petersburg. By 1809 Kiprensky

had produced quite a few Romantic portraits and landscapes. His *Portrait of Davydov*, whose subject had fought in the campaign against Napoleon's army, became a symbol of Romanticism in Russia. It showed not so much a war hero as a man who lived by his senses. The state of emotional uplift or concentration was developed in the works of Kiprensky (*Portrait of Ekaterina Avdulina*, 1822–23, plate 74; *Portrait of Count Alexander Golitsyn*, ca. 1819, plate 77) and of his younger contemporary, Briullov. The essential difference is that the brilliant maestro Briullov, particularly in formal works, places the accent on theatrical effects rather than on the inner world of his subjects.

As with Kiprensky, Briullov's best portraits are like novellas. They are more than simply full-length representations or busts. A countess is shown leaving a ball swiftly and unexpectedly, sisters are seen descending steps outside their house, the poet Alexei Tolstoy prepares for the hunt (*Portrait of Countess Yulia Samoilova Leaving the Ball with Her Adopted Daughter Amazilia Paccini*, before 1842; *Portrait of Sisters Shishmarev*, 1839; *Portrait Alexei Tolstoy in His Youth*, 1836, plate 89; all in the State Russian Museum). These plot motifs add drama to the portraits, in some manner replacing a profound exploration of character. In this respect they represent one of the facets of Romanticism, as brilliantly interpreted by the artist.

Briullov's *The Last Day of Pompeii* (1833) is one of the most famous history paintings of a Russian artist, a Romantic embodiment of tragedy. The theme of life on the edge was very popular at the time, not only among artists but also among poets and writers (Mikhail Lermontov, Pushkin). In that sense, the figurative arts in Russia in the first half of the nineteenth century fit right into the fertile culture of the period. The first thirty years of the nineteenth century are called the "Pushkin era." It was the classic era in Russian literature, which not only produced Pushkin but also Fedor Dostoevsky, Nikolai Gogol, and Lermontov. Russian figurative art reached its maturity during this time. The artists who opened the nineteenth century were the third generation of Russians brought up by the Russian school of art, the St. Petersburg academy. They were the direct heirs of a growing tradition; they achieved artistic skills of a Western European standard and were capable of astonishing Europe with their art. The scandalous mistake of Italian connoisseurs was to claim that a Russian artist could not have painted works like those Kiprensky showed in 1831–33 in Naples and Rome, works that were an unexpected and vivid proof of the equality of Russian art.

The high regard in which drawings and watercolors by Russian artists were held by Italians, French, and Germans is further evidence of their quality. The incredible popularity in Western Europe of the work of Briullov at last persuaded everyone that Russian art had earned its place in the sun. *The Last Day of Pompeii* was exhibited in 1834 in Milan with resounding success before it was shown in St. Petersburg.

Back in Russia, realistic tendencies were ripening as early as the 1820s. The Russian War of 1812 against Napoleon and the decisive role in it played by ordinary people, particularly the peasantry, heightened the interest of artists in a previously unpopular theme. The Academy of Arts, which had satisfied the demands of society's upper classes, was unable to handle the new interest in peasant themes. Alexei Venetsianov, who worked in a land-assessment office and was an amateur painter who took an accelerated course at the

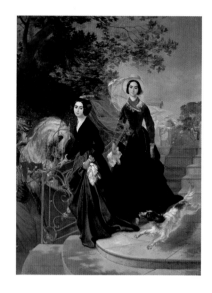

Karl Briullov, Portrait of Sisters Shishmarev, 1839. Oil on canvas, 281 x 213 cm. State Russian Museum, St. Petersburg

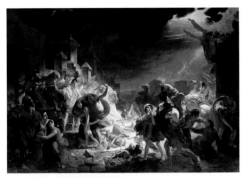

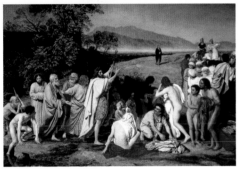

Karl Briullov, The Last Day of Pompeii, 1833. Oil on canvas, 456.5 x 651 cm. State Russian Museum, St. Petersburg

Alexander Ivanov, The Appearance of Christ to the People, 1836–after 1855. Oil on canvas, 172 x 247 cm. State Russian Museum, St. Petersburg

academy, devoted his life and work to the peasants. He left St. Petersburg for an estate near Tver in order to study peasant life there. Venetsianov created a school that accepted only peasant children, including serfs, who were not able to receive artistic training at the academy in those years.

The result was the appearance of a unique genre of paintings that took peasant life as its subject. In general, these scenes were not painted from life. Venetsianov, who was very familiar with the art of antiquity and the Renaissance, created a generalized picture of peasant life. The metaphorical nature of the images was part of the artist's concept. He was not as concerned about the truth of Russian peasant life as he was with demonstrating its significance and its value as an artistic subject. Many of his students followed in his footsteps, including Grigorii Soroka and Nikifor Krylov, who made quiet depictions of Russian peasant life that resonated in their translucent purity.

Besides Venetsianov's favored peasants, Russian artists of this period liked to paint merchants, actors, and craftsmen (Vasily Tropinin's *Portrait of the Music Lover Pavel Mikhailovich Vasilyev*, 1830, plate 78). Exhibitions from these years displayed a great variety of genres and themes. Nevertheless, history painting remained the most respected genre, especially among artists.

Alexander Ivanov was the preeminent history painter. Before graduating from the Academy of Arts he painted several works on mythological and biblical subjects. But his life's work became the painting *The Appearance of Christ to the People* (1837–57, page 105; smaller version, 1836–after 1855). The artist worked on this painting for more than thirty years. This was mainly due to the ambitious nature of the project Ivanov set for himself—to convey the various emotional states of people who receive new and vitally important information. The artist also wanted to present the scene of Christ's first meeting with mankind as a real, existing fact. To achieve this he made endless painted studies of water, stones, trees, and foliage (for example, plates 96 and 97). Besides the landscape, in which Ivanov wanted to achieve extreme authenticity, he sought to represent the psychological condition of each individual in the scene. The portrait studies, like the landscapes, form an enormous and almost separate body of work. The painting was completed and brought to St. Petersburg to be shown in 1858. The public reaction at the time was mixed. But for artists of later generations the painting and all the preparatory works for it became examples of artistic daring and discovery in the process of creating a canvas.

Ivanov, with his highly contemplative nature and philosophical clarity, summed up the era, encompassing the most fruitful tendencies of the past. In *The Appearance of Christ to the People*, Ivanov effectively completed the era of high classicism in Russian art, attempting to achieve a utopian ideal. He closed the era on the highest possible note at a time when the ideological basis and worldview of Russian classicism had narrowed dramatically. That foundation had crumbled gradually after the 1830s as a result of historical, social, and aesthetic influences. Nicholas I's personal interest in art and the taste imposed by the ruling elite, the bureaucratization and petty regulation of culture, and the ideological program that curtailed all possibility of creative dialogue between the individual and the state were not conducive to the continuation of classical traditions. Russian art took on a conflicted aspect. Briullov's

statements, and particularly Ivanov's, show that the contradictions in artistic life were perceived not only as personal and professional but also as social and historical. The growing self-awareness of artists gave rise to acute inner conflicts and a previously unknown relationship with the environment. Forced to fester under the reign of Nicholas I (1825–55), the conflict finally burst out in the rebellion of the "Fourteen,"[4] a socially significant action by the future Wanderers, who laid the foundation for a new era in the history of Russian art and for new principles in the practical sociology of artistic life. They brought to Russian art a new—not classical—type of artistic thought that had been anticipated by the realistic tendencies of the period between the 1820s and 1840s.

The focus on nature "as it is" and the rejection of the system of selection employed by artists who were brought up on classic ideals led art toward naturalism for a while. Of all the artists of the new generation, Pavel Fedotov remained closest to the old principles. His room on Vasilyevsky Island in St. Petersburg was filled with plaster casts of classical sculptures. There was also a chandelier hanging from the ceiling that Fedotov had borrowed temporarily from an inn for his painting *The Major's Proposal* (1848, page 103). However, a diligent study of antiquity did not keep the artist from painfully accurate depictions of the grim realities of his time. On the contrary, classicism taught him about beauty and harmony and selection, which made every detail expressive and necessary. The rest—subjects, situations, costumes, interiors—were inspired by life. Fedotov, more than any other artist of the first half of the nineteenth century, realized in his work the call to vitality and verisimilitude, which resounded in art from the very first years of the new era. Perhaps, he was one of the last artists of the classical tradition. Artistic imagination and the ability to compose and invent were part of his creative process. Indeed, Fedotov represents the start of a new era in Russian art.

Translated from the Russian by Antonina W. Bouis.

1. Maxim the Greek (ca. 1475–1556) was invited to Russia in 1518 by Basil III to translate church books. He was condemned by the Synod in 1505 and exiled to the St. Joseph of Volokolamsk Monastery.

2. I. I. Ioffe, "Russkii Renessans," *Uchenye zapisi Leningradskogo Gosudarstvennogo Universiteta. Series: Filologicheskie nauki* 9, no. 72 (Leningrad, 1944), p. 265.

3. Ibid.

4. In 1861 a group of fourteen students refused to paint examination pictures on mythological themes and demonstratively left the Academy of Arts, forming Russia's first ever commercial art association.

RUSSIAN ART OF THE FIRST HALF OF THE 19TH CENTURY
MIKHAIL ALLENOV

The art of the new era in Russia was introduced under the banner of Europeanism. The Russian cultural world had probably never been as freely and expansively open to wider European influence as it was under the reign of Alexander I (1801–25). None of the immediately preceding eras combined such a range of major artists with such a diversity of artistic themes and genres or such an abundance of masterpieces—from the grand ensembles of the squares of St. Petersburg and Moscow to the wax reliefs by Count Fedor Tolstoy, from the small-scale pencil portraits by Orest Kiprensky to the monumental figurative painting cycles of Alexander Ivanov that can be compared to such picaresque Russian literary works of the nineteenth century as Nikolai Gogol's *Dead Souls* (1842), among many others.

The expanded artistic perspective of this period, one that reflected a striving to comprehend the whole world and its history, relates to one of the basic concepts of Romanticism: "Suddenly, one could see far to the very ends of the earth." That phrase from Gogol's "Terrible Vengeance" (1832) was often used as a formula to express the Romantic perspective. But to the degree that the phrase is applicable to Russian art of the first half of the nineteenth century, "suddenly"—which the poet Vasily Zhukovsky referred to as "unexpected comprehension" and saw as the prerogative of genius[1]—is at least as essential to its understanding as the rest of the words. This phenomenon is almost miraculous and is accessible only to the uniquely intuitive artistic personality. Romanticism achieves universality through its opposite—by giving enhanced value to the unique and individual, the capricious and the whimsical. A new kind of artist emerged, one blessed with social status and psychological insight, the sort of character represented by men like Kiprensky and Tolstoy. They were no longer merely master craftsmen, bound by the corporative guild regulations that were preserved in modified form into the eighteenth century, but artists whose creative acts confirmed the significance of the unique and individual moment in art.

The approach of such artists to traditional forms of representation also became highly selective during this period; indeed, some ignored their artistic inheritance altogether. This situation can be expressed by lines from an early poem, "I never heard Ossian's tales" (1914), by Osip Mandelstam:

> Our kin and boring proximity
> We are always free to scorn.
> Many a treasure will go
> To great-grandchildren,
> Bypassing grandchildren,
> And once again the bard will compose
> Another's song
> And perform it as his own.

The early nineteenth-century Russian artists, who considered themselves entirely European, were bored by the proximity of the eighteenth century; artists like Kiprensky did not turn to the Russian artistic heritage of the late Middle Ages, however, but rather to that of the European seventeenth century. The Hermitage played an important role in all this: by the late eighteenth century its collection of European paintings was one of the best on the continent (in terms of both quantity and quality) and represented almost all the main periods, schools, and names. Count Alexander Stroganov's collection of paintings was also accessible to students of the Academy of Arts in St. Petersburg during this period.

The concept of art as essentially the work of the third estate vanished with the eighteenth century. The ranks of professional artists were soon joined by such members of the aristocracy as Tolstoy and Prince Grigorii Gagarin. Neither Alexei Venetsianov, who had his own school that produced a number of excellent painters, nor Pavel Fedotov, a painter and draftsman known for his satirical critiques of Russian life, studied at the academy. In a country characterized by rigid social regulation, the movement of aristocrats into the realm of professional artists met with considerable resistance; thus, while artistic activity became increasingly prestigious, the wealthy generally practiced it at home as a hobby. This gave rise to a large number of aristocratic amateurs. Dilettantism influenced, in turn, professional art in many ways, educating the taste of those social classes that included the chief consumers of art.

The genre system also became fully developed in Russian painting during this period: the landscape was redefined as a series of views; genre scenes in their two main forms— the idyllic and contemplative for peasant life and dramatic conflict for urban scenes—were exemplified in the work of Venetsianov and Fedotov; the interior genre scene was romanticized by the artists of Venetsianov's circle.

There was more correspondence and variety between artistic genres and forms during the first half of the nineteenth century. New creative possibilities opened up and with them there was a new sense of cultural mission and responsibility.

Russian architects of this period seem to have been chiefly concerned with the relationship between buildings rather than with the individual structures themselves. This relationship was articulated by rhythmic correlations and contrasts, which were evident, if at all, only from a great distance. For these correlations were not necessarily immediately visible; they were often intellectual rather than physical associations. The city itself became a sort of active participant in any architectural construction, an entity personified as the "city's face," an idea incorporating a sense of the expressions and reactions that reflect the city's memory. The face reacts to each and every invasion by architectural innovation. Simply put, the historical "memory of place" became an active participant in urban planning. The deeper the memory, the greater the demands of history on the artistry and wisdom of new builders. Inevitably this idea has a direct bearing on the traditional juxtaposition between "young St. Petersburg and old Moscow." Beginning in the early nineteenth century, this juxtaposition was to establish the plotline not only for architectural planning but also for historical and philosophical constructs and for literary criticism.

Fedor Alexeev, View of the Grand Canal in Venice from the Palazzo Flangini toward Palazzo Bembo, *late 1770s (copy of the painting by Canaletto). State Russian Museum, St. Petersburg*

Fedor Alexeev, who produced some of the most charming paintings of his day, sprang from *vedutism*, the Venetian tradition of topographical painting. Alexeev, who had studied in Venice after graduating from the St. Petersburg academy in 1773, went on to create the total illusion of being a true heir to the Venetian masters, who had developed a system of painting that arose from the union of earth and water; the architecture of Venice rises directly from the water, is reflected in it, and itself bears water's reflection in the moist air. This painting style magically coincided and found spiritual affinity in St. Petersburg, the "Venice of the North." The coincidence had to be seen and embodied on canvas. Alexeev did this in a series of views of St. Petersburg (the precise number is unknown), among them *View of the Palace Embankment from the Peter and Paul Fortress* (1794, plate 69) and *View of the Stock Exchange and Admiralty from the Fortress of Peter and Paul* (1810, State Tretyakov Gallery).

Alexeev also made a series of views that similarly revealed the genius loci of Moscow; in addition to panoramas, he presented numerous depictions of the interiors of the city's architectural complexes, among them *Cathedral Square in the Moscow Kremlin* (1800–02, plate 70). By contrast, the St. Petersburg works are dominated by a frontal and distant perspective. In Alexeev's work, St. Petersburg is represented as an "exterior" city while Moscow is shown as "interior."

Orest Kiprensky achieved firsts in many areas of Russian art: he was the first Romantic, the first painter and first portraitist of the nineteenth century, the first master of the pencil portrait, and so on. His primacy was combined with a singularity and artistic perfection that was unsurpassed in his time, and long after it. He was the portraitist of a generation in the throes of a historic transformation and thus one that perceived crisis as a permanent condition.[2]

Even the next generation considered the disruption of human life introduced by the nineteenth century to be unprecedented: "Previously, the character of the times changed barely perceptibly with the change of generations; our times changed several times within a single generation, and it could be said that those … who lived to see half a century saw several fully developed centuries run by them."[3]

This situation represented a challenge to artists who then had to create an image of the world as an "acoustic" milieu so sensitive that it resonates to the slightest oscillation. Kiprensky responded to that challenge. The focused attention of the early subjects of his portraits is not necessarily depicted in their faces but is rather suggested by their silhouettes, the line of their figures, their gestures, and their bearing.

In Italy, where nostalgia for the artistic glories of the past had reached saturation point, Kiprensky's style underwent a noticeable change. It was probably not by chance that his first Italian portrait—*Portrait of Count Alexander Golytsin* (ca. 1819, plate 77)—presents a readily recognizable mise-en-scène: a traveler contemplates the beauty of Rome from the highest point outside the city. The view itself, seen through an inexplicable arch (taken from paintings by old masters or from the stylized works of Kiprensky's contemporaries, the German Nazarenes) like the frame around a museum painting, points to the popular metaphor of Italy as an open-air museum.

Orest Kiprensky, Portrait of A.A. Chelishchev, *1809. Oil on canvas, 48 x 38 cm. The State Tretyakov Gallery, Moscow*

If Kiprensy's previous works had required the viewer to look at a beautiful person, they now called for the contemplation of a beautifully made object and the perfection of the artist's craft. With the seal of aestheticism, his style took on a specifically museum-like nuance, a cold refinement. There was a mirror smoothness to the painting and an engraving-like sharpness of stroke and a decorative quality to his draftsmanship. This is clearly evident in one of his pictures, one of the key examples of Russian late-Romantic painting, the *Portrait of Ekaterina Avdulina* (1822–23, plate 74). Created in Paris, the portrait is full of associations to great works of art in museum collections. Many have noticed references to Leonardo's *Mona Lisa* in the Louvre in addition to other Italian works of the sixteenth century, most notably Titian's *Portrait of Eleonora Gonzago* in the Uffizzi, from which the artist borrowed the window motif here.

In 1814 the Russian poet Konstantin Batyushkov expressed an essentially Romantic principle of landscape painting: "The landscape must be a portrait … otherwise what is in it?"[4] Just as the Romantic portrait must be devoid of artistic contrivance, showing the subject as a free individual undefined by social rank, landscape painting must represent an independent nature undistorted by artificial picturesque views.

The notion of creating a portrait of nature presumes a balance of natural elements in a chosen landscape scene. For artists, the climate and geography of Italy are incomparable in this respect. The country incorporates natural elements as diverse as the northern sky and snow and the arid desert of the south. Compared to the Italian landscape, others appear not quite right—here nature seems complete. Italy represents a portrait or even self-portrait of nature as an active, creative subject. Nature is comprehensively represented here: every rock, tree, mountain slope, and water surface appears to be the definitive example of its kind. The idea of landscape painting as representing a Romantic portraiture of nature emerged in nineteenth-century Russian art under the influence of Italy. If this was not a decisive factor in its decision, it must have encouraged the St. Petersburg academy to send its students to study in Rome and elsewhere in Italy rather than in Paris during the first half of the nine-teenth century. A permanent colony of Russians joined other European artists' colonies in Rome during this period.

The European fascination with Italy was reinforced by Napoleon's Italian campaign, which effectively united the warring factions of classicism and Romanticism and stimulated the fashion for Italian landscape views. But each camp nonetheless saw Italy from a different perspective. For a consistent classicist like Fedor Matveev, Italy was a collection of lovely views, each of which resembled an Arcadian landscape reminiscent of those of Claude Lorrain and Nicolas Poussin. This is essentially a culturally and historically derived view of nature.

"More than the paintings and statues, the sky draws me to Italy," wrote Ivan Kireevsky in 1832. "The southern sky must be seen in order to understand southern poetry and ancient mythology and the power of nature over man. That sky speaks not to the imagination as does the northern sky, or the stars or a storm; it is *sensually* beautiful, and it requires effort, tension, to enjoy it. Here the sky is so close (despite being deep), so close to man that he

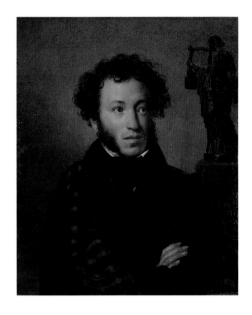

Orest Kiprensky, Portrait of Alexander Pushkin, 1827. Oil on canvas, 63 x 54 cm. The State Tretyakov Gallery, Moscow

does not need to stand on tiptoe to reach it, whereas in the north one needs to climb an entire ladder of Ossianic shadows to make the sky seem palpable."[5] This sentiment was shared by the "sons of northern fatherlands" (to use Ivanov's phrase), and their images of Rome and its surroundings were overburdened by pictorial associations; that particular landscape had made too many contributions to art, had too many privileges and pretensions to be painted. Thus, the imagination of some Russian Romantics, like that of Silvester Shchedrin, was drawn to the southern regions of the country, specifically to Naples. Pavel Muratov wrote of Naples that "the impressions of art and antiquity do not remain for long. They quickly yield to the unmanageable pressure of Neapolitan life. The abstract forms of statues, the faded colors of old paintings, and the incomprehensible images of the past quickly get lost and vanish in the noisy and brilliant spectacle of modern Naples bursting with life."[6] Paradoxically, perhaps, this flight from the conventions of classical painting into nature allowed the artists of this period to come closer to an authentic version of classical antiquity. According to Muratov, "The presence of nature in everything, a love for life, and the deep-breathing vistas of land and sea surrounding man composed the happiness of the antique world. And that happiness has not yet completely left Naples."[7]

Shchedrin began working in Naples in 1826. His landscapes form a number of thematic groups—large and small harbors in Sorrento and on the island of Capri, as well as grottoes, and terraces and verandas wreathed in grape vines. As a rule, Shchedrin depicted these subjects around noon when the southern landscape appears in all its brilliance and grandeur, immersed in a state of prolonged immobility. This is truly the "resounding silence" and "sleeping water" of Italy (to use the popular clichés of Russian Romantic poetry)—a land for forgetting passions and cares. Romantic dualism is alien to Shchedrin, whose work suggests no interest in the discord between dream and reality. Nor are his landscapes influenced by the Romantic obsession with infinity. Heinrich von Kleist saw nature as "arousing desire and longing" in the landscapes of Caspar David Friedrich, the preeminent German Romantic.[8] This was an absolutely alien concept to Shchedrin, in whose paintings the radiant sun seems close. The sea enters the field of vision in quiet bays and coves protected by mounds of stones, cliffs, sandbars, and sails of fishing vessels blocking the horizon. A kind of landscape interior—cozy, and on a human scale—is created. And yet the Romantic tension between ideal and reality is also present, but represented in a reworked, sublimated way. It is embodied in Shchedrin's paintings by a sense of the intensity of emotion that imbues a beautiful moment held in suspension, a state of joy and peace that is won from something different and alien and now experienced in the context of that contradiction.

The art of Vasily Tropinin, a former serf and a contemporary of Kiprensky, reveals an entirely opposite artistic approach. For during the Romantic era, Tropinin retained many of the conventions of eighteenth-century art in his portraiture. In the early period, he used a rococo palette with shades of complementary colors, dominated by a golden hue. He also used the typical rococo *contrapposto* in the poses of the figures and a soft brush to create an airy, shimmering texture. *Portrait of the Artist's Son* (ca. 1818, plate 80) is the masterwork of Tropinin's early career. It bears obvious traces of the style of the master of French rococo, Jean-Baptiste Greuze, which Tropinin copied in his youth. The custom at that time was to

Silvester Shchedrin, A Small Harbor in Sorrento near Naples, 1826. Oil on canvas, 44 x 60 cm. The State Tretyakov Gallery, Moscow

award the names of celebrated European masters to Russian artists. Kiprensky, for example, was "the Russian van Dyck," and Matveev, "the Russian Poussin." Tropinin was "the Russian Greuze"—"not so much for the pretty faces," wrote Alexander Benois, "as for the thick, bold brushstroke and the beautiful tone that had something in common with heavy cream."

For Tropinin, a person pursued a way of life in which the cult of amicable relations, hospitality, and a rather indolent lightheartedness reigned—the Moscow version of *il dolce far niente*. In his work, the focus of artistic vision moved from the Romantic personality, the ego itself, to the life and daily circumstances of the individual, where it dissolved. His figures are characters from an unrealized genre painting, genre in the form of portraiture.

Venetsianov systematized genre painting in Russian art. The very concept incorporates an interior dialogue with what is called "society"—the world of the city, the regime, and government service. It is a sort of recidivism into Russianism, a tendency thrown into the Romantic era from the previous century. The artist's world, stripped of drama and conflict in the narratives of his paintings, is not, however, devoid of a certain anxiety. It marks the faces of his figures, who never appear relaxed, much less happy. But they do not seem to suffer from sorrow or melancholy, the companions of indolence. What we see here is rather the secret unhappiness of people who know no indolence, who are entrusted with one of the most urgent of human tasks: the care of the land. It is the ethos of peasant life, similar to a mother's care. Maternity is a key theme in Venetsianov's mid-1820s paintings *Plowing: Spring* and *On the Harvest: Summer* (plate 82). Here there are no sowers or harvesters: the land is given over to the care of mothers.

Because of this proximity to eternal and unchanging human concerns, Venetsianov's world is filled with lofty images; in *Harvest: Summer*, the image of Mary, for example, relates to quattrocentro madonnas or early Russian icons. In the early 1820s Venetsianov founded a school at his country estate and trained wonderful painters there. In his pupils' studies of perspective, the genre of "the interior"—called "in the rooms" by contemporaries—crystallized into an independent branch of art.

Among Venetsianov's pupils was a number of serfs; one of them, Grigorii Soroka, was his most talented student. However, Soroka's works hardly suggest the despair that was ultimately to lead to his suicide. The artist's landscapes do not reflect the weather, and nature is not subject to change. Everything is bathed in a peaceful glow, one reminiscent of the light of white nights. The clouds melt in the sky and the mirror surface of the water of his lakes is unruffled. In Soroka's painting *Fishermen* (second half of 1840s, plate 84), the bow of the boat touches the tip of the boy's fishing rod resting on the shore, fixing the exact geometric center of the painting. The artist's fidelity to precise geometric axes gives the composition the implacability of a mathematical formula. The horizontal line is absolutely predominant. Even the clouds are subordinate to it, with their bases forming straight lines parallel to the horizon. It is as if the sky were a great static ocean with the white islands of the clouds sitting above it. This ocean immobilizes them as if they had arrived at last at their final harbor. It is impossible to imagine any diagonal motion that would violate the dominant horizontal by crossing and thereby crossing it out. A sensitive art historian has noted that this is a

world without a trace of a road leading beyond the horizon.[9] In other words, this is Utopia, a place that does not exist.

Soroka's works bear little relationship to his immediate environment and this reflects his views on what is appropriate in art. According to Soroka, life on earth is a vale of tears while art provides an image of paradise that counteracts spiritual confusion and disequilibrium. Art should reflect the balance of divine benevolence, allowing the world not to move or change in time but to remain, extend, and exist in space. The first act of god's benevolence was light. Thus light should be the primary focus of painting, since it enables the artist to create an illusion of reality on the canvas. Here, religious concepts meet with the fundamentals of Venetsianov's aesthetic teachings.

The basic opposition within the concept of genre in art is that of nature versus civilization. Venetsianov's concept of genre painting exhausts the first part, nature, but the second, civilization, is represented more fully in a metropolitan environment. This is the subject that formed Fedotov's concept of genre. The essential themes of his work lie in the whirlwind, merry-go-round, and kaleidoscope of life, in the idea of people as playthings of empty passions caught in the clash of fleeting and vain interests and in petty conflicts that are only ripples on the surface of life, the fleeting frivolity of existence.

Fedotov first exhibited his work publicly in 1848, when he showed his first genre paintings at the St. Petersburg academy: *The Newly Decorated Civil Servant* (*An Official the Morning after Receiving His First Decoration*) (1846, plate 98), *Difficult Bride* (1847, State Tretyakov Gallery), and *The Major's Proposal*. The artist's two versions of *The Major's Proposal* show several transformations in the handling of the figures. The major morphs from fatuous cartoon figure in the first version (1848) to elderly villain in the second (ca. 1851, plate 99); the matchmaker loses the cunning spark evident in version one, and in the second version a dullness appears in her face. In the first version the merchant looks reasonable, but in the second his face is frozen in an unpleasant grin. Even the cat, which in the first version seems to imitate the grace of the bride, becomes a fat, shaggy, and rude beast. In the second version, the bride's gestures have lost their refinement. While in the first version the artist's attention to the attractive details of the image creates the illusion that he is observing the scene through the eyes of the "sellers" and the "buyer" of the merchant's goods, in the second version, the value of the goods is reduced and is represented on the same emotional level as the bride's feelings. We are asked to observe the scene through her eyes, those of the victim of a dramatic conflict.

Produced in 1851 and 1852 respectively, Fedotov's *Encore, Encore!* (State Tretyakov Gallery) and *Gamblers* (Kiev Museum of Russian Art) were among his last paintings, but they hardly look like the work of the artist who created *The Major's Proposal*. The world now appears ghostly—situated somewhere between dream and reality—the result of the play of shadows, with an element of hallucinatory nightmare.

A lit candle set in a dark interior became a standard motif in Fedotov's late works. The artist noted in his diary: "They kill time until time kills them," an aphorism directly applicable to the situations in *Encore, Encore!* and *Gamblers*. The people in these paintings are

again playthings, victims of idle time. These are images not of Eternity or History, but of Timelessness created by means of the Romantic grotesque; the studies for *Gamblers* are reminiscent of the writings of both Fedor Dostoevsky and E. T. A. Hoffmann.

Karl Briullov was the genius who forged a compromise in Russian art between the ideals of the classical school and the innovations of Romanticism. There is probably no other Russian artist who achieved as much fame in his lifetime and who was literally adored by his students as well as emerging artists. Briullov's prominence was established primarily by his painting *The Last Day of Pompeii* (1833, page 93), a work that seemed to bridge antiquity and Romanticism.

In 1819, Briullov painted *Narcissus Regarding His Reflection*, a student assignment for the academy. In addition to conveying the movement of the nude figure in its statuesque splendor, he found a way to poetically animate the myth of the handsome young man entranced by his own beauty. The play of light and dark areas of the image, with a nod to Correggio and Caravaggio—the soft golden light surrounding Narcissus against the background of a shadowy landscape interior—is the student's independent discovery. The idea of animating classical form, of moving beyond the plaster casts used as teaching aids to render the living and sensual (if "noble" according to academic codes) beauty of nudity, reflected the influence of Romantic taste in the studio; this was the first attempt at "the symbiosis of antique and Romantic" (as N. I. Nadezhdin put it), one that would culminate in *The Last Day of Pompeii*. Incidentally, the figure of Narcissus in Briullov's painting bears a suspicious resemblance to the artist, whose appearance is well known from his numerous self-portraits. A self-portrait as Narcissus! Was this a revelation of self-knowledge and a warning to himself: "Sow character, reap destiny," as the proverb goes. Narcissism, self-love, drowning, and death in the embrace of the Apollonic beauty of one's own face, that is, aestheticism as a kind of suicide—how strangely prophetic in light of the artist's subsequent career.

The formal portrait is the kind of picture most influenced by social convention, and there thus tends to be at least a degree of formality in the model's presentation to the viewer. Briullov, however, always invented a real context that made the subject's appearance more convincing: a woman returning from riding, for example, or the Shishmarev sisters setting out for a ride (1839, page 92), or the young Alexei Tolstoy hunting in the woods and stopping to listen to the rustling of his prey in the undergrowth (1836, plate 89). In Briullov's *Portrait of Countess Julia Samoilova* (1832–34, plate 90), the subject smiles happily at the viewer as she carelessly tosses her shawl into the waiting hand of her Moorish maid and embraces her ward, who regards her adoringly. In 1832 Alexander Turgenev wrote in a letter from Rome to Pyotr Vyazemsky: "Countess Samoilova flew here (from Naples), I found her at Briullov's atelier in the pose of a running beauty with a Moorish woman and her ward."[10] Note the astonishing juxtaposition of "flew" (in real life) and "running" (in the painting's mise-en-scène), creating the image of a light-winged creature, half-nymph, half-angel, the kind of character who can only be imagined swooping through the air.

Romantic elements feature in many of Briullov's smaller portraits, as in his picture of Alexander Strugovshchikov, a poet and a translator of German poetry (1840, plate 88), for example. Meditative solitude, loneliness, and world-weariness are all motifs in these works.

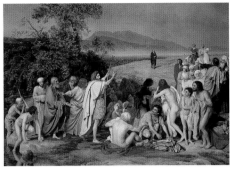

Alexander Ivanov, The Appearance of Christ to the People, *1837–57. Oil on canvas, 540 x 750 cm. The State Tretyakov Gallery, Moscow*

Alexander Ivanov, Via Appia, *1845. Oil on canvas, 44 x 61 cm. The State Tretyakov Gallery, Moscow*

Briullov deals with Romanticism as a fully developed system of signs and thematic and emotional formulas. His intimate portraits are most often defined by a circle of elegiac moods of a kind that his contemporaries had usually experienced in Romantic literature rather than in painting. This ease in the recognition of the expected gave the artist's works unprecedented popularity at the broadest and most varied levels of Russian society.

It was Ivanov who was to become master of a genuine synthesis between classicism and the discoveries of the Romantic era, one that did not merely represent a compromise between external signs and forms. He tried to find ways in which the juxtaposition between classicism and Romanticism at the turn of the century could be obviated by a new form of art that encouraged a dialogue between the two camps, one that embraced rather than denied inherent contradictions between them. Upon his graduation from the academy in 1830, Ivanov was sent to Italy. He lived in Rome for twenty-eight years, returning to St. Petersburg only six weeks before his death. "In Russia an artist and a serf are almost the same thing," he wrote bitterly.[11] He kept thinking that he could serve Russian art better in Italy, where he made European art the property of the Russian mind, than by being stuffed into the academy's uniform under the imperial reign of Nicholas I (1825–55) . Ultimately, Ivanov is as much a key figure for Russian art of the new era as Andrei Rublev was for the art of medieval Russia. In his paintings Ivanov created psychological and plastic collisions that were inherent to a situation, moments when people found themselves at the whim of fate, on the brink of a decision of a kind that forces a person to take responsibility, one that requires a concentration of spiritual energy. A decision of this momentum consequently revealed the limit or measure of the wisdom and spiritual and physical strength given to that individual by providence. As that limit or measure takes shape in the visible world, it can be seen and depicted. That is the goal of figurative art; that was Ivanov's position, his theme and method, realized most fully in the painting *The Appearance of Christ to the People* (1837–57) and the accompanying studies for it.

Ivanov's landscape studies show us nature devoid of people. The chief subjects of Ivanov's landscapes are old trees, mountains, soil, rocks hewn by water, and the light-bearing ocean—everything that carries the stamp of time, the eternal on a human scale. For Ivanov, the surface of the earth's crust is a map made by nature, capturing signs, traces, trajectories, and images of the actions of the creative forces of the universe that once formed the body of the earth. The role of the immeasurable distance that turned this activity into signs and wordless speech, written on the planet's rocky core, is played by time, incompatible with the scale of human life. Ivanov selects places rich in volcanic formations and paints them where they lack a cultivated layer, where the "bald skull" of the earth is visible. The artist's brush revives the earlier seismic activity, but only as a memory, a trace, an image of what was and had passed across the imperturbable brow of nature. In *Water and Stones near Palaccuolla* (early 1850s, plate 97) the contours of stones, shaped by water, still reveal their former general outlines, a memory of what was once a single cliff. Sparkling from within a rainbow created by light refracted in their grainy surfaces and simultaneously reflecting the blue sky, they are like frozen flames, related to the elements of sky and water.

In his treatise on painting, Leon Alberti wrote, "There are as many true *colors* as there are *elements*—four, from which, constantly diminishing, are born other forms of color. The color of fire is red, air—blue, water—green, and earth—gray or ash."[12] This idea is, in fact, drawn from ancient mythology. The very concept of original elements is akin to the sources, roots, and letters that were the building blocks of the cosmos in the natural philosophy of the ancients. In the same way, the blue, green, red, and white in Ivanov's study *Nude Boy* (1850s, plate 92) are not the colors of fabric but substrata of color itself. The artist gives the formulas for proto-elements—blue for hard and cold objects, emerald green for the soft land, red for fire, and sparkling white for drapery—and by gradually differentiating those elements he displays the ultimate complexity of their combination in the body tones. The border between the figure and its surroundings is an elusive threshold of progressive complexity in the combinations of color atoms. The human image here, as in all nature, reflects the limitation of complexity in the combination of original elements, the roots of natural substances. And here, man is literally and visibly the crowning point of natural creation, a figure representing the "golden age" of nature. He is not in nature; he is nature, its revelation, its heuristic moment, one witnessed by the artist.

Translated from the Russian by Antonina W. Bouis.

1. Vasily Zhukovsky, "Ob iziashchnom v iskusstve," in Zhukovsky, *Estetika i kritika* (Moscow: Iskusstvo, 1985), p. 356.

2. As V. O. Klyuchevsky wrote about Alexander I: "Probably no other sovereign had to experience such rapid turns of the wheel of history in different directions as did the Russian tsar in those years. When Napoleon stood at the gates of burning Moscow, Alexander was planning to move to Siberia, grow a beard, and live on potatoes and black bread; a year and a half later, dressed in a brilliant uniform and riding his bay Eclipse, he rode around without convoy through the streets of a defeated Paris, merry, smiling, and graciously responding to the joyous cries of the Parisian men and women he had conquered." V. O. Klyuchevsky, *Tetrads aforizmami. Aforizmy i mysli ob istorii* (Moscow: Exmo-Press, 2001), pp. 169–71.

3. Ivan Kireevsky, "Deviatnadtsatyj vek" (1832), in Kireevsky, *Kritika i estetika* (Moscow: Iskusstvo, 1979), p. 80.

4. K. N. Batyushkov, "The Walk in Academy of Arts" (1814), *Works* (Moscow, 1955), p. 330.

5. Kireevsky, p. 352.

6. Pavel Muratov, *Obrazy Italii*, vols. 2–3 (Moscow: Galart, 1993), p. 139.

7. Muratov, p. 148.

8. Kleist, cited in Alain Besançon, *Zapretnyj obraz. Intellektualnaia istoriia ikonoborchestva* (Moscow, 1999), p. 313.

9. Vladimir Obukhov, *Grigorii Soroka* (Moscow: Iskusstvo, 1982), p. 41

10. Turgenev, cited in A. V. Kornilova, *Karl Briullov v Peterburge* (Leningrad: Lenizdat, 1976), p. 133.

11. Ivanov, cited in A. A. Guber et al., eds., *Mastera iskusstva ob iskusstve. Izbrannye otryvki iz pisem, dnevnikov, rechey i traktatov*, vol. 6 (Moscow: Iskusstvo, 1969), pp. 308–09.

12. Leon Alberti, *Ten Books on Architecture*, vol. 2 (Moscow, 1937), p. 31.

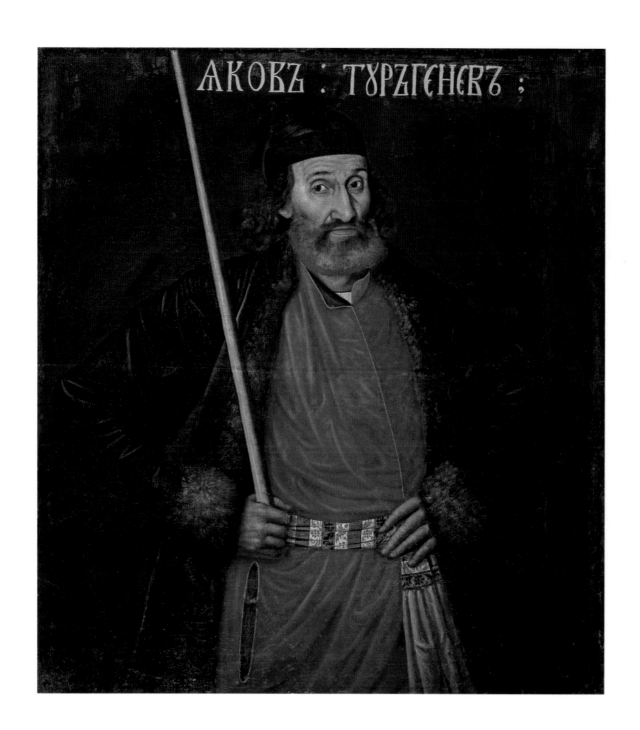

АКОВЪ : ТУРЗГЕНЕВЪ :

44. UNKNOWN ARTIST, ARMORY
CHAMBER SCHOOL, *PORTRAIT OF YAKOV
TURGENEV, SECOND HALF OF THE
17TH CENTURY. OIL ON CANVAS, 105 X
97.5 CM. STATE RUSSIAN MUSEUM,
ST. PETERSBURG*

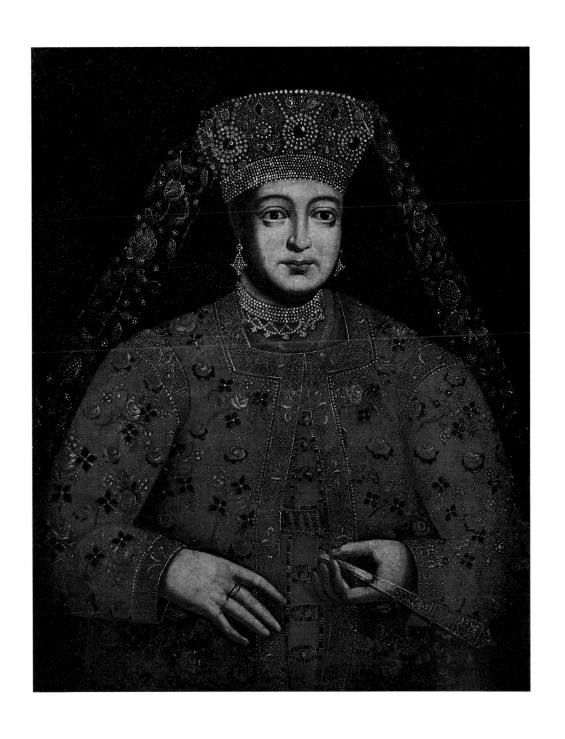

45. UNKNOWN ARTIST, PORTRAIT OF
TSARINA MARFA MATVEEVNA, BORN
APRAKSINA, SECOND WIFE OF TSAR FEDOR
ALEXEEVICH, EARLY 1680S. OIL ON
CANVAS, 89 X 70 CM. STATE RUSSIAN
MUSEUM, ST. PETERSBURG

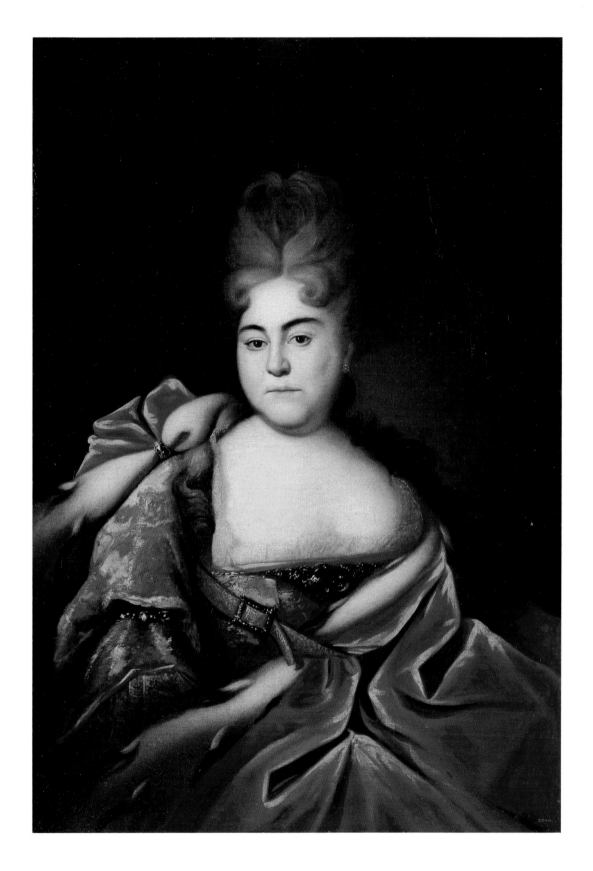

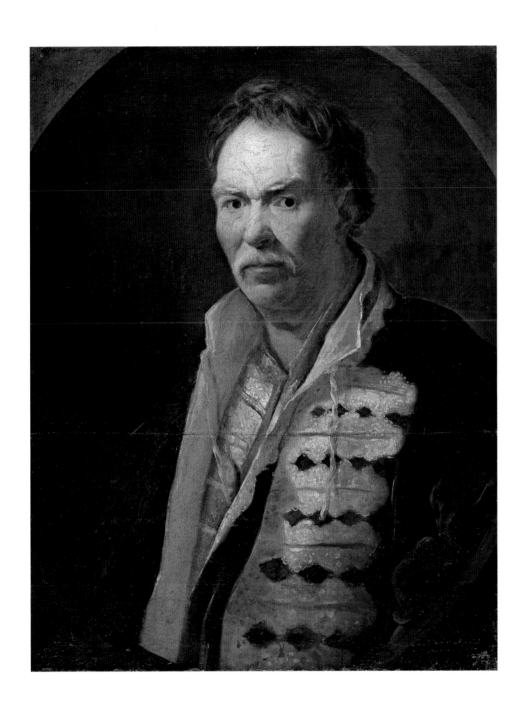

46. (OPPOSITE) IVAN NIKITIN,
*PORTRAIT OF TSAREVNA NATALIA
ALEXEEVNA*, 1715–16. OIL ON CANVAS,
102 X 71 CM. THE STATE TRETYAKOV
GALLERY, MOSCOW

47. IVAN NIKITIN, *PORTRAIT OF A FIELD
HETMAN*, 1720S. OIL ON CANVAS,
76 X 60 CM. STATE RUSSIAN MUSEUM,
ST. PETERSBURG

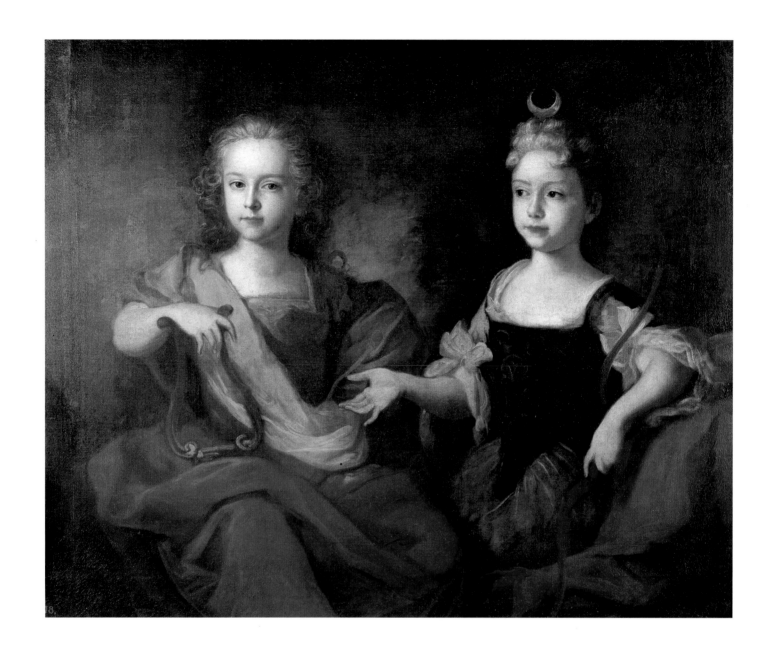

48. LOUIS CARAVAQUE, *PORTRAIT OF THE TSAREVICH PETER ALEXEEVICH AND TSAREVNA NATALIA ALEXEEVNA IN CHILDHOOD AS APOLLO AND DIANA*, 1722. OIL ON CANVAS, 92 × 118 CM. THE STATE TRETYAKOV GALLERY, MOSCOW

49. (OPPOSITE) BARTOLOMEO CARLO RASTRELLI, *PORTRAIT OF PETER I*, 1723. BRONZE, H. 102 CM. STATE HERMITAGE MUSEUM, ST. PETERSBURG

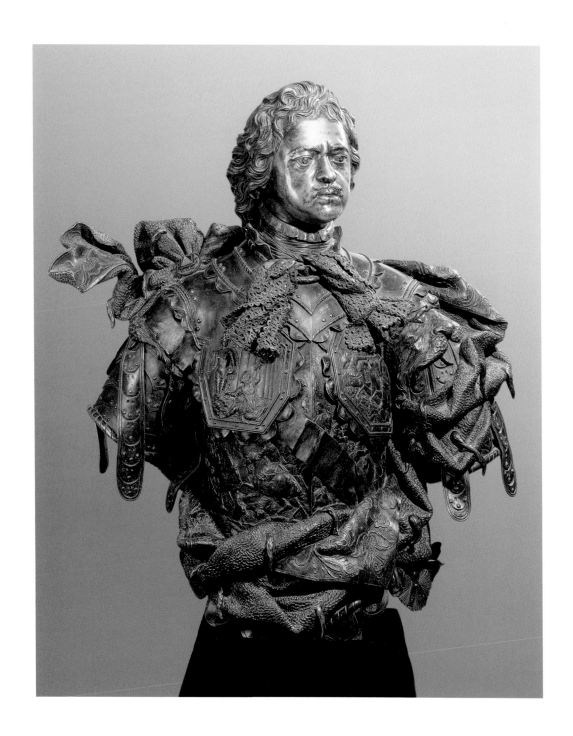

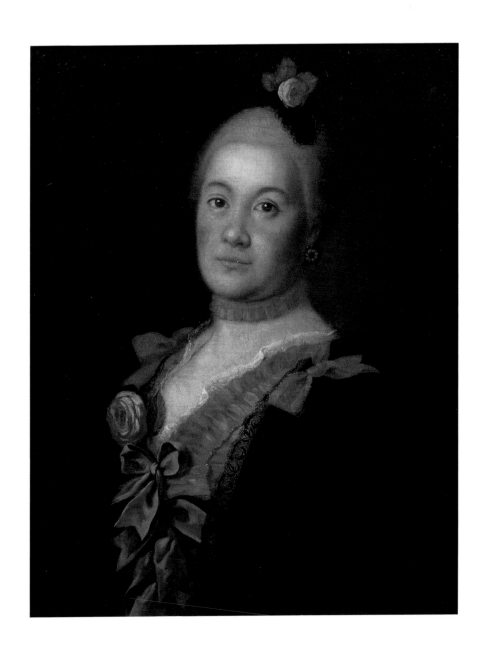

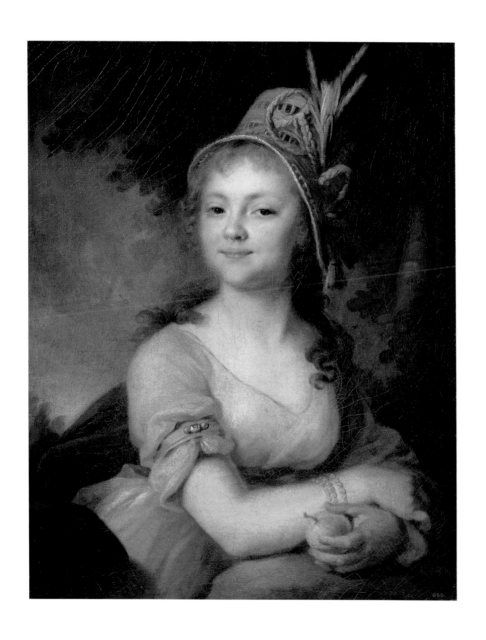

50. (OPPOSITE) ALEXEI ANTROPOV,
*PORTRAIT OF PRINCESS TATIANA
TRUBETSKAYA*, 1761. OIL ON CANVAS.
54 X 42 CM. THE STATE TRETYAKOV
GALLERY, MOSCOW

51. VLADIMIR BOROVIKOVSKY, *PORTRAIT
OF EKATERINA ARSENYEVA*, MID–1790S.
OIL ON CANVAS, 71.5 X 56 CM. STATE
RUSSIAN MUSEUM, ST. PETERSBURG

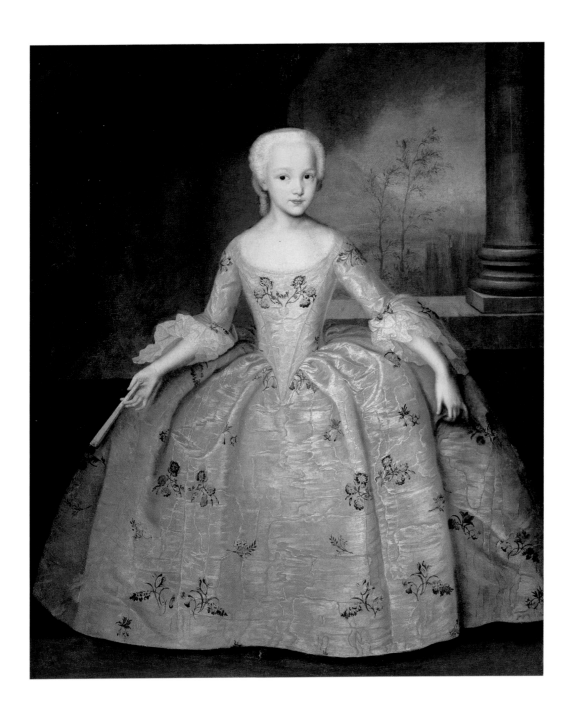

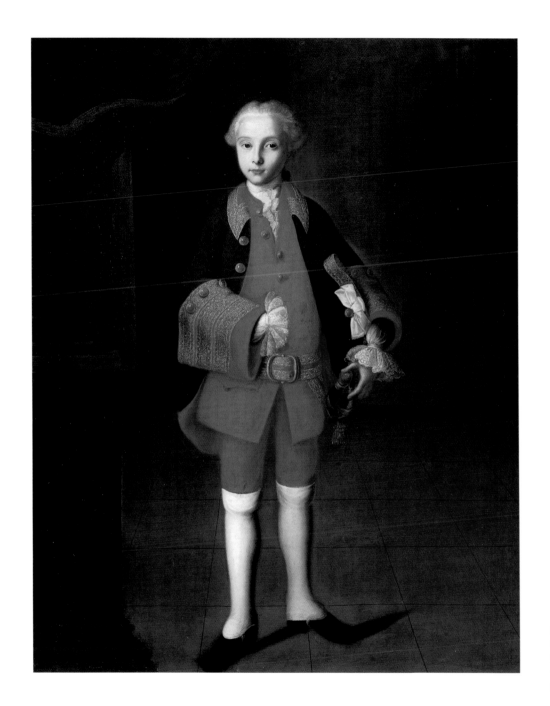

52. (OPPOSITE) IVAN VISHNYAKOV,
PORTRAIT OF *SARAH ELEONORA
FAIRMORE*, CA. 1749. OIL ON CANVAS,
138 X 114.5 CM. STATE RUSSIAN
MUSEUM, ST. PETERSBURG

53. IVAN VISHNYAKOV, PORTRAIT OF
WILHELM GEORGE FAIRMORE, SECOND
HALF OF 1750S. OIL ON CANVAS, 135 X
109 CM. STATE RUSSIAN MUSEUM,
ST. PETERSBURG

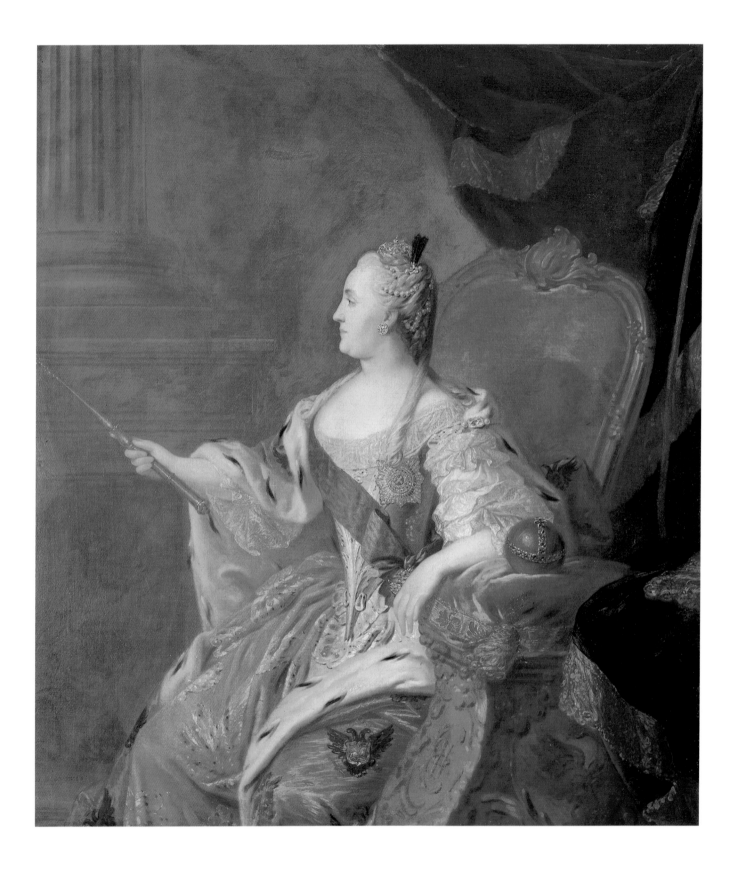

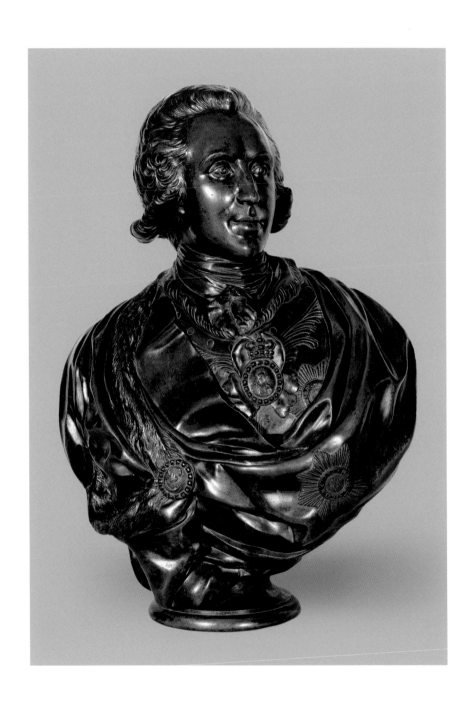

54. (OPPOSITE) FEDOR ROKOTOV,
PORTRAIT OF CATHERINE II, 1763. OIL
ON CANVAS. 155.5 X 139 CM. THE
STATE TRETYAKOV GALLERY, MOSCOW

55. FEDOT SHUBIN, *PORTRAIT OF
PRINCE PLATON ZUBOV*, 1795. MARBLE,
H. 70 CM. THE STATE TRETYAKOV
GALLERY, MOSCOW

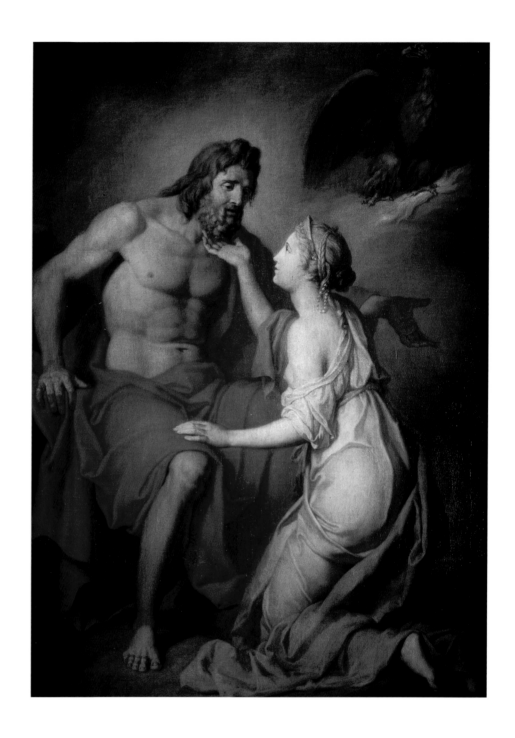

56. ANTON LOSENKO, *ZEUS AND THETIS*, 1769. OIL ON CANVAS, 172 X 126 CM. STATE RUSSIAN MUSEUM, ST. PETERSBURG

57. (OPPOSITE) ANTON LOSENKO, *VLADIMIR AND ROGNEDA*, 1770. OIL ON CANVAS, 215.5 X 177.5 CM. STATE RUSSIAN MUSEUM, ST. PETERSBURG

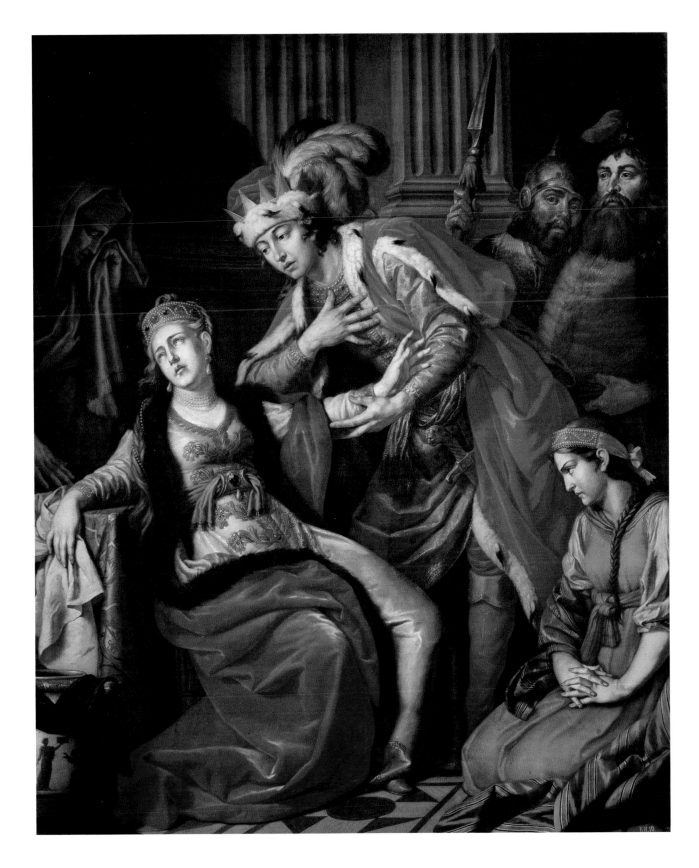

58. MIKHAIL SHIBANOV, PEASANT
LUNCH, 1774. OIL ON CANVAS,
103 X 120 CM. THE STATE TRETYAKOV
GALLERY, MOSCOW

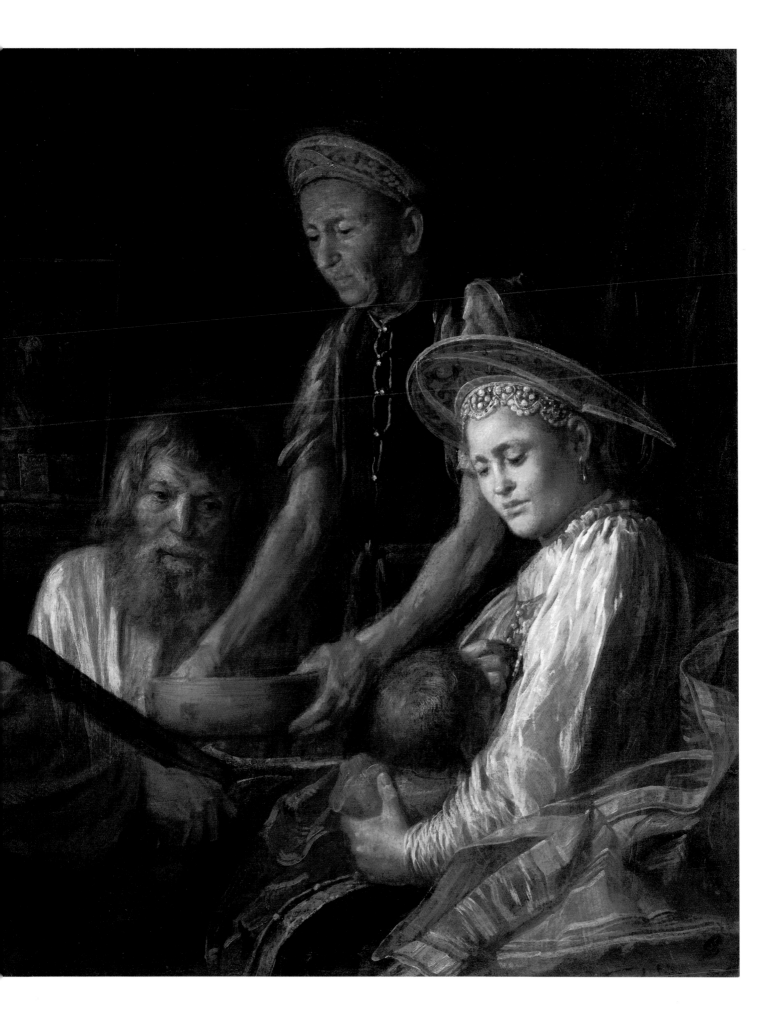

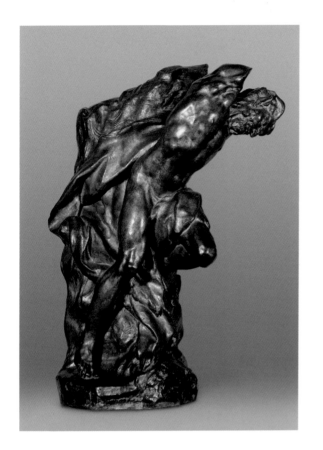

59. (LEFT) THEODOSII SHCHEDRIN,
MARSYAS, 1776, BRONZE, H. 69 CM. THE
STATE TRETYAKOV GALLERY, MOSCOW

60. (RIGHT) THEODOSII SHCHEDRIN,
SLEEPING ENDYMION, 1779. BRONZE,
H. 58 CM. THE STATE TRETYAKOV
GALLERY, MOSCOW

61. (OPPOSITE) FEDOR GORDEEV,
PROMETHEUS, 1769. BRONZE.
H. 63 CM. THE STATE TRETYAKOV
GALLERY, MOSCOW

62. (OPPOSITE) DMITRY LEVITSKY,
PORTRAIT OF ALEXANDER LANSKOI, 1782.
OIL ON CANVAS, 151 X 117 CM. STATE
RUSSIAN MUSEUM, ST. PETERSBURG

63. (LEFT) FEDOT SHUBIN, PORTRAIT
OF CATHERINE II, 1783. MARBLE,
H. 63 CM. STATE RUSSIAN MUSEUM,
ST. PETERSBURG

64. (RIGHT) FEDOR ROKOTOV,
PORTRAIT OF PRASKOVIA LANSKAYA, EARLY
1790S. OIL ON CANVAS.
74 X 53 CM. THE STATE TRETYAKOV
GALLERY, MOSCOW

65. (OPPOSITE) DMITRY LEVITSKY,
PORTRAIT OF *AGAFIA DMITRIEVNA
(AGASHA) LEVITSKAYA, DAUGHTER OF THE
ARTIST*, 1785. OIL ON CANVAS,
118 X 90 CM. THE STATE TRETYAKOV
GALLERY, MOSCOW

66. MIKHAIL SHIBANOV, PORTRAIT OF
CATHERINE II IN A TRAVEL DRESS, 1787.
OIL ON CANVAS, 70.5 X 56 CM. STATE
RUSSIAN MUSEUM, ST. PETERSBURG

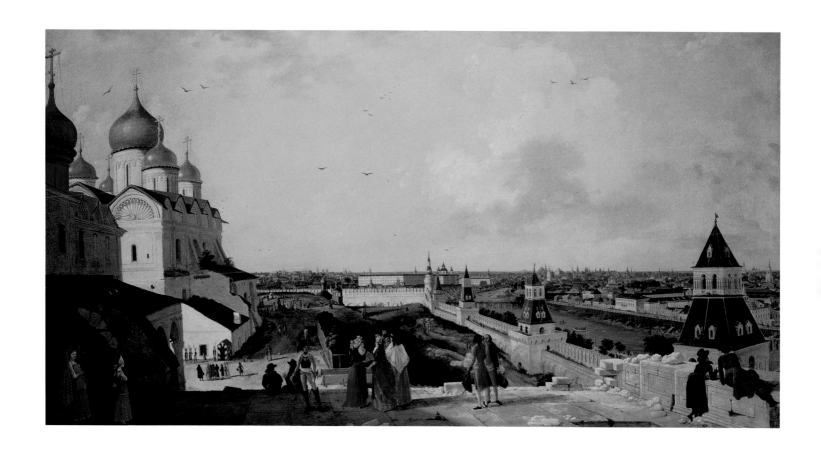

67. (OPPOSITE) JOHANN MAYR, *VIEW OF THE ADMIRALTY FROM THE VASILYEVSKY ISLAND EMBANKMENT*, BETWEEN 1796 AND 1803. OIL ON CANVAS, 76 X 116 CM. STATE RUSSIAN MUSEUM, ST. PETERSBURG

68. GÉRARD DELABART, *VIEW OF MOSCOW FROM THE KREMLIN PALACE BALCONY ONTO THE MOSKVORETSKY BRIDGE*, 1797. OIL ON CANVAS, 75 X 143 CM. STATE RUSSIAN MUSEUM, ST. PETERSBURG

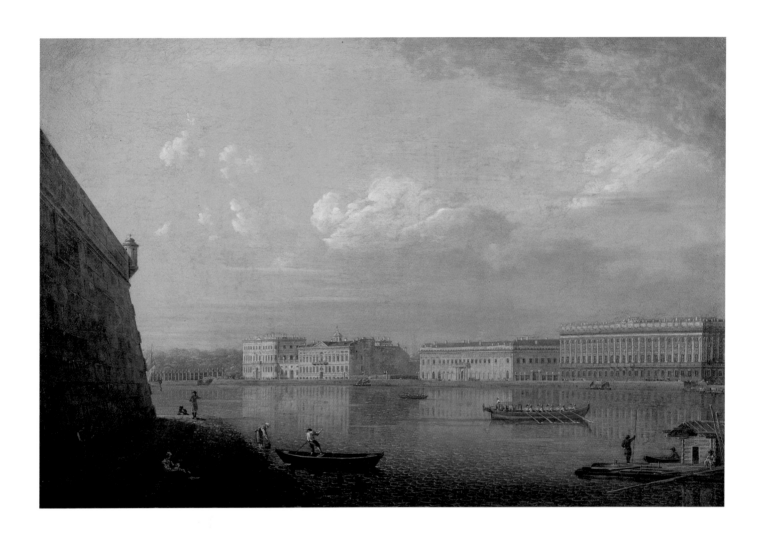

69. FEDOR ALEXEEV, *VIEW OF THE PALACE*
EMBANKMENT FROM THE PETER
AND PAUL FORTRESS, 1794. OIL ON
CANVAS, 70 X 108 CM. THE STATE
TRETYAKOV GALLERY, MOSCOW

70. (OPPOSITE) FEDOR ALEXEEV,
CATHEDRAL SQUARE IN THE MOSCOW
KREMLIN, 1800–02. OIL ON CANVAS,
81.7 X 112 CM. THE STATE
TRETYAKOV GALLERY, MOSCOW

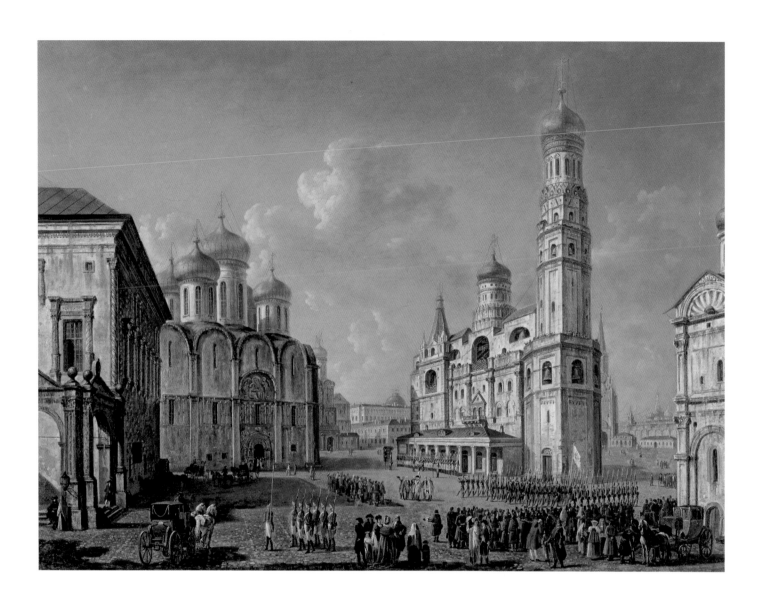

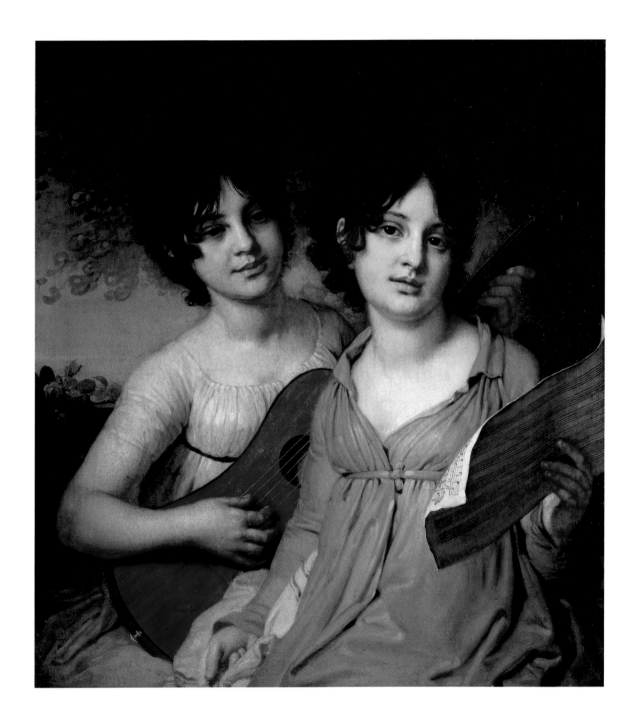

71. VLADIMIR BOROVIKOVSKY, PORTRAIT
OF THE SISTERS PRINCESSES ANNA AND
VARVARA GAGARINA, 1802. OIL ON
CANVAS. 75 X 69.2 CM. THE STATE
TRETYAKOV GALLERY, MOSCOW

72. VLADIMIR BOROVIKOVSKY, PORTRAIT
OF PRINCE ALEXANDER KURAKIN, 1799.
OIL ON CANVAS, 178 x 137 CM. STATE
RUSSIAN MUSEUM, ST. PETERSBURG

73. (OPPOSITE) OREST KIPRENSKY,
PORTRAIT OF DARIA KHVOSTOVA, 1814. OIL
ON CANVAS, 71 X 57.8 CM. THE STATE
TRETYAKOV GALLERY, MOSCOW

74. OREST KIPRENSKY, *PORTRAIT OF
EKATERINA AVDULINA*, 1822. OIL ON
CANVAS, 81 X 64.5 CM. STATE RUSSIAN
MUSEUM, ST. PETERSBURG

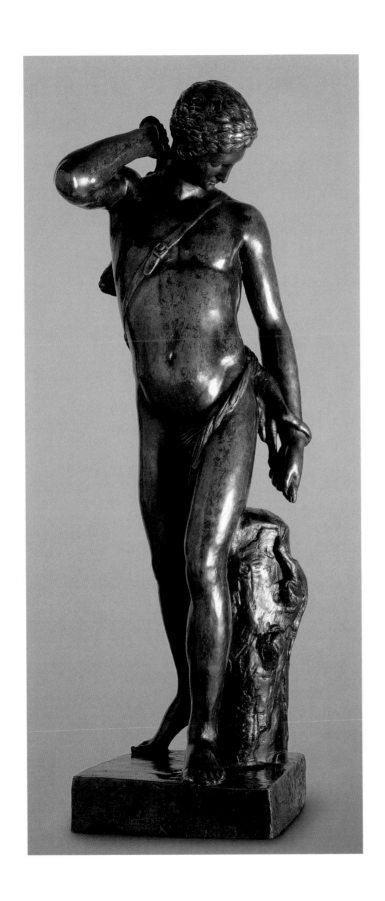

75. (OPPOSITE) OREST KIPRENSKY, *PORTRAIT OF COLONEL EVGRAF DAVYDOV*, 1809. OIL ON CANVAS, 162 X 116 CM. STATE RUSSIAN MUSEUM, ST. PETERSBURG

76. MIKHAIL KOZLOVSKY, *SHEPHERD WITH A HARE*, 1789. BRONZE, H. 81 CM. THE STATE TRETYAKOV GALLERY, MOSCOW

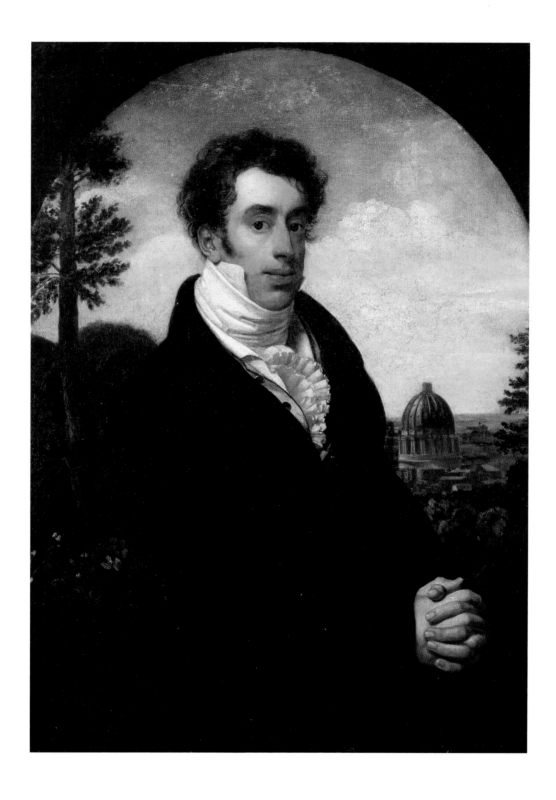

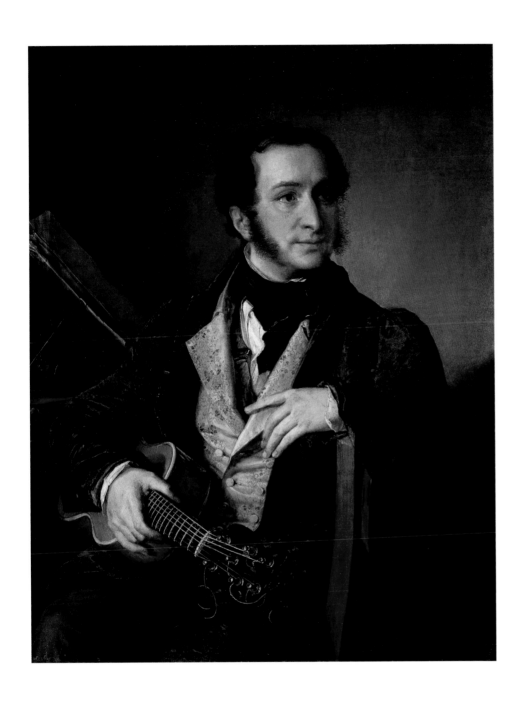

77. (OPPOSITE) OREST KIPRENSKY,
PORTRAIT OF COUNT ALEXANDER GOLITSYN,
CA. 1819. OIL ON CANVAS, 97.3 X
74.5 CM. THE STATE TRETYAKOV
GALLERY, MOSCOW

78. VASILY TROPININ, *PORTRAIT OF PAVEL*
MIKHAILOVICH VASILIEV, 1830S. OIL
ON CANVAS, 95 X 75 CM. STATE
RUSSIAN MUSEUM, ST. PETERSBURG

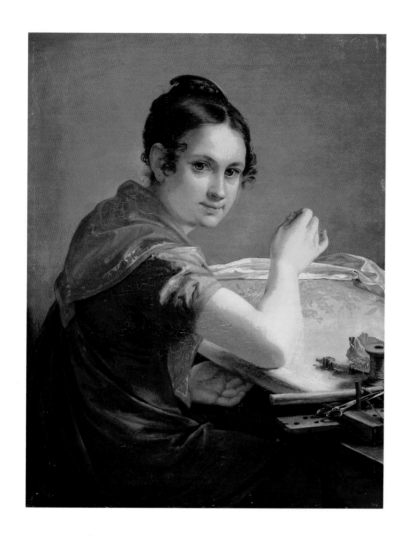

79. VASILY TROPININ, *GOLD
EMBROIDERESS*, 1826. OIL ON CANVAS,
81.3 X 63.9 CM. THE STATE TRETYAKOV
GALLERY, MOSCOW

80. (OPPOSITE) VASILY TROPININ,
PORTRAIT OF ARSENY TROPININ, CA. 1818.
OIL ON CANVAS, 40.4 X 32 CM. THE
STATE TRETYAKOV GALLERY, MOSCOW

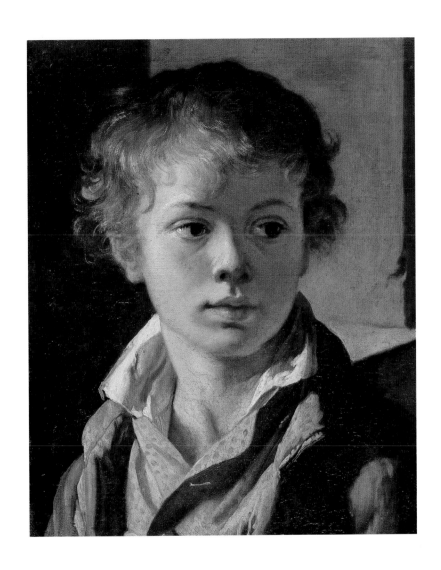

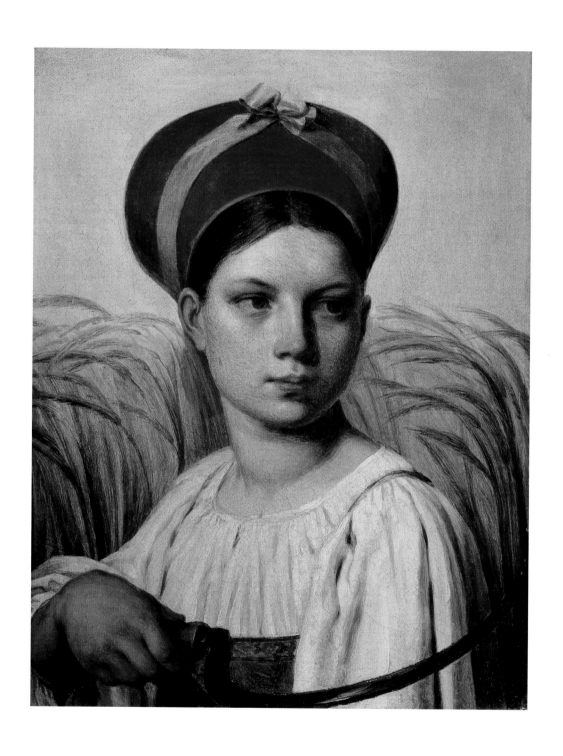

81. ALEXEI VENETSIANOV, *REAPER*,
1820S. OIL ON CANVAS, 30 X
24 CM. STATE RUSSIAN MUSEUM,
ST. PETERSBURG

82. (OPPOSITE) ALEXEI VENETSIANOV,
ON THE HARVEST: SUMMER, MID-1820S.
OIL ON CANVAS, 60 X 48.3 CM. THE
STATE TRETYAKOV GALLERY, MOSCOW

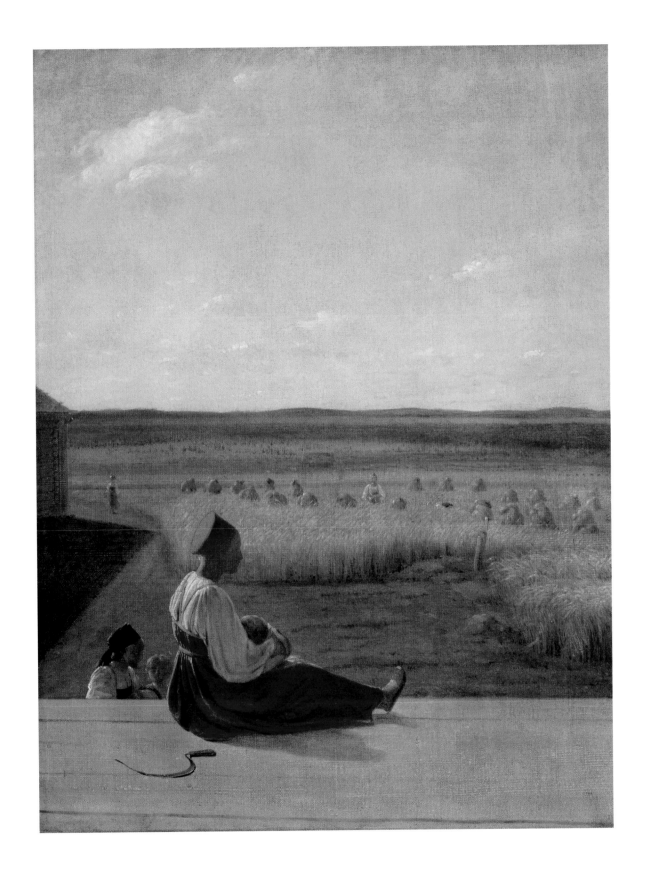

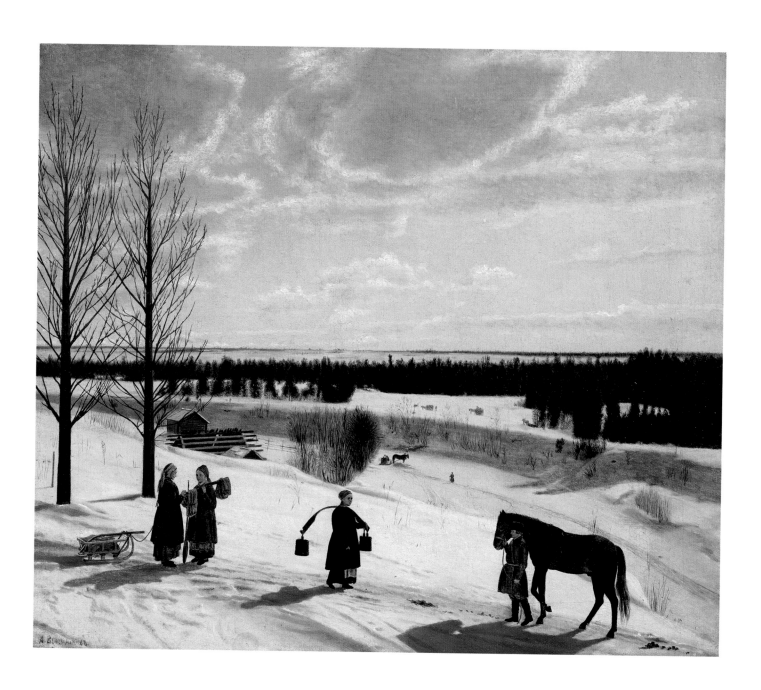

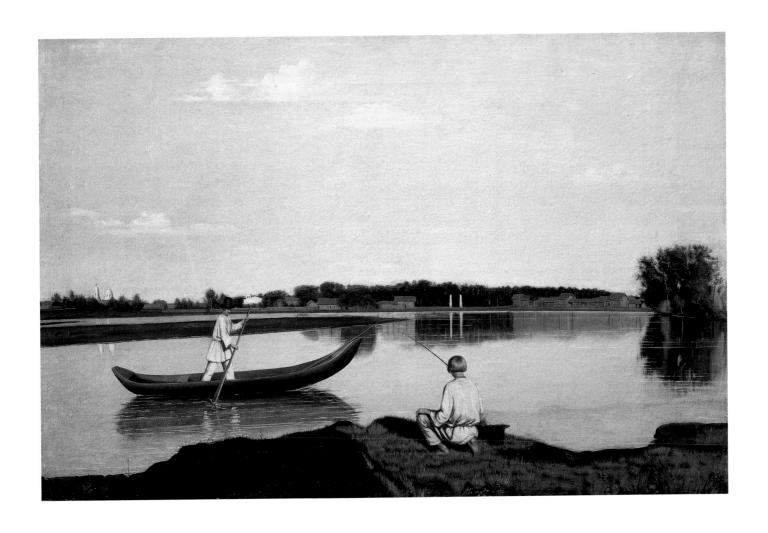

83. (OPPOSITE) NIKIFOR KRYLOV,
WINTER LANDSCAPE (RUSSIAN WINTER),
1827. OIL ON CANVAS, 54 X 63.5 CM.
STATE RUSSIAN MUSEUM,
ST. PETERSBURG

84. GRIGORII SOROKA, *FISHERMEN*,
SECOND HALF OF 1840S. OIL ON
CANVAS, 67 X 102 CM. STATE RUSSIAN
MUSEUM, ST. PETERSBURG

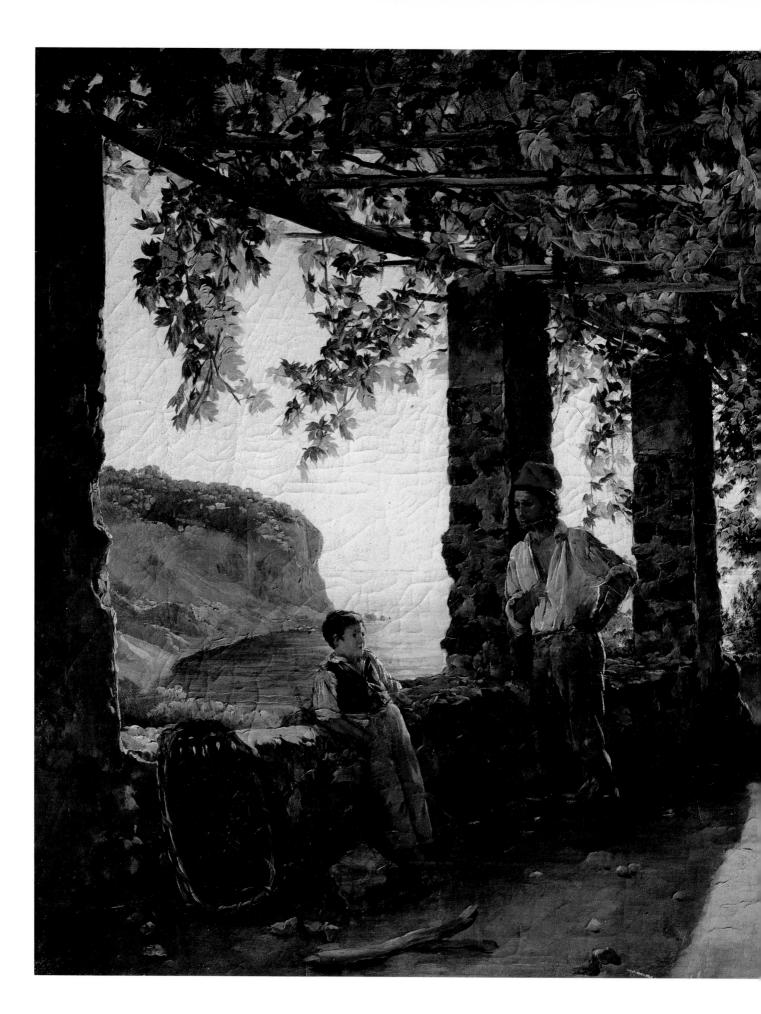

85. SILVESTER SHCHEDRIN, *TERRACE ON THE SEA COAST*, 1828. OIL ON CANVAS, 45.4 X 66.5 CM. THE STATE TRETYAKOV GALLERY, MOSCOW

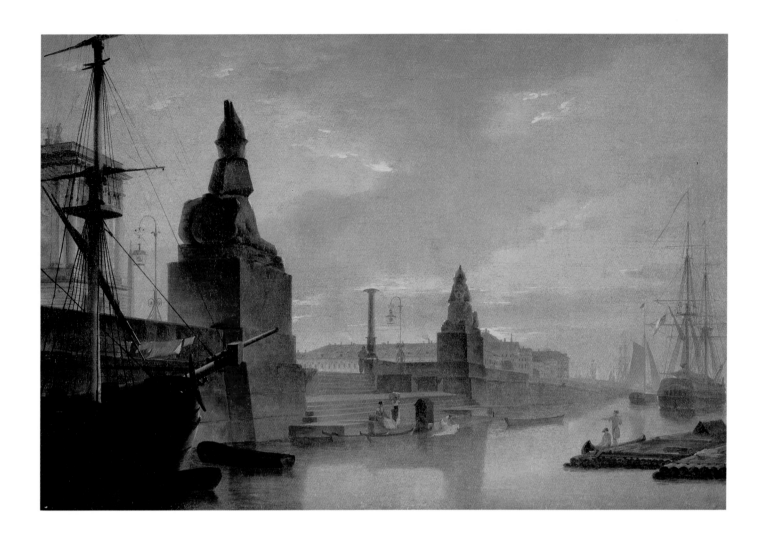

86. MAXIM VOROBIEV, *NEVA
EMBANKMENT NEAR THE ACADEMY OF
ARTS: VIEW OF THE WHARF WITH EGYPTIAN
SPHINXES IN THE DAYTIME,* 1835. OIL ON
CANVAS, 75 X 111 CM. STATE RUSSIAN
MUSEUM, ST. PETERSBURG

87. (OPPOSITE) SILVESTER SHCHEDRIN,
NEW ROME: ST. ANGEL'S CASTLE, 1824.
OIL ON CANVAS, 44.7 X 65.7 CM. THE
STATE TRETYAKOV GALLERY, MOSCOW

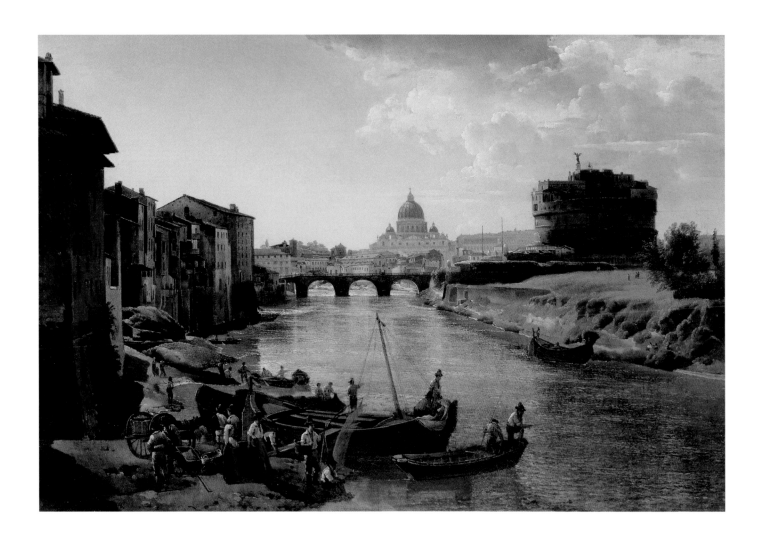

88. (LEFT) KARL BRIULLOV, *PORTRAIT OF THE WRITER ALEXANDER STRUGOVSHCHIKOV*, 1840. OIL ON CANVAS, 80 X 66.4 CM. THE STATE TRETYAKOV GALLERY, MOSCOW

89. (RIGHT) KARL BRIULLOV, *PORTRAIT OF ALEXEI TOLSTOY IN HIS YOUTH*, 1836. OIL ON CANVAS, 134 X 104 CM. STATE RUSSIAN MUSEUM, ST. PETERSBURG

90. (OPPOSITE) KARL BRIULLOV, *PORTRAIT OF COUNTESS JULIA SAMOILOVA*, 1832–34. OIL ON CANVAS, 269.2 X 200.7 CM. HILLWOOD MUSEUM AND GARDENS, WASHINGTON, D.C., BEQUEST OF MARJORIE MERRIWETHER POST, 1973

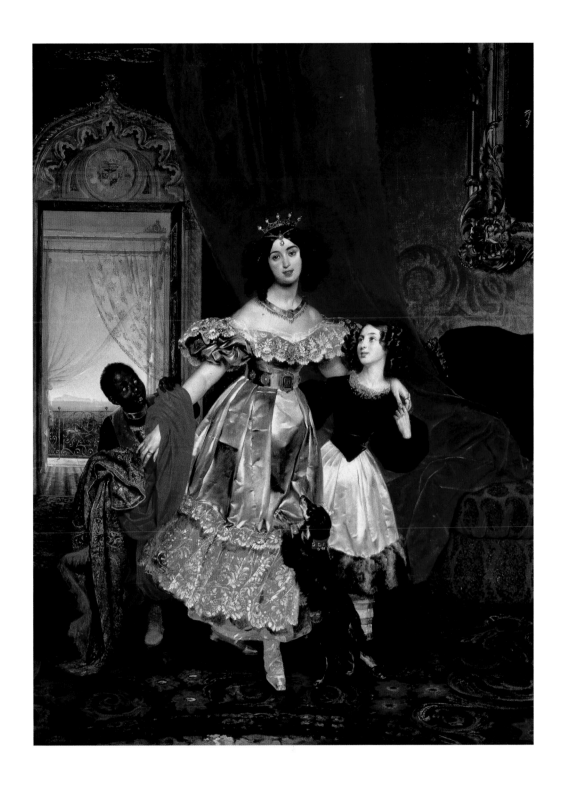

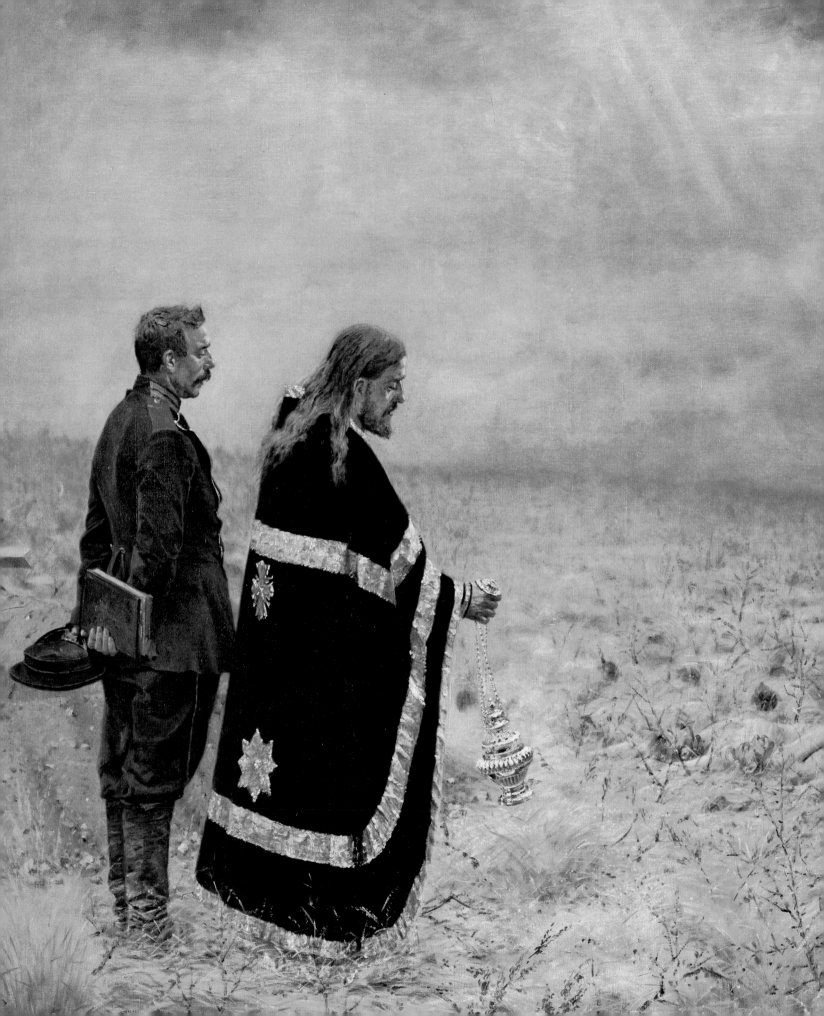

LATE 19TH CENTURY

RUSSIAN ART OF THE SECOND HALF OF THE 19TH CENTURY:
THE WANDERERS, PAVEL TRETYAKOV, AND HIS GALLERY
LIDIA IOVLEVA

In the mid-nineteenth century, the sociopolitical and economic life of Russia was await-
ing changes. The era of the glamorous but despotic emperor Nicholas I, grandson of
Catherine the Great, was approaching its end. Europe, which during the long years of
Nicholas's reign (1825–55) survived several revolutions, was going through the turbulent
development of new, capitalist economic relations, whereas Russia remained largely a
country of medieval feudal traditions. Serfdom, the slavery-like bondage of the country's
peasants, who made up the majority of its population, was a severe burden on Russia.
Serfdom chained people's initiative and hindered the economic development of the coun-
try. It was especially harmful to the moral condition of Russia's society, to its national
consciousness and self-respect. By the late 1850s, the necessity of abolishing serfdom was
clear. Russia's failure in the Crimean War (1853–56), which explicitly demonstrated the
nation's political and economic backwardness, further underscored this necessity. "My rela-
tion to my serfs is starting to cause me serious anxiety," the twenty-seven-year-old count
and neophyte author Leo Tolstoy wrote in his diary in April 1856.[1]

Russian society's interest in the fate of its peasants placed the peasant theme at the
center of attention throughout society, especially in the realms of literature, art, journal-
ism, and even music. This contributed to their general democratization. The democratiza-
tion of social life generally in the mid-nineteenth century caused a substantial flow of new
people to arrive in the universities and academies of the capital. They were children of
different *chins*, or ranks—merchants, petty bourgeoisie, small bureaucrats, clergy, peasants,
etc., who had had little or no access to education before. They came to be known as
raznochintsy, and they were the nucleus of a special stratum of Russian society, the intelli-
gentsia. To a large extent, the ideas and activities of the intelligentsia defined the unique-
ness of Russian culture in the late nineteenth century. The majority of Russian artists also
were *raznochintsy*. In the mid-nineteenth century, *raznochintsy* writers and revolutionary
democrats, such as Nikolai Dobroliubov (1836–61) and Nikolai Chernyshevsky (1828–89),
became acknowledged molders of public opinion. They, especially Chernyshevsky, called
almost openly for a peasant revolution for "land and liberty."

The Contemporary, a literary and social commentary journal, in which revolutionary
democrats actively participated, was widely distributed throughout Russia, promoting rev-
olutionary ideas. The public enthusiastically read works of poetry and prose by writers of
the "new wave": Nikolai Nekrasov, Mikhail Saltykov-Shchedrin, Tolstoy, Ivan Turgenev, and
many others who wrote truthfully about Russian reality. The general trend of Russian cul-
ture toward democratization and realism in the mid-1850s also received theoretical sup-
port. In April of 1855, *The Contemporary* published Chernyshevsky's abstract of his master's
thesis, "Aesthetic Relations of Art to Reality," which he had just defended at St. Petersburg
University. In it, the critic explicitly formulated the main principles of the new aesthetics:

The Wanderers, 1881, from left to right, standing: Grigorii Myasoedov, Konstantin Savitsky, Vasily Polenov, Efim Volkov, Vasily Surikov, Ivan Shishkin, Nikolai Yaroshenko, Karl Briullov, and (?) Ivashov; and sitting: Sergei Ammosov, Alexander Kiselev, Nikolai Nevrev, Vladimir Makovsky, Alexander Litovchenko, Illarion Pryanishnikov, Viktor Vasnetsov, Ivan Kramskoy, Ilya Repin, Nikolai Makovsky, and Alexander Beggrov

The Vasily Perov room in the Tretyakov Gallery, Moscow, 1899

"beauty is life" and "that subject is beautiful that in itself shows life or reminds us of it." However, a mere appeal to realism was not enough for Chernyshevsky. According to him, the artist has to have an active civic opinion and has to condemn reality and its dark sides and injustices. The poet Nekrasov's dictum, "You may not be a poet, but you must be a citizen," became a slogan of the entire Russian intelligentsia of the late nineteenth century.

Serfdom was abolished by decree of Alexander II, the Tsar Liberator (reign 1855–81), on February 19, 1861. Though peasants got their "freedom," they did not get land, and so the "cursed" peasant question did not lose its relevance for the Russian public. "The Muzhik [the peasant] is a judge now," wrote Ilya Repin already in 1872, at the time he was working on his painting *Barge Haulers on the Volga* (1870–73, plate 104), "and therefore one has to reflect his interests."[2] However, the peasant reform of Alexander II only increased the desire for change in Russian society, as did his reforms regarding the *zemstvo* (members of the local government), the judiciary, and the military.

In the artistic life of Russia in the mid-nineteenth century, the St. Petersburg Academy of Arts reigned supreme. New theories and new artistic ideas were strictly forbidden at the academy. Young artists, however, irretrievably gravitated to modernity. The conflict was all but inevitable.

In the fall of 1863 fourteen young artists, graduates of the academy and contestants for the gold medal, appealed to the board of the academy, asking that each of them be allowed free choice for their competition (or "diploma") painting. In this request the academy saw an expression of the hateful "revolutionary" spirit and a rebellion against the basis of the academic system. The "rebels" were refused their request. However, the young artists, led by Ivan Kramskoy, did not obey the authorities; they turned down the competition itself and the benefits it could offer. They withdrew from the academy and founded the St. Petersburg Artel of Artists, which became the first independent creative association of artists in the history of Russian art. The Artel existed for only a brief time, until the 1870s, and did not produce any great creative achievements. However, its significance for the liberation of art from bureaucratic restrictions, as well as the significance of the "revolt of the fourteen," was huge. As the next step on this path, in the late 1860s, early 1870s, these artists formed the Society for Traveling Art Exhibitions and became known as *Peredvizhniki*—or "Wanderers."

The new trends manifested themselves not only in the artistic life of St. Petersburg but also of Moscow. The artistic center of that city was, beginning in the 1840s, the Moscow School of Painting, Sculpture, and Architecture, which from its inception differed from the St. Petersburg Academy of Arts in its much more democratic teaching and admission policy. Moscow artists, starting with Pavel Fedotov, were most interested in authentic Russian reality. The new era enhanced the critical tone of their work. Not incidentally, it was in Moscow that the art of Vasily Perov, the most important representative of the School of Critical Realism, was developed. In his small and modest paintings, the life of the Russian people was represented with sincere empathy for the common man (or "small man," as the Russians socially defined him). This allows us to place Perov in the ranks of the mourners for all the "humil-iated and insulted," along with Fedor Dostoevsky and Nekrasov. A simple scene of folk life—a poor peasant's funeral (*Service for the Dead*, 1865, plate 101) or a peasant woman's

anguished wait for a husband drinking in a tavern at the city gates (*The Last Tavern at the City Gates*, 1868, plate 105)—was elevated by the artist to the level of true human drama. "Indignation against evil," to use Kramskoy's words, was central to the emotional tone of Perov's creativity. In 1872 Perov was commissioned by Pavel Tretyakov, an already fairly well-known Moscow collector, to paint a portrait of Dostoevsky. This became not only the best depiction of the famous writer, but also one of the best works of Russian portraiture of the nineteenth century.[3]

Toward the end of the 1860s, Russian realism grew strong enough for the artists to feel the need for a broader association than that of the St. Petersburg Artel. In the fall of 1869 six Muscovites (Perov as well as Lev Kamenev, Grigorii Myasoedov, Alexsei Savrasov, Vladimir Shervud, and Illarion Pryanishnikov) wrote a letter to St. Petersburg artists suggesting that together they should discuss the idea of creating a joint association. As a basis, they suggested organizing traveling exhibitions with sales of participants' works and allocating part of the profit for a special exhibition fund and a fund for mutual assistance. However, it became clear from the start that this distribution of profits from exhibitions was only one side of the coin. The other side, and more important for many, was the organization's manifest antiacademy orientation. This was very much in the spirit of the time. Exhibitions that were independent from the Academy of Arts moved around the country with a clearly propagandistic purpose. The new artistic rules and demands did not resemble those of the recent past.

St. Petersburg artists supported, though not unanimously, the Muscovites' suggestion. Kramskoy, the leader of the Artel, and Vladimir Stasov, a popular art critic, spoke for unification. Other artists followed them. On November 2, 1870, the statute of the Society for Traveling Art Exhibitions (the name of the new organization) was signed in the Ministry of the Interior. And in November 1871 in St. Petersburg (and subsequently in April 1872 in Moscow) the first exhibition was held and was warmly received by the public. After its inception during the late 1860s and early 1870s, the society existed for over fifty years.[4] Neither Russia nor Europe, before or since, has had a creative organization of artists of such longevity. However, the years of the flourishing of the society and of the Wanderers as an artistic phenomenon were in the last quarter of the nineteenth century. It was precisely then that the society enjoyed its highest popularity with artists and had the greatest influence in society at large. Up to the late 1890s the society united under its ranks practically all of the most gifted and most progressive artists of different generations—both old men and youths.

The slogan of the Wanderers was realism, the "truth of life," as that era called it, the truth in everything one sees and one depicts. "I don't need either rich nature, or magnificent composition and lighting effects and miracles of any kind. Let it be a dirty puddle, if only it has the truth, if it has poetry; and poetry can be contained in anything: it's the artist's business [to find it]," wrote Tretyakov, who fully shared the main ideals of the Wanderers, as early as 1861.[5] The "truth and poetry" of national folk life, national history, and Russian nature was preferred to everything else. The Wanderers went to Western Europe to study and perfect their painting technique, but they lived and worked in Russia.

In their art the Wanderers recreated an impressive panorama of Russian life from those years. The most widespread genre in their work was paintings of everyday life. These

*The Vasily Surikov room in the State
Tretyakov Gallery, Moscow, 1990s*

paintings showed a much greater development of the subject, more monumental composition, and more natural light than the small paintings by the artists of the 1860s (such as Perov's). Especially impressive was the social diversity of folk life they depicted. They ranged from the depiction of the work and everyday life of the postreform peasantry (Repin's *Barge Haulers on the Volga*)—which was becoming disenfranchised under the influence of new capitalist economic relations (*On the Boulevard*, 1886–87, by Vladimir Makovsky, plate 108), but still retained the poetic beauty of the patriarchal way of life (*A Village Sorcerer at a Peasant Wedding*, 1874, by Vasily Maximov)—to ironic reflections on the slipping away of the era of the old gentry (*Everything Is in the Past*, 1889, by Maximov, plate 109), and the circles and parties with revolutionary singing and recitals rapidly spreading among Russian intelligentsia (*A Party*, 1875–97, by Makovsky, plate 107). Even the traditional battle painting underwent radical changes under the influence of the Wanderers: the paintings by the greatest Russian battle painter Vasily Vereshchagin can be called battle paintings only so much as they are dedicated to military events. The main theme of Vereshchagin's work was the fate of the Russian soldier (a peasant by social background) who was, by the force of circumstances, thrown into the meat grinder of war, which was perceived by the artist as "universal evil," as a barbarity and a threat to civilization (*Mortally Wounded*, 1873, plate 129; and *Defeated: Service for the Dead*, 1878–79, plate 128).

The Wanderers introduced serious changes into history painting, the sacrosanct genre of the academic art of the past. They established the complete supremacy of national topics in history painting. Exceptions were made only for subjects from the New Testament, since they offered a wealth of material for moralizing on the meaning of life and the fate of man.

One can find the most important interpretation of national history among the Wanderers in the work of Vasily Surikov. His best paintings (for example, *The Morning of the Execution of the Streltsy*, 1881; and *Boyarynia Morozova*, 1887, page 10) are dedicated to events of the seventeenth century in Russia—a time of revolts and popular insurrections and an era of radical rupture by Peter the Great of age-old ways of life and ancient traditions. [6] Surikov liked to depict strong and interesting personalities, but the Russian people—suffering, protesting, or silent—were always the main characters of his epic paintings. He loved the beauty of folk costumes and national holidays (*Capture of a Snow Fortress*, 1891, plate 122) and the expressivity of peasant faces, especially those of women.

The most consistent painter on subjects from the New Testament among the Wanderers was Nikolai Ge. As early as the 1860s, the Russian public was struck by the veracity of his treatment of the Last Supper (see plate 134; larger, main version is in the State Russian Museum). In the 1880s and 1890s, when the artist became engaged with Tolstoy's moral philosophy, he started creating his "Gospel in colors" (just as Tolstoy created his "Gospel for the People"). However, unlike his famous friend and teacher, Ge promoted not so much the idea of "refraining from opposing evil by violence," but rather told the tale of the eternal confrontation between good and evil and between treason and repentance, which are inherent in human history and can be found in the stories of the New Testament (*Conscience: Judas*, 1891, plate 136).

In portraits, just as in genre paintings, the Wanderers sought to depict the panoramic scope of life. They created a large gallery of portraits, ranging from outstanding representatives of Russian culture—writers, poets, artists, scholars, etc. (*Portrait of the Writer Fedor Dostoevsky*, 1872, by Perov, plate 111; *Portrait of the Writer Leo Tolstoy*, 1884, by Ge, plate 110; and *Portrait of the Painter Ivan Shishkin*, 1873, by Kramskoy, plate 115)—to peasants (*Forester*, 1874, by Kramskoy, plate 118) and rebellious young *raznochintsy* (*Female Student*, 1880, by Nikolai Yaroshenko, plate 120).

One of the most important engagements of the Wanderers was with landscape painting. As in their history paintings, the supremacy of the national theme was central to their endeavors. The Wanderers' landscapes "recognized," as it were, Russian nature in its close relationship to people's lives. Specific emotional proclivities and a quest for expressive means by individual artists manifested themselves most fully in landscape paintings.[7] Two main approaches can clearly be seen in the Wanderers' landscape painting. The first was a lyrical poetic approach, represented by Fedor Vasiliev (*Wet Meadow*, 1872, plate 114), Savrasov,[8] and the *plein air* artist close to both, Vasily Polenov (*The Moscow Courtyard*, 1902, plate 131). The other approach gravitated to greater objectivization and monumentalization of the image in the landscape; this was the approach of Ivan Shishkin (*Rye*, 1878, plate 116; and *The Oaks of Mordvinovo*, 1891, plate 117). The work of Arkhip Kuindzhi (*After the Rain*, 1879; *Patches of Moonlight*, 1898–1908; and *At Night*, 1905–08; plates 125–27), marked with strong romantic tonalities, stands on its own, somewhat apart from everyone else's.

The apogee of the development of Russian realistic landscape painting was the work of Isaak Levitan. The life of nature in his paintings is represented in its insoluble link to the life and feelings of man and of the artist. Levitan's landscapes (*Evening Bells*, 1892, plate 130; *Spring: High Water*, 1897, plate 133; and *Twilight: Haystacks*, 1899, plate 132) are in equal measure paintings of nature and the expression of the sophisticated emotional life of man. A hidden psychological subtext is always present, and, in this sense, Levitan's work is very close to the stylistics of Anton Chekhov, who was a close personal friend of the artist. All this notwithstanding, Levitan's work, especially in the 1890s, heralds the arrival of a new stage in the development of Russian realism, in which the problems of art proper started edging out social and political content.

In the late 1880s and early 1890s, the Society for Traveling Art Exhibitions underwent a generational change. New, talented young artists arrived on the art scene, among them Abram Arkhipov, Konstantin Korovin, Mikhail Nesterov, Andrei Ryabushkin, and Valentin Serov. Levitan and Mikhail Vrubel also were part of this new generation. All of them (or almost all) were students of the old Wanderers and, in general, remained loyal to the legacy of realistic Russian art. However, their priorities shifted. The young artists were becoming increasingly interested in the problems of conveying color, light, and air; that is, in *plein air* and Impressionism (Korovin, Levitan, Serov, et al.) and, a little bit later, in Decorativism (Ryabushkin) and Symbolism (Nesterov and Vrubel). Russia and Russian art came to the threshold of a new era and to the next "change of landmarks." Though the Society for Traveling Art Exhibitions continued to exist, actively organizing exhibitions and attracting the public and new artists, its pinnacle was now in the past.

Pavel Tretyakov and family, 1884, from left to right, standing: daughters Alexandra, Vera, and Liubov; and sittting: Tretyakov, sons Vanya and Misha, wife Vera, daughter Maria, and relative M. Tretyakova

New people and new artistic societies appeared on the horizon. Owing to the efforts of a group of the young artists and critics—Leon Bakst, Alexander Benois, Sergei Diaghilev, Konstantin Somov, among others—a new literary and artistic journal, *The World of Art*, was founded in 1898 in St. Petersburg. An eponymous art society formed around the journal. To a large extent, the aesthetic postulates of this group were based on the rejection of the social realism of the Wanderers.

Coincidentally, the appearance of *The World of Art* took place at the same time as the death of the man who, in a way, was the symbol of the preceding era—Tretyakov, the creator of Russia's first public museum of Russian art. Tretyakov did an enormous favor to Russian realism. As Benois wrote, "Without his help Russian painting would have not been able to set out on its long and free journey, because Tretyakov was the only one (or practically the only one) who supported everything that was new, fresh, and worthwhile in Russian art."[9]

So who was Pavel Tretyakov? Where did he come from? And why did he alone, among so many collectors of the nineteenth century, succeed in realizing an idea he had conceived early in his youth: the creation of Russia's first publicly accessible museum of national art? Born in Moscow in 1832, Tretyakov was the son of a merchant. From his early youth he had to take part in the trade business of his father and grandfather. When he died in 1898, he was Moscow's "most respected resident" and one of its wealthiest,[10] having greatly increased the capital of his ancestors. However, as a true son of his time, Tretyakov naturally and profoundly absorbed the lofty democratic ideals of the generation of the 1860s, justly considering himself part of it. He said at the end of his life: "My idea from the very early years was to increase my wealth in order to return to society (the people) what I gained from society, in the form of some useful institutions. This idea stayed with me throughout my entire life."[11]

Tretyakov formulated his main goal in life early on: "to lay the foundation for a public repository for fine arts, accessible to all, which would be useful to many and pleasurable to everyone."[12] Thereafter, Tretyakov pursued his goal with the consistency and purposefulness that were part of his nature. His contemporaries were amazed at his acute natural intellect and inborn taste. He had no formal education (he was home-schooled and his instruction was mostly business oriented), but he possessed a broad knowledge of history, literature, painting, and theater. In 1902 Benois wrote: "Tretyakov was, by his nature and knowledge, a scholar."[13]

In his desire to create a museum of national art, Tretyakov was not alone among the art collectors of his time. The collections of Fedor Pryanishnikov in St. Petersburg and Alexei Khludov, Vasily Kokarev, Kozma Soldatenkov, and others in Moscow could have laid the foundation of such a museum, but all of them fell apart when their owners came to financial ruin or died. Their collecting lacked methodology—a "system" as it were—which only Tretyakov succeeded in developing. He guessed correctly that Russian art was developing toward realism, and he supported it with all means available to him. The range of Tretyakov's collecting was enormous. In the 1870s and 1880s dozens, if not hundreds of new works (such as *The Turkestan* series, 1871–72, by Vereshchagin) were incorporated into his gallery.

Tretyakov was strict and practical in his business deals, but when it was necessary, he would agree to bear very considerable expenses. Likewise, his taste in collecting was broad and inclusive and did not depend on a collector's whims. His main criteria were the high quality of the work and its historical significance. Tretyakov bought paintings despite critics' opinions and the censors' displeasure; he bought even those paintings which did not completely correspond to his vision and opinion, so long as they conformed to the spirit of the time. He even bought some paintings against respected and authoritative opinions, such as those of Tolstoy. Tretyakov clearly understood that the museum he was creating should not so much correspond to his personal tastes and inclinations, or anyone else's, as it should objectively reflect historical development. This was the essence of his "system."

In 1892 Tretyakov bequeathed his collection, which consisted of nearly two thousand works of painting, graphic art, and sculpture, to the city of Moscow and therefore to the Russian people as a whole.[14] By then, it was a fully formed museum, truly accessible to the public, with an established schedule and rules and a building built specifically to hold its collection—in Lavrushinsky Lane, where the State Tretyakov Gallery is still situated. The Moscow City Duma became the official owner, but Tretyakov remained the gallery's trustee for life and continued his indefatigable work to increase the collection and take care of the museum he had made such an effort to create. After Tretyakov died in 1898, a new era began—both in Russian art and in the life of the Tretyakov Gallery.

Translated from the Russian by Julia Trubikhina.

1. Leo Tolstoy, *Sobranie sochinenii v 22 tomakh*, Vol. 2: *Povesti i rasskazy 1852–1856* (Moscow: Khudozhestvennaya Literatura, 1972), p. 401.

2. Ilya Repin and V. V. Stasov, *Perepiska*, Vol. 1 (Moscow-Leningrad: Iskusstvo, 1948–50), p. 37.

3. Due to its value, *Portrait of the Writer Fedor Dostoevsky* (1872) by Perov is seldom loaned for any exhibitions. However, owing to the unique circumstances of the exhibition RUSSIA! at the Guggenheim Museum, this painting appears in the United States for the first time.

4. The last exhibition of the Society for Traveling Art Exhibitions was held in Moscow in 1922.

5. See a letter of Pavel Tretyakov to the landscape painter A. Goravsky, Otdel rukopisei Gosudarstvennoi Tretiakovskoi Galerei (Manuscript Department of the State Tretyakov Gallery), Fond 1, edinitsa khraneniia 4751.

6. History paintings by Surikov are, as a rule, very large in size, which usually creates difficulties in their transportation and therefore their inclusion in exhibitions.

7. As early as 1874, Ivan Kramskoy wrote to Ilya Repin in Paris, who made note of the Impressionists' painting: "We absolutely need to look for light, colors, and air, but the question is how this can be done in such a way that the most precious of all treasures—that of the artist's heart—is not lost in the process." Kramskoy to Repin, February 23, 1874, in Kramskoy, *Pisma. Stati*, vol. 1 (Moscow: Iskusstvo, 1965), p. 233.

8. Unfortunately, no works by Alexsei Savrasov could be presented in the exhibition RUSSIA! Its timing coincided with the opening of the 175th anniversary exhibitions of Savrasov's paintings in the State Tretyakov Gallery, Moscow, and State Russian Museum, St. Petersburg.

9. Alexander Benois, *Istoriia russkoi zhivopisi v XIX veke* (Moscow: Pereizdanie, 1998), p. 228.

10. There are still several nineteenth-century residential buildings that once belonged to Pavel Tretyakov. In Kostroma, a weaving factory founded by Tretyakov, is still active and is now called Kostroma Flax Manufacture.

11. See the letter of Pavel Tretyakov to his daughter, A. Botkina, of March 24, 1893. Otdel rukopisei Gosudarstvennoi Tretiakovskoi Galerei (Manuscript Department of the State Tretyakov Gallery), Fond 48, edinitsa khraneniia 813, l. 2 (verso).

12. From the first letter of Pavel Tretyakov's Will of May 17 (29), 1860. Otdel rukopisei Gosudarstvennoi Tretiakovskoi Galerei (Manuscript Department of the State Tretyakov Gallery), Fond 1, edinitsa khraneniia 4750.

13. Benois, p. 343.

14. Along with his collection of Russian art, Pavel Tretyakov bequeathed to the city of Moscow the collection of his younger brother, Sergei Tretyakov, who had died shortly before. Sergei Tretyakov had collected mostly works by European artists of the mid- and late nineteenth century. These works are now in the Pushkin State Museum of Fine Arts; some are also in the State Hermitage Museum and other museums.

FROM REALISM TO SYMBOLISM, 1860–1900
ROBERT ROSENBLUM

As the nineteenth century drew to a close, strange shadows began to pervade the look and feel of art. In both Eastern and Western Europe, as well as on the other side of the Atlantic, the impulse to explore territories that had been invisible to the majority of mid-nineteenth century artists—who wanted to paint only what the eye could see— kept growing. Slowly, the visible, material world began to fade from sight in overt and covert ways. Portraits, instead of securing the sitters' places in professional or family communities, started to probe more private feelings. Landscapes, rather than recording welcoming springtime grass and trees dappled with cheerful sunlight, gravitated toward a no-man's-land, depicting mysterious, unpopulated terrains remote from both urban and rural areas. Even still lifes, whether of food or flowers, began to transcend their domestic confines and disclose unexpected mysteries. As for narrative, the facts of contemporary life, flourishing in countless genre paintings of the pleasures and tribulations of workers and families, could be replaced by efforts to see, behind closed eyes, imaginative and spiritual worlds that might re-create the supernatural events of the Bible or the long-buried past, whether of historical fact or legend. In the traditional accounts of Western art, this evolution is usually defined by two "isms," Realism and Symbolism.

The first of these "isms" embraced the visible, empirical world (as Gustave Courbet said, "Show me an angel and I will paint it."). The second drifted into a world of inner experience, whether of private emotions or dreamlike fantasies, an internal realm that could be expressed (as was the case with an earlier "ism," Romanticism) in the most diverse spectrum of styles and imagery, as reflected throughout the art of the later nineteenth century in the United States, Denmark, Italy, and Russia.

These shifts of direction, from the visible to the invisible, from fact to feeling, can be discerned, to begin with, in the rich anthology offered here of some of Russia's late-nineteenth-century cultural heroes. In many of these portraits, the sitter is presented in a conventional format intended to declare his public stature. In Ivan Kramskoy's portrait of Ivan Shishkin (plate 115), painted in 1873, the heyday of Impressionism, the subject, an artist famous for cheerful, outdoor landscape views, stands posed, in a proud and proprietary way, against the kind of verdant, sun-shot, burgeoning nature associated with his professional reputation. Portraits of patrons of the arts from this period also display a public persona. Konstantin Korovin's 1903 rendering of the internationally renowned collector Ivan Morozov (plate 152)—who precociously acquired great Matisses for his Moscow residence—presents a man of wealth and elegance, formally dressed in evening attire, a white flower in his lapel echoing his white tie and shirt. Of a similar ilk is Mikhail Vrubel's por-trait of another cultural tsar, Savva Mamontov (1897, plate 138), a rich industrialist whose lavish patronage of the arts, especially the opera, earned him the honor of being called "a Russian Medici." Here, in fact, he seems to have usurped some imperial throne. Again, like Morozov, in formal attire, he radiates from on high an aura of official power, wealth, and

authority as he looks far above and beyond the earthbound viewer. But in Ilya Repin's 1883 portrait of another great patron of the arts, the merchant and textile manufacturer Pavel Tretyakov (plate 112), the mood has changed from public to private. Although the many gilt-framed canvases on the two walls behind him identify the philanthropic legacy of the sitter (who in 1856 founded the famous historical gallery of Russian art dating from the Middle Ages to the present, and who, in 1892, always thinking of the public's education, would give his collection to the city of Moscow), he himself seems lost in thought, one arm enclosing the other, his eyes turned inward, away from the spectator, as if we had caught him unaware.

This sense of our intruding into a closed, personal realm is further intensified in the portraits of three major authors of the period. In Repin's 1884 record of the short-story writer Vsevolod Mikhailovich Garshin (plate 113), we feel as if we had stumbled by accident into the writer's study, where we see, in a cropped view, a disorderly pile of papers and books on a humble wooden desk, and where we are suddenly confronted by the sitter's troubled gaze, as if he had caught us looking at his private diaries. In Nikolai Ge's portrait of the fifty-six-year-old Leo Tolstoy (1884, plate 110), we are again intruders; but this time we are unable to disturb the novelist's fierce concentration on transmitting his thoughts to pen and paper. Dark shadows engulf his body, with light striking only his forehead and manuscripts, making us feel that we are witnessing in silence a genius at work. It is a mood of loneliness and solemnity that, in fact, has many parallels outside Russian art, most particularly in the somber, lonely portraits by the American artist Thomas Eakins, Ge's contemporary. But far more surprising is Vasily Perov's 1872 portrait of the fifty-one-year-old Fedor Dostoevsky (plate 111), in which there is no clue at all to the sitter's public identity as, among other things, the author of *Crime and Punishment* (1866). What we see could almost be the record of a desolate, middle-aged man, totally shrouded in darkness, hands clasped as if to contain for the moment what we intuit as a frightening inner turbulence. Here, the sitter's public role as a great novelist is totally obscured by the disclosure of his loneliness and anxiety, a sense of gloom inspired by the details of his grim biography—the murder of his father, his years in a Siberian prison, and his ongoing battle with epilepsy.

Similar directions can be traced in the group of landscape paintings here. Shishkin's outdoor scenes are as accessible and comforting as a weekend in the country, the complements to his Impressionist contemporaries' constant coming and going to the tonic nature that lay beyond the Parisian suburbs. The sun is always shining here, whether over a gently windblown field of rye in *Rye* (1878, plate 116) or the luxurious blossoming of venerable oak trees that fill the sky with their health and vitality in *The Oaks of Mordvinovo* (1891, plate 117). But in the landscapes of Isaak Levitan, the mood changes. In *Evening Bells* (1892, plate 130) and *A Summer Evening* (1900), a crepuscular light prevails, turning the ordinary into something more evocative, in which light and dark, reality and reflection, begin to merge in a magical twilight zone. And in *Twilight: Haystacks* (1899, plate 132), Levitan even offers a parallel to Claude Monet's own serial paintings of haystacks (or, more correctly, grainstacks) from the same decade, re-creating these shaggy conical structures, the crude architecture of an agricultural landscape, dissolving with the deepening

Thomas Eakins, The Writing Master: Portrait of the Artist's Father, 1882. Oil on canvas, 76.2 x 87 cm. The Metropolitan Museum of Art, New York, John Stewart Kennedy Fund, 1917

blue light of sunset into phantom silhouettes. This current becomes far stranger in the landscapes of Arkhip Kuindzhi. His *After the Rain* (1879, plate 125) locates us in what might be the setting for a tale of the supernatural. The lone, diminutive building, crowning a distant hill, is soon to be obscured totally by sky invaded by the most ominous dark storm clouds, the equivalent of an apocalyptic vision. In *At Night* (1905–08, plate 127), we are transported to another extreme, where we stand mesmerized by the infinite expanse of a low horizon, interrupted only by the distant, frail silhouette of a horse, almost a preview of one of Salvador Dalí's mirages. Perhaps even more unsettling and spectacular is *Patches of Moonlight* (1898–1908, plate 126). Here, like a writer of science fiction, Kuindzhi immerses us in another surreal fantasy of dark billowing clouds and glimpses of milky moonlight illuminating the no-man's-land of some Arctic snowdrift. Unique as this seems, there are, in fact, parallels to this theme outside Russian painting. In Norway, Edvard Munch often painted unpolluted, snow-covered forests under moonlight, a primordial nature untouched by human presences. And in the United States, Winslow Homer, also at the end of the century, recorded the uninhabited, savage extremities of the North American continent on the rocky coast of Maine, often drenched in moonlight and constantly battered by the turbulent, oceanic waters.

If the most mysterious of these landscapes were inhabited, those who dwelled there would be creatures alien to the contemporary world, fit only for an environment that seemed to be perched on the threshold of something unreal or supernatural, perhaps an ancient legend, perhaps a Christian narrative, perhaps the domain of the afterlife. Indeed, in the landscapes of Kuindzhi we often feel that we are on the brink of some spiritual world that transcends the one we know, facing perhaps the unknown voyage from life to death. Such a scenario is, in fact, presented almost literally in two paintings that almost seem to cross that barrier. Perov's *Service for the Dead* (1865, plate 101) still belongs to a tradition of genre painting, with its vignette of peasant life; but like his *The Last Tavern by the City Gate* (1868, plate 105), not to mention his portrait of Dostoevsky, the mood is dark, desperate, and lugubrious. Here we watch the pathetic, bare-boned funerary homage of the rural poor. From behind, we follow an old work horse and a widow dragging, across a bleak winter landscape, a sled bearing a coffin, presumably that of her husband, along with two grieving children. They head toward an empty horizon, on the brink of a darkening sky, as if, metaphorically, this were the border from which there is no return.

This transformation of a landscape into death's domain becomes far more literal and gruesome in *Defeated: Service for the Dead* (1878–79, plate 128), by Vasily Vereshchagin. Vereshchagin was a uniquely eccentric artist who, having followed the invading Russian armies into both the Turkestan wars (1867–70) and the Russo-Turkish War (1877–78), became a passionate antiwar crusader. Using the hyperrealist vocabulary that he (like his fellow student Eakins) had learned in Paris from the Orientalist Jean-Leon Gérôme, he documented in excruciating detail the atrocities perpetrated on both the Eastern and Western battlefields. His painted evangelical propaganda, often censored as politically subversive both inside and outside Russia, moves from journalistic fact to supernatural fictions. In *Defeated: Service for the Dead*, a horrifying memento of the Russo-Turkish War, he translates

Claude Monet, Stack of Wheat (Snow Effect, Overcast Day), 1890–91. Oil on canvas, 66 x 93 cm. The Art Institute of Chicago, Mr. and Mrs. Martin A. Ryerson Collection, 1933

into a strange allegory the kind of pathos-ridden genre painting represented by Perov's humble interpretation of the passage from life to death. In a perfect union of church and state, we see on the left a military officer in contemporary uniform and a Christ-like priest who, in a mass funeral, blesses the countless Russian soldiers who died on the battlefield. Like updated versions of Dante and Virgil, wandering through hell, they seem to confront a scene from a modern inferno, an infinitely vast cemetery of corpses whose bodies have already merged with the earth but whose still fleshy heads, in regimented rows, evoke the lost souls afloat in a Christian Last Judgment. Here, we have clearly crossed the threshold between life and death, between reportorial fact and imaginative fiction. Looking at this contemporary interpretation of a new vision of the afterlife, we may not be surprised to find that many of Vereshchagin's contemporaries would be seeking again some kind of viable religious art, an art that could resurrect, now with new reaches of the imagination, the moribund traditions of Christian iconography.

The most conspicuous of these efforts to revive biblical narratives that, through personal more than communal piety, might again compel belief from spectators whose faith had so often been challenged by anticlerical revolutions, by Charles Darwin and Karl Marx, were the intensely individual readings of Christianity by Ge. This artist had painted his friend Tolstoy's portrait and shared with the writer a passionate belief that the Gospels might be rejuvenated through new, more subjective interpretations of their mysteries and meanings. In this respect, Ge distinguishes himself from Alexander Ivanov, who, in his religious paintings of the first half of the century, tried to perpetuate traditions dating back to Raphael. Ge also rejects the secularized religious art of many of his contemporaries. For example, Alexei Korzukhin in his painting *Before the Confession* (1877, plate 103) and Mikhail Nesterov in his *Taking of the Veil* (1898, plate 146) observe (like Paul Gauguin or would-be anthropologists) the rituals of the church and its pious followers as they were still practiced in a nineteenth-century world rather than attempting to reinterpret the heritage of biblical narratives. By comparison, Ge's *The Last Supper* (1866, plate 134) is an astonishingly original invention that seems to ignore the venerable medieval and Renaissance depictions of this dramatic event in favor of a wholly new staging of the narrative. Instead of the usual frontal symmetry of the scene, and the understated revelation of Judas's treachery, we are shown an oblique view of a reclining Christ and the stunned confusion of his disciples in the eerie setting of a darkened room. It is illuminated by a blue night sky, just visible through two small windows, and a raking beam of theatrical light that hits the table and casts ominous shadows across the figures. Most unexpected is the singling out of Judas, on the right, who separates himself from the group and who, like some Satanic apparition, casts a huge, dark shadow on the back wall. The spooky, supernatural effect lies somewhere between the traditions of the eighteenth-century Gothic novel and the twentieth-century horror film.

Later in his career, Ge distilled this narrative to an even more haunting image, *Conscience: Judas* (1891, plate 136), in which Judas, lit by the moon on an isolated darkening road, stands totally alone, his back to us, his face concealed, demanding that the spectator intuit his tormented guilt. A three-dimensional counterpart, in terms of a lone figure from a biblical narrative who compels psychological empathy into an invisible domain of

Henry Ossawa Tanner, The
Annunciation, 1898. Oil on
canvas, 144.8 x 181.6 cm.
Philadelphia Museum of Art,
Purchased with the W. P. Wilstach
Fund, 1899

complex emotions, is Marc Antokolsky's life-size bronze *Ecce Homo: Christ before the People* (after 1892, plate 135). The traditional depiction of the subject showed the assembled figures at the court and the presentation of the white robe for Christ to wear, a symbol of lunacy that would intensify his humiliation. Here, by contrast, we are obliged to project what we know of the story into this humble but noble figure who stands on the fragment of steps loosely evocative of the conventional imagery of the steps that ascend to Herod's throne. As in so many portraits of the period, we must turn from public narrative to the exploration of inward feelings.

Again, Russian art of the late nineteenth century should be seen in the context of the work of an international community of artists. Ge, for example, has strong affinities with the work of Henry Ossawa Tanner, an American artist who studied with Eakins and then, in 1891, settled in Paris. Tanner, like Ge, had the ambition of rejuvenating venerable Christian narratives by representing them as modern, realist dramas in historical clothing, often resembling movie stills from biblical epics. His *Annunciation* (1898), for example, follows the legacy of Ge's *The Last Supper*. In it the artist re-creates the time-honored depictions of Gabriel's appearance to the Virgin as an oblique glimpse into the shadowy bedroom of what appears to be a contemporary Palestinian woman, mesmerized by the supernatural glow of the floating angel. This is a wholly new staging that resurrects, in the present tense, the possibility of belief in miracles.

These flights of imagination that sought to re-create the Bible had their counterparts in growing artistic efforts to revisit national history. Russian artists, like those in other Western countries, often attempted to reconstruct, like the directors of movies about distant epochs, the great events of history, especially if the message could inspire patriotic fervor. A perfect example is Repin's *Zaporozhians* (1880–91, page 9). This painting transports the viewer to the 1660s, to the chauvinistic moment when a group of Ukrainian cossacks composed an insulting letter to Sultan Mahmoud IV, refusing his demand to accept Turkish rule. Repin depicts this rowdy scene as if he were a photojournalist on the spot, creating a snapshot record, cropped on all sides, of wild excitement and revenge shared by a cast clothed in accurate historical costume. As in modern action movies, the spectator is there, in the midst of the fray, an eyewitness to history.

But other Russian artists, with a different vision of the past, would reject this modern, photorealist style in favor of a language more historically appropriate to the scene depicted. This is clearly the case in another work that would turn the clock back to the same time zone, Andrei Ryabushkin's *A Merchant Family in the Seventeenth Century* (1896, plate 145), one of 263 works chosen to represent contemporary Russian art at the 1900 Exposition Universelle in Paris. Unlike Repin, Ryabushkin tries to evoke a remote national past, not only through the historical costumes, but also through the style of the painting. In this case, the wealthy merchant, as powerfully enthroned as a tsar, confronts us with his wife and three children. Their flattened, rigid postures and their static symmetry (reflected in the crude doll held by the daughter on the right) are further underlined by the austere geometries of the framed blinds and wooden walls behind them. Ryabushkin takes us back to the hieratic power of Russian medieval icons, as if this secular family were the heirs to those Christian deities fixed for eternity against a gold ground.

Russian legends and fairy tales also triggered fantasies about reviving styles that evoked a remote, mythical past. A master of this kind of archaism, in both painting and sculpture as well as in the decorative arts, was Vrubel, who, in recent years has become internationally recognized as the quintessence of Russian Symbolist art. In his large decorative panel, *Bogatyr* (1898), we are again taken back to the Middle Ages in both style and theme. Here is the archetypal Christian knight, the Russian version of Sir Lancelot, in a fairy tale forest, a hero ready to protect church and state. But this is a far cry from an earlier scene of Russian knighthood, Viktor Vasnetsov's *Knight at the Crossroads* (1878, plate 144), whose near photographic reconstruction of this long-lost world completely dispels its magic. Appropriate to the legends about these pious warriors, whose origins go back to the tenth century, Vrubel chooses a style that conjures up the antirealist look of medieval art, before correct anatomy and perspective had been invented. The knight and horse are swollen to the size of legendary giants, crushed against a landscape where dragons might roam. The image radiates the kind of worldly power familiar from Gothic altarpieces and stained-glass windows.

In a similar spirit, Vrubel also focused on a revival of precious decorative arts that often seem like archaeological relics of a lost civilization. His diminutive majolica sculpture, *Mizgir* (1898, plate 142), with its exquisite evocation of a bejeweled, fairy-tale costume that seems to have been spirited from an enchanted forest, wafts us off to another kind of Russian dream, in this case that of *Snegorouchka* (The Snow Maiden), daughter of Frost and Spring, a story Nikolai Rimsky-Korsakov made famous in his opera of 1881. Vrubel, who had also painted the Snow Maiden herself, here presents Mizgir, the object of her passion when she is granted the power of human love and then magically melts away.

These precious fragments of distant, imaginary worlds are essential to Vrubel's dreamlike visions. Africa provides the inspiration for two other diminutive majolica sculptures by Vrubel, both from 1891: the *Egyptian Woman* (plate 140), a strange mixture of Orientalist exotica and Western introspection, and the *Libyan Lion*, which looks like a tiny treasure that mirrors an ancient civilization where images were stylized into sharp geometric patterns that anticipate Art Deco. Of these evocative objects, none is stranger than Vrubel's *Sea King* (1897–1900, plate 141), another majolica sculpture that conjures up a remote Aegean civilization immersed in aquatic fantasies. This fearsome, little deity is a metamorphic marvel. Not only do its iridescent colors keep changing like those of the sea itself, but the gelatinous image keeps mutating into watery creatures: fish and coiling invertebrate fragments that in turn become a Neptune-like head with tentacular hair. Dalí's magical double and triple images are not far away.

Vrubel, like so many of his international contemporaries, sought to dissolve the material world into a fluid, shadowy domain where the imagination could set sail. Even in a painted portrait of his wife, the opera singer Nadezhda Zabela-Vrubel (1898, plate 139), who wears a summery, fashionable Empire-style dress for the occasion, her body, as a weight-bearing, tangible presence, disappears beneath a decorative camouflage of dappled brushstrokes that transform the two lenses of the lorgnette she holds into the floating, arched patterns hovering over her dress. She is as much a memory as a fact. But these

Claude Monet, Bed of Chrysanthemums, 1897. Oil on canvas, 81 x 100 cm. Kunstmuseum Basel, Museum für Gegenwartskunst, Permanent loan from the Emile Dreyfus Foundation

currents reach a sumptuous climax in a large, almost square canvas from 1900, *Lilacs* (plate 150), which practically smothers us. Vrubel's crystalline, fractured brushstrokes transform pigment into patches of color that bob and float in a dense sea of paint, a defiance of gravity that makes the dark female figure look like a beckoning, yet inaccessible mirage in an enchanted, perfumed garden bathed in moonlight. But unique as Vrubel's masterpiece may be, it also becomes part of an international community of paintings that, at the turn of the century, pushed the visible world to such extremes of sensuous refinement that, as in a dream, we can no longer find our bearings in reality.

The most famous distillations of this adventure, Monet's variations on the themes cultivated in his luxuriant private garden at Giverny, provide perfect complements to Vrubel's canvas, just as Levitan's *Twilight: Haystacks* can be seen as the Russian counterpart of the French Impressionist's fascination with the same rural theme. In *Bed of Chrysanthemums* (1897), a typical glimpse of a vital abundance of flowers in full bloom, Monet, like Vrubel, immerses the viewer in a gorgeous, unstable world of fluid color, of floral fragrance, where up and down, substance and shadow are fused in a shimmering whole. And as in Vrubel's painting, the square format here, anchored by neither horizontal nor vertical axes, contributes to our sense of being set adrift in the midst of a boundless space.

By 1900, Russian artists, like artists throughout Europe and America, had begun to peer through the looking glass of reality into strange new worlds invisible to earlier generations and ever more distant from the prosaic facts we can see and touch when we obey the pull of gravity. It was a path that would lead to otherworldly territories, soon to be sighted on Russian soil by Vasily Kandinsky and Kazimir Malevich.

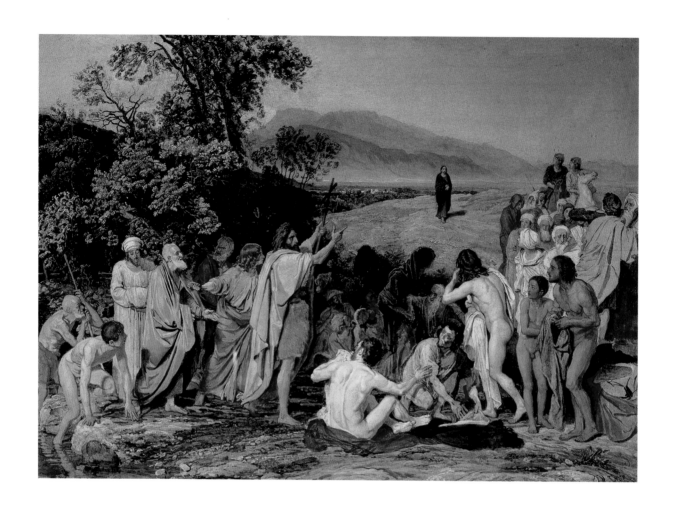

91. ALEXANDER IVANOV, STUDY FOR
THE APPEARANCE OF CHRIST TO THE PEOPLE,
CA. 1837. OIL ON CANVAS, 53.5 X
74.5 CM. STATE RUSSIAN MUSEUM,
ST. PETERSBURG

92. (OPPOSITE) ALEXANDER IVANOV,
NUDE BOY, STUDY FOR *THE APPEARANCE*
OF CHRIST TO THE PEOPLE, 1840. OIL ON
CANVAS, 47.7 X 64.2 CM. STATE
RUSSIAN MUSEUM, ST. PETERSBURG

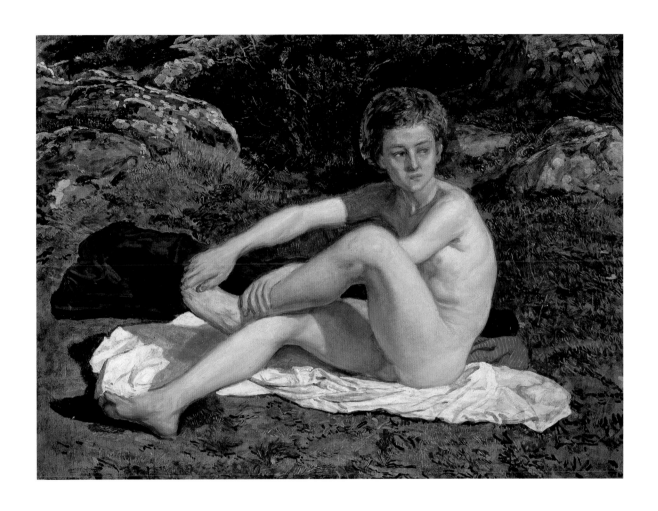

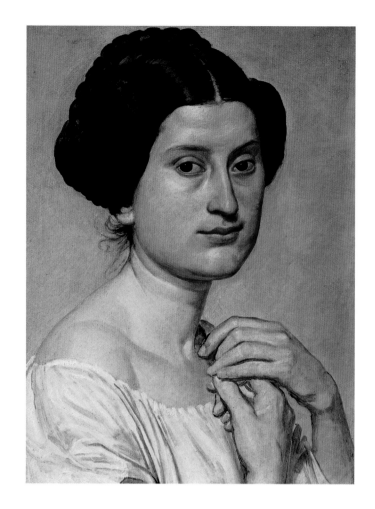

93. (LEFT) ALEXANDER IVANOV, MODEL
OF ASSUNTA, IN THE POSE OF CHRIST,
STUDY FOR THE APPEARANCE OF CHRIST
TO THE PEOPLE, 1840S. OIL ON PAPER,
MOUNTED ON CANVAS, 47.5 X 37.1 CM.
THE STATE TRETYAKOV GALLERY,
MOSCOW

94. (RIGHT) ALEXANDER IVANOV,
HEAD OF ST. JOHN THE BAPTIST, STUDY
FOR THE APPEARANCE OF CHRIST TO THE
PEOPLE, 1840S. OIL ON PAPER, MOUNT-
ED ON CANVAS, 51 X 44 CM. THE STATE
TRETYAKOV GALLERY, MOSCOW

95. ALEXANDER IVANOV, *FIGURE OF A RISING MAN; HEAD OF A FAUN; HEAD OF OLD MAN RISING*, STUDY FOR *THE APPEARANCE OF CHRIST TO THE PEOPLE*, 1833–57. OIL ON PAPER, 50 X 62 CM. STATE RUSSIAN MUSEUM, ST. PETERSBURG

96. (OPPOSITE) ALEXANDER IVANOV,
OLIVE TREE, ARICCA VALLEY, STUDY FOR
THE *APPEARANCE OF CHRIST TO THE PEOPLE*,
1846, OIL ON CANVAS, 61.4 X 44.4
CM. THE STATE TRETYAKOV GALLERY,
MOSCOW

97. ALEXANDER IVANOV, *WATER AND
STONES NEAR PALACCUOLLA*, STUDY FOR
THE *APPEARANCE OF CHRIST TO THE PEOPLE*,
EARLY 1850S. OIL ON CANVAS, 45 X
61.2 CM. STATE RUSSIAN MUSEUM,
ST. PETERSBURG

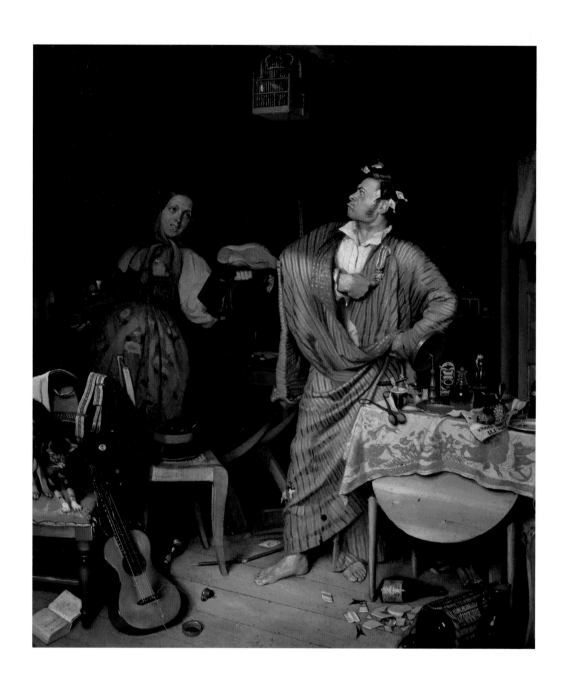

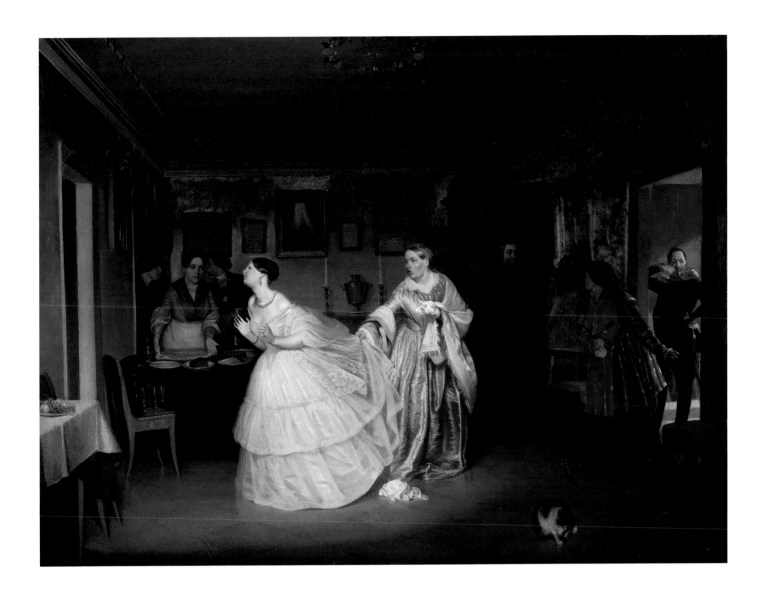

98. (OPPOSITE) PAVEL FEDOTOV, THE
NEWLY DECORATED CIVIL SERVANT (AN
OFFICIAL THE MORNING AFTER RECEIVING
HIS FIRST DECORATION), 1846. OIL ON
CANVAS, 48.2 X 42.5 CM. THE STATE
TRETYAKOV GALLERY, MOSCOW

99. PAVEL FEDOTOV, THE MAJOR'S
PROPOSAL, CA. 1851. OIL ON CANVAS,
56 X 76 CM. STATE RUSSIAN MUSEUM,
ST. PETERSBURG

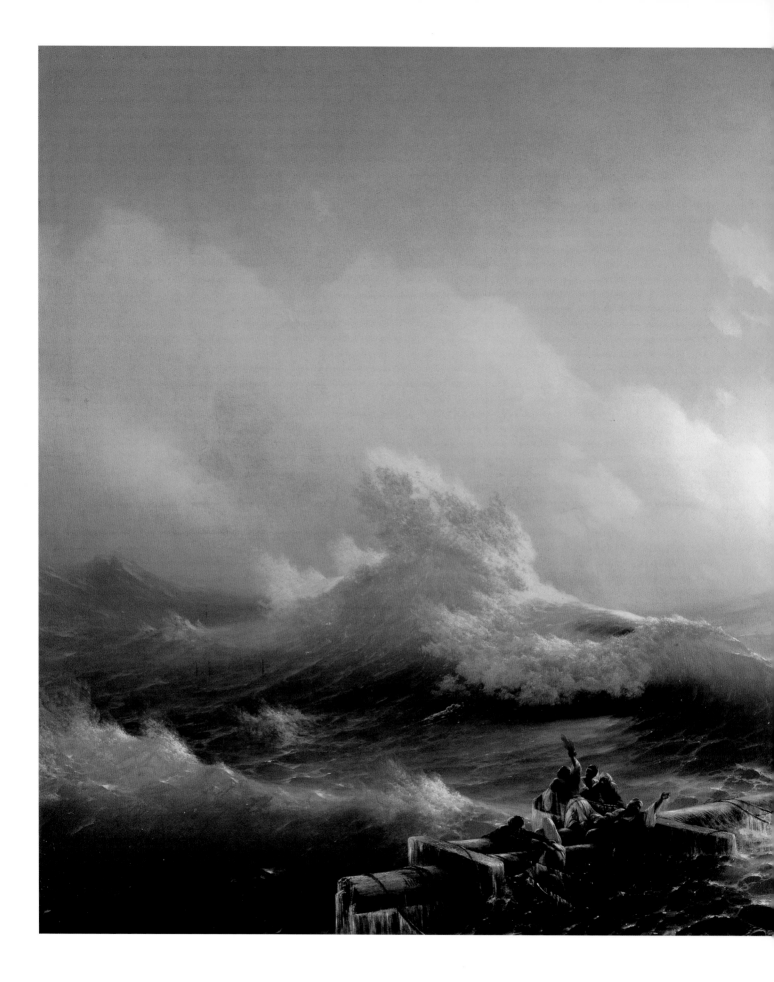

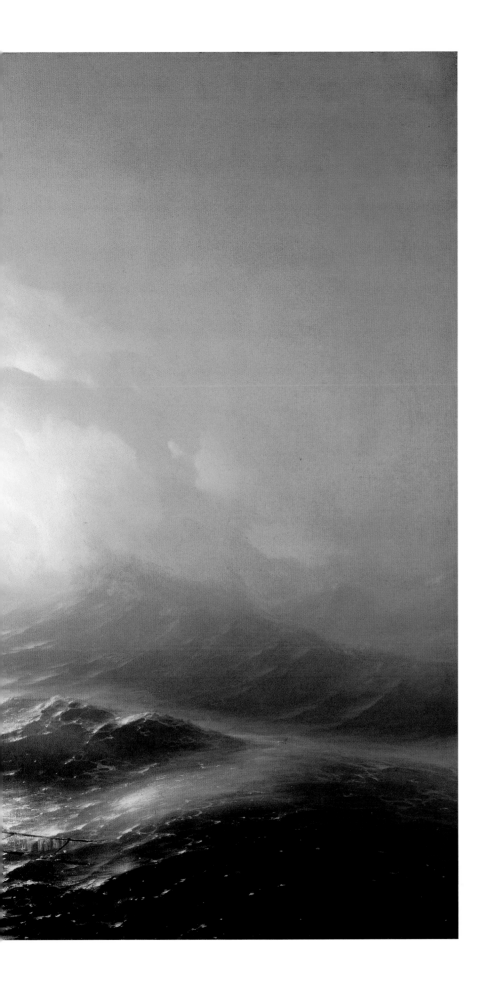

100. IVAN AIVAZOVSKY, *THE NINTH WAVE*, 1850. OIL ON CANVAS. 221 X 332 CM. STATE RUSSIAN MUSEUM, ST. PETERSBURG

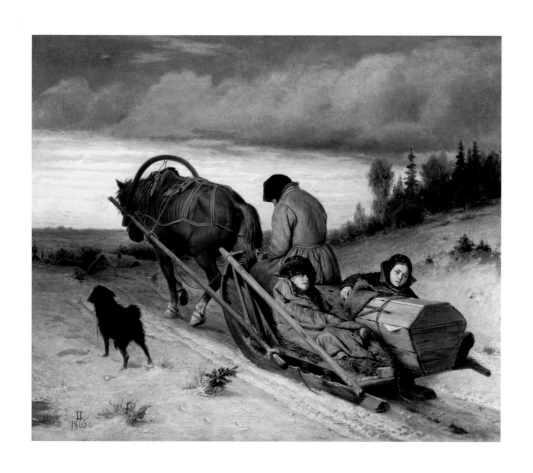

101. VASILY PEROV, *SERVICE FOR THE DEAD*, 1865. OIL ON CANVAS, 45.3 X 57 CM. THE STATE TRETYAKOV GALLERY, MOSCOW

102. (OPPOSITE) VASILY PEROV, *A MEAL*, 1865–76. OIL ON CANVAS, 84 X 126 CM. STATE RUSSIAN MUSEUM, ST. PETERSBURG

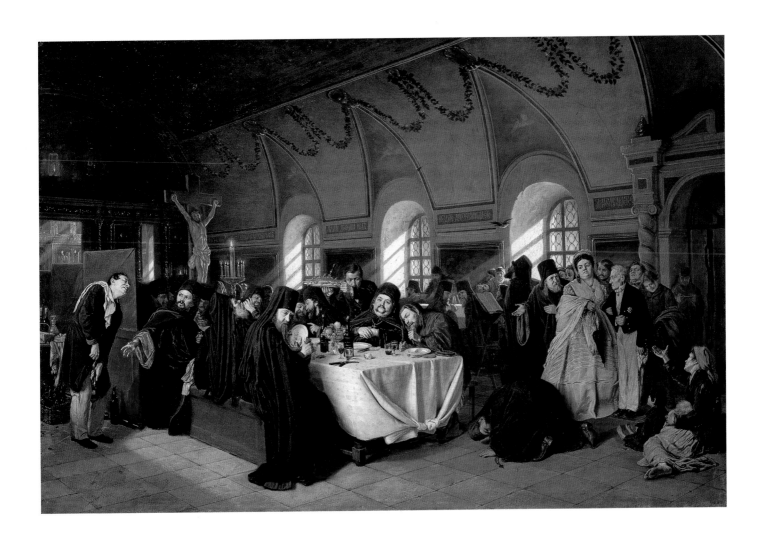

103. ALEXEI KORZUKHIN, *BEFORE THE CONFESSION*, 1877. OIL ON CANVAS, 108 X 160 CM. THE STATE TRETYAKOV GALLERY, MOSCOW

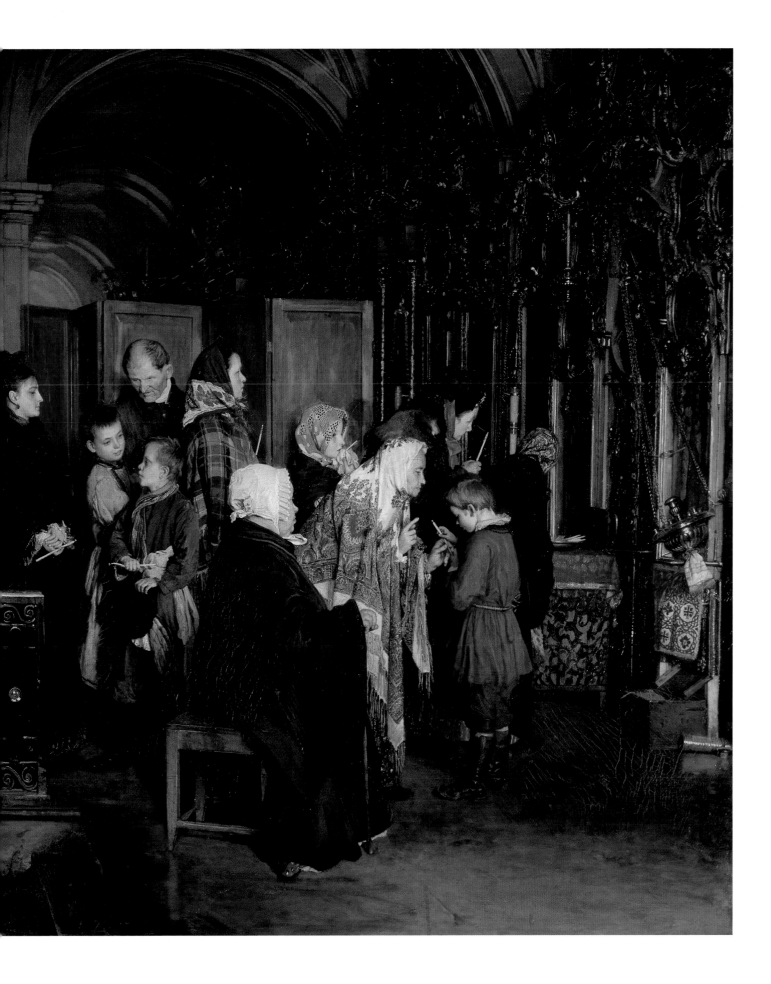

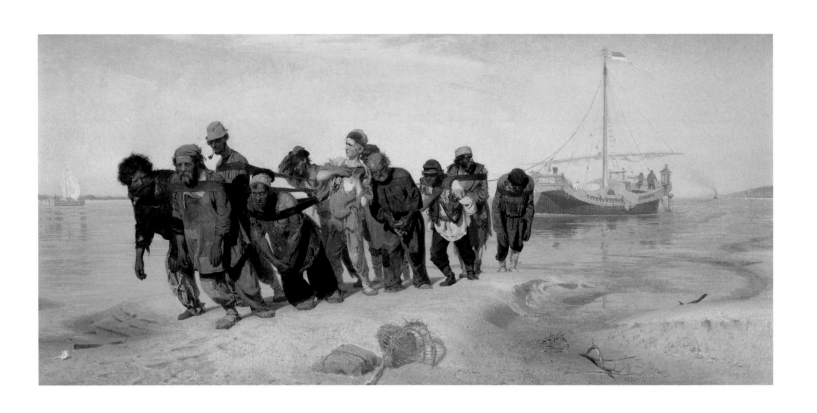

104. (OPPOSITE) ILYA REPIN, *BARGE HAULERS ON THE VOLGA*, 1870–73. OIL ON CANVAS, 131.5 X 281 CM. STATE RUSSIAN MUSEUM, ST. PETERSBURG

105. VASILY PEROV, *THE LAST TAVERN BY THE CITY GATE*, 1868. OIL ON CANVAS, 51.5 X 65.8 CM. THE STATE TRETYAKOV GALLERY, MOSCOW

106. VLADIMIR MAKOVSKY, CONVICT,
1879. OIL ON CANVAS, 76.5 X
113 CM. STATE RUSSIAN MUSEUM,
ST. PETERSBURG

107. (OPPOSITE) VLADIMIR MAKOVSKY,
A PARTY, 1875–97. OIL ON CANVAS,
108.5 X 144 CM. THE STATE
TRETYAKOV GALLERY, MOSCOW

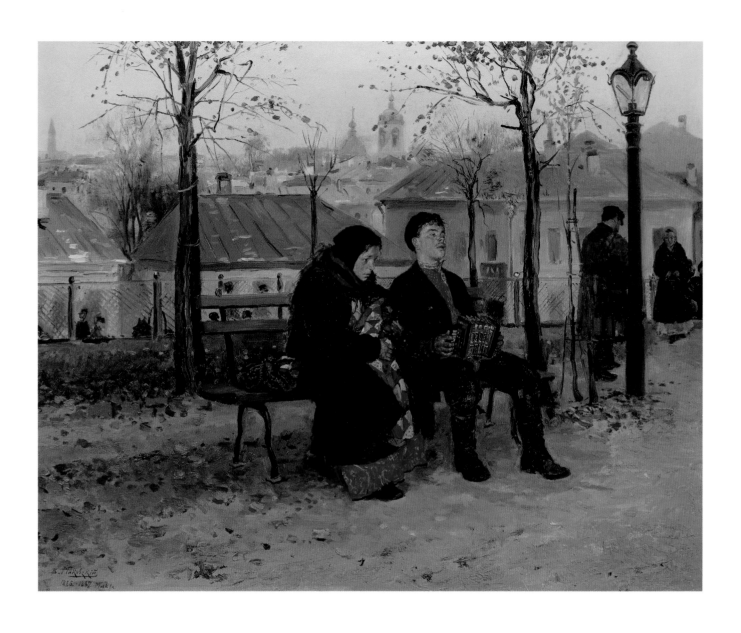

108. VLADIMIR MAKOVSKY, *ON THE*
BOULEVARD, 1886–87. OIL ON CANVAS,
53 X 68 CM. THE STATE TRETYAKOV
GALLERY, MOSCOW

109. (OPPOSITE) VASILY MAXIMOV,
ALL IN THE PAST, 1889. OIL ON CANVAS,
72 X 93.5 CM. THE STATE TRETYAKOV
GALLERY, MOSCOW

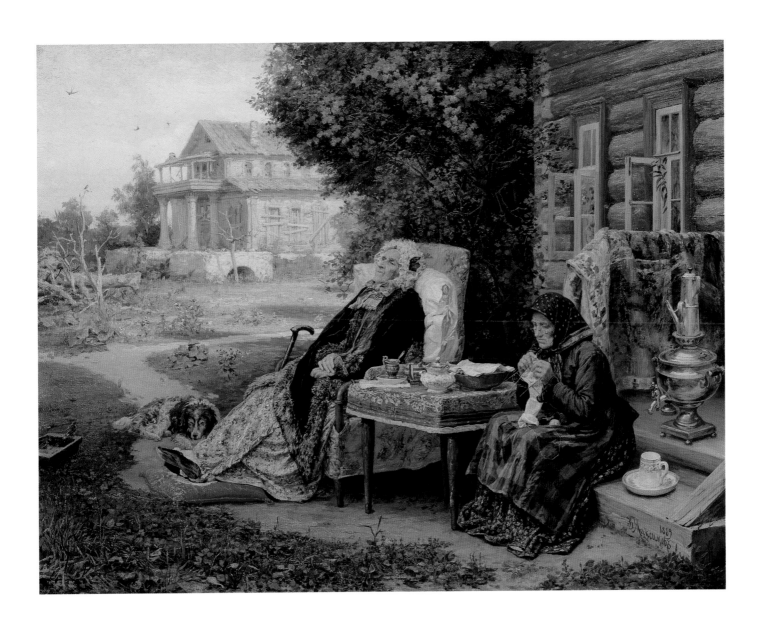

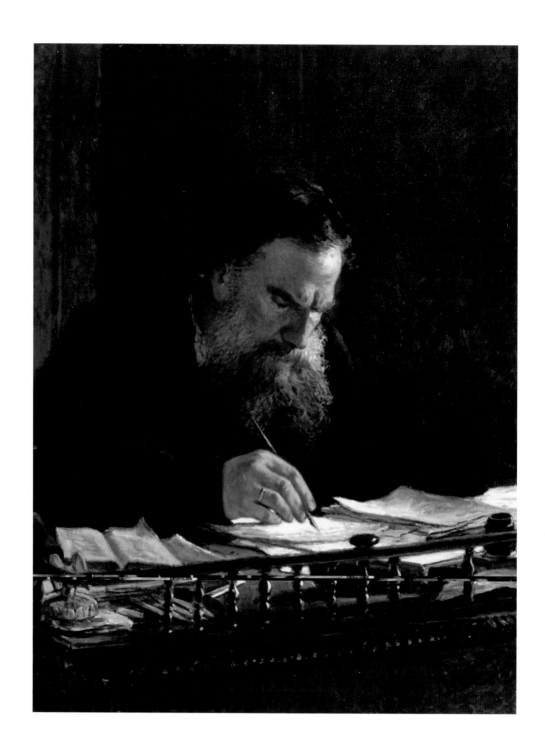

110. NIKOLAI GE, *PORTRAIT OF THE
WRITER LEO TOLSTOY*, 1884. OIL ON
CANVAS, 96 X 71 CM. STATE RUSSIAN
MUSEUM, ST. PETERSBURG

111. (OPPOSITE) VASILY PEROV,
*PORTRAIT OF THE WRITER FEDOR
DOSTOEVSKY*, 1872. OIL ON CANVAS,
90 X 80.5 CM. THE STATE TRETYAKOV
GALLERY, MOSCOW

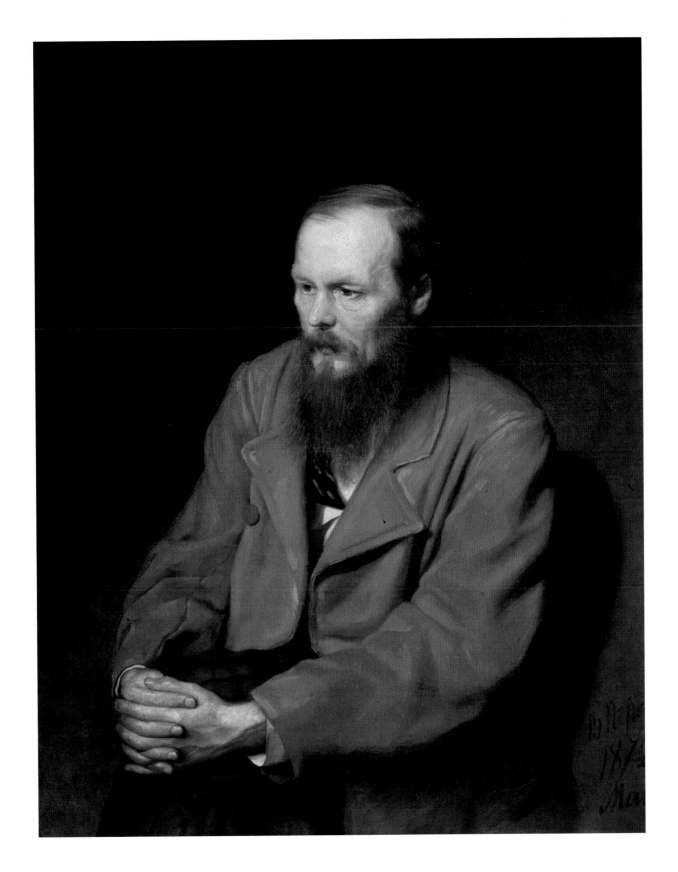

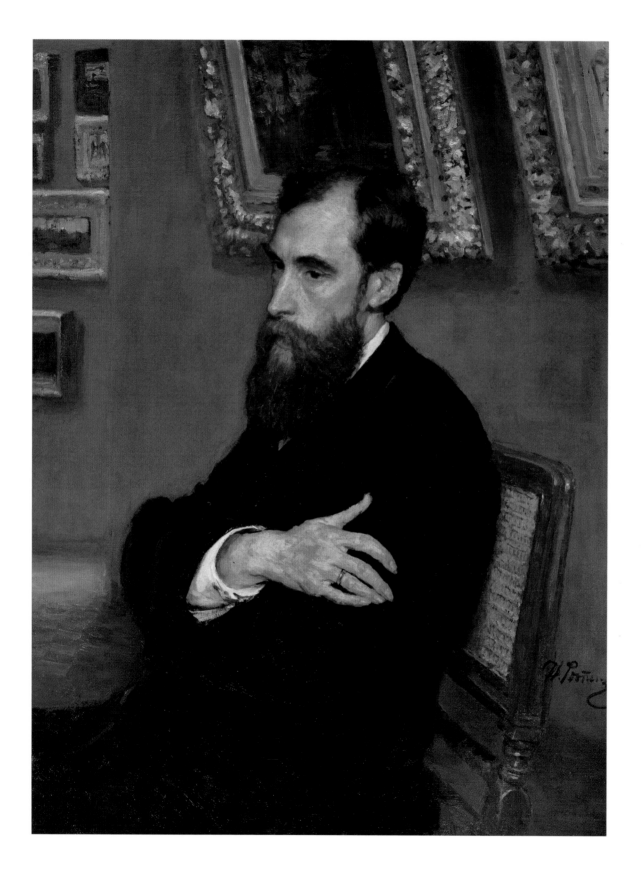

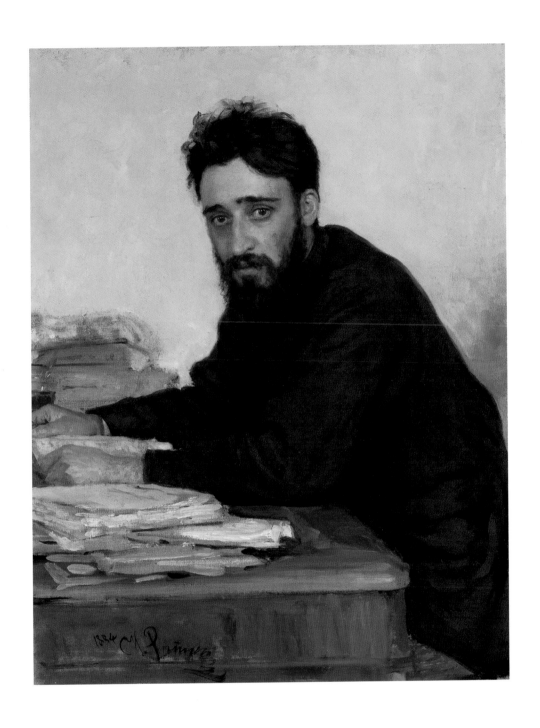

112. (OPPOSITE) ILYA REPIN, PORTRAIT
OF PAVEL TRETYAKOV, FOUNDER OF
THE TRETYAKOV GALLERY, 1883. OIL ON
CANVAS, 98 X 75.8 CM. THE STATE
TRETYAKOV GALLERY, MOSCOW

113. ILYA REPIN, VSEVOLOD
MIKHAILOVICH GARSHIN (1855–1888),
1884. OIL ON CANVAS, 88.9 X 69.2 CM.
THE METROPOLITAN MUSEUM OF
ART, NEW YORK, GIFT OF HUMANITIES
FUND INC., 1972

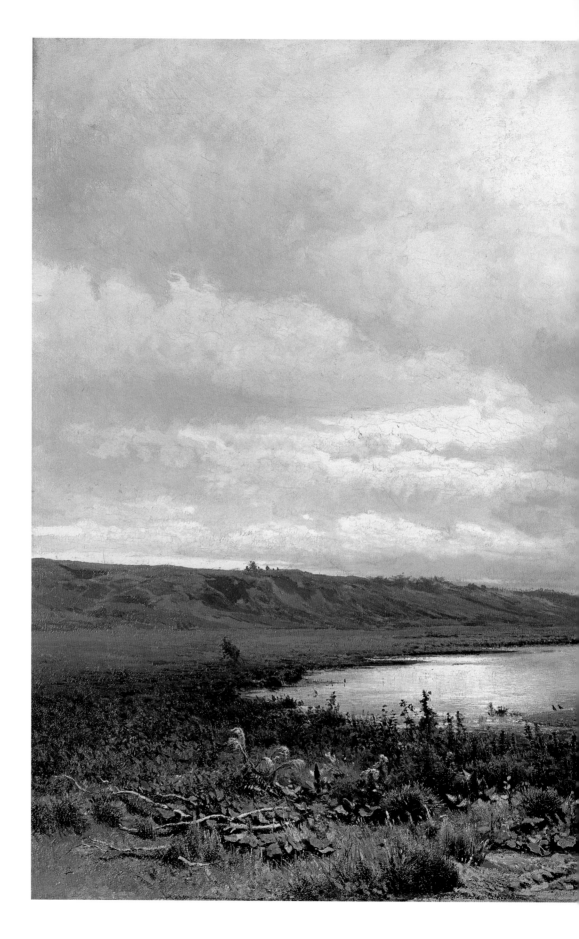

114. FEDOR VASILIEV, *WET MEADOW*,
1872. OIL ON CANVAS, 70 X 114 CM.
THE STATE TRETYAKOV GALLERY,
MOSCOW

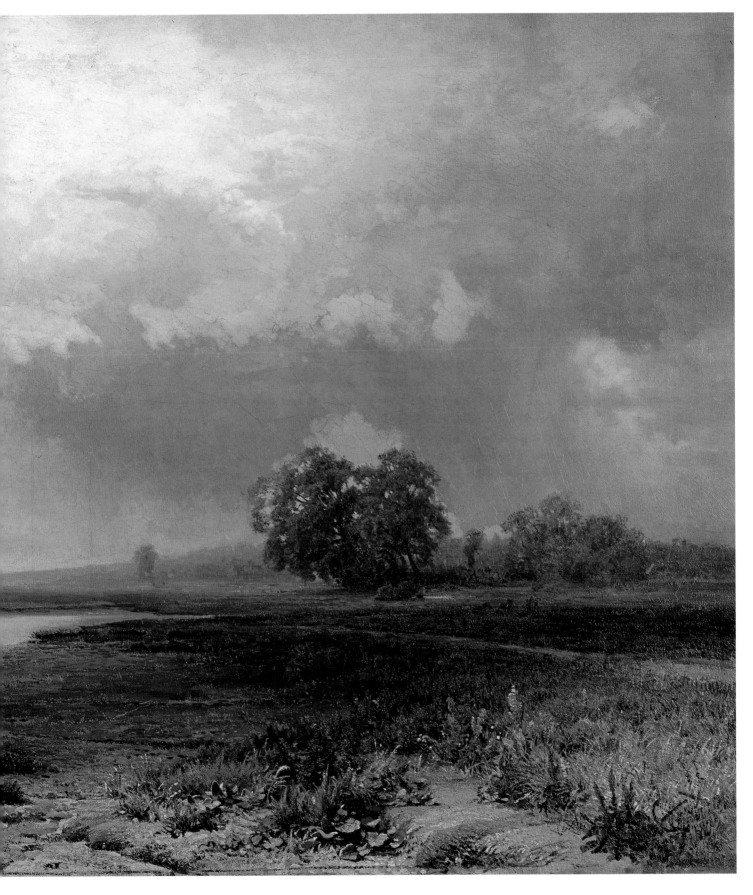

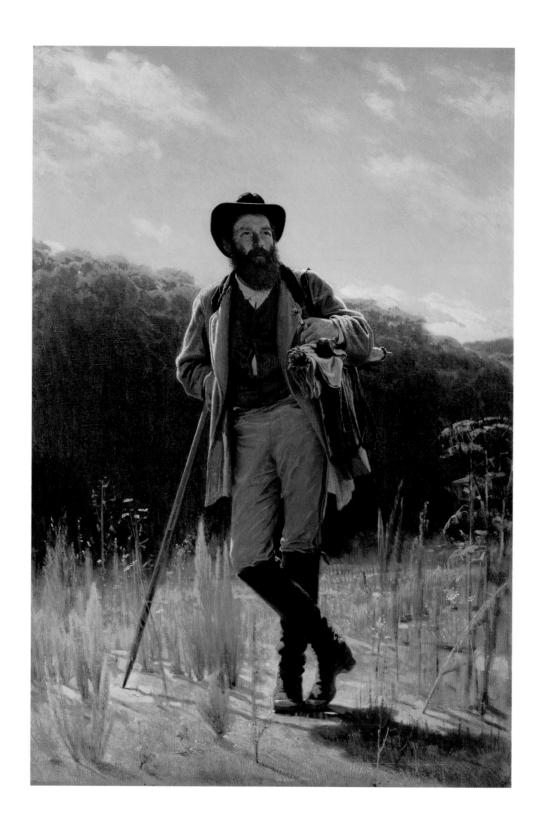

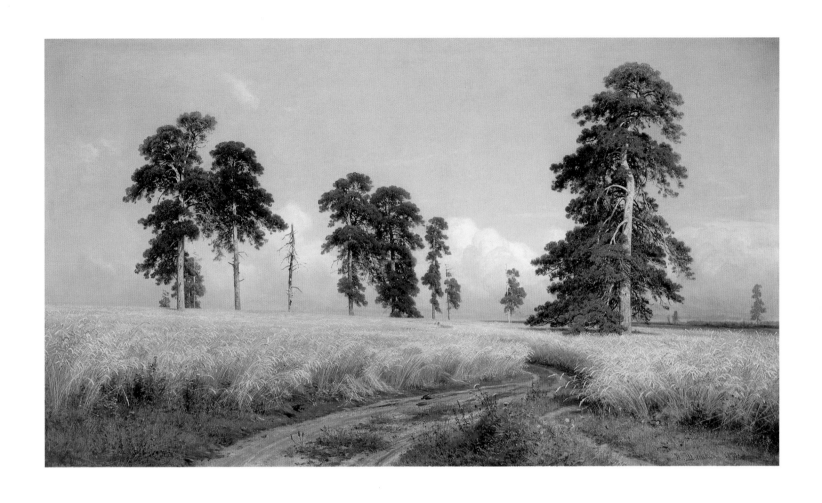

115. (OPPOSITE) IVAN KRAMSKOY,
PORTRAIT OF THE PAINTER IVAN SHISHKIN,
1873. OIL ON CANVAS, 110.5 X
78 CM. THE STATE TRETYAKOV GALLERY,
MOSCOW

116. IVAN SHISHKIN, *RYE,* 1878. OIL
ON CANVAS, 107 X 187 CM. THE STATE
TRETYAKOV GALLERY, MOSCOW

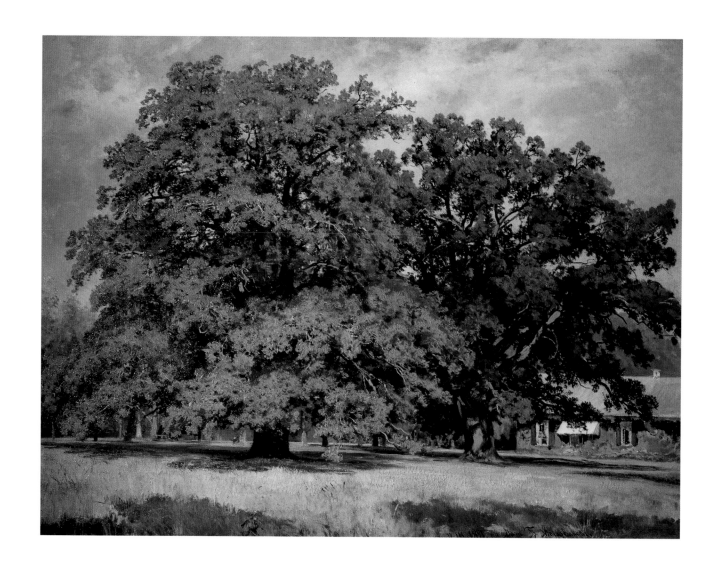

117. IVAN SHISHKIN, *THE OAKS OF
MORDVINOVO*, 1891. OIL ON CANVAS,
84 X 111 CM. STATE RUSSIAN MUSEUM,
ST. PETERSBURG

118. (OPPOSITE) IVAN KRAMSKOY,
FORESTER, 1874. OIL ON CANVAS,
84 X 62 CM. THE STATE TRETYAKOV
GALLERY, MOSCOW

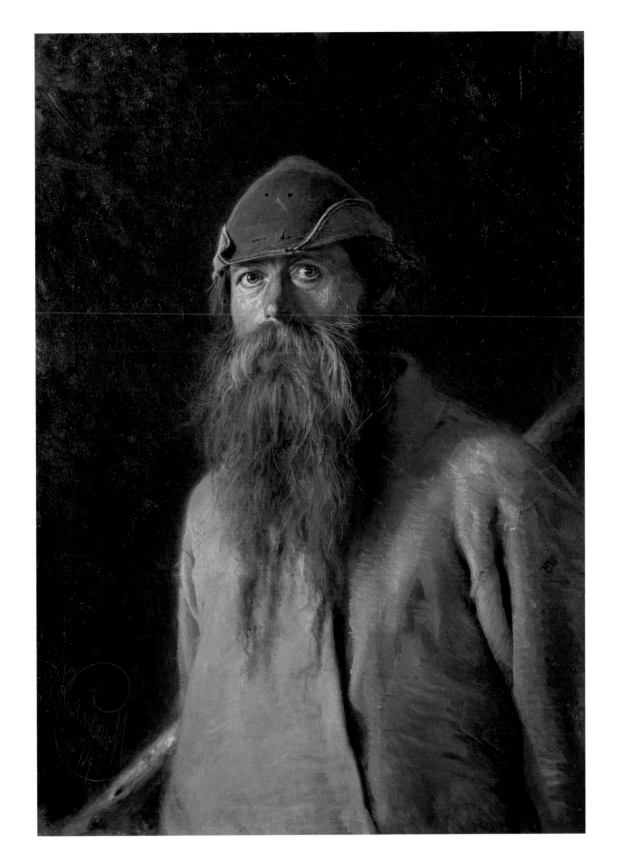

119. IVAN KRAMSKOY, *UNKNOWN
WOMAN*, 1883. OIL ON CANVAS, 75.5 X
99 CM. THE STATE TRETYAKOV
GALLERY, MOSCOW

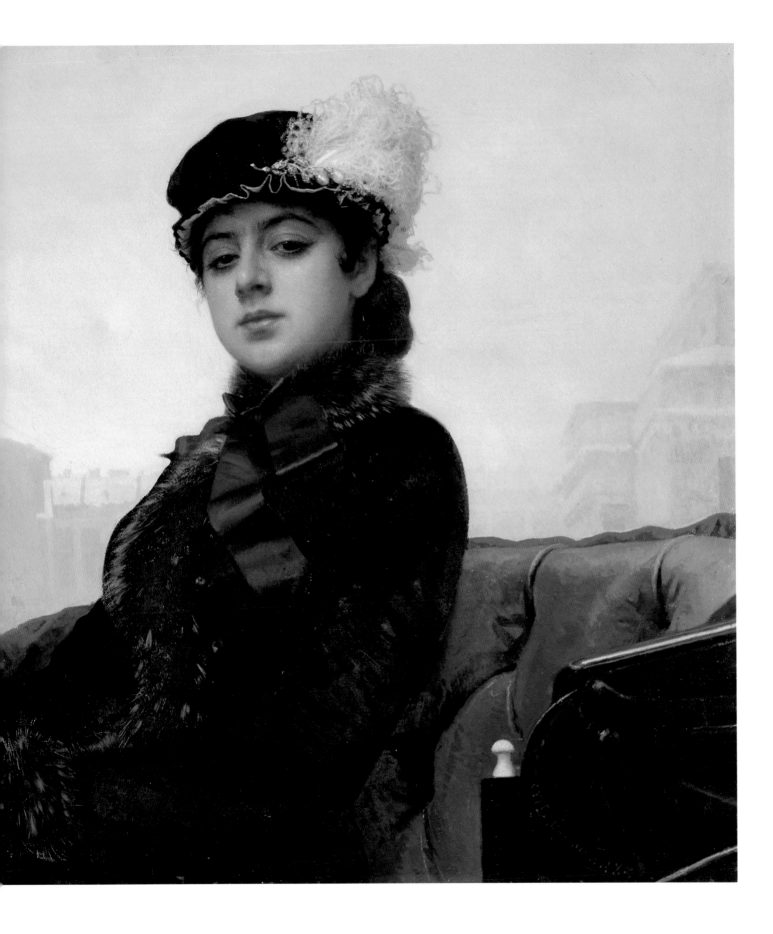

120. NIKOLAI YAROSHENKO, FEMALE
STUDENT, 1880. OIL ON CANVAS,
85 X 54 CM. STATE RUSSIAN MUSEUM,
ST. PETERSBURG

121. ILYA REPIN, PORTRAIT OF NADYA
REPINA, 1881. OIL ON CANVAS,
66 X 54 CM. RADISCHEV ART MUSEUM,
SARATOV

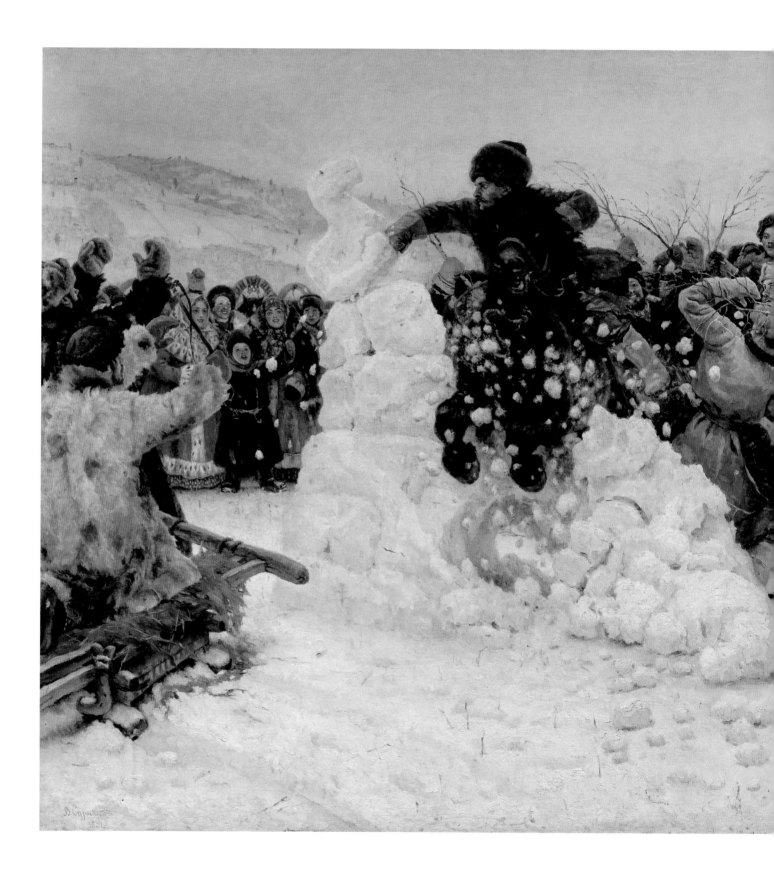

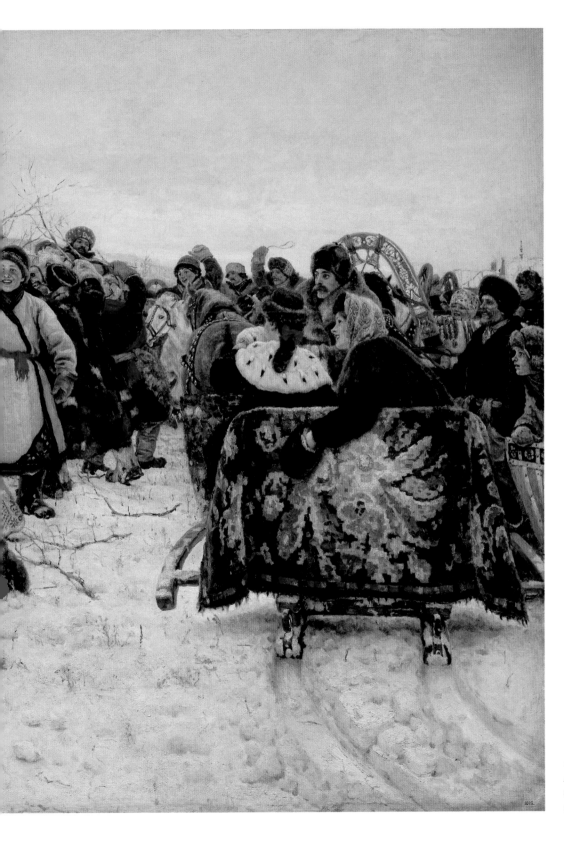

122. VASILY SURIKOV, *CAPTURE OF A SNOW FORTRESS*, 1891. OIL ON CANVAS, 156 X 282 CM. STATE RUSSIAN MUSEUM, ST. PETERSBURG

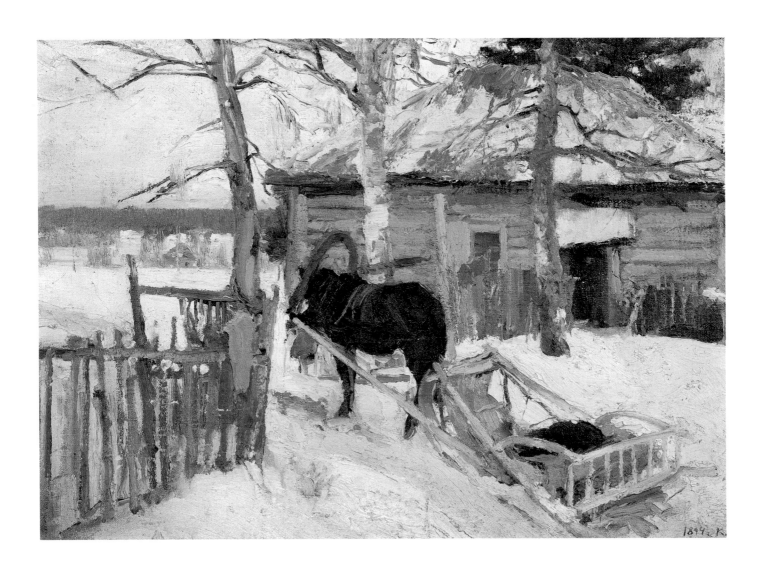

123. (OPPOSITE) VALENTIN SEROV,
PORTRAIT OF THE ARTIST KONSTANTIN
KOROVIN, 1891. OIL ON CANVAS, 111.2 X
89 CM. THE STATE TRETYAKOV GALLERY,
MOSCOW

124. KONSTANTIN KOROVIN, IN
WINTER, 1894. OIL ON CANVAS, 37.2 X
52.5 CM. THE STATE TRETYAKOV
GALLERY, MOSCOW

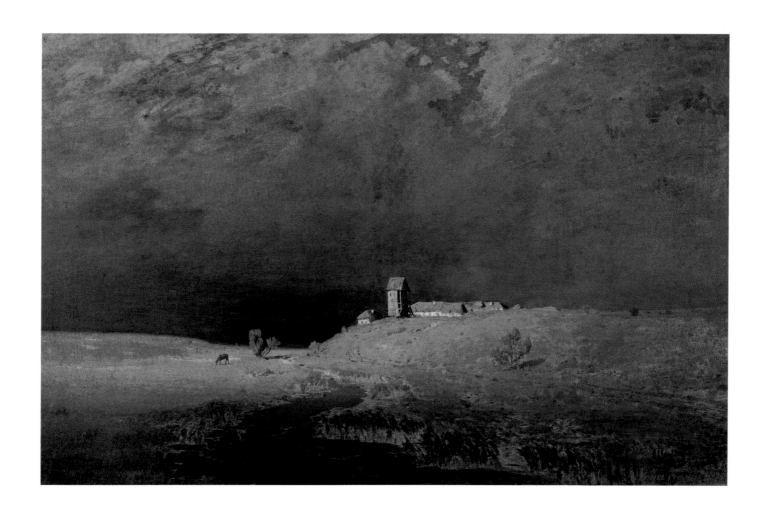

125. ARKHIP KUINDZHI, *AFTER THE RAIN*, 1879. OIL ON CANVAS, 102 X 159 CM. THE STATE TRETYAKOV GALLERY, MOSCOW

126. (OPPOSITE) ARKHIP KUINDZHI, *PATCHES OF MOONLIGHT*, 1898–1908. OIL ON CANVAS, 39 X 53.5 CM. STATE RUSSIAN MUSEUM, ST. PETERSBURG

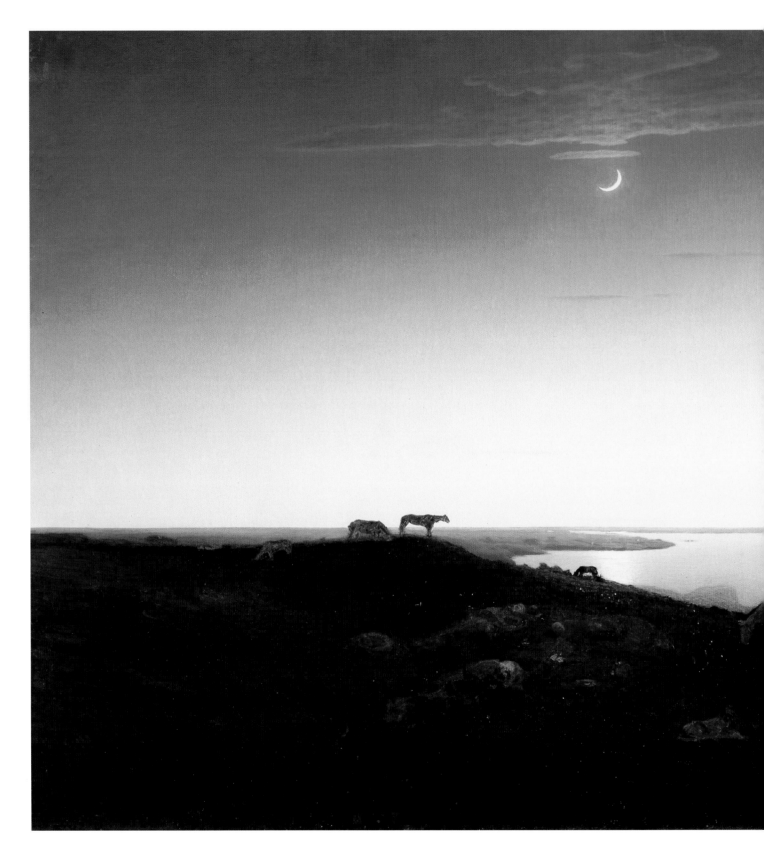

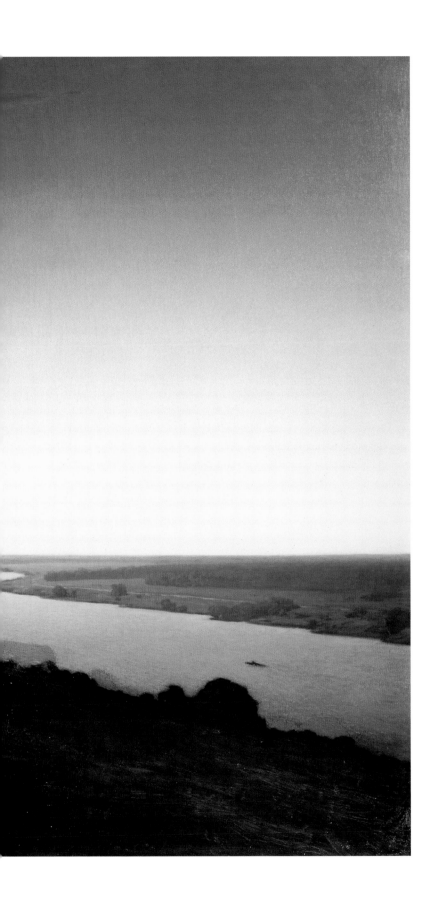

127. ARKHIP KUINDZHI, *AT NIGHT*, 1905–08. OIL ON CANVAS, 107 X 169 CM. STATE RUSSIAN MUSEUM, ST. PETERSBURG

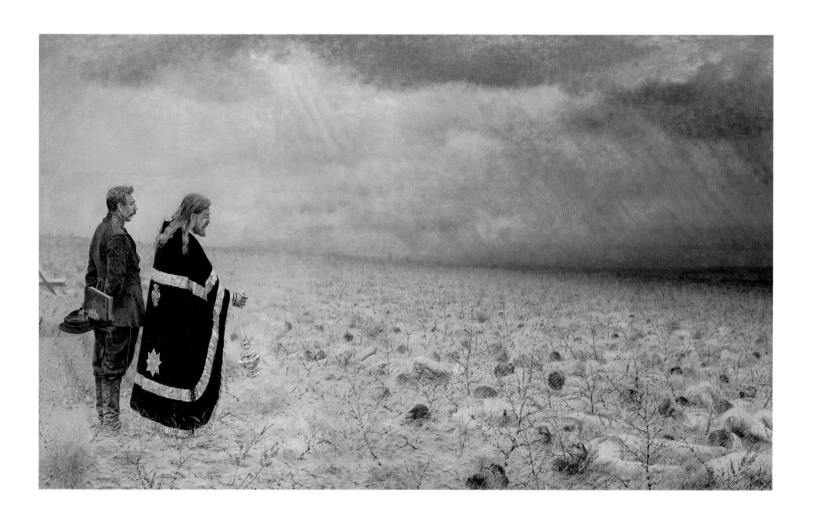

128. VASILY VERESCHAGIN, *DEFEATED:
SERVICE FOR THE DEAD*, 1878–79. OIL ON
CANVAS, 179.7 X 300.4 CM. THE STATE
TRETYAKOV GALLERY, MOSCOW

129. (OPPOSITE) VASILY VERESCHAGIN,
MORTALLY WOUNDED, 1873. OIL ON
CANVAS, 73 X 56.6 CM. THE STATE
TRETYAKOV GALLERY, MOSCOW

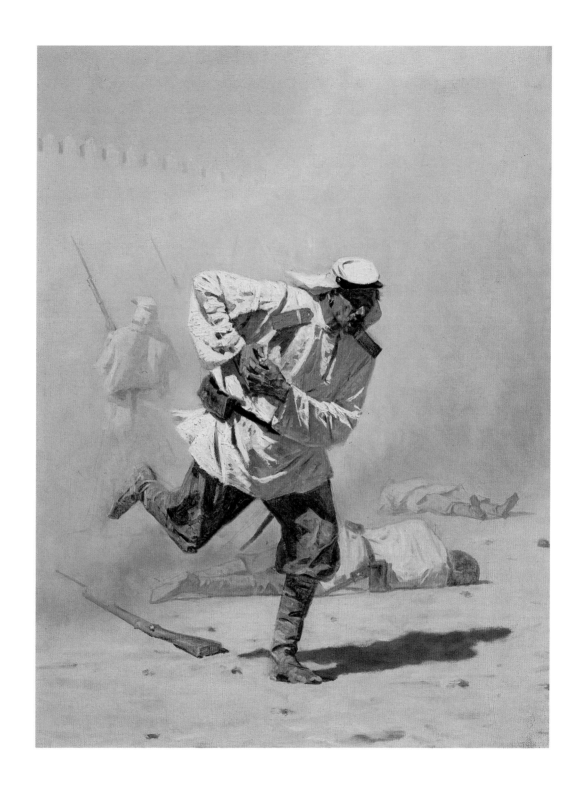

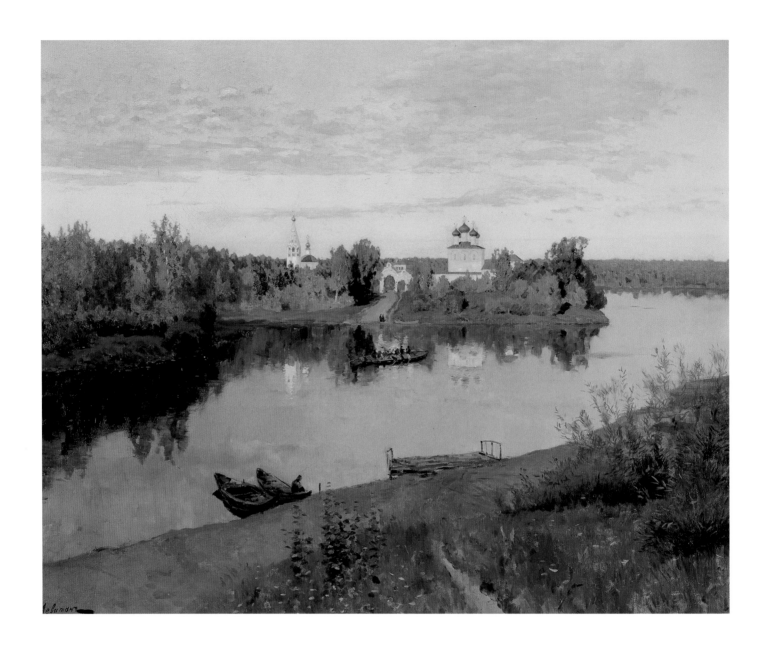

130. ISAAK LEVITAN, *EVENING BELLS*,
1892. OIL ON CANVAS, 87 X 107.6 CM.
THE STATE TRETYAKOV GALLERY,
MOSCOW

131. (OPPOSITE) VASILY POLENOV,
THE MOSCOW COURTYARD, 1902. OIL ON
CANVAS, 55.2 X 44 CM. STATE RUSSIAN
MUSEUM, ST. PETERSBURG

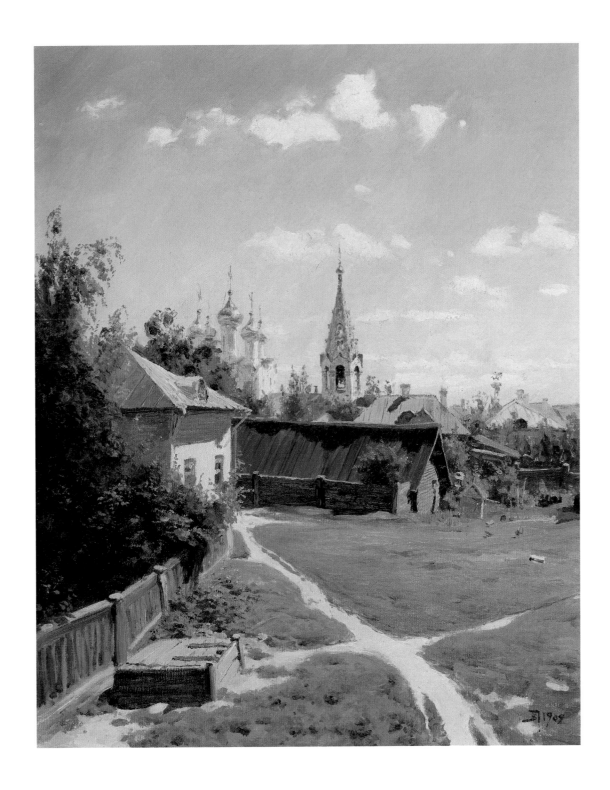

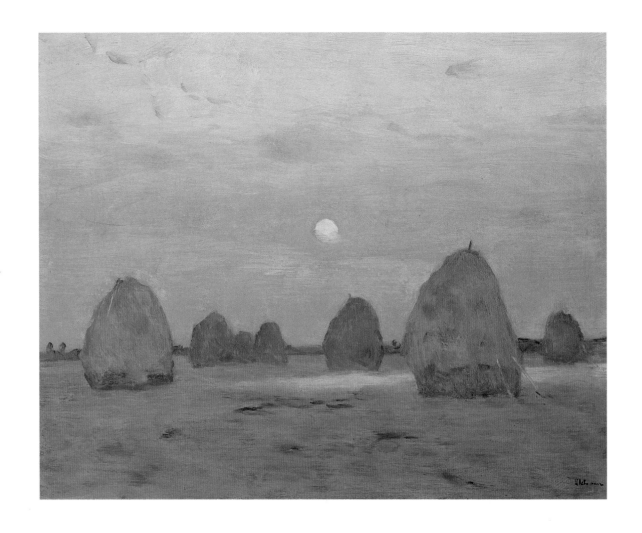

132. ISAAK LEVITAN, *TWILIGHT:
HAYSTACKS*, 1899. OIL ON CANVAS,
59.8 X 54.6 CM. THE STATE TRETYAKOV
GALLERY, MOSCOW

133. (OPPOSITE) ISAAK LEVITAN,
SPRING: HIGH WATER, 1897. OIL ON
CANVAS, 64.2 X 57.5 CM. THE STATE
TRETYAKOV GALLERY, MOSCOW

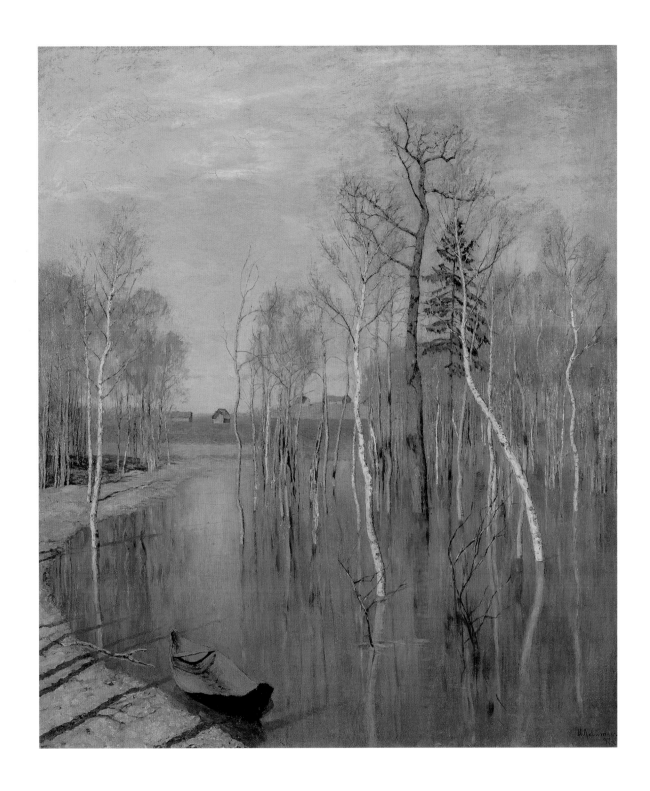

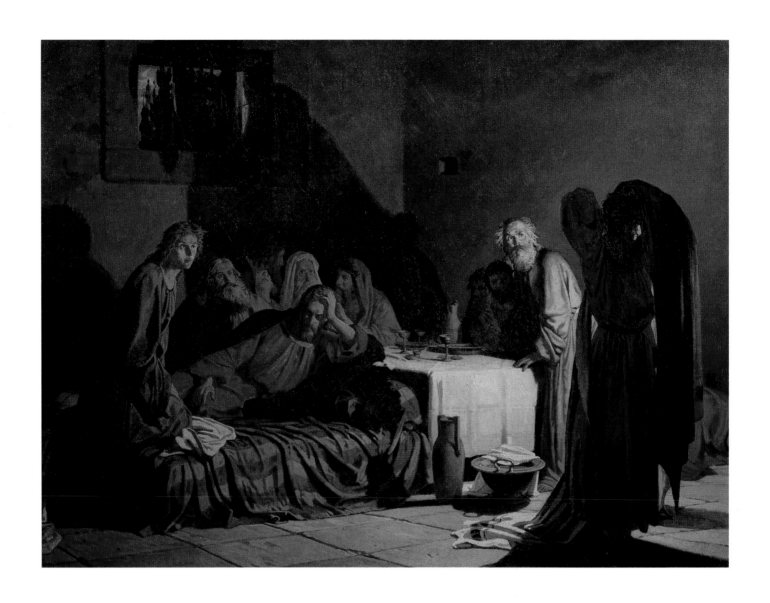

134. NIKOLAI GE, *THE LAST SUPPER*,
1866. OIL ON CANVAS, 66.5 X
89.6 CM. THE STATE TRETYAKOV
GALLERY, MOSCOW

135. (OPPOSITE) MARC ANTOKOLSKY,
ECCE HOMO: CHRIST BEFORE THE PEOPLE,
AFTER 1892. MARBLE, H. 100 CM.
STATE RUSSIAN MUSEUM,
ST. PETERSBURG

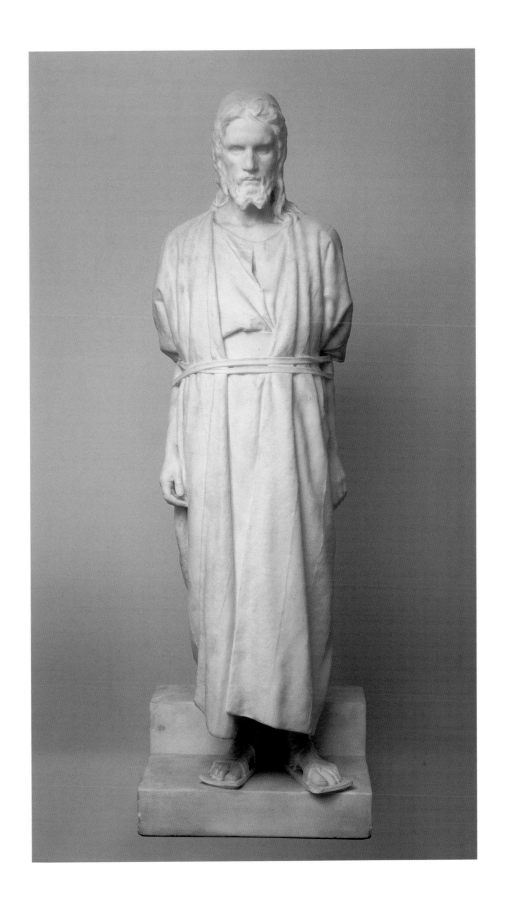

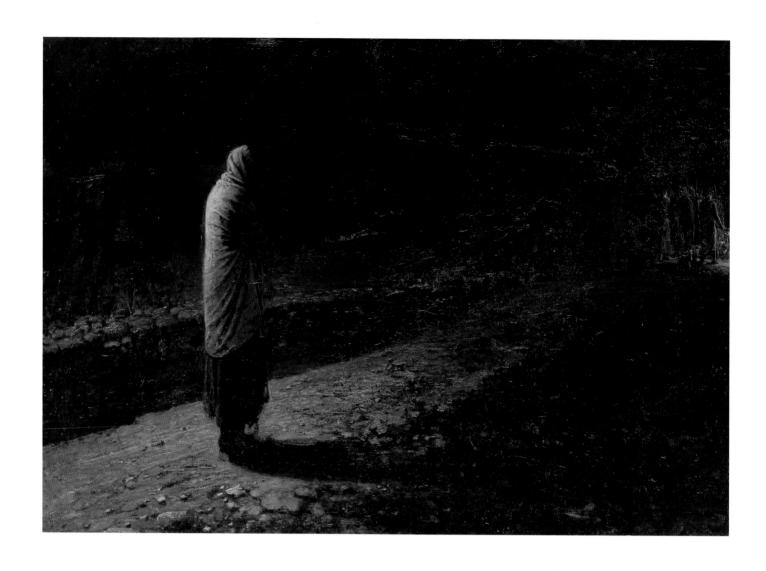

136. NIKOLAI GE, CONSCIENCE:
JUDAS, 1891. OIL ON CANVAS, 149 X
210 CM. THE STATE TRETYAKOV
GALLERY, MOSCOW

137. (OPPOSITE) VASILY POLENOV,
DREAMS (ON TOP OF A MOUNTAIN)
(FROM THE LIFE OF CHRIST SERIES),
1890–1900S. OIL ON CANVAS, 151 X
142 CM. STATE RUSSIAN MUSEUM,
ST. PETERSBURG

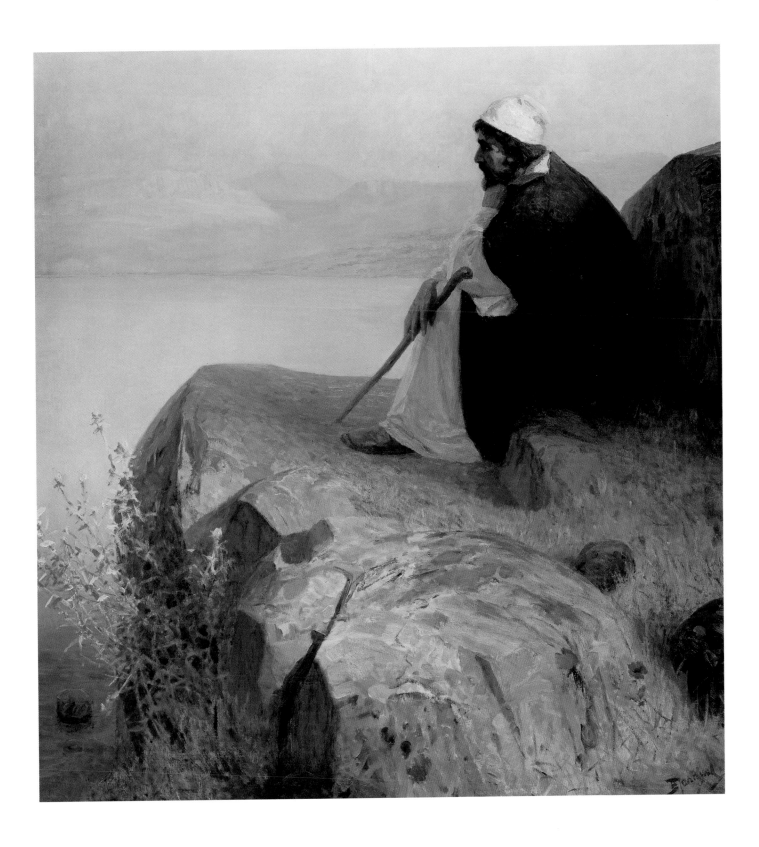

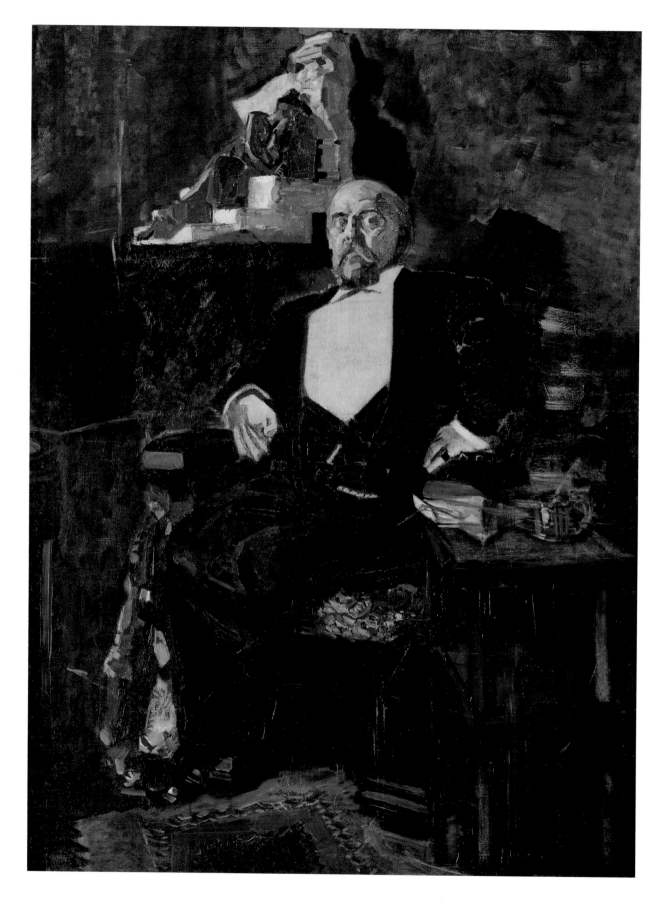

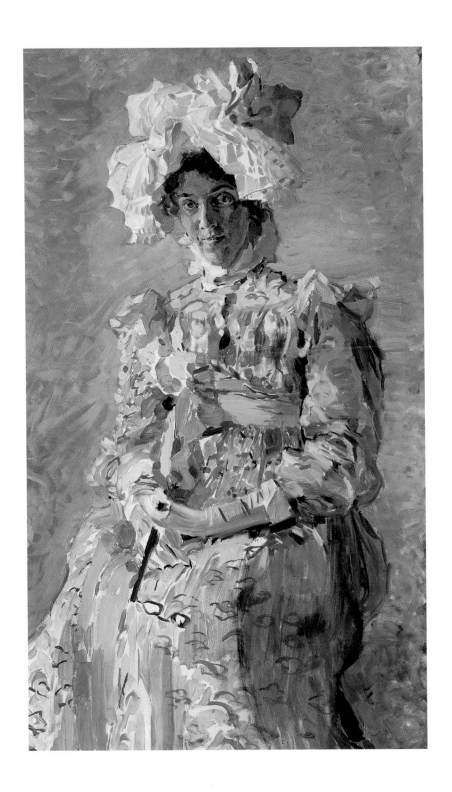

138. (OPPOSITE) MIKHAIL VRUBEL,
PORTRAIT OF *SAVVA MAMONTOV*, 1897.
OIL ON CANVAS, 187 X 142.5 CM. THE
STATE TRETYAKOV GALLERY, MOSCOW

139. MIKHAIL VRUBEL, PORTRAIT OF
*N. I. ZABELA-VRUBEL, THE ARTIST'S WIFE, IN
A SUMMER "EMPIRE" DRESS*, 1898. OIL
ON CANVAS, 124 X 75.7 CM. THE STATE
TRETYAKOV GALLERY, MOSCOW

140. (LEFT) MIKHAIL VRUBEL,
EGYPTIAN WOMAN, 1891. MAJOLICA,
H. 32.5 CM. THE STATE TRETYAKOV
GALLERY, MOSCOW

141. (RIGHT) MIKHAIL VRUBEL, SEA
KING, 1897–1900. MAJOLICA,
52.3 X 40 CM. THE STATE TRETYAKOV
GALLERY, MOSCOW

142. MIKHAIL VRUBEL, *MIZGIR*,
1898. MAJOLICA, H. 47 CM. THE STATE
TRETYAKOV GALLERY, MOSCOW

227

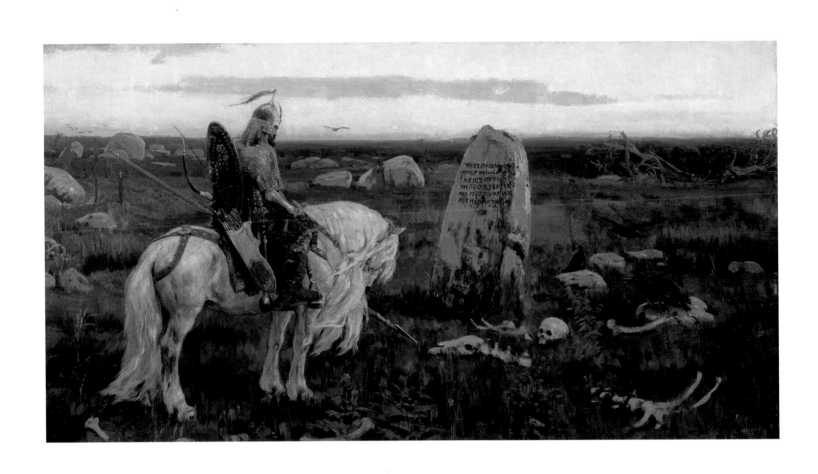

143. (OPPOSITE) SERGEI KONENKOV,
THE THINKER, AFTER 1905. MARBLE,
H. 56 CM. STATE RUSSIAN MUSEUM,
ST. PETERSBURG

144. VIKTOR VASNETSOV, *KNIGHT AT
THE CROSSROADS*, 1878. OIL ON CANVAS,
147 X 79 CM. MUSEUM OF HISTORY
AND ART, SERPUKHOV

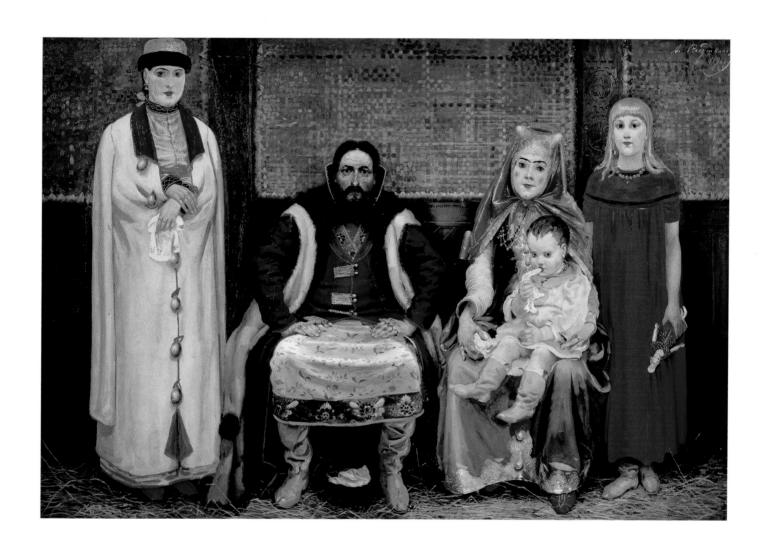

145. ANDREI RYABUSHKIN, *A MERCHANT
FAMILY IN THE SEVENTEENTH CENTURY*,
1896. OIL ON CANVAS, 143 X
213 CM. STATE RUSSIAN MUSEUM,
ST. PETERSBURG

146. (OPPOSITE) MIKHAIL NESTEROV,
TAKING OF THE VEIL, 1898. OIL ON
CANVAS, 178 X 195 CM. STATE RUSSIAN
MUSEUM, ST. PETERSBURG

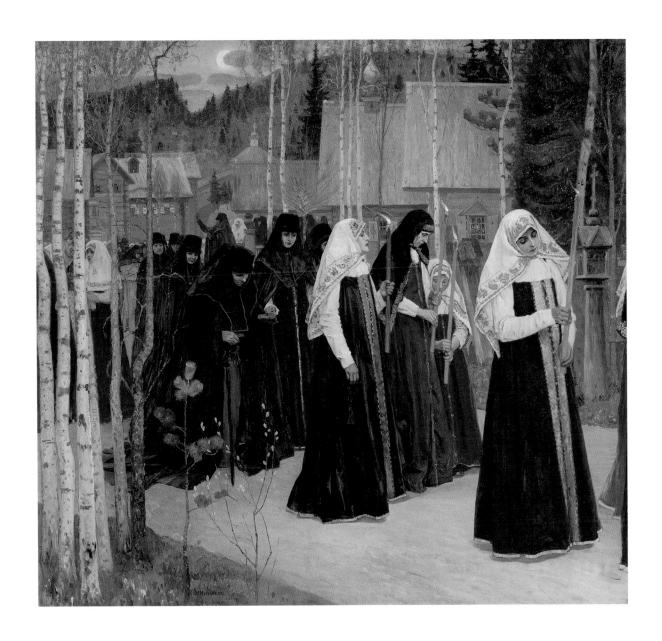

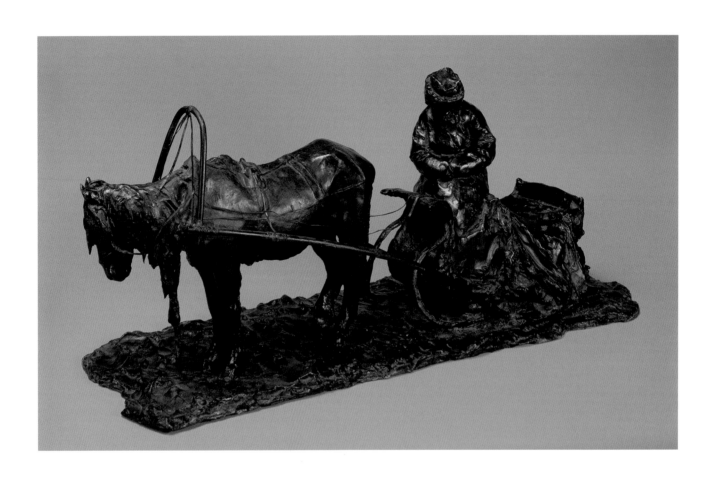

147. PAVEL TRUBETSKOY, *MOSCOW
CABMAN*, 1898. BRONZE, H. 24 CM.
STATE RUSSIAN MUSEUM,
ST. PETERSBURG

148. (OPPOSITE, LEFT) PAVEL
TRUBETSKOY, *PORTRAIT OF GRAND DUKE
ANDREI VLADIMIROVICH*, 1910. BRONZE,
H. 56 CM. STATE RUSSIAN MUSEUM,
ST. PETERSBURG

149. (OPPOSITE, RIGHT) PAVEL
TRUBETSKOY, *MARIA BOTKINA*, 1901.
BRONZE, H. 47.5 CM. THE STATE
TRETYAKOV GALLERY, MOSCOW

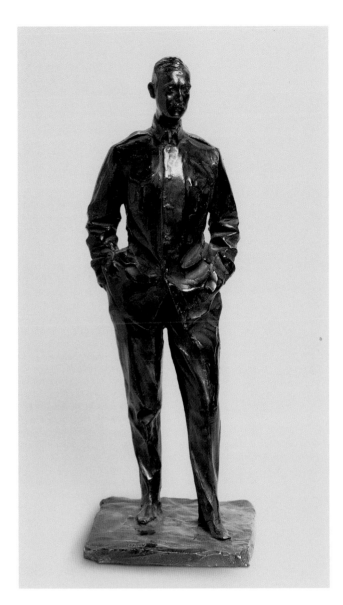

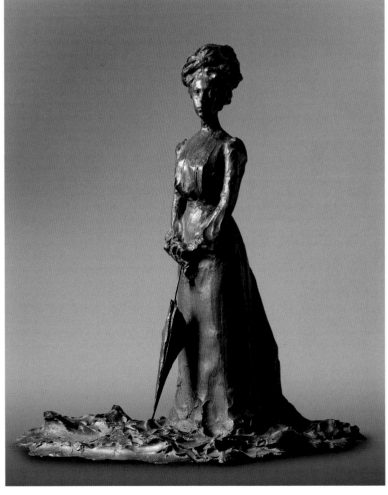

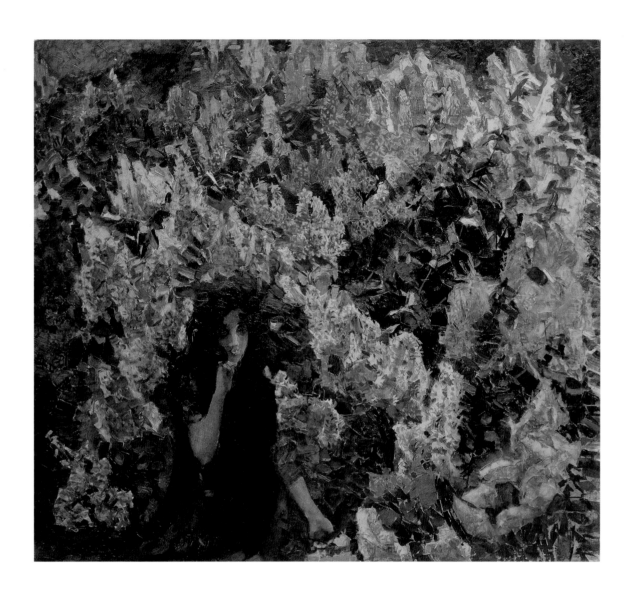

234

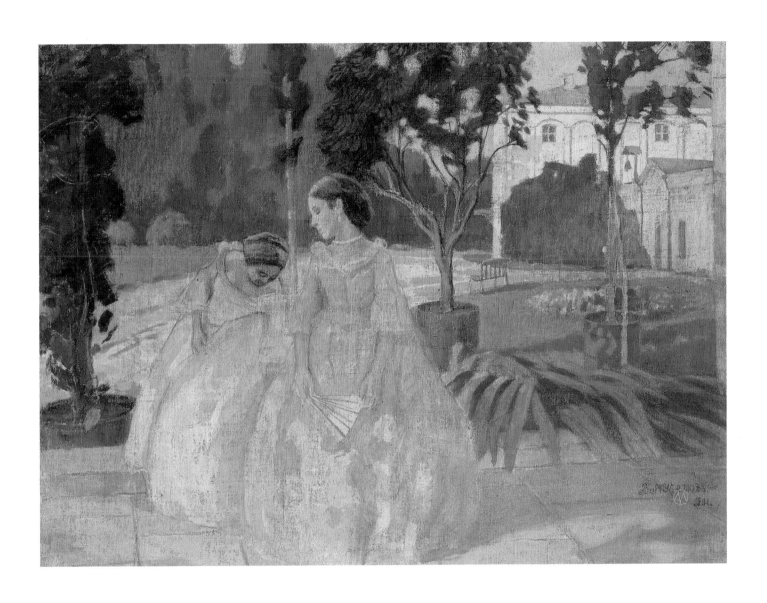

150. (OPPOSITE) MIKHAIL VRUBEL,
LILACS, 1900. OIL ON CANVAS,
160 X 177 CM. THE STATE TRETYAKOV
GALLERY, MOSCOW

151. VIKTOR BORISOV-MUSATOV,
GOBELIN, 1901. TEMPERA ON CANVAS,
103 X 141.2 CM. THE STATE TRETYAKOV
GALLERY, MOSCOW

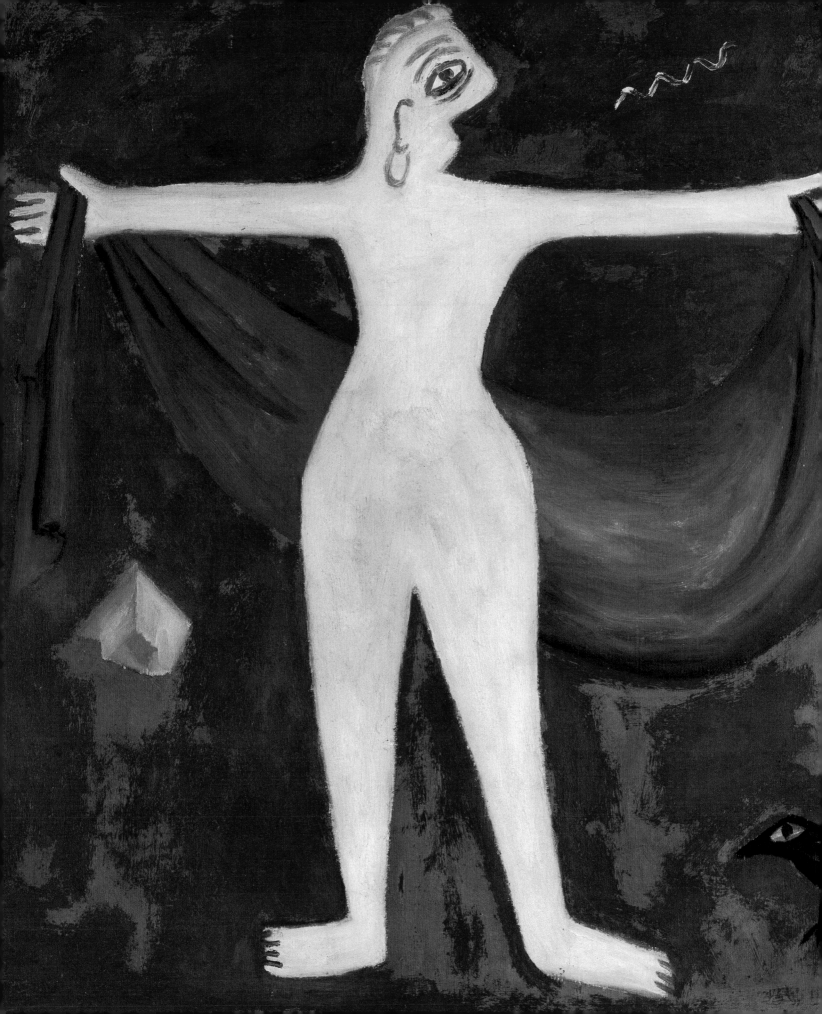

EARLY 20TH CENTURY
SHCHUKIN AND MOROZOV COLLECTIONS AND THE AVANT-GARDE

ALBERT KOSTENEVICH

The modern art of France appeared relatively late in the Hermitage. In 1904, Andrei Somov, director of the painting gallery, wrote that the paintings in the St. Petersburg museum were executed "no later than the early nineteenth century."[1] The works of the Impressionists and Post-Impressionists, as well as Henri Matisse, Pablo Picasso, and other twentieth-century masters, were acquired by the Hermitage in the 1930s and 1940s. The great majority of these works came from two extraordinary Moscow collections, those of Sergei Shchukin (1854–1936) and Ivan Morozov (1871–1921), whose ambitions were astounding even by today's standards. Both men had very similar artistic interests and belonged to the upper echelon of the trade and industrial elite.

Shchukin came from an old merchant line in Moscow and grew up in a large family where five of the six brothers became exceptional collectors. Sergei was third born, a sickly child deemed too weak to be sent to school and educated by tutors instead. In his youth, no one would have predicted that he would become the head of his father's firm, which held an important position in the Russian textile industry.

He grew up to be a strong-willed man who would go against general opinion when necessary. Shchukin's magnetism combined with an artistic sensitivity made him a great collector. His management of the mill's sales and production, and his ability to maneuver brilliantly in the domestic and international markets, earned him an excellent reputation in the financial world and the nickname "minister of commerce." In 1912 he became the head of the Moscow Merchant's Association, but his fame as a daring and enterprising businessman had come long before, during the national strike of 1905, when Sergei took advantage of the general business panic. He cornered the textile market by purchasing all existing stockpiles and then raising prices after the insurrection was over.

However, his financial success did not initially give rise to a desire to spend money on art, certainly no more than decorum required of a well-to-do businessman. The example came from his brothers, particularly Pyotr, who began collecting photographs and lithographs as a child. Later he sought out old books, engravings, documents, and ancient Russian wares, becoming a collector of unprecedented scope. While concentrating on Russian antiques, Pyotr Shchukin tried, as he put it, "to demonstrate the influence of the East and the West on Russian culture."[2]

The life of all the brothers was inextricably linked to Moscow, and only one of them, Ivan, moved in 1893 to Paris, where his apartment served as a center for the Russian art colony. Anton Chekhov, in a letter to his wife, called Shchukin an interesting man, adding that he dined with him every time he was in Paris. Ivan Shchukin's house on Avenue de Wagram was visited by Edgar Degas, Paul Durand-Ruel, Joris-Karl Huysmans, Odilon Redon, Pierre Auguste Renoir, and Auguste Rodin. Ivan treated the artists as his protégés and introduced them to his brothers. In 1898 he brought Pyotr, the revered director of his own museum, to the Galerie Durand-Ruel. As a result Pyotr's museum acquired such masterpieces

as Claude Monet's *Lady in a Garden* (1867, Hermitage) and Camille Pissarro's *Place du Théâtre Français* (1898, Hermitage), and canvases by Degas, Renoir, and Alfred Sisley.[3]

Sergei Shchukin made his first purchase of Impressionist paintings with Pyotr, perhaps prompted by his younger brother Ivan. By then Sergei had begun collecting: In the early 1890s he had acquired a number of paintings by the Russian realist Wanderers. Later embarrassed by them, Sergei sold his early collection when his interests quickly switched to the artists of Western Europe.

Concluding that the main artery of European painting ran through Paris, Shchukin decided to limit himself to the French school. But he did not embark immediately on the path that led to his fame as a collector with an infallible eye. Who now knows the names Guilloux or Maglin? Shchukin brought their paintings back from Paris in 1898, succumbing to the mysteriousness of Symbolism. But in the same year he made a wise purchase from Durand-Ruel of Monet's *Rocks at Belle-Ile* (1886, Pushkin Museum), which was considered quite daring at the time.

Enlightened society in Western Europe and Russia considered the Impressionists to be upstart charlatans, and anyone who dared to collect their works seemed an even greater charlatan in the eyes of many. Yakov B. Tugendkhold, an art critic and friend to Shchukin, wrote in 1914: "The first Monet landscapes Shchukin brought back created as much outrage as Picasso does now: no wonder a Monet painting was scribbled with a protesting pencil by one of Shchukin's guests."[4]

From the very beginning the important quality of Shchukin's approach to art was not an attempt to encompass everything, but the desire to concentrate on that which was most important. Enchanted by the Impressionists, Shchukin soon realized that the main figure of the movement was Monet, so he collected mostly his works, giving them the best room of his mansion, the music salon. No sooner had Moscow society begun to grow accustomed to Impressionism than Shchukin prepared a new blow. "Once," recalled the artist Leonid Pasternak, father of Boris, "Serov and I were at Shchukin's alone. 'I'll show you something,' he said, opening a heavy window frame and taking out his first Gauguin and then, laughing and stuttering, he added: 'A m-m-madman painted it and a m-m-madman bought it.'"[5]

By 1903–04 Shchukin's interests shifted to Post-Impressionism. He found the most daring innovators, and from that time his collection grew with the headlong development of French painting. Shchukin's collecting can be divided into three stages: the first, 1898–1904, when he concentrated on Monet; the second, 1904–10, the period of Paul Cézanne, Paul Gauguin, and Vincent van Gogh; and the last, 1910–14, with the works of Matisse, André Derain, and Picasso. The first Gauguins and Cézannes appeared in Shchukin's collection in 1903, long before the general recognition of these artists in Europe. A few years later his collection of Gauguins became the finest in the world. And in exactly the same way, by 1910 he owned a series of outstanding works by Matisse.

In 1904 Shchukin bought one of Cézanne's greatest works, *Mardi Gras (Pierrot and Harlequin)* (1888, Pushkin Museum) and *Bouquet of Flowers in a Vase* (ca. 1877, Hermitage), which were previously in the collection of Victor Choquet, the great French collector and comrade-in-arms of the Impressionists and Cézanne. A year earlier Shchukin had been

the first in Russia to acquire a Cézanne painting, *Fruits* (1879–80, Hermitage). For his part, Shchukin quickly distinguished Cézanne from the Impressionists and always "kept his eye on him," while he soon stopped acquiring Monet, Degas, and Renoir. In Cézanne's paintings Shchukin saw not only the *dernier cri* in European painting but also sensed ties to the art of ancient civilizations. "In Paris," Matisse recalled, "Shchukin's favorite pastime was visiting the Louvre's Egyptian antiquities. He found parallels there with Cézanne's peasants."[6]

In the same way, Gauguin's paintings attracted Shchukin not only by their decorative beauty and the beckoning exotica of distant Tahiti (this intrigued the indefatigable traveler, who had been to India, Palestine, and Egypt), but by their profound ties to previous eras— from the European Middle Ages to the ancient East. For the Moscow collector, his sixteen Gauguin paintings, which were given a place of honor in the formal dining room, somehow resembled the arrangements of icons in Russian churches, which were noted by the habitués of his gallery. Shchukin did not attempt to tout Gauguin as a genius right away. Aware that his artistic acquisitions would most likely be perceived as derangement, he initially hung the French master's works in rooms that were closed to visitors. "Sergei Ivanovich," recalled his close friend, the artist Sergei Vinogradov, "spared businessmen and did not shock them right away with painting fury. I remember that when he brought back the series of Gauguins from Paris he let them ripen for a long time."[7]

The addition of works by Cézanne, Gauguin, and Van Gogh to the Impressionist paintings brought his holdings on par with great European collections. Shchukin had to start thinking about turning the collection into a museum. Stunned by the sudden death of his beloved wife, Lydia, he drew up a will in January 1907 that bequeathed his entire collection to Moscow. The other tragedies that befell Shchukin around this time—the death of his son Sergei, who jumped into the Moscow River, and the suicides of his brother Ivan and his youngest son, Grigorii—changed the way he viewed his responsibilities as a collector. He decided to open his collection to the public. Whereas only well-known artists had been able to view his holdings before, his house was now open as a gallery on Sundays to all visitors free of charge.

The impact of the gallery was immediate. By 1908, Pavel Muratov noted, "Shchukin's painting gallery in Moscow belongs among the marvelous Russian art collections. It has enjoyed wide fame and just glory among artists and enlightened friends of art for a long time. Moreover, the gallery has had the most direct influence on the fate of Russian painting in recent years. It is bound to become the most powerful conductor in Russia of Western art tendencies, so vividly expressed in its works by Claude Monet, Cézanne, and Gauguin."[8]

When the above lines were written, Shchukin had already developed a special relationship with Matisse, who had become his latest passion. Russia heard echoes of the scandal of the exhibit of the Fauves at the Salon d'Automne 1905 in Paris. But that was also the period of the first Russian revolution, not the time to focus on art, and it was a while before those echoes were heeded. However, Shchukin continued to follow the course of events in the art world, and in May 1906 he asked Ambroise Vollard for Matisse's address.[9] Soon after, Matisse told Henri Charles Manguin that he had sold Shchukin a large still life that he had

Henri Matisse, Sergei Shchukin, 1912. Charcoal on white paper, 49.5 x 30.5 cm. Private collection, New York

Sergei Shchukin's house, Moscow, 1913

Shchukin's music salon, with paintings by Claude Monet and other Impressionists, 1913

found in the attic of his studio.[10] The work, *Dishes on a Table* (1900, Hermitage), attracted the collector primarily, it seems, because it illustrated Matisse's reaction to Cézanne's principles of art. Shchukin, in fact, quickly realized that Matisse was not an imitator but someone who would become the leader of a new movement. Even the public's hostile reaction to Matisse's innovations did not stop him.[11]

Matisse quickly discovered the Moscow collector was a man of rare artistic sense. The artist's opinion of Shchukin was retold by Ilya Gregorovich Ehrenburg:

He began buying my things in 1906. Very few people knew me then in France. Gertrude Stein, Marcel Sembat. That was it. They say there are artists whose eyes never make a mistake. That's the kind of eyes Shchukin had, even though he wasn't an artist but a merchant. He always collected the best. Sometimes I was reluctant to part with a canvas, I would say, "This didn't come out right, let me show you something else." He would look and finally say, "I'll take the one that didn't come out right."[12]

The appearance in Moscow of *Harmony in Red* (1908, Hermitage) and other paintings by Matisse turned Shchukin's gallery into a venue for the latest and most innovative works of the European avant-garde. But Shchukin continued his patronage of Matisse, and he commissioned *The Dance* and *Music* (both 1910, Hermitage) for his staircase, which became the culmination of his collaboration with Matisse. The creation of that ensemble, which was a great landmark in the history of European painting, was due not only to Matisse, but also to Shchukin. When the artist's son Pierre, who later became a dealer, was asked if his father would have painted panels on such a scale without Shchukin, he replied, "Why, for whom?"[13] Pierre Matisse spoke of Shchukin with the utmost respect, stressing not only the courage but also the restraint of the patron who never tried to impose anything on the painter and did not interfere in the creative process. The ideas for such important works as the Seville and Spanish still lifes and *Family Portrait* (1911, Hermitage) were suggested to Matisse by Shchukin as well. The evolution of Matisse's art, from the early still lifes to *Harmony in Red*, and then to the decorative symbolic canvases (*Game with Bowls*, 1908; *Nymph and Satyr*, 1908–09; *The Dance*; and *Music*, all Hermitage) and on to the Moroccan cycle and *Portrait of the Artist's Wife* (1913, Hermitage), had its impact on Shchukin. The formation of the collector's taste was determined by his interest in various phenomena of contemporary art, and his contacts with Matisse played an important part. Over time, Matisse became without a doubt the most prized of Shchukin's artists.

Shchukin's interest was not so much in expanding his collection in terms of completion as in having the *dernier cri* in painting. In May 1913 Matisse wrote to Shchukin about the possibility of obtaining Gauguin's most famous painting, *Where Do We Come From? What Are We? Where Are We Going?* (1897, Boston Museum of Fine Arts). The painting was in the possession of the Paris dealer Levesque, with whom Matisse was negotiating. The reply was completely unexpected: "Gauguin's paintings no longer interest me and the dealer is free to offer them to other amateurs."[14]

Shchukin's intuition told him that the truly new language of painting would come from Matisse and Picasso. He had thirty-seven paintings by Matisse and fifty by Picasso. It is

important to note that collecting for him was not merely a race to amass a large group of work but a desire to comprehend new art.

Lines from a letter informing Matisse of the arrival of *The Dance* and *Music* reveal his initial attempt to understand the works: "On the whole I find the panels interesting and hope to love them one day. I trust you completely. The public is against you, but the future is yours."[15] This is a significant confession that hints at the struggle between mind and heart. To find something "interesting" suggests possible doubt, even an ambivalence, but Shchukin knew from experience that the aesthetic sense that is alive does not remain unchanged. Similarly, when he bought his first Picasso paintings, Shchukin listened to his intuition and to some degree had to force himself to obey. Several years later Tugendkhold would write, "Let us for the time being follow Shchukin's example, who even when he does not understand Picasso says, 'He's probably right and I'm not.'"[16]

From the moment the Shchukin house opened its doors to the public, it became a museum to new painting, an exhibition hall (some paintings ended up there straight from the studios), and also a sort of training ground for young artists. These students, most of them from the Moscow School of Painting, Sculpture, and Architecture, became the gallery's most ardent visitors. Shchukin often acted as guide in his museum, and his fiery, stuttering explanations made the young artists' heads spin. The conflict between students and instructors, who were already losing their authority in the eyes of their charges, was fanned by the examples of work the young artists saw at Shchukin's, and which they readily reinterpreted. Graduates of the school, the artists of the Jack of Diamonds group, took up the cause of decorative folk arts (signs, trays, prints, engravings, and so on). Natalia Goncharova and Mikhail Larionov, just like Vasily Kandinsky or Kazimir Malevich, felt they were pioneers of the new art and looked back at folk culture in an attempt to grasp the profound essence of things. Shchukin developed the same attitude toward non-professional, "untaught" art.

Shchukin was the first major collector to purchase paintings by Henri Rousseau, which seemed strange even to the most enlightened appreciators of his tastes. But Shchukin realized that Rousseau was not merely a "Sunday painter," and his sense of color and arabesque gave him the right to expect a place in art history. The seven Rousseau paintings collected by Shchukin between 1910 and 1913 form a unique group.

The Moscow collector also had an early understanding of the prophetic nature of Picasso's art. It is believed that they were introduced by Matisse, who brought his Russian patron to the Bateau-Lavoir in September 1908. The next year, Shchukin bought his first painting by Picasso, seeing that he had become Matisse's main rival for the leadership of the French avant-garde. Becoming more aware of the significance of the young Spanish painter's work, and watching his latest steps very closely, Shchukin started hunting for Picasso's early works, which he would not have done for a lesser painter. His treatment was analogous for Derain, a younger contemporary artist whom he considered to be one of the era's leading painters after Matisse and Picasso. Shchukin saw Picasso as Matisse's antipode not only aesthetically but psychologically as well. Matisse brought joy and peace to the viewer. Picasso's paintings revealed visions of hell, eternal longing, and inevitable tragedy, but they also offered catharsis and purification through compassion.

Shchukin's dining room, with paintings by Paul Gauguin and Henri Matisse, 1913

Shchukin's Picasso room, 1914

After Shchukin's personal tragedies, he had no fear of representations of death. On the contrary, he sought them out, purchasing Picasso's *Composition with Skull* (1908, Hermitage) and a study for it, as well as Derain's *Still Life with a Skull* (1912, Hermitage).

When he moved on to Cubism, Picasso turned away from plot and psychological foundations, reducing the living multiplicity of the world to two-dimensional geometric shapes. In paintings such as *Three Women* (1908, Hermitage), he transformed the tragic to another plane.

Picasso's still lifes, from *Composition with Skull* to *Violin and Guitar* (ca. 1912, Hermitage), are not so much an impression of things as an investigation into the essence of people and objects. Impressionism was the culmination of the development of nineteenth-century painting and its main achievement. In Picasso's Cubist still lifes, the best of which were collected by Shchukin, Impressionism is not corrected, as in Cézanne's works, but excluded completely. The air, the flickering light, the complex modulations of color—all are decisively rejected. The break with the nineteenth century is most clearly seen in Picasso's intentional deconstruction and reassembly of form.

The greatest masterpiece of the Shchukin collection is Picasso's *Three Women*, a monumental work of Cubism. In a world filled with confusion, the painting expressed a longing for harmony. Its pyramidal construction is a formula for stability tested by the millennia, but only as rendered by Picasso does it paradoxically serve the theme of movement. *Three Women* appeared in the Shchukin mansion in late 1913 or early 1914. As soon as the collector heard that Gertrude Stein was parting with it he acted quickly to obtain the painting. From that moment until mid-1914, Shchukin acquired two dozen Picassos. On June 18, 1914, Daniel-Henry Kahnweiler wrote a letter offering nine works by Picasso, but Shchukin could not purchase them at that point. Soon after, World War I broke out, which put an end to his collecting.

Around the same time Sergei and Pyotr Shchukin began collecting in earnest,[17] Mikhail Morozov took an interest in the new French painting, thus paving the way for the collecting of his younger brother, Ivan. Their unusual family history is traced to their ancestor, the serf Savva Morozov, who was given permission by the estate owner to open a silk ribbon factory in 1797. The starting capital was five rubles from his wife's dowry. An astute businessman, Savva managed to buy his freedom. And through the efforts of subsequent generations, the family turned into one of the most powerful industrial dynasties in Russia by the end of the nineteenth century.

Mikhail Morozov (1870–1903) was an original, of the kind that even Moscow, famous for its striking individuals, did not often see. He was a scholarly historian, journalist, novelist, collector, bon vivant, wastrel, gentleman, a reveler who threw vast amounts of money to the wind, and a merchant who haggled over small sums because buying low was a matter of principle. He had energy enough for several men. "His collection, created in some five years," wrote Sergei Diaghilev in his obituary, "was added to annually by artworks brought from abroad and bought in Russia. I can imagine what a gallery the collection would have grown into if death had not cut off this good beginning."[18] Morozov owned a rare Renoir masterpiece, *Portrait of the Actress Jeanne Samary* (1878, Hermitage), and he apparently discovered Gauguin even before Sergei Shchukin. He was the first in

Russia to pay attention to the artists of the Nabis circle and to Louis Valtat, whom other European collectors did not notice.

Mikhail's brother, Ivan, began his personal collection later than the others of his circle, even though his attraction to the world of art began very early, when he and Mikhail took painting lessons from the young Konstantin Korovin, who became the most noted Russian Impressionist. After graduating from the Polytechnical Institute in Zurich in 1892, he returned to Russia, settling not in Moscow but in Tver to manage the family's huge textile factories there.

Mikhail Morozov, ca. 1900

Upon his return to Moscow eight years later, Ivan Morozov started living extravagantly and buying paintings. At first he collected only Russian works. Canvases by Alexander Benois, Konstantin Korovin, Isaak Levitan, Valentin Serov, Konstantin Somov, and Mikhail Vrubel— the same ones that Mikhail Morozov collected. In time the list expanded to include artists such as Marc Chagall, Goncharova, Pavel Kuznetsov, Larionov, and Ilya Mashkov, but not Kandinsky or Malevich; Ivan Morozov was not interested in such radical works. At the time his purchases stopped, his collection of Russian art contained more than 300 works (most are now in the State Tretyakov Gallery, Moscow).

Ivan Morozov's purchase of Alfred Sisley's *Frost in Louveciennes* (1873, Hermitage) in 1903 was the foundation of his greatest collection, French art. After his brother's untimely death, he continued acquiring new work, intending to build a gallery representing the new French painting on the level of Shchukin's.

From the beginning Morozov did not concentrate on a single artist or even a single group. His field of vision included all French painting from 1880, and he acted with such scope that he often surpassed Shchukin himself. "The Russian who does not haggle," Vollard called him. But not haggling did not mean acting rashly. This Russian treated collecting more thoughtfully than most. "Barely off the train," wrote Félix Fénéon, a critic and director of the Galerie Bernheim-Jeune,

> He would be installed in an art store's armchair, low and deep to keep the art lover from getting up while canvases pass before him in succession like episodes in a film. In the evening, Monsieur Morozov, a singularly attentive viewer, would be too tired to go even to the theater. After days of this regimen, he would return to Moscow having seen nothing but paintings; and he carried some with him, the most choice.[19]

Dreaming of his future museum, Morozov came up with a radical plan to remodel his mansion. The renovation was completed in 1907, which proved to be a watershed year for him. Far-reaching plans were evident in his comprehensive purchases, and his persistence was accompanied by luck. At the Galerie Durand-Ruel, Morozov found Monet's *Corner of the Garden at Montgeron* (ca. 1876, Hermitage). Around the same time, in Vollard's storage, he found a rather grubby rolled canvas of the exact same size (Vollard asked a fourth of the price) and realized that this *Pond at Montgeron* (ca. 1876, Hermitage) belonged with *Corner of a Garden* to a single decorative series. This was the start of that special part of the Morozov collection that encompassed unique large-scale decorative suites by French masters.

Valentin Serov, Portrait of Ivan Morozov, 1901. Tempera on board, 63.5 x 77 cm. The State Tretyakov Gallery, Moscow

In 1907 Morozov acquired his first canvases by Cézanne, Gauguin, and Van Gogh. Without showing preference for any of them, he sought out the best of their works. By then Sergei Shchukin had gone far ahead and it seemed that competing with him would be impossible, especially in terms of Gauguin. However, in just a year's time Morozov owned eight outstanding works by Gauguin (he eventually collected eleven). He had a group of paintings to rival Shchukin's. The works were not as homogeneous but no less exquisite in terms of quality.[20] Morozov's Gauguins are not merely beautiful but distinguished by their lyricism.

The significance that the posthumous exhibition of Cézanne at the Salon d'Automne of 1907 had for the fate of French, and then European, art was enormous. One of the most attentive visitors was Morozov.[21] It was then that he bought his first four Cézannes, including the astonishing *Still Life with Drapery* (ca. 1894–95, Hermitage). Sergei Makovsky, author of the first description of the Morozov collection, wrote:

Cézanne's soul was expressed best, perhaps, in the paintings without content, in the natures-mortes. Depicting countless times the same fruits and tableware, endlessly varying the same theme, apples, pears, or peaches vividly spotting the blue whiteness of a crumpled tablecloth, free of compositional problems, intoxicated by the unquenchable thirst "to imitate nature," he approached it up close; staring into its simplest obviousness, so to speak, and tried to fix with his brush not so much the objectness of "dead nature" and not so much its essence as the very structure of its charms.[22]

An outstanding example of the collector's planning and patience is Cézanne's *Blue Landscape* (ca. 1904–06, Hermitage), one of his favorite paintings. "I remember that on one of my early visits to the gallery," Makovsky wrote,

I was surprised by an empty space at the edge of a wall filled with works by Cézanne. "That spot is intended for a 'blue Cézanne'" (i.e., for a landscape of the artist's final period), Ivan Morozov explained to me. "I've been looking for one for a long time, but I can't make up my mind." That Cézanne spot was empty for more than a year, and only recently a new, marvelous "blue" landscape, selected out of dozens, took its place next to the previous selections.[23]

Morozov took his time when it came to acquiring the work of the great masters. His eye had become extremely fine-tuned and yet he still felt a certain lack of confidence. He needed the advice of an artist friend or dealer he trusted as additional impetus. "When Morozov went to see Ambroise Vollard," Matisse recalled, "he would say: 'I want to see a very good Cézanne.' Shchukin, he wanted to see all the Cézannes that were on sale and made his own selection."[24] Both methods were good because they suited the personalities of the collectors. For Cézanne, where a particular caution was required, the second method seemed to give better results. Morozov could trust Vollard in this case: however shrewd he may have been, he would not have dared offer the Moscow collector anything less than an extraordinary Cézanne. Without a doubt, in the early twentieth century, Morozov's ensemble of eighteen masterpieces by Cézanne was the best in the world, even though other collections, for

example the Paris collection of Auguste Pellerin, had more works. Morozov was justly proud of his collection, and when he was asked which painter he loved best, he named Cézanne.[25]

While Shchukin's collecting progressed in waves, with each crest greater than the last, Morozov proceeded in a different way. He built a more substantial collection, occasionally perhaps losing a piece he wanted, but in the final analysis achieving his goal, the planned vision of an ideal gallery of the latest painting.

Morozov's caution was part of his character. Stone by stone he built the gallery, leaving space not only for a "blue Cézanne" but for Edouard Manet, whom he considered one of the main pillars of the new painting. But he didn't want simply a Manet and not even a Manet of the highest quality, he wanted one of the best landscapes by the master, one that would reveal his ties with Impressionism. Morozov did not take great interest in *Bar at the Folies-Bergère* (1881–82, Courtauld Institute, London). He could have bought it at the *One Hundred Years of French Painting* exhibition in 1912 in St. Petersburg (Morozov was on the honorary committee).

Many people knew of Morozov's desire to obtain a Manet landscape, and at one point he enlisted the help of the art critic Valentin Serov. Manet's wonderful landscape *The Rue Mosnier with Flags* (1878, J. Paul Getty Museum, Los Angeles) was owned by Pellerin, who decided to sell his Manets and Impressionists in order to acquire works by Cézanne. Vollard immediately wrote to Morozov in Moscow, offering him the landscape. Morozov asked Serov, who was in Paris, to help. The latter, however, decided the work was "not interesting." Morozov highly valued the opinion of Serov, with whom he frequently attended Paris exhibitions; thus he declined Vollard's offer. Although it was a mistake not to purchase the landscape, it should be noted that not every suggestion Serov made was wrong. It was on his recommendation that the famous *The Red Vineyards at Arles* (1888) and *Prisoners' Round* (1890, both in the Pushkin Museum) were purchased from the Van Gogh exhibit at the Druet gallery in Paris.

However, when Morozov was not dealing with the founders of the new art, but with the most contemporary painters, he was more decisive. As early as 1907, his collection included *Bouquet (Two-Handled Vase)* (1907, Hermitage), just off Matisse's easel, soon to be followed by *Blue Pot and Lemon* (1897, Hermitage), which were the start of Morozov's unique group of the artist's still lifes. At the same time he acquired Maurice de Vlaminck's *View of the Seine* (ca. 1906, Hermitage), and Derain's *Drying the Sails* (1905, Pushkin Museum). Such works were often bought at exhibitions and were not expensive. For example, *Mountain Road* (1907, Hermitage) by Derain was bought at the Salon des Indépendants in 1907 for 250 francs. And with the purchase of Vlaminck's *View of the Seine*, one of the best Fauve landscapes, Vollard threw in some other works for free. Although Vollard was never known for his altruism, he had a special relationship with Morozov and Shchukin. For Vollard and Kahnweiler, collaboration with such collectors was proof of their own success in the fight for the new art. As the two burgeoning Moscow collections turned into actual museums, dealers wanted the truly marvelous works that passed through their hands to populate them.

The relationship between Shchukin and Morozov was unique. Although he gave Morozov his due for collecting the classics of the new art, Shchukin was aware of his own

Ivan Morozov's house, now the Academy of Fine Arts, Moscow

Morozov's Cézanne room, 1923

superiority in terms of obtaining the masters of the twentieth century. For it was Shchukin who had brought his younger colleague to Matisse's studio and later to Picasso's. He could not always understand Morozov's vacillations, but he had to respect them. Occasionally, they attended exhibits together in Paris, and even though there was still an element of rivalry, it took a back seat: both knew that they were serving the same ideal. Morozov could not be accused of lacking boldness. Otherwise why would he have become interested so early in the Fauve paintings? It is only in comparison to Shchukin that he seems indecisive. Morozov's style of collecting was certainly not static, but if there was an opportunity to fill a lacuna in the part of his collection that was considered the "classics" of the new art, he did not pass it up. For Shchukin, who was always trying to stay at the forefront of collecting, the classics were an overturned page.

The two men were different people,[26] even though they were united by a single passion. "The more expansive Shchukin liked 'to divine' an artist and 'launch' him into the world. He was attracted by the element of risk and pleased by the astonishment of numerous visitors; cautious and reserved, Morozov did not rush after the latest experiments of the innovators so much as try to create a clear and full presentation of the era just past," said the artist/writer Boris Ternovets.[27] "Perhaps it should be put this way," wrote Abram Efros, one of the most talented Russian critics of the early twentieth century:

> At Shchukin's, Parisian celebrities of the brush always appeared as if on stage, in full make-up and tension; to Morozov they came more quietly, intimately, and transparently. When a new reputation was just beginning to roll its thunder in Paris, Shchukin in an expansive gesture gathered up everything he could and took it to Moscow, grinning when the neophyte in Paris quickly turned into a master and his works were already "at Shchukin's in Znamensky Lane." Morozov, on the contrary, sought out choosily and at length something that he alone saw in a new artist and selected it at last, and in making the selection always added his own golden "correction." "A Shchukin master with Morozov's correction." I would call that the classic formula of our collecting of the new Western art.[28]

Shchukin kept to the major line of French painting, which went, according to him, from the Impressionists to Cézanne, Van Gogh, and Gauguin, and then to Matisse and Picasso. Fringe artists such as the Nabis did not interest him. Morozov behaved differently, and sought out those artists, which allowed him to find rare treasures by Pierre Bonnard, Maurice Denis, and Ker Xavier Roussel.

The first paintings by Bonnard appeared in the mansion on Prechistenka Street in Moscow back in 1906. The thirteen of his works that form the Morozov collection are indisputably among the outstanding achievements of French painting. *Train and Barges* (1909, Hermitage), *Early Spring* (1909, Hermitage), and *Evening in Paris* (1911, Hermitage), carry the master's soft voice, the special lyricism that belongs to him alone, and a charming slyness. It was to Bonnard that Morozov turned when he decided to install decorative panels on the main staircase of his house. The artist's work did not seem to have monumental qualities, but his large triptych *On the Mediterranean* (1911, Hermitage) became an outstanding achievement in decorative painting. Bonnard had never been to Moscow and the photograph

of the staircase probably did not give him a very clear impression of the architectural space (divided into three parts by two half-columns) that he had been commissioned to orna-ment.[29] We can only marvel at how well Bonnard "got it" with his triptych. When Morozov, delighted by the triptych, commissioned an additional two panels, Bonnard selected his customary themes of early spring and ripe autumn. Thus "brackets" were formed for the main part, the triptych where summer reigned, and the whole ensemble depicted the cycles of the seasons.

In Shchukin's collection Matisse and Picasso were sharply in the lead, and Morozov con-sciously avoided such preferences for particular artists. He had only three works by Picasso, but each was a masterpiece. The first was *Harlequin and His Companion* (1901), offered by Vollard for the modest sum of 300 francs. At the time, Picasso was on the periphery of the collector's attention, but five years later he acquired two great works by the master: *Young Acrobat on a Ball* (1905), the best composition of the pink period, which previously belonged to Gertrude Stein, and *Portrait of Ambroise Vollard* (1910), the highest expression of Cubism in a portrait. (All three paintings are now in the Pushkin Museum.)

The growth of the collections of Ivan Morozov and Sergei Shchukin was brought to a halt by the start of World War I, when both men faced more serious trials. The nationaliza-tion by the state of various industries, undertaken by the Soviet regime in the early summer of 1918, convinced Shchukin that the owners of these enterprises would suffer grave conse-quences. Shchukin, having already been arrested and imprisoned for a few days, decided that remaining in Russia was dangerous. That summer he secretly sent his wife and daughter to Germany. As soon as he heard that they had crossed the border safely, Shchukin followed them by a prohibited route.

In the meantime, Moscow underwent restructuring of its museums. After nationalizing royal palaces and monasteries, the people's commissars turned to the major private collec-tions. The first to go was Sergei Shchukin's gallery. On November 5, 1918, a decree was pub-lished in the newspaper *Izvestia*, signed by Chairman of the Council of People's Commissars, Vladimir Lenin. Shchukin's gallery became the First Museum of Modern Western Painting, and Morozov's the Second. Morozov was appointed assistant curator and managed to obtain permission in 1919 to travel abroad for medical treatment. It appears he settled in Germany, then made a trip to Paris and from there to Carlsbad, where he died soon after.

In Russia, after the first stage of museum reform came additional restructuring, and in 1923 the Shchukin and Morozov collections were combined. The new museum thus formed, called the State Museum of Modern Western Art, was given paintings from several other nationalized collections as well as the paintings of Western European masters that had been donated to the State Tretyakov Gallery by Margarita Kirillouna Morozova, widow of Mikhail Morozov.

However, soon after all the new Western European paintings were concentrated at the Morozov mansion, the State Museum of Modern Western Art had to relinquish some of the works, which were moved to the Hermitage in an exchange between Moscow and Leningrad. The timing of the first exchanges, on the eve of the 1930s, coincided with a tragic period in the life of museums in both cities, with secret sales to the West of the

best works. A certain inconvenience for these sales was created by the émigrés whose collections were nationalized. "It was even said that Shchukin was planning to get back his collections through the courts," said Pavel Buryshkin. "I remember that when I asked Shchukin whether that was true, he grew very agitated. He always stuttered, but here it got much worse, and he said: 'You know, Pavel, I collected not only for myself but also for my country and my people. Whatever happens in our homeland, my collections must remain there.'" [30]

The State Museum of Modern Western Art, the first museum of avant-garde art in the world, existed until 1948, when it was liquidated by a secret decree from Joseph Stalin. The collections were divided between the Pushkin Museum of Fine Arts and the Hermitage. The Hermitage received ninety-three paintings in the early 1930s and more than one hundred and fifty in 1948. After that, the Hermitage collection of French painting of the second half of the nineteenth century and the early twentieth century became so significant that it gave as good an assessment of the important phenomena of that period as the paintings long in the museum did of the art of the old masters. Along with paintings from the Shchukin and Morozov collections, the Hermitage received paintings by Léger, André Lhote, Amédée Ozenfant, and Léopold Survage, among others from the 1920s, collected by the Museum of Modern Western Art.

Fantastically enriched, the Hermitage could not display a single work from the State Museum of Modern Western Art. Exhibiting Modern art was virtually an act of suicide in those days of rigorous censorship by the Communist government. They stayed in the storerooms for a long time, where they could be seen by a few artists who had connections among the curators and a very few Western specialists who obtained permission. This art gradually became accessible to viewers beginning in the mid-1950s, after Stalin's death. First to be released were the works by the Impressionists, then Cézanne, Van Gogh, and Gauguin. In the late 1950s many works by Matisse and Picasso were still in storage. Several other works, given to the Hermitage on orders from the Ministry of Culture, were added to them. For instance, Léger's *Postcard* (1932–48, Hermitage) came to Moscow; the master's students, who were devout Communists, presented it with the best intentions to Stalin, somehow unaware that he could not tolerate that style of painting.

At the start of the next decade the majority of works formerly considered the "new painting" was exhibited in the museum. At that time the paintings that had belonged to Shchukin and Morozov began traveling abroad, and their life at the Hermitage took on new meaning.

Translated from the Russian by Antonina W. Bouis.

1. Brockhaus and Efron, *Encyclopaedic Dictionary*, vol. 81 (St. Petersburg, 1904), pp. 38–39.
2. Pyotr Shchukin, quoted in *The Shchukin Museum over Its Eighteen-Year Existence (1892–1910)* (Moscow, 1910), p. 1.
3. Later, in 1912, Pyotr's brother Sergei bought these paintings for his own gallery.
4. Yakov A. Tugendkhold, "Frantsuzskoe sobranie S. I. Shchukina," *Apollon* 1–2 (1914), p. 6.
5. Leonid Pasternak, *Zapiski raznykh let* (Moscow: Sovetskii khudozhnik, 1975), p. 63. He means, undoubtedly, *Wife of the King*, now at the Pushkin Museum, Moscow, even though this was not the first work by Gauguin that Shchukin acquired.

6. "Matisse parle à Tériade," *Art News Annual*, no. 21 (1952); reprinted in *Henri Matisse: Ecrits et propos sur l'art*, ed. Dominique Fourcade (Paris: Hermann, 1972), p. 118.

7. A. S. Vinogradov, "S. I. Shchukin. Pamyati primechatelínogo moskovskogo kollektsionera," *Segodnya*, no. 19 (January 19, 1936).

8. P. P. Muratov, "Shchukinskaya galereya," *Russkaya myslí*, no. 8bm (1980), p. 116.

9. Judi Freeman, *The Fauve Landscape*, exh. cat. (Los Angeles: Los Angeles County Museum of Art; New York: Abbeville Press, 1990), p. 116.

10. Ibid., p. 92.

11. I would like to quote a Russian artist, who wrote from Paris about the opening of the Salon d'Automne of 1907: "In one room Matisse reigns and the public at the opening laughs uncontrollably in there." M. Yu. Shapshal, a student of Leonid Pasternak, to P. D. Ettinger, September 30, 1907, in Ettinger, *Statíi. Iz perepiski. Vospominaniya sovremennikov* (Moscow: Sovetskii khudozhnik, 1989), p. 104.

12. I. G. Ehrenburg, *Lyudi, gody, zhizni*, vol. 5 (Moscow, 1966), p. 427.

13. Beverly White Kean, *French Painters, Russian Collectors: The Merchant Patrons of Modern Art in Pre-Revolutionary Russia* (London: Hodder & Stroughton, 1994), p. 161.

14. Sergei Shchukin to Henri Matisse, May 14, 1913, in *Matisse et la Russie*, eds. Albert Kostenevich and Natalia Semionova (Paris: Flammarion, 1993), p. 174.

15. Shchukin to Matisse, December 20, 1910, ibid., p. 168.

16. Tugendkhold, p. 30.

17. There is no precise data on when Mikhail Morozov began collecting paintings.

18. Sergei Diaghilev, "Mikhail Abramovich Morozov," *Mir iskusstva*, no. 9 (1903), p. 141.

19. Félix Fénéon, "Les grands collectionneurs," *Bulletin de la vie artistique* (1920), p. 355.

20. Alfred Barr, *Russian Diary: Defining Modern Art. Selected Writings of Alfred H. Barr, Jr.* (New York: Harry N. Abrams, 1986), p. 116. Subsequently Barr, founder of the Museum of Modern Art, New York, got to know both galleries, Shchukin's and Morozov's, and even preferred Morozov's Gauguins.

21. The Pushkin Museum archives has a copy of the catalogue of this exhibition with Ivan Morozov's comments.

22. Segei Makovsky. "Frantsuzskie khudozhniki iz sobraniya Ivan A. Morozova," *Apollon* 3–4 (1912), p. 11.

23. Ibid., pp. 5–6.

24. Fourcade, p. 119.

25. Fénéon, p. 356.

26. Kean, p. 102. Marguerite Duthuit, Matisse's daughter, recalled that Ivan Morozov was bluff, genial, and kindly, while Matisse characterized Shchukin, she said, as a perspicacious, refined, and very serious man.

27. Boris Ternovets, "Sobirateli i antikvary proshlogo. Ivan A. Morozov," *Sredi kollektsionerov* (Moscow), no. 10 (1921), p. 41.

28. Abram Efros, "Chelovek s popravkoi. Pamyati Ivan A. Morozova," *Sredi kollektsionerov* (Moscow), no. 10 (1921), pp. 3–4.

29. Bonnard's triptych *La Mediterranée* was shown abroad for the first time, at The Art Institute of Chicago and The Metropolitan Museum of Art, New York, in the 2001 exhibition *Beyond the Easel: Decorative Painting by Bonnard, Vuillard, Denis, and Roussel, 1890–1930*.

30. P. A. Buryshkin, *Moskva kupecheskaya* (Moscow: Sovremennik, 1991), p. 148.

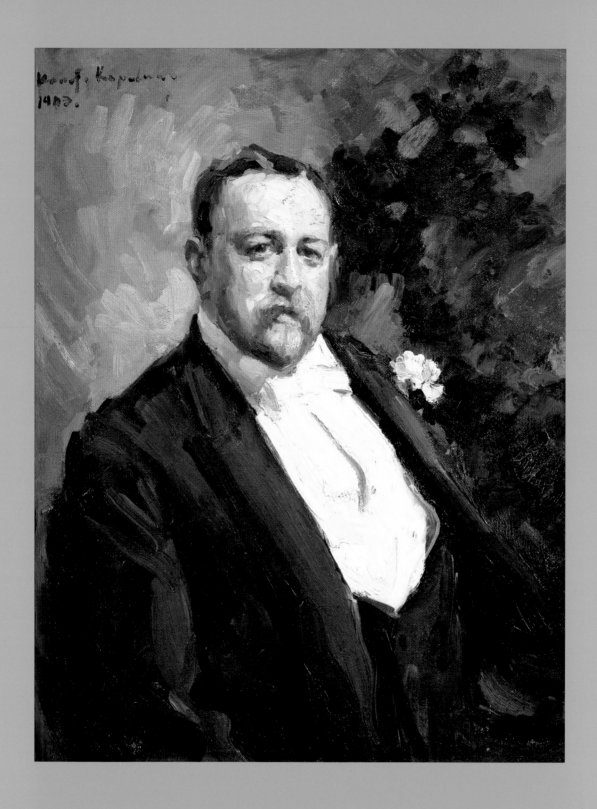

152. KONSTANTIN KOROVIN, PORTRAIT
OF IVAN MOROZOV, 1903. OIL ON
CANVAS, 90.4 X 78.7 CM. THE STATE
TRETYAKOV GALLERY, MOSCOW

153. CHRISTIAN CORNELIUS KROHN,
PORTRAIT OF SERGEI SHCHUKIN, 1915.
OIL ON CANVAS, 97.5 X 84 CM. STATE
HERMITAGE MUSEUM, ST. PETERSBURG

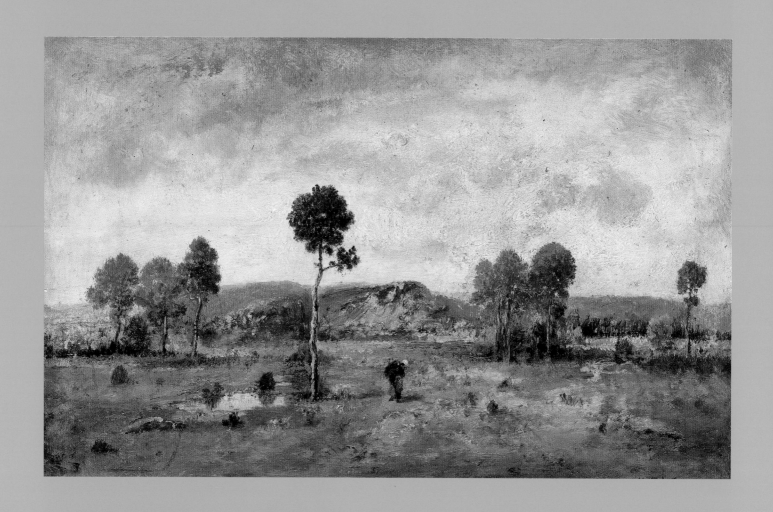

154. NARCISSE DIAZ DE LA PEÑA,
LANDSCAPE WITH A PINE TREE, 1864. OIL
ON PANEL, 21.5 X 33.5 CM. STATE
HERMITAGE MUSEUM, ST. PETERSBURG

155. (OPPOSITE) CLAUDE MONET,
POPPY FIELD, LATE 1880S. OIL ON
CANVAS, 60.5 X 92 CM. STATE
HERMITAGE MUSEUM, ST. PETERSBURG

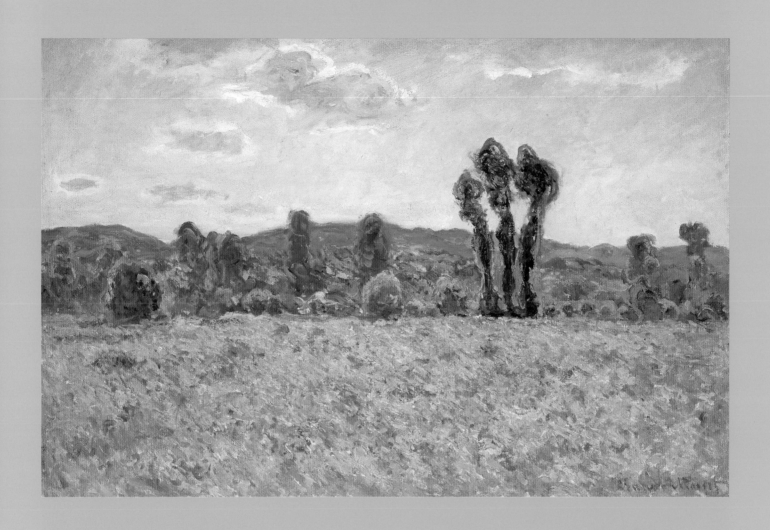

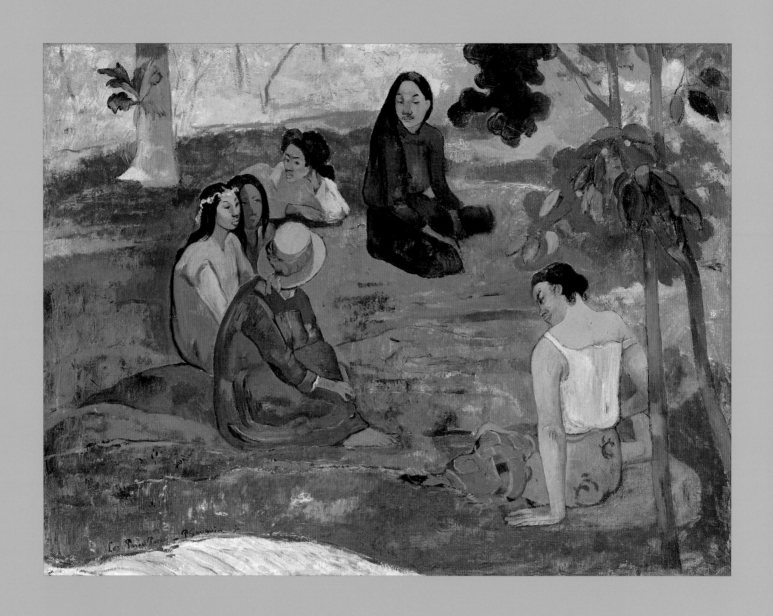

156. PAUL GAUGUIN, *CONVERSATION*
(LES PARAU PARAU), 1891. OIL ON
CANVAS, 70.5 X 90.3 CM. STATE
HERMITAGE MUSEUM, ST. PETERSBURG

157. (OPPOSITE) PAUL CÉZANNE,
LADY IN BLUE, CA. 1900. OIL ON
CANVAS, 90 X 73.5 CM. STATE
HERMITAGE MUSEUM, ST. PETERSBURG

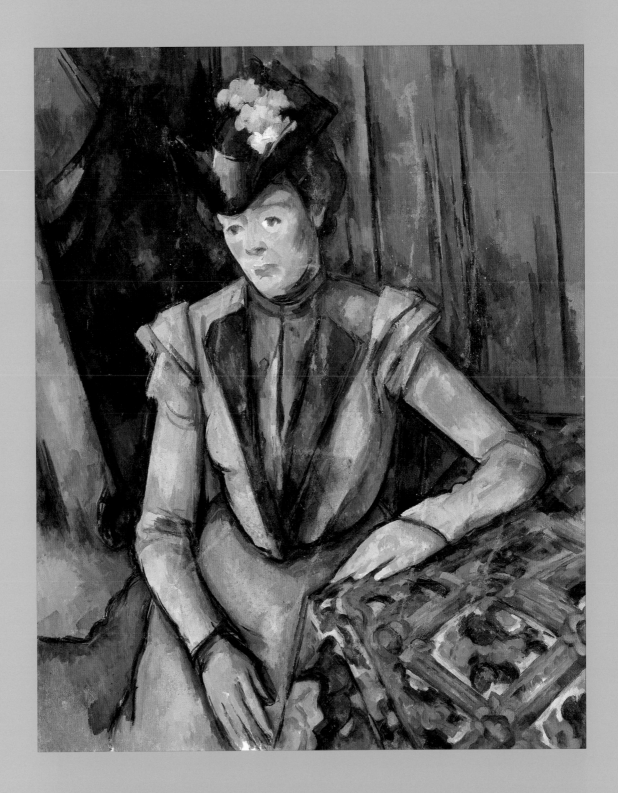

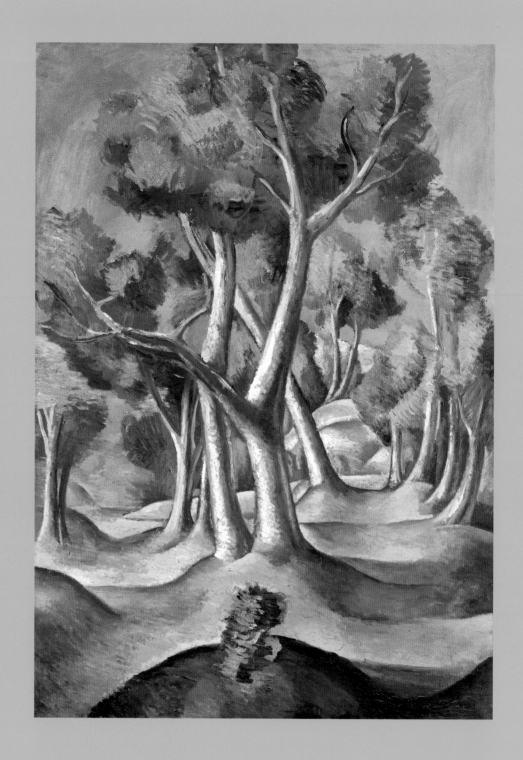

158. ANDRÉ DERAIN, *THE WOOD*,
1912. OIL ON CANVAS, 116.5 X
81.3 CM. STATE HERMITAGE MUSEUM,
ST. PETERSBURG

159. (OPPOSITE) MAURICE DE
VLAMINCK, *SMALL TOWN ON THE SEINE*,
CA. 1909. OIL ON CANVAS, 81.3 X
100.3 CM. STATE HERMITAGE MUSEUM,
ST. PETERSBURG

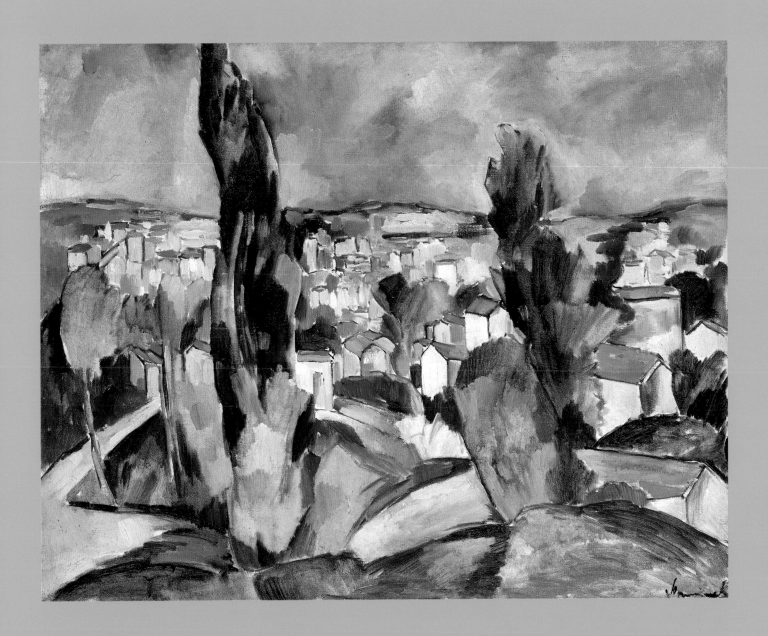

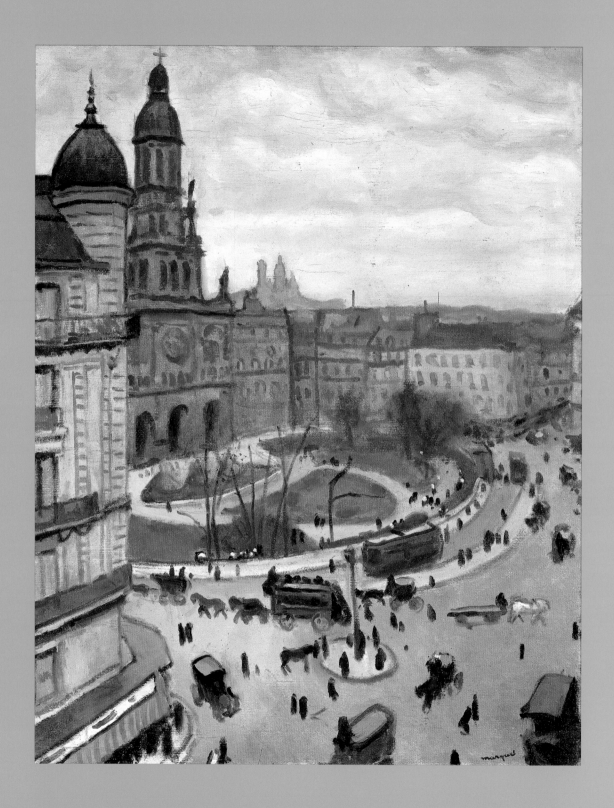

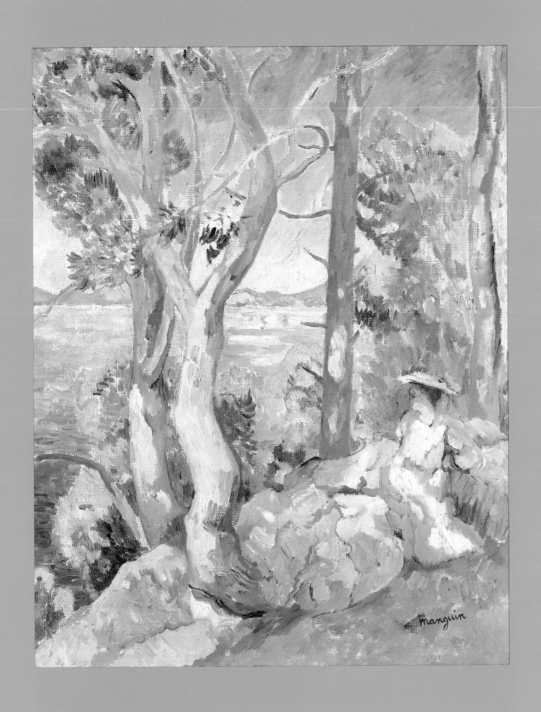

160. (OPPOSITE) ALBERT MARQUET,
PLACE DE LA TRINITÉ IN PARIS, CA. 1911.
OIL ON CANVAS, 81 X 65.5 CM. STATE
HERMITAGE MUSEUM, ST. PETERSBURG

161. HENRI CHARLES MANGUIN,
MORNING AT CAVALIÈRE, 1906. OIL ON
CANVAS, 81.5 X 65 CM. STATE
HERMITAGE MUSEUM, ST. PETERSBURG

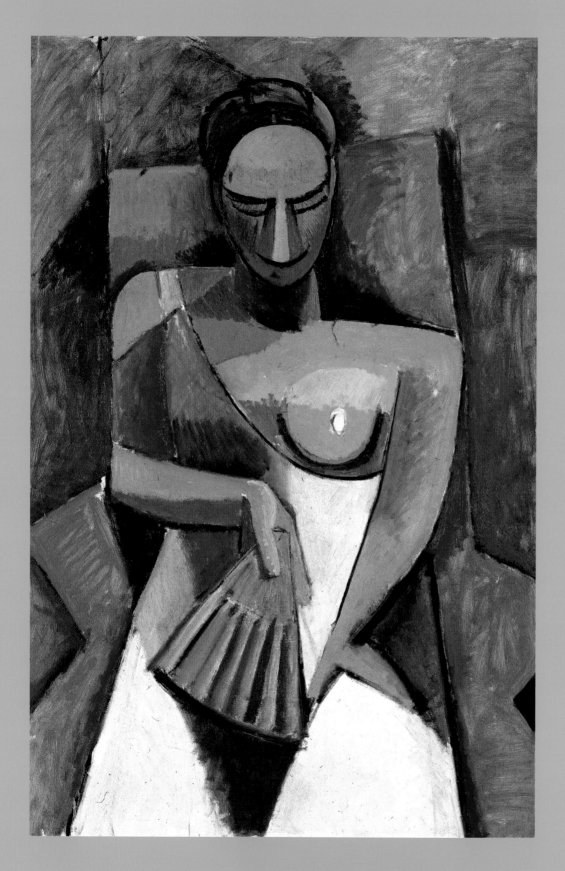

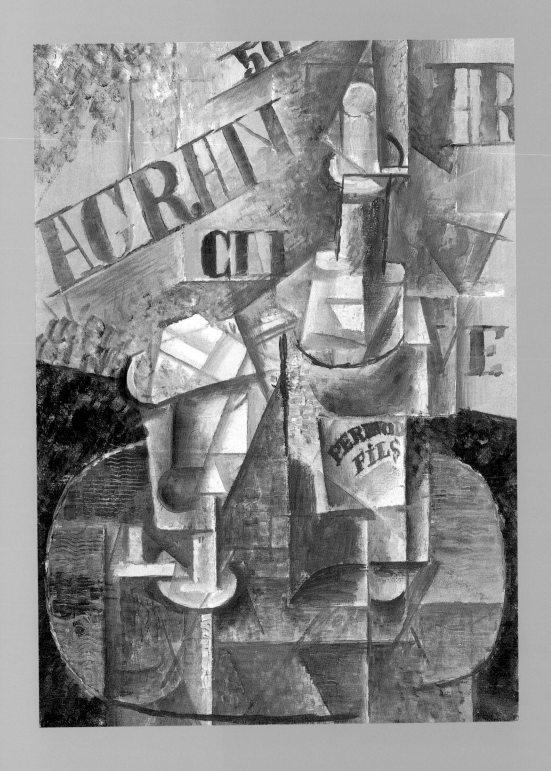

162. (OPPOSITE) PABLO PICASSO,
WOMAN WITH A FAN, 1907–08. OIL
ON CANVAS, 150 X 100 CM. STATE
HERMITAGE MUSEUM, ST. PETERSBURG

163. PABLO PICASSO, *TABLE IN A
CAFÉ (BOTTLE OF PERNOD)*, 1912. OIL ON
CANVAS, 46 X 33 CM. STATE
HERMITAGE MUSEUM, ST. PETERSBURG

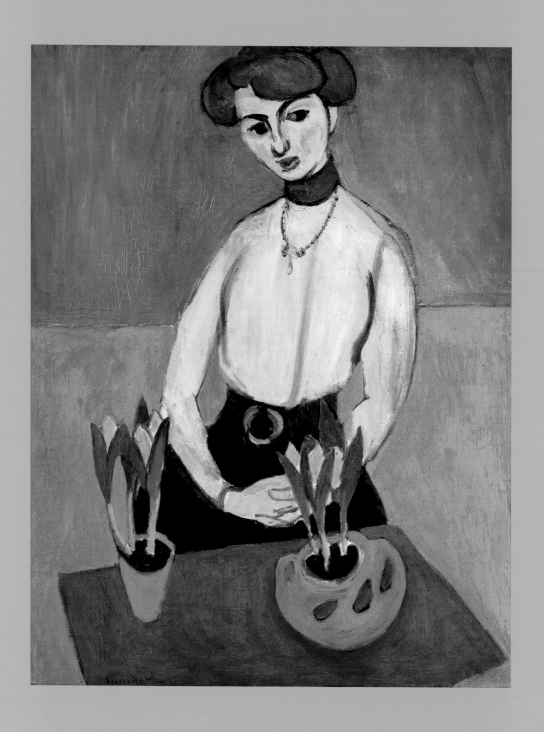

164. HENRI MATISSE, *GIRL WITH TULIPS*, 1910. OIL ON CANVAS, 92 X 73.5 CM. STATE HERMITAGE MUSEUM, ST. PETERSBURG

165. (OPPOSITE) HENRI MATISSE, *VASE OF IRISES*, 1912. OIL ON CANVAS, 117.5 X 100.5 CM. STATE HERMITAGE MUSEUM, ST. PETERSBURG

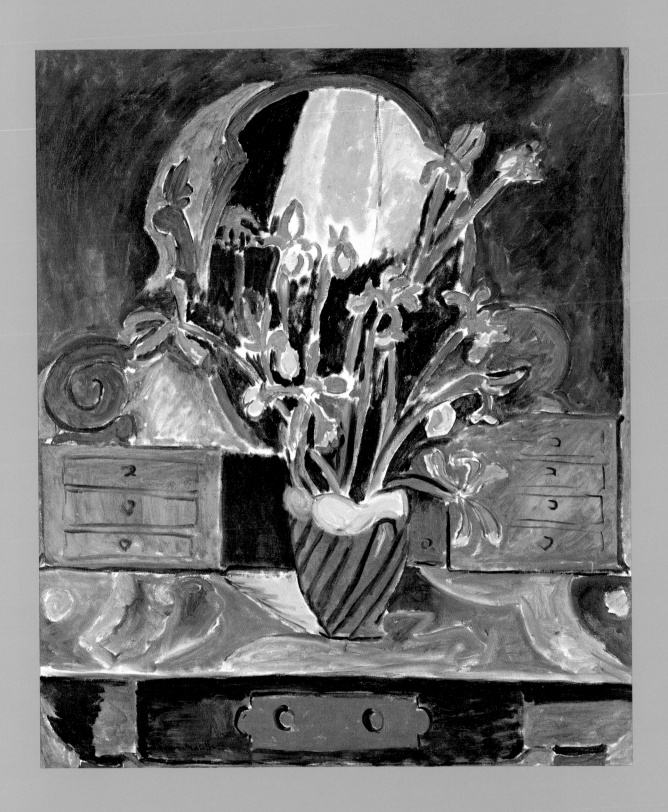

THE MANY FACES OF THE RUSSIAN AVANT-GARDE:
LATE 1900S TO EARLY 1920S
DMITRY SARABIANOV

The avant-garde movement in Russian art that emerged at the end of 1900s was rooted
in an expectation of societal change. The Russian Empire was going through a crisis
at the beginning of twentieth century. Revolutions occurred one after the other, and each
brought more destruction and fewer hopes for the future than the last. The art and litera-
ture of the pre-revolutionary decade, which Nikolai Khardzhiev, a connoisseur and scholar
of the Russian avant-garde, has dubbed "combatant,"[1] had their own, internal raisons
d'être. Russian art had no tradition of pioneering developments. Through the eighteenth
and nineteenth centuries, Russian painting, graphic art, sculpture, and architecture fol-
lowed the art of the developed countries of Western Europe, though Russian artists cer-
tainly reinterpreted Western discoveries in their own way. On the other hand, Russia had
a well-developed tradition of embracing the latest styles. New tendencies would quickly
win their place in the sun, replacing preceding styles and trends. There was a history of
drastic change in Russian culture, too, including two particularly sharp turns: in the tenth
century, Rus replaced its former pagan culture with the new Byzantine one; and at the
end of the seventeenth century, Russia—free from the Tatar-Mongol yoke—returned to its
European roots. The authentic face of Russian culture was shaped by these events. Equally
important was the artistic momentum that had accumulated by the turn of the nineteenth
century. At that time, Russian painters, after the prolonged prevalence of Realism and
academicism, took up Impressionism, modernism, and Symbolism—all at the same time.
This momentum, like a compressed spring, propelled the avant-garde forward.

At the time the avant-garde movement started, the resources of the previous movements
had not yet been fully depleted. Russian painting during this period was rather diverse. The
Wanderers' tradition of realism was still alive, though it was already approaching its end.[2]

Impressionism, which started its Russian journey along the lines of national plein-air
painting and later adapted the definitive French version of it, was fully realized in Konstantin
Korovin's decorative style and, in more restrained guises, in the work of the Union of Russian
Artists.[3] Symbolism and modernism allowed such artists as Mikhail Vrubel, Viktor Borisov-
Musatov, Pavel Kuznetsov, and Kuzma Petrov-Vodkin to develop their unique sensibilities.
Valentin Serov and the artists of the World of Art offered in their works a complex amalgam
of different styles. All these styles continued to exist even after the avant-garde took up its
rightful position on the front lines of artistic innovation: the representatives of the earlier
artistic groups and trends clearly had no intention of leaving the stage. This diversity at the
turn of the nineteenth century in many ways anticipated the remarkable multiplicity of avant-
garde attitudes in the 1910s. Evidence of the multifarious phenomenon that was the Russian
avant-garde includes the nonrepresentational art produced by Natalia Goncharova, Vasily
Kandinsky, Mikhail Larionov, Kazimir Malevich, Mikhail Matiushin, Vladimir Tatlin, and as
well as that, equally distinct, by Marc Chagall, Pavel Filonov, Olga Rozanova, Ivan Kliun,

Liubov Popova, Nadezhda Udaltsova, Alexander Rodchenko, Varvara Stepanova, and El Lissitzky. A wide range of other names can be added to this list. Such diversity is unequaled in the avant-garde art of other countries. The many faces of the Russian avant-garde emphasized the complexity of its structure, the aggressive tension between its many trends, and the unexpectedness of their interlacing. The penchant for sharp turns and leaps in the Russian art world contributed to the unprecedented gravitation to maximalism, to the desire of each "artist-inventor" to explore to the very end his or her creative position and to implement it with extreme consistency. One cannot deny Larionov's, Malevich's, Tatlin's, or Kandinsky's artistic consistency, but one should point out that this is a characteristic not only of the Russian avant-garde, but also of the European avant-garde in general. The same can be said of the demonstrative gesture of the avant-garde artist, of the "manifesto spirit" that characterizes avant-garde creativity, or of the rejection of the avant-garde's predecessors.

But it is important to remember that while these traditions were rejected, along with classicism, not all traditions were rejected. Simultaneously, new traditions were established—those capable of returning art to its origins. Ideas of "life-creation," advanced in the era of modernism and later transformed in a new way, once again became a life-giving source and gained global influence over art. Russian art and literature had always aspired to a profound philosophical exploration of reality, and they had an influence on avant-garde art of this period too. Russian icon painting represented "speculation in colors" (from the title of E. Trubetskoy's book, published in Moscow in 1916); Realist painting (and even more so, literature) pursued the contemplation of life through moral criteria. Russian culture would not give up these traditions. Even in those cases when the artist's conception fell into the framework of a purely formalist experiment, this experiment acquired a spiritual dimension, which could not be replaced by the idea of "art for art's sake," though many agents of Russian culture at the fin de siècle tried to impose this notion on art. The avant-garde preserved this resistance to formalism, though during the years of the totalitarian Soviet regime avant-garde art itself was considered formalist. Perhaps this resistance to formalism was behind the "unwitting traditionalism" (inadvertently manifested by the Wanderers, it was a criticism brought against Larionov even by his own colleagues), or the prophetic pathos of Filonov, Malevich, and Kandinsky that could equal that found in Russian Romantic literature. Finally, the "tradition of leaping forward," which characterized Russian artistic culture, defined the decisiveness of the sharp turn toward avant-garde art and established the incredible speed with which the new ideas spread.

At the very end of the first decade of the twentieth century, the first signs of the avant-garde movement appeared—initially in Moscow and St. Petersburg and, almost at the same time, in Kiev, Odessa, Kharkov, and other cities.[4] The Union of Youth, which later played an important role in the development of Russian art, was created in St. Petersburg at the end of 1909. A number of exhibitions were held in both Moscow and St. Petersburg—*Wreath-Stefanos, Wreath, Triangle, Golden Fleece, Impressionists*—which included work by Larionov, Goncharova, the Burliuk brothers, the future members of The Jack of Diamonds (Robert Falk, Pyotr Konchalovsky, Aristarkh Lentulov, Ilya Mashkov), and, occasionally, important French and German artists of the avant-garde. However, the new development was not only about

the exhibitions and the works displayed in them, which were still far from being consistently avant-garde. It was also about the new ideas and concepts that were being born. In St. Petersburg, Nikolai Kulbin, physician of the General Staff and an amateur artist, stands out. He organized exhibitions, presented papers and lectures on free art and free music, and published articles on these topics. Later, in 1914, he initiated the effort to invite Filippo Tommaso Marinetti, the leader of Italian Futurism, to visit Russia. Meanwhile, in his own work, Kulbin adhered to the traditions of Impressionism and Symbolism. Another notable figure was Voldemar Matvei (Vladimir Markov) of Riga, a student of the Petersburg Academy who wrote about African art and the theoretical problems of modern creativity.

In the formative years of the avant-garde movement, as had happened many times before, Western examples defined the first steps of the new journey. The French Impressionists, Paul Cézanne, Paul Gauguin, Vincent van Gogh, and Henri Matisse (the leader of Fauvism), as well as Pablo Picasso (the founder of Cubism), and other innovators quickly gained popularity among Russian artists. Russian collectors and patrons also played an important role, especially Sergei Shchukin and Ivan Morozov, who put together excellent private collections, especially of French artists, which were superior even to some of the collections in France. Before this, Russian painters had focused more on German and Northern European art. Now the priorities shifted to French art. It is true that, due to Kandinsky's mediation, the first exhibition of The Jack of Diamonds (1910)—one of the first important avant-garde exhibitions—presented, next to Albert Gleizes and Henri Le Fauconnier, a group of German Expressionists and Russian artists from Munich. Later, however, the prevalence of the French became indisputable. Up to the beginning of World War I, when artistic relations were interrupted, practically all of the most famous French Fauves and Cubists participated in Russian exhibitions.

If we trace the entire trajectory of the Russian avant-garde, it is tempting to suggest that it was destined from the outset to play an important role in the experimental and inventive artistic activity of the early twentieth century. This is why we keep searching for internal, as well as external, impulses in its sources and motivation. It is perhaps significant that the Russian avant-garde started out with Neo-Primitivism, which looked to traditional folk art—popular pictures (lubok), peasant toys, painting on wood, commercial signs, naive icons—and other types of popular art that, in different forms and shapes, continued to exist in Russia, unlike in other European countries. The founders of this movement, Larionov and Goncharova, had their predecessors in the representatives of The World of Art (Mstislav Dobuzhinsky) or The Blue Rose (Nikolai Krymov, Nikolai Sapunov). The members of The Jack of Diamonds, especially in their first years, uniquely combined Cézannism with popular decorative arts and "popular picturesque performance."[5]

Mashkov, Pyotr Konchalovsky, Alexander Kuprin, and even the more philosophical Falk all experienced a joyous surge of energy, even if only for a short period of time, as they were touched by the energy of picturesque primitivism and the expressive conventions of the lubok form. Aristarkh Lentulov, who had experienced the Parisian school of Le Fauconnier and Gleizes—La Palette Academy, one of the leading academies in Paris—and was acquainted with Robert Delaunay's Orphism, applied his experience to traditional Russian architecture and "constructed" folk Russian cities in his large paintings. The members of The Jack of

Diamonds were influenced by Cubism, but they only tentatively traced the Cubist line, as it were, in Russian painting. Russian Cubism was developed in later years by Malevich, Kliun, and others. As for nonrepresentational art, Lentulov seemed to have almost discovered it but stopped short of following it through.

The creative life of Larionov and Goncharova developed differently: they split from The Jack of Diamonds after its first exhibition, considering its representatives too inconsistent in their realization of their program. From 1912 to 1914 they organized their own shows—*Donkey's Tail, Target,* and *4*—exhibiting committed Neo-Primitivists, but also such leaders of new trends as Malevich, Tatlin, and even Chagall, who did not belong to any group. Russian Neo-Primitivism can be considered as a parallel development to French Fauvism and German Expressionism. It opened up for the artist an opportunity for the free transfiguration of the world, for the refining of the artistic image, and for unprecedented freedom of expression. Naive icons presented a pretext for a search for the primary image. Infatuation with the naive was not unique to Russian artists, however. The role played by the primitive art of so-called exotic cultures in the work of the Fauvists, Cubists, and Expressionists is well documented. However, in Russia, unlike other countries, it was primarily the national heritage that was valued, whereas the French and the Germans searched for sources of inspiration overseas.

Larionov, who boasted incredible vision and an extraordinary gift for self-reinvention, took Neo-Primitivism to its extreme manifestation in a short period of time—in his crude "graffiti" paintings (the *Soldiers* series, 1910–11) and in adopting the folk principle of combining fairy-tale or *byliny*-like texts with almost pictographic depictions of nature and man (*The Seasons*, 1912). He subsequently invented Rayonism—one of the first versions of nonrepresentational painting. Goncharova, working by Larionov's side, followed her own way in implementing different versions of the Neo-Primitivist principles. Her most successful realizations of these principles were her scenes of peasant and city life and her paintings on biblical themes. The artist assimilated the lessons of Cubism and Futurism (*The Cyclist*, 1913), used the innovations of Rayonism, and offered her own version of the nonrepresentational (*Emptiness*, 1913), which anticipated the future discoveries of the French and German painters of the mature avant-garde. Many followers of Larionov—Alexander Shevchenko, the brothers Kirill, Ilya Zdanevich, and Mikhail Ledantiu—expanded the Neo-Primitivist and Rayonist concepts and extended the painterly experience of the exhibition *Donkey's Tail* to neighboring countries, Georgia, in particular. It was in Georgia that the great Niko Pirosmanashvili was discovered—a worthy match to Henri Rousseau (Le Douanier). Larionov's younger followers, such as Vasily Chekrygin, Lev Zhegin, Sergei Romanovich, and other founders of the Makovets group, formed in 1921, decisively carried Larionov's influence into the sphere of the spiritual. The influence of *Donkey's Tail* extended almost to the entire field of the Russian avant-garde.

Let us now trace the other branches of the Russian avant-garde. One of them, which was rather close to Neo-Primitivism, shared elements of European Expressionism, though it never blended with it. The major representatives of this trend were Kandinsky, Chagall, and Filonov. Since Expressionism did not coalesce into a unified movement in Russia, the

Mikhail Larionov, Spring (from The Seasons series), 1912. Oil on canvas, 142 x 118 cm. The State Tretyakov Gallery, Moscow. See also Winter (1912, plate 181)

Natalia Goncharova, Emptiness, 1913. Mixed media on canvas, 80 x 106 cm. The State Tretyakov Gallery, Moscow

Pavel Filonov, Composition, 1919.

Oil on canvas, 117 x 154 cm.

The State Tretyakov Gallery, Moscow

representatives of this branch of the avant-garde were not related to one another either cre-atively or organizationally.

Kandinsky borrowed a lot from Expressionism and modernism in their pure German versions. He studied and worked in Munich, where he was surrounded by Vladimir Bekhteev, Alexei Jawlensky, Gabriele Münter, Maria Verevkina, and other Russians émigrés and had connections with many representatives of German culture (Franz Marc, Arnold Schönberg). Consequently, in Kandinsky's search for the spiritual and the "internal impera-tive"—those creative tasks that he formulated in his famous books *On the Spiritual in Art* (1911) and *Point and Line to Plane* (1926)—the German influence is pronounced. The artist, already beyond his first youth, experienced his first success at the very end of the first decade of the twentieth century, when he lived and worked in Murnau, not far from Munich. In the landscapes he painted there, he discovered the continuity of rhythmic movement, the inten-sity of the color-sound, and the impulse of self-expression. It was in this period that he began to move beyond the representational and search for the means to express the spiritual element, free from the chains of the material. The artist himself pointed to his *Composition with a Circle* (1911) as his first nonrepresentational painting. Soon he reached the apogee on this path—in his *Composition VI* and *Composition VII* (both 1913). The first was a nonfigurative representation of the biblical Flood, the second a depiction of the Last Judgment. In his unrestrained imagination, the artist soared in open space, all the while preserving a real feeling for the world's beauty and, remarkably, combining intuition with calculation. This combination provides a symbolic glimpse into the fate of a master influenced by two different national schools. His work in the service of these two schools continued for many years—first in Russia, during the years of the war and revolution, then in Germany, along-side the Bauhaus artists.

For Marc Chagall, the relationship with Western European art developed differently. Born in the provincial town of Vitebsk, within the Pale of Settlement (the designated area for Jews), and raised in a religious Jewish family, he was charged by his own childhood memo-ries and those of the people who had absorbed the history of the nation. As a result, all of his moves from country to country and from city to city (from Vitebsk to St. Petersburg to Paris to Vitebsk to Moscow to Berlin to Paris) during the most fruitful fifteen years of his life (1907–23) could not change his primary impressions of the world. Chagall had contacts with Cubism and Expressionism, and he absorbed and incorporated certain characteristics of Futurism, but he still kept to his own space and did not join any single movement. His dreamlike fantasies and the absurdity of his vision of the world were engendered by the reali-ties of Russian life. Chagall's world of *byt* (daily grind) falls into some new dimension; his "byt mythology" combines the insignificant and the everyday with the universal and eternal. The grotesque element that the artist constantly includes tempers, rather than exacerbates, the absurdity of the depicted situations. The absurdity does not, however, prevent Chagall from winning over the viewer with his warmth and with the humanity of his vision of the world.

Pavel Filonov's work, on the other hand, reveals the distinctly Russian roots of his creativity. As a parallel of sorts to German Expressionism, the artist's work is characterized by its more pronounced epic qualities. Filonov does not strive to impress the viewer in a

straightforward way, but through the expression of his own feelings. He subjects the object to artistic analysis; he deconstructs the world into its primary building blocks, views them through the magnifying glass of his analytical eye, and creates complex pictures of the world. In them, the past and the present are conflated, and primary images and primary meanings become objects of comprehension. They prophesize the future, allowing the artist to point the way toward a global golden age. An important feature of Filonov's paintings is always their technical perfection—their "made-ness" (*sdelannost*), as the artist himself called it.

The most promising and all-encompassing trend in the Russian avant-garde was a movement that was based on the influence of Cubism but absorbed the lessons of Futurism as well. It came to be called Cubo-Futurism. The name of this movement emerged as a result of a union between Futurist poets and Cubist artists, but it soon came to be interpreted in a broader way. Futurism in its "pure form" was not widespread in Russian painting. It was implemented as a program similar to that of the Italian Futurists and only in a few works by David Burliuk, Goncharova, Malevich, Rozanova, and some others. It was as if in Russia different trends sought to intersect and interweave. Where the French and Italians failed in their efforts to combine Futurism with Cubism, Russian painters succeeded. A good example of this synthesis is found in the work of Malevich.

Malevich rapidly overcame the huge stylistic distance from homespun Impressionism to Suprematism in only half a decade. Impressionism was followed by Symbolism and Neo-Primitivism, then by Cubism and Futurism, implemented in an exemplary way in his painting *Knife-Grinder* (1912). After that he expended a good deal of effort to develop the Cubo-Futuristic system that was later adopted by other painters, who at that time started grouping around Malevich. Such paintings as *Lady at a Tram Stop* (1913), *Englishman in Moscow* (1914), and *Aviator* (1914) recreate illogical, absurd situations. The objects are deconstructed and then reassembled; space and time are transfigured and fragmented, but the fragments fall into a certain system, allowing the re-creation of a virtual reality that is only indirectly coordinated with everyday reality. Proto-Dadaist illogic opened up the way to Suprematism, which was demonstrated in 1915 in Petrograd at the exhibition 0.10 by thirty-nine works, including the famous *Black Square*. Malevich presented his black square as a primary element of painting, as a formula for the universal feeling of the nonrepresentational and cosmic quality of Being, and as a feature of the equality between such categories as *all* and *nothing*. The mesmerizing effect of the *Black Square* is related to its ability to concentrate in itself limitless space, to be transfigured into other universal formulas of the world, and to express everything in the universe by concentrating this "everything" in an absolutely impersonal geometrical form and impenetrable black surface. After his Suprematist period, Malevich worked on the theory and philosophy of art for several years. In the twenties, not long before his death, the artist returned to figurative art and created the so-called second peasant cycle, in which he realized his idea of the estrangement of humankind, its impersonal nature and muteness, its lack of freedom and its doomed condition.

Other artists, whose creativity can be linked only indirectly to Cubo-Futurism, positioned themselves at a slight distance from Malevich. Many of them, such as David Shterenberg,

Vladimir Tatlin, Model, 1913.
Oil on canvas, 104.5 x 130.5 cm.
State Russian Museum, St. Petersburg

Installation view of 0.10 (also known as The Last Futurist Exhibition of Paintings), Galerie Dobychina, Petrograd, 1915; works shown include two of Vladimir Tatlin's Counter-Reliefs (1914–15)

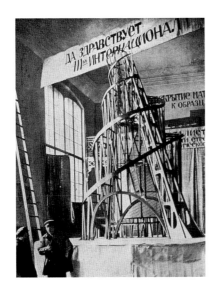

Studio view of Vladimir Tatlin's model Monument to the Third International *(1919–20)*

Natan Altman, and Vladimir Baranov-Rossine, spent long years working abroad. Each of them could be characterized by his individual manner: Shterenberg was defined by his laconism and the geometricity of his painterly constructions; Altman's signature combined Cubism with a tinge of neoclassicism; Baranov-Rossine was known for interweaving various stylistic versions of the avant-garde into "medium-typical interpretations."

The Moscow and St. Petersburg artists who first developed Cubo-Futurism and then Suprematism, found themselves closer to Malevich's line. The majority of them united in the Supremus group. Ivan Puni at that time was especially versatile in his avant-garde quest: he worked with found objects, in assemblage, and in the manner of Dadaist illogic in easel painting; he produced Suprematist canvases and painterly sculpture. In Berlin in 1921, he demonstrated his versatility in an exhibition at the Sturm gallery. Ivan Kliun, although he tried to apply himself in different areas, was more focused on Cubo-Futurism and Suprematism. He was interested in the problem of light-color coordination, and he sought to adapt primitive geometrical forms to limitless space.

The outstanding women artists Alexandra Exter, Popova, Rozanova, and Udaltsova— the "amazons of the Russian avant-garde" (a term first used by Benedikt Livshits in his book *One-and-a-Half-Eyed Archer*)—were connected with Supremus. Rozanova, who had been through a Futurist phase (1913–14), had become close to the Futurist poets and had succeeded in creating illustrated lithographic books. She demonstrated an extremely strong perception of form and color and romantic fantasy in both her Cubo-Futurist and nonrepresentational compositions. Udaltsova, who had studied at La Palette Academy together with Popova, managed the Cubist forms perfectly. Popova shifted from Cubo-Futurist experiments to nonrepresentational ones and achieved harmonious results in her *Painterly Architectonics* (1916–18). Later she created a series of *Space-Force Constructions* (1920–21), conjoining nonrepresentational forms and energetic lines. Exter, who visited Paris in the first decade of the twentieth century, contributed her unique artistry to the modern achievements of the Russian, French, and Italian avant-garde.

All of the aforementioned followers of Malevich experienced, to a greater or lesser extent, the influence of Vladimir Tatlin, who throughout his life sought to juxtapose his program with Malevich's system. After his short painterly period, when he created such perfect paintings as *Sailor* (1911) and *Woman Model* (1913), Tatlin turned to creating a series of works united under the same title—*Construction of Material* (which are most often labeled "Counter-Reliefs"). The most important tasks for him became combining materials (wood, metal, wallpaper, etc.), exposing the features of each one, and producing a utilitarian, economical construction. In these works, objects do not imitate anything; three-dimensional space is not depicted, but rather exists in reality; paint does not reproduce the color of some real object, but rather has meaning in and of itself. Tatlin was a founding father of Constructivism, which developed after the Russian Revolution and spread throughout Western Europe. He designed and, together with his assistants, built a model of the famous tower *Monument to the Third International* (1920), and expended a good deal of effort on the realization of a project for a flying mechanism without an engine (*Letatlin*). These projects remained utopian: they could never be implemented.

The Constructivist movement formed and developed at the beginning of the twenties. The most consistent representatives of this movement were Lissitzky, Popova, Rodchenko, Stepanova, Alexander Vesnin (who for a long time worked in Germany); the émigré artists Naum Gabo and Anton Pevsner; and members of the Society of Young Artists—Konstantin Medunetsky, the brothers Georgii, Vladimir Steinberg, and Gutsav Klutsis. Many of them went into industrial design, and made set designs for mass holiday celebrations, or stage designs. However, this did not exhaust their creative activity. Rodchenko, at the end of the 1910s and early 1920s, in his polemic with Malevich, created his painting *Black on Black* (1918); then, having rejected texture and painterly expressivity in principle, he presented his *Smooth Boards* triptych: *Pure Red, Pure Yellow, Pure Blue* (1921). At that same time, Rodchenko proclaimed line to be an "element of construction" and, in doing so, anticipated the principles of minimalism that became an integral part of twentieth-century art. Simultaneously Rodchenko created a whole series of perfect spatial constructions, composed of standard construction elements, which soon allowed him to turn to furniture design.

Lissitzky played a major role in the creation of the new style at that time. He made his series of *Prouns* (acronym for "Projects for the affirmation of the new"), paintings and drawing in the late 1910s and early 1920s in which he succeeded in combining Suprematist planes with the category of space. A peculiar "three-dimensional Suprematism" influenced the development of the architectural thought of the time. His work presented a platform for the unification of Suprematism and Constructivism.

Yet another important trend in the painting of the Russian avant-garde was related to the work of Matiushin, his wife Elena Guro, and his many students (first and foremost, Boris, Maria, Xeniia, and Georgii Ender, and Nikolai Grinberg), as well as Pyotr Miturich, Pavel Mansurov, and their later followers. This trend is usually dubbed "organic." Matiushin, who called his system "ZORVED" (from *"Zrenie+Vedanie"*—"Vision+Knowledge"), professed the new principles of "extended vision," positing a parallel between artistic creativity and nature. This parallel demanded, according to the artist, special education and special exercise of the senses in order to comprehend all the sophistications of natural life. Both in figurative and nonrepresentational compositions, Matiushin, with the help of a certain "natural symbolism," which also characterized the work of Guro, achieved incredible complexity in the relationship between light and color. The traditions of ZORVED were continued by some Russian artists (in particular, Vladimir Sterligov) in the second half of the twentieth century. This kind of dialogue between the Russian avant-garde and not only later Russian artists, but also with the international art of the mid- and second half of the twentieth century is rather typical: the Russian avant-garde artists of the first and second decades of the twentieth century looked into the future and foresaw much of what lay ahead.

Translated from the Russian by Julia Trubikhina.

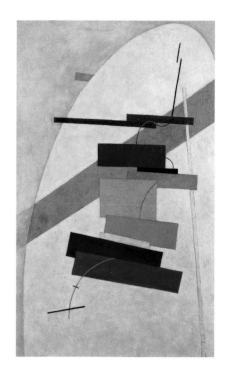

El Lissitzky, *Untitled*, ca. 1919–20.
Oil on canvas, 79.6 x 49.6 cm.
Peggy Guggenheim Collection, Venice
76.2553.43

1. N. Khardzhiev, K. Malevich, M. Matiushin, *Kistorii russkogo avangarda* (Stockholm: Almquist and Wiksell International, 1976), p. 131.

2. During the late 1860s–early 1870s, the former members of the St. Petersburg Artel of Artists, the first independent creative association of artists in the history of Russian art, formed the Society for Traveling Art Exhibitions and were known as *Peredvizhniki* (Wanderers).

3. The Union of Russian Artists was an exhibiting society active from 1903 to 1923.

4. See A. V. Kursanov, *Russkii avangard: 1917–1932 (Istoricheskii obzor)*. Tom 1: *Boevoe desiatiletie* (St. Petersburg: Novoe Literaturnoe Obozrenie, 1996).

5. See G. G. Pospelov, *Bubnovyi valet. Primitiv i gorodskoi folklor v moskovskoi zhivopisi 1910–kh godov* (Moskva: Sovetskii Khudoznik, 1990).

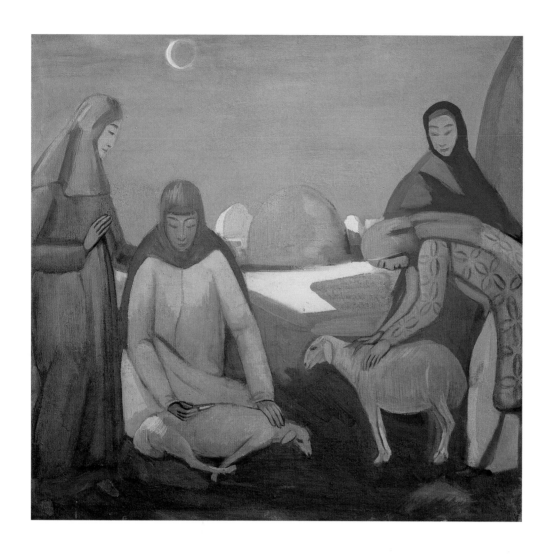

166. PAVEL KUZNETSOV, SHEARING
SHEEP, CA. 1912. TEMPERA AND PASTEL
ON CANVAS, 77.5 X 81.5 CM. STATE
RUSSIAN MUSEUM, ST. PETERSBURG

167. (OPPOSITE) VALENTIN SEROV,
THE RAPE OF EUROPA, 1911. OIL
ON CANVAS, 138 X 178 CM. PRIVATE
COLLECTION, MOSCOW

276

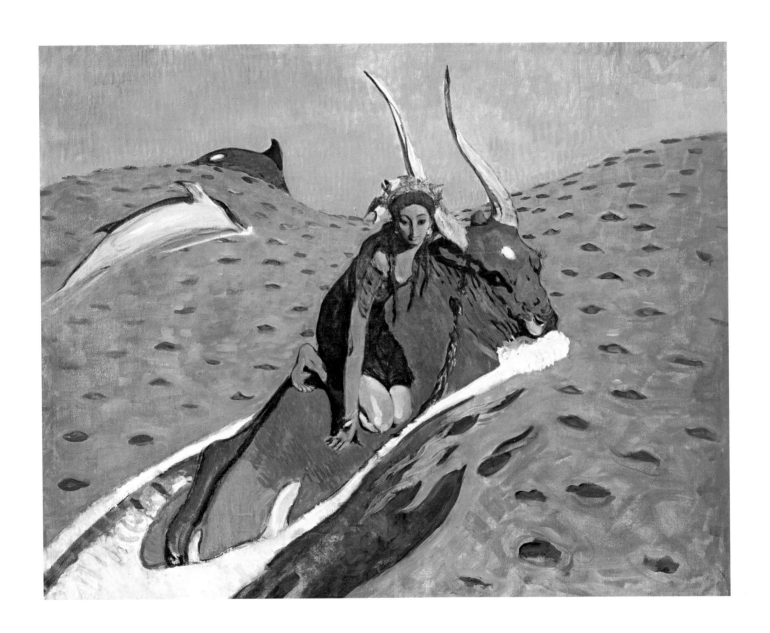

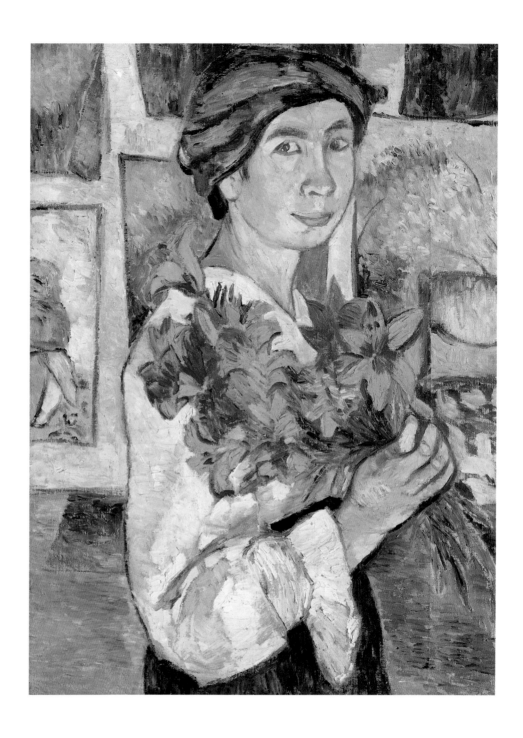

168. NATALIA GONCHAROVA,
SELF-PORTRAIT WITH YELLOW LILLIES,
1907. OIL ON CANVAS, 77 X
58.2 CM. THE STATE TRETYAKOV
GALLERY, MOSCOW

169. (OPPOSITE) MIKHAIL NESTEROV,
PORTRAIT OF THE ARTIST'S DAUGHTER,
1906. OIL ON CANVAS, 175 X 86.5 CM.
STATE RUSSIAN MUSEUM,
ST. PETERSBURG

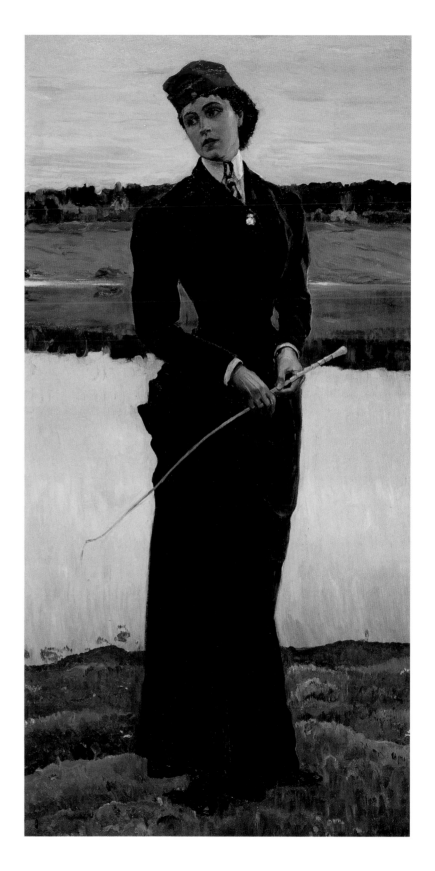

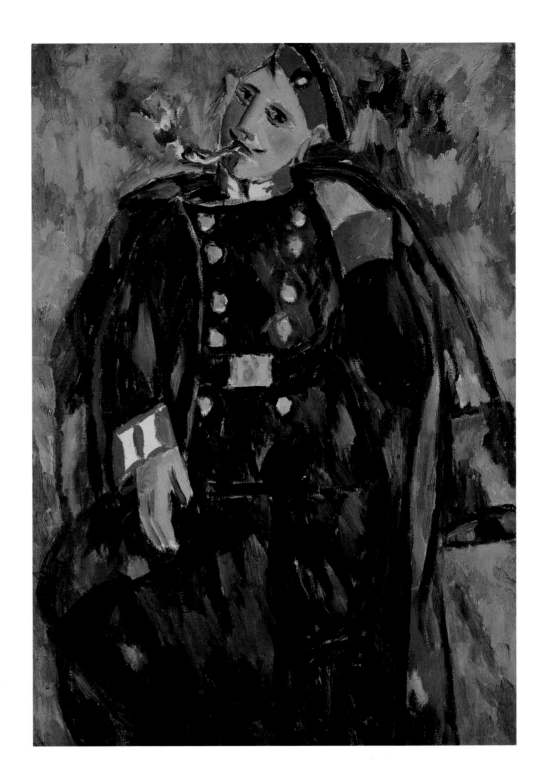

170. MIKHAIL LARIONOV, SOLDIER
(SMOKING), 1910—11. OIL ON CANVAS,
100 X 72.5 CM. THE STATE TRETYAKOV
GALLERY, MOSCOW

171. (OPPOSITE) MARC CHAGALL,
THE SOLDIER DRINKS, 1911—12. OIL ON
CANVAS, 109.2 X 94.6 CM.
SOLOMON R. GUGGENHEIM MUSEUM,
NEW YORK 49.1211

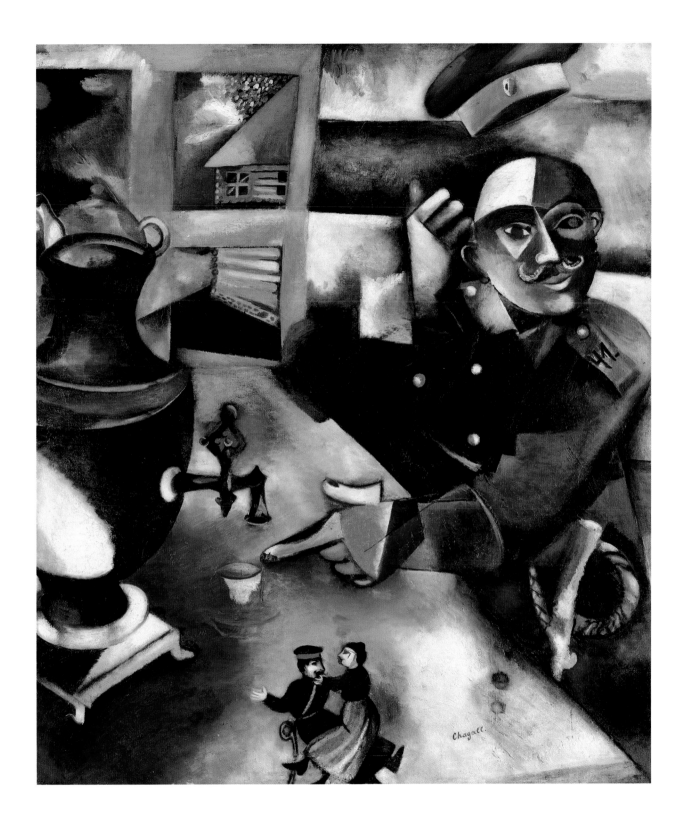

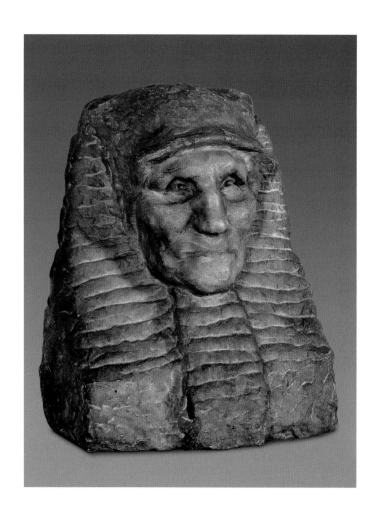

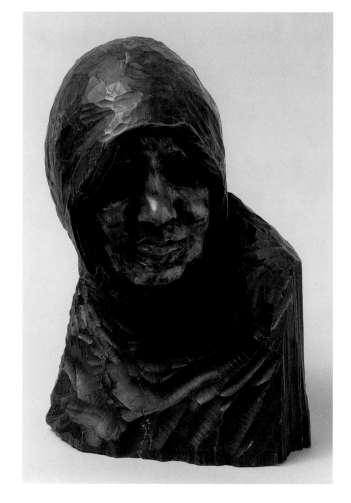

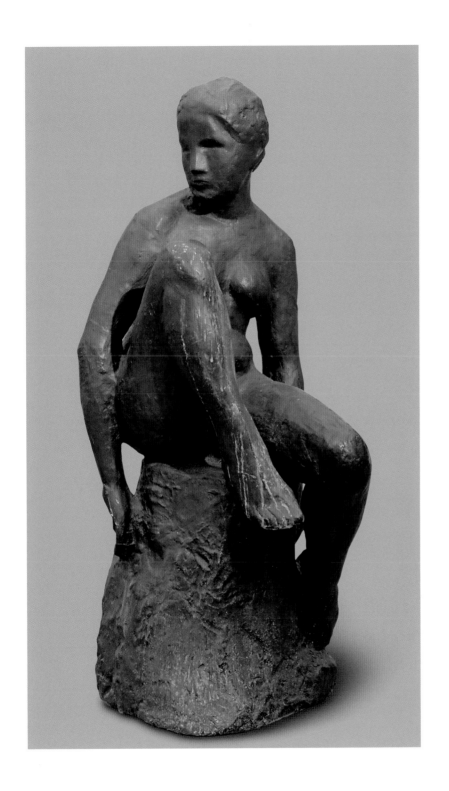

172. (OPPOSITE LEFT) ANNA
GOLUBKINA, *OLD WOMAN*, 1908.
MARBLE, H. 40.5 CM. THE STATE
TRETYAKOV GALLERY, MOSCOW

173. (OPPOSITE RIGHT) ANNA
GOLUBKINA, *PILGRIM*, 1903. WOOD,
H. 42 CM. STATE RUSSIAN MUSEUM,
ST. PETERSBURG

174. ALEXANDER MATVEEV,
SEATED WOMAN, 1911. BRONZE,
H. 120 CM. THE STATE TRETYAKOV
GALLERY, MOSCOW

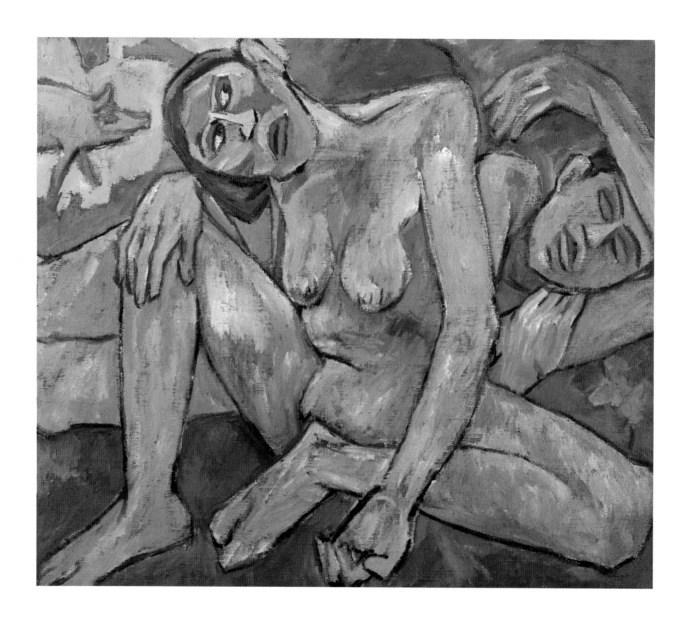

175. MIKHAIL LARIONOV, *VILLAGE BATHERS*, 1909. OIL ON CANVAS, 89 X 109 CM. KOVALENKO ART MUSEUM, KRASNODAR

176. (OPPOSITE) KUZMA PETROV-VODKIN, *ON THE SHORE*, 1908. OIL ON CANVAS, 128 X 159 CM. STATE RUSSIAN MUSEUM, ST. PETERSBURG

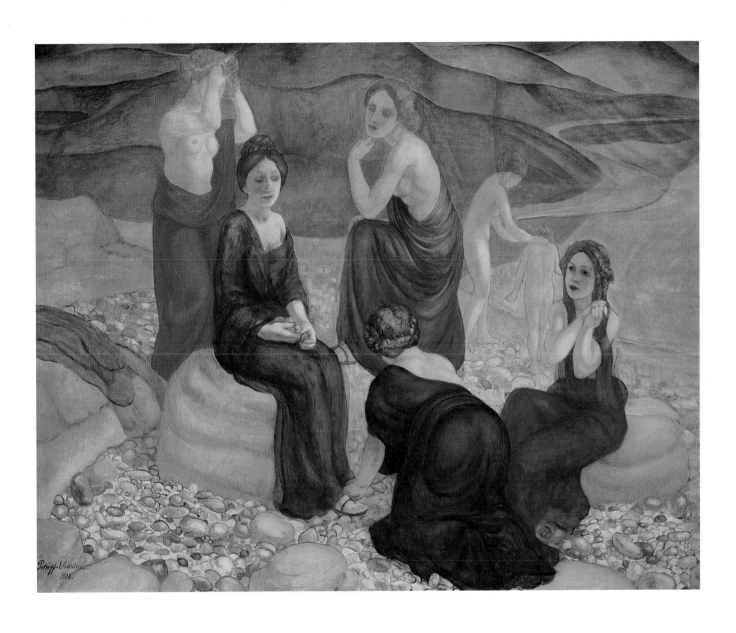

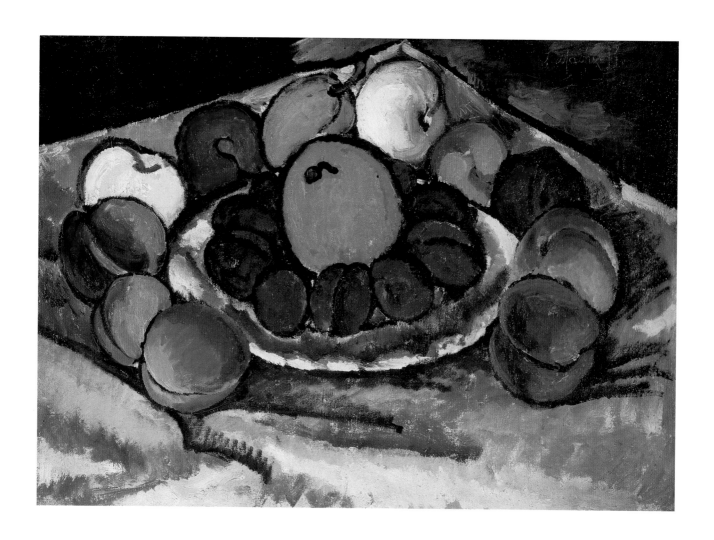

177. ILYA MASHKOV, STILL LIFE:
FRUIT ON A DISH, 1910. OIL ON CANVAS,
80.7 X 116.2 CM. THE STATE
TRETYAKOV GALLERY, MOSCOW

178. (OPPOSITE) PYOTR
KONCHALOVSKY, FAMILY PORTRAIT,
1911. OIL ON CANVAS,
179 X 239 CM. STATE RUSSIAN
MUSEUM, ST. PETERSBURG

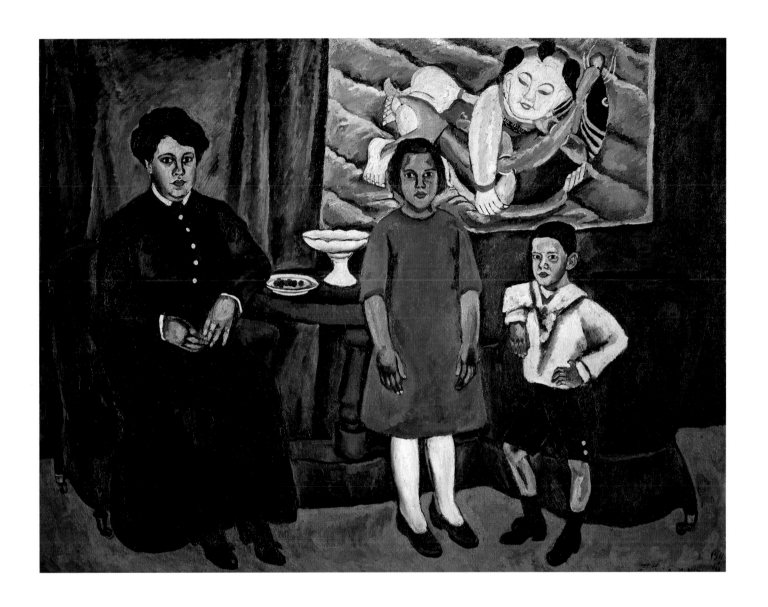

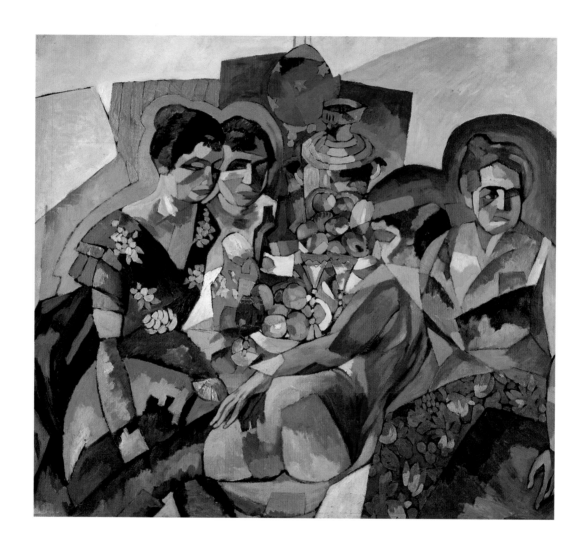

179. ARISTARKH LENTULOV, *WOMEN
AND FRUIT* (PANEL FROM DIPTYCH),
1917. OIL ON CANVAS, 142.5 X
159.5 CM. POZHALOSTIN REGIONAL
ART MUSEUM, RYAZAN

180. (OPPOSITE) ARISTARKH
LENTULOV, *MOSCOW*, 1913. OIL ON
CANVAS, 179 X 189 CM. THE STATE
TRETYAKOV GALLERY, MOSCOW

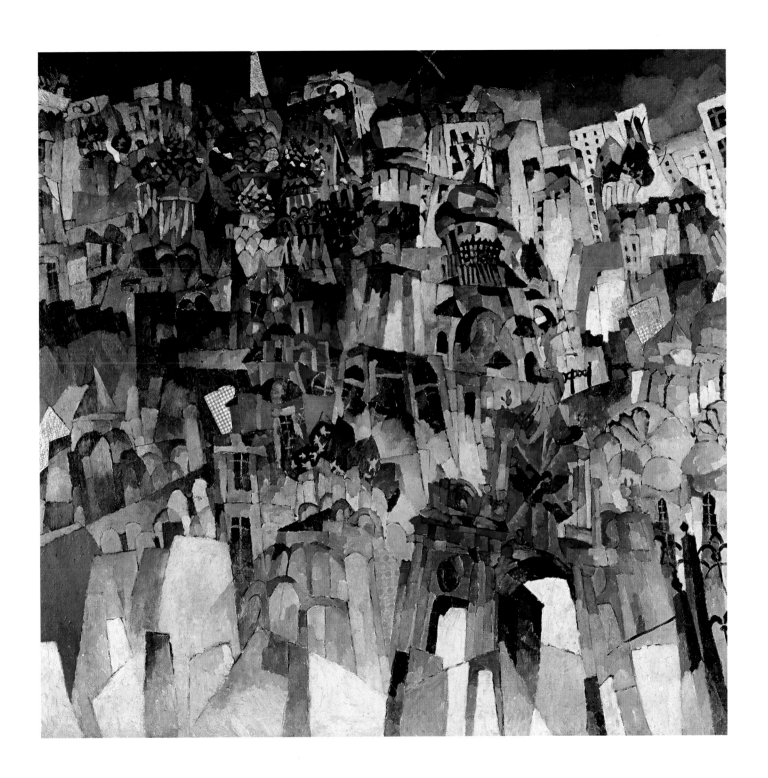

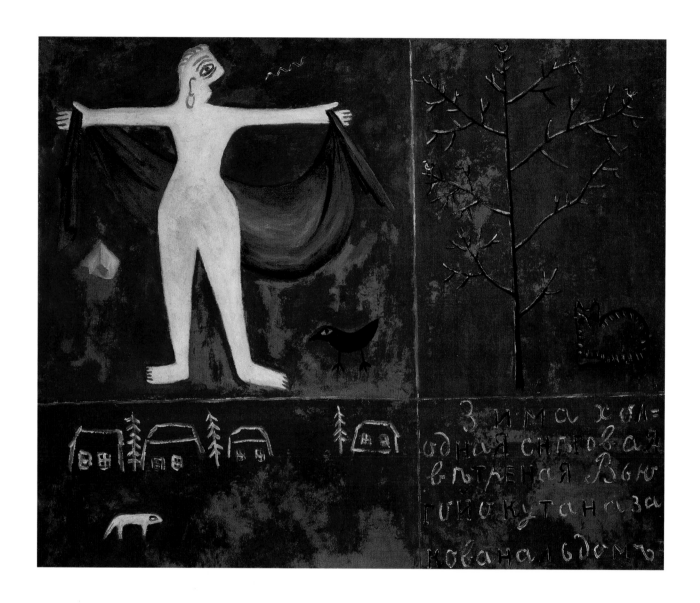

181. MIKHAIL LARIONOV, *WINTER*
(FROM THE *SEASONS* SERIES),
1912. OIL ON CANVAS, 100 X
122.3 CM. THE STATE TRETYAKOV
GALLERY, MOSCOW

182. (OPPOSITE) NATALIA
GONCHAROVA, *A GIRL ON A BEAST*
(FROM THE *HARVEST* SERIES), 1911.
OIL ON CANVAS, 167 X 128.5 CM.
KOSTROMA STATE UNIFIED ART MUSEUM

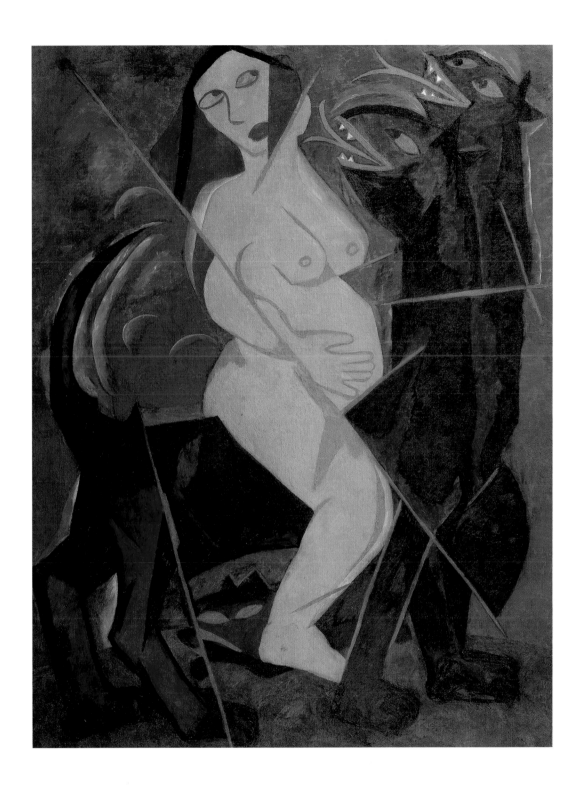

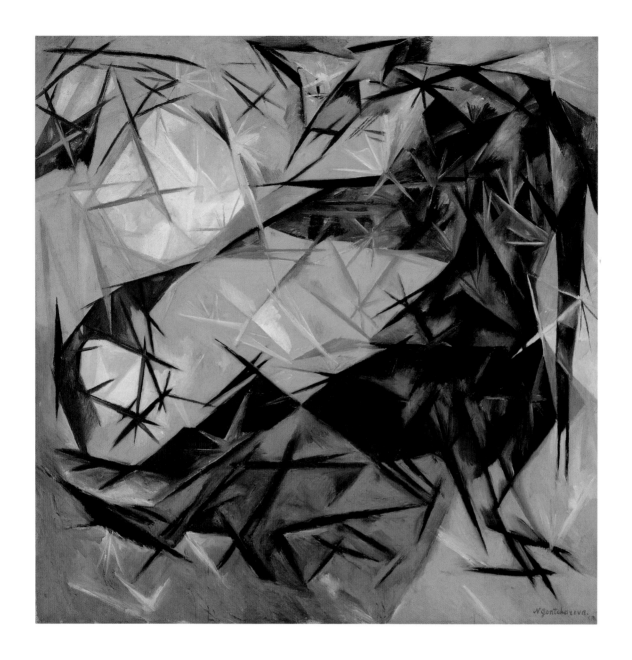

183. NATALIA GONCHAROVA, *CATS*
(RAYIST PERCEP.[TION] IN ROSE, BLACK, AND
YELLOW), 1913. OIL ON CANVAS,
84.4 X 83.8 CM. SOLOMON R.
GUGGENHEIM MUSEUM, NEW YORK
57.1484

184. (OPPOSITE) NADEZHDA
UDALTSOVA, *RESTAURANT TABLE, STUDY*
FOR RESTAURANT, 1915. OIL ON CANVAS,
71 X 53 CM. THE STATE TRETYAKOV
GALLERY, MOSCOW

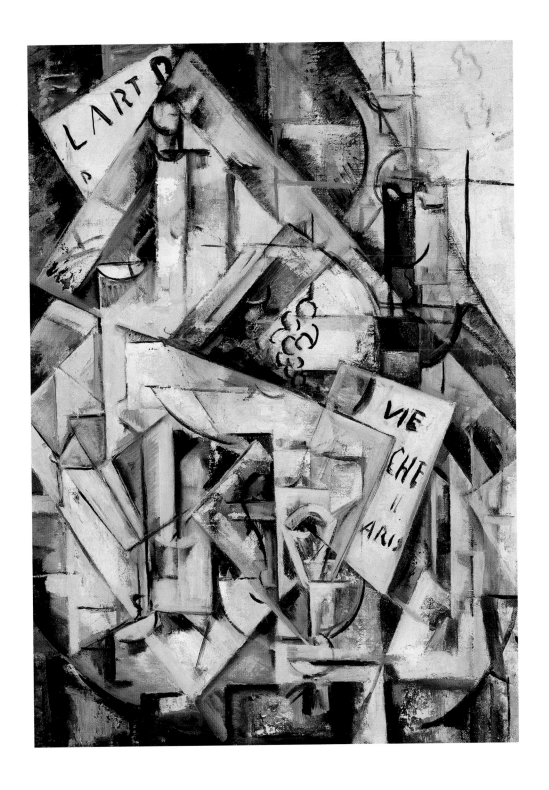

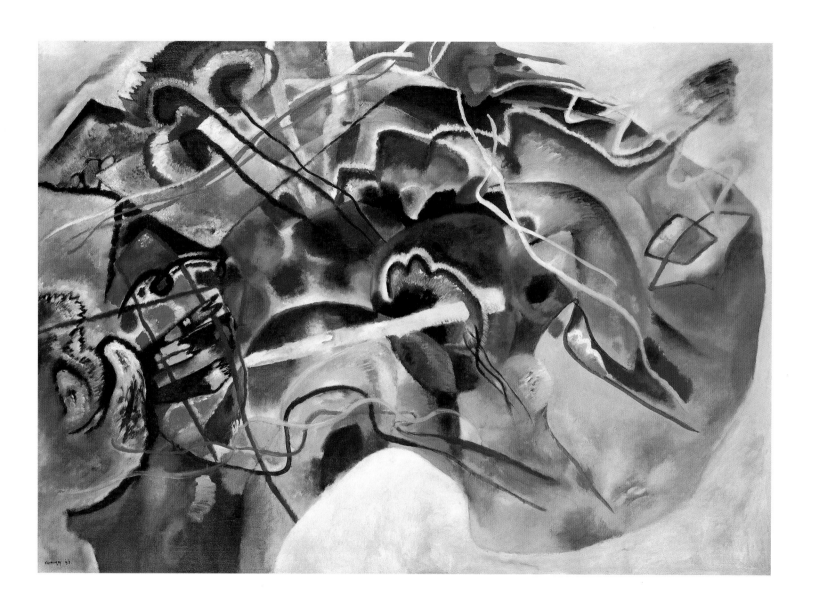

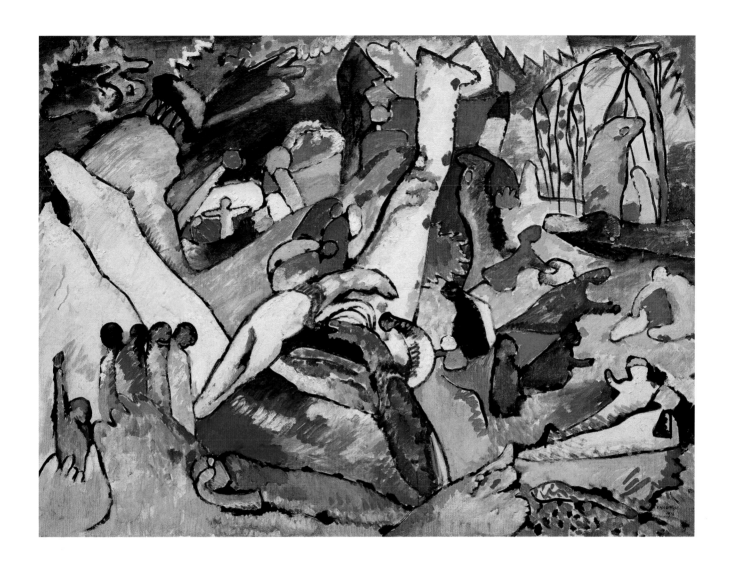

185. (OPPOSITE) VASILY KANDINSKY,
PAINTING WITH WHITE BORDER, MAY 1913.
OIL ON CANVAS. 140.3 X 200.3 CM.
SOLOMON R. GUGGENHEIM MUSEUM,
NEW YORK. GIFT, SOLOMON R.
GUGGENHEIM 37.245

186. VASILY KANDINSKY, SKETCH FOR
COMPOSITION II, 1909–10. OIL ON
CANVAS, 97.5 X 131.2 CM. SOLOMON R.
GUGGENHEIM MUSEUM, NEW YORK
45.961

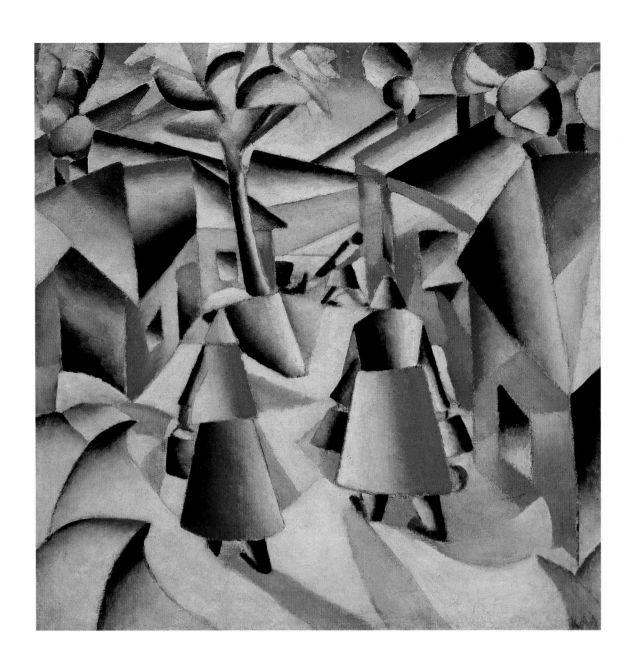

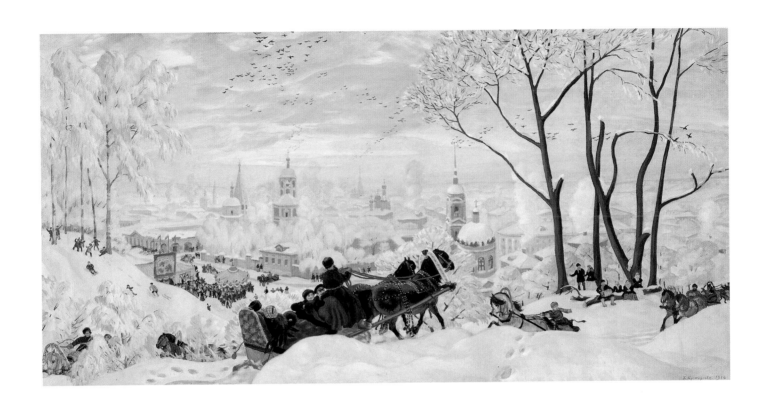

187. (OPPOSITE) KAZIMIR MALEVICH,
*MORNING IN THE VILLAGE AFTER
SNOWSTORM*, 1912. OIL ON CANVAS,
80.6 X 81 CM. SOLOMON R.
GUGGENHEIM MUSEUM, NEW YORK
52.1327

188. BORIS KUSTODIEV, *SHROVETIDE*,
1916. OIL ON CANVAS, 61 X 123 CM.
THE STATE TRETYAKOV GALLERY,
MOSCOW

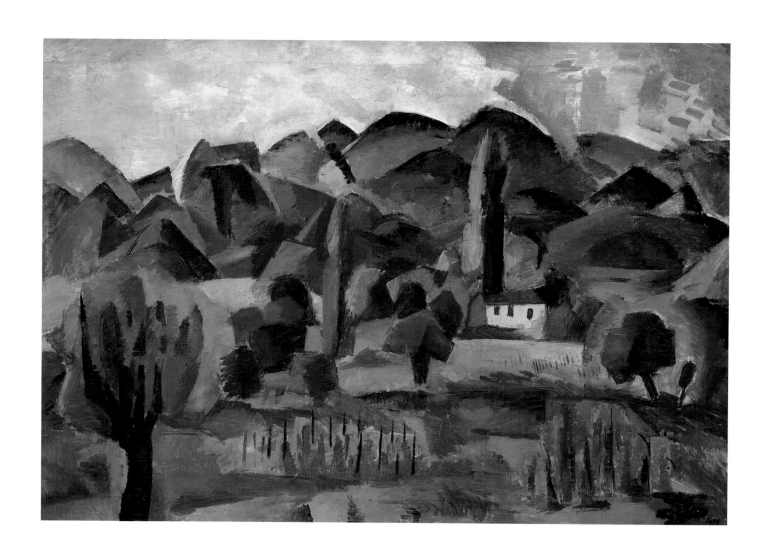

189. ROBERT FALK, *LANDSCAPE: IN THE MOUNTAINS*, 1916. OIL ON CANVAS, 81 X 118 CM. IVANOVO REGIONAL ART MUSEUM

190. (OPPOSITE) PYOTR MITURICH, *PORTRAIT OF ARTHUR LOURIÉ*, 1915. OIL ON CANVAS, 102 X 101.5 CM. STATE RUSSIAN MUSEUM, ST. PETERSBURG

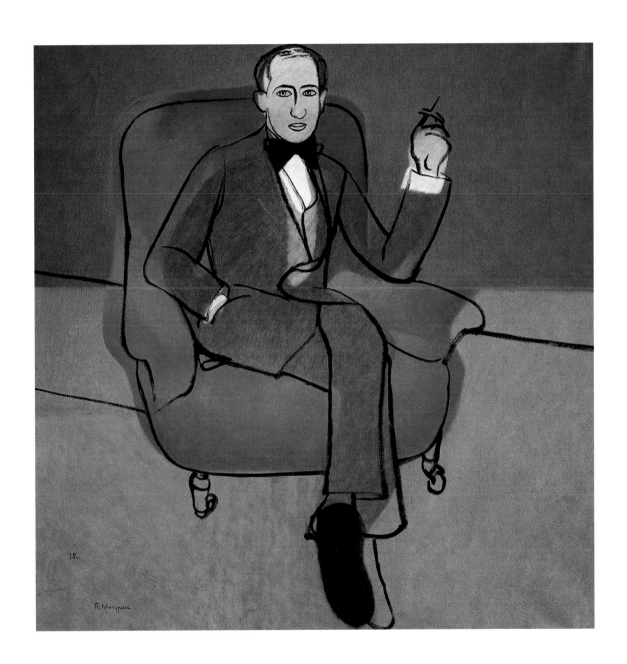

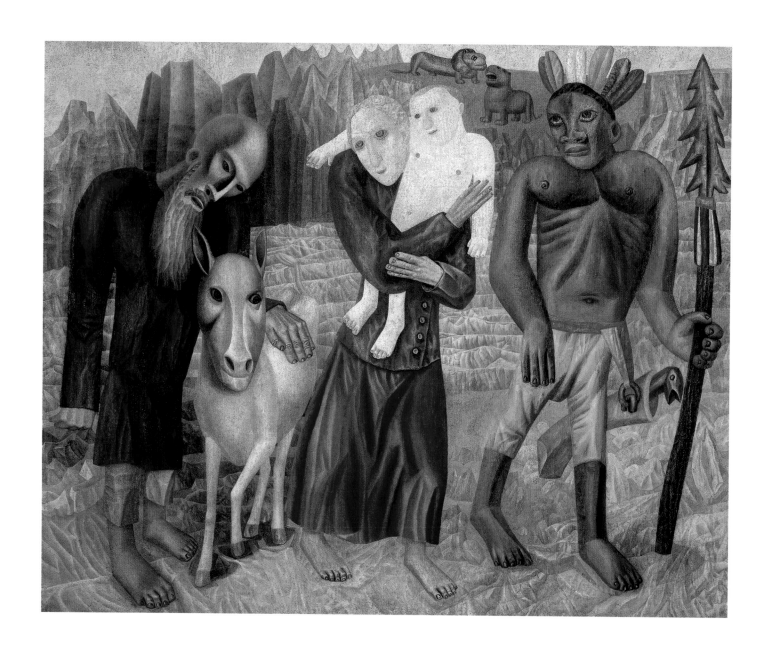

191. PAVEL FILONOV, *THE FLIGHT INTO EGYPT (THE REFUGEES)*, 1918. OIL ON CANVAS, 71.4 X 89.2 CM. MEAD ART MUSEUM, AMHERST COLLEGE. GIFT OF THOMAS P. WHITNEY, CLASS OF 1937

192. (OPPOSITE) PAVEL FILONOV, *GERMAN WAR*, 1915. OIL ON CANVAS, 176 X 156.3 CM. STATE RUSSIAN MUSEUM, ST. PETERSBURG

193. LIUBOV POPOVA, *PAINTERLY
ARCHITECTONICS*, 1916. OIL ON CANVAS,
88.7 X 71 CM. THE STATE TRETYAKOV
GALLERY, MOSCOW

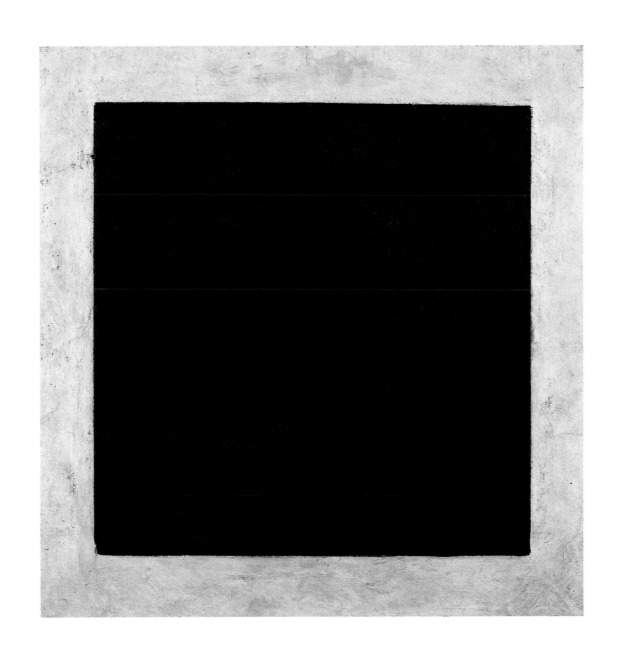

194. KAZIMIR MALEVICH, BLACK SQUARE,
CA. 1930. OIL ON CANVAS, 53.5 X
53.4 CM. STATE HERMITAGE MUSEUM,
ST. PETERSBURG

195. KAZIMIR MALEVICH, *SUPREMATISM*,
1915. OIL ON CANVAS, 87.5 X
72 CM. STATE RUSSIAN MUSEUM,
ST. PETERSBURG

196. (OPPOSITE) VLADIMIR TATLIN,
COUNTER-RELIEF (MATERIAL SELECTION),
1916. WOOD, IRON, AND ZINC,
H. 100 CM. THE STATE TRETYAKOV
GALLERY, MOSCOW

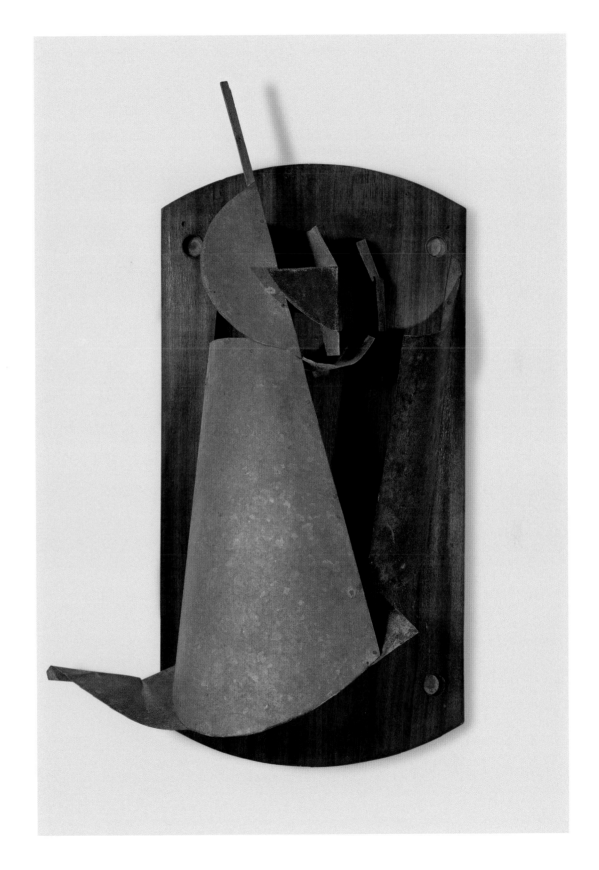

197. ALEXANDER RODCHENKO,
TRIPTYCH: PURE RED COLOR, PURE YELLOW
COLOR, PURE BLUE COLOR, 1921. OIL
ON CANVAS; THREE PANELS, 62.5 X
52.5 CM EACH. PRIVATE COLLECTION,
MOSCOW

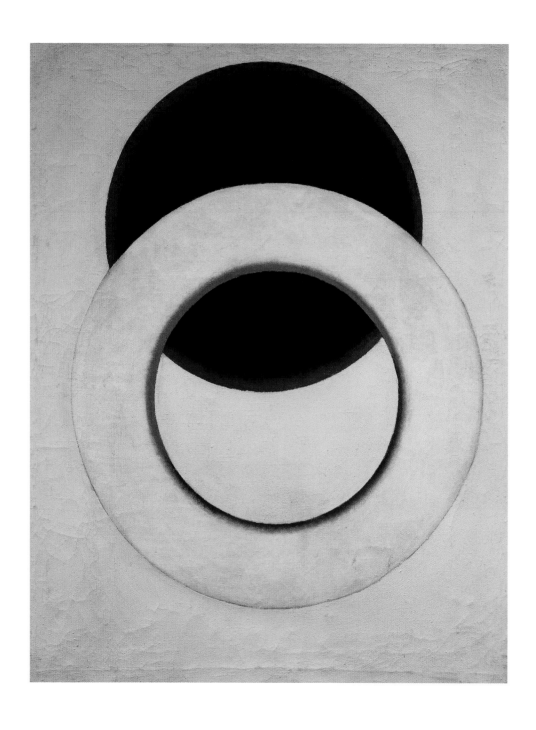

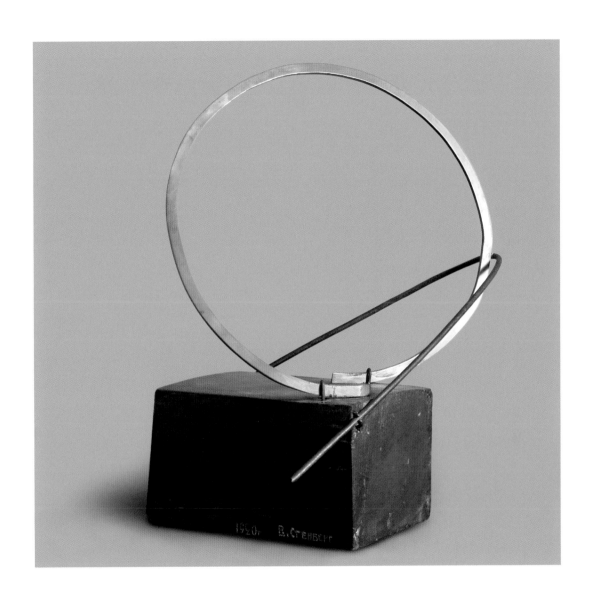

198. (OPPOSITE) ALEXANDER
RODCHENKO, *WHITE CIRCLE*, 1918. OIL
ON CANVAS, 89.2 X 71.5 CM. STATE
RUSSIAN MUSEUM, ST. PETERSBURG

199. VLADIMIR STENBERG, *SPIRAL*,
1920. METAL ON WOOD BASE;
H. 19 CM, BASE H. 8 CM. THE STATE
TRETYAKOV GALLERY, MOSCOW

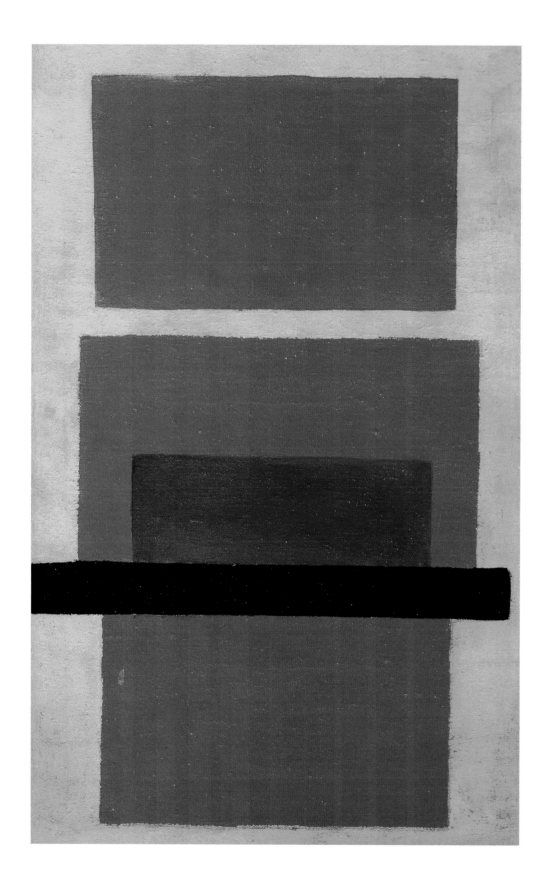

200. OLGA ROZANOVA, NON-OBJECTIVE
COMPOSITION (SUPREMATISM), CA. 1916.
OIL ON CANVAS, 85 X 60.5 CM. STATE
RUSSIAN MUSEUM, ST. PETERSBURG

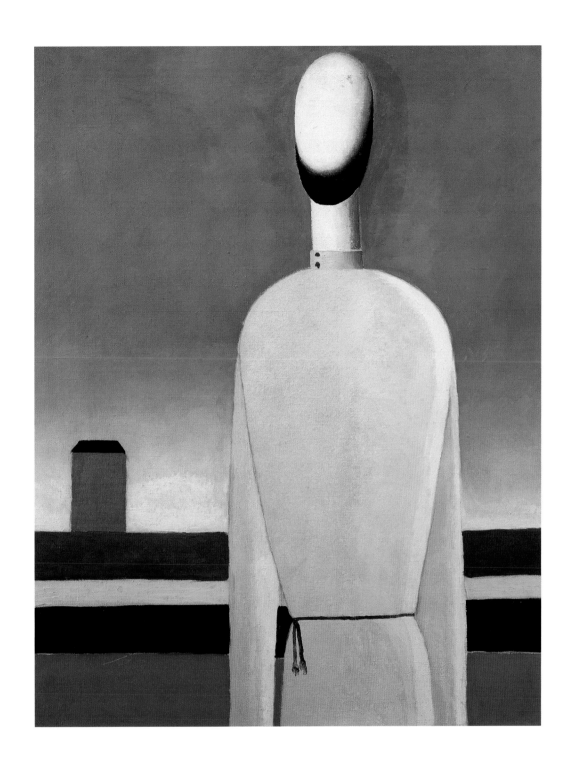

201. KAZIMIR MALEVICH, COMPLEX
PREMONITION (TORSO IN A YELLOW SHIRT),
CA. 1932. OIL ON CANVAS, 98.5 X
78.5 CM. STATE RUSSIAN MUSEUM,
ST. PETERSBURG

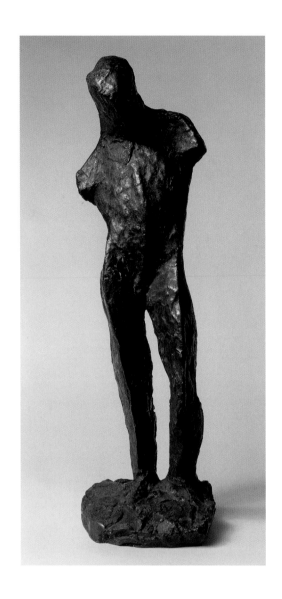

202. (LEFT) BORIS KOROLEV, *STANDING MALE FIGURE*, 1914. BRONZE, H. 49 CM. STATE RUSSIAN MUSEUM, ST. PETERSBURG

203. (RIGHT) KAZIMIR MALEVICH, *FEMALE FIGURE*, 1928–29. OIL ON CANVAS, 126 X 106 CM. STATE RUSSIAN MUSEUM, ST. PETERSBURG

204. (OPPOSITE) KUZMA PETROV-VODKIN, *MORNING*, 1917. OIL ON CANVAS, 161 X 129 CM. STATE RUSSIAN MUSEUM, ST. PETERSBURG

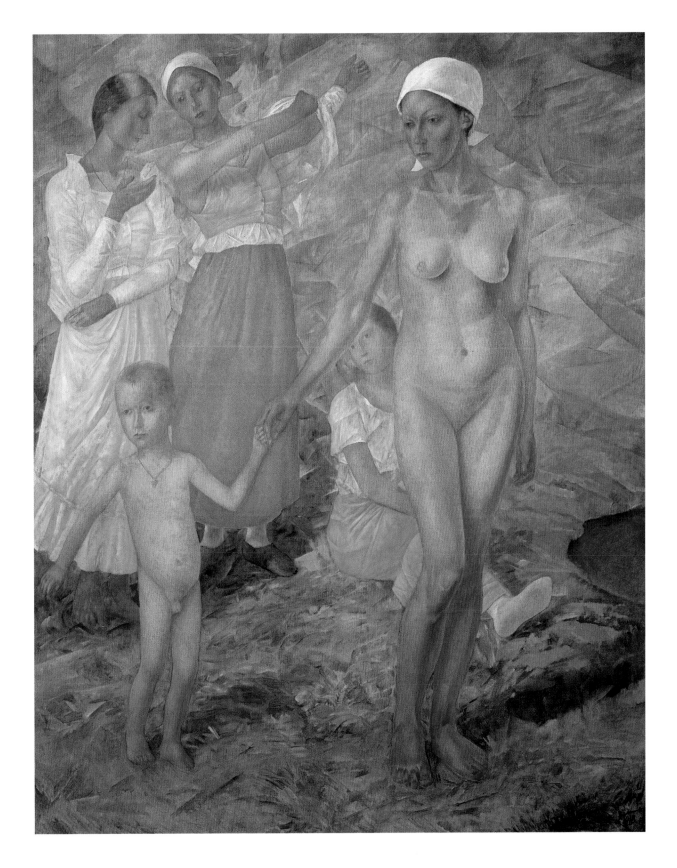

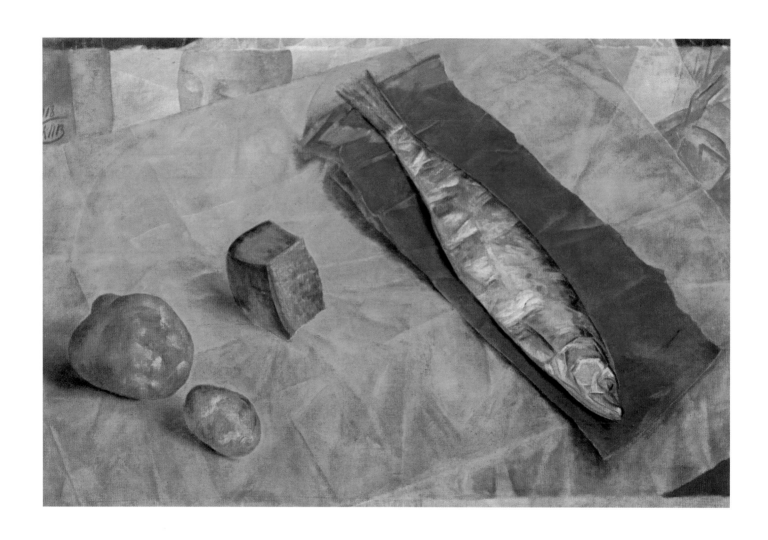

205. KUZMA PETROV-VODKIN,
HERRING, 1918. OIL ON OILCLOTH,
58 X 88.5 CM. STATE RUSSIAN
MUSEUM, ST. PETERSBURG

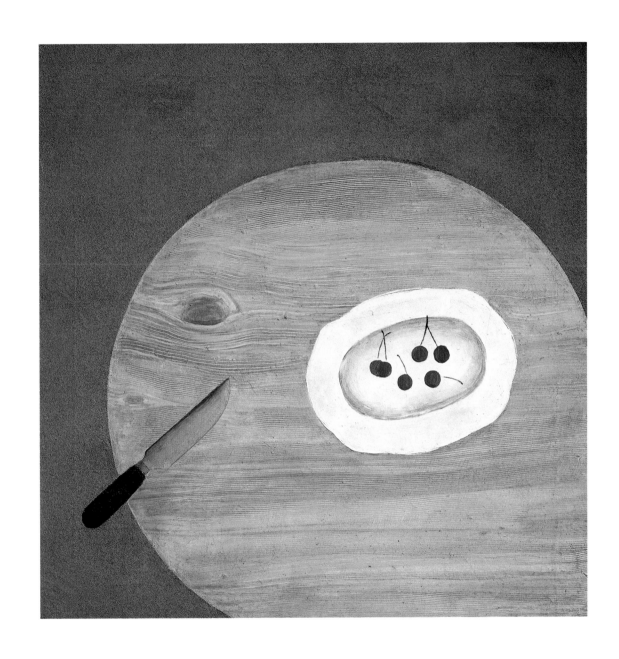

206. DAVID SHTERENBERG, *STILL LIFE WITH CHERRIES*, 1919. OIL ON CANVAS, 68 X 67 CM. STATE RUSSIAN MUSEUM, ST. PETERSBURG

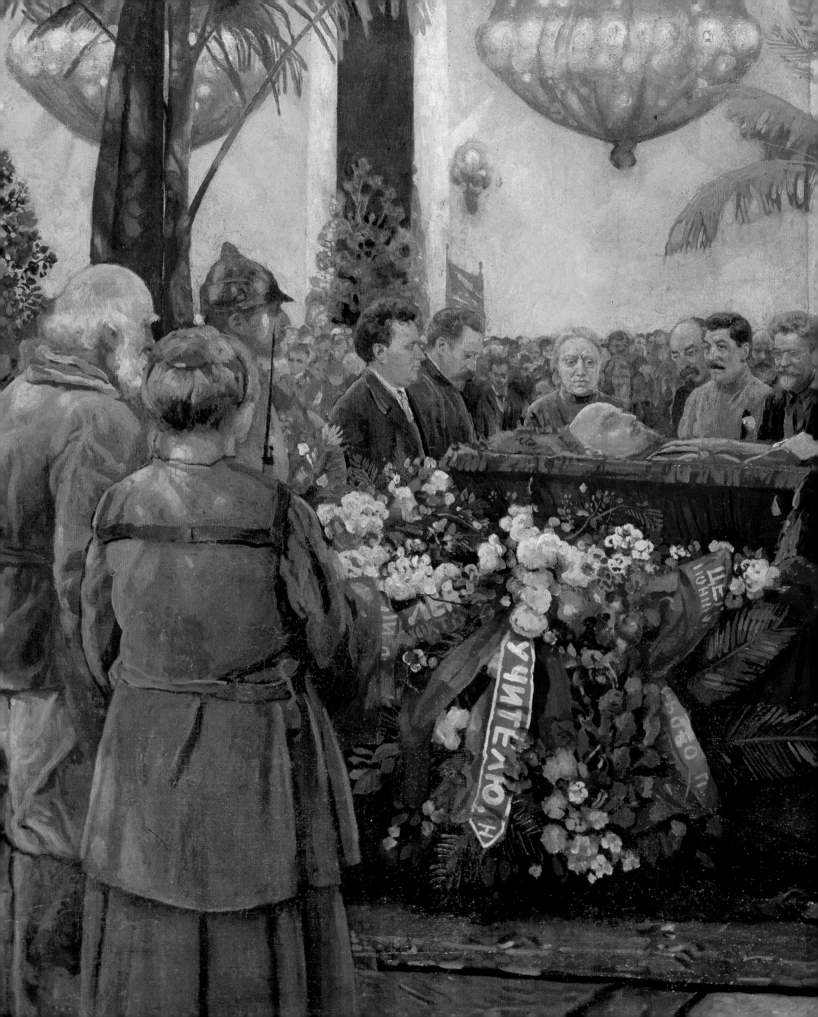

SOCIALIST REALISM THROUGH THE THAW

EDUCATING THE MASSES: SOCIALIST REALIST ART
BORIS GROYS | 318

EDUCATING THE MASSES: SOCIALIST REALIST ART
BORIS GROYS

From the beginning of the thirties until the end of the Soviet Union, Socialist Realism was the only officially recognized creative method for all Soviet artists. The plurality of competing aesthetic programs that characterized Soviet art in the 1920s came to an abrupt end when the Central Committee issued a decree on April 23, 1932, disbanding all existing artistic groups and declaring that all Soviet creative workers should be organized according to profession in unitary "creative unions" of artists, architects, and so on. Socialist Realism was proclaimed the obligatory method at the First All-Union Congress of Soviet Writers in 1934 and was subsequently expanded to encompass all the other arts, including the visual arts, without any substantial modification of its initial formulations. According to the standard official definition, Socialist Realist artwork must be "realistic in form and Socialist in content." This apparently simple formulation is actually highly enigmatic. How can a form, as such, be realistic? And what does "Socialist content" actually mean? To translate this vague formulation into a concrete artistic practice was not an easy task for Soviet artists, and yet the answers to those questions defined the fate of every individual Soviet artist. It determined the artist's right to work—and in some cases his or her right to live.

During the initial, Stalinist period of the formation of Socialist Realism, the number of artists, as well as artistic devices and styles, that were excluded from the Socialist Realist canon continually expanded. Since the middle of the thirties, officially acceptable methods were defined in an increasingly narrow way. This politics of narrow interpretation and rigorous exclusion lasted until the death of Joseph Stalin in 1953. After the so-called "thaw" and partial de-Stalinization of the Soviet system, which began at the end of the 1950s and continued until the dissolution of the Soviet Union, the interpretation of Socialist Realism became more inclusive. But the initial politics of exclusion never allowed a truly coherent Socialist Realist aesthetic to emerge. And the subsequent politics of inclusion never led to true openness and artistic pluralism. After the death of Stalin, an unofficial art scene emerged in the Soviet Union, but it was not accepted by the official art institutions. It was tolerated by the authorities, but works made by those artists were never exhibited or published, showing that Socialist Realism never became inclusive enough.

Soviet Socialist Realism was intended to be a rigorously defined artistic style, but it was also intended to be a unified method for all Soviet artists, even those working in different mediums, including literature, the visual arts, theater, and cinema. Of course, these two intentions were mutually contradictory. If an artistic style cannot be compared with other artistic styles in the same medium, its aesthetic specificity as well as its artistic value remains unclear. For Soviet artists, the main point of reference was the bourgeois West. The primary concern of the Soviet ideological authorities was that Soviet Socialist art not look like the art of the capitalist West, which was understood as a decadent, formalist art that rejected the artistic values of the past. In contrast, the Soviets formulated a program that appropriated the artistic heritage of all past epochs: instead of rejecting the art of the past, artists should use

Tatiana Yablonskaya, Bread, 1949.

Oil on canvas, 201 x 370 cm.

The State Tretyakov Gallery, Moscow

it for the sake of the new Socialist art. The discussion regarding the role of artistic heritage in the context of the new Socialist reality that took place at the end of the twenties and the beginning of the 1930s was decisive in terms of the future development of Socialist Realist art. It marked an essential shift from the art of the 1920s, which was still dominated by modernist, formalist programs, toward the art of Socialist Realism, which was concerned primarily with the content of an individual artwork.

The attitude of avant-garde artists and theoreticians toward artistic heritage was powerfully expressed in a short but important text by Kazimir Malevich, "On the Museum," from 1919. At that time, the new Soviet government feared that the old Russian museums and art collections would be destroyed by civil war and the general collapse of state institutions and the economy. The Communist Party responded by trying to secure and save these collections. In his text, Malevich protested against this pro-museum policy by calling on the state not to intervene on behalf of the old art collections because their destruction could open the path to true, living art. In particular, he wrote:

> Life knows what it is doing, and if it is striving to destroy one must not interfere, since by hindering we are blocking the path to a new conception of life that is born within us. In burning a corpse we obtain one gram of powder: accordingly thousands of graveyards could be accommodated on a single chemist's shelf. We can make a concession to conservatives by offering that they burn all past epochs, since they are dead, and set up one pharmacy.

Later, Malevich gives a concrete example of what he means:

> The aim (of this pharmacy) will be the same, even if people will examine the powder from Rubens and all his art—a mass of ideas will arise in people, and will be often more alive than actual representation (and take up less room).[1]

Malevich believed that new, revolutionary times should be represented by new, revolutionary art forms. This opinion was, of course, shared by many other artists on the "left front" in the 1920s. But their critics argued that true revolution takes place not on the level of artistic forms but rather on the level of their social use. Being confiscated from the old ruling classes, appropriated by the victorious proletariat, and put at the service of the new Socialist state, old artistic forms become intrinsically new because they were filled with new content and used in a completely different context. In this sense, these apparently old forms became even more new than the forms that were created by the avant-garde but were used in the same context by bourgeois society. This proto-postmodern criticism of "formalist trends in art" was formulated by an influential art critic of that time, Yakov Tugendkhold, in the following way: "The distinction between proletarian and nonproletarian art happens to be found not in form but in the idea of use of this form. Locomotives and machines are the same here as in the West; this is our form. The difference between our industrialism and that of the West, however, is in the fact that here it is the proletariat that is the master of these locomotives and machines; this is our content."[2] During the thirties

this argument was repeated again and again. The artists and the theoreticians of the Russian avant-garde were accused of having a nihilistic approach toward the art of the past, preventing the proletariat and the Communist Party from using artistic heritage for their own political goals. Accordingly, Socialist Realism was presented initially as an emergent rescue operation directed against the destruction of cultural tradition. Years later Andrei Zhdanov, a member of the Politbureau who was at that time responsible for official cultural politics, said in a speech dedicated to questions of art: "Did the Central Committee act 'conservatively,' was it under the influence of 'traditionalism' or 'epigonism' and so on, when it defended the classical heritage in painting? This is sheer nonsense! . . . We Bolsheviks do not reject the cultural heritage. On the contrary, we are critically assimilating the cultural heritage of all nations and all times in order to choose from it all that inspire the working people of Soviet society to great exploits in labor, science, and culture."[3]

The discussion of the role of artistic heritage set the framework for the development of the aesthetics of Socialist Realism, because it indicated some formal criteria that a Socialist Realist artwork should satisfy in order to be both Socialist and realist. The introduction of Socialist Realism initiated a long and painful struggle against formalism in art in the name of a return to classical models of art-making. In this way, Socialist Realist artwork was increasingly purged of all traces of modernist "distortions" of the classical form, so that at the end of this process it became easily distinguishable from bourgeois Western art. Soviet artists also tried to thematize everything that looked specifically Socialist and non-Western: official parades and demonstrations, meetings of the Communist Party and its leadership, happy workers building the material basis of the new society. In this sense, the apparent return to a classical mimetic image effectuated by Socialist Realism was rather misleading. Socialist Realism was not supposed to depict life as it was because life was interpreted by Socialist Realist theory as being constantly in flux and in development—specifically in "revolutionary development," as it was officially formulated.

Socialist Realism was oriented toward what has not yet come into being but what should be created and is destined to become a part of the Communist future. Socialist Realism was understood as a dialectical method. "What is most important to the dialectical method," wrote Stalin, "is not that which is stable at the present but is already beginning to die, but rather that which is emerging and developing, even if at present it does not appear stable, since for the dialectical method only that which is emerging and developing cannot be overcome."[4] Of course, it was the Communist Party that had the right to decide what had to die and what could emerge.

The mere depiction of the facts was officially condemned as "naturalism," which should be distinguished from "realism," a style that grasped the whole of historical development and recognized in the present world the signs of the coming Communist world. The ability to make a correct, Socialist selection of the facts of life was regarded as the most important quality of a Socialist artist. Boris Ioganson, one of the leading official artists of the Stalin period, said in his speech to the First Convention of Soviet Artists in the 1930s: "A fact is not the whole truth; it is merely the raw material from which the real truth of art must be smelted and extracted—the chicken must not be roasted with its

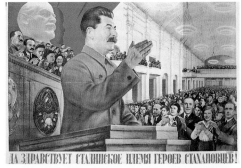

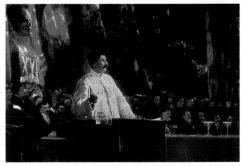

Gustav Klucis, Long Live Stalin's Generation of Stakhanov Heroes!, 1936. Poster, 72.7 x 101.3 cm. Russian State Library, Moscow

Alexander Gerasimov, Joseph Stalin Reports at the Sixteenth Congress of the VKP(b), 1935. Oil on canvas, 99.5 x 178 cm. The State Tretyakov Gallery, Moscow

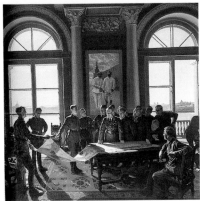

Alexander Gerasimov, Stalin and Voroshilov in the Kremlin, 1938. Oil on canvas, 300 x 390 cm. The State Tretyakov Gallery, Moscow

Alexander Laktionov, Captain Iudin, Hero of the Soviet Union, Visits the Tank Corps–Komsomol Members, 1938. Oil on canvas, 299 x 300 cm. Scientific-Research Museum of the Russian Academy of Arts, St. Petersburg

feathers."[5] And he argued further that the locus of creativity in the art of Socialist Realism does not lie in the technique of painting but in the "staging of the picture," which is to say that the painter's work does not essentially differ from the photographer's. A Socialist Realist painting is a kind of virtual photography, meant to be realistic but also to encompass more than a simple reflection of a scene that actually happened. The goal was to give to the image of the future world, where all the facts will be the facts of Socialist life, a kind of photographic quality, which would make this image visually credible. After all, Socialist Realism had to be realist only in form and not in content.

The apparent return to the classical was misleading as well. Socialist Realist art was not created for museums, galleries, private collectors, or connoisseurs. The introduction of Socialist Realism coincided with the abolishment of the market, including the art market. The Socialist State became the only remaining consumer of art. And the Socialist State was interested only in one kind of art: socially useful art that appealed to the masses, art that educated them, inspired them, directed them. Consequently, Socialist Realist artwork was made ultimately for mass reproduction, distribution, and consumption—and not for concentrated, individual contemplation. That explains why the paintings or sculptures that looked too good, or too perfect, under the traditional criteria of quality were also regarded by the Soviet art critic as "formalist." Socialist Realist artwork had to refer aesthetically to some acceptable kind of heritage, but at the same time it had to do it in a way that opened this heritage to a mass audience, without creating too great a distance between an artwork and its public.

Of course, many traditional artists who felt pushed aside by the Russian avant-garde of the 1920s undoubtedly exploited the change in political ideology to achieve recognition for their work. Many Soviet artists still painted landscapes, portraits, and genre scenes in the tradition of the nineteenth century. But the paintings of such leading Socialist Realist artists as Alexander Deineka, Alexander Gerasimov, or even Isaak Brodsky referred primarily to the aesthetics of posters, color photography, or the cinema. In fact, the successful pictures made by these artists could be seen throughout the country, reproduced on countless posters and in endless numbers of books. They were popular "hits," and it would be wide of the mark to criticize a pop song for lyrics that were not great poetry. A capability for mass distribution became the leading aesthetic quality in Stalinist Russia. Even if painting and sculpture dominated the system of visual arts, both were produced and reproduced on a mass scale comparable only to photographic and cinematic production in the West. Thousands and thousands of Soviet artists repeated the same officially approved Socialist Realist subjects, figures, and compositions, allowing themselves only the slightest variations to these officially established models, variations that remain almost unnoticed by an uninformed viewer. The Soviet Union therefore became saturated with painted and sculpted images that seemed to be produced by the same artist.

Socialist Realism emerged at a time when global commercial mass culture achieved its decisive breakthrough and became the determining force that it has remained ever since. Official culture in the Stalin era was part of this global mass culture and fed on the expectations it awakened worldwide. And an acute interest in new media that could be

easily reproduced and distributed could be found everywhere in the 1930s. In their various ways, French Surrealism, German Neue Sachlichkeit, Italian Novecento, and all other forms of realism of the time exploited images and techniques derived from the vastly expanding mass media of the day. But in spite of these resemblances, Stalinist culture was structured differently from its counterpart in the West. Whereas the market dominated, even defined, Western mass culture, Stalinist culture was noncommercial, even anticommercial. Its aim was not to please the greater public but to educate, to inspire, to guide it. (Art should be realist in form and Socialist in content, in other words.) In practice, this meant that art had to be accessible to the masses on the level of form, although its content and goals were ideologically determined and aimed at changing and reeducating the masses.

In his 1939 essay "Avant-Garde and Kitsch" Clement Greenberg famously attempted to define the difference between avant-garde art and mass culture (which he termed "kitsch"). Mass kitsch, he stated, uses the effects of art, while the avant-garde investigates artistic devices.[6] Accordingly, Greenberg placed the Socialist Realism of the Stalin era, as well as other forms of totalitarian art, on a par with the commercial mass culture of the West. Both, he averred, aimed to exert the maximum effect on their audiences, rather than engaging critically with artistic practices themselves. For Greenberg, the avant-garde ethos thus entailed a distant and critical attitude toward mass culture. But actually, the artists of the classical European and Russian avant-garde were very much attracted to the new possibilities offered by the mass production and dissemination of images. The avant-garde in fact disapproved of only one aspect of commercial mass culture: its pandering to mass taste. Yet modernist artists also rejected the elitist "good" taste of the middle classes. Avant-garde artists wished to create a new public, a new type of human being, who would share their own taste and see the world through their eyes. They sought to change humankind, not art. The ultimate artistic act would be not the production of new images for an old public to view with old eyes, but the creation of a new public with new eyes.

Soviet culture under Stalin inherited the avant-garde belief that humanity could be changed and was driven by the conviction that human beings were malleable. Soviet culture was a culture for masses that had yet to be created. This culture was not required to prove itself economically—to be profitable, in other words—because the market had been abolished in the Soviet Union. Hence the actual tastes of the masses were completely irrelevant to the art practice of Socialist Realism, more irrelevant, even, than they were to the avant-garde, since members of the avant-garde in the West, for all their critical disapproval, had to operate within the same economic conditions as mass culture. Soviet culture as a whole may therefore be understood as an attempt to abolish the split between the avant-garde and mass culture that Greenberg had diagnosed as the main effect of art operating under the conditions of Western-style capitalism.[7] Accordingly, all other oppositions related to this fundamental opposition—between production and reproduction, original and copy, or quality and quantity, for instance—lost their relevance in the framework of Soviet culture. The primary interest of Socialist Realism was not the artwork but the viewer. Soviet art was produced in the relatively firm conviction that people would come to like it when they had become better people, less decadent and less

Alexander Deineka, Goalkeeper, 1934. Oil on canvas, 148 x 164 cm. The State Tretyakov Gallery, Moscow

Alexander Deineka, Morning Exercise, 1932. Oil on canvas, 91 x 118 cm. The State Tretyakov Gallery, Moscow

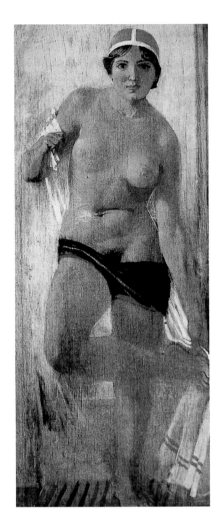

Alexander Samokhvalov, After the Cross, 1934–35. Oil on canvas, 143 x 64 cm. The State Tretyakov Gallery, Moscow

corrupted by bourgeois values. The viewer was conceived of as an integral part of a Socialist Realist work of art and, at the same time, as its final product. Socialist Realism was the attempt to create dreamers who would dream Socialist dreams.

To promote the creation of a new humankind, and especially of a new public for their art, artists joined forces with those in political power. This was undoubtedly a dangerous game for artists to play, but the rewards appeared at the beginning to be enormous. The artist tried to attain absolute creative freedom by throwing off all moral, economic, institutional, legal, and aesthetic constraints that had traditionally limited his or her political and artistic will. But after the death of Stalin all the utopian aspirations and dreams of absolute artistic power became immediately obsolete. The art of official Socialist Realism became simply a part of the Soviet bureaucracy—with all the privileges and restrictions connected to this status. Soviet artistic life after Stalin became a stage on which the struggle against censorship was played out. This drama had many heroes who managed to widen the framework of what was allowed, to make "good artworks," "truly realistic artworks," or even "modernist artworks" on the border of what was officially possible. These artists and the art critics who supported them became well known and were applauded by the greater public. Of course, this struggle involved a lot of personal risk and in many cases led to very unpleasant consequences for the artists. But still it is safe to say that inside the post-Stalinist art of Socialist Realism a new value system established itself. The art community valued not the artworks that defined the core message and the specific aesthetics of Socialist Realism, but rather the artworks that were able to widen the borders of censorship, to break new ground, to give to other artists more operative space. At the end of this process of expansion, Socialist Realism lost its borders almost completely and disintegrated, together with the Soviet state.

In our time the bulk of Socialist Realist image production has been reevaluated and reorganized. The previous criteria under which these artworks were produced have become irrelevant; neither the struggle for a new society nor the struggle against censorship are criteria any longer. One can only wait and see what use the contemporary museum system and contemporary art market will make of the heritage of Socialist Realism—of this huge number of artworks that were initially created outside of, and even directed against, the modern, Western art institutions.

1. Kazimir Malevich, "On the Museum" (1919), Essays on Art, vol. 1, ed. Troels Andersen (Copenhagen-New York, 1971), pp. 68–72.

2. Yakov Tugendkhold, "Iskusstvo oktiabrskoi epokhi" (Leningrad, 1930), p. 4.

3. Andrei A. Zhdanov, Essays on Literature, Philosophy, and Music (New York, 1950), pp. 88–89, 96.

4. Cited by N. Dmitrieva, "Das Problem des Typischen in der bildenden Kunst und Literatur," Kunst und Literatur, no. 1 (Moscow, 1953), p.100.

5. Boris Ioganson, "O merakh uluchsheniia uchebno-metodicheskoi raboty v uchebnykh zavedeniiakh Akademii Khudozhestv SSSR," Sessii Akademii Khudozhestv SSSR. Pervaia i vtoraia sessiia (Moscow: Akademija Khudozhestv SSSR, 1949), pp. 101–03.

6. Clement Greenberg, Collected Essays and Criticism, vol. 1 (Chicago: University of Chicago Press, 1986), p.17f.

7. On the relationship between the Russian avant-garde and Socialist Realism, see Boris Groys, The Total Art of Stalinism: Avant-Garde, Aesthetic Dictatorship, and Beyond (Princeton: Princeton University Press, 1992).

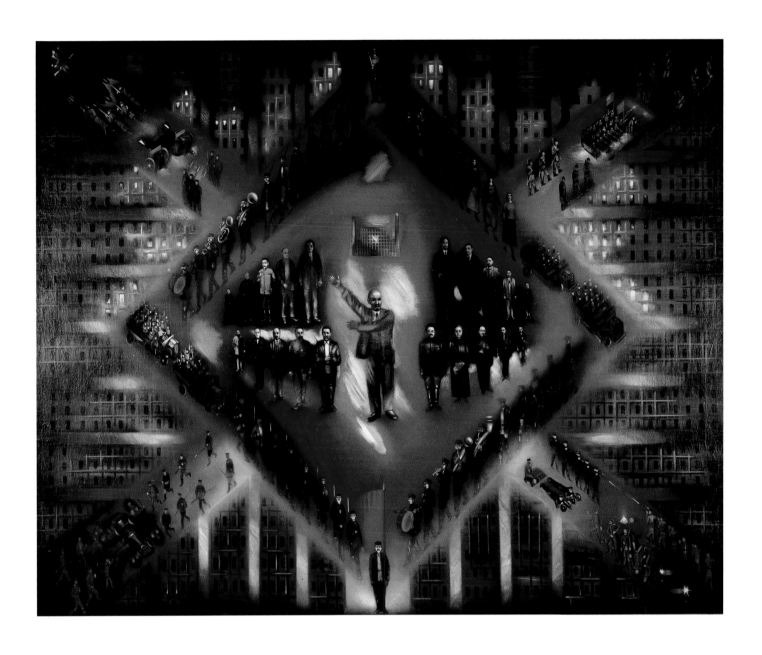

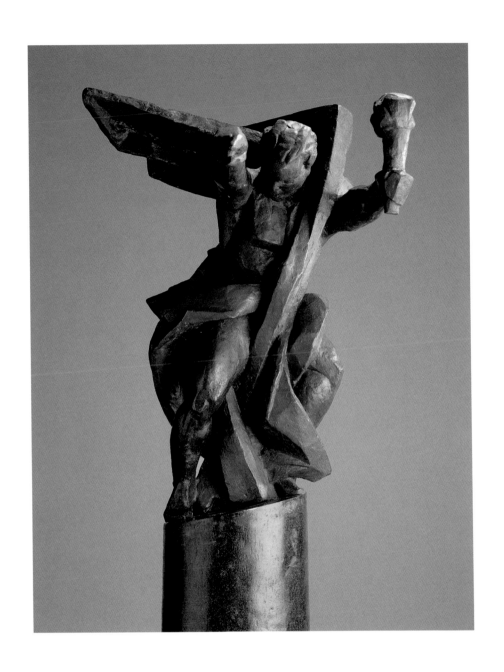

207. (OPPOSITE) KLIMENT REDKO,
UPRISING, 1924–25. OIL ON CANVAS,
170.5 X 212 CM. THE STATE TRETYAKOV
GALLERY, MOSCOW

208. VERA MUKHINA, THE FLAME
OF REVOLUTION, 1922–23. BRONZE,
H. 104 CM. THE STATE TRETYAKOV
GALLERY, MOSCOW

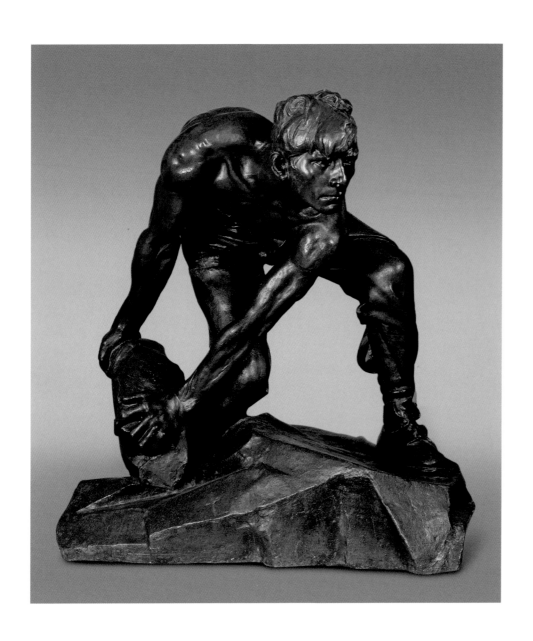

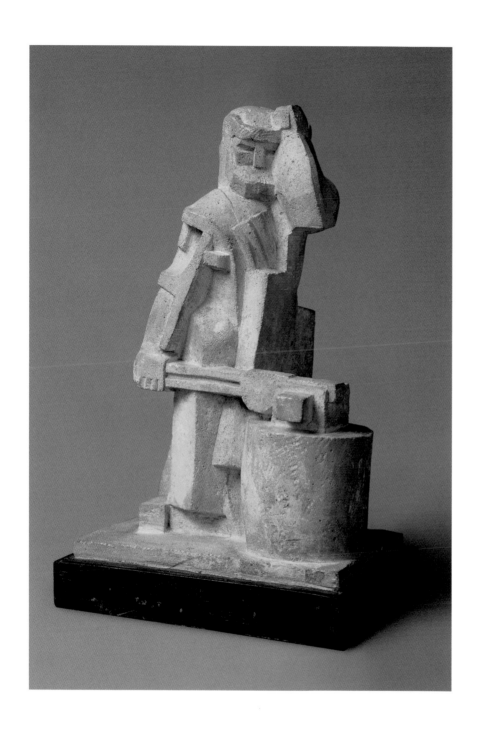

209. (OPPOSITE) IVAN SHADR,
COBBLESTONE—WEAPON OF THE
PROLETARIAT, 1927. BRONZE, H. 125 CM.
THE STATE TRETYAKOV GALLERY,
MOSCOW

210. JOSEPH CHAIKOV, *BLACKSMITH*,
1927. PLASTER WITH CEMENT POWDER,
H. 49 CM. THE STATE TRETYAKOV
GALLERY, MOSCOW

211. SERGEI LUCHISHKIN, *THE BALLOON FLEW AWAY*, 1926. OIL ON CANVAS, 106 X 69 CM. THE STATE TRETYAKOV GALLERY, MOSCOW

212. (OPPOSITE) ALEXANDER LABAS, *THE TRAIN IS GOING*, 1929. OIL ON CANVAS, 98.3 X 75.8 CM. STATE RUSSIAN MUSEUM, ST. PETERSBURG

213. ALEXANDER DEINEKA, *DEFENSE OF PETROGRAD*, 1927. OIL ON CANVAS, 210 X 238 CM. CENTRAL MUSEUM OF THE ARMED FORCES, MOSCOW

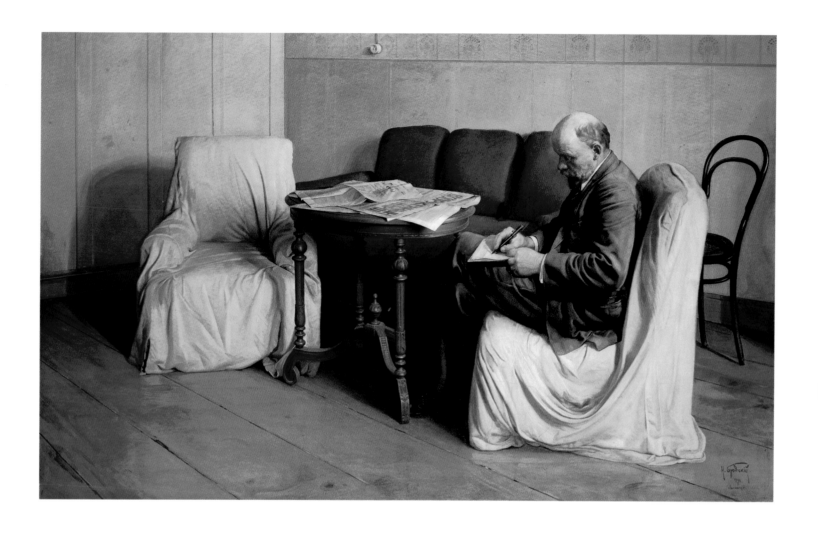

214. ISAAK BRODSKY, *V. I. LENIN IN THE
SMOLNY*, 1930. OIL ON CANVAS,
198 X 320 CM. STATE HISTORICAL
MUSEUM, MOSCOW

215. (OPPOSITE) ISAAK BRODSKY,
AT THE COFFIN OF THE LEADER, 1925.
OIL ON CANVAS, 124 X 208 CM.
STATE HISTORICAL MUSEUM, MOSCOW

216. (OPPOSITE) VASILY KUPTSOV,
ANT-20 "MAXIM GORKY", 1934. OIL ON
CANVAS, 110 X 121 CM. STATE RUSSIAN
MUSEUM, ST. PETERSBURG

217. SARAH LEBEDEVA, *PORTRAIT OF
VALERY CHKALOV*, 1936. BRONZE,
H. 36 CM. THE STATE TRETYAKOV
GALLERY, MOSCOW

218. ALEXANDER DEINEKA, FUTURE
PILOTS, 1938. OIL ON CANVAS,
131.5 X 160 CM. THE STATE TRETYAKOV
GALLERY, MOSCOW

219. VASILY EFANOV, *AN UNFORGETTABLE
MEETING*, 1936–37. OIL ON CANVAS,
270 X 393.5 CM. THE STATE TRETYAKOV
GALLERY, MOSCOW

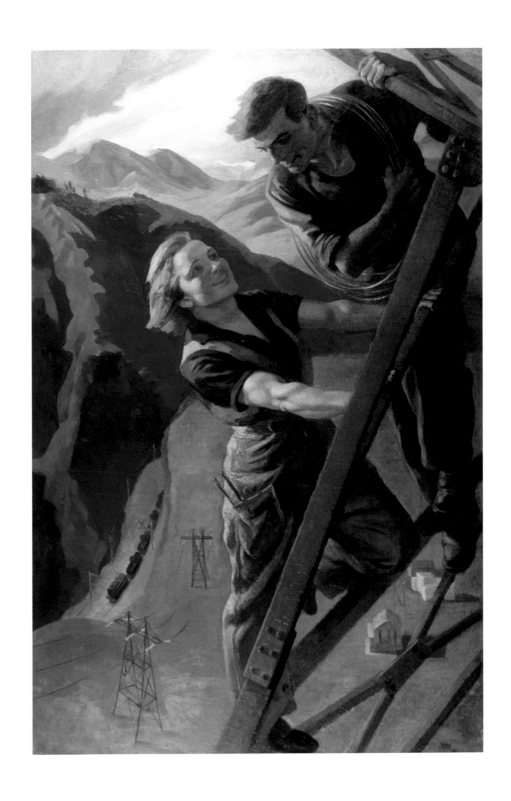

220. SERAFIMA RYANGINA, *HIGHER AND
HIGHER*, 1934. OIL ON CANVAS, 149 X
100 CM. KIEV MUSEUM OF RUSSIAN ART

221. (OPPOSITE) YURI PIMENOV,
NEW MOSCOW, 1937. OIL ON CANVAS,
139.5 X 171 CM. THE STATE TRETYAKOV
GALLERY, MOSCOW

222. ALEXANDER DEINEKA, *COLLECTIVE FARM WORKER ON A BICYCLE*, 1935.
OIL ON CANVAS, 120 X 220 CM. STATE RUSSIAN MUSEUM, ST. PETERSBURG

223. (OPPOSITE) SERGEI GERASIMOV, *A COLLECTIVE FARM FESTIVAL*, 1937.
OIL ON CANVAS, 234.5 X 372 CM. THE STATE TRETYAKOV GALLERY, MOSCOW

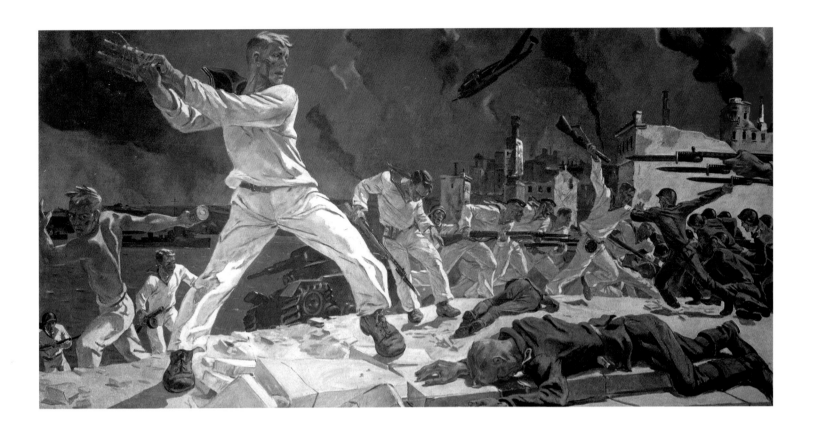

224. ALEXANDER DEINEKA, DEFENSE
OF *SEVASTOPOL*, 1942. OIL ON
CANVAS, 200 X 400 CM. STATE RUSSIAN
MUSEUM, ST. PETERSBURG

225. (OPPOSITE) PAVEL KORIN,
THREE, 1933—35. OIL ON CANVAS, 190 X
110 CM. THE STATE TRETYAKOV
GALLERY, HOUSE-MUSEUM OF PAVEL
KORIN, MOSCOW

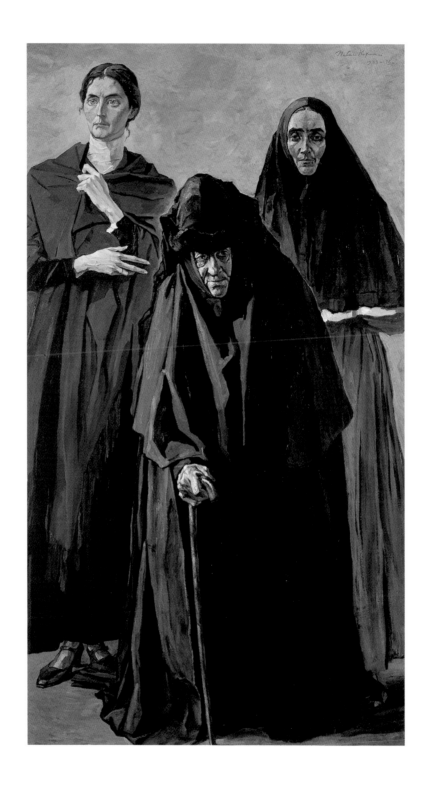

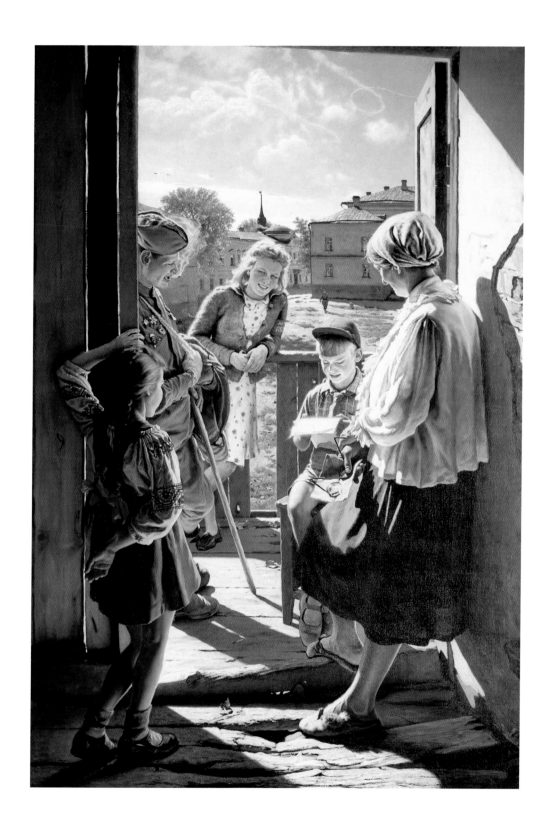

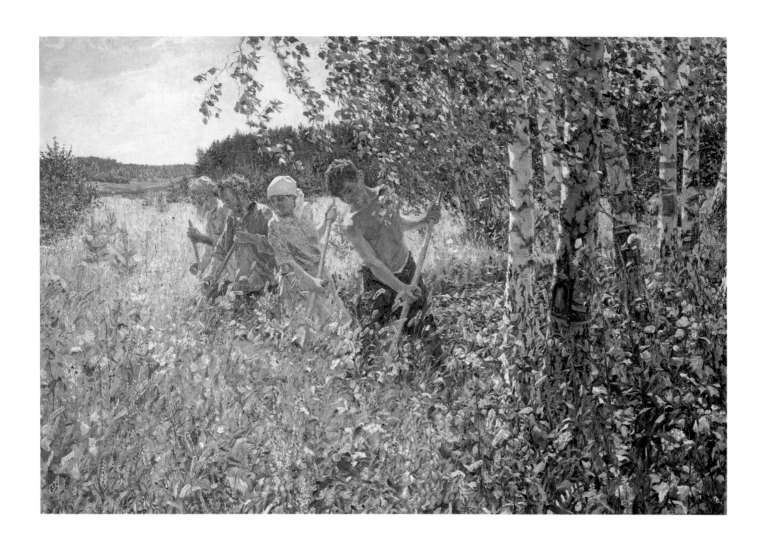

226. (OPPOSITE) ALEXANDER
LAKTIONOV, LETTER FROM THE FRONT,
1947. OIL ON CANVAS, 225 X
154.5 CM. THE STATE TRETYAKOV
GALLERY, MOSCOW

227. ARKADY PLASTOV, REAPING, 1945.
OIL ON CANVAS, 197 X 293.5 CM. THE
STATE TRETYAKOV GALLERY, MOSCOW

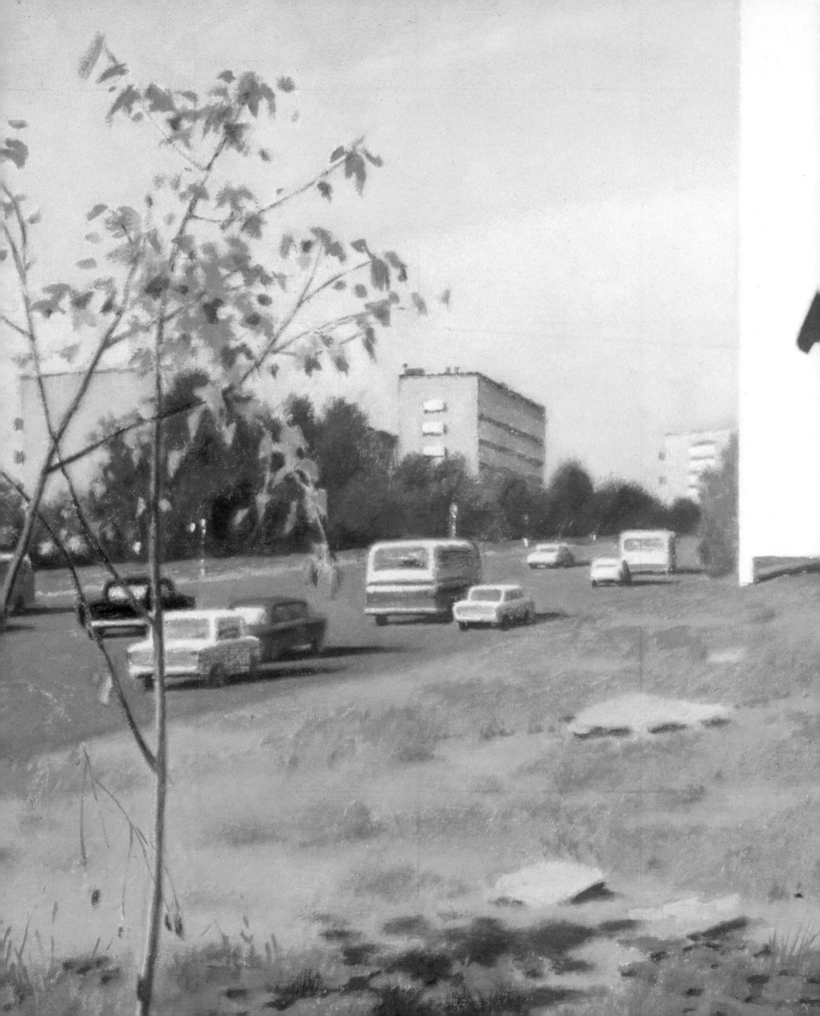

1957 TO THE PRESENT

OFFICIAL EXCHANGES/UNOFFICIAL REPRESENTATIONS: THE POLITICS OF CONTEMPORARY ART IN THE SOVIET UNION AND THE UNITED STATES, 1956–1977

VALERIE L. HILLINGS

A passage from the semifictitious story of Vannie Tomkins, an American journalist's wife living in Moscow in the late 1960s and early 1970s, captures Americans' fascination with Soviet artists working in an unofficial style during the height of the Cold War:

> Twice that second winter, Vannie had summoned up the courage to buy an abstract painting, as fearful of her taste as of the illicit transaction. The underground paintings, regarded by the authorities as "bourgeois" and "decadent," were permitted neither public exhibition in Russia nor an export stamp to be shown abroad. Officially, they were non-art executed by non-persons. [1]

Based on the author's own experience of living in the Soviet Union, Joyce Shub's *Moscow by Nightmare* (1973) appeared at a pivotal moment, when exhibitions, books, and numerous articles in the Western European and American mainstream and art press began to appear about Soviet artists working in styles other than Socialist Realism. [2] Western audiences voraciously consumed this information, which confirmed that the repression of Communism had not crushed the spirit of free expression embodied by art.

At the time, various labels including unofficial, underground, dissident, and non-conformist were applied to this art by Western critics, curators, dealers, and collectors; to varying degrees all of them imply a political motivation that was absent from most of the artwork produced in Russia at this time. The consistency with which Western authors linked the discussion of this art to the politics and buzzwords of the Cold War—such as bourgeois and decadent—underscores the degree to which the story of the artists as opponents of the official cultural policies of the Soviet Union became nearly as important as the serious evaluation of the art itself.

The seventies constitute a key decade in the history of U.S.–Soviet relations. This is as true of culture as it is of the political arena, in which U.S. President Richard Nixon and Soviet General Secretary Leonid Brezhnev advanced the policy of détente and, in 1972, signed the first SALT Treaty, which sought to limit strategic arms. The events that unfolded on the cultural front during this decade are unimaginable without the series of exhibitions and exchanges of the late fifties and sixties. I will consider here how the two countries employed both "official" and "unofficial" art as part of the overall discourse of the Cold War. To this end, I will examine a series of key events, exhibitions, and publications during the years 1956 to 1977 that reveal the degree to which contemporary art remained inextricably linked to the political agendas of both the United States and the Soviet Union.

The Thaw: The Fifties

In their 1967 book, *Unofficial Art in the Soviet Union*, Paul Sjeklocha and Igor Mead sought to correct the view that contemporary art in the Soviet Union was monolithic in style and always politically motivated. In 1963–64 the two men had served as staff members for an exhibition of American graphic art organized by the United States Information Agency (USIA), which traveled to a series of cities in the USSR. During this time, Sjeklocha and Mead had the opportunity to meet unofficial artists and critics.[3] In the introduction to the book, they argued that reports that Socialist Realism represented the sum total of contemporary Soviet art persisted because few Western authors had been given such access. Western audiences therefore had little indication that more individualistic art began to be produced after Joseph Stalin's death in 1953 and especially following Nikita Khrushchev's Secret Speech at the Twentieth Congress of the Soviet Communist Party in 1956, where he launched a scathing verbal attack on Stalin.[4]

The period of greater openness ushered in under Khrushchev led to a series of exhibitions of international modern and contemporary art in the USSR in the late fifties and early sixties that introduced a plurality of artistic visions to Soviet artists. Already in January 1957, an article appeared in the *New York Times* contending that the Khrushchev era had established an increase in artistic freedom. The writer observed a discernible backlash against the "court painters" under Stalin: "They have consigned to the storehouse hundreds of paintings of the Stalin era."[5] Indeed, such paintings as Gelii Korzhev's *Raising the Banner* (1957–60, plate 228) reflect a shift away from the slick finish and idealized, abstract heroes of Stalinist Socialist Realism.[6] Soviet citizens had the chance to see modernist foreign art that had been forbidden for decades in both a loan show of French Impressionist art held at the Pushkin Museum of Fine Arts in Moscow in the winter of 1956 and a Pablo Picasso exhibition seen in Moscow in October 1956 and in Leningrad in 1957; the exhibitions contributed to a debate over whether such art could be "compatible with Soviet Realism."[7]

The Sixth World Festival of Youth and Students in the summer of 1957 was a watershed; it introduced international contemporary art to the Soviet Union. The festival, which took as its motto "peace and friendship," brought 4,500 works by foreign artists from fifty-two countries to three, two-story pavilions in the Sokolniki Park of Culture in Moscow. Reports indicated that visitors engaged in verbal debates about the validity of the art on display. While some proclaimed their support of modern art—"half of mankind cannot be wrong"—others staunchly defended Socialist Realism, saying to the modernist enthusiasts, "Why don't you read Lenin?"[8]

The presentation of Abstract Expressionist and Tachist art made an especially strong impression, as did a studio in which Soviet artists could observe the working methods of their foreign contemporaries and work alongside them.[9] Artist Vladimir Nemukhin has explained: "Seeing live artists—Americans, French, others—who had painted abstract art suddenly opened another path to us."[10] The artist Lydia Masterkova echoed this sentiment: "For me 1957 was a turning point. Those were the years of Khrushchev's thaw."[11] In these foreign artists, the young Soviets recognized their own strivings toward pluralistic, personal expression.

In 1958, the United States and the Soviet Union signed the U.S.–USSR cultural exchange agreement, which included the fields of industry, technology, agriculture, medicine, education, the arts, sports, and science. In the area of visual art, two exhibitions held during the summer of 1959 served as its first concrete manifestation: one was a show of Russian art at the Coliseum Fair in New York, and the other a presentation of American art at the Sokolniki Park in Moscow titled the *Exhibition of American Painting and Sculpture*.[12]

Describing the Soviet presentation in New York, Howard Devree of the *New York Times* explained that the art more closely resembled American art of twenty to forty years earlier— "American genre and landscaping painting of utter realism"—than the large-scale, Abstract Expressionist canvases then most familiar to New York contemporary art enthusiasts.[13] He nonetheless acknowledged the "pretty high level of accomplishment and some keen observation in the work of these social realists, and little that might be called direct propaganda."[14] In fact, the roster of artists sent to this exhibition included not only such official artists as Alexander Gerasimov, but also artists like Pyotr Konchalovsky, who had belonged to avant-garde circles earlier in the twentieth century. Moreover, Devree observed that some of the works had been sent to previous exhibitions of international significance; most notable among them Arkady Plastov's *Harvest* (1945), which had garnered attention at the 1956 Venice Biennale.

Ironically, the subject of national representations at international art events had, just five years earlier, become a topic of debate between writers for the *New York Times* and *Sovietskaya Kultura*, a publication of the Soviet Ministry of Culture. Speaking about the 1953 São Paulo Bienal, *New York Times* writer Aline Louchheim (soon to be Saarinen) took issue with the fact that the U.S. government neither sponsored nor showed discernible support for the American exhibition.[15] Rather, the Museum of Modern Art's director René d'Harnoncourt had served as commissioner of the United States submission, and the cost of participation had been paid by the Rockefeller Brothers Fund.[16]

Louchheim pondered whether the lack of official State Department involvement in such international cultural events was more problematic than the possibility of "sending abroad the kind of art which would safely please our Congress."[17] Her comments undoubtedly referred to the October 1953 statement by senior USIA official A. H. Berding regarding the agency's policy on art exhibitions. He had stated that the government "should not sponsor examples of [America's] creative energy which are nonrepresentational." He summarized: "We are not interested in purely experimental art."[18]

A number of months later, Louchheim, by then Aline Saarinen, revisited this article in response to a piece by "M.P." that had appeared in the June issue of *Sovietskaya Kultura*.[19] Saarinen raised the important point that while many in America still regarded abstract art as Communist and an undesirable representation of the best in American art, the Soviets considered abstraction as "a decadent manifestation of capitalist society."[20] Writing about the São Paulo Bienal, the Soviet author had particularly condemned the work of the American artist Alexander Calder, thus underscoring the Soviet Union's rejection of abstract art.[21] M.P. criticized the millionaires who supported such art, incorrectly attributing the financing of the American contribution to the Bienal to the already deceased

Solomon R. Guggenheim, rather than to the Rockefellers: "And thus hold the head higher, Miss Louchheim! Perhaps in this haughty position you will not notice that the workers of authentic art with a feeling of loathing are turning their glances away from 'Abstract,' which is paid off with Guggenheim dollars."[22]

In contrast to the 1953 São Paulo Bienal, the 1959 *Exhibition of American Painting and Sculpture* was organized under the auspices of the USIA as a means of fostering mutual understanding between the U.S. and the USSR. The public debate surrounding the checklist for the show revealed remarkable similarities between the two countries' official perceptions of experimental art in the late fifties.[23] Early in 1959, the USIA selected a jury of four that included Lloyd Goodrich, the director of the Whitney Museum of American Art in New York; Henry R. Hope, the chair of the Fine Arts Department of Indiana University; the American sculptor Theodore Roszak; and Franklin C. Watkins, a painting teacher at the Pennsylvania Academy of Fine Arts. Watkins, who assumed leadership of the group, told *Art in America* magazine that the exhibition would have a "crosscut selection … that will state strongly and frankly what has been going on in America since about 1920."[24]

Watkins's comments appeared several months after *New York Times* writer Aline Saarinen had weighed in on what she regarded as the appropriate content for this show. In a February 1959 article in the form of a letter addressed to Goodrich, Hope, and Watkins, she claimed to be writing on behalf of "those of us who believe in the energy, strength, and originality of American culture."[25] Saarinen asked the committee members not to bend to the political will of the USIA, the State Department, Congress, and "pressures from outside officialdom": "We would encourage you, for instance, to make your selection of artists *solely* on the basis of their artistic significance—their intrinsic quality—and let the percentages of 'representational' and 'abstract' art fall where they may. A proscribed recipe of *kinds* of art would deflect you from finding the best art."[26] She also warned against picking weak artworks by known names and art made prior to 1917 (namely American realism), which "would not possibly 'explain' American art of today."[27] She noted that recent events had shown the interest of young Russians in modern art.

Indeed, just one month before the opening of the *Exhibition of American Painting and Sculpture*, Museum of Modern Art director Alfred H. Barr, Jr. delivered a lecture in Moscow on the invitation of the Soviet Society for Cultural Relations. Barr showed 150 slides of "contemporary, abstractionist, expressionist and experimentalist techniques" as well as "special film clips" of Calder and Jackson Pollock at work.[28] Alexander Zamoshkin, the director of the Pushkin Museum of Fine Arts, argued that Barr's demonstration revealed "the sterility of technique" and proved that "abstractionists, after two generations, have not advanced beyond [Kazimir Malevich's black square]."[29] It is ironic that Barr's lecture prompted Zamoshkin to acknowledge the historic Russian avant-garde, which at that time remained hidden from view in storage.

A few days prior to Barr's lecture, Saarinen's prediction that the U.S. government would move to restrict the view of American art presented at the *Exhibition of American Painting and Sculpture* came to pass. Wheeler Williams, president of the conservative organization the American Artists Professional League contacted President Dwight Eisenhower and then

U.S. Representative Francis E. Walter (D-Pennsylvania) to complain about the jury.[30] Congressman Walter, who shared Williams's reactionary views, attempted to use his position as the chair of the House Committee on Un-American Activities to recall a number of the works selected for the 1959 exhibition and already sent to Moscow.[31] On the floor of the Congress, he proclaimed that "of the 67 artists whose works have been chosen for the exhibition in Moscow, 34—a fraction more than 50 percent—have records of affiliation with Communist fronts and causes."[32]

Congressman Walter cited the specific Communist associations of twenty-two of the artists to support his argument that they should not be allowed to represent America at the exhibition. Walter, in a manner reminiscent of Senator Joseph McCarthy, who had died in May 1957, convened a series of hearings to both expose the alleged politics of the artists in order to vilify them as un-American and to criticize "meaningless abstractions" by some of the artists; he included Pollock's painting *Cathedral* (1947), which had been described by Williams as a "childish doodle."[33]

While in the early fifties this mode of attack on two fronts had resulted in the recall of other USIA-sponsored exhibitions, the intense glare of the media, coupled with a decision by President Eisenhower not to censor its contents, ultimately undermined Walter's campaign to have select works removed from the exhibition. Various sources compared Walter to the Soviets. In the United States, he was described as a self-appointed "patriot czar" trying to establish an American "ministry of culture."[34] Senator Philip Hart (D-Michigan) responded to his colleague by saying: "I believe that it is the Soviet Union which has lost face by attempting political censorship of its artists. We do not want to get ourselves into that situation."[35] In the Soviet Union TASS (the official news agency) argued that Walter had demonstrated that artists in the United States did not enjoy freedom of expression.[36]

President Eisenhower's announcement that there would be no recall of the art turned the tide. However, without consulting with the original jury, Eisenhower enlisted David Finley, the former director of the National Gallery of Art, to curate an additional section of American art from the mid-eighteenth century through the early twentieth century, which included such artists as George Caleb Bingham, John Singleton Copley, Thomas Eakins, Winslow Homer, and Gilbert Stuart.[37] And the president made clear that future shows would be subjected to tighter oversight.

During the run of the *Exhibition of American Painting and Sculpture*, Khrushchev visited the show. According to John Jacobs, the editor of the exchange journal *Amerika*, which was distributed in the Soviet Union to introduce its citizens to life in the United States, Khrushchev had a pronounced reaction to the modern art section, and he announced that a "boy pissing on the ground could do better than that."[38] After the 1959 show closed, a delegation of United States senators and their wives asked for the U.S. Embassy to arrange a tour for them. Their reaction to the art uncannily echoed Khrushchev's.[39]

Jackson Pollock, Cathedral, 1947.
Enamel and aluminum paint on
canvas, 181.6 x 88.9 cm. Dallas
Museum of Art, Gift of Mr. and Mrs.
Bernard J. Reis

Nikolai Andronov, Monday in
Ferapontovo, 1963–64. Oil on
canvas, 140 x 173 cm. Jane Voorhees
Zimmerli Art Museum, Rutgers,
The State University of New Jersey,
New Brunswick, The Norton and
Nancy Dodge Collection of
Nonconformist Art from the
Soviet Union

Eli Beliutin, Landscape, 1952.
Oil on canvas, 107 x 70 cm.
Jane Voorhees Zimmerli Art Museum,
Rutgers, The State University of
New Jersey, New Brunswick, The
Norton and Nancy Dodge Collection
of Nonconformist Art from the
Soviet Union

The Chill: The Sixties

By the end of the fifties, the emergence of the Severe Style of Soviet art (characterized by large scale, simplified forms and colors, and more personal subject matter that was not always optimistic), the various foreign art exhibitions, and increasing access to information about experimental twentieth-century Russian art before 1930, prepared the ground for a new generation of Soviet artists. At this time, the first group of artists since the twenties formed within the context of the Moscow Section of the Union of Artists. Known as the "Group of Eight," these artists used a plurality of approaches rather than a single style and had as a major goal the organization of joint exhibitions.[40] Although they held only three exhibitions, their cubistic, expressionistic, and semiabstract works significantly contrasted with Socialist Realism. For example, Nikolai Andronov's *Monday in Ferapontovo* (1963–64) shows a remarkably abstract, folk sensibility akin to Mikhail Larionov's paintings of around 1911–13 as well as the work of other Jack of Diamonds artists including Robert Falk and Konchalovsky. Vladimir Veisberg's abstract, white still lifes bear a strong resemblance to the Metaphysical paintings of the Italian artist Giorgio Morandi.

In November 1962, a number of the artists from the Group of Eight received invitations to participate in an exhibition commemorating the thirtieth anniversary of the Moscow Section of the Union of Artists. Held in the Manezh Central Exhibition Hall off Red Square, this anniversary show included two thousand paintings and sculptures not only by Socialist Realists and a select number of more progressive younger artists, but also by artists of the twenties through forties who had not been shown in such official exhibitions in decades; among them were Falk, David Shterenberg, and Alexander Tyshler.[41]

On November 26, 1962, nearly a month after the show in the Manezh had opened, Eli Beliutin, an abstract artist and founder of the Studio of Experimental Painting and Graphic Arts in 1954, held a one-night exhibition of the work of his students at his studio.[42] The unofficial show of abstract and semiabstract art, which included paintings by Beliutin and sculptures by Ernst Neizvestny, drew hundreds of people hoping to see the works, and among the 150 invited guests were Western journalists. This presentation, which lasted only a few hours, served as a preview for an exhibition planned to open at the Hotel Yunost three days later.[43] The Yunost show was postponed, but Dmitry Polikarpov, head of the Culture Section of the Central Committee of the Communist Party, proposed the display of works from that exhibition as well as pieces by additional artists in three small rooms on the second floor of the Manezh.[44]

Khrushchev, along with a group of high-level Communist Party officials, visited the exhibition on the evening of December 1, 1962. Unhappy with works such as a nude by Falk, Khrushchev launched into a tirade even more virulent than the one he had unleashed at the 1959 *Exhibition of American Painting and Sculpture*; he was especially offended by the more experimental contemporary works by Beliutin and his students, among them Vladimir Yankilevsky and Ullo Sooster. Khrushchev told Neizvestny, whose art the Soviet leader knew via his son-in-law Alexei Adzhubei—editor-in-chief of the paper *Izvestia*—that he must be a homosexual to have created such sculpture. Neizvestny impertinently challenged Khrushchev to produce a girl so he could prove "what sort of a homosexual"

he was.[45] The Soviet leader directed his rage at Neizvestny and the other artists, both those working in an abstract mode and in a figurative style. He proclaimed:

> Are you pederasts or normal people? I'll be perfectly straightforward with you: we won't spend a kopek on your art. Just give me a list of those of you who want to go abroad, to the so-called "free world." We'll give you foreign passports tomorrow, and you can get out. Your prospects here are nil. What's hung here is simply anti-Soviet.[46]

When he declared war on artists such as those in the special section of the Manezh exhibition, Khrushchev made clear that the seeming advancements in artistic freedom since 1956 had come to a halt. A few days later, these works were removed and a series of reactionary articles began to appear in *Pravda* and other official publications.

An Ideological Commission formed in response to the exhibition and headed by Leonid Ilyichev, the Secretary of the Central Committee of the Communist Party in charge of ideology and propaganda, held meetings with party leaders and members of the artistic and literary intelligentsia in December.[47] On December 17, Ilyichev threw down the gauntlet in a speech titled "Create for the People in the Name of Communism," in which he made clear that the policy of Socialist Realism remained in effect.[48] A group of prominent cultural figures including the writer Ilya Ehrenberg and the dean of Russian sculptors Sergei Konenkov wrote a letter of protest to Khrushchev, in which they asserted that the absence of different trends in art would lead to the stagnation of Soviet culture. They contended that the return to the strictures of the Stalinist model for art went against the zeitgeist.[49]

As evidenced by the aforementioned 1967 book by Sjeklocha and Mead, the cultural backlash in the wake of the Manezh affair did not curtail the development of unofficial Soviet art, nor did it prevent additional foreign exhibitions in the Soviet Union. While working as staff for the 1963–64 USIA exchange exhibition of American graphic art, Sjeklocha and Mead met with many unofficial artists, but they were keenly aware of the fact that these artists could not openly show their work.

The artists supplied Sjeklocha and Mead with information and both gave them and allowed them to photograph unofficial artworks. To prove the point that these more personal approaches to art put the artists at risk, the authors stated that they did not take notes "in deference to the prevailing fear which still remains in the USSR of the written word found by the wrong person."[50] They explained that the often very low quality of the pictures of the works in the book resulted from the fact that "meetings were arranged on the spur of the moment and the physical surroundings where the works were photographed often left much to be desired."[51] Additionally, many of these photos bore the caption "Artist anonymous" in order to protect the artists in question. The only exception to this rule was made for artists whose identities had already been exposed publicly through foreign exhibitions—there had by 1964 been a number of exhibitions in Europe—and publications or domestic criticism.

One of the best-known artists who had participated in shows abroad was Oscar Rabin. He stood at the center of a group of artists—including Rabin's wife Valentina

Ernst Neizvestny, Tree of Life, 1968–76. Bronze, 52 x 60 x 36 cm. Jane Voorhees Zimmerli Art Museum, Rutgers, The State University of New Jersey, New Brunswick, The Norton and Nancy Dodge Collection of Nonconformist Art from the Soviet Union

Kropivnitskaya, his father-in-law Yevgenii Kropivnitsky, his son Lev Kropivnitsky, Dmitry Plavinsky, Nemukhin, and Masterkova, among others—identified by the name of a village near Moscow, Lianozovo, where they gathered. The collector Alexander Glezer met them in December 1966, about a year after Rabin caused a commotion in the Soviet press with a solo exhibition in London at the Grosvenor Gallery. Glezer offered to help the group hold an exhibition in a space other than its members' apartments—the Druzhba Workers' Club. In the span of two hours on January 22, 1967, two hundred people saw this twelve-person group show, among them foreign journalists and diplomats.[52] According to Glezer, the diplomats all had KGB shadows, and consequently Pasechnikov, the deputy leader of the Culture Section of the Moscow Party Committee, and the section's art inspector Abakumov swiftly arrived and "temporarily" suspended the show. Glezer has noted that Abakumov "shouted: 'A typical provocation! Before the day's out all the Western radio stations will be whooping about these underground artists, and how they're breaking through and organizing themselves despite the obstacles.'"[53] Indeed, the Western press condemned the closure, a response that foreshadowed the historic events of 1974.[54]

The Showdown: The Seventies

In February 1974, the Soviet government sent the writer and Nobel Prize winner Alexander Solzhenitsyn into exile in response to his book *The Gulag Archipelago*. At the time, Rabin presciently predicted that the authorities would turn their attention to the most active unofficial artists.[55] In this climate, he proposed the realization of an outdoor exhibition, an idea he had put forth to the Lianozovo Group as early as 1969. By 1974, a new, younger generation of artists had emerged that included Vitaly Komar, Alexander Melamid, and Yevgenii Rukhin. Under Rabin's leadership, on September 2, 1974, a group of artists sent a written request to the Moscow Deputy Council of Labor asking permission to hold an exhibition on a patch of wasteland in a Moscow suburb on September 15. When the members of the Council summoned the artists to a meeting on September 5, they had to admit they could not find a regulation prohibiting the show, but they strongly advised against holding it.

The artists decided to move forward with their plans for the *First Fall Open-Air Show of Paintings*. At noon on September 15, the twenty-four participating artists and their guests, among them foreign journalists and diplomats from Western Europe, the United States, Asia, and Latin America, arrived to find a group claiming to be workers volunteering to transform the land into a park. When the artists moved further into the field in order to proceed with the show without disrupting the volunteers, the "workers" attacked them and their art with physical force, dump trucks, bulldozers, and high-pressure water hoses. Works of art were destroyed, and four artists, among them Rabin and his son, were arrested and tried for hooliganism. As Rabin noted, the fact that the Cheremushki Borough Court charged him with resisting the authorities "was tacit acknowledgment that the vigilantes had in fact been plainclothesmen."[56]

Three American journalists suffered injuries. Christopher Wren of the *New York Times* received a chipped tooth when a group tried to forcibly take his camera and punched him

Igor Kholin, Composition with Clowns, 1974. Oil on canvas, 69.2 x 51.8 cm. Kolodzei Collection of Russian and Eastern European Art, Kolodzei Art Foundation, Highland Park, New Jersey. Damaged during First Fall Open-Air Show of Paintings, September 15, 1974.

in the stomach. Reporters for the Associated Press and the *Baltimore Sun* also sustained injuries, and a journalist from ABC was "manhandled."[57] The next day, the chargé d'affaires in the U.S. Embassy filed a protest with the Soviet Foreign Minister. Glezer, who had helped to organize the event, gave a press conference in which he asserted: "We consider that the authorities should not be trying Oscar Rabin but those who carried out the violence yesterday."[58]

Rabin and the others responded by announcing their intention to hold a second open-air show on September 29, just two weeks after the first. Under the scrutiny of the world, the authorities granted permission for the *Second Fall Open-Air Show of Paintings*, which took place in the Izmailovsky Park. *New York Times* writer Hedrick Smith hailed it as "the biggest officially sanctioned show of modern and unorthodox art by Soviet painters since the avant-garde movement in this country in the nineteen-twenties."[59] Variously described as the "Russian Woodstock," and "a classic example of the influence of détente," the exhibition of approximately two hundred works by seventy artists had more than ten thousand visitors in a span of four hours. Among the exhibiting artists were four members of the Union of Artists, including Leonid Lamm, whose wife showed his work because at the time he was imprisoned for requesting an exit visa to Israel.[60] The majority of the artists had no official status; therefore, this exhibition marked the first public display of their art. The renowned poet Yevgenii Yevtushenko said of the show: "I see some good pictures, some bad ones, but the most important fact is that they are here in the first place."[61]

American art critic Douglas Davis and *Newsweek* Moscow bureau chief Alfred Friendly, Jr. echoed this sentiment when writing about the ten-day, September 1975 show held in the Bee Keeping Pavilion at the *Exhibition of Economic Achievements* in Moscow.[62] They noted that the exhibition, which included a number of Lianozovo artists such as Nemukhin, Masterkova, and Rabin, "was hardly first-rate. But its importance as an event was incontestable: after years of being ignored or opposed by the government, the dissidents were being shown and seen under 'official' auspices, indoors, for seven days."

Davis and Friendly contended that members of the younger generation, most notably Ilya Kabakov and Komar and Melamid, represented a better chance for Soviet art to become recognized both at home and abroad as "a vital aesthetic fact in contemporary Soviet life."[63] These and other unofficial artists were among those celebrated in such foreign exhibitions as *La peinture russe contemporaine* held at the Palais de Congrès in Paris in 1976 and the January 1977 exhibition *Unofficial Art from the Soviet Union* at the Institute of Contemporary Arts in London.[64]

When the Soviet Union sent *Russian and Soviet Painting*—the most comprehensive exhibition of Russian painting up to that time—to the Metropolitan Museum of Art in New York in April 1977, the only unofficial artists on the checklist were Nemukhin, Plavinsky, and Otarii Kandaurov.[65] Art historian John Bowlt, who served as a consulting curator on *Russian and Soviet Painting*, recounted the challenges posed by the contemporary section of the exhibition in an article that appeared in *Art in America* at the end of 1977.[66] He wrote that the Met understood that official Soviet contemporary art had to be included in the exhibition. While he admitted that the museum considered insisting on the inclusion of

Photograph of Second Fall Open-Air Show of Paintings, Izmailovsky Park, Moscow, September 29, 1974. Jane Voorhees Zimmerli Art Museum, Rutgers, The State University of New Jersey, New Brunswick, Dodge Collection Archive

Among the works exhibited at Second Fall Open-Air Show of Paintings was Leonid Lamm's I Am Flying (from the Seventh Heaven series; 1973).

Installation view of Russian and Soviet Painting, the Metropolitan Museum of Art, New York, 1977

unofficial art, it knew such a suggestion would have "brought forth a flat refusal from the Soviets and, no doubt, would have terminated negotiations."[67] Met director Thomas Hoving told the press that the subject of nonconformist art did not come up "because the Soviets do not recognize any artists other than union artists. They decided what they want to have exhibited because this exhibition represents their official position."[68]

Bowlt and his colleagues at the Met were stunned when twenty-five paintings from the sixties and seventies arrived instead of the agreed-upon eleven contemporary works. They weighed various possible responses, including refusing to hang the final section. A "decisive voice from within the Met hierarchy" refused this suggestion on the grounds it would both violate the terms of the agreement for joint exhibitions and jeopardize future projects with the Soviets, in particular a planned show of treasures from the Kremlin.[69]

As Bowlt pointed out in a 1977 article for the May–June issue of *Art in America, Russian and Soviet Painting*, like the 1959 *Exhibition of American Painting and Sculpture*, belonged to the history of exchange exhibitions between the U.S. and the USSR.[70] Beginning in 1971, Hoving and key members of his staff went to the Soviet Union to hold negotiations with the Ministry of Culture, discussions that broke off in 1973 and then resumed in 1974. In that pivotal year, Hoving and the museum's Vice Director for Curatorial and Educational Affairs Philippe de Montebello (currently the director of the Met) made three trips to the Soviet Union, which resulted in a protocol for three exchange exhibitions.[71] The success of this agreement can in part be attributed to its mention in the Nixon–Brezhnev communiqué of July 3, 1974.[72] Thus the policy of détente, like Khrushchev's thaw in the late fifties, assisted the realization of U.S.–Soviet art exhibitions.

Russian and Soviet Painting was, in many ways, a victim of its time. Mercilessly criticized by the American press, the Met was accused of allowing the Soviet Union to use the museum as a vehicle for propaganda and of acting as "a mouthpiece for a brutal regime that suppresses the values of artistic freedom to which all museums of art are properly dedicated."[73] Conservative art critic Hilton Kramer proclaimed that "Détente Yields a Dismal Show," which presented art that would "never have been exhibited … on aesthetic grounds alone."[74] He especially lambasted the contemporary art in the exhibition, which he contended was "produced in an aesthetic and moral void, and it is a scandal for our leading museum to show it."[75]

Bowlt took issue with Kramer's Cold War rhetoric—"Each time Mr. Kramer hears the words 'Soviet culture,' he reaches for his revolver and at such moments Mr. Kramer's vicious rhetoric is as prejudiced and as hysterical as the cloying propaganda of the Soviet Ministry of Culture."[76] But he agreed that while the contemporary paintings were typical of Soviet art at that time, they undeniably fell into the category of kitsch. Later in 1977 Bowlt wrote an article for *Art in America* on this very topic in which he noted the uncanny resemblance between the Soviet art in the Met show and department store art in the United States. He argued that this Socialist Realism, unlike that of the thirties and forties, had lost the "ideological impulse" and had in essence become bourgeois: "What is absurd is that Soviet critics use the most rhapsodical arguments to distinguish their kitsch from ours."[77] He further noted, "Ironically, it may be that the lyrical kitsch of official Soviet art … is more

appealing than most unofficial art to Western taste."[78] In this, he echoed many critics who cited another ironic comparison, the resemblance between Soviet art and the work of the American artist Norman Rockwell.[79]

Bowlt contended that the West's fascination with unofficial Soviet art, which he said was "in most cases … as banal as its official counterpart," stemmed largely from its links to the politics of the Cold War.[80] In fact the Met exhibition underscored the degree to which the notion of "freedom of expression" as a sign of democracy overshadowed the actual art being produced. This point was highlighted by a four-day protest exhibition, *The Art of Freedom*, organized by the American Jewish Congress and held at the Stephen Wise Congress House in New York during the opening of the Met show.[81]

Of the four participating artists, the most famous was Neizvestny, who had left the Soviet Union in 1976 and settled in New York. He spoke to the press about the Met show, which he called a "lie" on the grounds that it showed Russian avant-garde art that remained hidden from the Soviet public and that it emphasized official contemporary art, with the exception of Plavinsky and Kandaurov, who had never been part of official exhibitions at home.[82] He noted that *The Art of Freedom* intended to call attention not only to the difficulties faced by Jewish artists in the USSR, but also to the general plight of dissident artists who produced religious art, "social and political satire, and even art that falls into such nebulous categories as abstract or 'personal,' relating to the individual's concerns."[83] When Hoving was asked by WABC television reporter Bob Lape if he knew that the counter-exhibition would be held in conjunction with *Russian and Soviet Painting*, Hoving responded that he thought such an event would have the positive effect of presenting multiple perspectives, which in his view fell within the purview of art.[84]

By the time of the exhibition at the Metropolitan Museum of Art in 1977, large numbers of Soviet unofficial artists had emigrated to Western Europe, Israel, and the United States. Removed from their homeland and its specific sociopolitical climate, the artists not only had to navigate life in exile, but also the challenges of competing in the international art world. Those artists whose work more closely paralleled the Western styles then in favor— namely those working in a conceptual mode such as Eric Bulatov, Komar and Melamid, and Kabakov (who did not emigrate until 1988)—tended to be the most successful with Western audiences. As Bowlt predicted, because many unofficial Soviet artists worked in "provincial" styles, a good majority of them fell "by the wayside once they [were] bereft of the glamour of being politically taboo."[85]

The place of unofficial Soviet art within art history is intimately linked to its association with the larger discourse of the Cold War, as the boundary between art and politics, between the official and the unofficial, dominated the cultural conversation between the West and the Soviet Union during that time. The exhibitions, publications, and events of the period from 1956 to 1977 demonstrate how art served as yet another battleground on which the U.S. and the USSR debated whose political system offered the best way of life. The fact that most unofficial art was not political in form or content and did not fit into the "official" language of the international avant-garde has contributed to an emphasis, with significant

exceptions, on the story of the artists rather than the history of the art they produced.[86] Yet it is significant that this chapter in art history encompasses not only actual works and aesthetic questions, but also, and importantly, the broader notion of national American and Soviet culture during this key period in world history.

1. Joyce L. Shub, *Moscow by Nightmare* (New York: Coward, McCann & Geoghegan, 1973), pp. 33–34. I recently had the good fortune to speak with this author, who lived in the Soviet Union from 1967 to 1969. Like her alter ego Vannie, Shub traveled in unofficial art circles and experienced the simultaneous thrill of making friends and acquiring art and the risks of participating in activities officially banned. Joyce L. Shub, phone interview by the author, May 16, 2005.

2. Specific exhibitions will be discussed at length in this essay.

3. Paul Sjeklocha and Igor Mead, *Unofficial Art in the Soviet Union* (Berkeley and Los Angeles: University of California Press, 1967), p. xi. The *Graphic Art* show included work by such artists as Jim Dine, Jasper Johns, Robert Rauschenberg, and James Rosenquist.

4. For more on this historic event, see William Taubman's *Khrushchev: The Man and His Era* (New York: W. W. Norton & Company, 2003), pp. 270–99.

5. Harrison E. Salisbury, "Soviet Artists Ignore Old Line," *New York Times*, January 14, 1957, p. 3.

6. This painting was part of a triptych titled *Communists*. The other two panels were titled *Homer* (*A Worker's Art Studio*) and *The Internationale*. For more on Korzhev and his generation, see Matthew Cullerne Bown, *Socialist Realist Painting* (New Haven: Yale University Press, 1998).

7. Salisbury, p. 3. Picasso's Communist Party affiliation contributed to his acceptability during this initial period of political thaw.

8. Max Frankel, "'Bourgeois Art' Shocks Russians," *New York Times*, August 9, 1957, p. 2.

9. Michael Scammell, "Art as Politics and Politics in Art," *Nonconformist Art: The Soviet Experience 1956–1986*, ed. Alla Rosenfeld and Norton T. Dodge (New York: Thames & Hudson, 1995), p. 50.

10. Hedrick Smith, "Modernist Art in Soviet [sic] A Legacy of 50's Thaw," *New York Times*, September 23, 1974, p. 18.

11. Ibid.

12. The New York show opened in June, and the Moscow one in July. The latter was part of a larger exhibition displaying consumer goods and technology that served as the setting of the historic Kitchen Debate between Khrushchev and then U.S. Vice-President Richard Nixon. See Taubman, pp. 417–18.

13. Howard Devree, "Art: Soviet Presentation," *New York Times*, June 30, 1959, p. 29.

14. Ibid.

15. Aline B. Louchheim, "Cultural Diplomacy: An Art We Neglect," *New York Times*, January 3, 1954, p. SM16. This is especially interesting, as abstraction remained at the center of art debates in Yugoslavia at that time.

16. Much has been written on the connection between the activities of the Museum of Modern Art, the Rockefellers, and the CIA, especially in relation to Latin America. See Eva Cockcroft, "Abstract Expressionism: Weapon of the Cold War," *Artforum* 12 (June 1974), pp. 39–41.

17. Ibid.

18. Jane de Hart Matthews excerpted these comments, made at an American Federation for the Arts meeting in October 1953, in her outstanding article "Art and Politics in Cold War America," *American Historical Review* 18, no. 4 (October 1976), p. 778.

19. Aline B. Saarinen, "USSR vs. Abstract: A Leading Soviet Cultural Organ Attacks International Moderns," *New York Times*, August 22, 1954, p. X8.

20. Ibid. With this argument, Saarinen echoed the article "Is Modern Art Communist?" written by Museum of Modern Art director Alfred H. Barr, Jr. and published in *New York Times Magazine*, December 14, 1952, pp. 22–23, 28–30.

21. M.P. also took issue with Yugoslavia's Petar Lubarda, an artist working in a semiabstract, expressionist visual language and who was selected to underscore the country's break with the Soviet Union five years before in 1948.

22. Saarinen, 1954.

23. See the well-researched, and highly informative article by Marilyn S. Kushner, "Exhibiting Art at the American National Exhibition in Moscow, 1959," *Journal of Cold War Studies* 4, no. 1 (winter 2002), pp. 6–26.

24. Franklin Watkins, "U.S. Art to Moscow," *Art in America* 2, no. 2 (spring 1959), p. 91.

25. Aline B. Saarinen, "Thoughts on U.S. Art for Moscow," *New York Times*, February 22, 1959, p. X20.

26. Ibid.

27. Ibid.

28. "U.S. Abstract Art Aroused Russians," *New York Times*, June 11, 1959, p. 3.

29. Ibid.

30. Williams had previously criticized the inclusion of Roszak in a USIA exhibition. Although Roszak, born in Poland, had lived in the U.S. since the age of two, Williams resented this "newly made American" taking the space of native-born Americans. Goodrich had brought to the Whitney *Advancing American Art*, an exhibition canceled by the USIA in response to widespread criticism of the inclusion of art influenced by radical European trends rather than by indigenous American art. Congressman John Rankin (D-Mississippi) went so far as to proclaim that the figurative art in that show amounted to "Communist caricatures … sent out to mislead the rest of the world as to what America is like." Matthews, pp. 773, 777.

31. According to Matthews, the jury anticipated an assault on their selections. As a result, it released the checklist only after the works had already been packed for shipment to Moscow. Matthews, p. 778.

32. Francis E. Walter in U.S. Congress, *Congressional Record*, 86th Cong., 1st sess., June 3, 1959, p. 8789.

33. House Un-American Activities Committee, 1959, p. 915.

34. Kushner, p. 13.

35. Philip Hart in U.S. Congress, *Congressional Record*, 86th Cong., 1st sess., June 4, 1959, p. 9814. As Kushner noted in her article, this controversy arose at the moment when the Soviet Union had banned Boris Pasternak's novel *Doctor Zhivago*. Political cartoonists in the U.S. lampooned protests of this ban in light of the attempts to censor the art in the *Exhibition of American Painting and Sculpture*.

36. Kushner, p. 13.

37. In the end, the most popular section of the exhibition was *The Family of Man*, a selection of photographs curated by Edward Steichen, which had been traveling internationally since 1955. According to an article in the *New York Times*, "The photo show especially has grown steadily in popularity and the lines for it now are almost as long as those for Circarama." "Khrushchev Sees U.S. Show Again," *New York Times*, September 4, 1959, p. 3.

38. John Jacobs, phone interview by the author, May 17, 2005. The journal *Amerika* began publication in 1944 under the auspices of the Office of War Information. According to Jacobs, the impetus for exchange magazines arose in part from a discussion between Joseph Stalin and W. Averell Harriman. Publication of the journal was suspended from 1952 to 1956, when the State Department's Office of International Information assumed responsibility for *Amerika*, which also had a Soviet companion called *USSR: An Illustrated Monthly* published by the Soviet Embassy. *Amerika* was wildly popular, but was generally only distributed to the party elite and at a few kiosks. Jacobs has said that he and his colleagues hoped that the children of the elite would benefit from exposure to American life. His successor as editor, Leonard Reed, told the author that in around 1970 he would take a copy of the magazine to cafés in the Soviet Union and put it on a table. Inevitably young people would approach him (Leonard Reed, phone interview by the author, May 16, 2005). Jacobs similarly recounted an instance when he managed to hail a cab in Moscow in dense traffic after a sporting event simply by holding up a copy of the magazine. It should be noted that the magazine had many important and richly illustrated articles on American art, and that among the writers were Harold Rosenberg and Elaine de Kooning.

39. Jacobs, interview.

40. These eight artists were N. Androsov, B. Birger, N. Egorshina, M. Ivanov, K. Mordovin, the brothers P. and M. Nikonov, and V. Veisberg. Also at this time, Ernst Neizvestny emerged as a key figure. Igor Golomshtok, "Unofficial Art in the Soviet Union," in Golomshtok and Alexander Glezer, *Soviet Art in Exile*, ed. Michael Scammell (New York: Random House, 1977), p. 86.

41. It should be noted that Falk became an important teacher and mentor to a number of unofficial artists.

42. Eli Beliutin, interviewed in Baignell, p. 37.

43. Sjeklocha and Mead, p. 91.

44. Baignell, p. 4.

45. Ibid.

46. This passage was published in Sjeklocha and Mead, p. 94. They note that the British magazine *Encounter* covered this event (April 1963, pp. 102–03), but that they also fact-checked the substance of Khrushchev's speech with other sources.

47. Ironically, the attendance of Western journalists at the Beliutin studio show in November had raised the ire of Ilyichev, whose son was a student of Beliutin's. See Eli Beliutin, interviewed in Baignell, p. 37.

48. Bown, p. 407.

49. Priscilla Johnson and Leopold Labedz, *Khrushchev and the Arts: The Politics of Soviet Culture, 1962–1964* (Cambridge, Mass.: MIT Press: 1965), pp. 105–20.

50. Ibid., p. xii

51. Ibid.

52. Among the artists were Kropivnitskaya, E. Kropivnitsky, L. Kropivnitsky, Nemukhin, Masterkova, Plavinsky, Olga Potapova, Rabin, Edward Shteinberg, Nikolai Vechtomov, Vorobyev, and Anatoli Zverev. For more on this exhibition see Alexander Glezer, "The Struggle to Exhibit," in Golomshtok and Glezer, pp. 109–10.

53. Ibid., p. 110.

54. There were many other unofficial exhibitions held in the mid-to-late sixties, a number of them in such scientific research institutes as the Kurchatov Institute of Atomic Physics, all of them of extremely limited duration. For some insight into this phenomenon, see Peter Grose, "Soviet Scientists Back Modern Art," *New York Times*, February 25, 1966, p. 10. In 1969, the Lianozovo Group opened an exhibition at the Institute of World Economics and International Relations; it was closed forty-five minutes later. For five years after this show, such exhibitions were essentially impossible.

55. For more detail on what happened to the artists, see Glezer, p. 112.

56. Hedrick Smith, "Five Russians Are Sentenced in Moscow After Art-Show Fracas," *New York Times*, September 16, 1974, p. 2.

57. Christopher Wren, "Russians Disrupt Modern Art Show with Bulldozers," *New York Times*, September 15, 1974, p. 1.

58. Smith, "Five Russians Are Sentenced," p. 2.

59. Ibid., p. 1.

60. Lamm, who was arrested on December 18, 1973, remained in Butyrka Prison and labor camps for three years before he was released in 1976. In 1982, he emigrated to New York along with his wife and daughter. For more on his work, see *Leonid Lamm: Birth of an Image*, exh. cat. (Durham, N.C.: Duke University Museum of Art, 1998).

61. Smith, "Five Russians Are Sentenced," p. 1.

62. Douglas Davis with Alfred Friendly, Jr., "Rebels in the USSR," *Newsweek*, March 3, 1975, p. 51.

63. Ibid.

64. First published as a catalogue with the title of the exhibition, *Unofficial Art from the Soviet Union*, Glezer and Golomshtok published the same manuscript as a book in the United States under the title *Soviet Art in Exile*.

65. This exhibition, which ran from April 12 to June 16, 1977, ultimately included 156 paintings dating from the second half of the fourteenth century (icons) to 1976. While most of the greatest artists were included, the specific works sent in most cases were not the most outstanding examples by these artists. John Bowlt has noted that a particular disappointment was the Soviets' refusal to send any paintings by Orest Kiprensky. See Bowlt, "Russian Paintings at the Met: An Inside Look at Museum Diplomacy," *Art in America* (May–June 1977), pp. 75–79. After the Met, the show traveled to the Fine Arts Museum of San Francisco (August 6–October 9).

66. John Bowlt, "Soviet Surprise: Kitsch at the Met," *Art in America* (November–December 1977), pp. 120–21.

67. Ibid., p. 120.

68. Diana Loercher, "Soviet Art Show Jars New York: Exhibit at Met Shy of Dissidents, Jews," *Christian Science Monitor*, April 15, 1977.

69. In fact this show came to the Met in spring of 1979.

70. John Bowlt, "Russian Painting at the Met: An Inside Look at Museum Diplomacy," *Art in America*, (May–June 1977), pp. 75–79.

71. The first of these exhibitions took place in 1975, with Scythian Gold at the Met and one hundred masterpieces from the Met going to the USSR. The second (December 1976–August 1977) was a show of Russian costumes at the Met and of Pre-Columbian gold from the Met (November 1976–March 1977). In exchange for *Russian and Soviet Painting*, the Met was to send an exhibition of American realist painting at the end of 1977.

72. Bowlt, "Russian Painting at the Met," p. 77.

73. Thomas Halper, "Soviets Use Met for propaganda," *New York News World*, June 16, 1977; and Ruth Berenson, "Quid Pro Quo," *National Review*, June 10, 1977, pp. 680–81.

74. Hilton Kramer, "Détente Yields a Dismal Show," *New York Times*, April 24, 1977, p. D25.

75. Ibid.

76. John Bowlt, "Defending Détente Art," *New York Times*, June 19, 1977, Art Mailbag, p. 30.

77. Bowlt, "Soviet Surprise: Kitsch at the Met," p. 121.

78. John Bowlt, "Moscow: The Contemporary Art Scene," in Norton Dodge and Alison Hilton, *New Art from the Soviet Union*, exh. cat. (Washington, D.C.: Acropolis Books Ltd., 1977), p. 21.

79. One example of this is Elizabeth Kridl Valkenier's review, "Fullest Show of Soviet Paintings Yet," *Christian Science Monitor*, April 18, 1977, p. 22. While Valkenier did not consider this comparison as derogatory, many other writers did.

80. Ibid., p. 120.

81. The show ran from April 13 to 17, and the Met show opened on April 16. The four artists in the exhibition were Igor Galinin, Ernst Neizvestny, Alexander Richter, and Ilya Shenker.

82. C. Gerald Fraser, "Jews Protest Met Show," *New York Times*, April 13, 1977, p. 78.

83. Loercher, p. 4. Another informative piece on this exhibition is Joyce Purnick's "Two Soviet Art Shows Bow Here: One 'Official,' One by Outcasts," *New York Post Times*, April 16, 1977, p. 6.

84. Transcript from WABC's Eyewitness News, April 12, 1977, 6:45 PM, Radio TV Reports, Inc.

85. John Bowlt, "Art & Politics & Money: The Moscow Scene," *Art in America* (March–April 1975), p. 20.

86. Many Russian contemporary artists, including those already mentioned—Bulatov, Kabakov, and Komar and Melamid—have enjoyed wide success. As is generally the case, a select number of artists of a given generation tend to rise to the top of the field and secure a place in the history of art.

OFFICIAL AND UNOFFICIAL ART IN THE USSR:
THE DIALECTICS OF THE VERTICAL AND THE HORIZONTAL
EKATERINA DEGOT

In his "German Ideology," Karl Marx prophesized that under Communism, the division of labor would finally disappear, and it would become possible "to do one thing today and another tomorrow, to hunt in the morning, fish in the afternoon, rear cattle in the evening, criticize after dinner."[1] This description corresponds exactly to the way things were in the Soviet Union, especially after Joseph Stalin's death. In those days, every Soviet citizen—and this even applied to the General Secretary of the Communist Party, Comrade Brezhnev himself—was an "after-dinner" critic, passing judgment on the state in the kitchen, addressing an intimate audience, a circle of friends. These circles began to evolve into subcultures, becoming institutions of sorts. One of these, for an instance, was the circle of Moscow conceptualism (which formed around Ilya Kabakov, beginning in the late 1960s); another overlapping circle of a kindred spirit consists of the Sots Art group (which formed around Vitaly Komar and Alexander Melamid, during the same period). These unofficial subcultures may have found their identities in criticizing the Communist state, but they were criticizing the state from a point that the state itself had created. To put it differently, the birth of independent art after the World War II realized the Communist program of liberating the working population's "amateur creativity." Only now, those liberated citizens had turned their creativity against the state.

Thus, official and unofficial Soviet art were far closer to one another than it would initially seem. They not only shared common economic conditions, but they were also both defined by those key aesthetic decisions that had already been made in the 1920s; as was often the case in the Soviet Union, no one actually ever countermanded these (so that they still remain in force until today, at least in part). One of these decisions concerned the status of the artwork, the plane of its existence, and its functional surfaces. It is this decision that provides the point of departure for the following text.

At a historical gathering held at Moscow's Institute of Artistic Culture (INKhUK) in November 1921, the critic Osip Brik claimed that many artists had already withdrawn from easel painting,[2] that is—we might add—from static art on a vertical plane, a practice which calls for a passive, commercial reception of the artwork. The constructivists announced that they had departed into production, but in a more profound sense, their departure was a turn to the horizontal plane of social interaction. The entire system of Soviet art institutions—including both official and unofficial circles—was not constructed around the artwork and its paths to consumption, but around the artist, which is why the Soviet art system did not consist of museums and galleries, but of communities and groups. According to the original idea behind its foundation in 1932, the Soviet Artists' Union was a collective autodidactic circle of sorts, based on the exchange of experience and the mutual stimulation of creativity. In order to fulfill this function, the Artists' Union established the institution of "artistic councils" (soviets), bodies of deliberation whose role was not only to accept or

decline artworks for publication, but to "educate" errant union members through collective (self-)criticism. During the period after Stalin's death, many artists became dissatisfied with the concrete makeup of these official "artistic councils." This gave rise to unofficial art. Yet even if unofficial art presented an alternative to the official art system, it remained within the framework of the same Communist model of creativity, according to which live interaction between artists is more important and more productive than the completeness and formal perfection of their artworks.

This privileging of the axis of social interaction also entailed the accentuation of art's reproductive distribution; art spread to its audience horizontally and was delivered on horizontal media, through books, textbooks, magazines, and postcards. In the Soviet Union, almost all books were published with illustrations, and magazines often contained drawings, so that the publication of reproductions represented an alternative to the museums, while paintings were understood (and kept on deposit) as originals from which postcards were printed.[3]

In practice, however, easel painting was not only replaced by "horizontal" forms of reproduction that symbolized the social dimension of Soviet art. Even in the 1920s, its place was also being taken by "new verticals." which stood for the dimension of the state's political power. From the first years of the revolution onward, artists dreamed of technologies for the suggestive broadcasting of images onto vertical screens, from which they might be read simultaneously by a mass of people. The artists of the 1920s drew projects of "radio-orators" with projection screens, inspired by television. Images on vertical surfaces—intended for mass-reception, originating from a single source, which was concealed from the consumer—were the source of artistic and ideological authority for the entire duration of the Soviet period. Well into the 1980s, the state exerted total control over everything that was shown on vertical surfaces: it controlled movies, billboards, posters, panel-paintings, exhibition stands, and wall newspapers. It goes without saying that the state also continued to control traditional painting, which was still exhibited in museums, even if the paintings themselves had now become little more than ideological billboards.

Rotating one and the same medium from the horizontal plane to the vertical plane—mounting newspapers onto walls, for an example—signified its radical "officialization." The artists of Moscow conceptualism later worked with this gesture: Kabakov exhibited postcards on wall mounts allegedly made by his characters-collectors, while Dmitry Prigov applied certain magical "words of power" to the broadsheets of the Pravda in his newspaper series ("Perestroika," "Gorbachev," etc.). In contrast, transposing "vertical" media to the horizontal plane signified the potential application of a critical dimension. (For instance, during the late 1970s, Soviet students tried, as a joke, to play card games with postcards of Politburo members, attempting to figure out which of them was the "ace"[4] capable of "trumping" all the rest). Even in the context of Soviet censorship, horizontal media were still loaded with the potential for criticism. After all, newspapers, journals, or books are never presented as all-in-one icons; instead, they unfold as discourse, implying a historical narrative and stimulating the recipient's critical faculties. The recipient-reader always has at least a hypothetical possibility for supplying some form

of feedback. In contrast, the recipient-spectator of vertical media is captive to a one-sided broadcast. It is precisely for this reason that Soviet illustrators always had the reputation of being more progressive than Soviet painters in terms of both aesthetics and politics, which is why unofficial art (and Moscow conceptualism in particular) drew many of its protagonists from the world of book illustration. (These included Kabakov, Viktor Pivovarov, Vadim Zakharov and many others.)[5]

While it was possible to exert total control over all of the country's vertical media, it was just as impossible to keep its horizontal media under control. This eventually led to the schism in Soviet art of the postwar period, which resulted in official art (i.e., art distributed through state-controlled channels) and unofficial art (i.e., art that circulated through alternative networks).

These unofficial networks were founded on specific technologies (e.g., self-publishing, or "samizdat," which was typed out on a typewriter and spread from person to person), but they were also often purely imaginary (e.g., artworks that consisted of little more than a dialogue with another author). At the same time, as I have already mentioned, the majority of Moscow conceptualists made their living in the system of media distribution, through magazines and publishing houses, and grew up on fertile, "horizontal" terrain, while Sots Artists worked legally in the "vertical" sphere, manufacturing statues of Lenin or fairy-tale animals for children's playgrounds. As a result, they had different points of reference: while the conceptualists dedicated themselves to the criticism of texts and communication, the Sots Artists criticized the image as a medium for the political power of the state.

Nevertheless, we would be introducing a simplification of Manichaean proportions if we were to divide the entire Soviet art world into vertical (official, affirmative, and conformist) and horizontal (unofficial, critical, and individual) spheres. As early as the 1920s, Soviet artists began advancing a "third path" or a "third dimension" that would represent the dialectic between the vertical and the horizontal, a space in which state and society or the individual and the collective lie in constant interplay.

In this space, the artist can still inhabit a critical position. However, this position cannot be taken for granted, nor can it be considered as something static. Instead, it needs to be continually investigated and refined. It is precisely this position that made it possible to criticize Communism from within its own camp, and not from the positions of "anti-Soviet" dissidence usually ascribed to all unofficial culture and, for that matter, to all "good" artists who worked on the territory of the Soviet Union. This type of immanent criticism really did take place, even if it still needs to be recognized in those works that are usually understood as belonging to "official" or affirmative art. By the same token, we will need to recognize that those works usually understood as "unofficial" do not only contain a critique of Communism, but also a fascination for the grandiose, utopian space that Communism threw open.

The first artist to complete the historical turn in the direction of a three-dimensional dialectic between the vertical and the horizontal was El Lissitzky. In the early 1920s, he proposed to show his abstract compositions ("prouns") on a number of axes of projection. Citing the memoirs of Sophie Küppers, Yves-Alain Bois links this decision with Lissitzky's

impression of books lying on a low table, which can be seen from different angles. Bois interprets this as a rotation onto the horizontal plane, which enables Lissitzky to understand artworks as documents and texts in a way that prefigures conceptualism. Bois sees this turn as a break with the suggestions, catharses, and illusions that painting and cinema represent; according to Bois, Lissitzky has succeeded in pulling himself out of the dangerous swamp of devices that lead to the "aesthetization of the political."

However, there is something missing from Bois's appraisal. Since Lissitzky had sworn allegiance to dialectics, he knew that one could not only look at the horizontal plane from the top down, but also from the bottom up. In one of his "proun" texts, he suggests that we look at it from all sides, "peering down from above, investigating from below."[6] In another text on a book by the architect Erich Mendelssohn, he notes that "in order to understand some of the photographs you must lift the book over your head and rotate it."[7] From the late 1920s onward, in search of an artistic language for communism, Lissitzky begins to sense that the path to this language does not lie in flattening or "putting down" reality onto the surface of a piece of paper, but in "lifting" it into a suggestive, collectivizing, synthetic artwork, which should be looked at from "the bottom up." Lissitzky articulates this new perspective in his exhibition designs, in which he does not only cover the walls but also the ceilings with a continuous photomontage. (Examples include the Soviet Pavilion of the International Press Exhibition of 1928 in Cologne, and especially the Soviet Pavilion at the International Hygiene Exhibition of 1930 in Dresden.)

One of the best spaces to sublate the difference between the vertical and the horizontal is the sky, the vault of heaven, which, of course, is associated with the cathedral dome. It would go far beyond the scope and the needs of the present text to cite the huge list of works in Soviet art that depict the sky and aviation. One example is enough: in 1927, Vladimir Mayakovsky noted that the kind of emotional upswing that took place in the mass demonstrations of 1919 (when the demonstrators marched off straight to the front) was no longer possible. The only means of compensating for its absence would be to launch airplanes into the sky, creating "superfluous movements: heads thrown back, looking upward."[8] Incidentally, the Stenberg brothers depicted the same kind of movement on their poster for Dziga Vertov's film *The Man with a Movie Camera* (1929).

In forcing the spectator to "throw his head back to look upward," Lissitzky opts for a type of suggestive integrity reminiscent of the sacral space of a cathedral. Doesn't it follow, then, to accuse him of "aestheticizing the political" and of creating a dangerous cathartic illusion? Perhaps we should pay closer attention to Lissitzky's own words: "peering down from above, investigating from below." To observe from above means to look at the book as a "thing" or an aesthetic object; to investigate from below means to gaze at the airplanes flying overhead and to experience euphoria without losing the power of critical reason in the process. This may be difficult, but it is not impossible. Furthermore, it seemed to Lissitzky that only this kind of gaze—which includes a measure of belonging that is not accomplished from some exterior point of view but from "within"—could be truly objective. Gilles Deleuze writes about this phenomenon of the Soviet avant-garde in examining Dziga Vertov's theory of the kino-eye as an attempt at a dialectical, non-linear, "omnifaceted" gaze. In his

Stenberg Brothers, The Man with a Movie Camera, *1929. Lithograph, 100.5 x 69.2 cm. The Museum of Modern Art, New York, Arthur Drexler Fund and Purchase, 1992*

Alexander Rodchenko, Pine Trees
in Pushkin Park, 1927. Gelatin-silver
print, 22.5 x 15.9 cm. Collection
Première Heure, Paris

utopia of the "gaseous state of matter," everything is connected to everything else, so that the gaze is necessarily objective.[9] In fact, this is Soviet art's Great Utopia: the thirst for a synthesis of the vertical dimension of power with the horizontal dimension of sociality, of hierarchy with democracy. All works of Socialist Realist painting implicitly assume this kind of (heavenly, paradisiacal) space; they are always imagined in the sky, above our heads, even if they physically hang in frames on the wall.

Both in reality (architecture, film, painting) and in discourse, the creation of this space—unified though not totalitarian—was an aesthetic and ethical challenge that Soviet art and society were only able to answer in part; as we know, their "totality" became "totalitarian" all too often. De-Stalinization in art—the critical reflection on the images and attitudes of art from the epoch of Stalinism that took place in the art of the 1960s and 1970s—entailed a critical reading of this type of dialectical, omnifaceted space. This requires special emphasis, since Western critics often deprecated Stalinist art as "flat poster painting" without really considering its real dimensional dialectic. In fact, it was only the art of the 1960s that used poster painting as a means of criticizing Stalinism with its "heavenly" dialectic of space.

Unofficial art did not have a monopoly on this critical reflection, however: instead, it also often came from the official camp. In other words, critical reflection could often be found in art that was distributed through channels owned by the state. Probing the ground for a new critical approach, the earliest post-Stalinist pieces from the late 1950s and early 1960s were actually made in the framework of the Artists' Union. Their authors belonged to what Soviet official art critics described as the Austere Style,[10] a movement of young artists that emerged in the aftermath of the Twentieth Party Congress, at which Nikita Khrushchev unmasked the Stalinist "personality cult" (as he put it) and called for "the return to the norms of Leninist party life." (The truth about labor camps and political repressions was partly revealed but ascribed to Stalin's personal "mistakes" and the lack of healthy collectivism.) It was only in the 1970s that Sots Art and those Moscow conceptualists who worked with Soviet emblems (such as Erik Bulatov or Kabakov) put forth their own type of critical reflection on the art of Stalinism.

A few examples:

1. In 1957, when the debates around Stalin's cult of personality had reached their peak, Gelii Korzhev—who would go on to become one of the most significant Soviet painters—began his triptych *Communists*. In the triptych's central panel, *Raising the Banner* (plate 228), a participant of the revolution of 1905, a worker, is picking up the fallen flag from the hands of his dead comrade. This image literally illustrates the Twentieth Party Congress idea of the necessity "to raise the banner of authentic Leninism," to use a common newspaper cliché of those days. The political position of the artist—a dedicated Communist-Leninist—subsequently repelled the entire artistic community. This did not only include the dissident unofficial scene (which ignored Korzhev completely) but also the liberal and the high official communities, which, of course, were also crypto-anti-Soviet. Still, the painting *Raising the Banner* does not only represent the artist's political position, but also stands for the aesthetic principles that this position entails. It confronts us with nothing less than a

reflection on the theme of the frustrated monumental painting. To "raise the banner" also means to "raise the image," to reinstate it to its lost position, so that it might become more than just a flat, propagandistic vertical, gaining the dialectical context of an "omnifaceted," aerial (read social) space. According to the notions that dominated the 1930s, the *slogan*—a text hovering in the sky, between verticality and horizontality—had become the key work of Communist art. It is this state that Korzhev's banner is referring to.

Created under the impression of a trip abroad, the painting *Artist* (1960–61), also supplies an indirect insight into the author's system of values: a street artist draws portraits made to order on a street somewhere in Europe. Not without sympathy for the eccentric dreamer, Korzhev emphasizes that the portrait of the melancholic girl in the black sweater is executed in extremely bright colored pastels. But most importantly, the drawing lies directly on the ground. This horizontality is tragic (to Korzhev) because it symbolizes a connection of an exclusively personal quality, of the author to the client, bearing witness to the artists' social obscurity. In his own works, Korzhev gives preference to a shockingly dramatic verticality, whose frame of reference is obviously motion-picture projection, both in terms of composition and in terms of painterly quality (e.g., the series *Burnt by the Flame of War*, 1957–60; plate 230). Incidentally, this reveals the mechanisms behind Soviet art as a whole. These works are so explicit that they correspond to Clement Greenberg's definition of the "media-critical" art of modernism (a definition he posited roughly around the same time, by the way), which accentuates the flatness and the two-dimensional nature of the canvas as the basis for painting.[11] However, the basis of the Soviet artist's art lies in its projective nature, in cinema rather than painting, which is why it hardly excludes narrative and illusionist elements.

2. A completely different variety of Soviet painting can be found in the work of Dmitry Zhilinsky, another "official" artist who was close to the Austere Style in part. In his early, programmatic painting *Gymnasts of the USSR* (1965, plate 233), we see athletes in white uniforms, shown in a strangely concentrated moment (before a competition, perhaps). They almost seem like members of some quasi-monastic order that embodies the physical and—to an even greater extent—the intellectual dignity of the human being.

But is this human being a Soviet human being? This question is difficult to answer. Zhilinksy's allusion to the painting of the early Italian Renaissance—it is executed in tempera on a wooden board, almost like an icon—does not only have an aesthetic dimension, but is also implicitly political. The fact that Communist art had refused easel painting so programmatically entailed a ban on individual perception, and on what is known as the tradition of humanism as a whole. Soviet art history saw easel painting as a holdover from capitalism, a form of pathological degeneracy that had been gradually distorting the organic integrity of collectivist monumental art since the Renaissance.

Zhilinsky is criticizing Stalinist Socialist Realism for its impersonal quality: one of the gymnasts peers into the spectator's eyes so poignantly that his gaze is understood as an indication of the rich inner worlds of all the others. Although this person detaches from the group, Zhilinsky also simultaneously supplies us with an unambiguously positive appraisal of collectivity, a positive appraisal that can be found in an even stronger form in

Gelii Korzhev, Artist, 1960–61.
Oil on canvas, 159 x 195 cm.
The State Tretyakov Gallery, Moscow

much of his subsequent work, which draws upon icon painting and even Russian Orthodox ideals. Zhilinsky attempts to embody the typical Soviet idea of developing one's personality for the collective's benefit in a form that is located somewhere between the fresco (as a fact of collective experience) and the easel painting (as the experience of individualism). This being the case, the "verticality" of the fresco is organic and cannot be tilted or turned in any other way; it is not imposed upon the spectator, but belongs to his or her physical system of coordinates. It is this type of suggestive device that Zhilinsky attempts to use as a point of orientation.

3. As one of the sensational canvasses of the time, *Builders of the Bratsk Hydroelectric Power Station* (1960–61, plate 232) by the young member of the Artists' Union, Viktor Popkov, was among the first pieces to be painted in the Austere Style. Even if this movement was seen as breakthrough in the direction of the truth, the painting is only true to life in its details (e.g., the bandaged finger of one of its heroes). On the whole, however, it places its bets on strengthening its rhetoric and not on weakening it. Its heroes stand in the foreground as if on the edge of a theatrical stage, in the limelight, largely looking directly at the spectator; this Brechtian mis-en-scene is reminiscent of the devices used by the theater director Yuri Lyubimov in the Taganka Theater, which was so popular in those years. The veracity of the Austere Style lies in the openness of its rhetoric; it represents an avant-garde media consciousness, instead of presenting itself as realism.

The artist's program is a fundamental refusal of the aesthetics and ethics of "omnifac-etedness," of the "aerial" instance that gives form to this omnifaceted objectivity. It is no coincidence that the painting itself is dry and hard. (This is exactly what the Austere Style was accused of by its critics). Popkov's heroes are not shown in the sky on some construction crane (which is how a Socialist Realist artist would have painted them); they are not juxtaposed to any absorbing spatial perspective. Instead, Popkov returns the painting to one-dimensional verticality, cleansing it of everything excessive and thus heroizing it, openly admitting that his painting is actually a poster.

Nevertheless—and this is an important detail—Popkov assesses the vertical structure of the poster, propagandistic in nature, as something unconditionally positive only because it is represented by people and not by pure signs. In Popkov's painting, the builders are in the foreground, while the structures they have built in the background are almost invisible; it is almost as though Popkov has inverted the theatrical mis-en-scene of the kind of constructivist decorations we associate with the sketches of Liubov Popova from the 1920s. Even the control flags that the girl is holding are demonstratively lowered. Here, the artist is indicating his commitment to figurative painting, free of the influence of planar abstraction. From the Soviet artist's point of view, nothing but this "people's painting" can supply a space for genuinely critical statements, free because they are not expressed in the routinized, emblematic forms of Western post-abstract modernism.

4. As strange as it may seem, the structure of Popkov's painting—a lineup of people in the foreground and a distant background—is reminiscent of the paintings of Eric Bulatov and their grid of signs directly on the canvas's surface. Incidentally, both artists reproduce (and analyze) the paradigm of Soviet poster painting itself. For Popkov, there is a great deal

of positive honesty in this form: his message is that "our only weapon is rhetoric." Perhaps one could say the same of Bulatov.

It is common practice to read his paintings against the ethical and political horizon of opposition to the wall of ideology. In this reading, everything that is situated on a vertical plane is marked negatively (e.g., the bars of military decorations on the programmatic painting *Horizon*, 1972, etc.). Today, however, the painting *Long Live the CPSU* (1975) with its gigantic red letters against a blue sky, for example, appears somewhat differently. Rather than betokening a demonization of Communist symbolism, it seems to express a fascination with its immaterial nature. A similar fascination prompted Olga Rozanova to dream of painting with rays of light in the air in 1919. Incidentally, the slogans that Komar and Melamid executed at the very beginning of the Sots Art movement (1972)—in which they signed Soviet texts like "Our Goal Is Communism!" with their own names—express the same kind of interest in disembodied texts. This same fascination compelled Komar and Melamid to turn to the practice of simulated advertising as soon as they emigrated to the United States in the mid-1970s. In 1986, for instance, they enthusiastically used the Spectacolor light board in New York's Times Square for their project "We Buy and Sell Souls."

Commentators often say that Bulatov's work presents an elegy on the experience of the loss of depth, while the horizontal plane has become a utopian dimension of genuine reality. Then again, one might say instead that Bulatov's work depicts the vertical and horizontal planes in a dramatic state of mutual misunderstanding. In *Krasikov Street* (1977, plate. 239), for example, a string of people walk into the canvas toward Lenin, who greets them energetically from a huge poster. However, just as in the case of the lines in front of the Lenin mausoleum, a genuine meeting is impossible: two levels of reality fail to intersect in a tragic way. The thirst for a dialectic utopia is still there, but the machine that produces this utopian dimension has already been broken.

5. In Ilya Kabakov's famous installation *The Man Who Flew into Space* (1981–88, plate 255), we see a room whose inhabitant has disappeared by making use of a special machine of his own devising. Catapulting him through the ceiling and into the sky to catch a current of air—the hero has calculated his trajectory in advance—this machine has made it possible for him to flee this room forever.

The walls of the orphaned room are covered by Soviet political posters, which the hero has bought instead of more expensive wallpaper. These posters have already given some critics occasion to compare Kabakov's installation to Lissitzky's exhibition designs (such as the Soviet Pavilion at the Internal Press Exhibition of 1928, which was already mentioned above), which are usually considered as some of the most (aesthetically) successful examples of Stalinism's political self-advertisements.

It is possible that Lissitzky himself would not have protested this comparison, had he been able to see Kabakov's installation. In any case, the "Press" exhibition included a round ceiling panel with a spiral-shaped inscription that read "Workers of the World, Unite!" and "USSR" (all in German), which, of course, was nothing less than an invitation to "fly away" from the Western world and to land in the Soviet Union.

Vitaly Komar and Alexander Melamid,
Our Goal Is Communism!
(from the Sots Art series), 1972.
Paint on red cloth, 39.5 x 193 cm.
Jane Voorhees Zimmerli Art Museum,
Rutgers, State University of New
Jersey, New Brunswick, The Norton
and Nancy Dodge Collection of
Nonconformist Art from the Soviet
Union

Documentary photograph of Collective
Actions Group's Slogan, April 1978;
wording on banner translates, "I am
not complaining about anything,
and I like everything, despite the fact
that I have never been here and know
nothing about these places."

Usually, Kabakov's installation provokes the conclusion that its hero (and, as we know, its author) has fled a world filled to the brim with propaganda to the realm of authentic freedom. But what if we were to assume something different? Perhaps the hero did not find his freedom after completing his journey, but in the process, or better yet, even before ever departing, while building the machine and making scientific calculations (in his *free* time)? What if Kabakov's installation is really all about the freedom of creativity and self-realization, and not about escape? If this is the case, then the installation can be read as follows: descended from Lissitzky's photomontage, the Soviet posters contain homeopathic doses of Communism's emancipatory impulse. It is their (somewhat hysterical) energy that has activated the mad inventor's impetus, forcing him to fly up and away without allowing him to relax in his room thoughtlessly, like a petit bourgeois. He owes everything he has, including his liberation, to this energy.

Once we have understood this, we will not be too surprised that the unofficial artists of the 1960s and 1970s were more interested in the possibilities that the dialectical "omni-facetedness" of Soviet space had to offer, while the artists of the Austere Style denied themselves its benefits, feeling that they had sworn eternal allegiance to painting, which is always flat in nature.

Translated from the Russian by David Riff.

1. Karl Marx and Friedrich Engels, "The German Ideology," 1846 (1968), Marx/Engels Internet Archive (marxists.org) 2000, http://www.marxists.org/archive/marx/works/1845/german-ideology/ch01a.htm#a4.

2. See Christina Lodder, *Russian Constructivism* (New Haven: Yale University Press), p. 90.

3. I have discussed this topic in a more elaborate essay: Ekaterina Degot, "The Collectivization of Modernism. The Visual Culture of the Stalin Era," in *Dream Factory Communism*, ed. Boris Groys, Max Hollein (Frankfurt: Shirn Kunsthalle, 2003), pp. 85–105.

4. In Russian, the word *tuz* (ace of trumps) also means "boss" or "top brass."—Trans.

5. For a more detailed discussion, see Ekaterina Degot, "The Paper Media of Moscow Conceptualism—Moskauer Konzeptualismus," (Sammlung Haralampi Oroshakoff. Sammlung, Verlag und Archiv Vadim Zakharov. Kupferstichkabinett, Staatliche Museen zu Berlin. Cologne: Verlag der Buchandlung Walter Koenig, 2003), pp. 17–23.

6. El Lissitzky, "PROUN. Not World Visions, BUT—world reality" (1922), in Sophie Lissitzky-Kueppers, *El Lissitzky. Life, Letters, Texts* (New York: Thames and Hudson, 1992), p. 347.

7. El Lissitzky, "The Architect's Eye," in *Photography in the Modern Era. European Documents and Critical Writings, 1913–1940*, ed. and with an introduction by Christopher Phillips (New York: The Metropolitan Museum of Art, 1989), p. 221.

8. Varvara Stepanova, *Chelovek ne Mozhet Zhit Bez Chuda* (Moscow: Sphera, 1994), p. 203.

9. Gilles Deleuze, *Cinema 1. The Movement-Image* (London: The Athlone Press, 1992), p. 80f.

10. The Russian *surovy stil* is translated variously as "Severe Style" and "Austere Style" (cf. Matthew Cullerne Bown, *Matthew Cullerne Bown: Socialist Realist Painting* (New Haven and London: Yale University Press, 1998). *Surovy*, in this case, does not connote "strict" but rather indicates something basic and "primary," so that "austere" is probably the better translation.—Trans.

11. Clement Greenberg, *Modernist Painting* (New York: Arts Yearbook, 1, 1961).

BETWEEN PAST AND FUTURE
ALEXANDER BOROVSKY

The popular expression, "Russia is a country with an unpredictable past," applies to its history of art as well. The modern-contemporary paradigm is complicated by its continual appeal to the past. This relates not so much to art criticism, for it was born to propose new versions of history. More important is the question of how the modern-contemporary paradigm developed within the art itself. Entire strata of art are continually revisited, and the classic Soviet avant-garde was subjected to this process many times: it was presented in emotional and ironic contexts, and occasionally ruthlessly appropriated by the philosophical and speculative discourse. Socialist Realism in recent decades was politically ostracized, condescendingly contextualized in the international art of its time, and used as an object of play and conceptual discourse. At present, some young artists are turning to it in the search for a national, or just the opposite, a transnational identity.

The most recent stratum, so-called unofficial art, is also being rethought. The fact that Russian contemporary art is still in ferment and has not stabilized and formalized is a reality that does not suit many people. They try to overcome that situation on the level of personal creative projects (as if everything had finally become a normal representative of the internationally convertible mainstream, unoppressed by all that history, philosophy, and culture) and on the institutional level (the First Moscow Biennale of Contemporary Art, held in January 2005, was presented as a historic attempt at full-fledged reintegration into the mainstream global art world). I, however, find that instability and ferment that characterize contemporary art in Russia to hold meaning and form. If you take a number of significant and absolutely different works: *Malevich's Square and Fisa Zaitseva's Window* (1985) by Eduard Shteinberg, *The Man Who Flew into Space* (1986, plate 255) by Ilya Kabakov, *Land of Malevich* (1987) by Alexander Kosolapov, *Mother and Child* (1986) by Leonid Sokov, and *The Origins of Socialist Realism* (1982–83) by Komar and Melamid, it becomes obvious that a theme common to all of them, in one way or another, is their relationship to Russia's artistic legacy and how they selected their particular theoretical framework—critical, existential, metaphysical, or playful.

The history of contemporary Russian art begins with its opposition to Socialist Realism. Sotsrealism, as it is known, was a powerful phenomenon with ideological-conceptual, formal, stylistic, institutional, and even sacred components. As a direct tool of the Communist regime, it nevertheless could not have become a vital phenomenon with the support of Joseph Stalin and his cultural henchmen alone. It rested also on a certain cultural tradition. Russian artists had always been both frightened and attracted by the idea of being part of the state. Even the young and daring "Amazon of the Russian Avant-Garde" Natalia Goncharova admitted, "Art that glorifies the state was always the most majestic and most perfect art."

The relationship between art and the authorities in Russia, regardless of the character of the regime, has always involved an archaic significance and substance. First of all, the relationship is about power. From the second half of the nineteenth century, when Russian

artists first began to reflect on their position in society and in the state, art not only served the regime but had pretensions to a certain power of its own (spiritual, ideological, aesthetic). Classic Russian prose writers understood that mode of the arts—from Nikolai Gogol's prophetic *The Mysterious Portrait* (1842) to Gleb Uspensky's short story "She Straightened It" (1885). These ambitions were most frankly revealed in the avant-garde projects of the 1920s: the artists wanted to identify themselves with revolutionary changes and dreamed of creating a new reality on at least an equal footing with the new state. In the most paradoxical way, those ambitions made art vulnerable to appropriation by the state in the period of totalitarianism. The artists of the avant-garde considered themselves demiurges. The major artists of the Stalin era, who fully delegated their powers to the state, did not. They felt themselves clay in the hands of the Chief Demiurge, a situation in which there was modesty that was greater than pride. By the 1950s, Sotsrealism was weak and ill: its content had been exhausted and the sacred element had been lost completely. The state was banking on the artists' servility and on the observance of the ideological protective rituals. This suited the majority of craftsmen artists, but not the great artists, even those in the official camp—and there were such artists. Thus, the hermetic building of academic art created by Andrei Mylnikov, Evsei Moiseenko, and Dmitry Zhilinsky in the late Soviet era was a reaction to the new situation in the state system: a position completely privileged but without a hint of elitism. To some degree (for all these artists, quite pampered by the regime, had no intention of giving up their privileges), this was a form of escapism: since you have assigned us a purely ornamental or ritual role, they seemed to be saying, we are heading off into aestheticism, to serving the ideal, and so forth. Even the powerful painting of Gelii Korzhev, which turned the archaic and often simpleminded narrative element into a strong expressive gesture, seemed overly independent, in its real, not mythologized, democracy. The impression was that the authorities would have settled for a more routine art practice that carried no message but showed signs of obedience and of following the rules of the game. On the whole, in the late Soviet period, a few major artists created, within the confines of Socialist Realism, several other realisms and neorealisms that could easily have been related to certain Western versions of figurativism. (Today, in fact, the sad narrative parables of Natalia Nesterova, who was only minimally affected by official art as it died away, are in demand by the internationale of figurativists.) But the system, though it had lost interest in the creative and substantive aspects of its art, still did not relinquish its control. That control depended on isolation, and without Western contexts those various realisms were reduced to local phenomena.

Strange as it may seem, unofficial nonconformist art also arose out of frustrated ambitions for power. The creative youth in the late 1950s had many issues with the regime, not only about "life in art," that is, questions about social status, distribution of goods, freedom of exhibition and realization of their works, and so on. They demanded answers not so much about the quotidian aspects of art but about its very existence. (Before World War II, the poet Boris Pasternak, in a telephone conversation with Stalin, suggested with marvelous naiveté that they talk about "life and death," and naturally, the ruler ended the call.) The regime refused to deal with them directly, outside the official institutions of

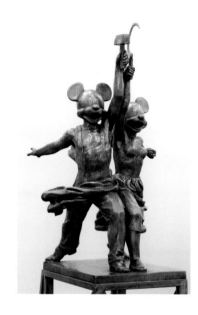

Alexander Kosolapov, Mickey and Minnie: Worker and Farmgirl, 2003–04. Bronze, 150 x 250 cm. Courtesy Marat Guelman Gallery, Moscow.

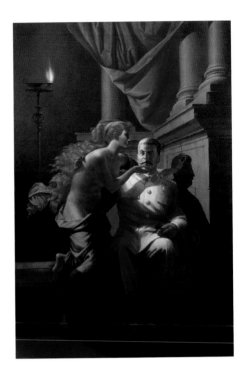

Vitaly Komar and Alexander Melamid, The Origin of Socialist Realism (from Nostalgic Socialist Realism series), 1982–83. Tempera and oil on canvas, 182.9 x 121.9 cm. Jane Voorhees Zimmerli Art Museum, Rutgers, State University of New Jersey, New Brunswick

Soviet culture (which transmitted the state's nonstop monologue through its bureaucrats). When the regime did talk to artists directly—let us recall the famous outburst by Nikita Khrushchev, then leader of the Party and the state, at the exhibition in the Manezh in 1962— it was unreasonably aggressive.[1] Being personally at war with the regime, facing constraints and even expulsion (in many cases provoked by the victims of the regime themselves) was a situation that, paradoxically, satisfied artists of the modernist persuasion: after all, it was a form of dialogue. If they expel me, that means they heard me out and rejected me, went the thinking, so at least now I can take my personal position and mythology to the West. Only the masters of postmodernism (first and foremost, Ilya Kabakov and the conceptualists of the older generation, and subsequently the Sots artists) violated that atavistic seriousness in their relations with the regime, giving their own position toward it a personally whimsical and private coloration. The situation of many modernist artists who ended up in the West is curious and instructive: they were clearly dissatisfied by the course of artistic process outside discourse with the authorities. They did not take seriously the power of a curator or dealer (some tried to achieve a mutual power, which led to numerous misunderstandings with dealers) and clearly yearned for a relationship with the state. As soon as the opportunity arose, they rushed back to Russia, trying to establish personal relations with mayors and presidents as representatives of the state. The paternalism of these relationships may seem hard to understand, to put it mildly, in the West. But in fact, it suggests a profoundly archaic yearning to identify oneself as a certain type of Russian artist. The postmodern artists automatically accepted the Western rules: it is difficult to imagine, say, Kabakov persistently trying to get the attention of the powers that be.

At the same time, even the subsequent generations periodically feel an atavistic need to work out relations with the state through the most radical critical gestures (a theme in the work of Alexander Brenner, Oleg Kulik, Avdei Ter-Oganyan, Anatoly Osmolovsky, the Blue Noses, and Marat Guelman, a dealer who for many years explored the theme of social activism in his authorial exhibitions). The fact that the state almost never reacts (with some exceptions, including the recent scandalous incident with the *Caution! Religion* exhibition, which did irritate state institutions)[2] is perceived by the artists as an insulting indifference: nothing personal, no blame and no praise. No real repressions, either.

Let us return to the genesis of contemporary Russian art. The *shestidesyatniki* (people of the sixties) initiated contemporary Russian art and remain its primary force. In the early 1960s (for the first time in decades), they entered into conflict with the USSR's artistic strategies and mores and in effect created an underground movement. They remain active artists of an acutely individual direction. The range of their goals is impressive—from the modernist heroic gesture of Ernst Neizvestny to Kabakov's conceptual and meticulous work and personal relationship with the Soviet environment; from the profoundly individualistic, self-absorbed metaphysical paintings of Dmitry Krasnopevtsev and Vladimir Veisberg to the refined technique of the Sots artists, who juggle mythological memes of mass consciousness; from the psychedelic paintings of Vladimir Yakovlev, which draw you into their emotional field (as in his famous flowers, which paradoxically resonate, in their symbolism and sexuality, with the flowers of Georgia O'Keeffe) to the subtle visual archeology of Dmitry Plavinsky.

But for the majority, there remains the *shestidesyatniki*'s greedy (and naïve from a post-modernist ironic position) faith in the creative spirit, with its formative and life-building potential. Oscar Rabin's seminal *Passport* (plate 236), created in 1964, continues to amaze with its active presence in our consciousness (or rather in the consciousness of people brought up in the Soviet era). Mikhail Roginsky went even further; in the sixties he persistently painted the reality of the impoverished Soviet lifestyle—doors, Primus stoves, cafeterias—so free of the conventional "artistic" manner that many consider him a forerunner of Sots Art. I do not think so: he was unlikely to have been concerned with socially critical gestures. The reduction of social and aesthetic concerns freed him to deal with objects per se, in a heightened, almost tactile way. A special, nonmimetic groundedness of the visual image in the consciousness is the theme of Oleg Vassiliev's *Ogonyok No. 25* (1980, plate 242), painted fifteen years later in completely different media and style: the banal photo cover of a popular Soviet magazine is "illuminated" by some perceptive flash that leaves a trace on the retina and the memory. Vladimir Yankilevsky's *Triptych No. 14: Self-Portrait (In Memory of the Artist's Father)* (1987, plate 249) blends elements of the quasireal and the transcendent. The central part—the stooped figure of an elderly Muscovite in a baggy coat reading a newspaper in a jolting metro—literally objectifies (the artist uses found objects) the specific time and place. The same figure in the right and left parts of the triptych, given in silhouette in the light and against it, cuts into another dimension of time.

Interestingly, this transcendental impulse permeates works that are figurative and far from one another in plastic form. There is nothing surprising in the fact that the transcendental impulse permeates abstract works.

The reemergence of abstract art (which originally sprouted in the 1910s in Russia, before it was assiduously trampled to death, seemingly forever) began in the second half of the 1950s and was related to that same generation of *shestidesyatniki*. What had revived the process? It can be interpreted in political terms: a weak post-Stalin thaw, an attempt to get out from under the totalitarian aesthetic, a turn toward representing the spiritual and the "hierarchy of spirits" (Nikolai Berdyaev). In addition, abstract art (especially after the American exhibition in Sokolniki Park in 1959, which had a powerful impact on young artists) was associated with the very concept of modernity. The temptation to use its language in order to be part of that same modernity was great. But the most important aspect had to do with artistic consciousness: abstraction was the enzyme in the long-ripening process of the personalization of Soviet art.

This did not mean that there was a predetermined abstract consciousness: what mattered was that through abstraction many artists discovered the possibility of creating individual, personalized pictures of the world. They discovered it and went their own way. Those who remained true to abstraction laid several fundamental paths for its authority, so to speak. Thus, still in the 1950s Yuri Zolotnikov created his first "signal" compositions—signs without denotation, a proto-image of a semiotically comprehensible picture of the world. They were works conceived as a systematized project, like the tables of Kazimir Malevich and Mikhail Matiushin, but with a more psychedelic character. At that time, the works of Vladimir Slepyan, Dmitry Leon, Mikhail Kulakov, Lidia Masterskova and other Moscow

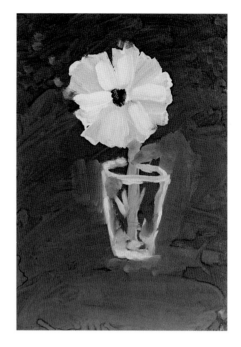

Vladimir Yakovlev, White Flower, 1974. Gouache on paper, 58.7 x 40.8 cm. The Norton and Nancy Dodge Collection, The Jane Voorhees Zimmerli Art Museum, Rutgers, State University of New Jersey, New Brunswick

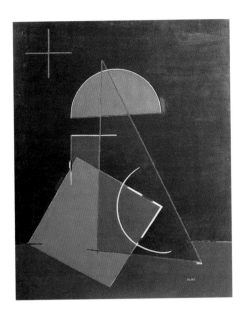

Eduard Shteinberg, Composition,
1987. Oil on canvas, 120 x 97 cm.
State Russian Museum, St.Petersburg

abstractionists rapidly took on a meditative, spiritual subtext. There was also an anthropological-archeological vector in Russian abstract art (which related to the Native American mythology of the founders of Abstract Expressionism). The greatest development was the geometric project (Francisco Infante, Vyacheslav Koleichuk, Lev Nusberg and the *Dvizhenie* [Movement] group, Mikhail Shvartsman, Shteinberg, Vladimir Nemukhin). These artists existed as a group in name only—the conceptualized technique of Koleichuk and the sacralized plasticism of Shvartsman are hard to unite, yet the force of attraction is still stronger that the force of repulsion: "Matter always falls into some of our mathematical frames, for it bears the weight of geometry" (Henri Bergson).

Perceiving the energetic impulse of Suprematism, Infante took its space-forming activity in a new direction in the 1960s. Rejecting both the global idea of Suprematism—going into the world's cosmic space—and Max Bill's ban on "naturalistic representations," he preferred working with real topoi. He placed materialized, "objectified," geometric objects in a natural environment. This created a synthesis—Infante called it an artefact—which can be fixed only by photography and exists only in that state. The artefact (photograph) is the result of a planned act of shape-formation. But it is at the same time a process—the process of the appearance and fixation of multifaceted and often unplanned, spontaneous connections among subjective, artificial, and natural forms, as a result of which the most paradoxical transformation can occur. The metaphysics of Shteinberg's works is tied to a continual appeal to "the spirit of Malevich." However, these "spiritualist séances" are deepened and actualized by two situations that are unexpected in Infante Suprematism: the museum situation (hence the classical tonal painting) and the existential situation (from which comes the desire to make the message biographical and imbue it with personal spirituality).

The most powerful movement in contemporary Russian art, which was very much in demand in the international context but retained its Soviet character, was Moscow conceptualism. Its main figure was Ilya Kabakov, and he was joined by Viktor Pivovarov, later to be followed by the Collective Action group (Andrei Monastyrsky, Nikita Alexeyev, Gelii Kizelvater, et al.); the founders of Sots Art (Vitaly Komar and Alexander Melamid, Alexander Kosolapov, Leonid Sokov, et al.) were in the orbit of conceptualism; and the next generation was represented by the "medical hermeneutics" group (Sergei Anufriev, Yuri Leiderman, Pavel Peppershtein, et al.)—just the list of names shows how strongly compartmentalized this movement was. Moscow conceptualism, like all others, presumes treating everything that exists, including art, as a text. Textuality presumes a procedure of total commentary. There is commentary on reality as text, on the depiction of reality as text, and even on the commentary on the depiction of reality as text. The procedure of commenting is related to the concept of a successful act of speech (as in *How To Do Things With Words*, 1961, by J. L. Austin, a founder of the speech acts theory, who maintains that there are verbs that do not merely describe but actually create reality). Commenting as a process has no end, that is, no final truth. This creates a need for constant change in the observer's position (and in the position of the observer's observer), in fact the issues of positioning form the nerves of Moscow conceptualism.

Kabakov and Pivovarov insisted, in their earliest works, on the impersonality of their experience. Consequently, they ceded the narrative to numerous "tellers," like Primakov Sitting in the Cupboard or Arkhipov Looking Out the Window (Kabakov) or "dramatis personae" or "agents" (later, Pivovarov), who personified the topographic and spatial situation of positioning. (Igor Makarevich's subsequent *Triptych: Ilya's Wardrobe [Portrait of Ilya Kabakov]* [1987, plate 250] subtly thematized that strategy.)[3] In his early albums, Kabakov proposed the position of absolute nonengagement and independence (for, strictly speaking, programmatic escapism, the demonstrative flight from reality even into metaphysics, still presupposes, in the other *shestidesyatniki*, a certain dependence on that reality). He fully admits the existence of reality, including Soviet reality. Moreover, he accents and even documents the objectivity of its existence (*Answers of the Experimental Group*, 1970–71, plate 237), both in his own consciousness and outside it. This begs the question of struggling against that reality, rejecting it, or pushing it out of one's mind. Artists of the modernist type and gesture, in accordance with the liberal tradition, compared the Soviet state to the Leviathan. Therefore, one had to fight it. The strategy of postmodern conceptualism was different. Their freedom was not in struggle but in the choice of position regarding Soviet material. This position can be conceptually analytical, or it can be playful. It can be distanced or proximate, to the point of mimicry (Kabakov's appropriation of the lowest forms of Soviet visual products—stands, postcards, and so on). There are distinctions by type of position—inside or outside the "Soviet body." (This is the basis of the poetics of Eric Bulatov, an artist who conceptualizes perception and works subtly with the comprehension of appearances: those received through perception and those inculcated ideologically as pictures. The impulse to position was taken up by Grisha Bruskin: in his works he sees himself as a collector and systematizer of the Soviet experience, creating hierarchies and lexicons.) But most importantly, this position can only be personal, private, authorial. It is chosen by the artist, not forced upon him. In this strategy of noninvolvement artists saw the highest degree of inner freedom. And in fact, this strategy proved itself, allowing them to continue an independent, universal commentary in the West, operating within different discourses of power.

Let us note: Kabakov and the artists of his circle did not tease the dying Soviet Leviathan. In some sense, they had a stake in its existence, as zoologists are interested in the existence of a rare, vanishing species. The next generation of the Moscow conceptual school did not avoid the temptation to pull the old beast's tail. The Sots artists mentioned earlier manipulated Soviet myth and ideology memes: deconstructing them, splitting them, and turning them inside out. There was no sacred cow the Sots artists did not take on: Lenin and Stalin, the Aurora and the mausoleum, state seals and awards, the red Pioneer tie and the honor boards. It looked as if everything was headed, as with Marx, toward a parting with Soviet history. Moreover, that iconography was then in demand in the West: reduced to its simplest form, the Soviet Union went down easily. (Especially in conjunction with the clichés of American mass culture: in the 1980s almost all the Sots artists moved to New York and diligently spliced the Soviet with the American.) A joke's a joke, but it's not enough to find a place in the history of contemporary art. A layer deeper than playing with myth memes was the issue of selecting an artistic language, in its historically determined drama. Kosolapov's

Vitaly Komar and Alexander
Melamid, I Saw Stalin Once When
I Was a Child (from Nostalgic
Socialist Realism series), 1982–83.
Tempera and oil on canvas, 183.2 x
137.8 cm. The Museum of Modern Art,
New York, Helena Rubinstein Fund

Vladislav Mamyshev-Monroe,
The Ideal Couple, 2004. C-print,
60 x 80 cm. Courtesy XL Gallery,
Moscow.

Land of Malevich (1987) uses a Socialist Realist hit, Alexander Gerasimov's painting Stalin and Voroshilov on a Walk (1938): the Kremlin wall and the leaders as Russian folk tale heroes. Only one thing is added—right on the wall it says: "Malevich." It really is funny, but as in Dada, there is much behind the humor. Later, the philosopher Boris Groys expounded the provocative thesis that there was a similarity between avant-garde and proletarian projects. The Meeting of Two Sculptures (1986, plate 244) by Sokov and The Origins of Socialist Realism (1982–83) by Komar and Melamid are essentially about the same thing. I think that there is one more, rarely noted, aspect in Sots Art: the discourse of the totalitarian childhood. Sots artists were the last artists to come out of a deeply Soviet background: for all their conceptual nihilism, they were seriously affected by the Soviet subconscious.

Sots Art used themes of taboos in adolescent consciousness, taboos that mixed childish sexuality and state repression. That is essentially what Komar and Melamid's series Nostalgic Socialist Realism (1980–84) is about: the first sexual stirrings in adolescents wearing Pioneer ties, the terrible, punishing gaze of Stalin through the window of his passing car.

In the early 1980s there came a generation that was psychologically free of the issues of Soviet identification, with all its headaches and phantom pains and strategies for neutralizing them. They felt at home in the transnational context, despite their marginal situation in society: nothing kept the exponents of the Apt-Art Gallery from creating their own version of New York's New Wave in their pathetic Moscow apartments or the Leningrad "new artists," first of all Timur Novikov and Sergei Bugaev-Afrika, from living à la Warhol. The Leningrad wild men created their own vital (and in some, synchronous) versions of new expressionism. In the 1990s, Novikov expressed the doctrine of new Russian classicism, shared by a large group of adepts. The cult of the Beautiful, Lofty, and Classical, which a priori did not fit the postmodernist mentality, was nevertheless reflected in a fully conceptual way, namely, along the High and Low divide. Novikov used this ambivalence in his textile collage tapestries (see plate 252), surrounding photo images of classical models with homespun frames. This represented a touching desire to humanize and domesticate the beautiful, to fence it in as something private. For an understanding of the poetics of the new classicism, this is a symbolic gesture as one of the last attempts in the last century to "save Beauty" with one's own hands.

In a review of the First Moscow Biennale of Contemporary Art, the Artforum critic John Kelsey, speaking of the Srarz exhibition at the Moscow Museum of Contemporary Art and its exponents Oleg Kulik, Vladislav Mamyshev-Monroe, the AES+F group and the Alexander Vinogradov and Vladimir Dubossarsky duo, said that Moscow has its own YBA generation (referring to London's Young British Artists). Although each of these artists has his own history (for instance, Kulik, the "man-dog" and creator of the Animal Party, has long been known for his social activism), in today's context they can be perceived as a group, together in the spotlight, ready for Saatchi-esque sensations. It is not only a question of the expense of these projects (which are large-scale and costly) and their exposure, though they have been feeding on media and public-relations support for a long time and have the qualities of forced spectacle, perfection of presentation, and a healthy sense of what museums and galleries like (and why not, although such practicality and open competition in the mainstream

is rather new for the Russian art scene). More important is this: the traditional reflection of contemporary Russian art on its position in life and history, and the nonstop transmission of artistic doubt stops here forever. There is simply no place for them in today's strong focus on expansion. The concept of *sovremennoe iskusstvo*, or contemporary art, in Russia presupposes a certain blessed vagueness caused by reminiscences and appeals to its own past. But here everything is different: concentration, muscularity, a readiness to leap. It is typical contemporary art in a clear conventional framework. This functionality is apparently necessary today. In the metaphor of the leap, I find something else much sweeter, which is clearly outside the mainstream: a different scale, a cosmic one. Something like the good old story Dostoevsky told about Russian schoolboys who felt ready to correct the map of the starry sky. At the Moscow Biennale, this scale was addressed by Valery Koshlyakov's installation Cloud (2004)—a modest but insistent attempt to reach the sky. And of course, it brings to mind the central theme of Kabakov that goes back to his early albums, *The Man Who Flew into Space* (1986). What a powerful triple leap—to push off from land and from the avant-garde cosmogenic myth: the Letatlin, which never did fly, but which accumulated over the years a gigantic underground force. Then, another point of departure: the Soviet apartment, clumsy, dilapidated, wingless, but paradoxically, a human environment. And so through the ceiling and straight into space! I think that besides everything else, this marvelous work, *The Man Who Flew into Space*, can serve as a metaphor for the state of Russian art that constantly turns to its past in its leap into the future.

Translated from the Russian by Antonina W. Bouis.

1. On December 2, 1962, Nikita Khrushchev visited the exhibition marking the thirtieth anniversary of the Moscow branch of the Union of Artists at the Central Exhibition Hall (formerly known as the Manege). The General Secretary of the Communist Party was harshly critical of the young artists who had been allowed to exhibit untraditional works, launching an angry tirade with political overtones and often profane language. Khrushchev's reaction, which was largely provoked by the rivals of the young, informal artists, escalated into an official ideological campaign against any divergences from the Party line on art. Following this episode, Soviet art split into three distinct branches—official, unofficial, and underground.

2. Caution, Religion! opened at the Sakharov Museum and Public Center in Moscow on January 14, 2003. Forty artists took part in the event, exhibiting many provocative works intended to elicit sharp public debate. On January 18, parishioners of the St-Nicolas-in-Pyzhi Church attended the show and threw black and red paint over the museum walls and exhibits. The visitors were accused of hooliganism, a charge dismissed in summer 2003. Instead, a criminal charge was brought against the curators of the exhibition—Yuri Samodurov, Lyudmila Vasilovskaya, and artist Anna Mikhalchuk. On March 28, 2005, the Tagansky District Court in Moscow convicted Samodurov and Vasilovskaya of "kindling religious dissent," fining each of them 100,000 rubles (about $3,500). Mikhalchuk was acquitted.

3. The hero is the artist Ilya Kabakov, an observer peering out of a wardrobe. He is, of course, driven into the wardrobe by the circumstances of Soviet life. The situation can, however, give rise to alternative interpretations. One is that he himself chose this position, which evolves from the topological to the social, providing a degree of independence from the Soviet environment (there is nowhere further for him to be driven; his personal space is reduced to an absolute minimum). There would also appear to be a hint at the concepts of an ambush or reconnaissance—although the observer is concealed, much is revealed to him. The sensation of the inevitability of his jumping out at the right moment also arises.

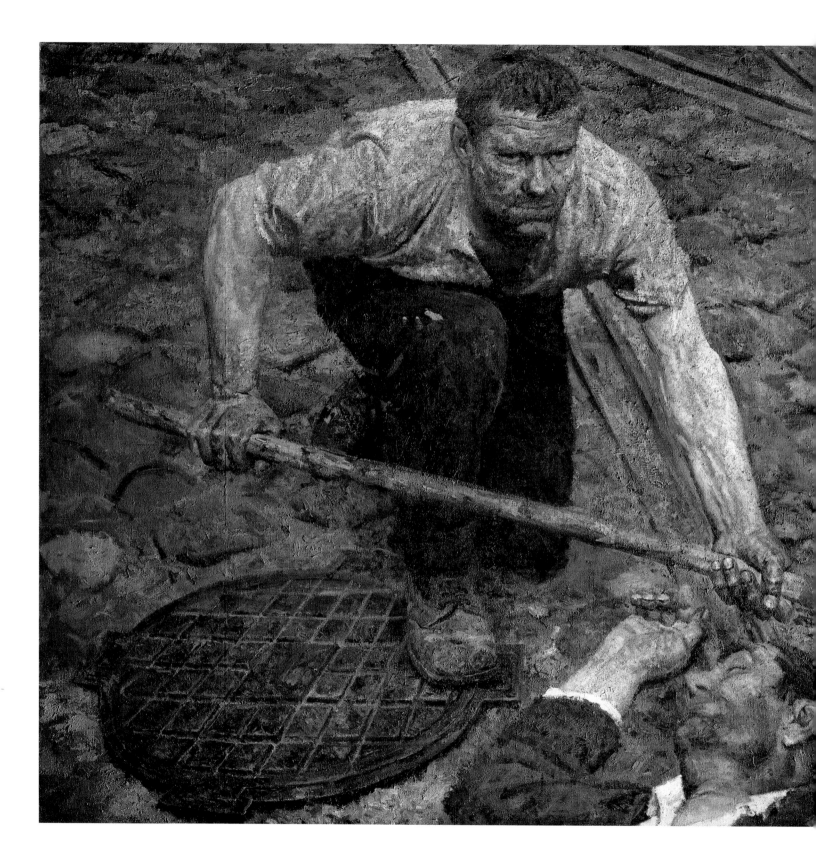

228. GELII KORZHEV, *RAISING THE BANNER*, 1957–60. OIL ON CANVAS, 156 X 290 CM. STATE RUSSIAN MUSEUM, ST. PETERSBURG

229. VERA MUKHINA, *PORTRAIT OF
COLONEL BARI YUSUPOV*, 1942.
BRONZE, H. 49.5 CM. THE STATE
TRETYAKOV GALLERY, MOSCOW

230. (OPPOSITE) GELII KORZHEV,
THE TRACES OF WAR (FROM THE *BURNT BY
THE FLAME OF WAR* SERIES), 1957–60.
OIL ON CANVAS, 200 X 150 CM. STATE
RUSSIAN MUSEUM, ST. PETERSBURG

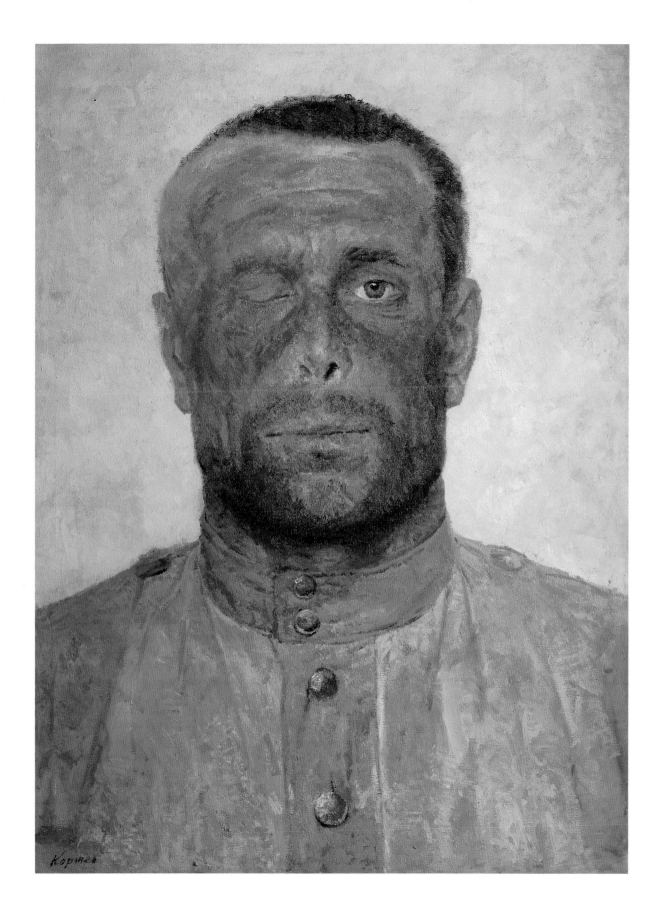

Корнеъ

231. TAIR SALAKHOV, *PORTRAIT OF THE COMPOSER KARA KARAEV*, 1960. OIL ON CANVAS, 121 X 203 CM. THE STATE TRETYAKOV GALLERY, MOSCOW

232. (OPPOSITE) VIKTOR POPKOV, *BUILDERS OF THE BRATSK HYDROELECTRIC POWER STATION*, 1960–61. OIL ON CANVAS, 183 X 300 CM. THE STATE TRETYAKOV GALLERY, MOSCOW

389

233. DMITRY ZHILINSKY, *GYMNASTS
OF THE USSR*, 1965. GESSO AND TEMPERA
ON PLYWOOD, 270 X 215 CM. STATE
RUSSIAN MUSEUM, ST. PETERSBURG

234. VIKTOR IVANOV, *IN THE CAFÉ GRECO*, 1974. OIL ON CANVAS, 185 X 205 CM. THE STATE TRETYAKOV GALLERY, MOSCOW

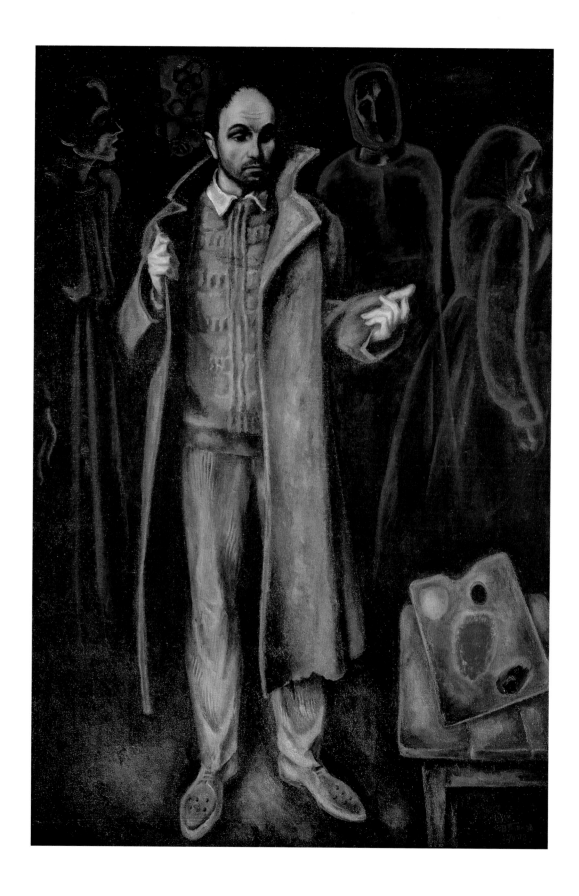

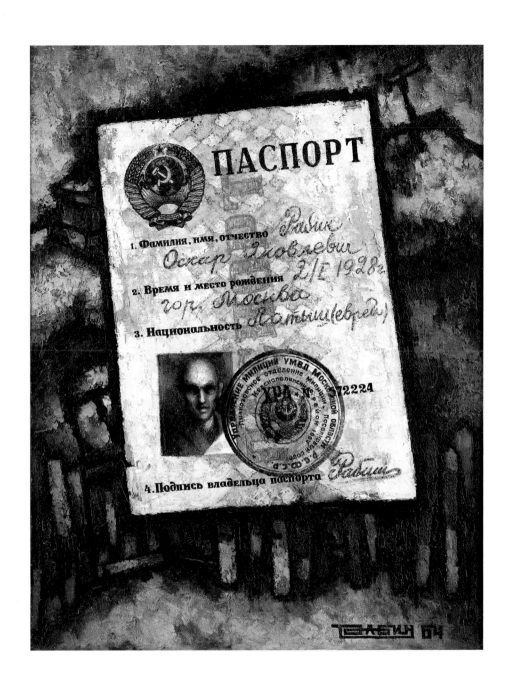

235. (OPPOSITE) VIKTOR POPKOV,
FATHER'S OVERCOAT, 1970—72. OIL
ON CANVAS, 176 X 120 CM. THE STATE
TRETYAKOV GALLERY, MOSCOW

236. OSCAR RABIN, *PASSPORT*, 1964.
OIL ON CANVAS, 70 X 90 CM.
PRIVATE COLLECTION, NEW JERSEY

238. ANDREI MONASTYRSKY,
CANNON/GUN, 1975. TEMPERA,
PAPER, AND CARDBOARD, 56 X 56 X
62 CM. THE STATE TRETYAKOV
GALLERY, MOSCOW

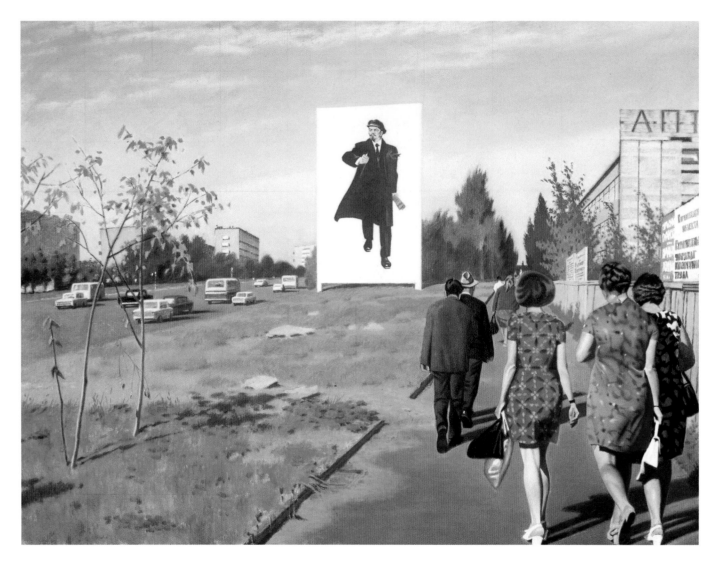

239. ERIC BULATOV, KRASIKOV STREET,
1977. OIL ON CANVAS, 150 X 198.5 CM.
JANE VOORHEES ZIMMERLI ART MUSEUM,
RUTGERS, THE STATE UNIVERSITY OF
NEW JERSEY, NEW BRUNSWICK,
THE NORTON AND NANCY DODGE
COLLECTION OF NONCONFORMIST ART
FROM THE SOVIET UNION

240. (OPPOSITE) ERIC BULATOV,
SUNRISE OR SUNSET, 1989. OIL
ON CANVAS, 200 X 200 CM. LUDWIG-
FORUM FÜR INTERNATIONALE
KUNST, AACHEN

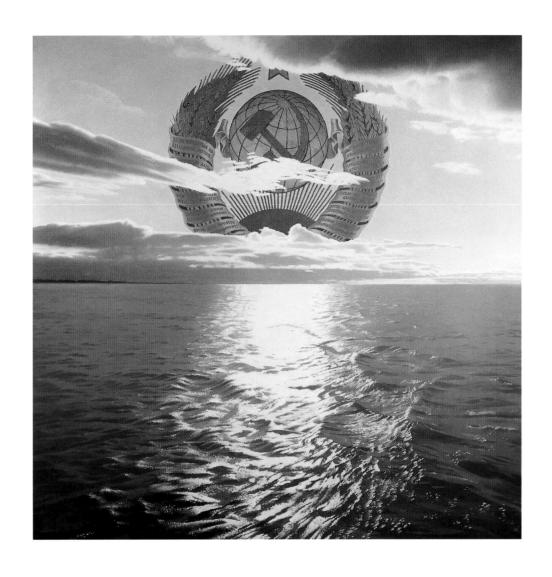

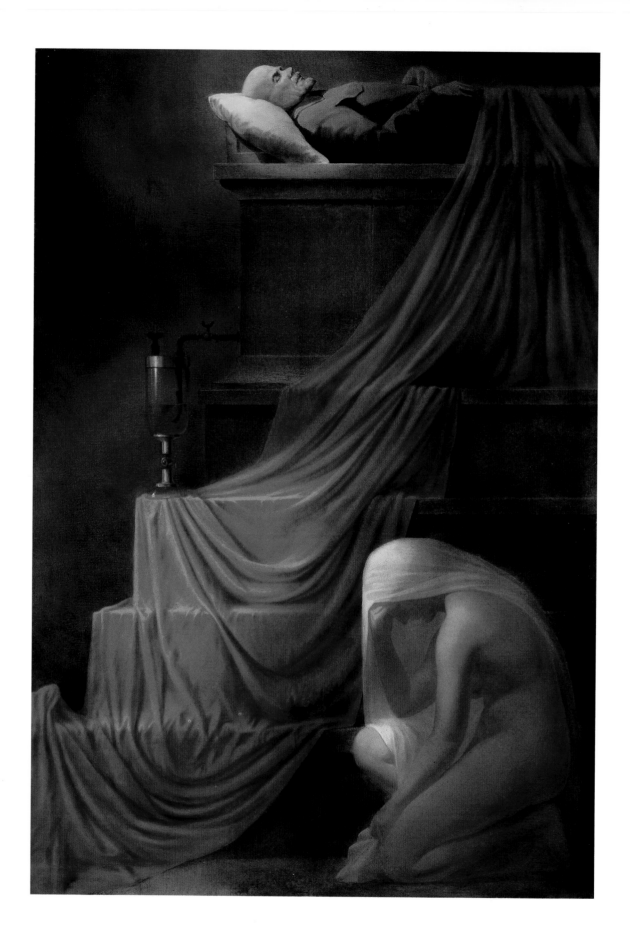

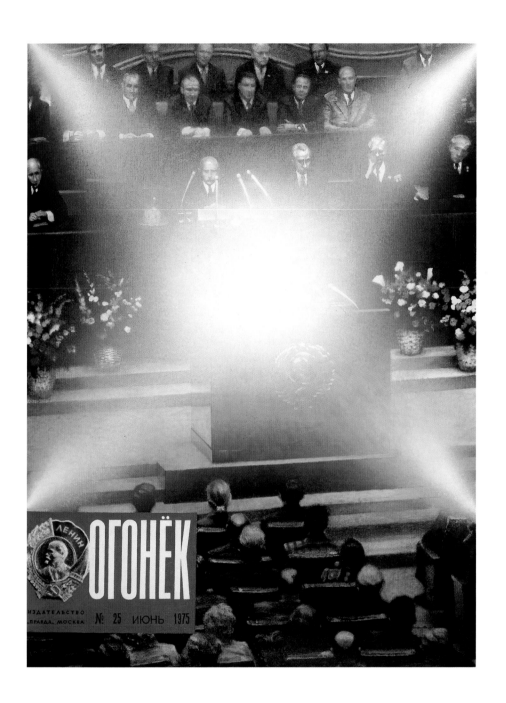

241. (OPPOSITE) VITALY KOMAR AND
ALEXANDER MELAMID, *LENIN LIVED,
LENIN LIVES, LENIN WILL LIVE* (FROM
THE *NOSTALGIC SOCIALIST REALISM
SERIES*), 1981–82. OIL ON CANVAS,
183 × 148 CM. COLLECTION OF
JÖRN DONNER, HELSINKI

242. OLEG VASSILIEV, *OGONYOK NO. 25*,
1980. OIL ON CANVAS, 122 × 91.7 CM.
JANE VOORHEES ZIMMERLI ART MUSEUM,
RUTGERS, THE STATE UNIVERSITY OF
NEW JERSEY, NEW BRUNSWICK,
THE NORTON AND NANCY DODGE
COLLECTION OF NONCONFORMIST ART
FROM THE SOVIET UNION

243. BORIS ORLOV, IMPERIAL TOTEM,
1989. PAINTED ALUMINUM, 254 X
139.7 X 91.4 CM. COLLECTION OF
ALEXANDRE GERTSMAN, NEW YORK

244. (LEFT) LEONID SOKOV, *THE MEETING OF TWO SCULPTORS*, 1986. BRONZE, 48.9 X 40.2 X 16.9 CM. SOLOMON R. GUGGENHEIM MUSEUM, NEW YORK. GIFT, JOHN SCHWARTZ 92.4030

245. (RIGHT) GRISHA BRUSKIN, *BOY WITH A SMALL FLAG* (FROM THE *BIRTH OF THE HERO* SERIES), 1987–90. STAINLESS STEEL, 142.2 X 83.8 X 40.6 CM. COURTESY MARLBOROUGH GALLERY, NEW YORK

246. MIKHAIL ROGINSKY, *BUFFET*,
1981–82. ACRYLIC ON PAPER 150 X
169 CM. INTERNATIONAL FOUNDATION
OF RUSSIAN AND EASTERN EUROPEAN
ART (INTART), NEW YORK

247. (OPPOSITE) NATALIA NESTEROVA,
METRO "REVOLUTION SQUARE", 1988.
OIL ON CANVAS, 160 X 200 CM.
LUDWIG-FORUM FÜR INTERNATIONALE
KUNST, AACHEN

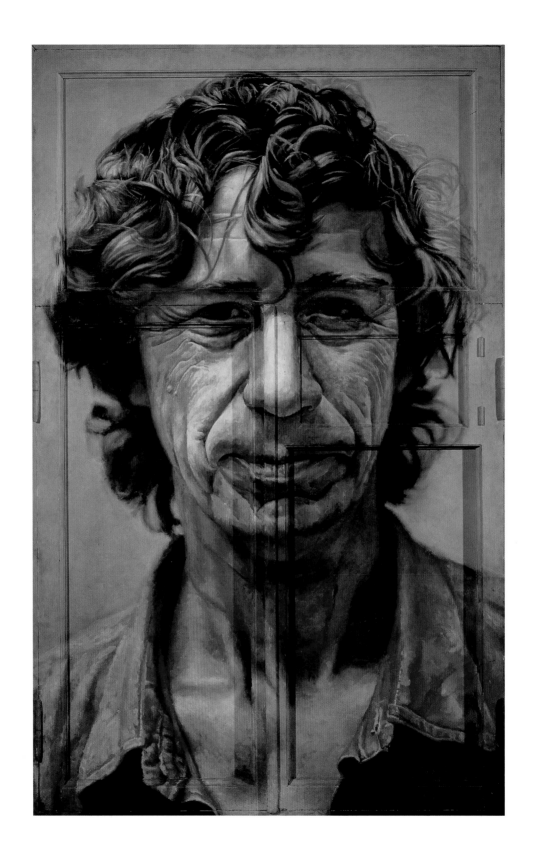

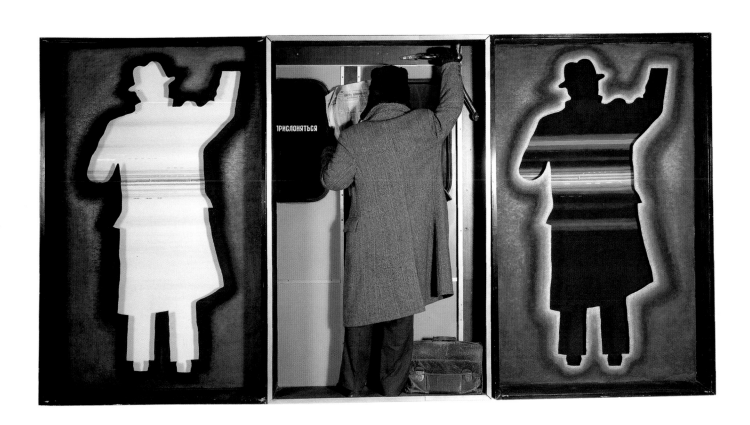

248. (OPPOSITE) IGOR MAKAREVICH,
TRIPTYCH: PORTRAIT OF IVAN CHUIKOV,
1981. OIL ON WOOD, 212 X 137 X
8 CM. STATE RUSSIAN MUSEUM,
ST. PETERSBURG

249. VLADIMIR YANKILEVSKY, TRIPTYCH
NO. 14: SELF-PORTRAIT (MEMORY OF
THE ARTIST'S FATHER), 1987. MIXED
MEDIA, 195 X 360 CM. STATE RUSSIAN
MUSEUM, ST. PETERSBURG

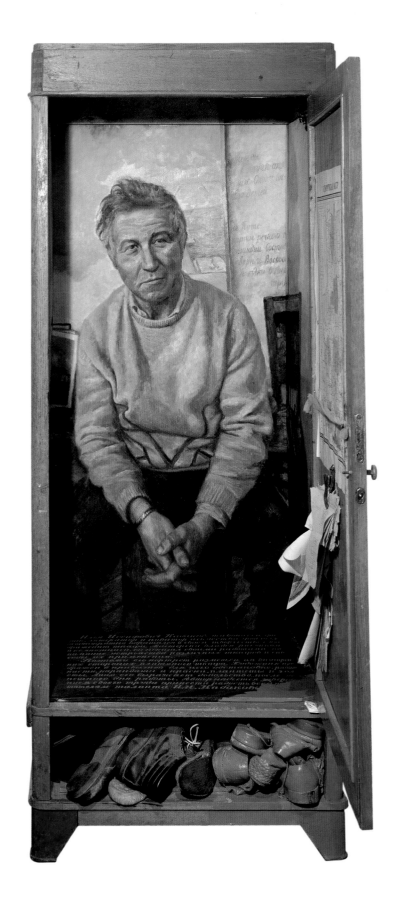

250. IGOR MAKAREVICH, TRIPTYCH:
*ILYA'S WARDROBE (PORTRAIT OF ILYA
KABAKOV)*, 1987. MIXED MEDIA, 209 X
75 X 60 CM. STATE RUSSIAN MUSEUM,
ST. PETERSBURG

251. (OPPOSITE) IGOR MAKAREVICH,
TRIPTYCH: *PORTRAIT OF ERIC BULATOV*,
1988. COMPREGNATED WOOD AND
ACRYLIC RESIN, 200 X 105 X
22 CM. STATE RUSSIAN MUSEUM,
ST. PETERSBURG

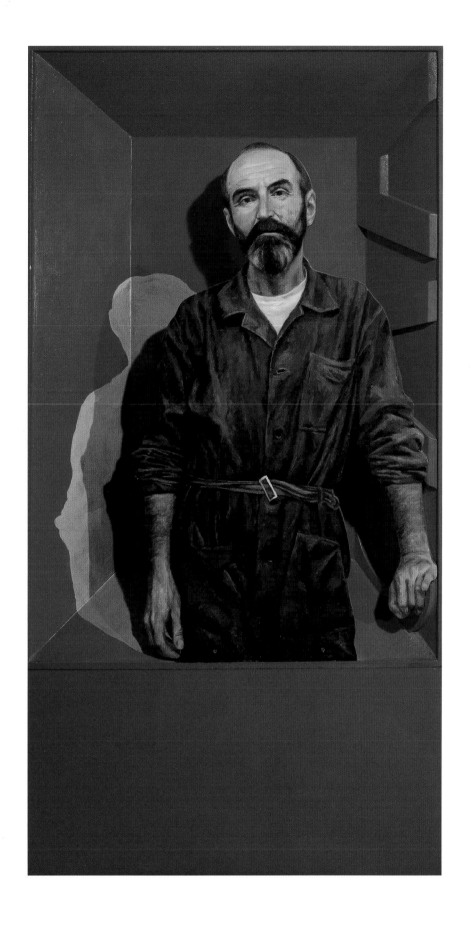

252. TIMUR NOVIKOV, AIRPORT, 1983. PAPER, OIL, CHALK, COLOR FOIL, STAMP, AND COLLAGE ON BLACK FLANNEL, 237 X 237 CM. STATE RUSSIAN MUSEUM, ST. PETERSBURG

253. (OPPOSITE) SERGEI BUGAEV, INDUSTRIAL UNCONSCIOUS II, SKETCH FOR MIR: MADE IN THE 20TH CENTURY, 2000. STEEL AND PHOTOGRAPHY ON ENAMEL, 319 X 165 CM. STATE RUSSIAN MUSEUM, ST. PETERSBURG

254. VLADIMIR DUBOSSARSKY AND
ALEXANDER VINOGRADOV, *TROIKA*,
1995. OIL ON CANVAS, 240 X 600 CM.
XL GALLERY, MOSCOW

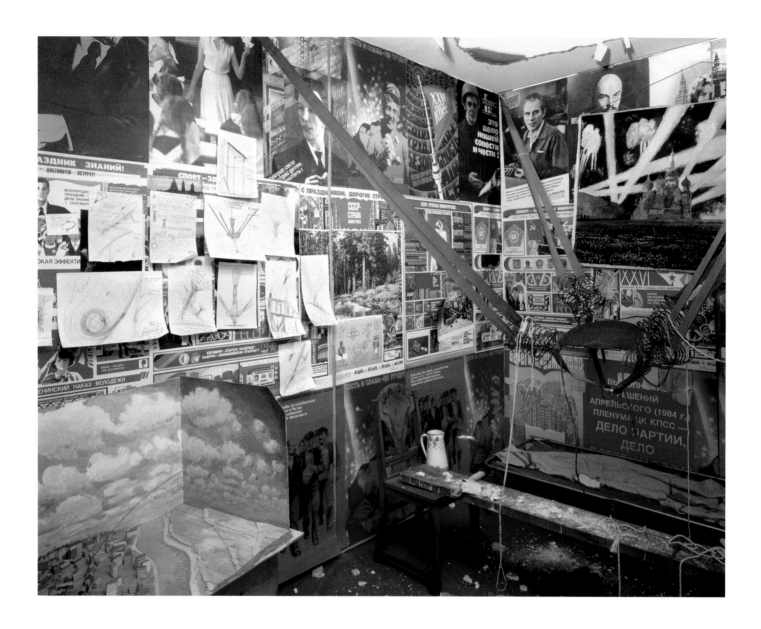

255. ILYA KABAKOV, *THE MAN WHO
FLEW INTO SPACE* (FROM *THE TEN
CHARACTERS* SERIES), 1981–88. WOOD,
RUBBER, ROPE, PAPER, ELECTRIC LAMP,
CHINAWARE, PASTE-UP, RUBBLE, AND
PLASTER POWDER, 96 X 95 X 147 CM.
MUSÉE NATIONALE D'ART MODERNE,
CENTRE GEORGES POMPIDOU, PARIS

256. (OPPOSITE) OLEG KULIK,
COSMONAUT (FROM *THE INSTALLATION
MUSEUM* SERIES), 2003. WAX, MIXED
MEDIA, AND VITRINE, 165 X 175 X
60 CM. XL GALLERY, MOSCOW

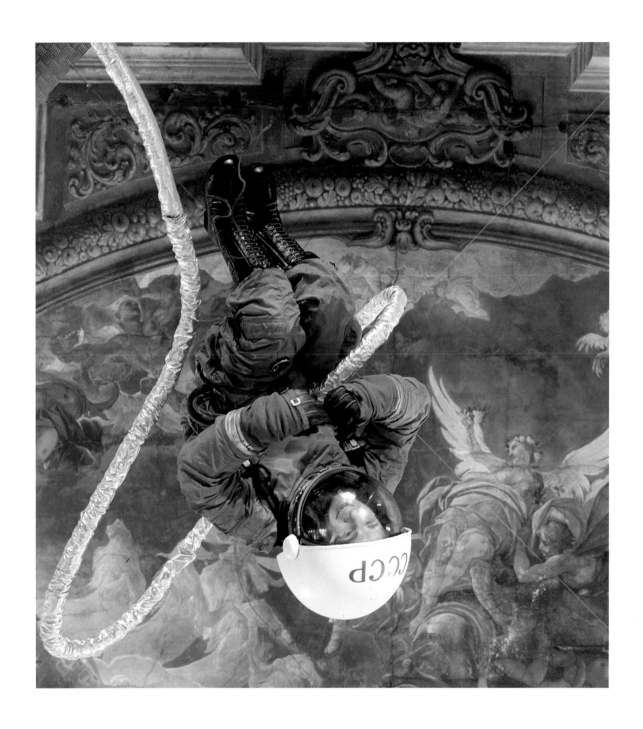

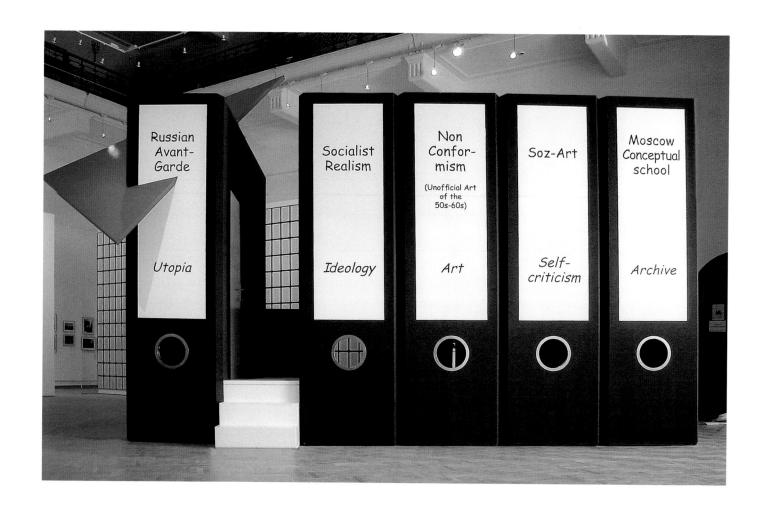

257, 258. VADIM ZAKHAROV,
THE HISTORY OF RUSSIAN ART—FROM
THE AVANT-GARDE TO THE MOSCOW
SCHOOL OF CONCEPTUALISTS, 2003.
PHOTO REPRODUCTIONS AND PLASTIC,
360 X 605 X 390 CM. MUSEUM FÜR
MODERNE KUNST, FRANKFURT-AM-MAIN

SELECTED BIBLIOGRAPHY

General Histories of Russian Art

Auty, Robert, and Dmitry Obolensky, eds. *An Introduction to Russian Art and Architecture*. Cambridge: Cambridge University Press, 1980.

Billington, James H. *The Icon and the Axe: An Interpretive History of Russian Culture*. New York: Alfred A. Knopf, 1966.

Bird, Alan. *A History of Russian Painting*. Oxford: Phaidon, 1987.

Grabar, Igor, Vladimir Kemenov, and Viktor Lazarev, eds. *Istoriya Russkogo Iskusstva*. 13 vols. Moscow: Akademiia nauk SSSR, 1953–64.

Hamilton, George Heard. *The Art and Architecture of Russia*. 3rd ed. New Haven: Yale University Press, 1992.

Leek, Peter. *Russian Painting: From the XVIIIth until the XXth Century*. Bournemouth, England: Parkstone, 1999.

Milner, John. *A Dictionary of Russian and Soviet Artists, 1420–1970*. Suffolk, England: Antique Collectors' Club, 1993.

12TH–17TH CENTURIES: THE AGE OF THE ICON

General

Alpatov, Mikhail. *Early Russian Icon Painting*. Translated by N. John Stone. Moscow: Iskusstvo, 1974.

Briusova, Vera G. *Andrei Rublev i Moskovskaia Shkola Zhivopisi*. Moscow: Moskovskie Uchebniki, Russkii Mir, Veche, 1998.

Brumfield, William, and Milos Velimirovich. *Christianity and the Arts in Russia*. Cambridge: Cambridge University Press, 1991.

Grierson, Roderick, ed. *Gates of Mystery: The Art of Holy Russia*. Fort Worth, Tex.: InterCultura, 1992.

Kochetkov, Igor, ed. *Slovar Russkikh Ikonopistsev XI–XVII vekov*. Moscow: Indrik, 2003.

Kondakov, Nikodim. *The Russian Icon*. Translated by E. H. Minns. Oxford: The Clarendon Press, 1927.

———. *Russkaia Ikona*. 4 vols. Translated by E. H. Minns. Prague: Seminarium Kondakovianum, 1928–33.

Laks, Anna, ed. *Russian Monasteries: Art and Traditions*. Translated by Kenneth MacInnes. St. Petersburg: State Russian Museum, Palace Editions, 1997.

Lazarev, Viktor. *The Russian Icon: From Its Origins to the Sixteenth Century*. Edited by Nancy McDarby and G. I. Vzdornov; translated by Colette Joly Dees. Collegeville, Minn.: Liturgical Press, 1997.

———. *Studies in Early Russian Art*. Translated by Katherine Judelson. London: Pindar, 2000.

Likhachev, Dmitry, et al. *Russia: Storia ed espressione artistica dalla Rus di Kiev al grande impero*. Milan: Jaca Book, 1994. (Also published in Russian as *Velikaia Rus: Istoriia i khudozhestvennaia kultura X–XVII veka*. Moscow: Iskusstvo, 1994.)

Livshits, Lev. *Russkoe Iskusstvo X–XVII vekov*. Moscow: Trilistnik, 2000.

Livshits, Lev, ed. *Drevnerusskoe Iskusstvo. Vizantiia, Rus, Zapadnaia Evropa—Iskusstvo i Kultura*. Moscow: State Research Institute of Art History; St. Petersburg: Dmitry Bulanin, 2002.

Onasch, Konrad, and Annemarie Schnieper. *Icons: The Fascination and the Reality*. Translated by Daniel G. Conklin. New York: Riverside Book Co., 1997.

Ouspensky, Leonid, and Vladimir Lossky. *The Meaning of Icons*. Translated by G. E. H. Palmer and E. Kadloubovsky. Crestwood, N.Y.: St. Vladimir's Seminary Press, 1982.

Smirnova, Engelina. *Moscow Icons: 14th–17th Centuries*. Translated by Arthur Shkarovsky-Raffe. Oxford: Phaidon, 1989.

Uspensky, Boris. *The Semiotics of the Russian Icon*. Edited by Stephen Rudy. Lisse, Holland: Peter de Ridder Press, 1976.

Monographs

Anisimov, Alexander. *Our Lady of Vladimir*. Prague: Seminarium Kondakovianum, 1928.

Danilova, Irina. *The Frescoes of St. Ferapont Monastery*. Translated by G. Strelkova. Moscow: Iskusstvo, 1970.

Demina, Natalia. *Andrei Rublev i Khudozhniki Ego Kruga*. Moscow: Nauka, 1972.

Fedorov, Boris. *Kirillo-Belozerskii Monastyr*. Leningrad: Iskusstvo, 1969.

Greschny, Nikolai. *L'icône de la Trinité d'André Roublev*. Nouan le Fuzelier, France: Editions du Lion de Juda, 1986.

Kochetkov, Igor, and Olga Lelekova. *Kirillo-Belozerskii Monastyr*. Leningrad: Khudozhnik RSFSR, 1979.

Likhacheva, Liudmila, et al. *Dionysius in the Russian Museum: The Five Hundredth Anniversary of Dionysius's Murals in the St. Ferapont Monastery*. Translated by Kenneth MacInnes. St. Petersburg: Palace Editions, 2002.

Sergeev, Valerii. *Andrei Rublev*. Moscow: Terra, 1998.

Vzdornov, Gerold. *Feofan Grek: Tvorcheskoe Nasledie*. Moscow: Iskusstvo, 1983.

THE IMPERIAL COLLECTIONS OF PETER THE GREAT AND CATHERINE THE GREAT

Allen, Brian, and Larissa Dukelskaya, eds. *British Art Treasures from Russian Imperial Collections in the Hermitage.* Exh. cat. Yale Center for British Art, New Haven; Toledo Museum of Art; Saint Louis Art Museum; State Hermitage Museum, Moscow; and Paul Mellon Centre for Studies in British Art, London. New Haven: Yale University Press, 1996.

Deriabina, Ekaterina, et al. *The Hermitage, Leningrad: Western European Painting of the 13th to the 18th Centuries.* Leningrad: Aurora Art Publishers, 1989.

Eisler, Colin. *Paintings in the Hermitage.* New York: Steward, Tabori & Chang, 1990.

Forbes, Isabella, and William Underhill, eds. *Catherine the Great: Treasures of Imperial Russia from the State Hermitage Museum, Leningrad.* Translated by Mark Sutcliffe. London: Booth-Clibborn Editions, 1990.

Kuznetsova, Irina, and Albert Kostenevich. *From Poussin to Matisse: The Russian Taste for French Painting: A Loan Exhibition from the USSR.* Exh. cat. New York: Metropolitan Museum of Art; Chicago: Art Institute of Chicago, 1990.

Neverov, Oleg, and Mikhail Piotrovsky. *The Hermitage: Essays on the History of the Collection.* Edited by Ninel Mikhaliova; translated by Inna Sorokina. St. Petersburg: Slavia Art Books, 1997.

Norman, Geraldine. *The Hermitage: The Biography of a Great Museum.* New York: Fromm International, 1998.

Piotrovsky, Mikhail, ed. *Treasures of Catherine the Great.* Exh. cat. Somerset House, London. London: Thames & Hudson; New York: Harry N. Abrams, 2000.

18TH AND EARLY 19TH CENTURIES

General

Alexeeva, Tatiana, ed. *Russkoe Iskusstvo XVIII veka. Materialy i Issledovaniia.* Moscow: Nauka, 1973.

———, ed. *Russkoe Iskusstvo XVIII–Pervoi Poloviny XIX veka. Materialy i Issledovaniia.* Moscow: Nauka, 1979.

Allenov, Mikhail. *Russkoe Iskusstvo XVIII–Nachala XX veka.* Moscow: Trilistnik, 2000.

Anderson, Roger, and Paul Debreczeny, eds. *Russian Narrative and Visual Art: Varieties of Seeing.* Gainesville: University Press of Florida, 1994.

Bowlt, John E., and Alison Hilton. *The Art of Russia, 1800–1850: An Exhibition from the Museums of the USSR.* Organized by the University of Minnesota Gallery with the Committee on Institutional Cooperation and the Ministry of Culture of the USSR. Minneapolis: The Gallery, 1978.

Chizhova, Irina. *Sudba Pridvornogo Khudozhnika: V. L. Borovikovskii v Peterburge.* St. Petersburg: Lenizdat, 2001.

Cracraft, James. *The Petrine Revolution in Russian Imagery.* Chicago: University of Chicago Press, 1997.

Danilova, Irina, ed. *Khudozhestvennaia Kultura XVIII veka. Materialy nauchnoy konferentsii, 1973.* Moscow: GMII im. Pushkina, 1974.

———, ed. *Vek Prosveshcheniia. Rossiia i Frantsiia. Materialy nauchnoy konferentsii "Vipperovskie chteniia–1987."* Moscow: Gosudarsvennii Muzei Iziashchnykh Iskusstv im. A. S. Pushkina, 1989.

Glinka, Natalia. *Besedy o Russkom Iskusstve: XVIII vek.* St. Petersburg: Knizhnyi mir, 2001.

Gray, Rosalind P. *Russian Genre Painting in the Nineteenth Century.* Oxford: Oxford University Press, 2000.

La France et la Russie au siècle des lumières: Relations culturelles et artistiques de la France et de la Russie au XVIIIe siècle. Exh. cat. Galeries Nationales du Grand Palais, Paris. Paris: Ministère des affaires étrangères, Association française d'action artistique, 1986.

Sarabianov, Dmitry. *Russia-Europa arte e architettura.* Milan: Jaca Book, 2003. (Also published in Russian as *Rossiia i Zapad: istoriko-khudozhestvennye sviazi, XVIII–nachalo XX veka.* Moscow: Iskusstvo XXI vek, 2003.)

Stavrou, Theofanis George, ed. *Art and Culture in Nineteenth-Century Russia.* Bloomington: Indiana University Press, 1983.

Monographs

Alexandrova, Natalia. *Fedor Rokotov.* Translated by Lenina Sorokina. Leningrad: Aurora Art Publishers, 1984.

Alexeeva, Tatiana. *Vladimir Lukich Borovikovsky i Russkaia Kultura na Rubezhe XVIII–XIX Vekov.* Moscow: Iskusstvo, 1975.

———. *Venetsianov and his School.* Translated by Carolyn Justice and Yuri Kleiner. Leningrad: Aurora Art Publishers, 1984.

Allenov, Mikhail. *Alexander Ivanov.* Moscow: Trilistnik, 1997.

Androsov, Sergei. *Zhivopisets Ivan Nikitin.* St. Petersburg: Dmitry Bulanin, 1998.

Barooshian, Vahan. *The Art of Liberation: Alexander A. Ivanov.* Lanham, Md.: University Press of America, 1987.

Caffiero, Gianni, and Ivan Samarine. *Seas, Cities and Dreams: The Paintings of Ivan Aivazovsky.* London: Alexandria Press, in association with Laurence King, 2000.

Goldovsky, G., and Yevgenia Petrova. *Karl Briullov, 1799–1852: Painting, Drawing and Watercolours from the Collection of the Russian Museum.* Translated by Kenneth MacInnes. St. Petersburg: Palace Editions, 1999.

Kaganovich, Abram. *Anton Losenko i Russkoe Iskusstvo Serediny XVIII stoletiia*. Moscow: Izd-vo Akademii khudozhestv SSSR, 1963.

Leontieva, Galina. *Karl Briullov: The Painter of Russian Romanticism*. Edited by Paul Williams and Valery Fateev; translated by Peter Deviatkin and Alla Zagrebina. Bournemouth, England: Parkstone, 1996.

Mikhailova, Kira. *Grigorii Soroka, 1832–1864*. Exh. cat. State Russian Museum, Leningrad. Leningrad: State Russian Museum, 1975.

Moleva, Nina. *Zagadki Rokotova, ili, Zhizn Velikogo Portretista Vremen Ekateriny*. Moscow: Novaia realnost, 1994.

Orest Kiprensky: Novye Materialy i Issledovaniia. Sbornik Statey. St. Petersburg: Iskusstvo-SPB, 1993.

Petinova, Elena. *Vasily Andreevich Tropinin*. Leningrad: Khudozhnik RSFSR, 1987.

Shumova, Marina. *Fedotov*. Translated by P. Case. Leningrad: Aurora Art Publishers, 1974.

———, ed. *Pavel Fedotov: k 175–letiyu so dnia rozhdeniia*. Exh. cat. State Russian Museum, St. Petersburg, and State Tretyakov Gallery, Moscow. St. Petersburg: Seda-S, 1993.

Valitskaya, Alisa. *Dmitry Grigorievich Levitsky: 250 let so dnia rozhdeniya*. Leningrad: Khudozhnik RSFSR, 1985.

Zhidkov, German. *Mikhail Shibanov, khudozhnik vtoroi poloviny XVIII veka*. Moscow: Iskusstvo, 1954.

Zimenko, Vladislav. *Orest Adamovich Kiprensky: 1782–1836*. Moscow: Iskusstvo, 1988.

LATE 19TH CENTURY

General

Eickel, Nancy, ed. *Russia, the Land, the People: Russian Painting, 1850–1910: From the Collections of the State Tretyakov Gallery, Moscow, and the State Russian Museum, Leningrad*. Exh. cat. Translated by Nicholas Berkoff with assistance from Karen E. Anderson and Sally Hoffmann. Renwick Gallery, National Museum of American Art, Smithsonian Institution, Washington, D.C.; David and Alfred Smart Gallery of the University of Chicago; and Fogg Art Museum, Harvard University, Cambridge. Washington, D.C.: Smithsonian Institution Traveling Exhibition Service; Seattle: University of Washington Press, 1986.

Elliott, David, ed. *Photography in Russia 1840–1940*. London: Thames & Hudson, 1992.

Ely, Christopher. *This Meager Nature: Landscape and National Identity in Imperial Russia*. DeKalb, Ill.: Northern Illinois University Press, 2002.

Gray, Camilla. *The Russian Experiment in Art, 1863–1922*. 2nd ed., revised and enlarged by Marian Burleigh-Motley. London: Thames & Hudson, 1986.

Guerman, Mikhail. *Russian Impressionists and Postimpressionists*. Translated by Chandra Troescher. Bournemouth, England: Parkstone, 1998.

Jackson, David, and Patty Wageman, eds. *Russian Landscape*. Exh. cat. Groninger Museum, The Netherlands, and the National Gallery of Art, London. Schoten, Belgium: BAI, 2003.

Kruglov, Vladimir, et al. *Symbolism in Russia*. Translated by Kenneth MacInnes. St. Petersburg: Palace Editions, 1996.

Nesterova, Elena. *The Itinerants: The Masters of Russian Realism: Second Half of the 19th and Early 20th Centuries*. Translated by Paul Williams and Jovan Nicolson. Bournemouth, England: Parkstone, 1996.

Sarabianov, Dmitry. *Russian Art: From Neoclassicism to the Avant-Garde, 1800–1917: Painting–Sculpture–Architecture*. New York: Harry N. Abrams, 1990.

Valkenier, Elizabeth Kridl. *Russian Realist Art: The State and Society: The Peredvizhniki and Their Tradition*. Ann Arbor, Mich.: Ardis, 1977.

———, ed. *The Wanderers: Masters of 19th-Century Russian Painting: An Exhibition from the Soviet Union*. Exh. cat. Organized by Intercultura, Fort Worth, Tex., and the Dallas Museum of Art, in cooperation with the Ministry of Culture of the USSR. Dallas: Dallas Museum of Art, 1990.

Monographs

Barooshian, Vahan. *V. V. Vereshchagin: Artist at War*. Gainesville: University Press of Florida, 1993.

Fedorov-Davydov, Alexei. *Issac Levitan: The Mystery of Nature*. Translated by George Nemtsky. Bournemouth, England: Parkstone, 1995.

Isdebsky-Pritchard, Aline. *The Art of Mikhail Vrubel (1856–1910)*. Ann Arbor, Mich.: UMI Research Press, 1982.

King, Averil. *Isaak Levitan: Lyrical Landscape*. London: Philip Wilson, 2004.

Kurochkina, Tatiana. *Ivan Nikolaevich Kramskoi*. Moscow: Izobrazitelnoe iskusstvo, 1980.

Lebedev, Andrei. *Vasily Vasilievich Vereshchagin. Zhizn i Tvorchestvo, 1842–1904*. Moscow: Iskusstvo, 1972.

Manin, Vitaly. *Arkhip Ivanovich Kuindzhi*. St. Petersburg: Khudozhnik RSFSR, 1990.

Rusakova, Alla A. *Mikhail Nesterov*. Leningrad: Aurora Art Publishers, 1990.

Shanina, Nadezhda. *Victor Vasnetsov*. Translated by V. Friedman. Leningrad: Aurora Art Publishers, 1979.

Shumova, Marina. *Vasily Perov: Paintings, Graphic Works.* Translated by Graham Whittaker. Leningrad: Aurora Art
 Publishers, 1989.
Shuvalova, Irina. *Ivan Shishkin.* Edited by Paul Williams and Valery Fateev. Bournemouth, England: Parkstone, 1996.
Valkenier, Elizabeth Kridl. *Ilya Repin and the World of Russian Art.* Studies of the Harriman Institute. New York:
 Columbia University Press, 1990.
———. *Valentin Serov: Portraits of Russia's Silver Age.* Evanston, Ill.: Northwestern University Press, 2001.
Van Os, Henk, and Sjeng Scheijen. *Ilya Repin: Russia's Secret.* Exh. cat. Groninger Museum, The Netherlands. Zwolle,
 The Netherlands: Waanders, 2001.

EARLY 20TH CENTURY

The Shchukin and Morozov Collections

Barskaya, Anna. *French Painting, Second Half of the 19th to Early 20th Century: The Hermitage Museum, Leningrad: A Complete
 Publication of the Collection.* Translated by Philippa Hentgès and Yuri Pamfilov. Leningrad: Aurora Art Publishers,
 1975.
Barskaya, Anna, and Albert Kostenevich. *French Painting, Mid-Nineteenth to Twentieth Centuries. The State Hermitage
 Museum.* Translated by Valery Dereviagin, Valery Fateev, and Yuri Kleiner. Florence: Giunti, 1991. (Also pub-
 lished in Russian as *Frantsuzskaia Zhivopis: Vtoraia polovina XIX–XX vek.* Moscow: Iskusstvo, 1991.)
Demskaya, Alexandra, and Natalia Semenova. *U Shchukina, na Znamenke.* Moscow: Arena, 1993.
Kean, Beverly Whitney. *All the Empty Palaces: The Great Merchant Patrons of Modern Art in Pre-Revolutionary Russia.* New
 York: Universe Books, 1983.
———. *French Painters, Russian Collectors: The Merchant Patrons of Modern Art in Pre-Revolutionary Russia.* London: Hodder
 & Stoughton, 1994.
Koltzsch, Georg-W., ed. *Morozov and Shchukin, the Russian Collectors: Monet to Picasso.* Exh. cat. Museum Folkwang,
 Essen; Pushkin Museum of Fine Arts, Moscow; and Hermitage, St. Petersburg. Cologne: DuMont, 1993.
Kostenevich, Albert, and Natalia Semenova. *Collecting Matisse.* Paris: Flammarion, 1993.
Kostenevich, Albert. *French Art Treasures at the Hermitage: Splendid Masterpieces, New Discoveries.* New York: Harry N.
 Abrams, 1999.
Ruckman, Jo Ann. *The Moscow Business Elite: A Social and Cultural Portrait of Two Generations, 1840–1905.* DeKalb:
 Northern Illinois University Press, 1984.
Semenova, Natalia. *Zhizn i Kollektsiia Sergeia Shchukina.* Moscow: Trilistnik, 2002.

The Avant-Garde
General

Andel, Jaroslav, et al. *Art Into Life: Russian Constructivism, 1914–1932.* Exh. cat. Henry Art Gallery, University of
 Washington, Seattle; Walker Art Center, Minneapolis; State Tretyakov Gallery, Moscow. New York: Rizzoli, 1990.
Bann, Stephen, ed. *The Tradition of Constructivism.* New York: Da Capo Press, 1974.
Bowlt, John. *Russian Art of the Avant-Garde: Theory and Criticism, 1902–1934.* New York: The Viking Press, 1976.
———. *The Silver Age: Russian Art of the Early Twentieth Century and the "World of Art" Group.* Newtonville, Mass.: Oriental
 Research Partners, 1982.
Bowlt, John E., and Matthew Drutt, eds. *Amazons of the Avant-Garde: Alexandra Exter, Natalia Goncharova, Liubov Popova, Olga
 Rozanova, Varvara Stepanova, and Nadezhda Udaltsova.* Exh. cat. New York: Solomon R. Guggenheim Foundation,
 2000.
Buchloh, Benjamin. "From *Faktura* to Factography." Reprinted in *October: The First Decade, 1976–1986.* Edited by
 Annette Michelson, Rosalind Krauss, Douglas Crimp, and Joan Copjec. Cambridge: MIT Press, 1987. First
 published in *October* 30 (1984), pp. 83–119.
Buck-Morss, Susan. *Dreamworld and Catastrophe: The Passing of Mass Utopia in East and West.* Cambridge: MIT Press, 2000.
Clark, T. J. "God Is Not Cast Down." In *Farewell to an Idea.* New Haven: Yale University Press, 1999.
Degot, Ekaterina. *Russkoe Iskusstvo XX veka.* Moscow: Trilistnik, 2000.
Dickerman, Leah, ed. *Building the Collective: Soviet Graphic Design, 1917–1937.* New York: Princeton Architectural Press, 1996.
Gough, Maria. *The Artist as Producer: Russian Constructivism in Revolution.* Berkeley: University of California Press, 2005.
The Great Utopia: The Russian and Soviet Avant-Garde, 1915–1932. Exh. cat. Solomon R. Guggenheim Museum, New York;
 State Tretyakov Gallery, Moscow; State Russian Museum, St. Petersburg; and Schirn Kunsthalle, Frankfurt.
 New York: Guggenheim Museum, 1992.
Kiaer, Christina. *Imagine No Possessions: The Socialist Objects of Russian Constructivism.* Cambridge: MIT Press, 2005.
Lodder, Christina. *Russian Constructivism.* New Haven: Yale University Press, 1983.
Petrova, Evgenia, Lidia Iovleva, and Alexander Morozov, eds. *The Knave of Diamonds in the Russian Avant-Garde.*
 Translated by Kenneth MacInnes. St. Petersburg: Palace Editions, 2004.

Rudenstine, Angelica Zander, ed. *Russian Avant-Garde Art: The George Costakis Collection*. New York: Harry N. Abrams, 1981.

Taylor, Brandon. *Art and Literature under the Bolsheviks*. 2 vols. London: Pluto Press, 1991.

Williams, Robert. *Russian Art and American Money, 1900–1940*. Cambridge: Harvard University Press, 1980

Yablonskaya, Miuda. *Women Artists of Russia's New Age, 1910–1935*. Edited by Anthony Parton. New York: Rizzoli, 1990.

Monographs

Arskaya, Irina, et al. *Kazimir Malevich in the Russian Museum*. St. Petersburg: Palace Editions, 2000.

Bois, Yve-Alain. "El Lissitzky: Radical Reversibility." *Art in America* (April 1988), pp. 161–81.

Dabrowski, Magdalena. *Liubov Popova*. Exh. cat. New York: Museum of Modern Art, 1991.

Dabrowski, Magdalena, Leah Dickerman, and Peter Galassi. *Aleksandr Rodchenko*. Exh. cat. New York: Museum of Modern Art, 1998.

D'Andrea, Jeanne, ed. *Kazimir Malevich, 1878–1935*. National Gallery of Art, Washington, D.C.; Armand Hammer Museum of Art and Cultural Center, Los Angeles; Metropolitan Museum of Art, New York. Los Angeles: Armand Hammer Museum of Art and Cultural Center, in association with the University of Washington Press, 1990.

Drutt, Matthew. *Kazimir Malevich: Suprematism*. Exh. cat. The Solomon R. Guggenheim Museum, New York, and the Menil Collection, Houston. New York: Solomon R. Guggenheim Foundation, 2003.

Gurianova, Nina. *Exploring Color: Olga Rozanova and the Early Russian Avant-Garde, 1910–1918*. Translated by Charles Rougle. Amsterdam: G&B Arts Int., 2000.

Harten, Jürgen, and Anatoly Strigalev. *Vladimir Tatlin Retrospektive*. Cologne: DuMont, 1992.

Kovtun, Yevgeny, Stanislas Zadora, and Nicole Ouvrard. *Filonov*. Exh. cat. Centre George Pompidou, Paris, and State Russian Museum, St. Petersburg. Paris: Editions du Centre Pompidou, 1990.

Lavrentiev, Alexander. *Varvara Stepanova: The Complete Work*. Translated by Wendy Salmond. Cambridge: MIT Press, 1988.

Nisbet, Peter, ed. *El Lissitzky, 1890–1941*. Catalogue for an Exhibition of Selected Works from North American Collections, the Sprengel Museum Hanover, and the Staatliche Galerie Moritzburg Halle. Cambridge: Harvard University Art Museums, 1987.

Noever, Peter, ed. *Rodchenko—Stepanova: The Future Is Our Only Goal*. Munich: Prestel Verlag, 1991.

Parton, Anthony. *Mikhail Larionov and the Russian Avant-Garde*. Princeton: Princeton University Press, 1993.

Roethel, Hans K., and Jean K. Benjamin. *Kandinsky: Catalogue Raisonné of the Oil Paintings*. 2 vols. Ithaca, N.Y.: Cornell University Press, 1982, 1984.

Vakar, Irina, and Tatiana Mikhienko. *Malevich o sebe, sovremenniki o Maleviche: Pisma, dokumenty, vospominaniia, kritika*. 2 vols. Moscow: RA, 2004.

Zhadova, Larissa Alexeevna, ed. *Tatlin*. New York: Rizzoli, 1988.

SOCIALIST REALISM THROUGH THE THAW

Banks, Miranda, ed. *The Aesthetic Arsenal: Socialist Realism under Stalin*. New York: The Institute for Contemporary Art, 1993.

Bown, Matthew Cullerne. *Art under Stalin*. New York: Holmes & Meier, 1991.

———. *Socialist Realist Painting*. New Haven: Yale University Press, 1998.

Groys, Boris. *The Total Art of Stalinism: Avant-Garde, Aesthetic Dictatorship, and Beyond*. Translated by Charles Rougle. Princeton: Princeton University Press, 1992.

Groys, Boris, and Max Hollein, eds. *Dream Factory Communism: The Visual Culture of the Stalin Era*. Exh. cat. Schirn Kunsthalle, Frankfurt. Osfildern-Ruit, Germany: Hatje-Cantz, 2003.

Kopanski, Karlheinz, Jewgenija Petrowa, and Karin Stengel, eds. *Agitation zum Glück: Sowjetische Kunst der Stalinzeit*. Exh. cat. Translated by Tatiana Kalugina. State Russian Museum, St. Petersburg, and Cultural Department, documenta Archiv, Kassel, Germany. Düsseldorf: Interarteks; Bremen: Temmen, 1994. (Also published in Russian as *Agitatsiia za Schaste: Sovetskoe iskusstvo stalinskoi epokhi*. Düsseldorf: Interarteks; Bremen: Temmen, 1994.)

Lahusen, Thomas, and Evgeny Dobrenko, eds. *Socialist Realism Without Shores*. Durham, N.C.: Duke University Press, 1997.

Morozov, Alexander. *Konets Utopii: Iz istorii iskusstva v SSSR 1930kh godov*. Moscow: Galart, 1995.

Reid, Susan E. "All Stalin's Women: Gender and Power in Soviet Art of the 1930s." *Slavic Review* 57, no. 1 (spring 1998), pp. 133–73.

———. "Socialist Realism in the Stalinist Terror: The Industry of Socialism Art Exhibition, 1935–1941." *The Russian Review* 60 (April 2000), pp. 153–84.

Tupitsyn, Margarita. *The Soviet Photograph, 1924–37*. New Haven: Yale University Press, 1996.

Wolf, Erika. "When Photographs Speak, to Whom Do They Talk? The Origins and Audience of *SSSR na Stroike* (USSR in Construction)." *Left History* 6, no. 2 (fall 1999), pp. 53–82.

Wood, Paul. "Realisms and Realities." In David Batchelor, et al. *Realism, Rationalism, Surrealism: Art between the Wars. Modern Art Practices and Debates.* New Haven: Yale University Press, 1993.

1957 TO THE PRESENT

General

Andreeva, Ekaterina. *Sots Art: Soviet Artists of the 1970s–1980s.* East Roseville, NSW, Australia: Craftsman House: G+B Arts Int., 1995.

"L'Art au Pays des Soviets, 1963–88." Special issue. *Les Cahiers du Musée National d'Art Moderne* No. 26 (winter 1988), pp. 1–110.

Degot, Ekaterina. *Contemporary Painting in Russia.* Roseville East, NSW, Australia: Craftsman House: G+B Arts Int., 1995.

Dodge, Norton, ed. *Aptart: Moscow Vanguard Art in the 80s.* Mechanicsville, Md.: Cremona Foundation, 1985.

Dodge, Norton, and Alison Hilton. *New Art from the Soviet Union.* Washington, D.C.: Acropolis Books, 1977.

Erofeev, Andrei. *Non-Official Art: Soviet Artists of the 1960s.* East Roseville, NSW, Australia: Craftsman House; G+B Arts Int., 1995.

Erofeev, Andrei, Tatiana Volkova, and Sergei Epikhin, eds. *Accomplices: Collective and Interactive Works in Russian Art of the 1960s–2000s.* Exh. cat. State Tretyakov Gallery, special project for the First Biennale of Contemporary Art, Moscow. Moscow: State Tretyakov Gallery, 2005.

Forbidden Art—The Postwar Russian Avant-Garde. Exh. cat. Art Center, College of Design, Alyce de Roulet Williamson Gallery, Pasadena, Calif.; State Russian Museum, St. Petersburg; State Tretyakov Gallery, Moscow; and Miami University Art Museum, Oxford, Ohio. Los Angeles: Curatorial Assistance, Inc.; New York: Distributed Art Publishers, 1998.

Karasik, Irina, comp. *Otdel Noveishikh Techenii, 1991–2001: Istoriia, kollektsiia, vystavki.* Edited by Alexander Borovsky. St. Petersburg: State Russian Museum, Palace Editions, 2004.

Kovalev, Andrei. *Between the Utopias: New Russian Art during and after Perestroika (1985–1993).* Roseville East, NSW, Australia: Craftsman House: G+B Arts Int., 1995.

Rosenfeld, Alla, and Norton T. Dodge, *Nonconformist Art: The Soviet Experience, 1956–1986.* Exh. cat. Published to accompany the exhibition *From Gulag to Glasnost: Nonconformist Art from the Soviet Union* at the Jane Voorhees Zimmerli Art Museum, Rutgers, the State University of New Jersey. London: Thames & Hudson, in association with the Jane Voorhees Zimmerli Art Museum, 1995.

Ross, David A., ed. *Between Spring and Summer: Soviet Conceptual Art in the Era of Late Communism.* Cambridge: MIT Press, 1990.

Solomon, Andrew. *The Irony Tower: Soviet Artists in a Time of Glasnost.* New York: Alfred A. Knopf, 1991.

Tupitsyn, Margarita, ed. *Sots art: Eric Bulatov, Vitaly Komar and Alexander Melamid, Alexander Kosolapov, Leonid Lamm, Leonid Sokov, Kazimir Passion Group.* New York: New Museum of Contemporary Art, 1986.

——, ed. *Margins of Soviet Art: Socialist Realism to the Present.* Milan: Giancarlo Politi, 1989.

Monographs

De Foras, Marie-Therese, et al., *Oscar Rabin: Retrospective Exhibition, 1957–1984.* Jersey City, N.J.: S.A.S.iE. Museum of Russian Contemporary Art in Exile, 1984.

Grachos, Louis, ed. *Afrika.* Los Angeles: Fisher Gallery, University of Southern California, 1991.

Kabakov, Ilya. *Ilya Kabakov: Ten Characters.* Exh. cat. Institute of Contemporary Art, London. London: ICA, in association with Ronald Feldman Fine Arts, New York, and Untitled II, New York, 1989.

Kabakov, Ilya. *Über die "totale" Installation / O "totalnoi" installiatsii / On the "total" installation.* Ostfildern-Ruit, Germany: Hatje-Cantz, 1995.

Lingwood, James, ed. *Erik Bulatov, Moscow.* Exh. cat. Institute of Contemporary Arts, London; MIT List Visual Arts Center, Cambridge; Newport Harbor Art Museum, Newport Beach, Calif.; and Renaissance Society at the University of Chicago. Zurich and New York: Parkett Publishers, in collaboration with ICA, London, 1989.

Ratcliff, Carter. *Komar and Melamid.* New York: Abbeville Press, 1988.

Stoss, Toni, ed. *Ilya Kabakov: Installations 1983–2000: Catalogue raisonné.* 2 vols. Düsseldorf: Richter Verlag, 2001.

Wollen, Peter. *Komar and Melamid.* Exh. cat. Fruitmarket Gallery, Edinburgh, and Museum of Modern Art, Oxford. Edinburgh: Fruitmarket Gallery, 1985.

INDEX OF REPRODUCTIONS